Going Public: A field guide to developments in art in public places

Written by
Jeffrey L. Cruikshank and
Pam Korza

Introductions by
Richard Andrews and
Kathy Halbreich

Editor
Pam Korza

Contributing Editor
Richard Andrews

Published by
the Arts Extension Service in cooperation with the
Visual Arts Program
of the National Endowment for the Arts

Going Public:
A field guide to developments in art in public places

Published by the Arts Extension Service
Division of Continuing Education University of Massachusetts
Amherst, MA 01003
413-545-2360

This publication was made possible through a cooperative
agreement between the Arts Extension Service and the Visual
Arts Program of the National Endowment for the Arts.

Library of Congress Catalog Card Number: 87-73446
ISBN 0-945464-00-2

Printed in the United States of America.

The Arts Extension Service, Division of Continuing Education,
University of Massachusetts at Amherst, works as a catalyst for
better management of the arts in communities through
continuing education for artists and arts organizations.

The National Endowment for the Arts, established by Congress
in 1965, exists to foster the growth and development of the arts in
the United States and to preserve and enrich the nation's cultural
resources, and provide opportunities for wider experience in all
the arts.

The Visual Arts Program provides support to organizations
that serve visual artists and fellowships to individual artists.
Funding for public art projects is possible through the
Art in Public Places category. The Visual Arts Program also acts
as a national forum to assist in the exchange of ideas and
as a catalyst to promote the best developments in the arts and
education about the arts.

Copies of *Going Public: A field guide to developments in art in
public places* may be obtained from the Arts Extension Service,
Division of Continuing Education, University of Massachusetts,
Amherst, MA 01003, 413-545-2360 .

Book design by Judy Kohn
Boston, Massachusetts

Printed by Excelsior Printing
North Adams, Massachusetts

Table of Contents

5 Foreword, by Richard Andrews
7 Acknowledgments
8 Introduction to the Guide, by Pam Korza
9 Stretching the Terrain: Sketching Twenty Years of
 Public Art, by Kathy Halbreich

The Administration of Public Art

14 **Why Public Art?**
15 The Phoenix 1990 Plan
16 Lessons from Dallas
17 Public Art Master Planning in Dallas: An outline
19 Conceptions of public art Washington
19 State Arts Commission Fact Sheet
21 The mission statement: a key tool
22 Summary

23 **Funding Models for Public Art**
23 Projects initiated by the private, not-for-
24 Two Arizona cases
27 Projects initiated by the public sector
27 Funding through the percent for art model
29 Seattle Percent for Art Ordinance
31 Flexibility: A goal of percent for art legislation
 Flexibility of funding source 31
 Flexibility of funding uses 31
 Flexibility in administrative authority 32
 Flexible administrative resources 33
 Flexible maintenance resources 34
 Flexible educational resources 35
36 Public art initiated by the private, for profit sector
39 Redevelopment
40 Los Angeles Community Redevelopment Agency model
44 Zoning
46 The promise of and problems with zoning
47 Bethesda: zoning for art

50 **Integrating Public Art in Community Planning**
50 Planning for action
51 Seattle
53 Seattle Municipal Art Plan
54 Dade County Fairmount
54 Park Art Association: an historical precedent in public
 art planning
55 Cedar Rapids
55 Summary

57 **Guidelines for Implementation**
59 Interagency coordination
59 Washington State Arts Commission Interagency
 Agreement
60 Project management: people and timelines
62 Sacramento Metropolitan Arts Commission Job
 Description
66 Artist selection procedures
67 Purchase or commission
68 Model procedures for artist selection Issues in artist
 selection
69 Arts On The Line: a case study in artist selection
73 Summary on artist selection procedures
74 The proposal stage: artist information needs
76 Agency information needs
76 Call forProposals, City of Concord, California
79 Contingency budgeting
80 Proposal contracts and fees
80 Ownership of proposal-related work
81 Contracts
82 Additional notes: scope of services
84 Compensation and payment schedule
85 Liability and insurance
86 Liability and insurance: an annotation by Barbara
 Hoffman
90 Realizing the vision
91 Fabrication and installation
93 Collaboration: artists and architects
96 "Artists on Design Teams"
99 Protecting the integrity of artwork and artist

103 **Community Involvement and Education**
10 Ways to participate
103 MacArthur Park
105 Arts On The Line
105 Ways to be informed: Events and programs
106 The media
108 A way to learn
109 Metro-Dade Art in Public Places
110 A way to react
110 Seattle Arts: Ways of seeing
111 Metro-Dade Art in Public Places Learning Package
112 First Banks

116 **Administering Public Art: A Summary**

The Preservation of Public Art

118 **Introduction**

120 **Threats and Rights**
120 Owner neglect
 Inscape, by Ed McGowin 120

123 Relocation
 Admiral Farragut, by Augustus St. Gaudens 123
 Gwenfritz, by Alexander Calder 124
125 Removal
 Chain Link Maze, by Richard Fleischner 126
 The Lincoln Building murals, by Richard Haas 127
 The 12 Labors of Hercules, by Michael Spafford 128
130 Inadequate planning/legal standing
 Freeway Lady, by Kent Twitchell 130
 California Art Preservation Act 130
131 Alteration
132 Artists' rights and "moral rights"
134 Summary

135 Collection Management
135 Purpose of a collection management plan
137 Goals of the public art collection
139 Acquisition of public art
140 Documentation, care, and deaccession
142 Funding collection management activities

147 Documentation
147 Accessing documents: accession number
148 Information needs
150 Photographic documentation
150 Protecting documents

151 Conservation
151 Clarifying terminology
152 King County Arts Commission Policy on Maintenance
153 Conservation record: a contract element
155 Conservation Record sample form
156 Conserving existing public artworks
156 Examination
157 Preservation and maintenance
158 Restoration: general principles
160 Vandalism
162 Summary

163 Review Procedures for Public Artworks
164 Gaining a perspective on controversy
166 Removal policies and procedures
 Summary of the review process 166
 Public Artwork Review Process: task force draft 167
170 Final thoughts

171 Public Education Policy

173 In Closing

Appendix

177 **Documents**

280 **Selected Bibliography**

284 **Resource List**

287 **Public Art Programs**

299 **Participants in the Public Art Policy Project**

Foreword

In 1965, when the National Endowment for the Arts was created, there were only a handful of ongoing public art programs in this country. In 1988, there are at least 135 annually funded programs at the state and local levels with many more single projects undertaken by communities. In the last 20 years over 518 art in public places projects in 47 states and the District of Columbia have received NEA matching funds. The last significant period of federal support for public art (prior to 1967) occurred during the 1930s with the Works Progress Administration (WPA) and Treasury Section Art Programs. The character of support for public art in 1988 is markedly different from the WPA period, and the change is most clearly seen in the local origins of most projects, as contrasted with the centralization of the WPA period.

Today, instead of a single program radiating out, we have hundreds of independent projects underway, many of which begin with good intentions and end, as they rightly should, as small, community-based projects which achieve their financial, artistic, and social goals through an ad hoc process. Other projects, or ongoing programs, have larger civic ambitions and undertake a lengthy process as they work with and through government agencies, define the goals of their project, seek out and select artists, meet with diverse community groups and enter into contracts for the creation and long-term care of artworks.

The increasing number of projects has provided artists, design professionals, administrators, and the public with a growing realization of the potential for artists to be involved in a wide range of projects, from art object to environment to urban plan. Yet even as the options grow they may often be accompanied by increased confusion among participants about the intentions for a project, its appropriateness for a site or an audience, and a lack of information about how best to bring intentions and reality together.

One aim of this publication is to provide a source of information on those processes which are central to the commissioning of a public artwork or the administration of an ongoing program. However, we are conscious of the fact that the vitality and diversity of public art in this country is, in part, dependent on a sense of experimentation, in both the artistic and administrative sense, and we are wary of providing a "how to" guide to public art. The most interesting projects and programs are formed from a clear understanding of the particular context, whether site or city, which then serves as the foundation for the meaningful involvement of artists in the building of public places. For this reason, the particulars of one public art program are not readily transferable to another city or situation.

There is a danger in the codification of public art processes as a means to offset controversy, and in particular, the tendency toward administrative definition of "successful" approaches to public art such as design teams, functional art, and community review processes. A too rigid classification for the bureaucracy of what, heretofore, have been situational and ad hoc responses to particular contexts may inhibit or limit exploration and yield an art of blandness and consensus. There are many valuable lessons to be gleaned from the failures and successes of the last 20 years: information about how projects begin, raise funds, select artists, work with the public; and the technical side of public art: contracts, ordinances, redevelopment authorities, and project management. There is much available information which needed to be gathered, reviewed, and evaluated before selecting projects or examples for this publication which might be of use to those initiating or continuing public art programs.

However, there is another side of public art which has raised many important and far-reaching concerns in recent years yet for which little documentation or analysis exists. The arena referred to here is responsibility for public art already in existence, encompassing the issues of conservation and maintenance as well as the often controversial options of relocation or deaccessioning. Here we include not only the art in public places of the past 20 years but also all those other works which we inherit from previous generations. The massive effort to restore the *Statue of Liberty* and the outcry over the request to remove Richard Serra's *Tilted Arc* are recent examples which indicate the need for thorough study of this area. All too often the excitement of commissioning new works of public art has overshadowed the need to evaluate and conserve that which already exists. However this is a murky area where art history and the need for change in the built environment may coexist, but may also clash mightily. Change is a necessary component of the building of cities, but its effect on the future of individual works of art is uncertain. This effect is greatly increased by the commissioning and creation of works of art which are conceptually and physically intertwined with a particular site. Such artwork, like works of architecture, tend to be preserved only as long as their original function is maintained or through the efforts of those who would save them for their artistic or historical merit.

We chose to explore these questions by convening three meetings to which artists and other individuals with experience in all the areas touched by public art were invited: art history, architecture, landscape design, law, administration, politics, community, and education. A total of 32 people participated in the meetings and subsequently reviewed and commented on documents to be included in the publication. The first meeting held in Miami on January 8 and 9, 1987 addressed the factors that bring public art into being while the second meeting held January 22 and 23, 1987 in Philadelphia looked at the preservation of existing art in public places. The final meeting held April 21 and 22, 1987 in Washington, D.C. reviewed the reports from the prior meetings and recommended the case studies and documents which would become the foundation of the publication.

This publication has been nicknamed a "workbook" on public art to convey the idea that it should be seen as a working document which provides insight into the efforts of those involved in a myriad of individual projects over the years. It is not a guidebook with a set of rules for public art but a source book of case studies and observations, sometimes contradictory, but reflective of the seriousness of purpose and sense of exploration which guides artists, administrators, community members, designers, and others as they seek to make more meaningful public places.

I would like to thank all of the panel members who lent their time and expertise to the meetings and who spent additional hours revising and seeking out documents for the publication. I particularly want to thank Pam Korza of the Arts Extension Service for her superb and tireless organization of the meetings and publication, Kathy Halbreich, who served as editor of the meeting transcripts and essential advisor to the project, and Jeff Cruikshank for an excellent job of writing this book from a challenging set of materials.

Richard Andrews
Director, Visual Arts Program
National Endowment for the Arts

6

Ed Carpenter, window for the Justice Center, Portland, OR, Metropolitan Arts Commission, 1983.
photo: John Baugess

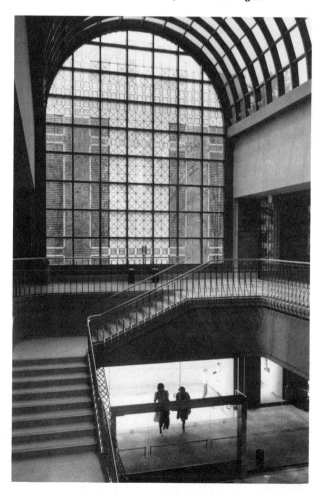

Acknowledgments

There are many people whose advice, participation, and review have lent validity and breadth to the topics of public art administration and preservation presented in *Going Public*.

It is to the credit of the Visual Arts Program of the National Endowment for the Arts, under the direction of Richard Andrews, that the Public Art Policy Project and this publication were initiated and funded. Special gratitude is extended to the Endowment for recognizing the importance of public art and for providing the leadership which guided all efforts toward addressing the information needs of those involved in public art. Bert Kubli was an extremely important advisor at many different points. I would especially like to thank Richard Andrews for his vision and insight. They were a constant guide and presence throughout this project. Without his thoughts this publication would not have been possible.

The task force meetings formed the foundation for this book. My thanks to Kathy Halbreich whose help was invaluable in designing the meetings and leading them to productive results, and to Marjorie Tuttle whose ambitious research uncovered a volume of materials analyzed in the meetings and which appear in this book.

The thirty-two panelists who comprised the task force and whose ideas form the primary content of *Going Public* are commended for their knowledge, vision, and commitment to public art and to this project and for the many hours spent in preparation, discussion, and review of information. They are listed in the Appendix section with biographical information. Cesar Trasobares of Metro-Dade Art in Public Places, Miami, and Penny Balkin Bach and Laura Griffith of the Fairmount Park Art Association, Philadelphia and their staffs deserve special thanks for cordially hosting the task force meetings in their cities. I would like to give special thanks to Barbara Hoffman, Sande Percival, Joyce Kozloff, Ari Sikora, and Pallas Lombardi who were contributing writers to the book and to those panelists who reviewed and commented on the draft: Jerry Allen, Paul Broches, Pat Fuller, and Joyce Kozloff.

The organizations, cities and towns, counties and states, and publications which generously lent documents, articles, and photographs to *Going Public* are too numerous to mention here and are credited where these items appear in the book. It is through these items that the story of public art today is, in large part, communicated.

The survey which resulted in the listing of Public Art Programs (see Appendix) was, fortunately, a much larger task than expected as the number of public art programs increased steadily even over the year of this project. We are grateful to the National Assembly of Local Arts Agencies for assisting in the distribution of the survey to local arts agencies, to the Washington State Arts Commission for lending its lists and files toward this research, and to Bill Flood and the Metropolitan Arts Commission of Portland, Oregon, for sharing their research of public art through redevelopment and zoning mechanisms. My sincere appreciation goes to Bob Duff, Rich Zbikowski, and Beth Songer, whose tirelessness and conscientiousness transformed a mass of data into a useful resource for the field; to Dierdre Whittaker and Judy Dill for their research assistance; and to Bob Coven for his constant encouragement and support.

Four individuals have, through their professionalism, tremendous hard work, good judgment, and skill made this book, not only possible, but a fulfilling experience. Jeff Cruikshank transformed volumes of meeting transcripts, summaries, documents, articles, and other materials into a functional manuscript with agility and understanding. He gave shape and style to a body of practical information with a constant concern for the reader's needs. (Thank you to The Winthrop Group, Cambridge, Massachusetts, for enabling this project to be completed by Jeff while working under its auspices.) Designer Judy Kohn not only accomplished the task of making this a workbook that works and a handsome publication all at once, but showed a sensitivity to the subject matter from the broadest concept to the finest detail. John Fiscella's copy editing lent precision and clarity at times when distance was difficult and must be thanked for his kind and subtle coaching throughout the editing process. And lastly, I am indebted to Carol Mellen, whose assistance on this entire project ran the gamut of responsibilities—always characterized by a quest for perfection, care for participants, and exceptional organization which made this enormous task manageable.

Finally, I would like to thank Miriam Williford, Associate Provost for Continuing Education and Public Service, Kevin Aiken, Administrator for the Division of Continuing Education, University of Massachusetts, Amherst, and Barbara Schaffer Bacon, Manager of the Arts Extension Service, whose support and flexibility throughout this project have enabled the Arts Extension Service to participate in this extraordinary opportunity.

Pam Korza,
Editor

Introduction to the Guide

Public art, perhaps more than any other recent development in the visual arts, has stimulated a network of communication involving many professions and all parts of the country. In search of information, ideas, and advice, arts administrators have called upon each other for instructive models. Artists grappling with new issues and procedures brought forth by the public context seek out other artists as well as experts in other fields for guidance and to exchange ideas. Mayors discuss the political, economic, and urban planning values of public art for their cities. Architects evaluate the merits of involving artists as collaborators in the process of designing the built environment. As with any new field of endeavor, the experience of those who have "been there" is a critical tool for "going there" oneself.

By centralizing some of the best knowledge and experience in the country into one resource, *Going Public* has done a considerable amount of the legwork for those who are new to public art. Through the experience of several model programs (reflecting programs of the participants in the NEA Public Art Policy task forces as well as others), we hope to prevent unnecessary re-invention of the administrative wheel while encouraging inventive artistic directions.

As a workbook, *Going Public* provides an entry point into the unique and multifaceted policies and processes of public art. That these processes are frequently challenging should not make them intimidating. The narrative, therefore, poses many of the questions which public art sponsors, artists, design professionals and others involved frequently ask themselves (as well as other questions which *should* be asked) in order to consider all relevant concerns. Through the numerous cases and annotated sample documents, the aim of the workbook is to provide useful and instructive tools which the reader might then examine and adapt for his or her own situation.

Going Public attempts to elucidate viewpoints of the task force panelists who participated in the Public Art Policy project. (For brief profiles of participants, see Appendix.) The findings of the book, then, rest on the experience and informed discussion of this panel and reflect both areas of consensus and divergence. Comments by individual task force panelists as well as others in the field who were sought out for their experience and viewpoints, are found in annotations to documents as well as in the text.

Going Public is geared primarily to assist the public art administrator who is coordinating an ongoing, publicly funded public art program. Secondarily, it is meant to provide artists with insight into the process of public art and with an educative tool toward understanding their own rights. But, because public art interfaces with government, design, urban planning, development, and other fields, professionals in these groups should also find it of value in understanding current issues in public art today. It is our hope that *Going Public* will serve as a frequent reference to which the reader will return again and again in planning public art projects.

The publication is divided into two main sections: The Administration of Public Art and The Preservation of Public Art. The material in each section is organized topically and can be utilized on a topic-by-topic basis. However, it is really by reading the book in its entirety that the relationships between specific planning and implementation measures and the welfare of public artworks are most clearly apparent. An overview of the whole process provides a context which is critical to achieving effective results.

Finally, public art today will not be the public art of the future. As more artists create work for public places, as community planners broaden their vision for art in the public realm, and as the public is increasingly involved and exposed to contemporary artworks, who can project what artistic directions, issues, and policies will emerge twenty years from now? Therefore, the life span of this publication is limited as the field changes rapidly. Much of what we learn about artworks' endurance (or lack of endurance) over time will necessarily guide future task forces to evaluate the existing and newly-created policies and procedures presented here in *Going Public*.

Pam Korza
Editor

Stretching the Terrain:
Sketching Twenty Years of Public Art
Kathy Halbreich

Almost every definition pertaining to the field of public art has undergone scrutiny and change since 1966, when, only a year after its inception, the National Endowment for the Arts began to explore ways in which to support the placement of art in public places. One wonders, with the advantage of hindsight, if the chairman and the 26 members of the National Council for the Arts—a panel of advisors appointed by the president—realized how complicated and controversial their effort would be. (For a history of the program through 1981, see *Art in Public Places*; and for speculations on more recent efforts, *Insights/On Sites*, Bibliography.) Even the understanding of what constitutes public art has shifted, as have the intentions of practitioners, the political realities faced by administrators of programs, and the expectations voiced by audiences.

Perhaps the most generative change may be reflected semantically. Both the recent practice of and critical discourse on public art suggest that equal stress be placed on the words "public" and "art." Clearly, the field is beginning to mature. Its impact on the shape of public places has in some cases been significant, and in others, promising. Evidence of this expanded view of public art and its power to transform daily experience is suggested by the mix of disciplines represented at the recent NEA-supported meetings which resulted in this book. Participants included artists, architects, developers, urban planners, conservators, lawyers, administrators, educators, art historians, and curators from both corporations and museums.

A quick look at the past may help us see these changes more clearly. Certainly few could take issue with the Endowment's original aim to honor America's great artists. However, the means first proposed—commissioning a sculpture and giving it to a city for siting in a public area—today seems both artistically and politically naive, suggesting more the somewhat imperious model of the museum curator than that of a government agency. Beneficence from afar was not especially democratic; fortunately, by the time this desire found its way into policy, the projects were to be initiated by individual public agencies and nonprofit organizations, thereby assuring local control of the projects. The applicants for federal funds were to be assisted in selecting an appropriate artist by experts from the region and beyond, some of whom were appointed by the Endowment, since the idea of public art in cities was untested and expert advice hard to find.

The first matching grant of $45,000 went in May of 1967 to the city of Grand Rapids, which, then in the midst of a major urban renewal plan, wanted to commission a sculpture to serve as a focal point of the plaza central to the new development. The Endowment's criteria for awarding the grant were the specific qualities of a site and the participation of various civic organizations in supporting the arts initiative. Soon after the grant was announced, a panel appointed by both the mayor and the Endowment gave the commission to Alexander Calder. The total project costs were $127,900, most of which was raised locally. Dedicated with musical fanfare in the spring of 1969, *La Grande Vitesse* was greeted with a mixture of jubilation, bemusement, and hostility. Although heated debate continued in the media for many months, Calder's sculpture eventually became the symbol of urban optimism the civic group desired. Today, its silhouette adorns the mayor's stationery and is emblazoned as well on the city's sanitation trucks.

Nearly 20 years later, in December of 1986, the Museum of Contemporary Art in Los Angeles was dedicated. Seen as the centerpiece of the city's downtown redevelopment, the museum was cited recently by Progressive Architecture, the influential design journal, as the "largest public artwork." The appellation is somewhat misguided, but the museum's existence is a vivid indication of a new strategy to use the power of art to revitalize a community, both psychologically and economically. In 1979, when the Request for Proposals for the 11.2-acre Bunker Hill parcel was written, private developers were already required by the Los Angeles Community Redevelopment Agency (CRA) to set aside 1 percent of the total construction costs for public art—a set-aside based on the successful "percent for art" programs which had been adopted increasingly for public construction projects by states and municipalities across the country. In this case, the mayor, influential members of the art community, and the CRA agreed that the developer of the Bunker Hill project would be required to allocate 1.5 percent (or $20 million of public funds) toward the construction of a new, privately maintained, nonprofit museum of contemporary art. This sweeping definition of public art became codified in CRA's 1985 policy and guidelines for developers, which stipulate that "public art may manifest itself in three basic components: On-Site Art in Public Places, On-Site Cultural Programming, and On-Site Art Spaces or Cultural Facilities." (See the CRA's Downtown Art in Public Places Policy, Appendix.) In its scope and elasticity, this definition remains anomalous, since the majority of public art programs use public capital construction funds for works of a permanent rather than temporal nature, with "permanent" usually defined as a period of at least 40 years.

So in two decades we have seen a shift in emphasis from studio work made monumental (in order to meet the scale of outdoor plazas) to monuments made to contain cultural artifacts; from a handful of arts activists attempting to commission a sculpture reflecting the

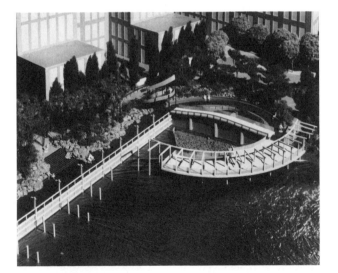

Mary Miss with Stanton Eckstut, architect and Susan Child, landscape architect, model for South Cove Waterfront, Battery Park City, New York City, Battery Park City Authority.

promise of urban renewal, to cities such as Seattle and Philadelphia funding artists to think—in tandem with other members of interdisciplinary design teams—about how public spaces might function as more congenial, social places; and from dedicatory brass ensembles to street performances and events tied to lunch hour traffic. While federal, state, and local agencies still provide a great deal of the impetus and muscle for public art projects, percent funds cannot always be stretched to finance all the innovative or ambitious projects. As the private and public sectors begin to cooperate in defining the civic responsibilities and sites they share, percent funds are used increasingly as venture capital—that is, to stimulate projects which, in breaking with earlier precedents of form, process, or intent, may seem promising but risky. While developers are not the Medicis of our age, public officials have begun to convince some that patronage of the arts can have beneficial economic as well as social repercussions. Private developers may follow the percent for art model as an integral element in their building plan, or as a negotiating tool with government.

It is heartening, too, that arts councils are beginning to rewrite their original percent for art ordinances so that art funds from several sites may be pooled, permitting allowances to be spent where most needed rather than where budgeted. While the users of some buildings clearly benefit from and appreciate the placement of paintings, prints, and sculpture in and around their environments, the increasingly early involvement of artists in the planning stages of those environments may make these later embellishments less necessary or compelling, as the spaces themselves come to possess a richer set of associations and functions.

But how have we arrived at this point, when it is possible to contemplate the artist injecting meaning as well as amenities into the planning of public spaces? Clearly, artists provoked this change, by engaging what traditionally had been thought of as extra-aesthetic issues. During the 1960s, Minimal artists such as Carl Andre and Richard Serra, in making work for a specific site, gave up the traditions of the studio artist. The form, posture, and placement of their sculptures were dependent upon—decided by—the "givens" of material, architectural setting, and topography. These were conditions external to the concerns of the studio artist. In some cases, Minimal sculptures were not intended to be appreciated as well-crafted or composed objects, but rather as indicators of the specific place. These sculptures made the experience of perception—of experiencing—apparent, central. At the same time, Vito Acconci was using his body as the material and the street as the theatrically charged site for his investigations into social responses and habits. He followed strangers, perhaps substituting his voyeurism for that of the gallery-goer. Scott Burton, too, blurred the distinctions between life and art in a series of activities in which he appeared dressed as a woman, drugged (to sleep at a gallery opening), or naked. Burton wanted to make art of moral consequence, challenging the self-reflexive and pristine principles of formalism, the traditional sexual roles of men and women, and the consequences of some government policies. (For additional background, see *Sitings*, Bibliography.)

At the same time, arts administrators and politically astute collectors were beginning to contemplate the role of art in the daily life of the community. Art began to be placed outside of museums, in central locations where the public didn't have to make a special effort to see it. In 1959, as part of its scheme for urban revitalization, the city of Philadelphia implemented the first percent for art ordinance; art became part of a municipality's sense of the future.

It is perhaps no accident that public art, the art form most dependent upon the public domain for its definition, became fundable, visible, and even commonplace during the activist era of the late 1960s and 1970s. This was a period of questioning; the social, political, and aesthetic systems of the past were being confronted and challenged. During those chaotic decades of political and social turmoil, cities were torn apart by unrest and their downtown areas abandoned. The middle and upper classes accelerated their flight to the tracts and malls of suburbia. The urgency of the times called for restorative action, often embodied in new social programs, ameliorating public gatherings, or memorials such as Richard Hunt's *I've Been to the Mountaintop*, initiated in 1974, and

Robert Morris,
Johnson Pit #30, Kent,
Washington, King County
Arts Commission, 1979.
photo: Colleen Chartier

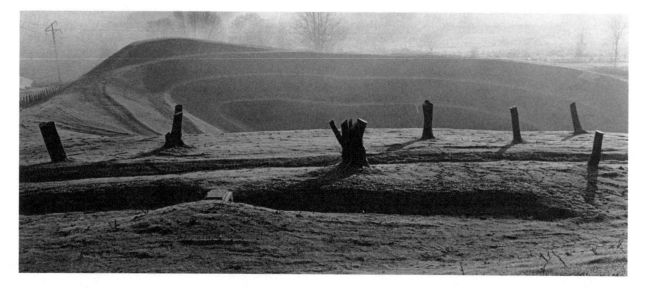

George Segal's *The Steelmakers*, begun in 1977. The latter works in particular spoke to the reasons underlying the country's sorrow, of a fleeting and fragmentary experience of change beyond understanding.

The cash-rich 1960s also saw an escalation in the prices of artworks, prompting many corporations to commission outdoor sculptures and other artworks as a means of identifying with the prestige and forward looking vigor of art. At the same time, some artists shifted their focus from making conventional objects for the commercial markets. As Robert Morris explained, the artist moved "from particular forms, to ways of ordering, to methods of production, and finally to perceptual relevance." Natural history replaced art history for artists such as Robert Smithson, who found the processes and elements of the earth his spur, symbol, and site. Having served in 1966 and 1967 as an arts consultant to a team of engineers and architects assigned to develop an air terminal between Dallas and Fort Worth, Smithson wrote, "A sense of the Earth as a map undergoing disruption leads the artist to the realization that nothing is certain or formal." Smithson's proposal—that the geological processes of the site and the construction of the terminal, as well as the aerial perspective of its audience, be integrated in an environmental work—was not accepted. Twelve years later, the King County (Washington) Arts Commission commissioned Robert Morris to reclaim an abandoned 3.69-acre gravel pit as part of its "EARTHWORKS: Land Reclamation as Sculpture" symposium. The project received $50,000 in grants from both the National Endowment for the Arts and the Federal Bureau of Mines. While only Morris's project was realized, other artists involved in this pioneering project in which art was used as a planning tool were: Beverly Pepper, Dennis Oppenheim, Lawrence Hanson, Iain Baxter, Mary Miss, and Richard Fleischner.

As artists began to explore the civic potential of public projects, federal agencies also were beginning to explore the scale and caliber of the public spaces they created, as well as the extent to which those spaces functioned efficiently. In September of 1977, Secretary of Transportation Brock Adams announced a policy underscoring the importance of quality in the built environment and requiring his department to pursue good design, art, and architecture. Local agencies such as the Cambridge (Massachusetts) Arts Council seized upon DOT's willingness to appropriate funds for the purchase of artworks in new transit facilities and rapidly developed pilot projects to explore the goals of Adams's policy. The Council's earlier attempts to engage the local transportation agency had been rebuffed; but with

support from the secretary's office, a program began to be formalized which eventually would serve as a national model. (See *Arts On The Line [AOTL]: A Pilot Project in the Arts and Transportation*, Bibliography.)

Despite the obvious success of the AOTL's ongoing program—over 39 artists have received commissions for permanent works and 25 for temporary installations since the program began—the administrators, who hoped to integrate the project's art and architecture were frustrated initially. Within four months of the program's inception, architects' drawings for the first four stations were completed, and three were sent out for bid. Artists were brought in too late to alter significantly either the planning or the architectural finishes of the spaces. Despite the intentions of the program, collaboration between artist and architect rarely exceeded professional cooperation; most of the artworks in the first four stations appear today as appendages to the architecture. Greater innovation was achieved in the administrative realm, where valuable practices were uncovered and formalized in areas such as selection procedures for sites and artists; the development of aesthetic as well as pragmatic guidelines; contractual agreements among artists, contractors, and agencies; informational efforts; and interagency cooperation.

The scope of the Red Line Extension and of the Arts Council's activist role in the affected communities necessitated the development of new ways of reaching segments of the community normally not involved in the niceties of connoisseurship; cooperation was achieved among merchants affected by the construction, community groups from various neighborhoods, schools served by the subways, and university galleries, as well as artists and craftspeople involved in both the literary and visual arts. Despite the difficulties encountered early on, one of the artists who has worked most effectively within this arena is Joyce Kozloff, whose projects for the Harvard Square subway station in Massachusetts, as well as for the Wilmington train station in Delaware, and the Humboldt Hospital subway station in Buffalo, New York, draws upon the architectural or ornamental systems indigenous to her site and held in special esteem by the people who use it.

If each station is considered as a microcosm of a city—that is, as mandating a great deal of interagency communication and a master plan for the artworks, as well as for their implementation and appreciation—the critical lessons to be learned from such integrated systems become apparent. In fact, it is evident that when considered as a network of public efforts, there is no great difference between a transit system which traverses a city and the city itself. Therefore, admin-

istrators have begun to emphasize the relationship of public art to the whole city, rather than to a plaza-like site which could be thought of as the equivalent of the traditional pedestal. Cities such as Seattle have sponsored major planning studies of the role and place of various types of public art in the life of different urban districts. (See *Artwork Network, A Planning Study for Seattle: Art in the Civic Context*, Bibliography.) Slowly, the somewhat myopic, site-by-site focus of some initiating organizations is giving way to a more comprehensive and coherent choreographing of public spaces.

Similarly, artists are beginning to interact as peers with architects and landscape designers. This trend has been accelerated, in part, by redevelopment authorities such as the Battery Park City Authority, which in 1983 convinced both the developer and architect to involve Scott Burton and Siah Armajani in the design of a 3.5-acre waterfront plaza, seen as a critical part of a 92-acre mixed-use development in lower Manhattan. Mary Miss and Jennifer Bartlett also have designed major parts of the Battery Park landscape, both of which currently are under construction. Robert Irwin has been working since 1985 with a psychologist and an architect to plan for the expansion of the Miami International Airport over the next ten years; his plan provides for the future intervention of other artists. Performance poet David Antin, video artist Nam June Paik, and sound sculptor Max Neuhaus already have visited the airport several times and are proposing a series of related works. Buster Simpson, a Seattle artist known for his ephemeral sculptures which often whimsically reflect the changes within an environment, is working with the city of Cleveland and a group of developers to unify a series of warehouses in an historic district being rehabilitated for mixed-use purposes. Sculptor Jackie Ferrara and architects Billy Tsien and Tod Williams are working on a plan to transform Hunter's Point, a 92-acre landfill site on the East River in Queens, New York, into a public park. Corporations are financing massive reclamation projects, such as the one Michael Heizer is completing in Ottawa, Illinois, funded by the Ottawa Silica Foundation.

Many artists now working in the public domain have made the social imperative of public art a primary focus. It is the means, as well as the end. Some even believe that the expression of the individual hand or of a private vision—no matter how searching, authentic, or original—must be displaced by a communal vision, tuned more to the factual characteristics of site and the activities of the user than to the idiosyncratic signature or psychology of the artist. Curiously, it now seems more difficult to preserve the meaning of a contemporary

object placed in a public context than to create an environment with meaning. But clearly, the impulse to create functional environments must not be confused with an attempt to imitate the architect's talents, or to decorate space with attractive architectural elements. The doctrine of functionalism is not devoid of content. Rather, as the dictionary suggests, it involves the design of furniture, architecture, and landscape in such a way that materials and form are determined primarily by considerations of the kinds of activities which are appropriate to a person, thing, or institution—in other words, a strategy hauntingly suggestive of the artistic statements of mission of the 1960s and 1970s. While such formal or abstract concerns as color and surface remain part of the creative equation, they are joined by the analytical models of the sociologist or anthropologist. Language and legible subject matter are no longer taboo ingredients.

What have we learned about the nature of public art and its impact on the constantly shifting state of a city's built environment? Clearly, different motivations (the whos and the whys) and mechanisms (the hows of ordinances, zoning incentives, and so on) inflect the final outcome as much as the conditions of the site do. Public art advocates must become conversant with languages other than that of art magazines; we need to understand the economic and social imperatives of government and development. We need to be certain of our goals and ensure that the system is flexible enough to allow those goals to be realized. (Some percent for art legislation, for example, precludes the early involvement of artists.)

And, as artists begin to wrestle with the results of poor urban planning and bad design, we must create interdisciplinary laboratories where discourse is central and experimental investigations are well supported. Like scientists, artists and their design colleagues need time away from public scrutiny if they are to invent new ways in which to make habitable, socially responsive public places. Not all the solutions uncovered in recent labora-tory-like settings—such as Art on the Beach in New York, Art Park in Lewiston, the Alternative Spaces Residency Program in Dayton, MacArthur Park in Los Angeles, and the Headlands Art Center in San Francisco—can or should be translated into more permanent forms or public domains, but the questions they raise are central to the development of the field. These programs, moreover, give artists a first chance to explore the set of issues surrounding public art, thus helping to increase the numbers of seasoned practitioners. Similarly, *Messages to the Public*, sponsored by the Public Art Fund in cooperation with Spectacolor, Inc., has offered artists as diverse in sensibility as Keith Haring, Jenny Holzer, David Hammons, Edgar Heap-of-Birds, Howardena

Pindell, Barbara Kruger, and Francesc Torres an opportunity to create a 30-second computer animated message for the light board at One Times Square, which 1,500,000 pass each day.

As the audience expands, so must our efforts to place the means and criteria for making substantial judgments in its hands. Controversy may be unavoidable, and even useful, but if the hostility is precipitated by a clouded process, we have served neither the artist nor the public. The art community and the public (often the advocates and the uninitiated, respectively) need to listen to each other in order to develop trust and a common language, if not a common agenda. Finally, we—those who love art, know its history, and have wrestled with its fragile nature—need to develop guidelines to care for the public domain. Clearly, the city—even more than the museum environment—is elastic, demanding new principles and techniques for conservation which can accommodate the alteration of the environment, as well as the preser-vation of great objects and spaces. Unlike museums, the public realm has no storage places, no warehouse where one can ponder in private how an object once lauded by the cognoscenti now can look so academic, so juiceless. Recent experiments—all valiant attempts to define public art and to challenge or strengthen the systems which make it possible—remain exposed to view. Criteria must be uncovered which will allow us to judiciously edit our environment, without sacrificing the faith, the creative potential, and the critical acumen of those who shape that environment, and who may not share an official or traditional sense of history or time.

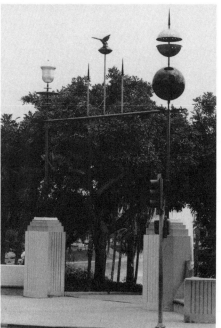

R.M. Fischer, éntrance gate and lighting for MacArthur Park, Los Angeles, Otis Institute of Parsons School of Design, 1986.

The Administration of Public Art

14 Why Public Art?

23 Funding Models for Public Art

50 Integrating Public Art in Community Planning

57 Guidelines for Implementation

103 Community Involvement and Education

116 Summary

The goals that have guided successful public art projects into being are as varied as the artworks themselves. In developing a program to celebrate the city's Tricentennial, the city of Philadelphia commissioned Isamu Noguchi to create the sculpture, *Bolt of Lightening: A Memorial to Benjamin Franklin*, to commemorate its great city father. In another project, artist Judy Baca's orchestration of over 250 teenagers, artists, and humanists to paint the Great Wall in Los Angeles aimed to document and recognize a multi-cultural history of California through the tradition of Chicano mural art. The mural serves as a simultaneous expression of the pride and permanence of various ethnic groups in California and proclamation of the power of cultural autonomy. And, when the Seattle Arts Commission and Seattle City Lights included artists Andrew Keating, Buster Simpson, and Sherry Markovitz on the design team for the percent for art project at Viewlands/Hoffman electrical sub-station in a Seattle residential neighborhood, it was with the idea that art could humanize the intrusion of an otherwise forbidding and unwelcome facility.

Inspired by individual projects and by exemplary ongoing public art programs such as those in Seattle, Miami, Cambridge, and Philadelphia, cities across the country have enthusiastically climbed aboard the public art bandwagon. Often, however, they have ignored a cultural planning process—especially critical when establishing an ongoing public art program—which asks some basic questions: Why public art? What difference will a public art program make in our community? What are the conceptions of public art held by city planners, civic leaders, the arts community, and the public? What happens when those conceptions diverge? What financial, administrative, and human resources must be in place in order to carry out a successful public art program? If these questions are not fully explored—in other words, if the *purpose* of the public art program is not clearly defined—the program may get off to a shaky start and continue to be plagued by doubt and problems.

For example, in 1985, the Madison, Wisconsin-based *Capital Times* reported:

"The city of Madison has had the money for public art since 1980, but—aside from one sculpture—just doesn't spend it. Under the 1979 ordinance that created the program, the city's public art program is entitled to roughly $30,000 in an average year. But since 1980, only $27,265 has been spent."

See "What Happened To Our Art?," Bibliography.

Why? For one, the city's first acquisition was not well received by the public. Then, the Madison Committee for the Arts, which recommends arts projects to the city council, wanted the annual appropriation to

The Phoenix 1990 Plan

1990: A Five Year Arts Plan for Phoenix, states: "Phoenix is falling behind. It is falling behind many Valley cities [of Maricopa County] and other cities in Arizona in one or more of the following ways: rate of forecasted future growth; commer-cial vigor; being thought of as the most desirable Valley city in which to live; and in its ability to continue to attract its proportionate share of new commercial and industrial facilities. Its image as one of the nation's prime growth cities of the future is still bright, but it is losing some of its shine."

Phoenix's mayor then argued that in other, more farsighted cities, economic success is directly linked to cultural excellence. He cites two busi-ness relocations away from Phoenix (one to Seattle and one to Tucson) and blames those losses to greater cultural opportunities elsewhere.

An Ad Hoc Advisory Committee on the Arts concluded that a percent for art program was a crucial prerequisite to "improving the look and cultural climate of the City." Other recommendations included:

— the creation of a publicly funded Arts Commission (which would administer the percent for art program);

— the establishment of methods to encourage private developers to include public art and cultural facilities in their developments; and

— the formal recognition of the Phoenix Arts Commission as an appropriate advocate for the visual "look" of the city and for enhanc-ing the city's awareness of its own cultural identity.

Specific public art objectives were formulated under each of these recommendations. The last recommendation cited above, for example, called for:

— special attention in the neighborhoods to clarify neighborhood identity through public art;

— improvements in the entrances to the city (its roads and airports) through art, landscaping, and signage; and

— an artwork of international significance, to serve as a centerpiece and symbol for the city.

It is still too early to assess the outcome of Phoenix's self-diagnosis and prescription. Nevertheless, it's clear that the city perceived and described municipal problems on the broad-est scale—and then evaluated and affirmed public art as an effective tool for solving those problems.

accumulate in order to have sufficient funds to pay for a major artwork. Unfortunately, city staff and council members viewed the arts money as they did every other budget line: If all the money wasn't spent by the end of a fiscal year, it was unlikely that more would be added the following year.

Finally, in 1985 the arts committee made an attempt to commission its second public artwork—a mural by Richard Haas, an internationally renowned muralist. With past arguments about the public art program still brewing, the mural became the subject of a long and heated election-year political debate. A citizen's taxpayer group, opposing a planned property tax increase, denounced the mayor's support of the mural expenditure. A mayoral candidate joined the opposition, thereby igniting a year-long controversy not only about the proposed mural, but also on the merits of the public art program itself.

The mural was finally commissioned, and in the long run, the most positive result of the controversy was perhaps that it forced the city and its arts committee to examine just what "public art" means to the cultural life of Madison. Albeit belatedly, the city has now embarked on a cultural planning process to consider this important question.

Fortunately, other cities—like Dallas and Phoenix—have pursued more deliberate paths. They have completed comprehensive planning processes *before* establishing their public art programs. As a result, they have been able to integrate public art into their complex urban fabrics.

Lessons from Dallas

In March of 1986, the Division of Cultural Affairs of the Dallas Department of Parks and Recreation launched an 18-month "master planning" study. The premise of the study was that if a proposed public art program were to have a reasonable chance of success, it would have to grow out of an effective community planning process. Only such a planning process, Dallas officials reasoned, would ensure that the proposed program would be responsive to the unique aspects of their city; and only a responsive program would win community approval. Working with a 30-member task force of interested citizens and design professionals, the Division of Cultural Affairs developed a plan for the study, defining the range of issues to be considered. A summary of that plan and the questions it raised is presented on the facing page.

The task force report, *Visual Dallas*, was completed in October 1987 and adopted by the Park and Recreation Board in November. It recommends the passage of a 1.5 percent for art ordinance, with .25 of 1 percent

A common understanding of what is meant by public art is, of course, the most essential definition. It was almost more reasonable to say what public art <u>does</u> than what it <u>is</u>. For instance, the Advisory Committee agreed that public art must:

- involve the public-- from selection process to dedication;

- serve socio-environmental function identifiable with people;

- be accessible to the mind and the eye;

- be integral to its site and respond to the concept of place making;

- integrate with the work of other design professionals;

- be of the highest quality;

- serve its city by enhancing the quality of life for its citizens, and contributing to its prestige;

- address its moment in time, i.e., the designers must speak to a multi-dimensional society in a time and place that will never be duplicated.

Even with these parameters, the Advisory Committee summarized that "public art is wide open."

Concurrent study was begun of ways to involve private sector developments in public art, including incentive zoning, public art mandates, etc.

To understand how the city works, we acquired land use and transportation studies, and zoning and development guides.

The inventory of existing artworks followed the procedures set forth in the pilot Public Monument Conservation Project of the National Institute for the Conservation of Cultural Properties. It was felt that the baseline of information about existing artworks should meet minimum standards being developed by the national project.

Public Art Master Planning in Dallas

I. Introduction

What is the history of public art in Dallas? What resources exist, and in what condition are they? What are the current policies regarding public art, and how are new initiatives limited?

II. Goals of the study

The goals of this study are:

● to aid in planning for the placement of public art in Dallas;

● to evaluate local urban design and urban development trends in Dallas, assessing their implications for the proposed Art in Public Places program;

● to determine the financial resources available to the city and recommend means of financing the proposed program;

● to draft ordinances, policies, and procedures for the program;

● to inventory and recommend sites for Art in Public Places; and

● to identify and discuss issues fundamental to the successful implementation of such a program.

These fundamental issues include the following:

● selection processes;

● the roots of controversy surrounding public art;

● public involvement and education;

● economic impact;

● public/private partnerships;

● thoughtful use of local and national artists, to ensure both high-quality art and community input;

● the experimental nature of the arts;

● conflicts between the art and design fields;

● artworks as functional objects in the urban context;

● the relationship of the program to other city agencies and programs;

● public art "collecting" vs. museum collecting; and

● "deaccessioning," or the removal of public art.

III. Model art in public places programs

It will be necessary to examine relevant programs on several levels of government, including:

● municipal (e.g. Seattle, Baltimore, Philadelphia);

● state (e.g. Washington, Colorado); and

● federal (NEA Art in Public Places category, GSA Art-in-Architecture program).

In addition, successful art-in-transit programs should be reviewed separately.

IV. Definition of terms

As terminology in this field can be both subtle and elusive, terms such as the following should be defined:

● public art;

● works of art (artworks);

● artist;

● others?

V. The urban context

How people relate to and use the city should be considered. This comprises such issues as:

● the city's aspirations (sense of community, expression of cultural diversity, economic and neighborhood development, etc.);

● contiguities and linkages within the city (parks and other public and quasi-public spaces, transportation hubs, entertainment centers, retail centers, civic institutions);

● circulation patterns (auto, transit, and pedestrian); and

● communications networks (commercial, cultural, and social).

(continued on next page)

Among the programs studied were: Seattle, King County (WA), Sacramento, Metro-Dade (Miami, FL), San Francisco, Philadelphia, Washington State.

Planners rode the public bus which crossed the Trinity River from 7 a.m. to 7 p.m. to observe user constituencies, popular stops, neighborhood character, etc.

Because public art is about creating a sense of place, selection of site is very important. Impact on neighborhood must be taken into account. This necessitates a collaboration with city planners who, ideally, begin to develop as proactive designers rather than reactive administrators.

The site inventory became a community planning process, where teams of artists, architects, landscape designers and urban planners met with neighborhood and homeowner's associations to explain the master plan project and identify opportunities in various parts of the city. Over 30 volunteer professionals were engaged in this process.

An extensive public information and advocacy campaign accompanied the project. Task force members are giving presentations to neighborhood, business, social and professional organizations throughout the city. Over 100 organizations were visited.

A series of presentations by artists and public art professionals has been developed to prepare local artists and the general public for this new program. Presentations will continue throughout the project.

Several model projects have been undertaken: a) A group of four artists are working with an engineering firm to design erosion control structures for stream channels and floodways throughout the city; b) An artist was commissioned to design water meter access covers for the city Water Department; c) An artist has been hired to identify ways of involving artists in the development of the Dallas Area Rapid Transit system.

The city's current development plans must be taken into account, including plans for the Arts District, the governmental complex, and various other projects.

Finally, the question should be asked, What's *unique* about Dallas? This raises such topics as:

● grid;
● topography;
● geography;
● climate;
● ethnicity;
● demographics; and
● social and political organizations.

VI. Inventory of sites for public art in Dallas

What are the available and appropriate sites and urban opportunities?:

● parks;
● municipal buildings;
● other public spaces; and
● privately-owned "public" spaces.

VII. Community awareness and preparation

How can local artists and the public be oriented to this new program? How can their input best be solicited?

VIII. Resources

What public art resources are available to Dallas as planning is undertaken? Sources of financial support should be examined, including:

● the city of Dallas;
● other governmental bodies (Texas Arts Commission, National Endowment for the Arts, nontraditional governmental sources, etc.); and
● the private sector (individuals, corporations, and foundations).

What artistic resources can be drawn upon? To answer this, it is necessary to:

● develop profiles of Dallas artists; and
● collect information on relevant organizations and institutions.

What other resources can be drawn upon?

● governmental;
● informational; and
● educational.

IX. Recommendations

Based on the information generated in the planning process, recommendations should be made regarding:

● *appropriate funding vehicles* (percent for art, private sector involvement, etc.);
● *the outline of a program*. This should include not only policies for public participation and management of the artwork (acquisitions, gifts and donations, maintenance and conservation, documentation, and deaccessioning), but also program implementation guidelines and selection processes;
● *ways of thinking about sites*. How does a site get considered for inclusion in this program? What are the relevant characteristics of a proposed site? How do we classify sites (priority, eventual priority, long-range, temporary)?
● *miscellaneous recommendations* (guidelines for festivals, symposia, and exhibitions; proposals for a municipal exhibition and performance space; artists' slide registry, etc.).

X. Implementation

Finally, how, when, and by whom will the plan be implemented?

being reserved for a permanent maintenance endowment and another .25 of 1 percent being reserved for program administration, artist selection, and community education activities. The proposed plan has been given a favorable recommendation by the Arts Committee of the Dallas City Council and will be considered by the full Council in late January 1988. Passage seems certain.

In a related development that grew out of the Dallas Master Plan, the Dallas Area Rapid Transit (DART) board passed in December 1987 a policy setting aside 1.5 percent of its rail system ($1.4 billion) budget for public art.

Conceptions of public art

Seattle has been a pioneer in the process of integrating urban and public art planning. In 1984, with its percent for art program in place since 1973, the Seattle Arts Commission (SAC) completed a study to recommend a public art planning process which would respond to the city not as a fixed outdoor gallery or sculpture garden, but as "a network of primary public places in a constant state of flux".

As in Phoenix and Dallas, SAC formulated broad questions which when answered, could elicit information about Seattle's history, existing artwork, proposed developments, and those public places which might be integrated creatively within the downtown area—in other words, the civic context.

Finally, the SAC raised what most arts administrators might acknowledge to be the most challenging issue of all: What conceptions of public art should be considered in devising an arts plan?

The history of recent and contemporary public art, as recounted in Kathy Halbreich's introduction, runs a gamut of artistic expression: from

Washington State Arts Commission

"The legislature declares it to be a policy of this state that a portion of appropriations for capital expenditures be set aside for the acquisition of works of art to be used for public buildings."

Chapter 176 Laws of 1974 RCW 43.46.090

Percent-for-Art Means Jobs and Economic Impact

Washington's Percent-for-Art program supports jobs for artists, statistically among the most underemployed segments of society.

A 1982 survey of Washington State artists shows:

% OF DOLLARS EXPENDED: Economic Impact

6.0 - 6.6% Returned to State in Sales Taxes

43% Purchase of Materials

9.45% Overhead (studio costs, utilities, and sales taxes)

47.55% Salaries and Wages

ARTIST STATISTICS: Jobs

26% Employ others in production of their work

$5,665 Average yearly income from sale of artwork

60% Require employment other than production of art

There is a demand for arts jobs:

The Arts Commission receives over 450 applications or proposals for artwork projects; 10% of applicants receive contracts.

Based on the Governor's Capital Budget Request, the ½ of 1% for art allocation would represent .0012% of the total proposed expenditures for capital construction.

This fact sheet, developed by the Washington State Arts Commission, was included in a successful 1983 effort advocating the passage of revised percent for art legislation. For more on Washington State's program, see the Percent for Art section under Funding and the Appendix for a reprint of the actual revised statutes.

Reprinted by permission of the Washington State Arts Commission.

FACT SHEET

Percent-for-Art Legislation Is The Top National Legislative Priority

From ARTS AND THE STATES - A Report of the Arts Task Force of the National Conference of State Legislatures, 1981:

"Percent-for-Art is perhaps the single most important bill that the Arts Task Force could recommend. It gives visibility to the arts. In addition to the employment of artists and the idea of recognition of the arts which it represents, the fact is much of this art is outside, it's seen by the public when they're walking or driving, and it begins to create an environment where art becomes important in one's life."

"Public artworks are important to the economic vitality of cities, making them more attractive places to live, work and visit."

"Percent-for-Art programs provide much needed commissions and sales for artists, who are statistically among the most underemployed segments of society."

"Quality public art is, almost by its very nature, controversial; historically, public taste and acceptance have lagged behind artistic creativity. Such controversy is not unhealthy. Rather, it is stimulating and educational and ultimately raises the public's awareness."

"Percent-for-Art has been endorsed by both major political parties in their national platforms."

Percent-for-Art Provides Citizen Access to Visual Art

With only five major art museums in the state, predominantly serving Western Washington (Bellingham, Seattle, Tacoma, Pullman and Cheney) the state's Art In Public Places program provides the greatest access to the visual arts in the state.

Works of art have been placed in schools, universities and community colleges, and state agencies in communities throughout the state.

It is estimated that over 500,000 Washington citizens have the opportunity to view works of art, often their first exposure to the artwork of ___ artists.

___ of art on display represent all ___ educational and cultural

art as object to art as humanizing element, means of land reclamation, or temporary celebration. Obviously, this is a diversity with which a public art program must come to grips. It must do so, moreover, within a specific urban context. In other words, what conceptions of art should be considered as Seattle devised its arts plan?

The SAC identified three overarching factors to be considered by both the artist who works in the public context and by the agency which commissions public artworks and acts on behalf of the public:

— the expressive vocabulary of the work;
— the relationship of the artwork to its public; and
— the relationship of the artwork to its site.

First, the commission noted that in creating a public artwork, an artist makes a basic decision about vocabulary: Will this work be abstract or representational? Many other questions of vocabulary ensue, of course, but this is a fundamental choice. It is sometimes assumed that for art placed in the public realm, representation (or realism) is a "safer" choice than abstraction. But Seattle's researchers also observed the opposite. Depending on the depicted subject matter, they wrote, "realism may ignite controversy."

Second, *the relationship of the artwork to its public* must be considered carefully. Any public artwork represents a communication between an artist and an audience that can assume various forms: aesthetic, didactic, functional, or symbolic. The aesthetic work presents the artist's resolution of a challenging aesthetic problem, while the didactic work instructs or informs. Functional artworks serve a useful purpose, and symbolic ones celebrate an individual, event, or collective aspiration through emblematic associations.

Third, the commission sought to generalize about the *relationship of an artwork to its site*. Noting that any rigid lines of demarcation are necessarily arbitrary, the SAC concluded that public artworks could generally be located somewhere on a continuum of site-specificity. They identified three broad groupings of increasing specificity:

— artworks whose artistic intention is not related to the specifics of a particular site;
— art designed for a particular site whose artistic intent could be transposed to another site, under similar conditions; and
— artwork whose artistic intention is inseparable from the particulars of a given site. (These works could be deemed "immovable." As we will see in later chapters, these artwork-site relationships present commissioning agencies with unique problems, as well as opportunities.)

Messages to the Public, Times Square, New York, an ongoing public art project of The Public Art Fund, New York in cooperation with Spectacolor, Inc.
photos: Jenifer SeAcor

Isaac Shamsud-Din, detail, mural for the Justice Center, Portland, OR, Metropolitan Arts Commission, 1983.

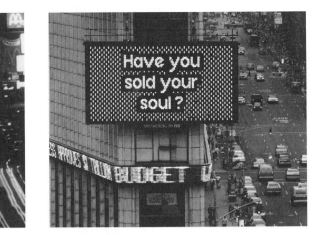

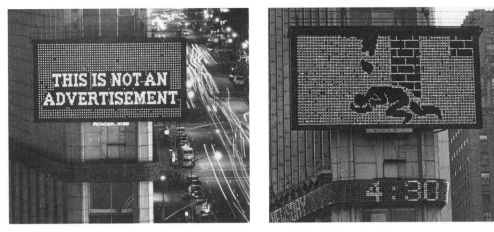

Art works from left:
Keith Haring, *Untitled*,
1982; Komar & Melamid:
*Komar & Melamid:
We Buy and Sell Human
Souls*, 1986; Antonio
Muntadas, *This Is Not
an Advertisement*, 1985;
Anton van Dalen,
*...because there was no
room for them in the inn*,
1987.

The mission statement: a key tool

In sum, it's no small undertaking to conceive of and implement a public art program. The Dallas, Seattle, and Phoenix planning processes outlined above suggest a range of complex issues to be considered, and the many constituencies to be accounted for, when a city tries to answer the question "Why public art?"

Although a given city may choose to start small—perhaps by commissioning only a single project—it must still address the entire spectrum of questions pertinent to a large-scale program. Even a single project has the potential to bring forward cynics and skeptics, who will demand evidence that public art can indeed be a significant contributor to the health of a community. The responsible arts administrator has to be prepared to offer that evidence.

The organizers of the comprehensive planning process in Dallas posed a variant of that question in advance: "Can public art make a difference?" Their statement of purpose answered that question affirmatively, by offering the following arguments:

— "Public art will give the city of Dallas a healthy, vibrant sense of place which will contribute to its prestige and identity for both its own people and for visitors."

— "Public art will provide citizens with a means for dialogue through involvement in the public art process."

— "Public art activates untapped resources. Primary among them are artists. A public art program gives artists a new source of income and an avenue for becoming involved in the city's functions. In addition, public art rekindles the historical precedent of collaborations between artists, architects, and city planners in a meaningful way. Finally, citizens of Dallas assume a role as members of the team, contributing a new order and identity to their own visual environment."

Summary

Can public art make a difference to a specific place and to a community? The answer is a qualified "yes." If a proposed public art project or program is to have a reasonable chance of positive community response and support from community leaders, it should grow out of an effective community planning process which is responsive to the unique aspects of a community.

But a solid base of community support is not in itself enough. The success of public art also depends upon freedom of thought and expression, because only those freedoms can open the doors to the most creative artistic results.

Striking this delicate balance—between responsibilities to a community and to creative vision—is the theme and goal of this workbook.

Robert Graham,
Monument to Joe Louis,
Detroit, Founders Society
of Detroit Institute of
Arts with funds from
Sports Illustrated, 1986.

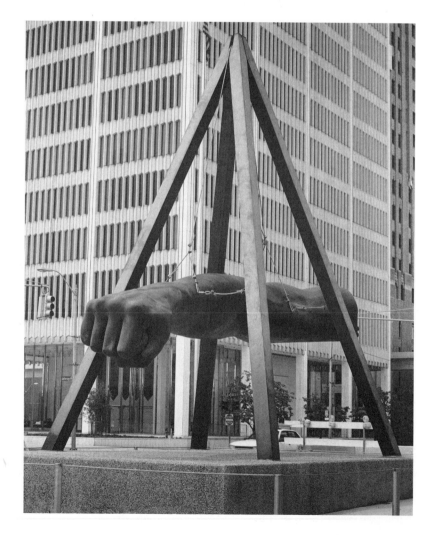

Where does the money come from to fund public art? It becomes clearer, as public art management matures, that the funding of public art must cover more than the creation of the artwork itself. Individual projects, as well as growing collections, also demand funding for:

— administration;
— care (both routine maintenance and extraordinary conservation measures); and
— educational activities within the community.

This section reviews existing models which guarantee funding for public art projects. The percent for art model is the most common mechanism used to fund art in public building projects. But new directions are also being tested whereby public planning mechanisms—such as redevelopment authorities and zoning regulations—are encouraging or requiring the inclusion of public art in private development projects. These public/private models are also discussed.

It should be pointed out that a multitude of public art projects, both major and modest in budget and scale, have been executed in the absence of any formal, guaranteed funding mechanism. For example, both of the Arizona public art projects described on the following page were initiatives mobilized by an individual artist or a core of people who perceived a need, agreed that public art was an appropriate solution, and secured a combination of specific funding resources.

Beyond the ad hoc nature of these particular projects, public art is a regular activity in many organizations in the not-for-profit sector as the following section describes.

Projects initiated by the private, not-for-profit sector

It is not surprising that private, not-for-profit organizations have been an important force behind the evolution of public art. Their missions are closely aligned with the interests of a public constituency and with the quality of the public environment. Private arts organizations, in particular, are concerned with new artistic directions and opportunities for artists, and are often freer to experiment artistically than their publicly funded counterparts.

It is difficult to generalize about specific funding methods employed by these groups. Typically, they mobilize a combination of public grants, corporate contributions, individual donations, and in-kind resources. For example, Visiting Artists, Inc., a nonprofit arts organization which has commissioned public artworks in Davenport, Iowa, is coordinating with the city the plan for a collaborative plaza design by artist Elyn Zimmerman and architect Paul Broches. A planning grant was awarded by the

24

The Winkelman Wall:
A Public Art Project in Rural Arizona

This case was prepared by Mirra Meyer, Director, Visual Arts and Community Development, Arizona Commission on the Arts.

Excerpts reprinted by permission of the Arizona Daily Star.

An artistic tribute
Downtown plot becomes a sculpture garden

by Robert S. Cauthorn, the Arizona Daily Star

Art's redemptive powers are often discussed in spiritual terms. In downtown Tucson, however, there is a more concrete example of the power of art: It was the tool that redeemed a rundown lot and turned it into a place to think, to eat lunch, to look at the stars, to enjoy.

The place is the Arlene Dunlop Smith Memorial Garden; it is the work of artist Barbara Grygutis.

"It's not 'art in a public place,' it's art creating a public place," Grygutis said recently.

The artist created the public place with a series of deep-blue ceramic sculptures, natural landscaping, a crushed-granite ground cover and stone walls bounding the small lot on North Granada Avenue north of West Franklin Street. The sculptures are carefully arranged around a small central plaza that Grygutis said responds to traditional Hispanic public places. Meanwhile, the broad open expanses of crushed granite are reminiscent of Japanese gardens.

Though the sculpture garden that reclaimed the empty lot was the creation of the artist, she said it would not have been possible without the vision and the support of the community.

Five years ago, Community Block Grant funds permitted the El Presidio Neighborhood Association to purchase and restore a building at 329 W. Franklin St. When the building was sold, the neighborhood association retained the 55-by-75-foot empty lot north of it.

Grygutis, 38, approached El Presidio's board with an idea: lease the land to her for $1 a year for five years and she would make a public sculpture garden dedicated to Smith's memory. Smith was a prominent member of the El Presidio neighborhood who was instrumental in local historic preservation efforts before she died in 1980. She is survived by her husband, Paul Smith.

The couple moved to El Presidio in 1951, and Smith said he approves of the sculpture for personal reasons and the neighborhood. "I for what it adds to the neighborhood. "I think the idea is beautiful because it's the kind of thing Arlene would have liked very much," Smith said. "I love it, I think it has a great spirit. I think the thing is innovative and beautiful and striking in concept."

The neighborhood association board approved Grygutis's plan and agreed to be a conduit for donations and grants for the nearly $45,000 needed.

Beyond making a piece of art, Grygutis had other personal concerns with the project. She is a long time resident of the El Presidio neighborhood and lives in a home she restored about two blocks from the sculpture garden. The artist has been an active force in El Presidio and is a former president of the neighborhood association.

"Initially, I was naive enough to think I could make one grant application, get $40,000, and be out in a year. That didn't happen," Grygutis said.

Instead, she raised money bit by bit, taking small and large donations

from individuals, businesses, and corporations. A few individuals became interested in the project and donated work and material. It was slow going: When Grygutis had enough money to make a wall, she made a wall; when there was enough to lay concrete slab, she laid slab.

"In this particular instance, because I had all this time—forced time—the result was much more detailed," the artist said. "I've had the time for this design to really evolve, and I feel the space is a lot stronger for it. This has made me think in a new way."

While raising money in small chunks was frustrating at times, Grygutis said her project proves that artists can accomplish large projects without a specific commission. "Strangely enough, whenever the money got low, something always came along," she said. "As much as you need the money, you don't want it to dictate the space.

"Actually, it's my gift to downtown. I'm a believer in downtown; it's how I feel about living downtown. I don't think that every lot downtown needs to reach its ultimate financial potential—I don't think everything in life needs to reach its ultimate financial potential. Some things need to be preserved because they are beautiful; not everything has to be a parking lot."

There is another aspect to the humanity angle—making a monument to Smith—that moved the artist. "I like this—I can't not be corny about it—I like the idea of designing something in someone's memory, in a very site-specific way. It became important that this space feel good because of the person that it's named for. It's very special, and I think it's important in terms of art."

Now that the sculpture garden is done, the artist is working on several large commissions and planning another public project. Grygutis' lease is up, and the El Presidio Neighborhood Association owns the sculpture garden. Jim Ronstadt, director of the city's Department of Parks and Recreation, said Grygutis and the neighborhood association are in the beginning stages of talks that might result in the city taking over the garden's maintenance.

photo: Tim Fuller

Winkelman, Arizona, population 1,060, is a copper mining town. Visible from every part of town is the towering 1,000-foot smokestack of the smelter which has identified Winkelman for most of the century.

Today Winkelman has another landmark—a serpentine adobe wall by artist Marilyn Zwak, carved and inset with chunks of malachite, pottery shards, and farming and mining scrap metal. The wall is the centerpiece of a roadside park. That an isolated town of 1,060 inhabitants could gain a public artwork like this one is a special achievement. Here is how it happened.

Winkelman is at the intersection of two state highways. At this intersection the town owned a vacant lot. Scattered with broken glass and roadside litter, this was Winkelman's face to the world.

Early in 1985, the mayor, Arnold Ortiz and the town clerk decided that something must be done about this entry point to signal passers-by that this was Winkelman. The germ of an idea of a roadside park took shape. At about the same time, Sylvia Kerlock, a local resident, was hired to do some planning and grant writing for the town . . . and the Arizona Commission on the Arts' "Guide to Programs" arrived in the town mailbox. Sylvia saw an opportunity for Winkelman in the Commission's Art in Public Places grants program. A work of art in the town! She applied for and received a $600 planning grant, to be matched from the town budget.

Sylvia formed a local steering committee which provided broad community representation: the postmaster, the justice of the peace, the mayor, a local artist/pipefitter, the school counselor, a freelance photographer. From outside the area she included the director of the Tucson Museum of Art, whose broad knowledge and sensitivity to the community were invaluable contributions.

The committee met four times during the planning year. Early meetings brought consensus on the general nature of the artwork desired, i.e., that it would symbolize Winkelman as a mining and ranching town and would be a source of pride for the community.

First the Arizona Commission's slide bank was used to identify a pool of artists. Then, three finalists met with the local steering committee, saw the site, and learned about Winkelman's history. They were asked to submit a rough model and budget. Through a series of selection meetings, adobe artist Marilyn Zwak was chosen.

When the models arrived, they were put on display in City Hall and featured in the local newspaper. Townspeople were invited to come in and vote for their favorite. The committee selected Zwak's proposal because they felt it met all their criteria: it dealt with the town's history, it was large enough to have real visibility at the intersection, and it required very little additional site preparation and expense.

They decided that one work of art for Winkelman might not be enough. They could get other sculpture later.

In October 1986, when the summer heat had passed, the artist moved her tiny trailer in behind City Hall and lived there during the weeks from October to April. The town's cash match took many forms: utilities for the artist's trailer, town workers who cleaned the site and helped the artist construct a fence, a community service worker assigned by the justice of the peace, and additional town workers who laid the foundation. A source of good clay, sand, and gravel was located on a nearby ranch and donated by the owner. ASARCO, the mining company, donated reinforcing rod, and later the chunks of malachite and discarded mining tools. The county donated use of a grader, and the town provided a backhoe. A concrete foundation was poured. The adobe mixing began, one wheelbarrow at a time, first with the help of another community service worker who lasted little more than a week. Volunteerism vanished. At last another community service worker arrived to

mix adobe. He became deeply involved in the project and stayed on as a volunteer to mix 174 of the 279 wheelbarrows of adobe. His signature is on the finished sculpture in recognition of his contribution.

Winkelman's Wall was dedicated in May 1987. People came that day to give speeches, listen, drink punch, take a stroll around the wall, and offer recognition to the nine people who steered the project and to the many others who contributed time and resources.

The completion of the wall and the artist's involvement in the community has generated several spinoffs: the formation of an art league, which is planning a local mural project; landscaping to relate the wall to the new fire station to be built nearby; desert wildflowers, supplied by the Department of Transportation, which will cover the highway frontage adjacent to the park; and postcards of Winkelman Wall to be sold at the convenience market across the road. Ongoing care of the wall has been assumed by the Art League, and volunteers are keeping the park tidy.

Budget

Artist fees	$9,600
Utilities	144
Photography and promotion	238
Phone	30
Materials	1,060
Insurance	300
Brass plaque	170
Salaries	500
Total	**$12,042**

In-kind Donations
Adobe materials
Malachite and copper cable
Equipment (backhoe and grader)
Labor (community service and town workers)
City Hall staff time
Mining and farming scrap materials
Railroad ties and flowering plants

National Endowment for the Arts' Visual Arts and Design Arts programs, and funds are expected from the state of Iowa, private gifts, and as part of a major downtown development project which involves parking and waterfront development.

In addition, private, nonprofit groups often serve as catalysts for the involvement of other sanctioning groups—local government planning and public works bodies, educational institutions, and, of course, the arts community. The Davenport project exemplifies this. Visiting Artists, Inc. is also working with the Downtown Davenport Development Corporation, a Riverfront Task Force, and other nonprofit groups concerned with downtown renewal efforts to ensure that the plaza project considers these overall renewal plans. Following are several other examples of the array of not-for-profit groups involved in public art.

Creative Time is an experimental arts organization which has won wide recognition for supporting emerging artists in the creation of provocative and innovative art projects, generally temporary in nature, throughout New York City. Creative Time's purpose is to provide artists with an opportunity to experiment artistically, while considering, not only the social and cultural concerns of the local community, but also the physical character of the site. The group is also particularly interested in the dialogue that takes place between artist and audience when a public artwork is created.

Creative Time both initiates projects and accepts proposals from individual artists for projects in particular spaces. Anita Contini, founder and former director of the organization, described Creative Time's activities in Insights/On Sites ⬤ as follows:

⬤ See "Alternative Sites and Uncommon Collaborators: The Story of Creative Time," *Insights/On Sites,* Bibliography.

"Our works and events take place in unexpected areas that generally lack cultural amenities but possess architectural, historic, and artistic value. We do not own any space, but we move freely about the city, using both indoor and outdoor sites that have been vacated, abandoned, or forgotten. We have presented exhibitions in vacant office lobbies and storefronts, abandoned subway stations, empty landmark buildings, and undeveloped landfill sites."

Besides receiving grants from traditional public sources, Creative Time has been notably successful in securing corporate grants and, particularly, in-kind advisory and material donations. The agency's strategy has often been to side step the traditional corporate foundation (from which monies are usually difficult to secure) and contact instead a targeted company's public relations and sales departments. These departments are approached as potential donors of promotion, printing, materials, or technical advice about the materials or engineering of a given project.

Angelica Hoffman, Project for Art on the Beach 1987, Hunter's Point, Queens, New York, Creative Time, 1987.
photo: Alyson Poll

See "Choreography and Caution: the Organization of a Conservation Program," Appendix.

Malcolm Cochran,
Chapels of Ease,
temporary work in the
National Site Works
component of the Arts
Festival of Atlanta, 1984.

Chartered in 1872, Philadelphia's Fairmount Park Art Association can proudly point to its record of the longest continuous involvement in public art in the United States. The association's commitment to the integration of art and urban planning has comprised both historic and contemporary issues. Projects have included: the landmark program and exhibition "Form and Function: Proposals for Public Art for Philadelphia," the initiation of a pilot sculpture conservation program ; and "Light Up Philadelphia," a pioneering investigation of creative urban lighting possibilities for the city.

As public art opportunities increase, there grows a need for a pool of artists who are experienced in the processes and the variables inherent in creating art for public spaces. This, in fact, is one of the most pressing issues in public art, and one which both Creative Time and Fairmount Park Art Association have successfully addressed by enabling artists to gain experience and experiment artistically on temporary projects.

Festivals have also afforded artists the chance to work on temporary projects. The Atlanta Arts Festival, the Maine Festival, and Boston's First Night (a citywide New Year's Eve celebration) have enabled many artists to work both on a large scale and in alternative spaces. Artpark in Lewiston, New York, and other artist residency programs like the Headlands Art Center in Sausalito, California, enable artists, with some funding support, to experiment on various scales and in indoor and outdoor environments.

Other not-for-profit groups which have been initiators of public art projects include historic commissions, chambers of commerce, and museums and visual arts organizations. Obviously, these groups, along with arts organizations, represent a wide range of organizational and civic motivations. So, their public art projects and programs are inspired by a variety of goals, including:

— encouraging artistic experimentation;
— providing opportunities for both emerging and established artists;
— inspiring or reinforcing a sense of civic pride;
— fostering the "beautiful," the "inspirational," the "provocative," etc.;
— addressing social issues and promoting civic responsiveness to them; and
— helping to integrate the arts into an overall community planning process.

While much attention is now being paid to guaranteed public funding mechanisms (such as the percent for art programs described in the following section), it is important to recognize that such independent projects

Buster Simpson, *Witness Tree*, exhibited at the Columbia Center, Seattle, Washington, 1985. Functional vitreous china pissoir produced in 1984 at the Kohler Company's plant in Wisconsin as part of the factory's Arts and Industry Program.

are important in the overall public art picture. In many cases, in fact, formal funding programs like percent for art have been adopted only after single projects have demonstrated the extent of local support.

Projects initiated by the public sector

There are 135 known public art programs across the country which use public money either for individual projects on a regular basis or for ongoing public art programs. They include agencies of municipal, county, state and the federal government. (The federal government is most notably involved through the General Services Administration's Art-in-Architecture program and the National Endowment for the Arts' Art in Public Places funding category through the Visual Arts Program.)
They include a variety of specific public agencies, such as transportation and national and state park services, as well as redevelopment agencies and planning commissions which require or encourage public art in private development.
Public funds are commonly designated for public art in one of three ways:
— appropriations on a project-by-project basis;
— appropriations in the form of line items in an administering budget; and
— percent for art legislation or ordinances.
State arts agencies such as New York, and North Carolina have a line item in their budgets which, rather than supporting art in state building projects, instead provides funds for public art activities initiated by agencies or artists within the state. ● See Public Art Programs, Appendix.
Municipalities have sometimes tapped unusual sources of city funds to support public art. These include:
— a hotel/motel tax (St. Louis, Missouri, and Corpus Christi and Brazos Valley, Texas);
— federal revenue sharing (Santa Cruz, California, through the City Arts Commission of the Department of Parks and Recreation);
— community redevelopment funds (Cambridge, Massachusetts; Thousand Oaks, San Jose, and San Francisco, California; Buffalo, New York; and Toledo, Ohio);
— lottery and special industry taxes (Casa Grande and Phoenix, Arizona); and
— bond issues (Seattle and Albuquerque).

Funding through the percent for art model

The typical percent for art law stipulates that a certain percentage of the cost of constructing or renovating a public building or site (or of a

See Seattle's ordinance, opposite page, and the Washington State ordinance, Appendix.

capital improvement project) shall be set aside for artwork. For the purposes of this publication, it is assumed that readers are generally aware of the means and ends of a "typical" percent for art program. Therefore, we will look at improvements upon the percent for art model, illustrated mainly by two programs: Seattle and Washington State. Both represent years of instructive experience within different settings—Seattle's urban environment and Washington state's rural as well as urban settings. Both also recently made formal amendments which suggest important changes and improvements for percent for art programs.

As a preface, it is important to remember that the statutes of percent for art legislation discussed in this section are not the goals in and of themselves, but rather the means toward realizing the mandate of the public art program. For example, if one goal of a percent for art program is to achieve city-wide integration of the arts into public spaces, then the legislation and ensuing policies should enable the most creative approaches and solutions. Unnecessary restrictions in the law, such as limiting the use of funds to the site which generates them, may pose problems later when logical sites for public art activity cannot be addressed because they do not have renovation or construction planned, or because sites which do are considered inappropriate for public art.

In such cases, the commissioning agency can choose to work within the constraints of the law, perhaps "bending" it where possible, and living with its limitations where necessary. Alternatively, the commissioning agency can seek to have the law amended, as did Seattle and Washington State. But in general, the goal should be to pursue from the beginning the broadest and clearest definition of the percent for art ordinance, rather than to operate under unsatisfactory restrictions and be faced with lengthy amendment processes later.

In brief, the typical elements of a percent for art ordinance include:
— purpose of the ordinance, i.e., why public art?;
— definitions of words which may cause confusion, such as "commission," "Municipal Arts Plan," "pooling;"
— the actual percentage to be allocated and how that figure is derived;
— the eligible sources of funds;
— the eligible uses of funds;
— the system for fiscal management of funds, e.g., how art allocations will be reserved and carried over from year to year, pooling of funds; and
— the designated commissioning agency's responsibilities and authority in administering the program.

Annotations to this ordinance by Diane Shamash, acting co-ordinator of Seattle's Art in Public Places program, point out strengths and weaknesses of the ordinance. Excerpts are also provided from Miami's Metro-Dade Art in Public Places ordinance to compare how the percent allocation is calculated, the allowable uses of the percent monies, and principles guiding art selection. *Reprinted by permission of the Seattle Arts Commission.*

If an ordinance is vague, the agency is at the mercy of whomever interprets it (city/ county/state law department); this can be a problem. It's best to fight for specific use of percent for art funds from the start, to provide the broadest and clearest definition of the ordinance, rather than change the ordinance later.

It's important to carefully define legal uses of percent for art funds to match the philosophy of the Commission, for example, artwork purchases vs. administration, collection management, and education. Seattle's percent for art ordinance does not mention the use of percent funds for administration, collection management, or education; our legal department has ruled that while we can use these funds for administration (as outlined in our Municipal Art Plan), we cannot for management and education. This does, in fact, reflect a policy that prohibits the use of percent funds for collection management and education in order to discourage a dwindling fund as the collection grows older (increased collection management needs), or exorbitant education costs. We are now facing the issue of how to increase our collection management budget (from general fund) without changing the ordinance.

Metro-Dade provides that: "To the extent the total appropriation is not used for the acquisition of works of art for said buildings, the remainder may be used for: (1) Program administration costs, insurance costs or for the repair and maintenance of any works of art acquired under this section; or (2) To supplement other appropriations for the acquisition of works of art under this section or to place works of art in, on, or near government facilities which have already been constructed."

It's important to define how the percent is calculated (total capital construction costs, total city-funded capital construction costs, total project development costs, etc.). Seattle's ordinance is somewhat vague on this issue, and we have been lucky that there has been a willingness to accept a broad interpretation for the calculation of these funds.

Metro Dade Art in Public Places program specifies, for example, that: "Construction cost is defined to include architectural and engineering fees, site work, and contingency allowances. It does not include land acquisition or subsequent changes to the construction contract."

Pooled percent for art funds are generally better than percent funds that are tied to the site of construction or department that generates them (more flexibility, more uses, etc.). Seattle has an accountancy act which specifies that one fund may not, however, benefit another; that is, while general percent for art funds can be pooled within a specific department, they cannot be used to benefit another department or fund source.

The inclusion of utilities in Seattle's percent for art ordinance has made an enormous difference in our program/ collection, since Seattle City Light percent for art monies provide about 80% of our annual budget!

Seattle Percent for Art Ordinance
Ordinance 102210 as amended

AN ORDINANCE authorizing allocation of certain funds for art in the construction of public works; providing for a review of suitable capital projects and for an artist selection process; and establishing a special fund designated "Municipal Arts Fund."

BE IT ORDAINED BY THE CITY OF SEATTLE AS FOLLOWS:

Section 1. Purpose. The City of Seattle accepts a responsibility for expanding experience with visual art. Such art has enabled people in all societies better to understand their communities and individual lives. Artists capable of creating art for public places must be encouraged and Seattle's standing as a regional leader in public art enhanced. A policy is therefore established to direct the inclusion of works of art in public works of the City.

Section 2. Definitions.
(a) "Commission" means the Seattle Arts Commission.
(b) "Construction Project" means any capital project paid for wholly or in part by The City of Seattle to construct or remodel any building, structure, park, utility, street, sidewalk, or parking facility, or any portion thereof, within the limits of The City of Seattle.
(c) "Eligible Fund" means a source fund for construction projects from which art is not precluded as an object of expenditure.
(d) "Municipal Arts Plan" means the plan required by Section 4(a) of this ordinance.

Section 3. Funds for works of art. All requests for appropriations for construction projects from eligible funds shall include an amount equal to one percent (1%) of the estimated cost of such project for works of art and shall be accompanied by a request from the Arts Commission for authorization to expend such funds after the same have been deposited in the Municipal Arts Fund. When the City Council approves any such request, including the one percent (1%) for works of art, the appropriation for such construction project shall be made and the same shall include an appropriation of funds for works of art, at the rate of one percent (1%) of project cost to be deposited into the appropriate account of the Municipal Art Fund. Money collected in the Municipal Arts Fund shall be expended by the Arts Commission for projects as prescribed by the Municipal Arts Plan, and any unexpended funds shall be carried over automatically for a period of three years, and upon request of the Arts Commission, carried over for an additional two years. Any funds carried over for three (3) years, or upon special request for five (5) years, and still unexpended at the expiration of such period, shall be transferred to the General Fund for general art purposes only; provided that, funds derived from revenue or general obligation bond issues or from utility revenues or other special purpose or dedicated funds shall revert to the funds from which appropriated at the expiration of said three (3) or five (5) year period.

The Metro Dade ordinance expands on its public art philosophy through articulation of these principles guiding art selection:

(a) Works of art shall be located in areas where residents and visitors live and congregate and shall be highly accessible and visible;

(b) Areas used by tourists, including the airport, seaport, beaches, parks and thoroughfares, shall each have a separate Master Plan which shall be incorporated as a portion of the Master Art Plan;

(c) The Trustees should consider the inherently intrusive nature of public art on the lives of those frequenting public places. Artworks reflecting enduring artistic concepts, not transitory ones, should be sought;

(d) The Trust's selections must reflect the cultural and ethnic diversity of this County without deviation from a standard of excellence;

(e) Final selection shall also take into account appropriateness to the site, permanence of the work in light of environmental conditions at the site, maintenance requirements, quality of the work, likelihood the artist can successfully complete the work within the available funding, diversity of the artists whose work has been acquired by the Trust.

The ordinance should establish a document that is the Municipal Arts Plan which gives the arts agency authority to make expenditures and a designated fund in the city treasury where department percent monies are deposited for administration by the agency. Seattle's Municipal Art Plan authorizes the purchase or commission of artworks during a designated year and needs only be signed by the mayor. This means that individual projects are not reviewed by the mayor or city council, but a comprehensive plan is adopted for the entire year. Also, by establishing a Municipal Arts Fund (cultural trust, etc.), the agency is given the authority to administer the percent monies, rather than the individual departments.

- 2 -

Section 4. Commission Authority. To carry out its responsibilities hereunder, the Commission shall:

(a) Prepare, adopt and amend with the Mayor's approval a plan and guidelines to carry out the City's art program, which shall include, but not be limited to, a method or methods for the selection of artists or works of art and for placement of works of art.

(b) Authorize purchase of works of art or commission the design, execution and/or placement of works of art and provide payment therefor from the Municipal Arts Fund. The Commission shall advise the department responsible for a particular construction project of the Commission's decision regarding the design, execution and/or placement of a work of art in connection with such construction project.

(c) Require that any proposed work of art requiring extraordinary operation or maintenance expenses shall receive prior approval of the department head responsible for such operation or maintenance.

(d) Promulgate rules and regulations consistent with this ordinance to facilitate the implementation of its responsibilities hereunder.

Section 5. Municipal Arts Fund. There is established in the City Treasury a special fund designated "Municipal Arts Fund" into which shall be deposited funds appropriated as contemplated by Section 3 hereof, together with such other funds as the City Council shall appropriate for works of art, and from which expenditures may be made for specific works of art or for works of art in accordance with the plan specified in Section 4(a) hereof. Separate accounts shall be established within the Municipal Arts Fund to segregate receipts by source or, when so directed by the City Council, for specific works of art. Disbursements from such fund shall be made in connection with projects approved by the Commission on vouchers approved by the Executive Secretary of the Arts Commission or such other person as may be directed by ordinance for specific projects, and the City Comptroller shall draw and the City Treasurer shall pay the necessary warrants and make the necessary transfers.

Flexibility: a goal of percent for art legislation

It may seem contradictory to argue against vagueness in defining percent for art law—as we have above—and in favor of flexibility in defining guiding policies and procedures. Specificity is desirable in defining elements of the law such as: the creation of funds for the program, from what base costs the percent figure is derived, and where administrative and fiscal authority lies. However, procedures for administering the program are best left generally stated in the ordinance to allow flexible approaches to site and artist selection, for example, as specific circumstances warrant.

Flexibility should manifest itself in a number of ways, including:

Flexibility of funding source

What sorts of building projects generate the percent monies? Existing percent programs demonstrate a range of types of construction projects to which the percent applies. Some pertain exclusively to the construction of new buildings. Others also include renovation projects, often stipulating a certain minimum budget size. Most are exclusive of land acquisition.

The most inclusive, such as Seattle's and the new Phoenix ordinance, make *all capital improvement* projects subject to the percent requirement. The Seattle program includes the city utilities (principally light and water), and the major construction agencies such as the building and parks departments. The inclusion of utilities in Seattle's percent for art ordinance has made an enormous difference in its program. Not only has Seattle City Light's percent revenues provided about 80 percent of that program's annual budget, but some of the most successful collaborations and innovative artworks have resulted from projects within the utilities' jurisdictions. The requirement of these art funds have forced a public art laboratory in prosaic locations which otherwise would have been unlikely sites and opened up greater possibilities for integration of art into the built environment.

Flexibility of funding uses

Not every eligible capital construction project is appropriate for a public artwork. (Underground wiring projects, or other similarly inaccessible sites, are clearly not the most promising opportunities.) Nor will every site generate enough dollars for a public artwork. "Pooling" of percent funds is a mechanism which eliminates the restriction that works of art must be limited to the actual site generating the funds. In other words, it allows percent funds generated at one site to be expended at one or more other sites (but usually limited to the department originating

the funds) and allows the arts agency to begin to consider the city as a whole.

Pooling was an important concept incorporated in the 1983 revised legislation for the Washington State Arts Commission. Aggregating the funds eligible for use on "any public building or land" enabled the Arts Commission to address sites and situations which had major public access and visibility, served a social or environmental need, or were responsive to artists' concepts for new works of public art and to better develop a public art program which considered the public as a critical criterion.

Washington's best pooling example is the four major projects that were developed using the Department of Correction's percent for art funds. One project provided the opportunity for artist Richard Turner to create a major work called *Memory's Vault* in a state park with site preparation provided by an inmate work crew. (State parks often have excellent lands and high public visibility, but rarely generate significant art funds.)

A second project provided for the purchase of a curated, portable collection of traditional and contemporary Native American art to tour among the schools. This project, incidentally, served as a model for pooling school funds for portable collections. Washington's schools generate a large number of construction projects—over 50 annually—which often have low budgets for art. Pooling has enabled the creation of portable collections with accompanying interpretive materials. These give schools a varied and educational exposure to art and serve a large number of artists at the same time.

A third pooling effort enabled artist David Ireland to work within a correctional institution, addressing a number of public areas within the Monroe Reformatory facility.

An additional advantage of pooling should be noted. It's not unusual for an administrative backlog to result when percent for art legislation mandates a proliferation of small projects. Pooling allows consolidation of smaller projects and allows administrative flexibility and more options for the public art program.

For more on Washington State's pooling stipulations, see Washington's Art in Public Places legislation, Appendix.

Travelling exhibit of Native American artwork, Washington State Arts Commission and the Department of Corrections.
© *ART on FILE, Chartier/Wilkinson, 1988.*

Flexibility in administrative authority

Given the multiplicity of agencies involved in some percent for art programs, what is the most effective administrative structure? How can agencies (the funding source, client agencies, and arts commission) minimize bureaucratic complication and simplify financial transactions?

See sections 4 and 5 of the Washington State legislation, Appendix.

The 1983 revised version of the Washington State Arts Commission's percent legislation addressed these questions, consolidating all administrative responsibilities of the program under the Arts Commission. It clearly establishes the Arts Commission as the agency with authority to implement the legislation, including:

— the right to ensure artistic advice for the state's collection;
— the right to determine projects and sites, including those affected by pooling of funds; and
— the right to contract directly with the artist and with other agencies on an interagency agreement basis, to assure their compliance with the terms of the contract between the artist and the Arts Commission.

These responsibilities and others are always executed by the WSAC in consultation with the other involved state agencies. The revised legislation eliminates duplication of effort in interagency billings, contracting, determination of project funds, and project negotiations by placing primary responsibility with the Arts Commission.

Flexible administrative resources

Until the recent past, most percent for art legislation has been aimed at the *commissioning* function. Some difficulties that have troubled percent for art programs seem to result from initial legislation characterized by lack of goals and specificity, restrictions on the use of funds, and inadequate consideration of the ramifications of the program such as long-term care of the art, and community education, which ensure the collection's vitality and value.

If funds are only allowed to be used to commission artworks, how can the costs of administration, maintenance, and education—all now recognized as essential to the success of percent for art programs—be covered?

Too much statutory vagueness in these areas, as Diane Shamash of the Seattle Arts Commission points out, can be very troublesome: "If an ordinance is vague, the agency is at the mercy of whoever interprets that ordinance—for example, the city, county, or state law departments." It is usually the best procedure for the arts commission to propose specifically how such administrative resources will be made available.

Some percent for art programs specifically set aside a portion of their percent for art revenues for administrative costs (26 percent of 126 publicly funded programs which responded to a survey— utilize some part of the art funds for administrative costs). For example, the Washington State

See Public Art Programs Listing, Appendix.

"Any general fund is subject to an annual appropriations process which may be iffy in a difficult year. The proposed Dallas allocation of 1.5 percent enables .25 percent to be put into a conservation endowment and .25 percent for administration, artist selection, and community education projects. One percent remains for actually commissioning art."

Jerry Allen, public art administrator

Arts Commission admits that its program would have made little progress without consistent staff attention, supported by the percent allocations. However, the fact that the total art funds are diminished as a consequence is also recognized as a major disadvantage. Another danger in this approach is that if the pace of city or state-sponsored construction slackens for an extended period, administrative costs will not necessarily decrease, since projects in progress will continue to demand attention. Meanwhile, city officials may have grown accustomed to percent for art "paying its own way" and conceivably the administrative costs could escalate in relation to the art costs.

An appropriate solution is for administrative monies to come from some sources outside the percent funds. (The same survey, see above, showed that 58 percent of the 126 respondees utilize other agency funds for administration.) The Phoenix Arts Commission's administrative funds, for example, come from the general fund of the agency. The commission was told that it could not use percent for art money to operate the overall program, except on certain large-budget projects and only with authorized approval. In a sense, such a restriction on funds may catalyze the release of funds elsewhere in a municipal budget by officially recognizing percent for art *administrative* costs as part of the agency's base budget.

In 1980, the Seattle Arts Commission went to the city council to gain funds above and beyond its percent for art revenues for use in "managing" its collection. This collection management activity would include maintenance of both percent artworks and non-percent artworks (historic works, gifts) and educational programs. Costs relating to ongoing commissioning of artworks are prorated and charged to the departmental funding source, for example, water, parks, or buildings, as a basic expense. The time that a Seattle Arts Commission employee spends on a given project is recorded routinely. Such documentation is cumbersome, but it legitimizes the use of city funds for public art administration and is comparable to the way city employees charge their time for the management of the overall building process.

Flexible maintenance resources

We have already noted that Seattle expends funds outside of percent for art revenues for collection management. This approach recognizes art maintenance as an operational cost, similar to park and building maintenance, street repairs, and so on.

The Washington State Arts Commission sought unsuccessfully (in its 1983 revised legislation) to have created what it views as an ideal fiscal structure for ensuring maintenance funds. A revolving fund would have

been established, into which all percent for art funds would be pooled and earn interest income, which could then be used for program administration, maintenance, and/or new acquisitions without dilution of the principal.

A middle ground is represented by the Metro-Dade Art in Public Places ordinance. The ordinance puts a spending priority on art acquisition, but also permits the use of funds for administrative costs, insurance costs, or the repair and maintenance of artworks. Requests for such uses are made by Metro-Dade APP staff and must be approved by its governing board, the APP Trust.

A final alternative is to reserve some proportion of percent for art revenues for maintenance—either on a project-by-project or pooled basis. Over the long run, the result of this approach is a better maintained but smaller collection, unless the overall percent allocation is increased. In most cases, therefore, this is the alternative of last resort. (For more on funding the care of public art works, see Collection Management Section.)

Flexible educational resources

It's fair to say that no program should begin without consideration of the process of community involvement and of the types of educational programs which can make artworks more meaningful to the people who will encounter them. But as with maintenance, a provision for funds to develop educational activities is often neglected in enabling ordinances. Here again, if derived directly from percent for art revenues, there will be less money available for art. In addition, percent for art monies are generally regarded as dedicated to capital construction and most city administrators may find it difficult to justify "education" as an element of capital construction. Paradoxically, however, community involvement and education are considered essential to the administration of public construction projects.

So the questions are: Are education programs important enough to link them formally to a percent for art program's official mandate? If so, how will they be funded, particularly if the ordinance prohibits these expenditures?

Deborah Whitehurst, executive director of the Phoenix Arts Commission, offers one perspective: "Education is fundamental to the function of any arts agency. They all use education as part of their mission. Education should be funded out of the agency's budget as a fundamental administrative cost."

Some recent developments suggest directions for the future. For example, the Metropolitan Arts Commission of Portland, Oregon, amended the county ordinance to add .33 percent to the existing 1 percent allocation to

be used predominantly for educational activities. The education funds are presently going toward the building of the Metropolitan Center for Public Art to be housed within the Portland Building (where the Arts Commission is also located). Run by the commission, the center will exhibit models of public art projects in progress, murals of past projects, molds used to cast *Portlandia* (the monumental sculpture on the exterior of the Portland Building) and related interpretive materials. In addition, public art walking tours will originate from the Center. Although limited in scope, this Center is a significant first step in acknowledging a responsibility for communication with the public.

Until such measures guarantee funds, educational programs continue to be ideally suited to public and private grants, and partnerships with other agencies and institutions. (For more on educational programs, see the Community Involvement and Education Section.)

Anne and Patrick Poirier,
Promenade Classique,
Alexandria, Virginia,
1986.
©*ART on FILE*,
Chartier/Wilkinson, 1988

Public art initiated by the private, for-profit sector

A broad range of public artworks are conceived of, funded, and implemented independently of public processes and public monies. For the most part, these projects have been sponsored by corporations which cite one or more of the following reasons for their arts-related activities:

— *enhancement of a given space* (whether for marketing advantage—"to attract and hold tenants," as Benjamin Holloway of the Equitable Life Assurance Company has phrased it—or for increased employee satisfaction and productivity);

— increased *corporate visibility* and the reinforcement of a progressive *corporate image* (either locally or further afield); and

— *investment* (on the assumption that the work of an established or promising artist will appreciate over time).

When a corporation chooses an artist or an artwork, it may do so in one of two ways:

— by executive "fiat," or

— with the assistance of an independent consultant or local arts institution.

In the former case, there is often a senior corporate executive involved who is well versed in the arts and is able to make informed decisions about purchasing, siting, and so on. For example, Pepsico's public sculpture park in Purchase, New York, was established in 1970 under the leadership of Donald Kendall, then Pepsico's chief executive officer. In this case, although Kendall has retired as CEO, he is still chairman of the Executive Committee and makes all decisions about the sculpture garden.

Scott Burton, Atrium Furnishment, Equitable Tower, New York City, The Equitable Life Assurance Society, 1986.
photo: Agnes Denes

Dallas developer Raymond Nasher places artworks from his personal
art collection into the public spaces of his commercial developments.
Nasher's North Park Shopping Center in Dallas contains a rotating collection of sculptures, including works by Tony Smith, Jonathan Borofsky,
and Beverly Pepper.

Corporations may choose to rely on the expertise of an arts professional in
making decisions about public art acquisitions. A consultant learns what
the company wants to accomplish and suggests the best means of achieving
those results. Often, this involves first helping the company establish long-
range goals for its public art activity, and second, introducing the company
to processes and members of the arts community.

Selection of the artist may be made by the corporate executive from
the consultant's recommendations, as in the case of *California Scenario*,
an environment created by artist Isamu Noguchi for developer C.J.
Segerstrom's South Coast Plaza Town Center in Costa Mesa, California.
The consultant, Tamara Thomas, worked with several goals and
variables to come to specific artist recommendations. These included:
the corporation's interest in an internationally renowned sculptor, the
architect's interest in a fountain, and an overall interest in the use of
natural materials juxtaposed with the contemporary office buildings of the
South Coast Town Center Complex. The final selection was made by
the corporate executive. (For further discussion of the role of the
consultant, see Guidelines for Implementation: Project Management
Section.)

The consultant might also compose a panel which recommends artists
to the developer as in the following example. Officials of the Alexandria,
Virginia-based developer Savage/Fogarty Companies called on Donald
Thalacker, then director of the Art-in-Architecture program of the General
Services Administration, to advise on the inclusion of public art in an
office complex project on the Potomac River in Alexandria. While Savage/
Fogarty was already committed from the start to an exemplary, professionally conducted public art project, Thalacker spent time discussing with
the company the range of artistic possibilities and the options for
identifying a pool of appropriate artists for consideration. The developer
agreed to the idea of a panel of three museum professionals, composed
by Thalacker, which would first hear the interests and goals of
Savage/Fogarty and the project's landscape architect, M. Paul Friedberg
and then develop a pool of artists for further consideration. The panel
made its recommendation of French artists Anne and Patrick Poirier which
Savage/Fogarty accepted wholeheartedly.

37

"**Venturing into the uncertainties of commissioned artwork is an uncomfortable prospect for many corporate clients. Part of our task is to familiarize them with the long history of this process—I mean, back to the Renaissance! A design process that is both familiar and open to the client's input gives them some measure of control and will yield more cooperation.**"

Paul Broches, architect

A fine arts consultant, Joyce Pomeroy Schwartz, was then hired to coordinate the public art project. The result, called *Promenade Classique*, completed in 1986, is a monumental outdoor sculpture and fountain installation consisting of colossal marble and bronze fragments reminiscent of archaeological ruins and set within a formal landscape garden.

Many corporate clients, however, are not prepared to deal with the notion of integrated or collaborative works which entail introducing artists at the initial building design stage. Mitchell/Giurgola Architects, a firm that frequently pursues artist/architect collaborations, has found an enormous difference between the willingness of a client to contemplate the purchase of a major, existing painting or sculpture and the higher risk process of commissioning a collaborative work.

Developers have an additional reluctance to pursue collaborative art projects that will affect their financial calculations in an indeterminate way. The architect attempting to encourage the developer will be well served by a qualified art consultant who can address the issue in market terms.

Finally, as cities begin to address larger design issues in the built environment, private developers may be encouraged or mandated by a public authority (such as a redevelopment or zoning authority) to include public art in their projects. This public/private relationship deserves further attention as an evolving method of tapping private monies for art in public places.

Two recent directions

Kathy Halbreich notes in the introduction that "while federal, state, and local agencies still provide a great deal of the impetus and muscle for public art projects, percent for art funds cannot always be stretched to finance all the innovative or ambitious projects."

Farsighted public officials have begun to see that the responsibility for creating successful public spaces must be shared by the public and private sectors. Only a handful of cities, through their development or redevelopment authorities, have formally crafted programs ensuring public art in private development projects. Most notable of the recent programs are the Los Angeles Community Redevelopment Agency (to be discussed in detail in this section) and Battery Park City Authority—an ambitious public art program which has fostered collaboration between designers and artists for various open spaces within the 92-acre, mixed-use development in lower Manhattan.

Still fewer models exist for the application of zoning requirements and incentives to public art. As one might guess, issues arising from the

differing motivations and systems of the public and private sectors make this new direction an even more challenging approach to the funding of public art.

Redevelopment

Most major U.S. cities have established an agency dedicated to the redevelopment of designated sites or areas within those cities. (The word "redevelopment" may or may not be a part of the agency's formal title.) Well into the 1960s, these agencies tended to take a broad-brush approach to blighted areas, often clearing whole neighborhoods in the name of "urban renewal." Since that time, redevelopment efforts have become increasingly focused and sophisticated, and it was only a matter of time before innovative arts agencies and city administrators began to link municipal development and arts policies. In 1959, the city of Philadelphia took the earliest step by establishing a percent for art program in its Redevelopment Authority. In the 1960s, Los Angeles's Redevelopment Agency orchestrated public artworks, but it was not until the '80s that a formal policy was established.

In 1979, the Sacramento Housing and Redevelopment Agency enacted a series of resolutions designed "to promote the aesthetic improvement of the City of Sacramento to the fullest extent possible." The resolutions established an art in public places program and stipulated that at least 2 percent of the total actual construction costs of all agency-directed building projects was to be expended on aesthetic improvements. In recent years, other cities such as Cincinnati and areas of cities such as Battery Park City (Manhattan) have developed public art programs.

One interesting feature of the Sacramento program is that the redevelopment agency "subcontracts" with the Sacramento Metropolitan Arts Commission for management of its art in public places program. The program also places emphasis on flexibility and on an early interaction between arts administrators and potential developers.

The Downtown Art in Public Places Policy of the Los Angeles Community Redevelopment Agency (CRA), enacted in 1985, drew upon the Sacramento model and experience. "Of all the municipal and redevelopment agency programs we reviewed," recalls Ari Sikora, former CRA senior policy planner for the central business district, "this one was the most carefully structured to really accomplish early integration of the arts component into *potential* redevelopment projects. Unlike Philadelphia's, Sacramento's program recognizes the reality of project evolution from *tentative* to *final* developer selection and, indeed, the

Gan Iwashiro, Untitled, New Otani Hotel & Garden, Los Angeles, Los Angeles Community Redevelopment Agency, 1977.

See Appendix for a reprint of the Downtown Art in Public Places Policy.

potential for significant changes in both project scope and design. Although some developers remain flexible on design, program, and even on the selected architect well past execution of the Disposition and Development Agreement, many lock in early on concepts which narrow the range of options for integrating art (e.g., object vs. art integrated into design vs. performance).

"Even during exploratory discussions, it is never too early for agency staff to introduce the goals of the arts program; artist selection options; and a clear, firm statement of the developer's procedural and fiscal obligations," Sikora continues. "In redevelopment, everything is negotiable to the last minute, and beyond. Vague or hesitant language, as in Philadelphia's policy, ensures a back-burner position for the arts component."

Today, the Los Angeles program is considered a progressive and comprehensive model for ongoing redevelopment programs. And, as Sikora suggests, the redevelopment approach is the best means—short of a privately executed collaborative effort—of integrating art into the earliest stages of a proposed private development project.

Subsequently, we will summarize the progressive aspects of the policy which created the Los Angeles program.

Los Angeles Community Redevelopment Agency model

The Community Redevelopment Agency's (CRA) Downtown Art in Public Places Policy (DAPPP) was the result of extensive research of public art programs across the country and consulting from public art experts who helped to shape the innovations of the CRA's policy. In August of 1985, the Policy was approved as applicable to the CRA's overall redevelopment plans for three downtown areas. The CRA pledged itself to promote these areas as cultural centers through the support and creation of programs, facilities, and public artworks across a range of artistic expression.

The policy requires that at least 1 percent of private development costs (total project costs exclusive of land) for new commercial and multi-family developments (with some exceptions) be allocated by the developer to support such efforts. Of that 1 percent, at least 40 percent is to be deposited in the Downtown Cultural Trust Fund. Each development has the option of choosing to implement its percent for art obligation via this combination of on-site program and Trust Fund contribution, or to make an exclusive .8 percent Trust Fund donation (and thereby eliminate on-site artwork). The Trust Fund, a distinguishing innovation of the CRA Policy, is a funding mechanism which aggregates portions of the individual private, site-specific percent for art requirement and redistributes these

"The redevelopment model in Los Angeles is a good one because the developer has an option; he can funnel the required funds into a central pool, or he can follow the processes for commissioning a work as outlined by CRA. Giving a developer a choice of how to participate is a gentle form of coercion."

Patricia Fuller, public art consultant

funds to finance cultural programs and art projects in downtown locations beyond those new private projects which generated the art funds. The Trust Fund, therefore, is a means of financing and siting artworks or programs that otherwise are infeasible, such as in neighborhoods without private investments or where development projects are too small or exempt from the DAPPP. Controversial or technically innovative artist-initiated proposals usually avoided by developers are specifically encouraged. Art projects funded by the Trust Fund are administered by the CRA and may occur anywhere within the redevelopment zone.

Goals:

Participants in the Los Angeles process carefully studied the Seattle Arts Commission's Artwork/Network study of public art in certain downtown districts as a model of firm policy commitment and a clear statement of art program goals and urban design objectives. The CRA's goal statement emphasizes its commitment to a high quality and diverse art in public places program, integrated into the fabric of the city and the daily lives of its citizens, and reflecting a broad range of constituents. It specifically encourages collaborative efforts and participation by women and minority groups traditionally underrepresented in such programs. Finally, it encourages a variety of art forms: temporary and permanent, object and event, single or dispersed locations.

> "The Trust Fund seems like a way for the developer to buy out of compliance, thus turning the funding over to those who have experience and interest in the potential for public art in the community."
>
> *Penny Balkin Bach, public art administrator*

Grand Hope Park is a project of the Los Angeles Community Redevelopment Agency.

CELEBRATED ARTISTS SELECTED TO DESIGN ART FOR PARK

Tony Berlant, Lita Albuquerque, Raul Guerrero, Adrian Saxe to Collaborate with Lawrence Halprin

The tall clocktower, part of the new park's design, will chime original compositions daily as part of the park art program.

In an art program unprecedented in Southern California, four of the state's leading artists have been selected to assist in the design of Grand Hope Park.

Lita Albuquerque, Tony Berlant, Raul Guerrero and Adrian Saxe will collaborate with landscape architect Lawrence Halprin to enhance the park's design with original art.

"This is one of the more ambitious programs across the nation for creation of a park from scratch—integrating art and artists in the process," according to Mr. Halprin, who has collaborated extensively with artists in his work.

Among the "art opportunities" on which artists will focus are the aesthetics of the clocktower, pergolas, children's play area, fountains, lighting and graphics. Artists will also be asked to identify potential locations for artworks along the Hope Street Promenade, the grand pedestrian avenue that will link the Central Library to South Park.

The artists were selected from more than 100 nationally by the park's art selection panel which includes Holly Burgin, member of the South Park Task Force; Mr. Halprin; Christopher Knight, art critic, Los Angeles Herald Examiner; Al Nodal, director of exhibitions, Otis Parsons Art Institute; and Connie Zehr, artist.

"I find this aspect of the CRA programming somewhat troubling. Percent for art legislation has always emphasized that artworks were just one more type of capital expenditure. To allow percent for art monies to be used for programming weakens that connection to capital construction and makes the percent for art program just one more tax to support the arts. One of the strongest rational bases for these programs is lost."

Jerry Allen, public art administrator

Art budget:

The CRA emphasizes that the art component of a project must be planned before construction of the overall project begins. The preliminary art budget is based on the *estimated* project costs. However, if the *final* project cost is higher than the cost figure used to calculate the preliminary art budget, the art budget must be increased to equal 1 percent of the actual total project cost. This total project cost must be determined by the developer within 30 days after funding of the developer's construction financing.

Early estimates of an art budget allow serious consideration of program options. This, in turn, facilitates the early selection and involvement of the artist in the design process.

Eligible public art components:

The CRA policy sets forth a diverse set of possibilities in the way public art can be manifested: on-site art in public places, on-site cultural programming, and on-site art spaces or cultural facilities.

On-site *art projects* are defined as broadly as possible, ranging from various types of sculpture to media arts such as sound, film, and holography, to fixtures such as gates, streetlights, and signage (provided that such fixtures are executed by artists in unique or limited editions). Unlike publicly funded percent for art programs which often legally restrict the use of funds to the creation of artworks with a specified life (e.g., 40 years), such privately funded projects are exempt from such restrictions and may contract to do more ephemeral projects or events. The CRA recognized that public art need not always be material or permanent.

In this vein, *on-site cultural programming* might include: performing arts, literary arts (poetry reading, storytelling), media arts (film and video, screenings and installations), education (lectures, presentations, etc., on art-related subjects), special events (parades, festivals, and celebrations), and even certain types of artist-in-residency programs.

Finally, the development of *on-site cultural facilities* in certain locations as a part of very large projects is seen as opening up another architectural-scale opportunity for commissioning artwork. In such cases, developers might decide to create gallery/exhibition space, performance space, arts education facilities, etc. Space developed in this way is exclusively available to nonprofit institutions, either through equity ownership or long-term lease (one such example being the Los Angeles Museum of Contemporary Art).

Other program aspects:

In addition to the preceding progressive guidelines, the CRA carefully outlined additional considerations for developers. Thorough guidelines

were laid out for the public art selection process, which would ensure that projects would both respond to the needs of a given site and community, as well as to the high artistic standards of the Art in Public Places program. Significantly, the Trust Fund enables flexibility and experimentation in the CRA's own public art efforts, for example, in allowing the initiation of projects by artists and community members. For example, planning grants for concept development and/or fabrication may be awarded to artists proposing projects for downtown.

Summary:
Since 1985, some 20 projects have moved through the Downtown Art in Public Places process, although half of these were initiated before the adoption of the policy. Of the remaining ten, two opted to contribute .8 percent to the Trust Fund, while the other eight chose to undertake an on-site project. The CRA reports a welcome diversity of projects, including exhibition spaces and performance events, and cites a stylistic diversity and multi-cultural range among artists.

The CRA sees two procedural problems which sometimes pose particular challenges: (1) guarantee of early artist involvement in the project development/design process, and (2) technical assistance to artists inexperienced in public art.

The redevelopment context is perhaps the best opportunity for *early artist* involvement and early integration of the arts component into the overall development of a private developer's project concept and design. Because a developer always hopes to leverage a minimum of out-of-pocket expenses to secure maximum agency commitment, a project design is rarely finalized until extensive discussions have taken place between developer and agency staff. This happens throughout the first six to 12 months depending on the project scope. Theoretically, this negotiating period allows ample time for agency staff to introduce the goals and procedures of the art program through orientation meetings where a range of ideas can be discussed.

In practice, developers are usually resistant to dealing with art in the early stages. Architecture is necessary to secure financing; art is not. Often the lack of financing commitment is used to excuse putting off the art program. Also, because of the pressure to make projects "real," CRA's non-arts staff are more focused on other project aspects (design, development scope, financing, etc.) during the early stages. Additionally, if a developer chooses to convene a panel to select an artist, this further expands the time, and the developer may proceed with design before the panel process has finished and an artist is selected. Consequently, unless the artist is part of the developer's design team, or unless the art component (such as a

43

theater or museum) has been predetermined by staff as a redevelopment objective, the art program will usually lag behind overall project conceptualization.

"The first line of defense," according to Ari Sikora, "is a firm policy commitment and a clear statement of art program goals and urban design objectives. Beyond that, staff dedication and constant vigilance cannot be overstressed. Every project is nurtured into existence by a large cast of characters; each sees his aspect as critical to the success of the project. Priorities are communicated by department heads, but also most importantly by the agency director and board member. The most carefully crafted plan, although preferable to a vague policy, is, in the final analysis, only as good as its upper level support and lower echelon follow-through. Single-minded dedication on the part of the arts coordinator seems crucial to keeping both levels committed and the art program on track."

Artists' lack of expertise or familiarity with large-scale or complex design processes has frustrated developers, the CRA staff, and artists at critical design review stages. The policy goals of encouraging a variety of art forms, participation by women and minorities, and using artists as design team members has inevitably led to the introduction of players new to the process and unfamiliar with agency procedure, architectural and engineering terminology, issues of permanence, liability, city codes, and so on.

While one intention of the Trust Fund has been to provide a budget line item for *technical assistance* or professional services to artists, limited staff resources have not realized the potential for these services. Artists are made aware that knowledge gaps are to be expected and that when they become apparent, artists are entitled to ask for and receive assistance. Likewise, CRA staff assists developers with advice on such things as contracts between artist and developer.

Zoning

Zoning is a well-established regulatory tool in city planning. It is used to regulate the use, scale, and form of buildings and land, the density of development, the height and various other architectural features of buildings, and the percentage of a given lot which legally can be developed. This percentage is expressed in terms of the floor area ratio (F.A.R.) which is the ratio of the building's floor area to the lot size. Zoning sets limits on the negative consequences of individual development decisions—for example, to minimize the impact of commercial and industrial areas on residential areas.

Howard Ben Tre,
Drinking Fountain, and
Jim Sanborn, *Stone
Column*, Artery Plaza,
Bethesda, Maryland,
1986.
photo: Francoise Yohalem

The fundamental difference between redevelopment plans and zoning codes is that redevelopment is based on *contractual* relationships. Development projects carried out under the auspices of a redevelopment program are the result of a consensus reached between developers and public officials; that consensus leads to a project-specific contract. Redevelopment, as one development director has remarked, is "jawboning." It is process-oriented.

Zoning, by contrast, is *product*-oriented. Like redevelopment, it encourages people to think about their communities on the large scale and over the long run. But in part because it doesn't provide for interaction, zoning has traditionally been a relatively inflexible tool of public policy. Within the last two decades, revisions and applications of the zoning concept have emerged, some of which, while not without problems, appear promising as means of supporting public art.

Conventional zoning regulations have been used explicitly to support public art—for example, in San Francisco, where the zoning ordinance stipulates that a developer *must* provide for publicly accessible art, just as he or she must observe setback guidelines, design parameters, and so on as a necessary factor of development.

See Section 149 of the San Francisco Planning Code, Appendix.

Another zoning method which has been used frequently to encourage public art is *incentive* or *bonus* zoning. This is a technique whereby a community secures certain amenities (such as public space, space for retail shops, or building setbacks) in a development by granting extra income-generating benefits to the developer—most often by adjusting the F.A.R. to the developer's advantage. For example, a developer may be permitted to add floors to a structure in exchange for extra open space or community facilities on the property.

Recently, a number of communities have used incentive zoning to promote public art. The city of Mountain View, California, *encourages* public art in development projects in one area of the city by offering a bonus of an additional 1,000 square feet per acre of floor area. In other instances, public art is required as a companion to other incentives. In Seattle, the Department of Construction and Land Use requires public art when certain public amenities are incorporated into a development project. It is the inclusion of these amenities with the art which enables a F.A.R. bonus.

As a final example, Portland, Oregon's Metropolitan Arts Commission has drafted guidelines for review which would encourage public art through the awarding of bonus F.A.R. Within Portland's guidelines is the requirement for at least 25 percent of the public art budget associated with the bonus F.A.R. to be contributed to a Public Art Fund (similar to the

Los Angeles Community Redevelopment Agency's policy) for reallocation on behalf of artworks elsewhere in Portland. The Arts Commission would administer the public art program and Public Art Fund. Portland's Planning Bureau has approved the guidelines. The City Council meets in early 1988 to approve the central city plan of which the public art program is a part.

Perhaps the most ambitious incentive zoning experiment is underway in Bethesda, Maryland, and is presented as a case study (see opposite).

Other zoning techniques include *overlay zoning* and *contract zoning*. Overlay zoning enables a community to vary its regulations within the same usage zone—for example, within a given commercial or residential zone. In effect, a second zone is created within the existing zone and new regulations are "overlaid" on the existing codes. This approach has been employed to identify and protect historic districts, theater and arts districts, wetlands, and other specialized environments.

Contract zoning involves a commitment on the part of the local government to rezone an area in exchange for acceptance of deed restrictions by one or more property owners. Contract zoning, then, begins to move toward the process focus of the redevelopment authority. The courts have not looked favorably on arrangements reached through contract zoning. Overlay zoning and contract zoning appear to be promising avenues for proponents of public art; however, both are still untested in the public art context.

The promise of and problems with zoning

Various zoning mandates and incentives have been put forward as useful means of harnessing private development monies in support of art in public places. In the hands of the best city planners, it is argued, these private dollars can spur a city to a program of public art which is integral to private-sector growth and which creates well-designed and publicly accessible private spaces. There is the potential for artists to be involved in and to influence the early design stages of development projects. And, proponents of zoning incentives argue, other areas of a given city stand to benefit through the establishment of a central fund where all or part of a development's public art allocation could be pooled.

All of this potential has yet to be realized, since the zoning model has hardly been tested. Moreover, it has been criticized by planners, developers, and artists on a number of counts. For example:

Art may be seen as a means of masking poor architecture or may even perpetuate poor urban planning. Richard Kahan, former chairman of the Battery Park City Authority and now with the Continental Development Group,

"Usually a city has to take what a developer shows up with. The idea of having to compete with ideas for a parcel, rather than just being able to buy out your competition, is intriguing. It might force some to abandon old formulas and—heaven forbid—think."

Jack Mackie, artist

Bethesda: zoning for art

In 1982, the Montgomery County (Maryland) Planning Board approved an amendment to the Bethesda Master Plan designed to support a number of public amenities, including public art. The zoning code created for use in the early 1970s permitted an increase of density in return for community benefits, which were to be negotiated between the urban design division of the Maryland-National Capital Park and Planning Commission (M-NCPPC) and developers. The results of these negotiations were then to be submitted to the planning board for approval. Utilization of this incentive zoning technique had not been so comprehensively achieved until Bethesda's plan was implemented.

A key departure in the county's plan was the concept of the design competition, quickly dubbed by the local media the "Bethesda Beauty Pageant." Numerous developers had applied for permission to build in the metropolitan Bethesda area. Under the previous zoning rules, each proposed development would have been considered in isolation, on a first-come, first-served basis. Under the new cooperative zoning application procedure, developers had to enter a one-time competition, in which their proposals were judged according to four criteria:
— uses for residents;
— enhancement of the pedestrian environment;
— visual and functional effectiveness; and
— provision of a management and maintenance organization.

John L. Westbrook II, then head of urban design for the M-NCPPC, was the chief architect and spokesman for the plan. "We have the most innovative zoning tools to weigh and balance the different resources," he told the *Washington Post* in February of 1983. "We look collectively, not at isolated cases. That is what is unique. That is what has never been done before" (see "Bethesda's Beauty Pageant," Bibliography).

Developers had predictably mixed feelings about the process. While eager to build in the Bethesda area, some adamantly objected to the degree of specificity called for by a competition in the early stages of the development process, saying that they would be locked into those specifics prematurely. They also objected to the expense entailed in producing such detailed proposals. M-NCPPC officials had two responses. First, they noted, only specificity would allow them to make a sensible assessment of individual plans. Second, specificity allowed comparison from plan to plan and tended to "protect" those developers who could actually build what they proposed from being edged out by more grandiose, but less practical plans.

To date, results have been mixed. Ten proposals were submitted to the original competition; nine of these were adopted with modifications. A wide range of artworks and environmental improvements are in progress or have been executed, including sculptured botanical elements on two sites (one involving sculptor Martin Puryear and the other involving artists Howard Ben Tre and Jim Sanborn), a painted pedestrian walkway by Jerry Clapsaddle, and a glass sculpture by Rockne Krebs.

"Most of the public art is excellent," Westbrook wrote in a 1986 *Place* article (see "Places of the Art," Bibliography). "However, the art may not appeal to the general public as much as we had hoped. Instead, it often reflects the tastes of the building owners."

Nevertheless, Westbrook remains committed to the concept of incentive zoning in support of public art. "The aims of the Bethesda experiment were valuable," he wrote at the conclusion of the *Place* article, "and I hope the undertaking proves to be among the first of many."

"One must look very deeply into one's soul to evaluate the value of the amenity (in this case the artwork) in relation to the F.A.R. increase, which is not merely a mathematical formula, but results in urban conditions of greater density, bulk, populace, and strain on the public infrastructure—all challenges to the quality of life."

Paul Broches, architect

"In the private sector, you see art operating in a realm where the operative value system is at cross-purposes with the creation of art. That's the problem of trying to accomplish public goals through private means."

Patricia Fuller, public art consultant.

summarized this concern as follows:

"Redevelopment authorities tend to look at things in holistic ways. Zoning, as a means of implementing a public art program, frightens me because it is so general in its outlook and covers such broad areas of a city. Incentive programs raise a number of specters. One of these is the destruction of whatever design principles are at work in a city. Density, for example, is destroying cities to the degree that it really doesn't matter what kind of public spaces we have, because there's no environment left. If the site has enough value, you can impose a great amenity package, but the opposite is true as well. Maybe the public art program is more important to incorporate in the least valuable real estate areas."

Artists caution that the conception of artworks as "amenities" relegates them to the realm of add-ons, as opposed to integral and necessary components of the environment.

Developers are often resistant to public art requirements which they don't perceive as contributing to their primary interest: the economic viability of the development. The struggle between the public authority's control and the demands of free enterprise should be clearly understood in terms of the goals and reasonable expectations of each side.

"I don't believe in incentives; I believe in coercion and a fair process," notes Richard Kahan. "I would not compromise [public art] objectives simply because the developer doesn't want it. But I think it is a real mistake for any program to be built on the assumption that the developer is interested in doing those things that the public wants. Public art advocates should be reasonable about what they can expect from the developer, and then—if the goals are worthwhile—they should somehow force the result.

"The things that really frighten a developer are uncertainty, unfairness, vacillation, changes in the rules, processes that are not clear. I think a developer might be willing to take greater [artistic] risks where he feels that there is a rational, cohesive community. I think a developer is entitled to a certain amount of insulation from the community process and to a reasonable timetable. I don't know how you persuade developers to undertake a public art program, because everything in the budget is either necessary or revenue-producing. It's best if the art can come out of the construction budget rather than his own pocket—like the sprinklers do."

There is an inherent difficulty in imposing on the private sector those art selection and implementation procedures used in publicly funded programs which are designed to evaluate artistic quality and invite community input. Decisions made by developers without assistance from arts professionals may result in public art which follows safe conventions rather than

fostering new artistic directions. Lack of community input may result in art of little or no meaning to the local community, and even negative public reaction.

Artists most often must negotiate, contract, and otherwise deal directly with developers, lacking the benefit of a public art administrator who can serve as advocate for the artist's interest throughout the process. The benefits of an experienced public art coordinator are, not only to smooth the process, but also to support the artistic integrity of the project.

Summary of redevelopment and zoning

Participants in the public art field, including representatives of urban planning and private development, agree that these new directions in funding public art through the private sector should continue to be explored and refined. They represent not only significant sources of funds, but new opportunities for artists as well.

Most importantly, however, they enable both publicly and privately funded spaces to be considered together in an overall approach to public art for a city. Yet, while arts commissions and redevelopment and zoning bodies may share the goal of ensuring that public and private spaces in our cities achieve a coherent, well-designed whole, all must realize that the approach must be more than compliance with public art requirements. A logical first step must be to involve artists in defining the policies that govern these public spaces. By doing so, artists are recognized as citizens contributing both a concern for community values and quality environments, and an expertise which may affect the way a community approaches art in its public spaces.

So far, we have made a case for the value of involving artists in the design of public places, looked at a range of organizations which initiate public art, and considered sources and models currently employed to fund public art programs. In the following sections, we will examine many issues, policies, and processes related to how a public art program is *implemented*.

Planning for public art options

In the previous section on zoning, it was argued that the inclusion of artists on zoning boards could ensure earlier intervention in the urban design process by both artists and arts administrators. Ample opportunities exist for positive and anticipatory collaborative thinking and planning, but only if the processes of government are structured toward that end. Ari Sikora comments:

"Large-scale public works projects (highways, utility lines, municipal street furniture, mail and police boxes, bus benches and shelters, and traffic signs) are among the biggest budget line items. They loom frequently and large in our daily experience but are uniformly dreary, oppressive, or worse. Decades of effort by architects to 'clean up,' consolidate, and 'design' street furniture elements have too often resulted in the ugly being replaced by the boring. Flood control channels and wilderness firebreaks, instead of taking shape as ethereal earth works, scar the urban and natural landscape. What an opportunity for public art programs to merge engineering virtuosity with artistic sensibility. I would love to see artists *routinely* involved in the federal and state highway programs, Army Corps of Engineers' projects, and so on. Transforming the next hydroelectric pork barrel project into an extraordinary visual and auditory experience might make it almost all right.

"What is needed, however, is a national network of in-house advocates able to track five-year capital improvement program budgets, influence design options, recommend experienced artist collaborators, and identify feasible 'replacement cost' projects, before decisions must be reversed. This could transform an environment!"

Planning for action

This calls for a specific, long-range, and comprehensive plan which guides a city to action by addressing the creation, integration, and maintenance of art in the city. A public art master plan ensures a coherent artwork acquisition program by:

— providing a framework of policies and procedures which guide artwork acquisition with a plan for the city as a whole;

— establishing an approach for selection of specific locations for public art projects;

50

Architects are turning 57 acres of marshy landfill into an experiment in environmental engineering and public art

New Jersey's window on the sky

A modern-day Stonehenge
At certain times of the year, the sun rises and sets between the mounds of earth, framed by the pairs of parallel poles when viewed from the hub: (1) winter solstice sunrise; (2) winter solstice sunset; (3) equinox sunrise; (4) equinox sunset; (5) summer solstice sunrise; (6) summer solstice sunset. At summer solstice, when the sun reaches its highest point in the northern sky, sunlight shines through the steel structure (7) at noon, casting a circle of light into a steel ring on the ground. The pond (8), ringed with wildflowers and grasses, is a drainage system for the landfill. Torches (9) at the peaks of the mounds burn methane, the byproduct of the landfill process. Paths up the side of the Sky Mounds (10 & 11) align with the brightest stars in the night sky, Cirius and Vega; tunnels in the mounds align with the setting of those stars.

— defining relationships of art in public places to other city goals and mechanisms (planning, budgetary, etc.);

— engaging the community in the design of the plan; and,

— ensuring the role of artists in developing the plan, as well as participating actively in the design of public spaces.

As a result, the plan institutionalizes a discussion of the broadest range of artistic possibilities and recognizes artists as thoughtful contributors to the design of the environment. Comprehensive planning also encourages interdisciplinary discussion and collaboration.

In this section, we will look again at the Seattle experience and consider how that city, having articulated a broad vision, then developed a practical plan to integrate public art into the process of municipal governance. We will also look at similar efforts in Dade County, Florida; Cedar Rapids, Iowa; and Philadelphia.

Seattle

The Seattle Design Commission was an outgrowth of the city's Municipal Arts Commission, established in the late 1950s to review both public art and capital projects. In 1968, the city passed a Forward Thrust bond issue, which provided funding for new parks, community centers, roads, bridges, electrical infrastructures, and so on. At that point, Seattle officials decided to formalize both the selection of design consultants and the critiquing of the city's capital projects through the creation of the Design Commission.

The membership of the Design Commission was creatively defined. According to the commission's charter, its eight members were to include two licensed architects, an urban planner, a landscape architect, two engineers, a professional from outside of the design field, and a "professional fine artist." In the commission's early years, this "fine arts" seat was filled by a variety of artists, including musicians. But as the city's percent for art program, established in 1973, focused increasing attention on art and architecture, the commission found it important to reserve the seat for a visual artist or a visual arts professional, and preferably an artist with experience in public art design-team situations. Through the Design Commission, therefore, Seattle ensured that artists could have an impact on the planning of major capital improvements in the city beyond that guaranteed by the Seattle Arts Commission.

Seattle has also led the way in the practical integration of public art within municipal planning and budgeting processes. In 1984, the Seattle Arts Commission carried out a study with the objective of developing a rationale for making site recommendations for public art projects within a network of primary public places, in particular, downtown areas (see also

Barbara Noah, *Forms of Power: Love, Physical, Law, Money, Mind*, Canal Substation, Seattle, Seattle City Light, 1985. Photos courtesy of Seattle Design Commission.
overview photo: Gary Vannest
detail photos: Stephen Huss

See *Artwork/Network*,
Bibliography.

Why Public Art Section). It was the philosophy of the arts commission that it could "support the city's sense of identity by sponsoring artworks at these places of social commerce or significant public meaning. Art commissioned and created in relation to these areas will contribute to the vitality of the city, reach a wider audience and further define a place's significance."

The research process assessed present and projected landscapes of downtown Seattle, as dictated by such factors as transportation patterns, population trends, projected development, and the role of commerce. Specific prospective sites for public art were also evaluated in terms of their character and uses. Most importantly, this was not a list of sites nor a template to be used for all time or all situations. Rather, the study was a primer to urban design and the function of public art in the city which provided a variable method for future site selection. It recognized the changing uses of the city, the public's expectations about public art, and the vast and also changing scope of artistic forms which would force unique solutions to art in public places.

Following is the set of criteria, excerpted from *Artwork/Network*, used by the Seattle Arts Commission to analyze a site's suitability for public art:

— Is a site on public property, or property readily available to the public art process?;

— Does a site suggest art opportunities that would extend the breadth and quality of the Art in Public Places Program? Each recommended site had to offer challenging sets of circumstances and allow for a wide range of artistic solutions;

— Will innovative art on the site enhance the pedestrian/streetscape experience? One of the draft Land Use and Transportation Plan's (LUTP) primary goals is to " . . . commit ourselves to quality, and assure ourselves that new development contributes positively to the physical environment of our downtown." We concur with that general goal and base our site recommendations on this premise;

— Is the site situated in the network of public places? Does the site fall within the prominent paths of circulation (entry point, transit corridors, and malls), or is the site situated near a place of congregation (parks, transportation centers, entertainment and retail centers, etc.)?;

— Finally, by looking at other city planning proposals, we were able to suggest both current and future sites for the arts commission to choose among and to suggest additional locations for temporary artwork. Each of our recommendations falls into one of the following categories:

priority sites: these sites meet all four criteria and presently exist in downtown Seattle;

future sites: these sites lie within proposed development areas. When the sites are constructed, they would fit all four criteria and so become priority sites. The arts commission should monitor the progress and scale of development in these target areas;

temporary sites: although these sites also fit the four criteria, they are privately owned or may be subject to future development. Due to these limitations, these sites are included as possible locations for temporary artwork installations.

The Seattle Design Commission's efforts and the *Artwork/Network* study represent ongoing or long-term planning for public art in Seattle. On an *annual* basis, the Seattle Arts Commission operates from a Municipal Art Plan. In brief, the Municipal Art Plan:

— tracks the capital improvement projects to be initiated and identifies those which are deemed to be appropriate for public artwork and are a source of percent for art monies;

— itemizes each city department's public art commitments in fiscal terms;

— monitors carry-over funds for projects still in progress, as well as unprogrammed monies in the Municipal Art Fund; and

— documents the status of each public art project in terms of schedule and funds appropriated and expended.

The Municipal Art Plan, then, is the real working plan whereby the city makes evident its commitment to public art activities on an annual basis.

Reprinted by permission of the Seattle Arts Commission.

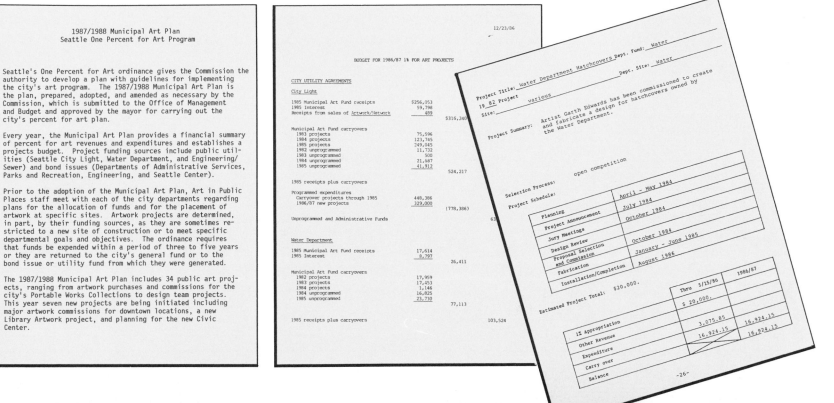

Dade County

Most, if not all, municipal percent for art programs see the annual public art plan as a necessary planning and management tool. Another model program, Metro-Dade Art in Public Places, works from an annual plan, but also from its overall Master Plan which is a companion piece to its Implementation Guidelines. ● The Master Plan defines the types of spaces that are characteristic of the Dade County metropolitan area's subtropical climate and tourist orientation, such as its airport and seaport, and its parks, beaches, and thoroughfares.

For example, in addressing Miami's beaches, the Master Plan guides public art projects in concert with system-wide development of beaches. Beaches are described as major resources, used extensively by residents and visitors and strongly identified with Dade County's image. Emphasis is directed toward public artworks:

— with environmental features such as water, light, wind, sand, and air; and

— at sites under development or being improved where art can be integrated into the planning process.

In addition, the Metro-Dade Master Plan expresses a commitment to addressing the sociological characteristics of the county, especially the multi-cultural and multi-lingual nature of its population.

● See Metro-Dade Master Plan, Appendix.

Fairmount Park Art Association
—an historical precedent in public art planning

The Fairmount Park Art Association in Philadelphia was chartered in 1872 to promote the "adornment and development along artistic lines of the parks and public places of American cities." While the Art Association devoted considerable attention in its early years to the erection of monumental statues, its 1906 report noted that "the tendency of its officers and members is to interpret its purpose in terms of the most liberal and inclusive effort for the expression of high civic ideals in forms whose beauty and dignity are synonyms for Art." In addition to specific artworks, therefore, the FPAA concerned itself with protecting the banks of the Schuylkill River, with rationalizing the city's parkway system, and with the development of a generous park system—a necessary concern, the FPAA noted, for a city whose undeveloped lands were threatened by the "ruthless advance of private enterprise."

In 1952, Philadelphia revised its city charter to strengthen the hand of its mayor. Among numerous other provisions, the new charter gave the mayor responsibility for appointing all members of city committees, including a newly created art commission which superceded the Municipal Art Jury established in 1911.

"The Art Commission," according to the revised charter, "shall be composed of eight appointed members and the Commissioner of Public Property. Of the appointed members, one each shall be a painter, a sculptor, an architect, a landscape architect, a member of the Fairmount Park Commission, and an experienced business executive, and two shall be members of a faculty or governing body of a school of art or architecture."

By 1985, the Philadelphia City Planning Commission was urging a further integration of art (and, by extension, the advocacy of the FPAA) into the urban planning process. In a working paper entitled "The Economy of Center City," the commission advocated the development of special districts that include public art as part of their definition and urged the city to "commission artists to create public art and help design public spaces that are (connected) focal points, little city centers, and attractions."

Through a reexamination of existing processes and resources, therefore, a city with a tradition of public art continues to seek new ways to incorporate artists in its planning processes and also to incorporate arts planning into the broader municipal capital improvements projects and budgeting cycles.

Cedar Rapids

Of course, any call for early and thoroughgoing planning can be mistaken for a call to "bureaucratize." When maneuvering within a municipal bureaucracy, moreover, it is sometimes tempting to favor process over product. The example of Cedar Rapids, Iowa, shows that it is possible to approach a master plan for public art without an ongoing percent for art structure and as a tool for initiation of a public art program.

In 1985, Cedar Rapids was one of two cities awarded funds by the NEA to conduct a preliminary study of how art could be integrated successfully in the urban context. The Art in Public Places Committee of the Cedar Rapids/ Marion Arts Council used the funds (matched by city and county governments and community contributions) to hire a team of nationally recognized design professionals (Martha Schwartz and Ronald Lee Fleming) and artists (Andrew Keating, Nancy Holt, and Mark Allen Lere). Outsiders were chosen, according to Gina Marie Crandell, advisor to the project, because "they do not see Cedar Rapids on a daily basis and have not become so familiarized with the area that they have stopped noticing it." Yet local participation in the process was extremely important and was ensured by planned forums in which the teams heard the ideas and concerns of special interest groups and the public.

The design team was sent materials prior to its first visit which included the city's history, slides, and other information of value. Then the design team toured the city for a week, talking with civic leaders, artists, and community groups and visiting potential sites for artworks. The team's ideas, which took the form of preliminary proposed ideas in sketch form rather than polished proposals, were presented at a town meeting in May 1986. Response to the package of sketches was generally favorable. The team's efforts have already seemed to "light some fires," according to Med Bickel, chairperson for Art in Public Places for the Cedar Rapids/ Marion Arts Council.

For example, a downtown businessperson's group has taken steps to examine possible design approaches—including the possibility of public art —to revitalize an ailing section of the downtown area. To raise money in order to hire consultants and develop a plan, the involved businesses have created a self-imposed tax. A final report on the design team's work is to be presented to the community in the spring of 1988. The Art in Public Places Committee will use reactions to the report to determine the next step toward realizing some or all of the design team's ideas.

Summary

"Public art really hasn't received the level of visibility and concern that other public values have," notes public art consultant Patricia Fuller,

"Imaginative, visionary proposals can galvanize support behind otherwise vague, well-meaning attempts to use public art to enrich the public realm. These proposals will be all the more effective when the community affected is somehow engaged in the process."

Paul Broches, architect

55

"**Public art really hasn't received the level of visibility and concern that other public values have.**"

Patricia Fuller, public art consultant

"because it's not yet part of a city's overall planning. It's a good idea for arts agencies and advocates to understand how cities develop and execute long-range capital and economic development plans. The research information about the city and its future which goes into them provides a basis for thinking about public art. Opportunities for public art can be identified and planned for as part of a city's overall development, rather than on a site-by-site basis as they occur."

Richard Kahan cites Battery Park City's World Financial Center development in New York as another useful model of the advantages of artists' involvement and of long-range planning for the arts: "The brilliance of the Battery Park master plan was that public places and streets were the first things established; the design of buildings came later. We all shared a dissatisfaction with art plopped on plazas, and the focus of the master plan helped us establish the innovative role of the public artist. Artists certainly think about the physical environment and the ways human beings react to it in ways that are very different from those of an architect or an urban planner; that's why I think they should have a role in determining the master plan." (For more on the Battery Park City project, see Guidelines for Implementation: Collaboration Section.)

Jack Mackie and Buster Simpson, 1st Avenue Bus stop Benches and Trees, Seattle, City of Seattle Engineering Dept., Dept. of Community Development, Seattle Arts Commission, 1979 to present.

Quarry scraps, including discarded fragments from the State Capitol building and other structures, along with plantings of sandstone, red plum, and red maple trees, form an ongoing laboratory situation for artists in the creation of this "linear park and urban arboretum."

In this section, we will first look at three preliminary activities: the creation of standard operating procedures, the establishment of a basis for interagency coordination, and the definition of a project management process. Then, the various aspects of bringing a public art project to fruition will be reviewed, including: methods for selecting artists, artists' proposals and contracts, issues of artwork fabrication and installation, artist/designer collaborations, and related concerns of protecting artistic integrity.

Implementation guidelines outline standard operating procedures, which govern how people working within a given program will carry a public art project from conception to completion and must usually be approved by the appropriate official bodies.

In most cases, these guidelines first restate the overall program mission and *goals*, such as: expanding public experience of art through the highest quality art in public spaces, making available artwork that contributes to a sense of community identity, and providing opportunities for artists to create new works and participate in planning and design of public spaces. In addition, each program may have other goals which express particular interests. For example, the City of Seattle's one percent for art guidelines express a commitment to artists residing in the Northwest, stipulating that at least half of the money expended by the program over a five-year period for artists' commissions and purchases of existing work must benefit artists associated with that region of the country. As stated previously, the development of specific policies and procedures should support the overall goals of the program.

Next, the guidelines describe basic and key *procedures*, including:

— methods and responsible agencies for determining eligible and appropriate *sites* (see also Integrating Public Art in Community Planning Section for site-selection criteria used in Seattle's *Artwork/ Network* study);

— interagency relations and methods for resolving differences;

— ways that the *community* can be empowered to express its hopes for (and concerns about) given projects;

— methods and criteria for *artist selection*, including which committees (if any) are involved and their composition; and

— how projects are implemented, including the development of public information and educational opportunities, contract preparation and approval policies, and fiscal procedures; and

— how projects are documented and artworks maintained.

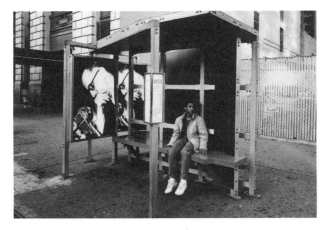

Dennis Adams, *Bus Shelter II* (Bertolt Brecht testifying before the House Un-American Activities Committee in 1947), New York City, Public Art Fund, Inc. in cooperation with the New York City Dept. of Transportation, 1987.
photo: Peter Bellamy

"It's difficult to transfer wholecloth one set of guidelines to another context. Flexibility in defining guidelines is important, but once in place, you also have to aggressively facilitate guidelines in order for a project to work."

Patricia Fuller, *public art consultant*

58

It is important to remember that no set of universal guidelines exists. Procedures must be relevant to how local agencies and the community operate if they are to be effective. Moreover, even guidelines which seem ideal at a given point in time must be able to be reviewed and, perhaps, revised periodically in light of unforeseen or changing situations.

See Appendix.

The Implementation Guidelines from the Metro-Dade Art in Public Places program ⬤ are presented as a model because they are particularly inclusive. Besides including the above procedures, other areas often neglected in the developmental stages of a program—public information and community education, care and maintenance of artworks, and gifts of artwork—are also addressed.

Public information and community education: Recognizing that the success of a public art program is measured, in part, by the community's awareness of and respect for public artwork as a cultural resource, the Metro-Dade APP guidelines expresses a commitment to encouraging greater public understanding of the goals and methods of the program. It suggests a comprehensive approach to educational experiences for both residents and tourists to Dade County. (See also Community Involvement and Education Section.)

Care and maintenance of artwork: Recognizing that the image and value of the public art collection depends, in part, on it being in good condition, Metro-Dade APP takes responsibility for the care of artwork and for developing systems (with the possible aid of consultants) for documentation, condition monitoring, and repair or relocation (see Conservation Section).

Gifts of artwork: Recognizing the potential for gifts of art from collectors, artists, or foreign cities or countries, Metro-Dade APP acts as a review body for the county government and, in doing so, seeks to protect the integrity of the collection by requiring the review of any proposed gifts of artwork (as well as funds or sites for artwork) according to the same criteria used for all other APP projects.

Metro-Dade's guidelines make important strides toward recognizing these three areas as crucial functions of a public art program. Nevertheless, even more detailed development of separate policies and procedures for each of these areas should be devised concurrently with implementation guidelines. In the case of conservation, for example, it is only by determining from the start, the roles of different agencies in ongoing maintenance functions and funding, that the work will receive the necessary attention; or that decisions regarding removal of a work will be based on standards, fair process, and appropriate professional expertise.

Interagency coordination

Public art most often requires the involvement of multiple agencies. For example, the percent for art model involves a *funding source* (an agency of city, county, or state government); an *administering agency*, (often the publicly funded state or local arts agency, but sometimes another public department such as Parks and Recreation); a *recipient agency* (which has jurisdiction over the site and is most often the funding agency), and *advising agencies* (in such areas as legal matters, permits, etc.). Projects initiated outside an ongoing, publicly funded program include other possible players—corporations and developers, community action groups, ad hoc citizens' art groups, artists' organizations, and so on.

The separate or overlapping goals, concerns, and working methods of such a variety of partners can result in conflicting visions, confused roles and processes,unrealistic expectations, self-compounding bureaucratic delays, and a host of other management problems. The arts agency professional, for example, may have little or no knowledge of the design, permit, and management processes which lead to the construction of a new building. The funding and advising agencies (like an architect or developer) may have a limited sense of the range of artistic possibilities for public art or of the value of ascertaining community interests and concerns.

Commonly, close communication of collaborators is a necessary action, too often resorted to only after a problem or conflict has arisen. But in the public art field, as in most potentially contentious public processes, agencies must *develop ongoing working relationships and educate one another* about their own intentions, needs, concerns, and processes. *Time* must be committed to the development of understanding and trust among different agencies. Experts in the public dispute resolution field caution that "you have to go slow to go fast," and this is certainly true for public art. The artist's methodology is usually very different from, for instance, the architect's; therefore, agencies unaccustomed to contracting with artists have to become familiar with those differences. Similarly, artists and arts administrators need to respect the methods of the design professions. In fact, the artistic process can often benefit in unexpected ways from existing resources and systems, such as tying into design and construction funds for related costs of artwork which is made integral to the building.

"It helps to have written materials for dealing with other departments or agencies," notes Patricia Fuller. "In Dade County, Miami, we developed a two-page summary about the program which we used in initiating conversations with the department heads and then in talking with the

Reprinted by permission of the Washington State Commission on the Arts.

59

Washington State Interagency Agreement for Commissioning of Artwork

This AGREEMENT is made and entered into this _____ day of _____, 19___, by and between the WASHINGTON STATE ARTS COMMISSION, hereinafter called the "ARTS COMMISSION" and _____, hereinafter called the "AGENCY".

WHEREAS, pursuant to RCW 43.17 all state agencies shall allocate 1/2 of 1% of the appropriation for the original construction, and for universities and colleges to include major renovation or remodeling work in excess of two hundred thousand dollars, for the acquisition of WORKS of art;

WHEREAS, the ARTS COMMISSION contracts with the artist for the commissioning of WORKS OF art;

WHEREAS, the AGENCY desires the WORK of art to be placed within its jurisdiction;

NOW THEREFORE, the ARTS COMMISSION and the AGENCY, for the consideration, covenants, conditions and under the conditions hereinafter set forth, do agree as follows:

The ARTS COMMISSION does hereby agree to accept the following responsibilities and to perform the following services:

1. Determine the amount to be made available for the commissioning of WORKS of art, in consultation with the AGENCY;

2. Designate project sites, selection, contracting, commissioning, reviewing of design, execution and placement, acceptance, maintenance, and sale, exchange, or disposition of WORKS of art, in consultation with the AGENCY;

3. Provide copies of contracts and related materials to the AGENCY for their records;

4. Provide a plaque (public notice) for the WORK; and

5. Insure and assume liability for the WORK when the WORK is in the possession or under the jurisdiction of the ARTS COMMISSION.

The AGENCY does hereby agree to the following conditions for the display of artwork through the Art in Public Places Program:

1. Transfer its 1/2 of 1% art allocation to the ARTS COMMISSION for expenditure by the visual arts program; ARTS COMMISSION administrative expense to be taken from the available 1/2 of 1% art allocation per RCW 43.17;

2. Display the WORK in a location frequented and open to the public;

(continued on next page)

Starts on previous page.

project managers. Everyone was therefore working from the same information about how the program works. In Seattle and Miami, a document goes to all department heads—along with their annual budget forms—so that when they submit their capital budget requests, there is a line for percent for art for each project."

In general, agencies working together in the public art process should ask such key questions as:

— Which agencies are necessary to involve in the execution of this project or program?

— What are the specific reasons for their involvement? Will a given agency contribute a site, funds, expertise (whether artistic, administrative, or technical), official or symbolic sanction, or a link to an important constituency?

— What will be the role and responsibilities (if any) of each agency in: *fiscal administration* (determining what funds are available for a given project, raising additional funds, accounting for expenditures, paying artists and contractors, etc.); *program administration* (conducting artist selection processes, serving as liaison with and advocate for artists, coordinating community involvement, approving finished artworks, and promoting and documenting artworks); and *maintenance and legal matters* (determining the terms of contracts with artists and contractors, executing routine maintenance, taking financial and administrative responsibility for extraordinary conservation efforts)?

— At what points in the process should each agency be involved? Who will lead contacts with the community?

— What are the existing systems for decision making, fiscal management, and communication, e.g., by committee or by department heads? Do they need to be augmented or amended? (For example: Are there useful precedents which enable flexibility in payment systems, contractual arrangements, etc.?)

The Washington State Interagency Agreement for Commissioning of Artwork clarifies the specific responsibilities of the Washington State Arts Commission and of the agency within whose jurisdiction the public artwork will be. In general, clarity and specificity are time-consuming in the short run, but time-saving in the long run.

Project management: people and timelines

Agencies provide the funds and the systems which allow public art to come into being, but it is *people* who actually make it happen. Unfortunately, though, the right person is not always in the right position. In many cases, a percent ordinance is passed, and an agency—be it a city planning

commission, an arts commission, or a parks and recreation department—finds itself the administrator of a program with few or none of the needed qualifications to carry it out.

The first responsibility of the agency, therefore, is to recognize that professional staff is critical to the management of a public art program. This usually indicates the need for a central coordinator.

Obviously, that coordinator's role varies greatly with the scale of the project. Many projects do not demand permanent, full-time staffing. The Winkelman, Arizona, project (see Why Public Art section) is an example of one with minimal administrative needs: A group of townspeople worked with the artist to bring the project to fruition. But any ongoing public art program should commit itself to retaining a professional staff to oversee the program and to manage projects.

What makes a public art coordinator effective in that role? The coordinator assumes the pivotal role of guiding the public art process. He or she coordinates the efforts of a multitude of participants so that the full potential of the project(s) can be realized.

The coordinator's role therefore demands a sensitivity to the range of artistic possibilities and a familiarity with artistic resources. The coordinator must firmly represent and defend the interests of the artist and the intended artwork from the beginning to the end of a project. At the same time, the public art coordinator must understand the interests and needs of all the other players in the public art process, and possess the political skills to balance those interests. (This means, for example, that the public art coordinator must understand the processes, schedules, language, and economics of the design and construction fields in order to integrate the artist into those processes.) Finally, the public art coordinator needs organizational skills to anticipate, plan for, and implement the complex layers of competing schedules, information requirements, budgets, and programmatic needs.

A job description issued in 1987 for the public art coordinator for the Sacramento Metropolitan Arts Commission details other important skills and qualifications. (See next page.) Jennifer Dowley, who formerly held this position, provides commentary which emphasizes the coordinator's threefold role as advocate, catalyst, and visionary.

"I've worked on projects where the administrator has been an obstacle," notes artist Joyce Kozloff, "and on others where the administrator has facilitated the process every step of the way. It's that one person who can make a difference. While I think a background in art is very important, the success of an administrator has as much to do with interpersonal skills and commitment to the artists."

61

Marilyn Zwak,
Winkelman Wall,
Winkelman, Arizona,
1987.
photo: Chuck Koesters

Annotations by Jennifer Dowley, former APP coordinator for the Sacramento Metropolitan Arts Commission, point out important qualities for a public art coordinator which are not articulated along with the skills outlined in this job description. In addition, excerpts of the job description for the coordinator at the Los Angeles Community Redevelopment Agency elaborate on the expertise required of the public art administrator in community relations, contemporary art, and planning and management.

Reprinted by permission of the Sacramento Metropolitan Arts Commission.

Sacramento Metropolitan Arts Commission

800 Tenth Street, Suite 2
Sacramento, California 95814
(916) 449-5558

A Public Agency

Director
Wendy A. Ceccherelli

Commissioners
Dennis Wilkerson, Chair
Carol Borden
Judy Gordon
John Horrell
Brigitte Rehorn
Wendy Scribner

Charles Smithers
Maggie Upton
Glenda Van de Mark
Carson Wiley
Tom Witt

PLEASE POST JOB OPENING

COORDINATOR
Art in Public Places Program
Sacramento Metropolitan Arts Commission

Salary: $2218.84 - $2697.07/month

The Sacramento Metropolitan Arts Commission is seeking a full-time arts administrator to manage its Art in Public Places Program. The program is fully developed and has been operating since 1979. There have been nearly 80 works commissioned for a total of $12 million in commissions to artists. Currently, there are 45 projects in progress, ranging from an $800 purchase to a $250,000 City park designed by Siah Armajani. The coordinator must work with four different governmental entities (City, County, Transit Agency, Redevelopment Agency) in the management of the program and coordinate all projects with a 5 member Committee of Arts Commissioners.

Experience

2 years full-time experience in planning and administering a public art program.

Education

Equivalent to a Bachelors Degree in art, arts administration, or related field.

Examples of Duties

1. Develop and implement policy, procedures, projects, and research to further the goals of the Art in Public Places Program.
2. Work with the Commission's Art in Public Places Committee to develop policy, projects, planning and evaluation.
3. Coordinate artist selection process.
4. Write, negotiate and monitor artists' contracts.
5. Serve as liaison between artists, architects, City/County Departments and community groups.
6. Prepare project budgets and plans.
7. Develop and implement a community education program.
8. Initiate press and public relations for the program.
9. Serve as the Commission's representative on the Board of Directors of Cammy Awards, a county-wide Design Awards program.

10. Serve as spokesperson for the Commission on visual arts issues.
11. Represent the Commission at national art in public places meetings, before community groups, and other government agencies.
12. Prepare reports for City Council and the Board of Supervisors.
13. Research and prepare funding requests for occasional projects.
14. Provide direction for the management and maintenance of the City/County art collection.

Qualifications

1. Thorough acquaintance with art in public places issues.
2. Ability to manage up to 40 projects all at different phases of completion.
3. Ability to work successfully with a diverse constituency.
4. Ability to manage administrative details.
5. Ability to work with artists, arts professionals, design professionals, and individuals and groups not acquainted with contemporary art.
6. Excellent verbal and written communication skills.

Excerpt
from the Los Angeles Community Redevelopment Authority job description for coordinator of its Art in Public Places Program.

Summary of Duties: Leadership for art programs on private development sites will be provided in developing project review criteria; standards and programs; performance schedules; selection procedures; briefing selecting bodies as to Agency objectives and policy and their relationship to individual project objectives; briefing artists and architects on objectives; promoting cooperative relationships between artists working with developers and their architects; monitoring implementation; and, throughout the process, maintaining liaison between the staff, relevant community groups, developers and the Arts Advisory Committee.

Qualification Requirements: The position requires substantial knowledge of contemporary art in general and public art in particular as well as the related disciplines of architectural and urban design and planning. A comprehensive understanding of arts and cultural issues as they apply to downtown Los Angeles is essential as is an understanding of the national dialogue as it is currently emerging. Familiarity with management and administrative systems, especially as they pertain to arts programming; ability to implement long-range strategic planning, management and supervision skills within a large public agency that deals with large scale, complex development activity is essential.

The person must be able to work with a wide variety of people (developers, artists, architects, city agencies) and work effectively and tactfully with individuals of diverse socioeconomic and ethnic backgrounds; including differences of age, sex, and physical condition, and to interpret the Agency's program and planning issues to individual citizens in community meetings. The position requires that one be an effective representative of the Agency in diverse circumstances.

This job description leans more toward administrative qualities than curatorial/visionary ones-- a problem as I see it. Anyone can shuffle papers, but not everyone can shape a good public art program.

One of the critical tasks of a good public art administrator is to provide new opportunities for artists to create work in a public context. A good administrator keeps in touch with

artists and artists' issues and keeps the bureaucratic process flexible enough to accommodate them. I have felt that I functioned primarily as the artists' advocate (creating a space within the city/county systems for them to work) while at the same time accommodating needs of the system (legal, political). The administrator is primarily a catalyst to establish a climate for artists to work creatively within a community structure.

This is not to say an administrator functions without vision or artistic integrity. Vision is necessary to recognize opportunities for artists' interaction within a system. Vision is necessary for the structuring of selection processes and bureaucratic systems that allow for flexibility for artists, adherence to high quality standards, and that treat artists with respect.

Experience suggests that the development of a body of public art of the highest artistic standards is best assured if the project coordinator's "bureaucratic base" is within a city's or state's arts commission or the equivalent. "Operations of percent programs have shifted to a more centralized decision-making process," says Sande Percival, project manager for Washington State's Art in Public Places program. "The responsibilities for selecting artists, as well as for caring for the art, are vested with the arts commission even though the works are officially owned by the state and are part of its collection. That's good, because the commission turns to its professional staff for advice on these issues."

However, Percival points out the shortcomings of this model, as well: "The major flaw of most state programs is that they don't have the necessary [financial] support or administrative staff to follow through every step of the way. Also, some have been politically naive about the way buildings are built, as well as how decisions are made."

All of this assumes that the arts commission has a track record in presenting visual arts and in effectively interfacing with a variety of community concerns and interests. In cases where an arts commission has been established with the sole or primary purpose of administering a newly adopted public art ordinance, it is especially critical that the arts commission assess its strengths and weaknesses and seek out existing expertise within other local arts organizations as well as professional qualified staff.

In the case of single or sporadic projects where establishing a permanent coordinator's position is impractical, a common alternative has been to hire an arts consultant to advise on and sometimes manage a project through to completion. There are many arts consultants practicing today, with a broad range of experience in arts management. However, the unique challenges of public art administration usually argue for the hiring of a consultant with specific experience in that field. Moreover, the consultant should observe clear and ethical working procedures. The Association of Professional Art Advisors ● has articulated the following principles:

— A consultant should not maintain an inventory of artworks and should have no economic affiliations with artists, artists' estates, foundries, or other fabricators;

— A consultant should not accept fees or gifts from artists, artists' estates, dealers, or fabricators;

— A consultant should be remunerated for his or her expertise and services only by the commissioning agency and should not realize any sort of financial gain from the commissioning of a specific artist or work of art. The consultant should be paid on an hourly or daily rate, rather than receiving a percentage of the cost of the public art project.

"You need to have people on the board who understand the relationship between public art and building a city; the issues are different from simply giving grants to performing arts organizations."

Sande Percival, public art administrator

● See Resource List, Appendix.

Siah Armajani, *NOAA Bridge,* Western Regional Center, Seattle, National Oceanic and Atmospheric Administration, 1983.
© *ART on FILE, Chartier / Wilkinson, 1988.*

See NOAA Chronology, Appendix.

Timelines

The nature and scope of a public art project dictates, to a large extent, the amount of time needed to bring it to fruition. Obviously, the commissioning of a public artwork for a specific site involves many more steps, and thus a greater time commitment, than the purchase of an existing work. The artist selection process used (e.g., open competition, limited competition, direct invitation) can also influence the time commitment.

The *timeline* is a key tool in public art project management. It plots all key activities over the life of the project. As a working document, it establishes the relationships—causal and sequential—of various interrelated activities, such as:

— artist and art selection;

— contract negotiations;

— fabrication and installation;

— building or renovation plans (including bidding and construction schedules); and

— public involvement and education programs.

In 1983, a major public art project was completed at the site of the National Oceanic and Atmospheric Administration's (NOAA) Western Regional Center in Seattle. NOAA officials determined as early as 1976 that an art program using .5 percent of construction costs ($250,000) would be set in motion at the Center. The Seattle Arts Commission, in conjunction with the National Endowment for the Arts, worked on behalf of NOAA to develop and administer an artwork program and an artist selection procedure. (The commission paid special attention to involving the community liaison committee originally formed to provide community response to the building itself.) What resulted was a project involving five artists: Siah Armajani, Scott Burton, Doug Hollis, Martin Puryear, and George Trakas, each of whom addressed a specific site along the shoreline of Lake Washington.

The chronology for the NOAA project has been reconstructed and effectively illustrates some important considerations to be taken into account at the outset of a public art project. In general, a timeline should be designed to provide:

adequate time to coordinate and educate the agencies involved, and to structure the overall plan for the project. NOAA spent five months in discussion with the Seattle Arts Commission and NEA clarifying key points, such as: the unique character of the site; ways for the local community and building users to have meaningful impact on the project; professional artist selection procedures; definition of the role of each agency; and the right and responsibility of the Western Regional Center to manage its own art program;

timely input from the community. The NOAA public art plan involved the local community advisory committee (the Sand Point Community Liaison Committee) at key points in the project's evolution, including: at the outset of the project, when NOAA's construction plans were first announced; during the development of criteria for the artwork project to be presented to the artists; prior to the convening of the artist selection panel; during the meeting of the artist selection panel; during the artists' first visit to the site; during the artists' second visit to the site, when the artists presented preliminary artwork ideas; and during the artists' presentations of final proposals;

sufficient time for an artist selection process which is sensitive to the artist(s), the selection panel, the community, the agency, and the proposed site. NOAA organizers allowed three months for artists to respond to a public announcement of the project and for artist selection panelists to research and gather material on specific artists under consideration. As a general rule, organizers should recognize that artists, like other professionals, have existing commitments. They should therefore allow reasonable time for artists to learn about and respond to a call for entries or an invitation to compete. The artist selection process should not be held prematurely or otherwise rushed in order to meet external funding deadlines;

realistic fundraising objectives, which, when met, ensure that the project can move forward with assurance that the artist(s) will be paid; and

coordination between the architect's, the contractor's, and the artist's processes and schedules. This is very often the greatest challenge in the management of a project. The methodology of builders and architects differs from that of artists and public agencies. The interest in integrating artists early in the design process necessitates advance thought and planning. For obvious reasons, this interest is not always shared by developers. "Speed is very important to a developer," says developer Richard Kahan. "You can't tell him that artists work within a different timeframe . . . but often technical considerations such as timetables are used as a power tool against the artist."

The Los Angeles Community Redevelopment Agency continues to find early integration of the artist to be a problem. (See Funding Models Section for details.) The CRA's experience confirms that the administrator must play a critical role in recognizing what is at stake for the architect, the developer, and the contractor if a schedule is delayed. The administrator must ensure that the artist's design process conforms, as much as possible, to existing timelines. At the same time, however, he or she must ensure flexibility on the part of the design and construction professionals. This is

"A big abuse of artists' time is when agencies or individuals commissioning a proposal for art don't have the funds to execute it. They get together enough money for the proposal and hope to use it to raise the money for the piece, or possibly for a whole program. This is a big if. *Too* big."

Joyce Kozloff, artist

"Speed is very important to a developer. You can't tell him that artists work within a different timeframe . . . but often technical considerations such as timetables are used as a power tool against the artist."

Richard Kahan, developer

See LA CRA Downtown Art in Public Places Policy, Chart C, Appendix.

"It's important to start out by going through the processes, by comparing timetables and flow charts, by defining common jargon. Since there is a qualitative difference in a process and a product in which an artist participates early on, it's clearly most efficient to involve an artist at the beginning, when the artist's ideas can most affect the building. You invest, then, when the creative potential is greatest, rather than in retrofitting a solution at the end."

Patricia Fuller, public art consultant

See also *Insights/On Sites*, Bibliography; and the Los Angeles Community Redevelopment Agency's Downtown Art in Public Places Policy, Appendix.

the only way to ensure the artist's participation in the early design phases.

The timeline in the Los Angeles CRA's policy document is a useful example of plotting both the distinct and overlapping activities of an "art program" and a "building and landscape program." It starts with preliminary project development discussions between the CRA and a developer and carries through to the approval of final construction drawings and art plans.

While involving the artist too late or allowing insufficient time for the artist to develop and implement a project are common problems, too long a timeline can pose an equally difficult situation. Joyce Kozloff points out that proposals for Arts On The Line projects were submitted in 1979 and artworks were not finally installed until 1985. For artists, this raises such questions as: How long can an artist sustain a fresh interest in an idea? How can an artwork representing an idea formulated six years earlier reflect the current thinking of an artist? How can budgets accommodate inflation and fluctuations in the value of the dollar (especially relevant for artists who work with fabricators in foreign countries)? How can we provide for the execution of posthumous artworks? While ample time for planning is critical, adequate—but not protracted time—for implementation seems to everyone's advantage as well.

Artist selection procedures

Selecting an artist is the single most important decision in the public art process. Selecting the "right" artist can seem a complicated and sometimes daunting task.

There are many legitimate concerns which grow out of the artist selection process. For example: Who should participate in the decision making? Which process is likely to lead to the best result? In the overall plan of the project, when should the artist be selected, particularly if the agency seeks to maximize the artistic possibilities? Are participants in the process fully aware of the range of artists and artistic directions appropriate to a particular public art project?

This last question should be addressed relatively early in the planning process. Public art offers unique ways to enhance public spaces. This topic has been discussed in the Why Public Art and Integrating Public Art in Community Planning Sections. As in most complicated tasks, understanding fully the range of options available can reduce the monumentality of the job at hand and open it up to creative, administrative—as well as artistic—directions. Therefore, a period of exploration and study by project participants, devoted to learning what public art can be, is usually time well spent. Sande Percival describes an early stage of the process of working

Joyce Kozloff, vestibule,
Wilmington, Delaware
Train station, 1984.
photo: Eugene Mopsik

with architects, public officials, site users, and community advisors which encourages questions and discussion:
"We show slides of projects which artists are doing across the country to help people get a sense of what they might expect. We don't keep them in the dark about the possibilities. Their role is to identify what their needs and dreams might be and what problems they foresee. These are the things that might spark the selection of a particular artist or direct that artist's research. After we've completed this initial phase of education, we decide on an approach, be it a purchase, a commission, or contracting with the artist as part of a planning/design team."

The goals of the artist selection process are threefold:
— to implement the agreed upon goals of the project through an appropriate art selection;
— to seek quality and integrity in the artwork; and
— to choose an artist (or artists) who will best respond to the distinctive characteristics of the site.

The selection method used grows out of these overall goals. It is also an outgrowth of other relevant factors, such as:
— whether the artwork is being purchased or commissioned;
— the size of the budget available for artwork;
— the sponsor's interest in working with more or less well-known artists; geographic restrictions on artist eligibility; a serious attempt to represent the work of women and artists of color;
— the sponsors' preferences (if any) concerning the nature of the artwork (e.g., medium, form);
— potential locations for the work and limitations or opportunities presented by the site;
— the extent to which architectural design has been developed, that is, is a design team approach possible and appropriate?;
— the resources of time, money, and personnel which can be devoted to the selection process.

Purchase or commission

Hundreds of extraordinary public art projects, past and present, have reinforced the conclusion that the commission, rather than purchase, of new artworks offers the most artistic and economic flexibility and gives the artist an opportunity to respond to unique environmental characteristics and community interests. However, the purchase of existing works may be the most appropriate alternative in certain situations, particularly existing interior spaces. For example: "portable" or art bank collections have been developed by public art programs in many cities and states, including Seattle, Hawaii, and Washington state. Here the goal may be to reach many more

sites through the use of a rotating collection. Sometimes it also supports a particular programmatic emphasis such as in Seattle, where the Portable Works Collection features Northwest artists.

Direct purchase of work may also compensate for limitations of site or budget. Where there is an existing site with only a few thousand dollars allocated for art, purchase of existing works may be a more cost effective route. However, many programs have commissioned successful public artworks with very minimal budgets.

Model procedures for artist selection

Through the experience of several exemplary public art programs, four basic methods of selecting artists have evolved:

— open competition;
— limited competition;
— invitation; and
— direct purchase.

It is important that each program or single project adopt and adapt an approach to fit its own circumstances. Nevertheless, the methods presented through the example of the Arts On The Line program (see opposite) have been tested and refined, and address concerns for quality of artwork, fairness to artists, involvement of the community and the consideration of community interests, and an appropriate selection panel composition.

Issues in artist selection

While the experience of Arts On The Line addresses many of the key issues in the artist selection process, there are several aspects of any program's selection process which deserve some additional attention. These include:

The role of the project architect in selection of artist and art: In keeping with the dictum that aesthetic decisions should be made by arts professionals who have extensive knowledge about contemporary art, and to avoid any aesthetic "conflict of interest," the appropriate role of the project architect is usually to inform and advise the art panel in a nonvoting capacity. However, the architect should play a major role in developing criteria for selecting the artist and should be involved in the review of artists' proposals.

The inclusion on the art selection panel of individuals from outside the locale of the art project: It is generally agreed that the selection panel should have representatives both from within and outside the local area. In most cases, outsiders are better able to look at a site with fresh eyes and may notice opportunities that local people overlook. They are generally

This case is drawn from the Arts On The Line Eight-Year Report, by former AOTL director Pallas Lombardi. See Bibliography.

Arts On The Line:
a case study in artist selection

In 1978, the Massachusetts Bay Transportation Authority (MBTA) and the Cambridge Arts Council (CAC) became long-term partners in a pioneering effort to humanize subway stations through a public arts program: Arts On The Line. The program was developed and administered by the Cambridge Arts Council over eight years, with funding from the U. S. Department of Transportation through MBTA.

Four new stations were to serve as the sites for a series of commissioned and site-specific public artworks. Arts On The Line staff designed and implemented a process for MBTA to use in selecting twenty artists for the four new stations.

Policies and criteria: In its earliest public art efforts, prior to 1978, MBTA did not have a formal art program. This led to several problems:
— In many cases, artwork was sited in dark and little-used sections of the station platform;
— Local artists resented the program because no public announcement or solicitation of work was made;
— The artists commissioned often ran into severe difficulties in getting paid and had problems with contractors and contracts.

Based on research of other public art programs, AOTL staff formulated the following basic policies to address these problems:
— All artists (local and non-local, known and unknown) would have an equal chance in a selection process;
— Selection of art and artists would be by experts experienced in contemporary public art, in order to ensure artwork of the highest quality;
— The community surrounding the future art site would be involved during the selection process. This would ensure that the art

would reflect a sense of the place for which it was being commissioned and would ultimately help the art gain community acceptance;
— Since public monies were to be spent, the process had to be democratic, professional, and open to public scrutiny and commentary.

The next step was to develop specific criteria to guide the selection process. From the beginning, the art was conceived of as being environmental and intimate—as opposed to isolated or monumental—and was intended to cover the broadest range of artistic possibilities. It was also meant to be thoroughly integrated into the architecture of the stations. Four criteria emerged:
— artistic excellence;
— appropriateness to the site;
— durability of design and materials; and
— minimum maintenance requirements and maximum resistance to vandalism.

A flexible artist selection procedure was designed. Its goals were to ensure:
— aesthetic decision making by arts professionals;
— involvement of the artist at the early design stage, (to guarantee that art would be integrated into the station design and not be an add-on);
— coordination of all phases of the project by an art consultant;
— creation of a long-term dialogue between the artist and architects;
— community participation;
— creation of a site biography: demographics, history, future, socioeconomic description of the community, and architectural design of the station; and
— art that would not conflict with transit safety and operations.

Selection and advisory committees: An art committee was established for each station, usually ranging from 10 to 15 people. Each committee consisted of two subgroups—an advisory group and an art panel. (Sometimes the proximity of two stations allowed an art panel to serve both;

however, separate advisory groups were established for each station.) All members of the overall art committee were selected by the AOTL director, with advice from MBTA representatives who already had extensive contacts in the community.

Each advisory group consisted of individuals with a clear stake and interest in the site, such as:
— an MBTA representative (designer, engineer, project coordinator, architect, etc.);
— a community development representative;
— a representative of the local historical society;
— local residents;
— local business representatives; and
— an arts administrator.

The advisory group's role was to "charge" the art panel, providing members with enough information about the given station's social and physical context to enable the panel to make informed decisions and select appropriate artists. The information might include:
— design aspects of the future station;
— technical information, such as where signage was to be located, pedestrian traffic flow, the station's physical environment (e.g., temperature), etc.;
— a profile of current and potential users of the station;
— distinctive features of the community and its history; and
— types of art of particular interest to the community.

While advisory group members were nonvoting participants, the process was designed to give them repeated opportunities to have an impact on artist selection.

The art panel, by contrast, consisted of three knowledgeable professionals in the arts and related fields: artists, curators, arts administrators, arts writers, and educators. Each panel was comprised of an artist, a resident of the station community, and an individual from outside Massachusetts. Panelists could serve on only one jury—a stipulation which prevented the dominance of one aesthetic standard and ensured that the pool of selected artists would change regularly. To avoid potential conflicts of interest,

continued on next page

69

Cambridge Arts Council and MBTA representatives were *not* voting members of the selection committee; likewise, private gallery owners and artist agents were not invited to serve on the art committee.

AOTL's artist selection procedure: The artist selection procedure was developed as an informed and systematic selection process which would, nevertheless, provide flexibility. AOTL's seven-step procedure can be summarized as follows:

❶ *Meetings with art committee*: a series of meetings of the entire committee, designed to discuss roles, selection guidelines, and artistic criteria. The AOTL director provided an overview of public art in Cambridge and across the country, and organized a tour of the station site "to educate panels fully as to the social, environmental, and physical context of each station and to formulate a program for that station."

❷ *Meetings with art panel, MBTA, architect, and review of Artbank*: working sessions designed to consider more specifically budget and possible locations for artwork (although siting was to be left up to the artist, for the most part) and to generate a list of artist candidates. Panelists met first to create a preliminary list of artists from the Art Council's Artbank, a slide registry representing over 700 artists nationwide. The Artbank is designed to ensure that:

— a broad range of artwork would be considered by the panel;
— panelists would be reacquainted with familiar artists' work and introduced to new artists; and
— artists could show their work on a roughly equal footing.

In addition, panelists were encouraged to provide slides of the work of artists whom they believed to be suitable for consideration, based on their understanding of the site. Advisory committee members were welcome to attend and observe all discussions relating to budget, site, and artist selection.

❸ *Method for artist selection*: a decision by panel members as to which of four artist-selection methods would be most effective. The four methods were:

— *open competition*: The site and commission were widely publicized. Proposals were accepted from all artists, and no proposal development fee was paid. Usually, the art panel decided to have AOTL run the competition, and a "call to artists" was mailed to each artist registered with the Artbank.
— *limited competition*: A small number of artists were invited to participate in competition for a station commission. Each artist was paid a fee to develop a proposal, working in cooperation with the AOTL administrator, the MBTA, and the architect.
— *invitation*: Based on reputation and experience, an artist was invited and paid to develop a proposal for a site, working in cooperation with the AOTL administrator, the MBTA, and the architect.
— *direct purchase*: Although direct purchase was the easiest of the four methods to administer, it was used only once in the program's history. There were two objections to direct purchase, in most cases: first, it worked against the concept of commissioning artists to collaborate and/or cooperate in designing a work specifically for a particular station; and second, the art was more likely to be an independent work of art and therefore unable to meet the MBTA's art criteria.

In most cases, limited competition (among a small number of invited artists) or invitation (of a single artist) were the preferred methods. Open competitions, although arguably the most democratic approach, presented a number of problems. First, they entail a great deal of administrative work, including:

— announcing the project;
— handling a volume of proposals (AOTL often received hundreds of proposals in response to national promotions);
— responding to numerous requests for more specific information;
— coordinating an initial screening of proposals by the art panel, the results of which were submitted to the art committee, which in turn made recommendations to the art panel, which made final aesthetic decisions;
— publicizing the results and informing all artists of decisions; and
— returning materials to artists.

Other, nonadministrative objections to open competitions were heard. Many artists, for example, were unwilling to spend time developing proposals without the likelihood of a commission. Open competitions, moreover, are often considered exploitative of artists—that is, eliciting free work from professionals who ought to be paid for their labors.

Limited competitions, of course, overcome some of the problems and objections cited above. Nevertheless, administrators must devote equal time to assisting all of the competing artists; and artists may still feel undermotivated and/or inadequately compensated for design work.

❹ *Artists develop proposals*: artists are paid to develop specific proposals, based on extensive background information, site visits, etc. AOTL negotiates a proposal contract with the artist(s), specifying time limits and fees for proposal-related work, etc. Artists were given at least two months to develop proposals and as much logistical support as necessary.

❺ *Artist presentations*: the entire art committee meets for hour-long presentations by artists explaining their specific project proposals. Most artists showed slides of past work, many provided written proposals, and some constructed and demonstrated elaborate project models. Flexibility and sensitivity to the artist's inclinations regarding the presentation process were key objectives since there is no standardized format.

❻ *Art committee discusses proposals*: members of the advisory group respond to each proposal for the benefit of the art panel. While group members were asked to address issues bearing on their respective expertises (i.e., architecture, historical concerns, safety, etc.), they were also encouraged to address other issues.

❼ *Art panel makes decision*: the panel attempts to reach a unanimous decision. When unanimity proves impossible, a simple majority is deemed sufficient.

See Appendix.

"Developers are interested in public art because it will enhance their building's marketability. This kind of reasoning does not support art with any edge to it. The developer is also motivated to avoid controversy. Given all of this, I am surprised developers are ever given the right to make aesthetic decisions. It's inevitable that they will figure out who the safe artists are, just as they have figured out who the safe architects are."

Richard Kahan, developer

"To get around the public agency bid system in finding an architect, you can do a qualifications-based selection as opposed to the usual fee-based selection, or, you can go through upcoming capital projects five or more years in advance and find the projects you want to champion. For the arts agency, part of it is being part of the system long enough and having a good track record so as not to be a threat."

Sande Percival, public art administrator

more objective in reviewing the work of local artists. Local participation is important, of course, to ensure that the local artistic community is represented in considerations. Local representatives also play a key role in helping the rest of the panel understand the context within which the artwork will appear.

The role of the developer (or designee, such as an architect) in cases where public agencies mandate or encourage public art in private development projects: In the private sector, absent any public mandate, a developer, architect, or corporate executive or curator has greater liberty to make individual decisions regarding the artist and artwork selected. The issues of artist selection can become complicated, though, in instances where public agencies—such as redevelopment agencies or zoning authorities—mandate or encourage public art in private developments.

The Los Angeles Community Redevelopment Agency has provided safeguards in its policy ⬤ to ensure decisions resulting in projects of artistic excellence. While developers have the option of suggesting a particular artist, that suggestion must be reviewed by a CRA-appointed arts advisory committee which provides short- and long-range guidance to the APP program. Developers are, however, encouraged to employ (with the help of CRA staff) a professional art panel or consultant to recommend artists. The decision as to which selection process is most appropriate is made jointly by the developer and the Arts Advisory Committee.

The formulation of an interdisciplinary collaborative team: There are three basic ways that design teams may be composed: (1) both parties are chosen by the commissioning agency, (2) the commissioning agency asks either the artist or architect to choose the other team member (or, at least, to provide input in the review of prospects), or (3) the team forms itself, either because the artist or architect proposes a collaboration or because an agency expresses interest in proposals from pre-established teams.

The first method, the "forced marriage," may be based on the agency's knowledge of the work of each party and what may appear to be a compatibility of aesthetics and/or approach. But most artists and architects are opposed to forced collaborations, pointing to the need for both parties to enter into the collaboration, first of all, clear on what a collaboration means and second, committed to the idea. Then, it is critical to have genuine interest in the work of the other team member, and an ability to work with existing personalities, approaches, and philosophies.

In Davenport, Iowa, the approach taken by Visiting Artists, Inc. and the City for the development of a public plaza enabled three competing artists each to select a collaborating design professional from a pool created by

Kenneth Noland, atrium wall with interactive color bands and Scott Burton settee, bench, and balustrade, Jacob Wiesner Building, Massachusetts Institute of Technology, Cambridge, 1985.
photo: ©1985 Steve Rosenthal

the project's steering committee. The team accepted by the committee was artist Elyn Zimmerman and architect Paul Broches of Mitchell/Guirgola Architects. The committee believed that charging the artist with establishing the partnership helped to put the dual disciplines on equal footing.

Of the three methods of forming a design team listed above, the latter two offer a greater chance for a team whose members will be committed to each other and the process from the start, respect each others' work, and share excitement for the design possibilities at hand.

The difficulties resulting from art selection by committee: Many observers have commented that art-by-committee leads to dull, common-denominator choices. This argument suggests that since tastes in art are subjective and therefore vary radically, group decision making leads inevitably to choices which the greatest number can "live with"—and therefore compromise quality and limit artistic options. Others counter that when a number of arts experts are brought together, the range of choices becomes greater, and the arrayed expertises of the panel is likely to lead to quality decisions.

Due to limited time and money, art selection panels usually meet at only the artist selection stage of a project and provide no carry-through after that point. This may create problems. As urban planner Ari Sikora points out, in the context of public art in the redevelopment arena, "One of the ironies of using the panel process is that potentially no one has a proprietary interest in the art object. The developer says, 'I submitted myself to the process, but you really accomplished this.' The agency doesn't take responsibility for it, because it's the developer's art, and the panel is no longer around. There is no one to rush forward and wholeheartedly defend the work of the artist if it is attacked."

The same objection could be raised in the context of publicly funded public artworks. In such cases, however, the agency has administrative responsibility for the program, and can advocate for (and defend, if necessary) the choices that are made. But there is general agreement in the public art field that an art panel's expertise could be of great value at additional points— that is, both before and after artist selection.

For example, once artists are selected to develop proposals, the art panel might be reconvened to hear artists' proposals, to ask technical, budgetary, and programmatic questions, and to assist in the final selection if it is impending. The 1987 revised guidelines of the General Services Administration's Art-in-Architecture program calls for three visits by the NEA-appointed art panel to the public art site:

— first, before any artists are considered, in order that the panelists may

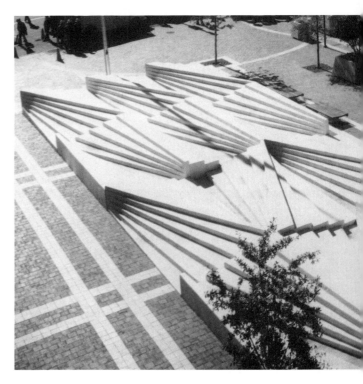

experience the site firsthand and learn directly from community, architects, and project coordinators about the nature of the project;
— second, for the artist-selection panel meeting; and
— third, when the artist's proposal is presented.
All three meetings have in attendance representatives from the community and building users.

Summary on artist selection procedures

We have devoted considerable attention in this section to artist selection procedures employed by Arts On The Line. The comparable processes of three other public art programs—Metro-Dade Art in Public Places, the Los Angeles Community Redevelopment Agency, and the project executed by the National Oceanic and Atmospheric Administration in Seattle, appear in the Appendix. Collectively, this reservoir of experience suggests three overriding principles which should guide the establishment of specific procedures in other programs:

The decision making process should strive for the most creative, highest quality artwork for a given site. Specialists should be called upon to lend breadth and depth of knowledge and resources to the endeavor. It is generally agreed that aesthetic decisions should be made by arts professionals with a perspective on contemporary art of national or international scope. Since public art presents unique challenges—technical, aesthetic, administrative, and political—unlike those found in the museum or gallery setting, the panel should include at least one member with specific experience in public art.

When public art involves public money, the development of an accountable selection process—that is, one which accommodates public participation—is a program priority. Relevant information about the social and physical context for the artwork is critical to an informed and appropriate selection. Community members provide necessary information about the context of a public art project. Participation of this nature fosters a feeling of investment in and ownership of the artwork. Community input (as well as owner, agency, and user needs and concerns) should generally be expressed by community members serving as nonvoting but actively involved, members of advisory subcommittees. Community representatives can also play a major role later in the process, presenting the artwork to the community at large and developing a broader base of support for it.

The artist should be selected no later than—and ideally before—the architect's conceptual design stage. When this is the case, the artist is able

Athena Tacha, *Ripples*, Federal Building, Norfolk, Virginia, General Services Administration, Art-in-Architecture Program, 1979.

to participate in design discussions which affect the spaces within which artwork may be envisioned and to meet with the community. This is more likely to lead to artwork which is truly integrated into the design of a given public space.

The proposal stage: artist information needs

The Arts On The Line case study (see previous section) made the point that artists need a good deal of information even before they are selected to work on a project. In order to decide to pursue a project and then make a responsive preliminary proposal, artists must have a clear sense of relevant parameters (site, budget, schedule) and contextual factors (current and potential audiences, political and historical considerations, etc.).

The structural design of the Thunderbird Fire & Safety Equipment Corporation Headquarters building in Phoenix was modified according to the concept for this mural by Richard Haas. Commissioned by the Thunderbird Corporation, 1985.
photo: Peter Jordan

It is the coordinator's responsibility to manage the flow of information to the artist from the commissioning agency, from any advisory bodies, and from the community. This entails considerable judgment as to what factors come to bear on a given project and what information is needed for an informed and workable proposal. Joyce Kozloff provides an artist's perspective:

"I'm all for the agency giving lots of information to the artist. It's better to err on the side of too much input, rather than too little; and, of course, the artist should have the option of disregarding it if he or she wishes.

"However, there are ways in which information can be *presented* which are too directive, or downright intrusive. All artists experience people who want them to do work like what they've done before. This is conservatism or lack of imagination, I suppose. You would think they'd want you to develop new ideas; but very often, an agency will have an actual artwork in mind that they think you can execute, and the information you're given is to lead you toward creating what they have in mind."

"When you select an artist, you have certain expectations which are usually based on previous work. This is natural, but it is also dangerous, because an artist is, by nature, a fluid and changing person. Every project is an opportunity to invent something new. What I try to establish at the beginning of a project is total freedom, knowing full well that never happens."

Richard Haas, artist

At the same time, it is important that the commissioning agency help the artist understand relevant social and political realities of a community or public art site. Joyce Kozloff offers a cautionary note:

"This is an example of a situation in which I came perilously close to making a disastrous mistake out of ignorance. In the information packet prepared by the [public art commissioning] agency in Buffalo, there were various details about the history of the city, one being that the original inhabitants were the Seneca Indians. I decided to do a "Seneca piece." I visited the reservation, community center, and museum; and began library research.

"Several months passed and I was well into developing my ideas when, in a phone conversation, the administrator, Nina Freudenheim, made a passing remark that there was discontent in the Seneca community about a Jewish woman from New York doing a Seneca piece.

"Well, I worried about that and, in fact, scrapped my original idea. (In the final artwork, Seneca ornament is one part of an overall compilation of decoration in Buffalo architecture and craft.) My error was to think of the Seneca as an historical fact, rather than a living political entity. Anyway, I think I learned from this episode that the research and development stage has to be thorough and that one needs input from people in the community."

Kozloff's comments suggest some useful points. One is that relationships are important in the information collection process. The Seneca community had to feel free to express its concerns to someone. The local agency's role as liaison between artist and community is important. However, this should not preclude the artist from having the opportunity to openly discuss his or her ideas with the community. In such cases, the agency should seek to prepare participants for a productive dialogue. The coordinator must understand that a project could become unnecessarily complicated if the concerns of either side are not fully explored. The coordinator's role is to anticipate, scout, investigate, and evaluate if a concern is substantial enough to affect a project's direction, and whether the artist's creative freedom is at peril. And finally, as Kozloff's anecdote suggests, artists can usually be expected to be sensitive to these important issues.

Another important point is that information gathering is a shared responsibility with an implied sequence. The coordinator first shares existing information with the artist and suggests to the artist how additional information can then be collected. Specifically, the agency needs to identify which people and organizations are directly affected by the project, and which can contribute further relevant historical, cultural, and sociological insights. How the artist obtains this information depends, in part, on the

This call for proposals by the City of Concord, California, was run in the tradition of a design competition following the premise that competition promotes excellence. A program kit available to all competitors provided detailed information such as: the purpose of the project, historic and current uses of the plaza site, goals for use of the plaza, desired utilitarian elements of the plaza (lighting, seating), art/design opportunities, and competition rules and procedures. For more information on how to run a design competition, see Design Competition Manual, published by the Design Arts program of the National Endowment for the Arts (Bibliography). *Reprinted by permission of the City of Concord, California.*

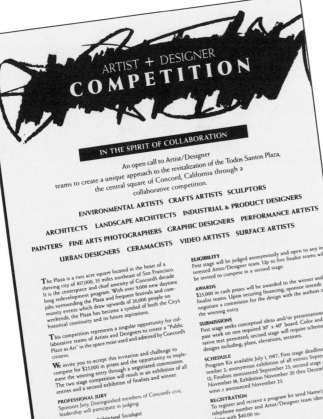

artist's time commitment. (Proposal fees should take research time into account.) It also depends on the artist's degree of comfort with and interest in researching and talking with people in the community. If the agency feels that the project would benefit from exchange between the artist and community, this may well become a criterion for artist selection.

Information checklists

The commissioning agency should provide the following standard information to enable the artist to develop a proposal:

Project information:
— art budget, including eligible costs and proposed payment schedule;
— projected time span of the project;
— schedule for design, construction, and installation, including all schedules of related contractors (e.g., architects, landscape architects, fabricators), stipulating when the artist is expected to be involved and to accomplish certain work;
— legal disposition of the site (i.e., evidence that the site has been officially sanctioned for the proposed public art project);
— complete and up-to-date site plans;
— photographs of the site;
— building, zoning, or other relevant regulations indicating the agent or agency responsible for obtaining permits and agreements;
— statement of the site's substructure, if known ;
— relevant environmental regulations;
— preliminary preferences regarding the proposal's format and content (to be renegotiated with each artist individually);

Community information:
— community demographics, including description of the social fabric of the neighborhood near the artwork;
— profile of the user agencies at the site, and of current and intended site use;
— history of the community and/or site;
— summary of existing cultural activities and organizations; and
— survey of the community's political and social concerns.

Agency information needs

The proposal is the first opportunity for the artist to express his or her concept for the artwork and for the agency to review that concept in terms of its artistic merits and its technical and financial requirements. This phase of the project is one with a great deal of potential for productive interactions between the artist, the agency, and the community. But if

it is not clearly defined, considerable confusion may ensue. The public art coordinator has an important responsibility to facilitate and guide the proposal process.

The commissioning agency should establish development phases for the proposal. For sites with new construction, these should correspond to the design phases of a construction project, to ensure that the art has the greatest potential to be integrated with relevant construction or renovation projects. For existing sites, the proposal phase should be tailored to the agency's and artist's needs. The Fairmount Park Art Association in Philadelphia, for example, observes three distinct phases in the proposal process: a *conceptual* stage, a *research and development* stage, and a *contractual* stage.

During the *conceptual* stage, the artist develops one or more ideas in general terms, leaving room for modification based on reactions from the project planners and community participants. Preliminary site visits are often essential for the artist to gain a clear image of the site and to discuss project goals in detail. Artists should be compensated for time, travel, and expenses associated with such site visits. The Washington State Arts Commission, for example, pays artists $250 to $500 per day for their time, exclusive of travel and per diem. When there is a risk that a project won't happen, WSAC apprises artists of that fact ahead of time but still pays for proposal development if a project cannot come to fruition.

It is important in the conceptual phase that both sides feel free to ask questions—and raise doubts, if necessary—before the artist invests much time in any one approach to a project. "Artists who are not used to the process often wrestle with how far to go in the conceptualizing stage," notes Patricia Fuller. "They are unfamiliar with the notion of leaving the idea flexible enough so that the public part of the process can influence it. It is important to realize that this is not a temperamental defect, but rather, the result of moving from one professional situation to another."

In the *research and development* phase, the artist is given time to develop and refine his or her ideas in response to issues raised in the conceptual stage. For example, the agency may encourage the artist to consult with an engineer or architect for technical advice or with local suppliers about costs of materials. The artist may decide to spend additional time researching the community or its history to further develop the content of the artwork.

The commissioning agency usually requests information about the artist's previous artwork and experience in public art. Sometimes this is unknown, as in cases when artists unfamiliar to the commissioning agency are discovered through an open competition. But even when the artist is well

"There are many different ways in which artists work. Some do lots of quick sketches, while others slowly develop very finished presentation drawings. Some artists do a lot of research, while others work in a more internal fashion. It is important that we not establish rules for how artists create."

Joyce Kozloff, artist

Buster Simpson, proposal
for living bust of George
Washington made
of ivy and steel for the
Washington State
Convention & Trade Center,
Seattle, 1986.
photo: Jake Seniuk

Carolyn Law and Dennis
Evans, proposal for
environment incorporat-
ing Fire-related imagery
and Fire performances
for the Fire Training and
Service Center, North
Bend, Washington,
Washington State Arts
Commission, 1986.
photo: Jake Seniuk

known, this information can still provide useful background to members
of boards and advisory committees, some of whom may not be familiar with
the artist's work.

There are at least three elements which should be developed in any well-
conceived final proposal:

a description of the proposed artwork, and appropriate visual support. This
may take the form of a model, a drawing, or other type of visual aid which
represents the work in its proposed site. In the design field, exhibition-
quality drawings or models are paid for as an "additional service" beyond
the agreed-upon fee. Polished renderings or models may be prepared by a
professional other than the artist; in such cases, they should be considered
an added cost. As appropriate, the size, materials, colors, finish of the
work, and method of fabrication should be indicated. In addition, the artist
should present evidence demonstrating the project's structural integrity
and its conformance to applicable safety codes and similar regulations;

a timeframe for completing the project, including key benchmarks
throughout the fabrication process. Of course, the agency may well dictate
the timeframe for project completion. In such cases, the artist needs to
evaluate this timeframe. If it seems unrealistic, the artist should propose
revisions; and

a detailed and well-researched budget. In the opinion of one artist, artists
"hit the panic button" when they have to do a budget. Cooperation and
research are the best tools for minimizing the anxiety. Administrators and
artists should work together to create a detailed budget for the proposal.
Expenses such as the following should be considered:

— artist's fee;
— labor costs (assistants, contracted services, etc.);
— studio and operating costs;
— travel, accommodations, and per diem expenses related to site visits
 and research;
— fabrication costs;
— mechanical, electrical, plumbing, or similar contracted work;
— site preparation costs (subsurface and surface);
— transportation of artwork to the site;
— rental of storage space, if relevant;
— installation costs;
— insurance (whether required by the agency or desired by the artist)
 during fabrication, delivery, and installation;
— plaques or labels identifying artwork (unless supplied by the agency); and
— photographic documentation required by the agency.

> "I have had knockdown, drag-out battles with artists to get them to figure out what it's really going to cost, and to ask for enough money to do the project."
>
> *Patricia Fuller,* public art administrator

Korczak Ziolkowski, model for *Crazy Horse* memorial to be carved out of rock in background, Black Hills of South Dakota, in progress. ©*ART on FILE, Chartier/Wilkinson, 1988*

Many artists present budgets which are unrealistically low. This often occurs because the art budget, as in the case of percent for art projects, is a fixed figure. In order to leave sufficient money to cover materials, contracted services, and so on, artists often shortchange themselves by reducing their own professional fees. In other cases, ignorance of hidden costs (or of the amount of time a project may actually take) results in unbudgeted expenses that the artist has to assume. On rare occasion, the artist may make changes which alter the nature of the originally proposed project. This latter option may be problematic, of course, since the agency involved has contracted with the artist for a specific artwork. But such changes may represent essential improvements which have the project's best interests in mind.

"The artist must be serious about assembling a budget which is feasible," explains Patricia Fuller." I have had knockdown, drag-out battles with artists to get them to figure out what it's really going to cost, and to ask for enough money to do the project. The bottom line for me, as an administrator, is that I don't want to see the artist get halfway through the project and run out of funds. That's not good for me, or for the artist, or for the program.

"And when large sums of money are being discussed for what some might consider a questionable expenditure of public funds, it is absolutely necessary to be able to refer to a concrete budget—one which indicates how the funds are going to labor, materials, and perhaps into the pockets of local suppliers."

Contingency budgeting

Budgeting for the unknown means including a contingency line in the budget. Contingency funds are reserved for expenses which could not have been anticipated in the original budget, such as increases in materials costs if a project is delayed or costs related to site preparation. In such cases, contingency funds are a kind of insurance to the overall project, in addition to protecting the artist and the agency.

There are a few possible approaches to contingency budgeting. A commissioning agency may elect to add onto the art budget a minimum sum (such as 10 percent of the sum allocated for a given project) as a contingency reserve to be used upon mutual agreement between the agency and the artist. In such an approach, a $100,000 project allocation would actually represent a $110,000 commitment on the part of the agency. Any fixed percentage (such as 10 percent) may prove too high or too low for a given project, but experience suggests that 10 percent is a reasonable starting point for determining an appropriate contingency reserve.

Some agencies avoid a separate contingency line by insisting that the municipality or municipal agency with control over the site take responsibility for site preparation and unexpected costs. But there is no guarantee that such costs will, in the end, be absorbed by the agency.

Proposal contracts and fees

The commissioning agency should, in one of two ways, contract with the artist for the creation of a proposal. In the case of competitions, with multiple artists involved, a separate proposal contract is standard. If an artist has been invited to do a commissioned work, the proposal terms may be contained either in a separate contract or in the contract for the commission. In the latter case, a termination clause should be included which gives both parties the option to terminate the relationship after the proposal review. This ensures that the artist will be compensated for time and materials invested up to that point. In any case, *artists should receive a design fee whether or not a project is ultimately commissioned.*

In situations which can quickly expand in scope, such as master plans, it is often helpful to have a design services contract which stipulates that the artist work during certain phases of the design process with the architect, but under a separate contract, so that the artist is not responsible for (and does not incur the added expense of) all the drawings and presentation models. Otherwise, additional services—such as the preparation of presentation models, environmental impact reports, and so on—should be specified in the initial contract, and the artist should be compensated accordingly.

Ownership of proposal-related work

Before moving on to a consideration of contracts, it is important to reflect briefly on the ownership and disposition of work created during the proposal process.

Generally speaking, proposal fees to artists are insufficient to cover acquisition of drawings or models. Unless the agency is expressly paying for acquisition of drawings or models—and has so stated in its contract with the artist—all drawings and models should remain the property of the artist. This rule of thumb is somewhat complicated by the fact that policies of some public agencies prohibit the payment of fees without the receipt of a product. But, as attorney Barbara Hoffman explains, "It is important to distinguish between an idea and a product. In most cases, the client is paying for the artist's time in designing, not for the purchase of a working drawing or model." Many agencies now accept a photograph or photocopy of a drawing as the required "product."

"Although I would support two contracts—one for the proposal phase and another for the commission—I don't think the legal consequences are different than if an artist were to negotiate a single contract with a termination clause. Two contracts may engender a bit more psychological uncertainty than one by suggesting less commitment."

Barbara Hoffman, attorney

"I believe all of my sketches and models are my property, and I stamp them with my copyright. These materials may be all I end up with—and things not held by the artist tend to get lost."

Richard Haas, artist

Some agencies have found practical reasons to modify their standing policies. Storage and care of an accumulating collection of models and drawings, for example, have caused the Washington State Arts Commission to question why the agency needs to retain possession of proposal-related visuals. Contracts can be modified to anticipate most agency needs and to eliminate the need for storage. For example, if the agency needs access to a given drawing for exhibition purposes, this limited use can be agreed upon in the artist/agency contract.

Contracts

Like the proposal, the contract should be regarded less as an intimidating document, and more as an important step in a process. The contractual stage is an opportunity for each side to propose and exchange terms. There may very well be differences in views and interests between the contractor and contracted party.

As urban planner Ari Sikora notes, "During negotiations the positions necessarily reflect self-interest. The relationship is temporarily that of adversaries." An important objective of the negotiation process is to identify critical points with which either side absolutely cannot comply—points that either must change or that, unchanged, must be assessed in terms of potential impact. This is especially important for the artist, who is often in the weaker bargaining position. If, for example, the artist finds it impossible to comply with the agency's insurance requirements, this must be expressed and resolved, either by concessions on the agency's side, mutual compromise, or—most drastically—ending the relationship altogether. Concessions are rarely satisfying to the conceding side, but they are often preferable to all the alternatives.

The contract negotiation phase, then, is an opportunity for both sides to hold firm or to modify their positions until both are satisfied with the "package" that it describes.

How can the artist's position be protected in contract negotiations? "The best solution," says one artist, "is for the artist to write the contract and give it to the agency." While this is certainly a preferred solution for some artists, legal fees and the artist's weaker bargaining position may make this a less than ideal process. And in most real-life situations, the artist is not invited to draft his or her own contract. This doesn't mean, however, that the artist must accept unchanged the standard contract presented by the agency. The artist should have the assistance of an administrator who can articulate the artist's position and who has sufficient authority to influence the outcome of negotiations. One public art administrator suggests that in cases where contracts are exceptionally complex, or where they present major concerns to the artist, the artist should hire a lawyer knowledgeable

Mary Miss, model for the Tip O'Neill Federal Building, Boston, General Services Administration, Art-in-Architecture Program, 1987.

81

about contract law to review his or her contract. Many local arts organizations as well as Volunteer Lawyers for the Arts can recommend lawyers who work specifically with artists.

The contract phase is a continuation of the proposal stage. Before attempting to enter into a written contract, the artist and the agency should have raised and resolved most of the significant questions regarding the feasibility of the proposed artwork, including artistic and technical considerations, budget, and anticipated completion date. The contract then establishes agreement on the artist's scope of services; legal matters, such as warranties, reproduction rights, and artist's rights; and compensation and payment schedules.

The content of a contract depends in large part on the specifics of the project at hand. Terms for the purchase of an existing artwork are simpler than ones for the commission of a new artwork. A collaborative effort between an artist and a design professional creates other variables. This section focuses on the commissioning of a new work and also considers the special requirements of a collaborative project.

The single best model of a commissioning contract between an artist and a city agency was prepared in 1985 by the Committee on Art Law of the Association of the Bar of the City of New York. It is the result of extensive research into model public art programs and their contracts, and is informed by both domestic and foreign art law. Because of its analysis of the issues underlying contract terms, the New York Bar's Model Agreement is reprinted in full in this book ⬤ and forms the core of this section on contracts. It is important to read the complete agreement, including the preface and the annotations which appear throughout. The narrative which follows in this section provides additional commentaries on establishing scopes of services and compensation and payment schedules. Approaches to issues of indemnification and insurance are also updated in annotations in the subsequent Liability section.

⬤ See Appendix.

Jack Mackie in collaboration with Mark Spitzer and Chad Kirk, architects, model for *Waterwall*, Convention Center Station, Seattle, Downtown Seattle Transit Project, 1987.

Additional notes: scope of services

The New York Bar Association's Model Agreement suggests two basic premises about the scope of the artist's services for a straight-forward public art commission. First, the artist performs all necessary services and provides supplies through all phases of the project, unless otherwise stipulated in the contract. Second, the artist retains control over all aesthetic aspects of the artwork, subject to the approval of the commissioning agency.

Unusually complex projects have special problems. The architect who served as primary coordinator between the artists and the Downtown Seattle Transit Project (DSTP) notes that scope of services was the single

most difficult element to define in the artists' contracts. DSTP involved a half-dozen artists on design teams for public art within the new transit system.

In each artist's contract, the artist's services were divided into two phases: Phase I, related to design; and Phase II, related to fabrication. Artist Jack Mackie explained that, "the joy of the DSTP design scope was that it was broad enough to leave a wide range of options open." The artists actually participated in developing the overall project's aesthetic criteria and the documents necessary to describe the character of the design. In Mackie's words, "Not only did we get to play the game, we got to write the rules, too."

But, one outgrowth of an extremely early involvement of artists is that no artwork or design product is easily defined at the time of contracting since the fundamental idea is to bring artists and architects together before ideas have emerged. The complexity is compounded if the art that emerges from this process is fully integral to the architecture itself. Therefore, the scope of work may encompass issues of liability, design standards, and scheduling.

For example, in the DSTP project, the question emerged as to who would actually create the contractor's bid drawings and specifications. Artists lacked the license and the drafting skills needed to accurately document their designs, but the architect's contract had not anticipated the impact of the artists' work on their time and fee schedules. To accommodate the architect's involvement, funds were moved from the art budget to the architect's.

Such situations must be seen as variables, and it may be necessary to have a basic scope of services with built-in flexibility to add fees for the artist or design professional as the needs and the schedule become more clear. Mid-course adjustments in the scope of services and delineation of professional responsibilities will thus be necessary to the design process.

The scope of services section of the contract should also address how significant changes in scope (whether proposed by artist, agency, or design professional) will be handled. A "significant change" can be defined as any change which affects site preparation, scheduling, the work's concept, installation, or maintenance. If generated by the artist, any such changes should be submitted in writing to the agency at an agreed-upon stage in the design phase, which is stipulated in the contract. The agency can then review the merit and feasibility of the proposed change.

Similarly, the contract should protect the artist from requests by the agency to revise or abridge services, or to perform additional services

83

See sample Scope of Work from the DSTP project, Appendix.

84

beyond the scope of the work as originally defined. The contract should be structured so that the artist can *consider* such a request—in other words, choose to: decline the request, comply with it and propose additional compensation, if warranted; or negotiate a compromise.

Compensation and payment schedule

Closely related to the scope of services is the schedule for compensation. The New York Bar Association's Model Agreement provides two alternative approaches to payment: one a straightforward fixed-fee arrangement, whereby the artist is paid when certain objective "benchmarks" are reached; the other a more flexible payment scheme, designed for circumstances where the later stages of a commissioning process are too vague to have dollar figures attached to them. Such projects call for a continuing redefinition of the compensation schedule.

The former approach to payment is preferable, in most cases. Payment of fees should be linked to the submission of required materials or services, rather than to arbitrary points defined by either the agency or the artist. When percentages of the total contract amount are used to establish the degree of completion of certain stages of the artwork, the percentages should be tied to objective results. This assures the agency that the artist has fulfilled certain obligations and assures the artist periodic and timely payments.

See the Downtown Seattle Transit Project Scopes of Work, Appendix.

In the sometimes dense thickets of a contract, it is easy to lose the thread of common sense and to forget that in every public art project, an individual artist is taking significant risks. The commissioning agency should make every effort to limit and contain those risks. For instance, whenever possible, contracts should specify that unforeseen costs which are not the fault of the artist (such as those arising from difficulties in site preparation or documented delays which result in increased material costs) should *not* be assigned to the artist. (See the previous discussion on contingency budgeting.)

Similarly, contracts can and should be structured in such a way as to recognize and take into account the artist's financial circumstances. Consider the following account of a bureaucratic problem, excerpted from an Arts On The Line eight-year summary report, and the flexible contractual response devised by AOTL administrators:

The long timeframe for payments to artists was one of the most frustrating aspects of managing the project. Once an artist completed a stage of work and the administrator either received substantial documentation or did a studio visit to confirm that the work was complete, she would approve the artist's invoice and forward it to the MBTA (Massachusetts Bay Transportation Authority) site/project person

Terry Allen, *Lead Tree,* lead-covered eucalyptus tree with sound component, The Stuart Collection, University of California, San Diego, 1986.
© *ART on FILE, Chartier/Wilkinson, 1988*

for approval and submission to the general contractor. Although the specifications instructed the general contractor to pay the artist's invoice upon receipt and not to await reimbursement from the MBTA on its monthly billing, things did not usually happen this way. The contractors would often wait until their billing to the MBTA [schedule with the art expenditure listed on it] was approved and a check received before they would submit the artist's invoice to their home office, often out of the area, for payment. This usually meant that an artist would complete a stage of work and not receive a check for three months, during which many phone calls were made to the contractor to ensure that the paperwork was moving along. It was a slow bureaucratic process that resulted in frustration and aggravation to the artist and the administrator, as this timeframe had not been anticipated in advance.

Later on in the program we were able to prepare artists for the slow payment process and adjust their stage-payments accordingly, so that they did not have cash flow or schedule problems. In some cases we increased the 15 percent advance payment and negotiated to cover additional storage costs if the general contractor was delayed, so that the artist did not have to absorb the cost.

Liability and insurance

Liability insurance premiums have escalated dramatically in recent years, reflecting increases in the frequency and settlements of damage suits. While this escalation is a problem for many professionals—from doctors to day-care center operators—it has specific and troubling implications in the art world.

These implications are twofold. First, insurance companies (or their lawyers) may increasingly come to restrict artistic expression by defining certain works (or locations, or even media) as being too risky to insure. Second, more and more artists may be disqualified from participating in the public art process because they simply can't afford the necessary insurance.

Why is insurance necessary? In many cases, the answer is statutory. Cities and states usually require their contractors to carry liability insurance, and artists may be required to present proof of insurance covering fabrication, installation, and workmanship. The more important reason, though, is protection of the artist. A number of trends are converging to increase the artist's exposure, and those trends must be reflected in insurance coverage. For example, it now seems that artists may be liable not only for injuries sustained by subcontractors during fabrication and installation, but also for those sustained by the public *during the entire life of the artwork*.

The trend toward collaborative efforts between artists and design professionals also poses questions of shared liability.

But for many artists, the price is too high, especially considering their own limited assets. "Fortunately," as one artist was quoted in a Dallas newspaper, "I don't own very much. If anybody sues, they won't get anything."

In fact, if somebody sues, they may get *everything*. And even short of total disaster, there are plenty of opportunities for the uninsured artist to be burned badly. "I have worked with artists who have risked not having insurance," reports Pallas Lombardi, former director of the Arts On The Line program. "They were lucky. Their studios did not catch fire, they didn't have water damage problems, and their stored work was never stolen, lost, nor damaged.

"But one artist's installation was inadequate, and a few of his pieces were stolen. He didn't carry insurance, so he had to bear the cost of replacing the work and redoing the installation to secure the work properly."

The New York Bar Association Model Agreement touches on some of these issues ⬤ but the thinking on them has evolved since the drafting of that document. Additional commentary—although not a formal annotation considered by the New York City Bar Association's Art Law Committee, which drafted the original document—has been provided as follows by Barbara Hoffman, former chair of the Bar's Subcommittee on Art Law. Hoffman provides a brief introduction to the field of liability and insurance, and offers insights on several of the questions which have arisen in the public art field.

⬤ See Risk of Loss and Indemnity sections of the Agreement, Appendix.

Liability and insurance: an annotation by Barbara Hoffman

Since the publication of the Model Agreement (reprinted in the Appendix), questions of liability, insurance, and indemnification have gained prominence in the public art forum, in part because of the increased cost of insurance premiums, and in part because of the increasingly innovative and complex nature of the projects which are undertaken. This section expands upon the annotations in the Model Agreement.

A basic understanding of the concept of liability in the public art context is a prerequisite to any discussion of indemnification or insurance. To understand the potential liability of an artist who is commissioned to create a work of art in a public space requires identification of the various sources of legal responsibility which influence and regulate the artist's activities, including: (a) laws, codes, ordinances, and other regulations; (b) the contract between the artist and the commissioning body; and (c) common law (i.e., negligence).

Jackie Ferrara'a *Norwalk Platform* at Memorial Lake Park in Norwalk, Ohio functions as a performance stage and was built by a crew offered by Cardinal Industrial, a modular housing maker; 1984
photo: Ellen Eisenman

Liability for injuries and property damage to others arises when the artist breaches a duty, and this breach is the proximate cause of damage. These duties are generally derived from the sources stated above. A duty is "breached" when the artist fails to perform the duty as measured by the appropriate *standard of care*.

The form of arrangement between the parties may establish a standard of care, as can the standard applied to normal practice in the profession. Other measures for the standard of care are: *expressed* and *implied warranties*; the *tort standard*, based on general negligence principles; and a general duty imposed on the artist to those who may be foreseeably injured by his work product. Express warranties are specific contractual representations. Implied warranties are those (whether created as a matter of law or by special circumstances) which may bind the artist even though they are not specifically included in the contract. The tort standard —that is, the standard of care usually exercised by practitioners of a profession—is usually the basic standard of care required in negligence cases.

A manufacturer has traditionally been held to a stricter standard of care than negligence. In product liability cases, for example, *strict liability* is applied to the manufacturer of a defective product, and liability is established through proof of manufacture. A provider of services, by contrast, is usually held to the negligence, rather than the strict liability standard.

Architects are considered providers of services, as are most artists who contract to provide public art. For example, the General Services Administration contract is a services contract, even though it often results in the creation of an object. Absent a contractual provision to the contrary, a provider of services is generally *not* seen as warranting that his or her particular product is fit for the purpose intended. However, particularly where the entire work is fabricated in the artist's studio and then delivered to the site, it may be argued that the artist is a "merchant of goods." In this case, the warranties of the uniform commercial code, Article 2, may be applicable and a general disclaimer may be desired.

What steps can an artist take to limit his or her liability? At the level of the contract, an artist should define precisely the scope of services and eliminate all obligations which are beyond the capacity of the artist. As a matter of common sense, artists should not become involved in projects beyond their scope of experience or competence.

It has been suggested that the transfer of liability back to the commissioning agency may be an effective way to limit the artist's liability. Transfer of liability is, in effect, an *indemnity clause*; and this is one of the

most advantageous contract terms for an artist. Very simply stated, indemnity involves the shifting of liability from one party to another, and it can be accomplished either by contract or by the operation of legal doctrine.

After the expressed warranties concerning the work of art have expired, it make sense to transfer the liability back to the commissioning body for two basic reasons. First, that body owns and controls the work. Second, it is almost impossible for the average artist to absorb the costs of carrying insurance forever, whereas most municipalities carry this kind of insurance as a matter of course.

Should artists insist on a "hold harmless" indemnity clause? Whenever possible, artists should insist upon a "hold harmless" clause. Many standard public art contracts, in contrast to the Model Agreement, now try to impose a hold harmless clause on the artist for all claims arising out of the contract. The artist should try to eliminate this clause or narrow it to specific instances. The advice of legal counsel in this area is particularly important. As a general rule, a person can't be indemnified without explicit language in the contract to that effect.

As for the artist's liability, even with an indemnification clause, it is forbidden in most states to attempt to indemnify yourself against your own sole negligence. Such a blanket indemnification is considered against public policy. A case in point regarding the indemnification clause involved contract negotiations between artists and the Downtown Seattle Transit Authority for public art projects in the transit system referred to previously under Scope of Services. The resolution is described by Seattle artist Jack Mackie:

"An artist's ability to mount a defense if there were a suit brought was the big issue. At best, an artist is a small business and just going to court would threaten bankruptcy. We said that if Metro wanted the work of artists in the project, they would have to assume legal responsibility. After much back and forth, they said they would pick up defense if we would assume any judgments assigned by the courts. We said yes, because we were willing to agree that all structural, civil, architectural, mechanical, and electrical work would be coordinated and approved by the DSTP's architectural/engineering firm. Liabilities other than negligence by the artist are assumed by an insured firm, not by the individual artist."

Should artists carry some sort of blanket liability insurance, or is this an overblown issue? The answers are "yes" and "no," respectively. The cost of insurance premiums is a most serious problem, and arts administrators are beginning to act on that realization in a number of ways. First, some agencies are carrying insurance for the artist. For example, in the

MacArthur Park public art project in Los Angeles, artists were named as additionally insured by the commissioning agency under its liability insurance policy covering public liability, property damage, and products liability. Artists were also covered by workmen's compensation during the time that they were on park property.

The New York City Transit Authority (NYCTA) provides reimbursement to the artist for "actual, necessary, and reasonable expenses for the cost of obtaining and maintaining insurance coverage" if required by the agency. (NYCTA has not required insurance if fabrication is done off site.) Some agencies now require the artist to carry liability insurance only for activities carried out while the artist actually controls the work. The New York Public Art Fund and the California Arts Council state that the artist no longer has to carry bodily injury or property damage insurance. In effect, they're saying to the artist, "You cover the design and the object up to the fabrication stage, and someone else will cover fabrication and installation." The Fairmount Park Art Association itself has often entered into the contract for the construction or fabrication of a project, rather than having the artist do so. This shifts the liability from the artist to the agency.

Other agencies are taking a hard look at how much coverage they really need. For example, an extra $100,000 of liability insurance may effectively double the premium that an artist has to pay and may not really be necessary. An administrator may well ask, "Do we really need $500,000, or will $400,000 be enough?" From the artist's point of view, that may mean $1,000 on a $10,000 total commission—obviously, a significant difference.

Joint ventures between architects and artists are becoming more common. From a legal standpoint, a joint venture is quite similar to a partnership, with the main difference being the more limited scope of purpose. Artists should be aware, though, that some architectural insurance policies exclude joint ventures. Whenever a true joint venture is contemplated, both the artist and the architect should consult with a competent attorney and insurance broker, and set up arrangements which are favorable to both parties.

Does the current liability crisis suggest that the pertinent laws have to change? If the sorts of creative actions outlined above become prevalent, then the problem of high premiums will be minimized and the laws won't necessarily have to change. In other words, if the artist doesn't have to buy open-ended and blanket liability insurance, then he or she may not face ruinous premiums.

That's the good news. The bad news is that if anything happens in the areas

Jody Pinto,
Fingerspan, Fairmount
Park, Philadelphia,
Fairmount Park
Art Association, 1987.
*photo: © Wayne Cozzolino,
1987*

in which artists *are* responsible, they still risk losing all their assets. There is no easy solution in sight. Artists Equity, for example, has researched the problem and has not yet been able to come up with a group liability insurance plan. The American Council for the Arts has been working to update these issues as well. For the time being, artists should voice concerns to their professional service associations.

As a general rule, artists would benefit from a competent insurance broker. For example, some artists find that they are able to obtain adequate coverage through a rider on their homeowner's policy. But again, this is, in part, dependent on the flexibility of the insurance agency involved.

In sum, both agencies and artists should carefully evaluate what is reasonable protection for the short- and long-term, mindful of unnecessary excesses in coverage as well as adequate precautions in the contract for, and in the engineering of, the artwork.

Realizing the vision

"Public art," notes Al Nodal, director of the MacArthur Park public art program in Los Angeles, "is all about human relations." Human relations in the public art context is an immensely challenging process. It involves not only systems of communication, but also the manner in which people communicate. It entails clear definitions of roles, lines of authority, and accountability, but also demands flexibility and a willingness to improvise. At still other junctures, it may involve confrontation or compromise. It is not enough (although it is crucial) to articulate a common goal. Participants must agree to it. The players in the public art process must also be willing to help each other understand the particular knowledge each holds (and lacks) about art, engineering, community interests, and so on. They must also help each other see how these particular skills can contribute to the overall process.

Judith Simonian works in the presence of interested onlookers on a matching pair of tiled pyramids created for the MacArthur Park Public Art Program in Los Angeles. The pyramids are connected by an underground speaking tube. During on-site fabrication or installation, discussion with the artist is an effective way for community members, construction crews, and project managers to learn about the artist's process and intent. Commissioned by the Otis Art Institute of the Parsons School of Design, 1985.
photo: Dianne Jackson

"It takes someone with vision and power to make the difference between whether or not a project happens according to its potential. It's a funny hybrid position; you sit at the confluence of all these different and often competing concerns. You manage communications and interpret the issues for each of the participants. You have to have a very strong point of view and no point of view; if you don't listen to others, you'll never be able to invent anything of interest."

Patricia Fuller, public art consultant

From this, it is evident that many of the responsibilities of these processes fall to the public art coordinator. Edison said that genius was 10 percent inspiration and 90 percent perspiration. While those who are most effective in public art management are often blessed with innate talents in human relations, these qualities are difficult to instruct and are honed through experience. A brief summary of the key role of the public art coordinator is in order (see also Guidelines for Implementation Section: Project Management). What are the skills and qualities required to steer a project to fruition? Speaking broadly, they are:

— an understanding of the artistic vision, and a commitment to carry that vision through to realization;
— an understanding of the interests of all players;
— the organizational skills to anticipate and plan for likely outcomes;
— the ability to implement complex "layers" of schedules, budgets, and programmatic elements.

In this next section, we examine some selected pitfalls and problems that can arise in the implementation phase.

Fabrication and installation

What is the sequence of activities from the design of the artwork to its installation, and who takes responsibility for them?

To a certain extent, the answer to this two-part question evolves with each project. The AOTL Action List is a chart prepared as an administrative tool for the Arts On The Line project. It defines in detail a sequence of tasks, and where responsibilities for those tasks lie. Pallas Lombardi offers a number of annotations to this "action list."

First, pertaining to specifications for site preparation and installation (step 3), she suggests that the artist's proposed artwork should be included in the architect's final design drawings, and that that document be supplied to the contractors who bid on the job. Assuming that the artist's specifications are comprehensive enough, contractors are then able to build accurate cost estimates for site preparation, fabrication (if applicable), and installation into their bids.

Regarding technical requirements of fabrication (step 11), Lombardi points out that no individual administrator is an expert in the technical aspects of fabrication across the broad spectrum of artistic media. To a certain extent, therefore, the administrator is dependent upon the knowledge of the artist in the fabrication phase. However, it may prove helpful for the artist to consult with an engineer before fabrication begins, to identify and head off possible technical problems. This is particularly true if the artist has any doubts about safety issues, the capacities of a given material, and so on.

See AOTL Action List, Appendix.

Sam Gilliam, *Davis with
a D*, Davis Square
subway station, Somer-
ville, Massachusetts,
Massachusetts Bay
Transportation Authority
and Cambridge Arts
Council, 1983.
photo: Cymie Payne

And finally, regarding on-site fabrication or installation (steps 21-25),
Lombardi offers a blunt warning:

"Administrators and artists should not be naive. An artist (or his or her crew)
will *not* be allowed to work on a union job. Although I tried many times to
convince unions of the specialness and needs of the artists to do their own
installation, the unions forced the client and contractor to provide union
labor to work under the artist's direction."

Administrators and artists are sometimes tempted to postpone the installa-
tion of artwork until union workers are off the job, thereby protecting a
budget which may not have anticipated installation at union scale. When
art is integral to a building structure or landscape, though, such delays are
impractical. In many cases, moreover, the artist is a subcontractor to the
general contractor, and is therefore required to complete his or her work
within the contractor's timeframe. The delaying tactic may also generate
additional expenses for the artist, such as the rental of specialized
equipment, and make a project economically impractical. Again, as Lombardi
indicates, it's extremely difficult to persuade union workers that on-
site preparation and installation of an artwork is so specialized that it falls
outside their competence.

In the case of Arts On The Line, many artists chose not to do installation
themselves and benefited greatly (especially in financial terms) by
having the contractor assign the work to his appropriate subcontractor.
Joyce Kozloff's tile wall installation was executed by a subcontractor and
supervised by Kozloff and her assistants. The cost of installation
was not deducted from her art budget, since the general contractor had
bid the job expecting to have his subcontractor install such a tile
wall.

Some earlier contract negotiations between Arts On The Line and general
contractors were not as successful. At the Davis Square station, for
example, the contractor reduced the station art allowance of $125,000 by
approximately $25,000 (or 20 percent) to cover costs of installation, thereby
affecting all the artworks. Sam Gilliam's *Davis with a D* wall sculpture had
moving parts deleted as a consequence, and Jack Gregory had to reduce
the number of tiles in his work. James Tyler found, to his dismay, that he
had to do additional work prior to installation, because the contractor (who
was paid $2,000 to set the foundations for the artwork) did not follow
specifications precisely enough.

The solution settled upon by AOTL and the MBTA is to *plan ahead*: to
build enough money into the budget for union installation and to put very
specific clauses into the contractor's and artist's contracts which govern the
delivery and installation phases. Contracts specify, for example, that the
project budget must include separate line items for site preparation and

Elyn Zimmerman,
Terrain, detail of garden
and plaza for corporate
conference facility, O'Hare
International Center,
Chicago, 1986.

installation of the art, as well as the art allowance. Moreover, the MBTA, AOTL, and the project artist now work together to identify highly motivated union laborers who would work well under the artist's supervision.

One artist's observations:

Other obstacles unique to environmentally-oriented public artworks are described by artist Elyn Zimmerman.

"The artist working in public art," she notes, "is dependent on an army of people contributing different expertise and labor." The artist may have difficulty understanding the language and methods of the architect, electrician, water engineer, or bureaucrat, but must be willing to trust (or confront) when areas of disagreement arise. For example, when a contractor translated construction drawings for one of Zimmerman's works incorrectly and poured concrete in an area only half the size specified, the artist held firm. She insisted that the mistake was not hers, and the concrete area was eventually repoured at the subcontractor's expense.

Aesthetic decisions, Zimmerman emphasizes, are often best made by the artist once he or she is on site. This may be impractical or impossible when the artist must depend upon subcontractors who, in turn, must observe tight schedules and use heavy equipment judiciously. Even if on-the-spot decisions are possible, she cautions, they aren't always satisfying. In many cases, they must be made immediately, with no chance of subsequent reversal. This may make the artist feel *less* in control of events, rather than more.

Collaboration: artists and architects

Given the various social and aesthetic trends outlined in the introduction to this workbook, it was only natural that many artists should begin to focus on places, rather than objects, as a vehicle for artistic expression. Successful collaborations in the distant past—like those of Renaissance Italy—have provided inspiration for contemporary practitioners in both fields. "Plop Art" (the object on the plaza) subsided as artists were increasingly injected into new realms, some of which had previously been the exclusive preserve of architects. The result, in some cases, has been antagonism and frustration; but in others, genuine and productive collaborations between artists and architects have occurred. Following are a few examples of such productive collaborations.

The Seattle Arts Commission is generally credited with being the first to explore the use of design teams on contemporary public art projects. The now famous Viewlands-Hoffman electrical substation was Seattle's earliest collaborative project, completed in 1979. It was architect Richard Hobbs

See "Artists and the Visual Definition of Cities: the Experience of Seattle," *Insights/On Sites*, Bibliography.

94

who suggested that artists selected through the percent for art program be included in the design phase, along with the architectural team. There was, at that point, no clear idea how this collaborative process would work —and, in fact, problems arose with differences in language and approach. Artists preferred that concepts be left open to change, while the architects' blueprint approach was more pragmatically inclined. But persistence, patience, and a collective willingness to invest additional time paid off and resulted in a whimsical and humanized substation, with electrical components color-coded in bright pastel colors, artist-created warning signs, and a whirlygig compound created by two Washington naive artists.

The waterfront plaza of the World Financial Center, in Manhattan's Battery Park City, is the result of a large-scale collaboration begun in 1983 between artists Scott Burton and Siah Armajani and architect Cesar Pelli. The site is within Battery Park City and was developed by the Battery Park City Authority, a public-benefit corporation created by the New York state legislature. Richard Kahan, then chairman of the authority, explained in a *New York Times* article (9/22/85) how the notion of an artist/ architect collaboration evolved:

"We started with a very serious dissatisfaction with the kinds of public spaces that architects had been designing. We wanted to do better. As we began to look through slides of outdoor sculpture, we felt equally dissatisfied not with the sculpture itself, but with the positioning of it, with the process, with something that said that an architect designs a space, then says, 'I want something over there 30 feet high and red, and probably friendly, because this is a big public project.' We found something as wrong with that as we did with the spaces themselves.

"Victor Ganz, the chairman of our art committee, spent the summer in Italy, and when he came back he said, 'Why can't we have spaces like those 16th century piazzas in Italy?'

"We began to think, who designed those spaces that we like so much? Were they artists? Were they architects? What was Alberti, what was Bramante, what was Michelangelo? You can argue both ways; I'm not here to debate whether architecture is the mother art or that those people were sculptors and painters who also happened to be architects as a secondary undertaking. But the point was that it was one human being approaching a problem and not two disciplines arguing, fighting over turf, with the artist clearly relegated to the inferior position by the architect—at least in this century.

"Our first intention was to have artists design these spaces and have architects provide technical support. We went to Cesar Pelli, the architect for our project, and we said, 'Scott Burton and Siah Armajani are going to

design the plaza in front of your office buildings.' He said, 'Never! I am an artist. I don't need artists in this space.' But we were going to have this experiment of ours. It was, in fact, public property and money, for that plaza was public. Pelli said, 'I think you're dead wrong, but I'm going to do everything in my power to prove you right.' He admitted later that his point of view was architecture, their's was art. They felt it differently. They walked on the site and dealt with the human experience differently, they had different objectives. They suggested alternatives that he had never considered, and he came back with others. He is now a proselyte on behalf of these collaborations."

Both of these projects embody a genuine collaboration, one in which a fusion of the artists' and designers' ideas is realized in a result where the individual contributions of each team member are not readily apparent. In other cases, as in the project for the National Oceanic and Atmospheric Administration in Seattle, five artists and an architectural firm *cooperated* on a project. They supported each other's ideas and worked toward a whole, which still retained individual artistic and design statements.

The questions of when to take a collaborative approach and how to form a team have been addressed in an earlier section (see Guidelines for Implementation Section: Artist Selection Procedures). To examine how the actual collaborative process has worked in several Seattle projects, see "Artists on Design Teams," included in this section. The article is a thoughtful presentation of many of the key issues of collaboration: attitudinal and procedural, aesthetic, and technological.

The following section summarizes the advantages and inherent difficulties of collaboration as currently perceived by professionals in the field.

Advantages and difficulties with collaboration

The most important advantage is in the end result. As architect George Suyama noted in an issue of *Private Visions, Public Spaces*, "A successful collaboration provides a context for design professionals and others to do work that transcends and dissolves the boundaries between their disciplines in a way that produces a product that could not have been conceived of individually . . . an alloy, a melting together of different materials to develop something that has a greater strength than any of the ingredients alone."

An artist's different way of viewing things can affect the direction and tone of a project. For the architect, a collaboration represents a chance to step outside the rigid boundaries of a discipline. Architect Cesar Pelli commented on the Battery Park City collaboration: "What Scott [Burton] and Siah [Armajani] proposed was unlike what an architect would have proposed.

For more detail on the collaborative process in this project, see also "The Chemistry of Collaboration: An Architect's View," *Insights/On Sites*, Bibliography.

World Financial Center at Battery Park City, New York City

See Bibliography

See *Five Artists at NOAA*, Bibliography.

Reprinted by permission of the Seattle Arts Commission from *Seattle Arts*, November 1983.

ARTISTS ON DESIGN TEAMS

The Art in Public Places program was established by a City ordinance which sets aside 1% of City project capital improvement funds for the purchase, commissioning and installation of artworks in City-owned public places. Where feasible, the funds are used to include artists on design teams for City construction projects.

by Nancy Joseph

You are driving on Fremont Avenue in North Seattle when something unusual catches your eye. First you notice the colors—unexpected bright pastels. Then you notice the playful forest of whirligigs twirling in the breeze. You now realize that what you are viewing is an electrical substation, and that the colorful shapes which caught your eye are transformers. Or, perhaps you are walking along Broadway on Capitol Hill and come upon a couple testing their dancing skills on a set of bronze "dancesteps" which are embedded in the sidewalk. These and other site-related artworks are appearing all over the city, largely due to the involvement of artists early in the design phase of the City of Seattle's construction projects. Artists Andrew Keating, Buster Simpson and Sherry Markovitz were brought in to work on the design of the colorful Viewland-Hoffman electrical substation, along with the project architects, engineers and landscape architects when the project began. Jack Mackie was the artist-member of the design team for the Broadway Local Improvement District (LID) Project, the purpose of the project being to improve the street and adjacent pedestrian areas of Broadway. Including artists in the design process meant that they had the opportunity to affect the tone and direction of the project rather than just respond to it after the construction was completed.

Design teams are not familiar territory for most artists. They generally design, modify and construct their artworks without the input of others. The team concept is not new to architects, however. They regularly work with engineers and landscape architects, pooling their skills for a more successful product. Still, the word "team" can mean different things to different people, and the degree of integration of the various disciplines involved inevitably varies from project to project. Whether the result is a true collaboration, in which the team's voice stands out and individual contributions are not clearly defined, or is a product of cooperation, in which individual voices are recognized but are related to one another, the team approach enhances the resulting work. Bringing an artist into the team, with concerns that differ from those of the other members, adds to the possibilities for the project. As Barbara Swift, a landscape architect who worked with artist Jon Gierlich on the design phase of the West Seattle Bridge project, points out, adding the art element in the design phase of a construction project is "like adding one more spice into the curry; it really makes it a lot richer."

Jon Gierlich likes to point out that the union of a variety of disciplines is not a new idea. "We were integrated—the artist, engineer, architect—for thousands of years, and then all of a sudden in the last 150 years we've been disenfranchised. I don't understand how we could have a cultural memory so short."

Richard Hobbs of Hobbs/Fukui/Davison architects agrees that artists should be an integral part of the design process, and was the first architect to include artists on the design team for a City of Seattle construction project (Viewland-Hoffman Substation) from the beginning of the project. He did not see this inclusion as being particularly bold or unusual, although it was to have a major effect on the way artist involvement in construction projects is handled. As Hobbs explains the reasons for including artists early, "When we were selected by City Light we were told that artists will be involved in the project at some point, because the project qualified for 1% for

> "To make a really successful design team work, you need a basic philosophy that says it's the quality of the idea, not the author of it, that's the most important thing."
>
> Gerald Hansmire

Jack Mackie's bronze dancesteps can be found at eight locations along Broadway on Capitol Hill. Each set of steps teaches a different dance step, including the tango, foxtrot, rhumba and busstop.

Art funds, I mentioned to Bob Bishop (City Light architect) that the way we work is, that if you're going to work with somebody on a project you bring them in at the beginning, before anything is there and before anybody has preconceived ideas. That seemed very realistic to us. We thought, 'If that's the process we use, why not do it with this?'" The resulting Viewland-Hoffman Substation won several design awards, and although Hobbs admits that there were some trying times during the design process, he considers the Viewlands "probably one of the most satisfying projects I've ever been involved with. It's one of the most challenging things we've done."

When Hobbs was looking for artists for the design team, his primary concern was that the artists be "conceptual, not just surface-treatment artists." The ability to conceptualize is important when an artist joins the design process at the beginning of the project, since many options are open and the only guides for direction are the site and the audience. The artist has the chance to enrich the site through artwork, and help the audience see more than it might have thought was there. The viewer who explores "Viewlands," where color accentuates the bold forms of the transformers and whirligigs emphasize the power of the wind, may never have given substations

a thought, or a look, before. Similarly, at the new headquarters of the National Oceanic and Atmospheric Administration (NOAA) at Sand Point, George Trakas wanted to provide access to the water, and to encourage viewers to experience the interaction of land and water in a new way. As one of five artists to create works for the site, Trakas designed and built a multi-level arc-shaped wood and steel "dock" along the shores of Lake Washington. One of the objectives in his work is to "address the needs of the public: access, availability. These issues are always a tool."

Trakas' artwork is subtle, and yet very effective. The alteration of a site does not

have to be dominating to be successful. It is the design team's responsibility to discern the needs of the audience and fulfill those needs, and often the most spectacular approach is not the most successful. As Gerald Hansmire, the architect for the Broadway LID explains, a truly successful project "may end up looking very much like something you've seen before, but does it really produce in the same way?" He finds that many art and architecture critics look at a project "for its uniqueness as an image, as opposed to its uniqueness in the way it functions, and people who are highly design and ego motivated get their strokes from that praise (of the work) as a unique item

which is identified with just them, and not from the fact that it might be a neat idea, and the neat idea is not to be very extraordinary."

To subsume one's own ego to create a work that is the product of group thought is no mean feat. That ability is necessary, however, for a team process to be effective. Hansmire believes that "to make a really successful design team work, you need to have a basic philosophy that says it's the quality of the idea, not the author of it, that's most important." He recognizes that "to sustain yourself as an architect or an artist, a lot of times you have to have a

very strong individual ego to put up with all the stuff you go through to get where you are. A lot of people who are very good at their given profession wouldn't make a good team component on a design team. They just don't know how to work that way." Artist Andrew Keating agrees that some people are not meant for the design team approach, but sees the cause as lack of confidence. "A lot of times people who aren't confident come on more egotistically and are more defensive. I think it takes a lot of confidence for someone to collaborate. You have to be confident to allow your vision to be subsumed or joined with somebody else's."

In most cases, even design team members who are open to the challenge of the team approach feel the need to carve out

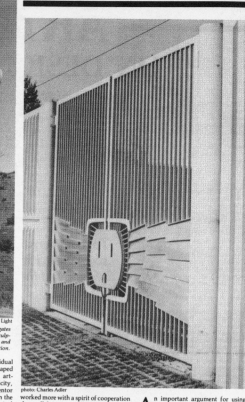

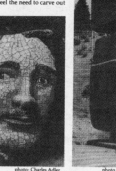

photo: Charles Adler

photo courtesy of Seattle City Light

Artworks at the Creston-Nelson Substation share an electrical theme, and include gates designed by Merrily Tompkins and fabricated by Clair Colquitt; an 'electrical abuse' sculpture by Clair Colquitt; and a bust of inventor Nikola Tesla designed by Clair Colquitt and fabricated by Merrily Tompkins. Works by Ries Niemi are also included at the substation.

an individual niche for themselves in the project. Sometimes the process of "defining one's turf" happens unconsciously, while other times it is a very deliberate action. Andrew Keating wishes that at the start of a project "the whole thing could be an open book" with everyone sitting down to discuss how they can, as a group, design the best work possible, but doubts that is entirely possible. He has found that in the beginning, "people are all jockeying to determine what areas are going to be their own. It seems like at the beginning it's always a process of defining what the artist is going to take on." His teammate, Buster Simpson, points out that, at least on substation projects, some areas really are more difficult than others to share. "You're asking for a lot of trouble when you go into the (transformer) yard itself, because it's engineers' territory and everything there is pretty straightforward." He adds that "it's really sacred ground when you consider the fact that these guys are dealing with 127,000 volts."

The three artists who joined the design team for another electrical substation project, Creston-Nelson Substation in South Seattle, spoke at length with the artists on the first substation design team and decided to approach their project differently. Artist Clair Colquitt, who worked with artists Merrily Tompkins and Ries Niemi, explains that they decided "nothing was going to go on inside 'tech land.' There's going to be a place for the artists to work and a place for everyone else to work and they shall not collide, so that we won't have to deal with the politics on that level. . . . If you're going to give and take art inside the substation walls, you are always going to run up against both management and labor and everybody on every level, so we stayed out and smoothed our road." The resulting design is an artwork path, winding up a small hill on the out-

side of the substation, with individual sculptures placed in lightbulb-shaped clearings along the path. All the artworks share the theme of electricity, from a four-foot-tall bust of inventor Nikola Tesla, an important figure in the history of electricity, to an "electrical abuse" sculpture which teaches, with humor, about the use and abuse of electrical connections.

It is clear that the definition of the word "team" varies depending on the people involved. While the Creston-Nelson artists created individual sculptures, the overall design of an "electrical path" was planned through a group design process. In addition, Colquitt designed the head of Tesla which Tompkins constructed, and Tompkins designed a gate which Colquitt constructed. In staying clear of the architect's and engineer's areas and creating their own works, the artists

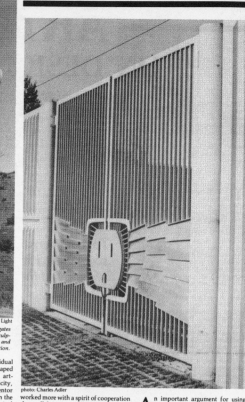

photo: Charles Adler

worked more with a spirit of cooperation than collaboration, still benefiting from the input of other team members.

In contrast to the Creston approach, Jack Mackie worked very closely with the architects and engineers on the Broadway LID project. He considers the bronze dancesteps, which formally bear his authorship, a product of group thought. "The idea is not mine, it's the team's, but it came through me. It was the team's idea to do things in regard to pedestrians. The architect looked at how to make people move in one fashion, the traffic engineer was doing it with people and with cars and with movement, I was doing it in another form of movement. We're all talking about the same thing."

An important argument for using design teams on construction projects is that team members' skills complement one another, technically as well as conceptually. In some situations, the artist's opportunity to use the technical expertise of other team members has had a significant effect on their work. Artist Paul Marioni, when designing a cast glass wall for the lobby of the North Police Precinct Station which is currently under construction, received assistance from the project's architectural firm, Shavey Degrasse Shavey. Architect Larry Yuan calculated what would be the best curve for the wall, taking measurements, using a computer, and then using personal judgment. Marioni is very pleased with the results. "He worked out a very beautiful curve for the wall. I don't think that was particularly his responsibility—I think it was something he wanted to do."

Carolyn Law, who is currently working on a design team for the expansion of the Broad Street Substation, has found the expertise of City Light engineers, and particularly engineer George Deleau, invaluable. In designing a complex fence for the station, she faced many technical questions which were out of her realm of knowledge. She went to City Light for technical advice, and got emotional support as well. She describes City Light, her client for this project, as "more than willing to help. They did troubleshooting at the beginning (for engineering problems), and were very generous in lending me their time and expertise. They were good at clarifying what their desires were in terms of art being a part of the project and how important it was to them. . . . They were always accessible.

Emotional as well as technical support

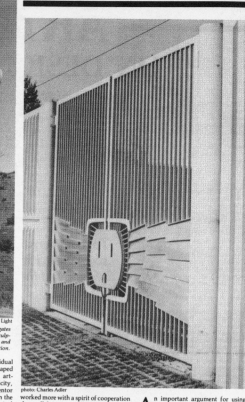

photo courtesy of NOAA, © Colleen Chartier

George Trakas's wood and steel artwork, "Berth Haven," hugs the shore of Lake Washington at the National Oceanic and Atmospheric Administration's (NOAA) Sand Point headquarters.

> *"When you hire an artist for a design team process, it's different every time. We're the random element. Let's hope we remain the random element because that's what they're hiring us for."* —Buster Simpson

is essential for a design team project to work well, whether one's strongest supporter is the client, architect or other artists on the design team. Barbara Swift believes that "it helps for the artist to have somebody who is a real advocate, or have access to some kind of support," and finds that the willingness of the client to be open minded is also a great help. "The attitude on the part of the client's representative is really important. If, in the West Seattle Bridge design project, Bruce Wasell (Seattle Engineering Department Project Manager) hadn't had that kind of attitude of being willing to leave avenues open, opportunities would have been really closed down to just about 'zip'."

Often, artists get their strongest encouragement from other artists, since they can easily understand each other's needs and problems. Chuck Greening, who has worked with other artists on several projects including the Meridian Archway in Wallingford and the sundial at Gasworks Park, considers the emotional support artists supply each other one of the best things about working together. "You're sharing this tremendous responsibility and there's so much to do and think about, that if you spread that out, you'll find that people do want to share it." Another benefit is that "it's sometimes really helpful to get another opinion, have someone point out a visual relationship that might be missing. It's more fun."

Artists' sharing of ideas with each other is particularly important on a design team project because it gives them the opportunity to clarify and refine their plans before presenting them to the full design team. The other members of the team view the artists as a unified group, so even if each artist has a different viewpoint, they need to come to some agreement before presenting their ideas to the team. Clair Colquitt considered the communication and agreement between the Creston-Nelson artists to be an essential ingredient in retaining the respect of the rest of the team. As he describes their approach, "Before every meeting, we met among ourselves so we could present a unified front. You don't want to come into a meeting with a bunch of architects saying, 'I hadn't thought about that.' You come in swinging, with a big pile of ideas and they're kind of flabbergasted and pretty soon they come to expect it and respect it."

In the same way that artists depend on each other for constructive criticism, they also find the other members of the design team to be a great "sounding board" for their ideas. On the Broadway LID project, Jack Mackie found it reassuring that none of his ideas would be presented to the public until the team had discussed them. "They made me verify that I knew what I was talking about conceptually, and why. It had to clear the design team before it would get out the door." For Carolyn Law, the design team was her toughest audience. She felt at times that they were more "stubborn" than constructively critical, but in hindsight she views their doubting attitude as valuable in strengthening her own confidence in her idea. Her response to their questions was to "go back over my designs again and again. In a way it had its plusses because there was a certain point when I had to say, 'Listen, I've thought about the design a thousand times, I've decided that this is the way to resolve it and you're just going to have to go with it,' and honestly could say that because I had really done my research."

Due to the unique makeup of each design team, the experience will always be different. Whether the team is very supportive or somewhat critical, whether the project involves one artist or a team of artists, the only certainty is that the process will not be easy. This is mainly due to the fact that architects,

artists, engineers and landscape architects all work differently, and though they may all be open to working as a team, there are inherently some "bumps in the road." For artists, the first difference they see when they join a design team is that, since artists have not been a part of the team process until recently, they have to figure out where they fit in. As Andrew Keating explains, "When you go into it, the architect's role is defined, the landscape architect, engineer and other consultants as well. The artists are really in such a pivotal position but also totally at the bottom of the ladder and there's nothing really defined about the role." Buster Simpson considers that lack of definition the most important quality for the artist on the design team. "We're the random element.

This view of the Viewland-Hoffman Substation shows the whirligig compound and Andrew Keating's mural along the substation's back wall. Also shown are one of Keating's danger signs for the substation, and a detail of one of the whirligigs created by Emil and Veva Gehrke. Sherry Markovitz and Buster Simpson also were artist members of the design team.

Let's hope we remain the random element because that's what they're hiring us for."

Besides the difference in role definition, there are important differences in working methods. The language of artists and architects is different. Architects use blueprints, while for artists, a sketch of their proposed design is often sufficient. Buster Simpson says that the Viewland architects "turned us around on a lot of procedural things—the way to communicate for one thing, the way to present ideas. It was a learning process. They have a whole way of going about it and we came in on their process, so we

had a quick learning of how things had to be dealt with." Many artists involved in design teams have found architects' need to see things in a familiar format frustrating. The artists on the Creston-Nelson Substation were getting little reaction from the design team when they brought in their drawings, until they decided to make their drawings look like blueprints. "Just plain drawings on blueprint had a much greater effect than if they were on regular paper. We thought at first, 'We can't do this, it would be much too cynical.' But it worked!" Andrew Keating does not believe that artists should necessarily yield to the architect's request to have the designs presented to the team in an architectural format. "I feel it's important to not necessarily give it to them in their own terms because then you're saying, 'Well, you people can't grow and change; the artist has to do all the changing,' and if it's a collaboration, both have to." Architect

Gerald Hansmire agrees with Keating. "Your mechanical engineer doesn't produce presentation drawings either, but architects have learned to work with that. And they could learn to work with it with an artist too." Keating does feel, however, that just as he would like architects to read his drawings as he produces them, it is the artist's responsibility to understand the architect's language. "Their language is so specific and so necessary and so much a part of their process that you really do have to be able to understand how to read a blueprint and just know what's going on on that level."

On the North Police Precinct Project, good communication was made a priority from the very start. Architect Merch DeGrasse had Paul Marioni visit his firm

call the artist and tell him about this. This little change in slope is probably going to effect the character of his design.' It builds them into the whole communication system." The Viewland-Hoffman Substation team did have consistency in terms of who was involved, and architect Richard Hobbs prepared and sent team members memos on every meeting so they had a summary of what had happened. The consistency and documentation were helpful.

Good communication is essential to a design team, and understanding the "language" of other team members is only part of the communication process. Equally important is maintaining a consistent group of people on the team and making sure that they are all informed when any changes are made. It is important for everyone to know who to contact if information needs to be passed along. If that information chain is broken, problems can develop. During the design phase of the Broad Street project, Carolyn Law found that she was "having meetings with different people (from the architecture firm) all the time." The result was that her connections with any one architect were unclear, and changes were being made in the architectural design without her being informed of them. "As you get down to trying to tighten up your ideas for the project, those little (changes) can really throw you for a loop if they get decided when you're not there." As Barbara Swift notes, "the earlier the person gets on the project, the more chance there is that the architect or whoever else is involved is going to start to say, 'I should

and make a presentation to his staff, not about the project, but about himself and his work, just to acquaint the artist and the staff. Marioni believes that that initial visit was valuable because "then everybody was comfortable talking to me. They got a hint of my personality, they saw what kinds of things I'd done and that I liked experimenting and was willing to take a chance."

More options are available to the artist who is part of the team during the early design stages, before the architects must finalize their plans. The artist who comes in later has less opportunity to have work integrated into the architectural design, and the integration of the disciplines is one of the goals of the design team process. Just developing initial concepts is time-consuming; the more time the team has to share ideas, the better. Gerald Hansmire stresses that team members must be "willing to search for ideas. It sometimes takes patience." Once an idea is adopted, time is needed "so you can measure if it's a good decision, otherwise you tend to go in this direction for a while and that direction for a while and never focus in." When more than one artist is involved in a project, extra time is needed so that the artists can become acquainted. When the Viewlands team was initially formed, Andrew Keating found that "they approached us (artists) as if we were a united front, yet none of us had ever worked together. We really didn't even

Paul Marioni's cast glass wall for the lobby of the North Police Precinct will be installed in 1984. Architect Merch Degrasse added a lobby skylight to provide light for the work.

know each other that well. So we were feeling each other out, and then they were feeling us out."

The approach to scheduling is another difference between artists and architects. Architects, because they work with engineers and contractors, must finalize their plans early, and follow formal schedules for the various phases of the design process. Artists are used to having the freedom to change their ideas as they go along, particularly if they are constructing their work themselves. "When it's finalized on paper for an architect, that's how it is going to be in the end," says Jack Mackie. "When it hits paper for me, it's a guarantee that it's going to change, and perhaps radically, before it hits final." Sometimes artists must finalize their plans early if they are going to integrate their work with the rest of the team's design. It requires, says Andrew Keating, "a certain kind of planning that artists aren't used to." Still, he points out, not all freedom to make changes is lost when a design is finalized. His approach would now be to "get approval for the concept and to keep refining it. The artist has to be able to find a way to tie something down that still allows him to maintain some freedom."

An issue particularly important for artists to recognize, in terms of finalizing their designs, is that when working with architects, engineers

with ideas when the architects were finalizing their designs. They were not familiar enough with the architectural process to realize that as the architects finalized their plans, the artists were losing the option of integrating their work into the architect's design. Keating recalls, "They had all these schematic design development, construction design—all these phases that were completely new to us, and it seemed to us that everything could be done at the last minute." Richard Hobbs remembers that "the artists came up with lots of ideas: we plastered the walls with ideas. But we had a schedule to maintain and a budget to maintain. We each had our way of working and were trying to put two definite directions of approach together. It took us time to find a way to make the two approaches work." The Viewland-Hoffman Substation was the first design team project, and artists have since been given a brief introduction to the restrictions and scheduling details of a design team process before they join design teams.

Liza Halvorsen's raku tile mural covers the walls and front desk of the South Police Precinct lobby. She also designed and fabricated brick tiles for the building's exterior walls and steps.

Artists may have trouble finalizing their designs when they join a design team because they are not used to the opportunity to work with a "clean slate." Since they do not have the restrictions of an already designed site, imaginations may run wild. Buster Simpson remembers his artist-team being "like kids in a candy shop. We went in there, 'Wow, the sky's the limit. Let's go for it.'" They soon found that too many ideas are as bad as too few; they were still coming up

and contractors, late changes in the artwork design are complicated and will cost money. "It is important for an artist to understand how complicated it becomes on a public job to make a change. A change in cost is involved, and the architect's approval and the arts approval and the contractor's estimate of what that will cost," says Gerald Hansmire. He is quick to add, however, that his personal philosophy is that although "that kind of thing is a hassle," when changes are important to the artist it shouldn't be viewed as "a limitation or reason for not doing it." The expense of making changes becomes more of a problem when an artist comes into the process late, as with Jon Gierlich on the West Seattle Bridge design project. "Any change I made was going to cost and they were at budget. I could have petitioned to make changes, but it was made clear that everything I do that alters anything they've done is going to cost money." As a result, Gierlich had to work with many limitations.

On the positive side, when an artist is able to coordinate designs with the rest of the design team, there is the possibility of sharing budgets and creating a stronger piece. Carolyn Law has found, in designing the fencing for the Broad Street Substation, that "because my work is so integrated into the project, there's a huge overlap of budget. Since I'm replacing one whole section of fence, it's a question of whether it's just materials that overlap or materials and labor that overlap and so forth. But City Light is going beyond that. They've said they'd be willing to come up with more than the overlap of materials if necessary to do the job." The same sort of generosity with budget, to ensure the best result, was found on other projects, with the architect offering to cover certain costs. At the South Police Precinct, the architects, Arai/Jackson, offered to cover the cost of having a tile setter install the raku tiles created by artist Liza Halvorsen, so that she could in turn use her budget to produce more tiles. In the case of Paul Marioni's glass wall at the North Police Precinct, the architect says that "initially it was going to be straight and flat even though I wanted a curve in it, but I couldn't with my budget come up with the steelwork and the reinforcing for it because I was already extending myself to the limit on the glass casting. The architect liked the idea of putting the curve into it and thought it would enhance it, so he agreed to take that out of his budget."

Another approach to sharing budgets is exemplified by Clair Colquitt's construction of large steel gates for the entrance to the Creston-Nelson Substation. He was able to fabricate the gates less expensively than a regular contractor, and yet have them be a unique product, rather than traditional gates. The cost of

the artist-designed gates was covered entirely by the construction budget, rather than the '1% for Art' budget, because gates for the substation had been included as a necessary item in the construction budget from the start.

There are great opportunities as well as difficulties inherent in including artists on design teams for construction projects. For architects, artists present a fresh viewpoint. For artists, the design team provides the opportunity to approach an overall site rather than be restricted to a specific area. Artists on design teams have to learn a new "language," as well as learn how to focus on specific ideas earlier than they do in their private work. The learning process, and the necessity to be open to having other team members criticize one's ideas, can be difficult. Andrew Keating finds that "when you finish a project that big, you put all that stuff behind you and forget, and truthfully, the pain was enormous sometimes. There were times when it seemed like it was impossible to do anything, like . . . you were trapped." Buster Simpson, having worked on several design teams, offers several pieces of advice to artists joining design teams. "Before saying too much, go in there and check things out. There's something about looking like a hungry puppy dog that scares people in the professions. It's good to get clear with yourself first what you want and get really focused on it, and then work out with them how to go about achieving it." His final comment, which reinforces his view of the artist as the "random element" on the team, is this: "Don't make a profession out of this. It's good to go back into your own little studio—research laboratory—and recharge yourself, or else we (artists) will establish another profession ourselves which will in turn produce norms which we are trying to denormalize."

November 1983
Design & Production: Nancy Joseph

Seattle Arts

305 Harrison
Seattle, WA 98109
(206) 625-4223

Seattle Arts is the newsletter of the Seattle Arts Commission, an agency of the City of Seattle. It is published monthly and mailed by request free of charge. Permission is not required to reprint articles found in *Seattle Arts* as long as proper credit is given.

City of Seattle: Charles Royer, Mayor

Commissioners: Shawn Wong, Chair; Carol Washington, Vice-Chair; Wayne Barclay, Russel Barsh, Joan Ross Bloedel, Tom Dunn, Anne Gerber, Sibyl James, Sherry Markovitz, John A. Moga, Joyce Moty, Robert Ohashi, Alberto Rafols, Linda Spoerl, Barbara Alston Swift.

Staff: K. Diann Shope, Acting Director; Richard Andrews, Art in Public Places Coordinator; Lyn Kartiganer, Art in Public Places Project Manager; Barbara Thomas, Artists-in-Residence Coordinator; Daphne Enslow Bell, Public Information; Francine Feuerman, Nancy Joseph, Nancy Duncan, Steven Huss, Program Assistants.

(The Seattle Arts Commission is a City of Seattle Department consisting of 15 policymaking volunteers appointed by the Mayor and confirmed by the City Council, and a professional staff working together to "promote and encourage public programs to further the development and public awareness of and interest in the fine and performing arts in Seattle." This year the Commission will allocate approximately $692,000 in program funds and will complete artwork projects for public places funded at almost $275,000 by 1% for Art funds.)

See *Insights/On Sites*, Bibliography.

"There may be a certain recalcitrance on the part of design professionals if they feel their turf is being invaded. Therefore, the clarity with which the collaboration is conceived is key to establishing constructive working relationships. On a rather prosaic level, for instance, the design professional's fee should account for the time spent assisting the artist. On a loftier level, those architects not already embracing the notion of integrated art projects need to be made aware of the historical precedents and the potential for artwork to add a significant level of meaning to their building."

Paul Broches, architect

Sculptors work within a cultural tradition that draws on different sets of ideas, forms, and attitudes that did not come from an architectural tradition. Even when they used architectural elements, they used them as no architect would. I am not saying their choices were good or bad; they were part of a different tradition."

By incorporating the artist's thinking early on in the design process, there is greater potential for a variety of creative solutions and for art which is integrated into the design of a site. In addition, the art budget can often go farther through coordination with the contractor's standard processes (such as site preparation), access to equipment, materials, and labor.

Clear impediments to successful collaborations exist—impediments of knowledge, attitude, and practicality—and must be recognized:

There is a divergence in training, knowledge, and methodology between artists and designers, which can cause confusion, frustration, unwanted compromises, and a slowed-down process. Each partner must learn as much as possible about the language and approach of the other's work and respect those differences for their positive contributions to the process. Again, however, such a learning process takes time.

Egos may be threatened, as collaboration presents a specter of loss of control and the compromise of personal vision. In discussing his role on one aspect of the Battery Park City project, artist Ned Smyth conceded that "a collaborative relationship means giving up some of your power." Few professionals are entirely willing to abandon preconceived notions (especially successful notions) of end results and to begin a collaborative process with a mental "clean slate."

Artists and architects alike complain about "forced marriages" arranged by sponsoring agencies. Agencies need to think carefully about team-member selection processes and strive for a basic compatibility in terms of philosophy, aesthetic, and personality.

The process of collaboration taxes the time, energy, and financial resources of artists, architects, and the administering agency. All parties considering collaboration must first evaluate their commitment to the process, given these unusual demands. If possible, the agency should be prepared to compensate for extra time. Artists and architects, for their part, must still recognize that the nature of collaboration may lead to unexpected expansion of the anticipated time commitment.

Recent successful artist/architect collaborations raise a paradoxical question. Will these prominent model projects be overidealized and tempt agencies, artists, and architects to mimic them for all ongoing projects rather than experiment with different concepts for commissioning public art?

A key first question for consideration is: In terms of *this specific project*, is a design team approach appropriate? Clearly, some projects don't lend themselves to collaboration. Does this one, given its budget, timeframe, known participants, and goals?

When the collaborative approach is chosen, an implicit imperative is that every collaborative effort must be allowed to find its own dynamic, challenges, and creative possibilities. It is different and more difficult than a *cooperative* working relationship between two professionals—artist and architect. A collaboration which is no more than the restatement of a fad or trend defeats its own purposes.

On balance, it seems that many projects *can* benefit from a collaborative approach. It seems, too, that collaborations can help the larger master plans that shape the broad patterns of our communities. Collaborations require basic and important discussions about the very nature and value of public art in relation to the crucial issues of public spaces.

Protecting the integrity of artwork and artist

Throughout the preceding sections, special attention has been paid to artists' concerns and rights. In the Proposal Section, for example, agencies were cautioned to refrain from imposing their own preconceived notions on the artist. It was also suggested that the public art coordinator provide assistance to the artist with the proposal in order to troubleshoot budgetary, technical, and other potential weak points.

Similarly, the Contracts Section addressed issues of responsibility in terms of the artist's anticipated participation in the project and certain legal protections such as copyright, insurance and indemnification.

But cases abound which illustrate that a good contract isn't necessarily an ironclad guarantee that the artist will be treated fairly and professionally, or that the artistic concept will be protected from internal or external assaults. The commissioning agency must understand the importance of its actions and its continuing responsibility to the *artist* throughout the complex process of bringing a public artwork to successful completion. Again—as in previous sections—the pivotal role of the coordinator is emphasized.

See "How Public Art Becomes a Political Hot Potato," Bibliography.

Nevertheless, as artist Robert Irwin recounts in a 1986 article in *ARTnews*, some of those same administrators seem to create haphazard procedures or suffer from inadequate knowledge about the making of art. As a result, they wind up placing unrealistic demands on the artist.

Often, the problems are technical in nature and may at first strike the project coordinator as inconsequential. Only later do they emerge as having

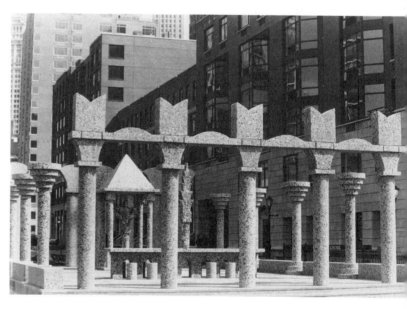

Ned Smyth, *The Upper Room*, Battery Park City, New York City, Battery Park City Authority, 1987.
photo: Devin Mann

See Bibliography.

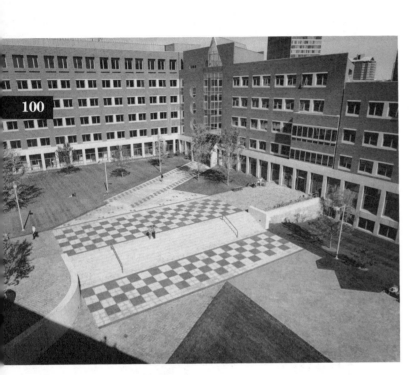

100

Richard Fleischner,
granite inlay and stairway
for site of the Jacob
Wiesner Building,
Massachusetts Institute of
Technology, Cambridge,
1985.
photo: ©1985 Steve Rosenthal

a tremendous impact on the artist's ability to realize his or her vision. Richard Fleischner made this point in *Artists and Architects Collaborate*, describing the artists/architect collaboration on the Wiesner Building at the Massachusetts Institute of Technology: "In MIT's Buildings and Grounds [department], there are people who probably control more of the look of MIT than any architect. They send the people out to water the grass and shovel the snow. There was once an amazing discussion. Down in New York at a meeting [in the architect's office], there was this argument again that [Fleischner's proposed] steps couldn't work. Why not? 'Because how will we shovel them in winter? We don't have the manpower.'"

Defining what is reasonable, in terms of the logistical aspects of public artworks, is necessarily an ongoing process. It is also a balancing act, which must protect the artist's concept and also acknowledge the sorts of operational considerations to which Fleischner refers.

A recent case involving Chicago-based artist Irene Siegel provides yet another perspective on the vulnerability of the artistic vision. Siegel was one of three Illinois artists commissioned in 1985 to work on a newly constructed regional library in Ravenswood, a suburb of Chicago. Her fresco, which draws upon themes from Virgil's *Aeneid*, covers the walls of one of the building's meeting rooms. Although preliminary sketches for the fresco were approved by a distinguished review panel (including arts professionals and a community representative), neighborhood residents began expressing their disapproval of Siegel's work as soon as she began to create the fresco murals on the library walls. "This was a work that should never have gone up," complained one local activist. "We are not telling artists how to live their lives, but there was no community involvement in this. The city doesn't seem to care what we think in the neighborhood."

The community was equally demonstrative in its rejection of the artwork itself, likening it to the graffiti generated by street gangs—a perceived menace which was then becoming increasingly visible in the Ravenswood community.

James Futris, chairman of the percent for art program in Chicago which administered the project and head of the panel which selected the library artists, ascribed some of the controversy to the fact that Siegel had to create her work in the library itself—and therefore in the public eye. As he commented to one reporter, "It's a little vulnerable, wouldn't you say? Tasting a cake before it's baked?"

"Our fear," said one of the panelists who approved Siegel's original sketches, "is that people will try to stop the work before it's finished. The [selection] process was followed to the letter. The main thing I'm concerned about is artistic expression."

Forced to reassess its selection procedures, the percent for art program essentially stood behind its panel and process, making minor changes. The community's reaction was evaluated as premature—the completed area of the fresco measured only four square feet and the controversy reflected the feelings of only a small and politically motivated group within the community. Siegel, it should be noted, was allowed to continue work on the mural.

The following, then, are several guiding principles for achieving a fruitful relationship between artists and administrators—one which promotes integrity in both process and final results:

— Artists are hired for their professional contributions and should be treated with the same measure of respect afforded architects, engineers, and other professionals. In practical terms, this requires the allocation of sufficient time, information, and financial resources and demands continuing respect for both creative ideas and process;

— Artists are part of the general public. They are responsible citizens who care about the life of a neighborhood or city. Administrators should guard against controversies which degenerate into us-versus-them standoffs;

— Increasingly, artists are interested in helping to solve the problem of designing sensitive public places. Not surprisingly, they can play various roles in the public art process. They may act as catalysts, advisors, planners, jurors, and designers, as well as object-makers;

— Public art coordinators should serve artists as their advocates as well as serving their agencies as administrators. In so doing, they must understand how bureaucratic and political processes—not to mention construction, public reaction, and budget constraints—can come to bear on the artistic process. Having helped to identify artistic visions of integrity and enduring value, the commissioning agency and the original sanctioning and funding bodies must defend those visions vigorously. In some cases, the commissioning agency may have to work to change unproductive processes and laws;

— Administrators have to recognize controversy as a potential element of *any* public process—including public art. The challenge is to manage controversy in a fair and constructive manner.

Community education and involvement are all too often employed as *defensive* maneuvers in response to public outcry against a particular artwork. By all accounts, this is too restrictive a use of these key tools.

"If this is public art, it's in the public trust. You set up this very careful system. One: You want the highest quality. You're asking intelligent artists to make work. Two: It's a free democracy. There has to be a sense of *responsibility*. The system for selecting public art has to ensure excellence and freedom, but also guarantee responsibility of statement on the part of the artist. It's as simple and as complicated as that."

George Segal, artist

The following section examines community awareness about art on a number of levels. It suggests how education may be used to channel and limit public controversy. It also explains how a commitment to education, as a normal aspect of the public art process, is essential to the well-being of public artworks over both the short and long terms.

Andrew Leicester's, *Prospect V-III*, memorial to coal miners on the campus of Frostburg State College, Frostburg, Maryland, is a testament to effective community involvement. The work consists of a series of small cottages each representing important points in a miner's life. Leicester worked closely with people in the community to understand the particular dreams, losses, and achievements of miners and to portray them through symbols and objects. In the Infant Miner's Room, a cradle in the form of a coal cart set on tracks leads down to the shaft; the tracks hinting at the social forces in a mining community that determine an individual's fate; the butterflies metamorphose into black lungs. Work clothes hang from the ceiling of the Rotunda on pulleys, the way miners used to dry them after a long day in the wet mines.

An attempt was made by an art committee to stop the project because of the death-related imagery, but miners forced the project to proceed. Commissioned by the Maryland State Arts Council, 1982.
photo: Bruce Peterson

"The very notion of public art is somewhat a contradiction in terms. In it, we join two words whose meanings are, in some way, antithetical. We recognize "art" in the 20th century as the individual inquiry of the sculptor or painter, the epitome of self-assertion. To that, we join "public", a reference to the collective, the social order, self-negation. Hence, we link the private and the public in a single concept or object from which we expect both coherence and integrity. This is no idle or curious problem but is central to an issue that has plagued public art in modern times: the estrangement of the public for whose benefit the artwork has been placed. "

● See Appendix.

Certainly, not all public art alienates the public. However, this introduction to Jerry Allen's article, "How Art Becomes Public", ● leads to a series of complex and provocative questions about the relationship of public art to public and vice versa. How is public art defined? By its placement? In terms of its audience? By its expression of social values or images?

This section begins by encouraging an exploration of these questions, keying on Allen's article and the five tentative conclusions he offers about making the meeting of public and art a "constructive engagement." Collectively, these conclusions argue for a program of community involvement, information, and education. The remainder of this section sketches several model programs that afford the public various ways to participate in, react to, and learn about public art.

Ways to participate

The merits of involving community members in the process of developing public art projects has been a theme which recurs throughout this book. Most successful public art programs, such as the National Oceanic and Atmospheric Administration's project and Arts On The Line (see Guidelines for Implementation: Artist Selection Procedures Section) develop productive ways of involving local citizens, the artist community, and special interest groups in the public art process. A closer look at some other examples will illustrate these methods.

MacArthur Park

A public art project for MacArthur Park in Los Angeles is an example which holds the community in a position central to the development of public art created expressly for the site. In 1983, Al Nodal was hired by the Otis Art Institute of the Parsons School of Design in part to devise a means of introducing public art to MacArthur Park, a deteriorating and crime-ridden 32-acre park adjacent to the school and close to downtown Los Angeles. Like the Westlake district around it, MacArthur Park had

once been a showpiece, but had decayed badly over several decades. The initial impulse was simply to use art and design to improve the park for the benefit of the students and as a gesture to the neighborhood. Maybe art could improve the park, and then, perhaps, the park could improve the neighborhood.

Rather than act independently, Nodal believed that Otis had a "moral responsibility to produce [the proposed program] in an atmosphere of mutual understanding with the public." However, no ready mechanism for joint participation existed, so the MacArthur Park Community Council, a committee of local businessmen, representatives of the parks and police deparments, and members of the city council was formed to foster neighborhood involvement in and leadership for the project. The council focused first on immediate needs of improving safety and the park's overall cleanliness, but soon became an advocate for the public art program as a symbol of change for the community. A plan was created for a four-part program of temporary and permanent artworks, design improvement, performing arts, and the community council.

Eleven artists were selected by a panel of art professionals representing local and national experience. The panel stipulated that the mix of artists should reflect the rich ethnic mix of the Westlake neighborhood. The selected artists began their involvement by spending two weeks in residence at the Park Plaza Hotel, next to the park, and met with the MacArthur Park Community Council, local organizations, and individuals.

In general, the artists' resulting proposals emphasized positive aspects of the park's history, topography, and community; in particular, the multi-cultural and elderly populations in the vicinity of the park. Many of the artworks have a functional component, providing seating and lighting, and all make the park more inviting for use. At the same time, many of the works contain strong aesthetic, political, or social statements which are of particular relevance to the surrounding community, such as Luis Jimenez's *Border Crossing*, which depicts a border crossing by illegal aliens or Alexis Smith's *Monuments*, which refers back to the 1930s, a time of glory for the park.

An important lesson of MacArthur Park is that the community played an integral role in shaping the course of the park's revitalization. Enactment of a public art program catalyzed action on broader issues of concern. As a result, public constituencies feel invested in both the artwork and the broader improvements made to the neighborhood. This sense of invest-ment greatly increases the odds that the public artwork—and the park which hosts it—will succeed and endure.

Douglas Hollis and Richard Turner, *A Garden of Voices*, sculptural bench with speakers for poetry broadcasts, MacArthur Park, Los Angeles, 1986. *photo: Dennis Keeley*

Arts On The Line

To underscore the value of conscientious and thoughtful ways to involve the community in a public art process, we will again cite the example of the Arts On the Line (AOTL) program. AOTL is only one aspect of a broader policy of the Massachusetts Bay Transportation Authority (MBTA), whereby citizens in affected neighborhoods around Boston have had the opportunity to influence the planning, design, and construction of two major subway reconstruction and extension projects.

According to the MBTA, there are many benefits which result from an effective community outreach program:

— "Experience has shown that feelings of ownership reduce vandalism in public spaces, thereby tending to prolong the life of capital investments. The art program's involvement has helped develop a neighborhood's personal identification with transit stations;

— "Public education programs not only inform the community about public art and how to be part of the decision-making process, but also encourage artists to participate in the program;

— "The positive approach of Arts On The Line public programs stress the positive aspects of subway construction and help mitigate its negative and disruptive consequences;

— "Education projects, especially those involving film, writing, and publicity help contribute to the documentation of the process, which is useful to the program itself and its replication elsewhere."

Ways to be informed

The development of opportunities for meaningful dialogue among artists, project planners, and a community is perhaps the most effective way to build trust and cooperation, and to inform the community about a public art program or project. But head-to-head meetings have their limitations, since they generally reach and influence only the direct participants and need to be organized around specific communities. To have a broader impact in the community, it is important to employ a range of methods, including media relations, events, and special programs.

Events and programs

The Sacramento Metropolitan Arts Commission developed in 1982 a six-week sculpture festival, Sculpture Sacramento, to increase awareness of its newly established percent for art program. Its goal was to demonstrate the range of public sculpture through temporary installations as the percent program got underway. The arts commission commissioned ten installations and unveiled them with a media campaign which encouraged public

Alexis Smith, bronze suitcase with quote from Raymond Chandler, MacArthur Park, Los Angeles, 1986.
photo: Dennis Keeley

television to air programs on sculpture. It provided lecturers for community groups and helped arts organizations to screen films on related subjects. The campaign was effective in increasing awareness and anticipation for the planned public art program.

In Cambridge, the Temporary Art Program played a prominent role in the evolution of the Arts On The Line program before completed stations or finished permanent artworks were available for public view. Merchants in affected areas were concerned that potential customers might be driven away by construction-related noise, grime, and temporary barriers. Moreover, it was clear that commuters would suffer through disruptions of their normal routes, habits, and schedules. The Temporary Art Program was designed to mitigate some of these negative impacts of large-scale subway construction projects.

The Temporary Art projects largely reflected the impressive technologies of subway construction. For example, an open competition called Words from Below was held to select writers who would describe the subway construction experience, with the resulting articles published in local newspapers. Photographers were commissioned to document the construction process, and their work appeared on local television stations.

The media

Most people become informed about public art in their community through the media. But sponsoring agencies often regard the media with anxiety. To many, media coverage of public art seems characterized by an excess of controversy-engendering headlines and a paucity of insightful art criticism. The media respond that public art projects are news because they are supported by taxpayers' dollars, inhabit popular public spaces, and are often disliked by those who encounter them. For the program administrator, the key question is how can one interact with the media in ways that help the public develop an awareness and appreciation of public art in a positive light?

The following section examines the role that the media might play and offers suggestions from experienced arts administrators as well as from media representatives.

Engage the media at every stage

Too often, it is not until a public artwork is installed that the media is informed of the project. Consider the advantages of the opposite approach. When Isamu Noguchi was commissioned to create an homage to Benjamin Franklin for the city of Philadelphia, the *Philadelphia Inquirer's* architecture writer, Tom Hine, was invited by the Fairmount Park Art Association (which had commissioned the work) to follow the process from

Claes Oldenburg's *The Clothespin* is frequently included in the Philadelphia media as an easily adaptable graphic symbol as well as a symbol of the city's public art collection.

Commissioned by the National Land Investment Corporation and the Philadelphia Redevelopment Authority, 1976.
photo: courtesy of Office of the City Representative

"It's better not to ambush people with art, sneak it in at night. Arts administrators should not view themselves as the guardians of civilization, fighting off the emotional responses of the barbarians."

Tom Hine, *architecture writer*

"The media are susceptible to events or pseudo-events. So if the artist is going to be in town, have him walk around the neighborhood and talk about what he sees. That can make a very good TV story."

Tom Hine, *architecture writer*

its inception. Hine conducted interviews with members of the art association, with Noguchi and his engineer and with the fabricators. In all, four articles appeared in the *Inquirer* before the sculpture was even installed. From the art association's point of view, these articles were both thorough and responsible in their presentation of the process of creating public art.

"The fascinating thing," recalls Fairmount Park Art Association executive director Penny Balkin Bach, "was that I knew [Tom Hine] didn't like the sculpture all that much. I understood that after the installation, he was going to publish his critical response to the work; that anything went. And it sure did. However, by the time Tom was ready to do his very critical evaluation of what he saw, a good portion of the public was well prepared to read it and to form their own opinion of the sculpture."

Look at the project with the media's eyes

A second strategy is to identify elements of the project that both journalists and audience will find interesting. This often means staging appropriate events or finding human interest stories. For example, the execution of *Portlandia*, a sculpture by Raymond Kaskey in Portland, Oregon, was chronicled in over 80 local newspaper articles. Barry Johnson, a reporter for *The Oregonian*, credits the ability of Portland's Metropolitan Arts Commission (which commissioned the work) to capitalize on the dramatic elements of the sculpture's conception, fabrication, and installation. It was a national media event when the enormous sculpture was transported down-river to the city and then through the city streets to its perch on architect Michael Graves's Portland Building.

Hine also offers observations on the types of issues which contain inherent public interest value and which may tend to ignite controversies: I don't know what role the media play in all of this. We are essentially a reacting influence. In large part, I decide what I'm going to write based on whether the situation engages me. It doesn't take very many people calling or writing us to get a response of some sort from the media, provided that the situation is interesting. The case of the Admiral Farragut sculpture poses the question, 'Does the public have a right to the real thing, or is a copy good enough?' That's a really interesting issue. And if it's an interesting issue, I'll write about it. That's my role." (For more on Farragut, see Rights and Threats Section.)

The task for the administrator, then, is to strike an elusive balance. It involves identifying the positive, the celebratory, and the inherently exciting aspects of a given public art project and then promoting them. It also involves being prepared, if controversy erupts, to help the media and the public participate in an informed debate.

Raymond Kaskey, *Portlandia*, Portland Building, Portland, Oregon, Metropolitan Arts Commission, 1985.

Junior high school
photography students
photograph Tony
Rosenthal's *Ingathering*
on a Metrorail public art
tour, Miami, Metro-Dade
Art in Public Places.
photo: Colette Stemple

"But art has a history, and artists make art
with an understanding of this history and with
some expectation that the viewer has a
vague knowledge of it as well. You expect people
to look at your work with the eyes you used to
make it. Unfortunately, those are false
assumptions."

Alexis Smith, artist

Make art unavoidable

A third strategy is to make art ubiquitous. As we have seen in previous sections, public art intersects with urban planning, design, private development, transportation systems, and governmental processes. Artists and their work come to bear on people in all sorts of settings: in their neighborhoods, on the subways, and at work. Similarly, the fabrication of contemporary artworks may well involve complex materials and technologies. As some public art becomes less a process of making an object and more of making a place, other types of journalists—in addition to arts writers—have reason to examine it.

It is useful to determine which writers are likely to take a personal interest in a given project and to analyze what their particular "hook" will be. It is also valuable to establish a primary contact who will develop cumulative knowledge about the project. Some administrators caution that it may be necessary to provide background—that is, an informal educational process—to those writers and editorial review boards who are uninitiated in public art (a group which may include even experienced arts writers).

Working with the media is an opportunity for the sponsoring agency to inform the public about public art. But it is only one of several such opportunities. "We will never do our job well enough," notes reporter Barry Johnson of *The Oregonian*, "that you won't have to worry about community education."

A way to learn

As Jerry Allen states in his above-mentioned article, "The process of bridging the gap of understanding between the artist and the public through public education should be a part of every public art project." There is a notable disparity, Allen notes, between how the public envisions art and how artists pursue it. Those members of the public who are less familiar with contemporary art have been conditioned—through the legacy of centuries of monuments with readily accessible symbolism or imagery—to using certain kinds of interpretive tools to approach art. Many are frustrated that contemporary art has diverged from their ability to interpret it. As a whole, Allen concludes reluctantly, the public lacks sensitivity to the art of our time.

A valuable aspect of the education process is to establish links between contemporary art and inherited artistic traditions. "[Contemporary] art has never been promoted as having a history, as being an intellectual discipline, as having a body of knowledge that you can learn about before you make a judgment," artist Alexis Smith says.

The next section recounts how two very different programs—one a percent for art program, and the other a corporate collection—have approached this and other educational challenges.

Metro-Dade Art in Public Places

Metro-Dade Art in Public Places has designed an educational program which strives to place its contemporary public art collection in just such an art historical context. It is also perhaps the most comprehensive approach to education about public art in conjunction with local public schools.

When the program's enabling ordinance was revised in 1983, expenditures were permitted for developing educational programs (as well as for maintaining the public art collection). What evolved was a program which reaches out to students from kindergarten through grade 12, and into the junior college and state university systems.

In brief, the program provides training which enables art teachers to include public art as part of their regular curriculum. Public artworks in Dade County serve as the focal point. Through learning packages supplied to and employed by teachers, Metro-Dade public artworks are put in an art-historical context and are also discussed in terms of their artistic and social qualities.

The specific strategic components of Metro-Dade's educational programs are:

the development of detailed curricula which directly relate to the nature of the artworks in the public art collection. For example, with the guidance of APP staff, college art and humanities staff were asked to participate in the development of the curriculum for the community college humanities course unit on public art. For art teachers in grades K through 12, "learning packages" ⬤ provide informational materials, including prescribed lessons, slides, discussion scripts, and art activities. The objective is to make it as easy as possible for teachers to use the information in the classroom without having to research or compile it themselves;

the institutionalization of this curriculum into teachers' plans. The sanction of school and college administrators causes art in public places to be seen as a valid element of the curriculum, as well as being in keeping with the overall mission of the public school system.

Teachers were generally interested in the program and willing to participate. Official approval of the subject also enabled interested teachers to receive recertification credits by attending a special intensive workshop. Of course, mandated teacher participation was sometimes necessary.

Grades 5 and 6 students' proposals for site-specific sculptures for the South Miami Elementary School.

⬤ See Sample Learning Package, this section.

"We should be careful not to conclude that if people don't like public art, they are not sufficiently educated about art. Neither the teachers nor the students have to like the art."

Joyce Kozloff, artist

See Appendix.

In some cases, teachers had seen controversial media coverage of public art projects and expressed reluctance to teach about a program which had left some taxpayers disgruntled. Others were simply more rigid in their definitions of "art" and excluded much of the public art collection from those definitions. As APP director Cesar Trasobares noted, "At some point, regardless of all these democratic ideas, you need to say, 'Well, if we do it, we have to have everybody's cooperation.' It was not necessarily the most humanistic way of getting at the problem, but it was the only way to get every single teacher to participate."

The philosophy behind Metro-Dade's school program is to begin public art education early in the lives of residents of Dade County and thereby to build a constituency for public art. Within the agency's broader community education program—including activities such as tours, video programs, and publications—the goal is not to generate any particular concensus among the general public about public art, but rather, to achieve an informed "tolerance for and understanding of art that one may not initially like," says Cesar Trasobares. "Education objectives vary from community to community, because each particular audience has its own set of associations and meanings."

A way to react

The apprehension felt by many when they encounter contemporary art sometimes results from a lack of effective tools with which to communicate a response. Others may have the misapprehension that there is only one "right" way to experience art. When the art form doesn't conform to one's existing frame of reference—as indeed, much public art does not—the result can be intimidating.

The education process, therefore, needs to consider the varying degrees of experience that potential viewers have had with art and provide means whereby less experienced viewers can gain both communication tools and confidence in their personal reactions.

Seattle Arts: Ways of seeing

In this educational realm, a specific effort of the Seattle Arts Commission deserves attention. In a 1984 issue of its newsletter, *Seattle Arts*, the commission ran a series of three articles by art educator Joan Loeb. Entitled "Ways of Seeing," Loeb's series coaches the viewer of public art toward personal ways of experiencing art and suggests cognitive and sensory tools by which the viewer can understand that artwork on his or her own terms.

The "system" Loeb describes involves a series of questions which the viewer can ask him- or herself upon encountering a difficult artwork. The

Artist Betye Saar installing On Our Way, Dr. Martin Luther King, Jr. Plaza Metrorail station, Miami, Metro-Dade Art in Public Places, 1986.

SAMPLE
ART IN PUBLIC PLACES LEARNING PACKAGE

METRORAIL STATION

Dr. Martin Luther
King, Jr. Plaza

AREA

The station is the first positive
building statement in the area
after the 1980 riots. Incorpora-
ting a full service daycare center
and parking facility, it is seen as
a hopeful start for community
growth. Joseph Caleb Community
Center vicinity.

PUBLIC ARTWORK

Artwork: "On Our Way" (See Fig. III, p. 12)
Artist" Betye Saar

In the democratic spirit of the late Dr. Martin Luther King,
Jr., the artist has chosen to commemorate the common man by
including randomly selected images of local community members
in her work. The images became the pattern for silhouette
figures of enameled metal installed to mingle with and
reflect the passage of travelers through the Metrorail
station. The human figure is an important element in
Ms. Saar's work as well as color, pattern, texture, beauty,
and mystery. She depicts the energy of people and objects
using abstract shapes and squiggles.

Based in Los Angeles, Betye Saar has received many awards for
her work including two grants from the National Endowment for
the Arts. Her formal training was in California universities
where she now teaches. Her heritage is Black, Irish, and
Indian and much of her work is autobiographical. Since the
late '60's Saar's work has evolved from social and political
statements to the exploration of her personal heritage and
beliefs.

APPLICATION
(RELATED PROJECTS/ART HISTORY/APPRECIATION)

ACTIVITY: Enamel
 + * Collage, Patterning
 + * Collage, Mural

ART HISTORY/APPRECIATION
 Genre painting
 Mark Chagall
 The Elder Peter Brueghel
 Japanese Cloisonee
 French Limoges

REFERENCES: Bates, Kenneth, F., Enameling, (Funk &
Wagnall, New York, 1951.)

Liebman, Oscar. Collage Fundamentals,
Stravon Educational Press, 1979.

Seeler, Margaret. The Art of Enameling,
Von Nostrand Rinehold, Co. 1969.

*Curriculart:

 Level 3-4 Lesson Plan 509-512--Collage
 Level 5-6 Lesson Plan 516, 518, 521--Collage

+ See "Post-Tour Suggestions and Exercises"
* Curriculart - Designed for Dade County Art Education curriculum
grades K-6, contains lessons in all basic media

ADDITIONAL CLASSROOM EXERCISES AND ACTIVITIES
SAMPLES

MURAL

Objective:

 To develop an understanding of shape, patterns,
 rhythm and color as it relates to compositional
 organization in mural design. To promote an
 awareness of how an artist relates his/her work
 and philosophy to the context of a project site.

MOTIVATION/EXPLORATION

To convey Martin Luther King, Jr.'s democratic message of the importance
of the common man Betye Saar chose to relate her artwork, "On Our Way,"
at the Dr. Martin Luther King, Jr. Metrorail station, to the people of
the Liberty City area who were the users of the station. For the
artwork, Saar created patterned silhouettes of people from the neigh-
borhood, whom she drew at a public event held in the community months
prior to the fabrication of the forms. The figures were placed in
the station at stairways, escalators, and large wall panels to reflect
the passage of travelers through the station as they hurry to and
await their trains. Saar added her own symbology to the figures with
the inclusion of a pattern of zigzags, curved forms, and dots that she
uses to express energy. It is the artist's hope that residents will
return to the neighborhood in future years to visit the artwork and see
themselves memorialized.

MATERIALS

Cut and/or colored paper, scissors, paint, markers, brushes and simple
mono-printing tools.

LESSON

1. Children may trace each other on large mural paper or on colored
 paper to be cut out and glued to mural sized paper. Emphasize
 action poses. Discuss shapes--negative and positive, overlapping
 and repeated--to create design rhythms and patterns.

2. Discuss patterning (as related to Saar's squiggles of energy, e.g.,
 happy patterns, color patterns, nervous patterns, etc.), and how
 to create it, e.g., zigzag = energy, horizontal lines = calmness.
 Create a pattern that relates to the pose and 'personality' of
 the people shapes. Relate color to the mood of the pattern.

3. The mood of patterns can also be related to color study. Happy
 colors, sad colors, calm (cool) colors, energy (hot) colors.

ART HISTORY

Discuss the history of WPA murals, the New Deal mural projects in the
U.S. in the thirties, refer to examples of Thomas Hart Benton murals.
Example: "Joplan at the Turn of the Century, 1896-1906."

APPRECIATION

The idea of immortalizing people through portraiture can be explored by
choosing a few examples of self and commissioned portraits, and
discussing how the subjects' personalities and the time periods in
which the portraits were made are captured.

Discuss with students how they are creating history - how their own
lives and work will gain historical relevance with time.

COLLAGE

The mural concept can be expanded through the use of a collage/assemblage
lesson...adding layers of texture and dimensional items to create a more
complete personality interpretation.

CURRICULART

To supplement this lesson, Curriculart, the Dade County Art Education
curriculum unit (designed for grades K-6) contains lessons in all basic
media.

		Level 3-4
Murals	Lesson 215	
	233	5-6
Collage	509-512	3-4
	516, 518, 521	5-6
Printmaking	311	3-4
	522	5-6

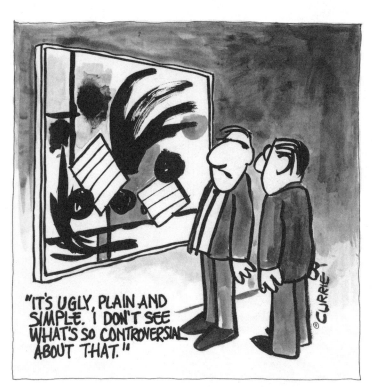

"IT'S UGLY, PLAIN AND SIMPLE. I DON'T SEE WHAT'S SO CONTROVERSIAL ABOUT THAT."

First Bank (Minneapolis) commissions a cartoonist whose work expresses the "employee point of view" about the Bank's art collection. The cartoons accompany every document that employees receive about the art program. Lynne Sowder, who directs the program says, "I think the cartoons are part of the reason people saw our survey and responded to it — because we talked to them in their language."
Cartoon by John Currie, reprinted by permission of First Banks.

goal is to help the viewer explore the mood which the piece creates and to find internal points of reference which he or she can use to relate to the artwork. For example, what does this material (stone) mean to me? How did it affect the way the artist worked? What other artworks that I'm familiar with are made of stone? How does this piece relate to those? Loeb's writing is direct, engaging, and remarkably free of the arts-jargon which can scare off the uninitiated.

First Banks

Another approach is embodied in the education program of First Banks, Minneapolis, whereby employees and visitors to the bank are offered very direct opportunities to react to artwork in the bank's collection.

The bank's philosophy and rationale for collecting contemporary art are explained by Dennis E. Evans, president and chief operating officer:

"At First Banks we believe that in a world where change is the most fundamental phenomenon of life, the stimulating ideas of contemporary artists can deepen and enrich modern business practice. These ideas help us recognize the natural diversity of our world and encourage us to explore our own potential as creative, compassionate, and courageous human beings."

"Lynne Sowder, curator and director of the bank's Visual Arts Program, puts it another way. She says that art is particularly important in conservative institutions, "where there is a tendency for people to put the blinders on. Art is a way of reminding us there's always more than one way of looking at a problem."

First Banks's collection includes only works created since 1980. The bank has been adventurous, progressive, and even aggressive in its acquisitions. From the outset, controversy has accompanied the program. (The first installation was greeted with near-universal hostility, and all of the employees working in its vicinity threatened to resign en masse.)

Recognizing this controversy, the Visual Arts Department has spent considerable time creating educational materials and programs intended to help people understand the artwork in the bank's collection. But the primary goal of these programs is to put less emphasis on the *object*, and greater emphasis on the *process*—that is, how the viewer engages with and reacts to the artwork. Sowder explains: "The object becomes secondary, in the sense that we remove the onus of having to like or dislike it. That doesn't mean, however, we think our [acquisitions] decisions are unimportant."

The educational program has a number of standard educational components, such as interpretive labels, essays, and videotapes to accompany artworks. But these have inherent limitations. "In the workplace," Sowder explains, "the amount of time people will spend accessing the educational information is limited."

As a result of this informal observation, the Visual Arts Department decided to put extra emphasis on surveys and seminars, all of which would concentrate on process, rather than product, recalls Sowder. The survey, ultimately sent to some 3,000 bank employees, asked very direct questions about whether people liked or didn't like the art (and the art program in general), and what they thought about the ongoing educational activities.

The survey "was predicated on a profound fear that I was not hearing my audience because I had never asked them what they wanted to know about the art they didn't understand."

Lynne Sowder, Visual Arts, First Banks

Eric Bainbridge, *DIN-O-SAUR*, 1985. First Banks collection.

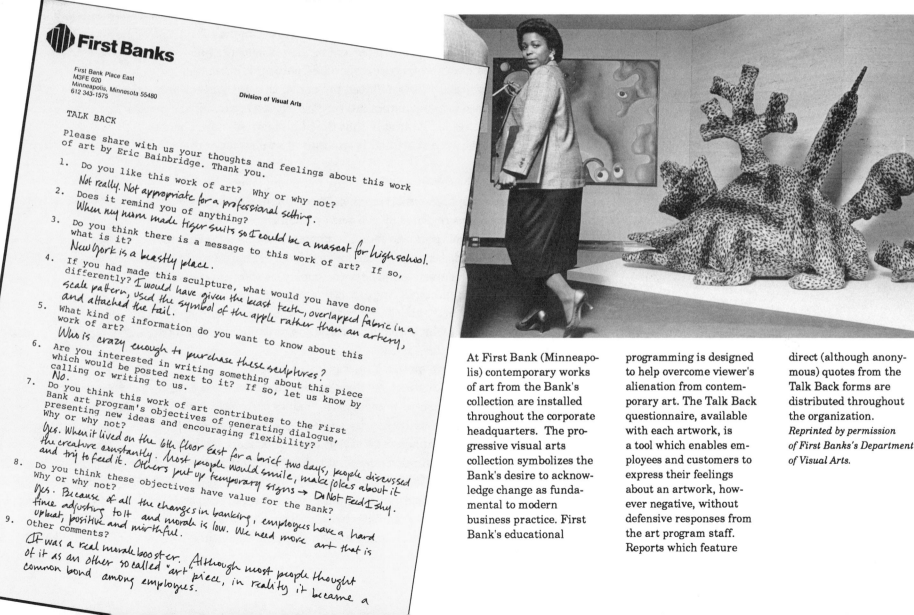

At First Bank (Minneapolis) contemporary works of art from the Bank's collection are installed throughout the corporate headquarters. The progressive visual arts collection symbolizes the Bank's desire to acknowledge change as fundamental to modern business practice. First Bank's educational programming is designed to help overcome viewer's alienation from contemporary art. The Talk Back questionnaire, available with each artwork, is a tool which enables employees and customers to express their feelings about an artwork, however negative, without defensive responses from the art program staff. Reports which feature direct (although anonymous) quotes from the Talk Back forms are distributed throughout the organization.
Reprinted by permission of First Banks's Department of Visual Arts.

The results were predictable, for the most part. By a margin of three to one, recalls Sowder, survey respondents "really hated the kind of art the bank was collecting." Equally telling, many respondents attached multiple pages of vigorous and negative comments about individual artworks.

The results of the survey were quickly made available to the bank's workforce. No effort was made to downplay the overwhelmingly negative feelings of the majority toward the artworks. Nor was any effort made to play up an interesting statistic: that of the 69 percent of survey respondents who didn't like the artworks, almost a third said that the art nevertheless improved the work environment. Thus, a significant group of employees valued the collection as a whole even though they didn't care for the type of art being collected.

Other interesting findings emerged. The Visual Arts program administrators were surprised to learn that 70 percent of the respondents had read didactic labels posted next to the artworks, and 84 percent appreciated having these cards available. This reinforced the notion that the labels were an indispensable device to help viewers interpret provocative art. Finally, 33 percent of the respondents said that they had learned more about art or that their curiosity about art had been aroused as a result of the bank's collection.

The blunt findings of the survey shocked many bank employees. They also surprised many bank administrators, some of whom were concerned that the negative feelings revealed by the survey might force a change in the nature of the art program. In fact, the opposite seems to have happened. The survey provided a "safe" outlet for previously suppressed reactions. Through this relatively simple device, employees were able to work through initial anxieties and misgivings, and the program was not compelled to qualify its aesthetic outlook. Subsequently, a series of seminars was conducted, the goal of which was to continue the dialogue prompted by the survey.

Without a doubt, the survey/seminar project was successful in extending the breadth and depth of the dialogue about art in the workplace.This was demonstrated in numerous ways—letters of support and encouragement sent to the department by bank employees; a greater willingness on the part of employees to accept challenging art in their work areas; and an increased awareness about the role of art in the workplace.

The Visual Arts Program has continued to administer other surveys and invites regular commentary on specific artworks through "Talk Back" questionnaires. Comments are published in the bank's monthly

newspaper. Through the Talk Back program (questionnaires, reports, informal meetings and unrehearsed video sessions), Sowder has learned that it is "the authoritarian mechanisms by which the art arrives in people's lives, not the art itself, which most disturbs our audience." As a result, First Banks has undertaken an even more radical project to "deregulate" the art program through projects like Controversy Corridor (a non-customer contact area which holds works banished by six or more employees), Employee Art Selection (teams of employees selecting works for their work areas), and You Be The Curator (exhibitions of works selected and commented on by employees).

These new programs are designed to further engage the audience by empowering them through direct involvement. "It is the dialogue which is the object," Sowder states, "and only by empowering our audience can we begin to learn about the interrelationships between art, its context, and its audience."

"The key," says Sowder, summarizing First Banks' experience, "is to give the viewers faith in the validity of their own responses, and faith in a process whereby—once they feel empowered—they are willing to begin to learn."

Lynne Sowder, Visual Arts, First Banks

115

The "big picture" is what public art is all about. It cannot be separated from its context, whether physical or social. It can contribute not only to the enhancement of specific public spaces but also to the development of the overall design and character of a community.

When one considers the amazing scope of activities described in the first half of this workbook—including funding, legislative initiatives, inter-agency coordination, artist selection, proposals, contracts, fabrication, installation, and community education—it's clear that art in the public realm demands keen administrative sensibilities and skills. Not only does the public art administrator need to coordinate the work schedules of artist and designer, negotiate contracts, orchestrate community advisory committees, and occasionally counterbalance skepticism or outright hostility on the part of public officials and community members, in addition, he or she must always keep sight of, and act upon, the goals which inspired the program in the first place.

To become too narrowly focused on administrative details can lead to a compromise of programmatic or artistic goals. Certainly, such details are important, even critical. But experimentation—the lifeblood of art—may be sacrificed if one becomes too absorbed in day-to-day bureaucratic detail. The administrative process, therefore, must be kept in perspective. It is a means to an end. The underlying cultural and aesthetic goals of a program should guide all procedural decisions.

The same point holds true once an artwork is completed and in place. While the second half of the book—on the preservation of public art—is presented as a separate subject, there is rarely so neat a distinction in real life.

The policies, processes, and relationships which bring a work into being must also be called upon to preserve that work in its sometimes difficult existence out in the world.

In "The Preservation of Public Art," we will look at specific measures which can be taken to compensate for past damage or programmatic short-comings. But we will also emphasize the planning techniques which, if implemented early enough, will help to effectively protect our artworks from such damage and help them thrive in the public context.

The Preservation of Public Art

118 Introduction

120 Threats and Rights

135 Collection Management

147 Documentation

151 Conservation

163 Review Procedures for Public Artworks

171 Public Education Policy

173 In Closing

"It would be an arrogance for any generation to declare that this object is so sacred that it has a permanent place on earth."

Jerry Allen, public art administrator

"Art is long and life is short. Don't we want to select the best work of our time and break our necks to preserve it?"

George Segal, artist

Public art, as we have already noted, comes in a multitude of conceptual packages. Some of those packages are intended to be temporary. Christo's wrapped environments, for example, aren't intended to endure, except perhaps in photographic documentation or local myth. Guerilla art, street art, and performance art may never exist as objects. They may last for only a few minutes or hours.

But many public artworks are intended to endure. In fact, permanence is often assumed when a public artwork is commissioned. Permanence, obviously, demands preservation. But what is meant by "preservation"?

In the realm of public art, the term preservation must encompass a range of meanings. First, since the essence of public art is its "public-ness" (that is, its physical accessibility to the public), preservation means keeping the work on public display. Second, preservation comprises all those activities related to the physical conservation of the work, which ensure that work's physical well-being. Third, preservation involves the development of promotional and educational efforts which will maintain the work's visibility and meaning in the community, for this and subsequent generations. And finally, preservation means documenting the work, both in view of the historic record and for practical reference concerning the artwork's disposition in the future.

To preserve public art successfully, we must understand the nature of public spaces. We must recognize that change is the only constant in the public, built environment. This is in clear contrast to the protected confines of the museum, where permanence is a reasonable goal. In such a mutable environment, the central questions become: How can we accommodate change? How much change can we accommodate? What kind of "editing" function is appropriate? (Editing can be accomplished by the stray lightening bolt, by the vagaries of public opinion, or by urban redesign.) When public art is funded by public dollars, should the public have input as to the fate of an artwork? And, what are the special concerns for public artworks which are created for a specific site or are physically integral to a building or site?

There are no easy answers to these questions. And many heated debates have occurred around these issues such as the well-known controversy around Richard Serra's *Tilted Arc*. Moreover, very few public art sponsors have engaged them in a systematic way. This lack of systematic investigation necessarily makes the conclusions and suggestions in the remainder of this book—dealing with the preservation of public artworks—more tentative. One fact is clear, however: that the planning stages and the post-installation life of a public artwork are inextricably linked. The approach

taken by administrators and artists in the planning stages has a profound impact on the principles which will subsequently preserve a given artwork.

The following case studies illustrate typical threats to the integrity of existing public artworks. They examine artists' rights, the management of a public art "collection," the development of a formal conservation program, and the relocation and removal of public artworks.

One additional point: the museum model of artwork conservation exists as one of the few tools for developing perspective on the management and care of public art, yet the museum model translates only imperfectly to the public art realm where the regulation of influences is impossible. Yet some conservation principles do translate effectively. For example, public art, like "private" art, should be seen as intrinsically valuable. As artist Elyn Zimmerman puts it, "I often feel as if a distinction is being made between public art and art held by a museum. I don't like that distinction. What if the public were made to feel that the museums had spilled their valuables out into the streets? Would they then be willing to care for the outdoor works?"

In fact, it is only by emphasizing the value of public art in the same terms as more conventional art forms that administrators will attain the high standards of care and preservation which characterize conservation in the museum world. Again, an education process is a key tool and often a prerequisite for success.

Through education, public art can be viewed, correctly, as a respected cultural asset. "By suggesting that contemporary art is linked to work deemed to be of historical value," explains art historian Sam Hunter, "you give the public a sense of continuity. It places contemporary efforts in a serious context, a context that is part of the life of an evolving culture." Thus, education can be seen as a guarantor of preservation—which itself guarantees cultural continuity.

Gerald Walburg, *Indo Arch*,
Sacramento,
Sacramento Metropolitan
Arts Commission,
1977.
photo: Daniel D'Agostini

The sponsoring organization's overriding responsibility—to protect the integrity of the artistic vision—has been emphasized throughout previous sections of this workbook. When an organization initiates and implements a public art program, or even a single project, it must ensure that the "delivery system" defends, rather than distorts or compromises, the artist's intent.

In subsequent pages, protection of artistic intent is reiterated in the context of completed public artworks. Issues covered include:

— owner neglect of the long-term care of public artworks;

— relocation;

— physical alteration (whether from natural causes, human interventions, etc.);

— removal; and

— inadequate project planning with negative post-installation consequences.

This broad range of challenges to the long-term health of public artworks underscores the need for coherent, comprehensive preservation policies and procedures. While systematic, applied efforts in this field are limited, as was noted in the introduction to this section, policies and procedures from the best current programs are included in subsequent sections.

Owner neglect

Who is responsible for the care of public art?

On the face of it, this might seem a simple question to answer. But the involvement of multiple agencies in the public art process can greatly complicate things. One example comes from the Fairmount Park Art Association, in Philadelphia.

"While the Association was in a position to commission numerous works of art over an extended period of time [for the city of Philadelphia]," explains executive director Penny Balkin Bach, "through donation, the city was the owner in the long run. There is often a difference between the patron, the owner, and the agency that has jurisdiction or custodianship over the work. Over the years, as cities, agencies, and public art have evolved, there has been a diffusion of responsibility. . . . In many cases, no one has a proprietary interest in the art except the artist."

Inscape, by Ed McGowin

This problem can be exacerbated by *private* ownership—as is illustrated in the following example: In 1975, a private developer in Washington, D.C., commissioned a prominent Washington-based sculptor, Ed McGowin, to create a sculpture for an office plaza in downtown Washington. The work was

funded half by the developer and half by the National Endowment for the Arts. The application for NEA funding was submitted by a local museum, which served as an "official sponsor" or fiscal agent for work. The result was *Inscape*, a hollow steel sculpture containing a collection of artifacts visible through small windows cut into the face of the sculpture. The objects were lit by neon tubes concealed within.

Inscape was well received as public art, that is, until the evening in 1982 when a thief overcame the supposedly tamper-proof screws which protected the contents of the sculpture. A number of the bronzed objects which made up the tableau were stolen, and the lighting system was destroyed.

No provision was made in the contract for maintenance or restoration of the work. McGowin was willing to repair the work (and made two proposals to donate his time to do so), but a *new* owner of the office building, having no interest in the artwork, focused on relocating the sculpture to a less vulnerable site. The NEA, as a funding source, had no legal involvement in the work and affirmed that the owner of the artwork was implicitly responsible for its acquisitions. The local museum which had participated in the original fundraising effort expressed its willingness to assist—but only to the extent of once again lending its name to fundraising efforts.

Five years after the work was vandalized, it was removed from its site without notice to McGowin by the second owner who had "inherited" the work. Its fate and current whereabouts are unknown as of this writing.

Two issues emerge from this case. They are issues which are central whether an artwork is conceived independently or as part of a percent for art or redevelopment program:

— Responsibility for monitoring and implementing care of the artwork must be clearly defined among the participating groups and the artist's desired role clearly stipulated. This accountability must be supported by an allocation of money and technical resources to cover ongoing maintenance costs and plans for covering extraordinary conservation expenses;

— The problem should be recognized that the responsible agency may not always meet its stated commitments. Absent "moral rights" laws (see Conservation Section), how can the artist be protected against such agency negligence? Can the responsible agency be held accountable for such negligence? And can subsequent owners of a building be held responsible for the care of artworks acquired by previous owners?

121

Ed McGowin, *Inscape,*
Washington, D.C., 1977.

This *New York Times* article and letters to the editor raise issues about the conservation and relocation of public art— in this case, Augustus St. Gaudens' statue of Admiral Farragut from its 105-year post in New York's Madison Square Park. It raises questions such as: Who has the authority to decide the fate of a work of public art? Should artwork created for public display ever be denied that right? What preventative and restorative efforts are possible to save public artworks from irreparable damage? *Reprinted by permission of The New York Times.*

THE NEW YORK TIMES, SATURDAY, MARCH 15, 1986

Put Miss Liberty in the Met, Too?

By Joan K. Davidson

Since July 9, 1776, when New York patriots, on first hearing the Declaration of Independence, pulled down the statue of George III, public sculpture has had the power to move Americans. Now, another statue raises important public issues.

It is the bronze Admiral ("Damn the torpedoes—full speed ahead!") Farragut by Augustus St. Gaudens, a great American 19th century sculptor. This splendid work, commissioned for New York City's Madison Square Park, was unveiled in 1881. The architect Stanford White designed for it a superb stone pedestal-bench, and the two parts together represent a landmark in this nation's sculpture. Farragut, commander of the Union fleet, defeated the Confederate forces in the battle of New Orleans, and the work, like so much sculpture of the period, commemorates the heroism of the Civil War.

Today, the naked base sits forlorn in the park while Farragut travels as the centerpiece of the Metropolitan Museum's St. Gaudens exhibition. On its return to New York in three months, the statue may be added to

To keep Admiral Farragut's statue company

the Met's collection, there to be on view during business hours, at the regular fee. The museum would see to it that a copy is made for the park.

In the museum, the statue, ringed about by railing and guards, would supposedly be safe – rescued from graffiti, bird droppings, vandalism and weather, including acid rain. Museum-goers would enjoy it; scholars would study it against the Met's broad sculpture holdings. And the drafty space of the American Wing's atrium, in need of a monumental work, would have one at last.

Fine! Or is it?

This sculpture belongs to the public – to be seen, touched, leaned against, at any time of day, in every light, season and weather. Free. By what authority can it simply be taken away? The work is the central element of the place, and in the harsh, anonymous city, places with character and some amenity help make life supportable. The place is not some forgotten corner but a charming small park, increasingly used and valued by the growing population of its newly thriving neighborhood, the Flatiron district. Thousands pass through and by this park every day. How could the removal of the sculpture fail to diminish the place?

Not to worry, says the Met. A replica will be there, shining and new – and devoid of the creator's hopes and passion, bearing no witness to the passage of time. But one doubts that a replica honors the democratic vision of a citizenry worthy of the most precious art.

And after Farragut, what? For their own good, why not also sequester the Public Library's lions? City Hall Park's Nathan Hale? Grand Central Terminal's Mercury? Times Square's Father Duffy and George M. Cohan? Fifth Avenue's General Sherman, and Atlas? The Museum of Natural History's Theodore Roosevelt? Central Park's Indian Fighter? Upper Broadway's Giuseppe Verdi? Columbia University's Alma Mater? Harlem's Abraham Lincoln with a black child? The Bronx's Henry Hudson, and General Washington at Valley Forge? Brooklyn's Ulysses S. Grant at Bedford Avenue, and the Soldiers and Sailors Memorial in Grand Army Plaza? Indeed, the Statue of Liberty herself? In the end, the city could be swept clean of the people's art.

With no other way to protect these works their removal might have to be borne. But there is another way. Experts have demonstrated that technology and curatorial skill can now clean, repair, restore and maintain bronze statues.

So the Farragut issue involves not preservation alone but also the meaning of art, the role of institutions and the allocation of public funds. What is the esthetic of public art — to age naturally, acquiring patina, or to remain forever virginal? Shouldn't

great museums serve the cause of public art by training conservators, encouraging inspection of public sculpture at its site, joining environmentalists and other citizens in pressing government to eliminate acid rain and to maintain public spaces? How shall we define the responsibility of public agencies to protect and conserve the common heritage?

And while the discussion goes on, let Admiral Farragut go home to Madison Square Park.

Joan K. Davidson is president of the J.M. Kaplan Fund, which supports the arts and environmentalism in New York, and human rights.

Why Admiral Farragut Needs to Come In From the Park

To the Editor:

Joan K. Davidson's March 15 OpEd article on the prospective move of Augustus St.-Gaudens's statue of Adm. David Farragut from New York City's Madison Square Park to the courtyard of the American Wing in the Metropolitan Museum of Art touched on a very important issue. The well-being of public art in American cities has been ignored and neglected for too long.

The Parks Department and the Central Park Conservancy have struggled to maintain the city's public statuary with limited budgets and private funds. The pollution and vandalism of urban environments are hostile to works of art in stone and bronze. Nineteenth-century stone sculptures displayed outdoors are in such bad condition that many have suffered irreparable damage. Though there are several ways to clean and preserve bronze in outdoor settings, no single one is considered both safe and suitable. The cardinal rule in conservation is reversibility (that is, that any treatment undertaken on a work of art can be undone, leaving no effect). Relocating any statue to an interior space, whether the Metropolitan Museum, City Hall or a sculpture museum — the Bargello in Florence, say — is unequivocally reversible.

Such a course is not unprecedented. It has been followed for Michelangelo's "David" and Donatello's "St. George" in Florence and, most recently, for the horses of San Marco in Venice. These works also once stood in public places, but their artistic merit was deemed important enough for them to be moved indoors, with copies installed in their stead. How would the Italians, or the art-loving citizens of the world, for that matter, have been served if "David" had been left to erode in the Piazza della Signoria?

The "Farragut," St.-Gaudens's first public commission, is one of the greatest works by an American artist.

The success of the monument is the result not only of Farragut's image, but also of the beautifully modeled surface and the decorative details that embellish it. The statue, while in fairly good condition, nevertheless needs to be properly housed. If the day should come when we either clean up our polluted atmosphere or develop a fail-safe method of protection against it, then the "Farragut," (if indeed it were to become a loan from the city to the museum) could be reinstalled in Madison Square Park. Meantime, the cost of a first-rate copy — one that could satisfy the discerning eye of the City Art Commission and the Parks Department — has been pledged by a private donor. It would be erected on the original site of the "Farragut," facing Fifth Avenue at the northwest corner of the park, whence it was moved in the 1930's and set on a copy of Stanford White's pedestal (the original of which had sadly deteriorated).

There are probably only a half-dozen pieces in this city of such unquestionable artistic quality that they must be brought inside. A major effort is needed to preserve the remainder before they require the drastic kind of restoration the Statue of Liberty has undergone. There, the entire torch, the symbol of freedom and hope to

millions, had to be completely replicated because it was past repair.

In this penultimate decade of the 20th century, we have made such remarkable strides in technology that we sometimes find it easy to believe everything can be fixed. Recent events have proved us wrong. Even a work of art is not eternal unless we find a way to hand it down safely to succeeding generations.

LEWIS I. SHARP
New York, March 20, 1986
The writer is curator of American paintings and sculpture at the Metropolitan Museum of Art.

•

To the Editor:

One can only applaud Joan K. Davidson's plea that the Farragut statue by Augustus St.-Gaudens be returned to Madison Square.

Permit me to add a coda to her plea: make certain it goes back to its original site facing Fifth Avenue, south of 25th Street.

For some reason, circa 1936, the statue of the great admiral was moved to its present site in the park's northeast corner, where it was virtually lost. It was meant to face our proudest thoroughfare and parade ground.

HENRY HOPE REED
President, Classical America
New York, March 22, 1986

Relocation

There is ample historical precedent for relocating significant public artworks. Venice copied the horses of San Marco and Florence replicated Michelangelo's *David* so that the originals could be displayed indoors, safe from the weather and the ravages of modern day pollution. The conservation field adheres to the principle which underlies these examples: that the best preservation practices are those which are *reversible*. The relocation of a deteriorating artwork (sometimes replaced by a duplicate at the original site) is one of the few such practices that is entirely reversible.

Admiral Farragut, by Augustus St. Gaudens

The replication/relocation debate was rejoined two years ago in New York City, when the Metropolitan Museum of Art announced its willingness to house Augustus St. Gaudens's monumental *Admiral Farragut*, then on a three-month loan from its home at Madison Square Park for a traveling St. Gaudens exhibition. After the tour, the Met offered to create a privately funded replica of St. Gaudens's masterpiece for the park and to provide permanent shelter to the original. A number of experts declared themselves in favor of the move, citing the pollution-related threats to public artworks of stone and bronze in general and evident deterioration of the Farragut sculpture. But other authorities argued against the plan. Couldn't the same logic be applied, they asked, to relocating the *Statue of Liberty*? "In the end," wrote one, "the city could be swept clean of the people's art."

Following a series of letters to the editor in *The New York Times* advocating that *Farragut* be left in the park, the Parks Department decided to follow the public's wishes and decline the Met's proposal. The public's right to access to the artwork in its original setting won out. The situation calls attention to an issue which may very well surface again with other works. Which is of greater importance—protecting the integrity of the artwork or maintaining access to it by the public for whom it was intended?

The Farragut sculpture also evoked issues pertaining to relocation. Somewhat simultaneous to the Met's offer, the status of the Farragut monument was being reviewed by the Parks Department for another reason. Plans were at hand for the restoration of Madison Square Park to its original appearance. The question arose as to where to site the Farragut sculpture within the park—at its original location in the northwest corner or at its present location to which it had been moved during the WPA era.

While the Parks Department at first favored the idea of moving the sculpture back to its original location, further investigation is causing some

"The experience of an authentic sculpture as opposed to a copy is an important experience. I don't think we should surrender to public delinquency and vandalism by removing original works from the public domain. We must fight it. Each time you give way, something else disappears, and the whole fabric of life begins to disintegrate."

Sam Hunter, art historian

123

rethinking. The archives show that the original place was chosen because the surroundings suitably matched the nobility of the sculpture. It was sited across from a fashionable hotel where many of the intelligentsia gathered, and it overlooked a main street where the sculpture could preside over parades.

In the present day, the site has changed radically. It has lost its elegance, with the older buildings torn down and replaced by warehouses. In addition, busses now idle all day directly in front of where the sculpture used to be. If the monument were relocated there, these recent environmental changes would visually obscure the sculpture as well as expose it to the constant fumes of the busses.

Despite these problems, the Arts Commission of New York City, which makes final decisions on the status of all public artworks funded by the city, feels that the sculpture should be moved back to its original location, thereby restoring the whole park faithfully to its original state.

The Parks Department, as of this writing, is obtaining a formal conservation report to assess the sculpture's current conservation needs as well as the potential long-term effects of the bus fumes. It continues to discuss with the Arts Commission and other arts agencies where *Admiral Farragut* should rightfully stand.

Relocation has come into sharpened focus in the contemporary public art field as well. The controversial case of Richard Serra's *Tilted Arc*—commissioned by the General Services Administration for the Jacob K. Javits Federal Building in lower Manhattan, and the object of a relocation campaign—has become the focal point for discussions concerning the process of relocating a work. ● Despite this concerted attention, however, broad and troubling questions remain open. For example: What are the artist's rights, and what are the public's rights? What happens when those rights conflict (or seem to conflict)? What assumptions are made about the permanence of public art? What are the unique issues arising from a work created for and dependent upon a specific site for its meaning or effect?

● The case of *Tilted Arc* is examined in detail in "Public Art and Public Policy" by Judith H. Balfe and Margaret J.Wyszomirski; see Appendix.

Gwenfritz, by Alexander Calder

Consider the case of Alexander Calder's *Gwenfritz*, a monumental stabile which Calder designed in 1965 specifically for the west terrace of the National Museum of History and Technology. The sculpture—Calder's first major commission in Washington, and one in which he took a special interest—dominated its surroundings for 15 years. Its strongly angular black forms contrasted with and complemented the museum's west facade, and the white reflecting pool which surrounded the sculpture underscored Calder's original conception of the piece as part of a highly

See "Calder: Out of Site,"
The Washington Post,
Bibliography.

energetic landscape. As he described it to a friend: "I wanted great jets
arching as from fire hoses over and in front of the piece and coming from
the pool".

In 1983, however, the Smithsonian Institute decided to erect a recreation
of a 19th-century bandstand on the sculpture site. *Gwenfritz* was
disassembled and moved to a new location on the corner of Constitution
Avenue and 14th Street NW. There, according to the Smithsonian's
press release, the sculpture would "serve more fully as a focal point" and be
"more accessible to visitors."

Calder, of course, had nothing to say on the matter, having died in 1976.
It is not difficult to imagine what he might have said, however. Like Serra's
controversial sculpture in downtown Manhattan, Calder's *Gwenfritz* was
designed for and in response to a specific site. Even if the Smithsonian's
relocation had been an especially sensitive one—and many critics have
argued that it was not—it would still have represented a diminishment of
the work as Calder conceived it.

Clearly, *some* relocations are justified. (Once the decision was made to
construct the Aswan Dam, there were only two possible fates for the
ancient statues at Abu Simbel: relocation or submersion.) But the merits of
other proposed relocations are not so clear-cut, and must be considered
on a case-by-case basis. The *Gwenfritz* example underscores the need for
artist contracts to attempt to anticipate possible future courses of action, as
well as the responsibility of the sponsoring agency to serve as the
artist's advocate, even (and perhaps especially) when the artist is not there
personally to do so.

In the Review Procedures for Public Artworks Section, we will look
more closely at the rights of artists regarding relocation and removal, both
in response to public objections to a work on its site and for reasons of
conservation.

Removal

The removal of public artworks presents unique issues. First, as noted
earlier, the essential and distinctive characteristic of public art is its availa-
bility to the public. With the exception of certain celebrated iconic works
(for example, the *Mona Lisa*), museums have sufficient flexibility to take any
given work out of the public view. But to remove a public artwork from public
display violates an essential quality.

On the other hand, the public environment is constantly changing. This
suggests that there must be some circumstances within which
removal might be appropriate. What are those circumstances? How can
the artist be protected against unjust removal of a given work, either
in response to community pressures or the whims of a capricious owner?

Following are several cases which illustrate these complicated questions. They are useful cautionary tales, with a typical mix of good and bad planning, as well as good and bad circumstances.

Chain Link Maze, by Richard Fleischner

In 1978, Richard Fleischner was commissioned by the University Gallery of the University of Massachusetts at Amherst to create a sixty-foot square chain link maze, to be situated on the campus near the football stadium. The finished work's visual appeal and interactive character helped make it a popular campus attraction. (It became a sort of initiation rite for undergraduates to find one's way in and out again.) But this very popularity threatened the artwork's future. Within eight years of its original commission, the work had become badly dilapidated. In addition to being overused, the work had suffered from the idiosyncrasies of its site. The marshy land upon which it had been constructed tended to heave with repeated freezings and thawings, and many of the work's supporting posts had been thrown up and out of alignment.

The net result was that the maze came to bear little resemblance to the original artwork. At this juncture, the University Gallery asked Fleischner to visit the site to consider what could be done about the work's condition. Initial discussions were not encouraging. Restoration would have meant rebuilding it from scratch—at four times the original commission price. Both sides agreed that the work should be dismantled; the artist offered to donate a small limestone sculpture to the university.

When these decisions were announced to the university community, there was an unexpected outcry from the student population. A number of them organized a Coalition to Save the Maze, which hoped to find a way to restore or replace the artwork. In response to this student-based initiative, the University Gallery met with representatives from Physical Plant to assess the possibility of rebuilding the work using the university's physical plant labor. This time, it was understood, it would be necessary to build a concrete pad for the maze, to avoid the problems created by the shifting ground.

Once again, university officials concluded that they did not have sufficient resources to rebuild the work according to the artist's specifications. At this point, the Gallery met again with Fleischner. He then suggested that the students be encouraged to build their own maze. Such a maze could not, of course, resemble Fleischner's original, but might satisfy the students' demand for an interactive, playful environmental piece. Subsequently, a student competition was held, and a winner was selected by campus-wide committee. The final winning design, yet to be built,

will incorporate leftover chain link from Fleischner's work, as well as painted wood components.

In this case, the integrity of the artwork (and by extension, the artist's reputation) would clearly have been compromised if the artwork had been allowed to stand in poor condition. The sponsoring agency took appropriate action both in contacting the artist and in responding to the campus community's expressed needs. But the case also underscores the need for careful consideration of the long-term impact of decisions made at the commission stage, the decision, for example, to proceed with installation even without a proper concrete base for which funds were not available at the time. The artist's contract, moreover, never spelled out terms for maintenance of the piece. In retrospect, it seems possible that the life of the work could have been extended through preventive maintenance and other measures.

The Lincoln Building murals, by Richard Haas

The need for specific contract language protecting the artist and the artwork—in particular, against infringement by the owner of a building—is underscored in the following case.

Architectural muralist Richard Haas was commissioned by a private developer to create a mural on three sides of a building in Washington, D.C. The building, across from the historic Ford Theater and adjacent to the building in which Abraham Lincoln died, is considered by the National Park Service (NPS) to be of historic significance. The developer proposed to undertake an NPS-sanctioned rehabilitation of the building, thereby earning a preservation tax credit of $412,000.

The mural was to encompass three sides of the building. The north and south faces were to depict different images of Abraham Lincoln, and the east facade (the front of the building) was to be adorned with a decorative architectural illusion. These three elements were conceived of by Haas as constituting a single and complete artwork.

The developer and his architect met with NPS to go over plans for the intended restoration. NPS approved the plan (including the proposed mural) as being in keeping with the historic nature of the building. The Park Service declined an opportunity to review the design of the mural, stating that painted elements were reversible and, therefore, not subject to review. Shortly thereafter, in a letter to NPS, the architect reiterated his understanding of the agreement—a letter to which NPS did not respond. The murals on the building's east and south facade were then executed.

Shortly before the following April 15th tax deadline, NPS informed the developer that final certification for the anticipated tax credit would not be

granted by NPS unless the developer removed the decorative mural
on the front of the building, and also agreed to abandon plans for the still-
incomplete north facade. NPS explained that the murals, with the
exception of the painting on the south wall, were now considered inapprop-
riate for the building and the setting. In response, and in time to meet
the tax deadline, the developer painted over the east facade mural.
As of this writing, the fate of the other elements of the work remains in
limbo.

What lessons can be drawn from this unhappy tale? First, and most
important, we see the consequences of a contract which lacked
specific language limiting the developer's control over the work. The devel-
oper, under externally-imposed deadline pressures with serious
financial implications, had every incentive to sacrifice the mural, and
none to save it.

We can also see the consequences of the lack of a public art coordinator,
empowered to serve as the artist's advocate. A coordinator could have
identified and headed off some of the procedural problems which developed;
for example, insisting on formal, prior approval of the mural designs
from NPS. A coordinator might also have stimulated a useful debate about
the assumed "reversibility" of painted surfaces.

The 12 Labors of Hercules, by Michael Spafford

The Washington State Capitol was constructed in the mid-1920s, and
embodies the ornate architecture unique to public buildings of the
Greco-Roman period. Included in the architect's original design were large
walls of varied configurations designated for "mural paintings." Included
were four large walls for murals in each of the House and Senate
chambers. Lack of funds had prevented the commissioning of the murals
during the building's construction, and, although periodic efforts had
been made over ensuing decades to revive the murals concept, it was not
until 1979 that the state legislature appropriated the necessary funds to
execute them.

With funding finally secured, the Department of General Administration
was asked by the legislature to design and implement an artist selection
process. An open competition was subsequently conducted among
Washington State artists, and the finalists' proposals were reviewed by a
panel consisting of a prominent collector, an artist, an art historian, and a
professor of architecture. Two legislators declined an invitation to
participate in the selection panel meetings, explaining that such decisions
ought to be made by experts.

In due course, two well-respected Washington painters, Michael Spafford
and Alden Mason, were selected to do the murals. Spafford proposed a

Richard Haas, murals on
south and east facades of
the Lincoln Building,
Washington, D.C.,
Wynmark Development
Corporation, 1985 (before
removal of the east facade
mural ornamentation).

highly stylized depiction of the 12 Labors of Hercules, to be executed on
two panels to be placed behind the galleries along the sides of the chamber.
Images of the Fall of Icarus and the Chimera would be placed in the
front and back of the chamber. These designs were reviewed by both the
selection panel and the General Administration and approved with
enthusiasm.

Spafford first completed the two side panels, and those panels were
installed prior to determination of funding which precluded completion of
the remaining two murals. An immediate storm of controversy broke.
Several members of the House labeled the murals "pornographic," citing in
particular a scene of Hercules wrestling with Hyppolita. While these
critics were not immediately successful in their campaign to remove the
works, they did succeed in 1982 in passing a resolution that required the
murals to be concealed by large curtains, installed specifically for that
purpose.

Following a period of calm, the legislature, in 1987, subsequently voted to
remove both the Spafford and Mason artworks, citing incompatability
of the artworks with the proposed decorative surroundings. Both Spafford
and Mason claimed breach of contract, pointing out that the works were
intended as permanent and, in the case of Spafford, were never installed in
their entirety. They further argued that since the works were created for
the particulars of their sites, removing them was tantamount to destroying
them. In ensuing months, a defense fund was set up by members of the
arts community, intended to help Spafford and Mason pursue their breach-
of-contract claim.

The verdict of the courts has been mixed. On the one hand, the contracts
were not specific enough in their language regarding removal and the
legislature was thereby able to remove the murals. On the other hand,
Spafford was awarded damages of $35,000 for the state's fraudulent termi-
nation of his original contract. The judge, notably, went out of his way to
chastise the state for its treatment of the artists, supported the site-specific
argument for the murals, and surrounded his decision with the following
statement: "We cannot tolerate the destruction of art in a free society,"
further stressing the responsibility of the state to hold its works of art in
trust for future generations.

For our purposes, the Spafford and Mason cases underscore two key
questions. First, to what extent can public officials reverse judgments—
especially judgments reached through a careful and approved process—
purely on aesthetic grounds? Second, once a work of art is in existence,
should it be protected from second guessing and requests for alteration which
might have been more properly handled by the artist during the proposal
phase? These are obviously key questions, given the extent to which

CALIFORNIA ART PRESERVATION ACT
Cal. Civ. Code §987 (West Supp. 1985)

§987. PRESERVATION OF WORKS OF ART

(a) Legislative findings and declaration. The Legislature hereby finds and declares that the physical alteration or destruction of fine art, which is an expression of the artist's personality, is detrimental to the artist's reputation, and artists therefore have an interest in protecting their works of fine art against such alteration or destruction; and that there is also a public interest in preserving the integrity of cultural and artistic creations.

(b) Definitions. As used in this section:

(1) "Artist" means the individual or individuals who create a work of fine art.

(2) "Fine art" means an original painting, sculpture, or drawing, or an original work of art in glass, of recognized quality, but shall not include work prepared under contract for commercial use by its purchaser.

(3) "Person" means an individual, partnership, corporation, association or other group, however organized.

(4) "Frame" means to prepare, or cause to be prepared, a work of fine art for display in a manner customarily considered to be appropriate for a work of fine art in the particular medium.

(5) "Restore" means to return, or cause to be returned, a deteriorated or damaged work of fine art as nearly as is feasible to its original state or condition, in accordance with prevailing standards.

(6) "Conserve" means to preserve, or cause to be preserved, a work of fine art by retarding or preventing deterioration or damage through appropriate treatment in accordance with prevailing standards in order to maintain the structural integrity to the fullest extent possible in an unchanging state.

(7) "Commercial use" means fine art created under a work-for-hire arrangement for use in advertising, magazines, newspapers, or other print and electronic media.

(c) Mutilation, alteration or destruction of a work. (1) No person, except an artist who owns and possesses a work of fine art which the artist has created, shall intentionally commit, or authorize the intentional commission of, any physical defacement, mutilation, alteration, or destruction of a work of fine art.

Reprinted from *Art Law*, vol.1, by permission of the authors, Franklin Feldman, Stephen E. Weil, and Susan Duke Biederman.

See "Freeway Mural: A Lady in Waiting," Bibliography.

percent for art programs are funded by cities and states, and are, therefore, subject to political pressure.

Inadequate planning/legal standing

These cases suggest that preventive measures might have alleviated at least some of the problems relating to the disposition of existing public artworks. If, for example, contracts had included explicit terms similar to moral rights laws (covered later in this section) and concerning reasonable and unreasonable cause (and compensation) for relocation, removal, or conservation, then the owners and commissioners of the artworks would almost certainly have been more deliberate and reflective about their actions and the artists would have legal grounds for mediation of disputes. It also seems clear that inadequate community involvement and education programs lessen the likelihood of future acceptance, as in the case of Richard Serra's *Tilted Arc*. The artwork could have been introduced to its plaza (and to the users of that plaza) in a more effective fashion, using an education program to help the community come to terms with a challenging and uncompromising work.

Freeway Lady, by Kent Twitchell

The following case, concerning the murals of Los Angeles, illustrates both the vulnerability of public artworks and the often complicated interplay among four forces: artistic intent, administrative interventions, political realities, and the law. Los Angeles's murals received national attention when ten new highway murals were commissioned as part of the 1984 Olympics art program. But murals are certainly not new to Los Angeles County, which contains over 1,000 outdoor murals. It is one of the pre-Olympics murals which serves as the case in point.

Artist Kent Twitchell painted *Freeway Lady* in 1974, as part of the City-wide Murals Program funded by the county with support from the National Endowment for the Arts. Up until the initiation of the program in the early 1970s, mural painting had largely been confined to East Los Angeles. Program administrators were eager to promote the creation of murals elsewhere in the city. That eagerness is reflected in the imprecise agreements they reached with property owners. "It was tough enough to get people to agree to giving us the buildings," former program director Lukman Glasglow told the *Los Angeles Times* in 1987. "There was not a lot of track record emotionally or visually for people to have their buildings painted. So just getting that done, we feel, was an accomplishment. In retrospect, we blew it by not having safeguards built into that."

Freeway Lady was painted on the side of a commercial building overlooking the Hollywood Freeway. Neither the artist nor the Citywide Murals Program drew up a contract with the building's owners spelling out means of protecting the mural. California's art preservation law specifically excludes artworks which can't be removed from buildings without damage to either the artwork or the building. Therefore, when the building's owners leased the wall surface to an advertising group which, in late 1986, painted over most of *Freeway Lady*, neither artist nor agency had any recourse.

The resulting public outcry only underscored the fact that many of the city's murals are vulnerable both to gradual decay and overnight destruction. No provision was made, for example, for maintenance of the ten highway murals commissioned by the Los Angeles Olympic Organizing Committee and under the authority of Caltrans, the state transportation agency. Currently, individual artists and supportive arts groups are providing stopgap maintenance. The transportation agency has the documented right to destroy any mural which might impede the widening or rebuilding of a highway.

The fact that few public art sponsors plan for comprehensive protection of the artworks they are supporting results, in part, from an understandable preoccupation with getting the job done, that is, overcoming all the various obstacles which can hinder the creation of public art. But this lack of planning for the protection of artwork also results from the sometimes conflicting interests of artists and property owners. Simply put, a building owner may be reluctant to allow the creation of an artwork such as a mural, if the artwork threatens to limit the building owner's rights to demolish, sell, or even remodel the property. But these early challenges, if not confronted, may mean the loss of important cultural assets later.

Alteration

What safeguards exist, or should be created, to protect artists' reputations and the integrity of their creations against unauthorized alteration or destruction?

The unfortunate episode concerning another of Alexander Calder's works illustrates the importance of these questions. In the mid-1950s, the Greater Pittsburgh International Airport commissioned a Calder mobile for its central rotunda. Originally black and white, the mobile was repainted by decision of airport officials in the county's colors of green and yellow. Airport officials also concluded that some elements of the mobile were hanging too close to the ground and added counterweights to elevate the lower elements. Evidently not satisfied with the intermittent movements of the

California Art Preservation Act, *continued from page 130*

(2) In addition to the prohibitions contained in paragraph (1), no person who frames, conserves, or restores a work of fine art shall commit, or authorize the commission of, any physical defacement, mutilation, alteration, or destruction of a work of fine art by any act constituting gross negligence. For purposes of this section, the term "gross negligence" shall mean the exercise of so slight a degree of care as to justify the belief that there was an indifference to the particular work of fine art.

(d) Authorship. The artist shall retain at all times the right to claim authorship, or, for just and valid reason, to disclaim authorship of his or her work of fine art.

(e) Remedies. To effectuate the rights created by this section, the artist may commence an action to recover or obtain any of the following:

(1) Injuctive relief.

(2) Actual damages.

(3) Punitive damages. In the event that punitive damages are awarded, the court shall, in its discretion, select an organization or organizations engaged in charitable or educational activities involving the fine arts in California to receive such damages.

(4) Reasonable attorneys' and expert witness fees.

(5) Any other relief which the court deems proper.

(f) Determination of recognized quality. In determining whether a work of fine art is of recognized quality, the trier of fact shall rely on the opinions of artists, art dealers, collectors of fine art, curators of art museums, and other persons involved with the creation or marketing of fine art.

(g) Rights and duties. The rights and duties created under this section:

(1) Shall, with respect to the artist, or if any artist is deceased, his heir, legatee, or personal representative, exist until the 50th anniversary of the death of such artist.

(2) Shall exist in addition to any other rights and duties which may now or in the future be applicable.

(3) Except as provided in paragraph (1) of subdivision (h), may not be waived except by an instrument in writing expressly so providing which is signed by the artist.

(h) Removal from building; waiver. (1) If a work of fine art cannot be removed from a building without substantial physical defacement, mutilation, alteration, or destruction of such work, the rights and duties created under this section, unless expressly reserved by an instrument in writing signed by the owner of such building and properly recorded,

shall be deemed waived. Such instrument, if properly recorded, shall be binding on subsequent owners of such building.

(2) If the owner of a building wishes to remove a work of fine art which is a part of such building but which can be removed from the building without a substantial harm to such fine art, and in the course of or after removal, the owner intends to cause or allow the fine art to suffer physical defacement, mutilation, alteration, or destruction, the rights and duties created under this section shall apply unless the owner has diligently attempted without success to notify the artist, or, if the artist is deceased, his heir, legatee, or personal representative, in writing of his intended action affecting the work of fine art, or unless he did provide notice and that person failed within 90 days either to remove the work or to pay for its removal. If such work is removed at the expense of the artist, his heir, legatee, or personal representative, title to such fine art shall pass to that person.

(3) Nothing in this subdivision shall affect the rights of authorship created in subdivision (d) of this section.

(i) Limitation of actions. No action may be maintained to enforce any liability under this section unless brought within three years of the act complained of or one year after discovery of such act, whichever is longer.

(j) Operative date. This section became operative on January 1, 1980, and shall apply to claims based on proscribed acts occurring on or after that date to works of fine art whenever created.

(k) Severability. If any provision of this section or the application thereof to any person or circumstance is held invalid for any reason, such invalidity shall not affect any other provisions or applications of this section which can be effected without the invalid provision or application, and to this end the provisions of this section are severable.

See Bibliography.

mobile, they added a motor and drive system to regularize its motion. And finally, a kiosk covered with advertisements and notices was installed in the open space below the mobile, effectively destroying the mobile's relationship with that space. Unlit and increasingly grimy, the piece was removed in 1978.

The story has a happy ending: After Calder's death, public opinion forced the return of the mobile to its original state and site. But the sequence of events—even including the triumph of public opinion—remains troublesome. In his article "Art and the Law: Moral Rights Comes to New York", Walter Robinson cites this and a number of similar cases. Robinson finds especially disturbing that it is not only vandals who capriciously alter or destroy public artworks; it is all too often the owners of those works who take such liberties.

Such acts of alteration or destruction are not necessarily malicious. (The Pittsburgh airport administrators presumably thought they were acting in the interest of the public.) Nor is it necessarily clear the nature of the relationship between a work and its environment. For example, many artworks are created in response to the character of a particular site. Changes in that site, even if the artwork remains undisturbed, may impinge significantly on the original artistic intent (as with the Farragut sculpture described previously). And, of course, the constant flux and shifting usage of public spaces sometimes necessitates the relocation of a given work.

In cases of site-specific works, does unauthorized relocation constitute a "destruction" of the artwork?

These cases and questions underscore a primary responsibility shared by the public art administrator and the artist. They must build legal precautions into contracts to protect a given artwork. Models for such protective language exist in "moral rights" laws and are explained in the following section.

Artists' rights and "moral rights"

The actions of Pittsburgh's airport administrators were objectionable, but they were also entirely legal. Equally egregious cases can be cited.

Observers in and out of the art world were shocked several years ago when an enterprising businessman announced plans to slice a work by Picasso into one-inch squares, which were then to be sold individually. Many were further shocked to discover that there were no legal means to block the proposed venture. Until the very recent past, the owner of an artwork has had the right to alter that artwork in any way he or she chooses.

Moreover, the owner has been able to continue to display the altered piece as the artist's own work. This is still the case in all but three states in the United States.

§5.5. FINAL OBSERVATIONS ON THE CALIFORNIA AND NEW YORK MORAL RIGHT STATUTES

An advantage of drafting a statute is that by writing a set of rules against a historical background one can readily draw on the experiences of the past. An area where a series of general problems have arisen can be analyzed in terms of a theoretical number of issues and potential solutions; cases that were unpersuasively decided can be rectified.

With respect to the California and New York statutes, there has been a paradoxical result. When California enacted its moral right statute it could have drawn on the substantial European experience. Yet it can be readily seen that lawmakers selected only a small amount of that precedent. The statute's focus is on the "alteration" or "destruction" of a work of "fine art." Application of the law, however, is limited to works of "recognized quality," a concept that did not exist in the traditional view of the moral right of an artist. While the underlying rationale for this limitation was the fear that the statute might become a vehicle through which little-known artists could publicize their work, it nonetheless does not quite fit with the claimed justification for a moral right. New York, despite the recent enactment of the California statute, has moved in a different fashion. By contrast, the key assumption of the New York statute is that the work shall have been "publicly displayed or published." It is not relevant under the New York statute whether the work is deemed by persons other than the artist to be of "recognized quality."

If the underlying basis of the right is "moral," what significance attaches to the fact that the work may be of recognized quality? Similarly, what moral basis is there for saying that for a work to be protected it must be publicly displayed or published? Do not both the California and New York statutes, albeit in different ways, potentially protect economic rights rather than rights that would generally be deemed personal to the creator? Has not the California statute, by limiting the persons with standing to sue to those who have created works of "recognized quality," permitted the courtroom to be a forum where quality and one's view of artistic merit becomes the dominant issue? Would paintings once exhibited in the Salon des Refusés or Dada or graffiti art be subject to protection?

Reprinted from *Art Law*, vol. 1, by permission of the authors, Franklin Feldman, Stephen E. Weil, and Susan Duke Biederman.

Such excesses have led lawmakers in a number of European countries to adopt "moral rights" laws on behalf of artists. These are rights of control over a work after it has been sold. In particular, they are rights to control the physical integrity of the artwork, and by extension, the artist's reputation. France has perhaps the longest tradition of *droit moral*, with cases dating back to the 19th century. The Berne Copyright Convention of 1928, to which most European states (but not the United States) are signatories, also embodies the principle of moral rights.

In part because of the American emphasis on property rights—and many view art as only a specialized sort of property—all moral rights bills introduced on the federal level to date have failed. In late 1987, Senator Edward Kennedy of Massachusetts reintroduced the Visual Artists Rights Act of 1987. The bill would prohibit unauthorized distortion, mutilation, or destruction of works of art and allow an artist to disclaim authorship if a given work has been distorted. If enacted on the federal level, such a bill would eliminate the inconsistencies which arise when policies are carried out on a state-by-state basis.

But in the continued absence of a federal statute, it has fallen to the states to fill the moral rights void. Unfortunately, only three have done so: California, New York, and Massachusetts. And it is clear that even in those three states, a significant number of variations and loopholes have arisen.

California was the first state to pass a moral rights law, which went into effect in 1980. Like many pioneering efforts, it has its limitations. One loophole is the exclusion of art which can't be removed from a building without damage either to the art or the building. (The Massachusetts law, passed in 1985, extended protection to such artworks.) A second loophole involves photographs and prints, which are not afforded protection. On the other hand, the California law specifically prohibits the *destruction* of artworks, in addition to their defacement. New York's moral rights law, which went into effect in 1984, protects photographs and prints, but does not address the destruction of artworks.

Briefly, the New York law prohibits the owner of an artwork from reproducing or exhibiting it in "altered, defaced, mutilated or modified form" without the express permission of the artist. If the altered artwork is reproduced or exhibited, and if that reproduction or exhibition harms the artist's reputation, the artist is entitled to collect damages. Three types of "alteration" are specifically exempted by the law: (1) alterations resulting from competent efforts at conservation; (2) inaccuracies resulting from printing and other reproduction processes; and (3) changes resulting from the passage of time.

The very term "recognized quality" speaks to a certain acceptance that transcends any personal injury or harm to the creator. Works of "recognized quality" may be very different from works that have substantial market value, either on initial sale or in the secondary market.

At another level, some statutes provide their own impediment. It may very well be that an artist who is considering instituting a suit in California would be well advised to avoid confronting the issue of whether his art is of recognized quality. Even if he proves all elements of his cause of action — other than recognized quality — will he not walk out of the courtroom with second thoughts about having instituted the litigation? While monetary damages may or may not be won in the California courts, personal affront is likely for an artist-plaintiff facing an inhospitable "trier of fact."

To some degree a similar situation prevails in New York, where actions or potential damage to the artist's reputation is necessary to state a cause of action. In such an action, the defense might well be that the artist-plaintiff has little or no reputation to damage. The New York statute functions as an extension of the law of defamation, and actions under it are subject to the same pitfalls as actions for libel or slander: The cure may be more painful than the disease.

Not all arts administrators are happy with the New York law. Some have expressed concern about its vagueness. What constitutes a "modification," for example? Do artists now have the legal right to approve such procedures as installation, which have traditionally been the exclusive domain of museums and galleries?

Artists, too, have their problems with the New York law. They complain, for example, that it is unfair for the law to restrict legal actions to living artists and thereby to preclude a deceased artist's estate from seeking legal redress. Some have encouraged New York's legislators to amend the bill to prohibit outright destruction of artworks and to extend its coverage to film and video. In addition, by exempting alterations caused by the passage of time, legislators may have unintentionally protected owners who fail to care for an artwork. On balance, however, those in the New York artistic community welcome the law's symbolic value. If the European experience is any guide, moral rights laws can change how we think about art. They can emphasize the artist's continuing interest in the work after its title shifts from artist to owner. And finally, they can serve as a model when it comes to adopting protective language in contracts between artists and commissioning agencies.

Summary

The title of this section "Threats and rights," captures a basic dynamic in public art. The artist, through a public artwork, makes a statement, be it aesthetic, emotional, historical, political, sociological, or personal. This statement exists not in the sanctuary of a museum, but in an ever-changing public context, a realm which may well challenge or threaten it. Both the artist and the public art administrator must become skilled and knowledgeable in areas of artists' rights. Both should avoid placing themselves in a reactive, after-the-fact posture, which is all too often limited to containing or reversing damage. Instead, both should seek to operate in a constructive, anticipatory posture, inventing the safeguards which will allow public artworks to keep contributing to the public environment. Yet a caution should be added here because the aim should not be to protect all public artworks through all time, without regard to the specifics of each case. There will be works of public art which do not stand up well to the ravages or judgments of time and should be removed from public view. A suggested method for reviewing existing works which balances the need for preservation with the acknowledgement of this fact is subsequently examined in the section titled Review Procedures for Public Artworks.

During the Great Depression, over 300,000 artworks were created by artists working under the auspices of the federal government's Federal Art Project (the most well-known art program of the Works Progress Administration, or WPA). The program, controversial at the time, is instructive for both political and practical reasons. According to a study conducted two decades ago by Francis V. O'Connor, ● there is a great deal of confusion about the fate of many of those 300,000 artworks.

● See *Federal Support for the Visual Arts: The New Deal and Now*, Bibliography.

Many were evidently destroyed or sold as surplus after the liquidation of the WPA, sometimes for reasons as mundane as a lack of suitable and available storage space. Others were destroyed because they were seen, correctly or incorrectly, as having little value as art. Others were simply lost. Many changed hands and/or locations a number of times. Local "renovation" efforts resulted in many murals being painted over in post offices, hospitals, schools, and other public buildings. Some artworks have been recovered in locales ranging from junk shops to government warehouses; but many others were auctioned or sold to private dealers.

The federal government, it should be noted, made a substantial effort to record the destination of artworks. But even this effort came to naught when the allocation cards which recorded this vital information vanished without a trace.

Our response, 50 years later, has to be mixed. On the one hand, we can understand the situation of those charged with managing such a colossal collection of public artworks. On the other hand, we are shocked and dismayed that such a vast cultural resource was largely destroyed through faulty procedures and inadequate policies. Certainly, our nation's cultural heritage has suffered. Of equal concern is the plight of those artists whose work was lost or destroyed and whose artistic development during that time can only be inadequately documented.

Purpose of a collection management plan

Why is it important to establish a plan for the ongoing management and care of a public art collection? A collection management plan aims to prevent the problems illustrated by the WPA case. Such a plan, when guided by the overall goals of the public art program (see Why Public Art?), outlines specific policies and procedures designed to govern the disposition of public artworks in a collection. Concurrently, the collection management plan underscores the sponsoring agency's commitment to a *professional* approach to management of a vital public resource.

Who should devise the collection management plan? Because the management of artworks (particularly those in the public realm) requires a variety of

135

Christopher Sproat, U.S. Courthouse, Madison, Wisconsin, General Services Administration, Art-in-Architecture Program, 1987.
photo: M. Bachman

WORKSHEET

Establishing a Collection Management Plan

I. Purpose/philosophy of the plan

II. Purpose/philosophy of the collection

III. Definition of Collection (scope, location, existing documentation)

IV. Who is involved in preparation and review of the plan?

V. Who implements the plan?

VI. How is it funded?

VII. Management Areas:

 A) Recordkeeping

 B) Storage

 C) Care and Handling

 D) Archival materials

 E) Security and fire protection

 F) Staffing

VIII. Periodic review of management plan (who, when, how)

skills, the management plan must comprise a range of perspectives. The plan may be drafted by the agency which has overall responsibility for collection management, but it should also have direction from artists, curators, conservators, and the agreement of other administrators who are involved in day-to-day maintenance issues.

Who should implement the plan? It is important to consolidate responsibilities for managing the collection under one particular entity. In many percent for art programs, public artworks are cared for by whatever department happens to own them and with whatever money and personnel they happen to have. But an art collection requires specific and specialized expertise. As one public art administrator said, "It's too important to just go through low bid process."

The term "collection," when used in the context of public art, generates mixed reactions. Some critics suggest that the use of the term leads subtly to an emphasis on a body of public artworks. This may diminish the merit of individual, independently developed projects. Others point out that the implication that there is a deliberate curatorial focus does not hold in the case of an evolving body of public art, since each public artwork is first a response to some particular aspect of the public environment.

The term "collection" is used here simply to describe a body of public artworks whose protection is under the auspices of a particular agency. An effective collection management plan, through its policies and procedures, should address the following issues:

— the goals of the collection;
— methods of acquiring public artworks;
— requirements for the documentation of public artworks;
— responsibilities and methods for care of the collection (including both maintenance and conservation); and
— proposed methods for deciding on relocation or removal.

If these issues are addressed thoughtfully, a collection management plan justifies itself in several ways:

— Public art which is well cared for demonstrates civic pride and the ongoing commitment of the commissioning agency to the cultural vitality of the city;
— Systematic care and review of public artworks ensure that the original intent of the artist is preserved at the lowest cost;
— A well-managed asset retains its value and may even appreciate in value. For example, it has been estimated that the publicly owned collection of monumental abstract paintings in the commercial

See "The Empire State Plaza Collection," Bibliography.

concourse of the Empire State Plaza in Albany, New York, is now worth some $12 million—or ten times its original cost. According to the March 1987 issue of *Capital Region*, that appreciation probably helped persuade the New York State legislature to appropriate funds to restore eight of the paintings when they were badly damaged in 1985 by a knife-wielding vandal;

— It is less expensive to maintain artworks on a routine basis than it is to restore badly neglected artworks;

— Public art sponsored by public or nonprofit organizations are held as a public trust. Sponsoring agencies have a legal obligation to protect these public assets. Beyond this legal obligation, they have a moral obligation to be careful stewards of objects of cultural significance for the benefit of succeeding generations.

To some agencies, especially those that have only recently started to sponsor artworks, preservation issues may seem far in the future. But experience suggests that even works created within the last five years may be showing the detrimental effects of the environment, of vandals, or of changing public contexts. Moreover, the first few years of an artwork's public life may well be the most difficult ones in terms of the public's reaction. Just as it is preferable to have ongoing maintenance of an artwork in its original state rather than reclaim a damaged one, it is sensible for an agency to be able to respond with the aid of a clearly articulated policy when public controversy arises.

Goals of the public art collection

Every sponsoring agency should have clearly stated goals for its acquisitions. These goals often reflect the purpose found in an organizational mission statement or in the enabling legislation which establishes a percent for art program.

The stated purpose of the King County (Washington) percent for art program is, as the enabling ordinance states, "to expand the opportunities for its citizens to experience art in public places, thereby creating more aesthetically pleasing environments."

The ordinance also articulates a number of specific goals, including:

— creation of a variety of types of visual art;

— equitable distribution of commissions among artists;

— equitable distribution of works of art;

— collaboration between artists and design professionals, including architects, landscape architects, and engineers;

— enhancement of the creative environment for artists in King County; and

— selection of artists based on qualifications.

Roland Perry, *Elk,* Portland,
Oregon, 1900.
photo: John Baugess

The program also articulates an additional guiding principle: "Recognizing the sensitive nature of public art, artists shall be given maximum freedom to reach creative solutions to the problems they have been employed to solve."

Obviously, many of these goals and principles apply not only to the creation of public art, but also to its preservation. To the extent that this is true, they should be reiterated in the collection management policy.

In addition to these broad policy statements, more specific artistic or process-oriented goals for the collection should be articulated. They may be defined at the outset or evolve as the program begins to take shape in practice. In Seattle, for example, the concept of "design teams" was identified as the dominant, although not the exclusive, philosophical approach to public art. Various states, including Washington, Alaska, and Hawaii, have developed "artbanks," portable collections which allow for the exchange and rotation of artworks among various public departments. This rotation allows a variety of art to reach a broader audience and, according to the Washington State Arts Commission, enhances the educational value of its collection. Another goal which the Washington Commission has set for its collection is the development of state "landmarks" to be located throughout the state at appropriate tourist-oriented sites (rest areas, bridges, ferries, waterways, state parks, etc.). Each of these different approaches will necessitate variations in collection management needs.

How can an agency develop or evaluate an existing acquisition philosophy? An inventory of existing public artworks is a useful starting point. Many communities already own or have stewardship over public artworks. These works may be historical monuments or more contemporary works acquired through individual initiatives. An inventory enables the agency to place present aspirations in the context of past efforts. For example, threads may emerge which point to significant historical, geographical, environmental, or aesthetic influences. The research done during the inventory process may also point out past conservation problems and provide useful information to develop a strategy for current and future care of artworks.

In sum, by conducting an inventory, an agency can first get a clear picture of the artworks in its collection. Then, it may decide to use this information toward two other purposes:

— developing directions for future acquisitions policies; and
— developing conservation policies.

Acquisition of public art

A public art program's guidelines for implementation define methods for selecting artists and artworks. These may include direct purchase or commission through open competition, limited competition, or an invitational process. These selection methods are not described here, since they are examined at length elsewhere (see Guidelines for Implementation: Artist Selection Procedures and Proposals).

Gifts of public art, however, deserve separate attention. Two cases help to illustrate some important concerns.

In 1986, a private collector in Allentown, Pennsylvania, in response to requests from city officials, donated dozens of monumental sculptures in his private collection to the city. According to the stipulations of the donor, the works were placed without advance public notice and without any chance for community review. The public response to the sculptures was mixed. Many residents vocalized dissatisfaction with the placement of the sculptures and some with what was felt to be a selection of works of lesser significance than those the donor had given to other institutions. Many in the community resented the implication that city residents either wouldn't care one way or the other about the sculptures or weren't qualified to participate in a productive discussion about them. A year later the sculptures remain standing and the Allentown Arts Commission is exercising its role along with the donor to relocate some pieces to more favorable sites.

That same year, a different case arose in New York City, when the New York Municipal Art Commission, which oversees all acquisitions of public art by the city, stopped accepting *any* gifts of art to the city until it could conduct a thorough evaluation of its existing policy and procedures. The effective "freezing" of the collection was the result of a series of incidents in which gifts of artworks were unofficially accepted by the city's parks department and were later deemed unacceptable by the Municipal Art Commission because they did not meet the commission's standard of quality.

In light of the old adage about looking a gift horse in the mouth, the concept of sponsoring agencies turning down gifts may sound strange. And yet, as the preceding cases illustrate, gifts should be reviewed just as carefully as works which are purchased or commissioned; that is, in light of the purpose, goals, and criteria of a comprehensive plan for public art.

The Metro-Dade Art in Public Places program established a policy that refers proposed gifts of public art to its Art in Public Places Trust—

the body which approves all public art acquisitions—in light of recommendations from its Professional Advisory Committee. Potential donations are reviewed with the following criteria in mind:

— the quality of the work;
— maintenance requirements;
— conformance to structural and fabrication standards and applicable safety codes;
— donor conditions;
— availability of an appropriate site for the work;
— the advice of administrators at the proposed site; and
— staff research.

Gifts are accepted only if sufficient funds are provided by the donor to pay for installation, framing, or base (if applicable); illumination; and other display needs such as an identification plaque. Resources must also be provided for any operational expenses and required current and future maintenance by specialists.

Proposed donations of commemorative works are referred first to the Art in Public Places program staff, who meet with the potential donor and coordinate a review of the work by a committee, including community advisors and others interested in the proposed site. If subsequently acquired, the work then becomes a part of the Metro-Dade Memorial Artworks Collection. Other, non-commemorative works are integrated into the Metro-Dade Art in Public Places Collection.

Several questions should be asked and answered as a sponsoring agency develops a gifts policy:

— Who will review the proposed gift? What are the appropriate criteria, policies, and procedures to guide the review?;
— What is the donor's role in decisions regarding the location and future disposition of the proposed artwork?;
— What conditions proposed by the donor should be accepted as reasonable, and which should not?;
— Should special provisions be made for gifts of state (e.g., gifts from sister cities or visiting foreign dignitaries)?

Documentation, care, and deaccession

In the following sections, we will address three important concerns of overall collection management: *documentation*, *care*, and *deaccession*.

Briefly stated, records generated in the *documentation* process chronicle the administrative, legal, and artistic processes whereby a given artwork comes into a collection. They also document any changes in the artwork's status, such as relocation or significant repairs, which occur while the

Peter Richards and George
Gonzales, *Wave Organ*, San
Francisco, 1986.
© *ART on FILE*,
Chartier / Wilkinson, 1988.

artwork is in the collection. In addition to this registrarial function, the
documentation process elicits and organizes information about the artwork
and the artist, and helps establish both within a cultural context.
Documentation, then, responds to administrative, historic, and cultural
needs.

The *care* and conservation of a collection is an ongoing responsibility, and
systematic approaches to maintenance and monitoring the condition of
artworks are essential. Safety measures (eliminating or minimizing the
threat of theft, vandalism, fire, and climatic damage) should be devised for
each work in a collection. Over the long term, it is also important to
establish a plan for involving professional conservators in the evaluation and
treatment of public artworks.

Finally, we examine the issue of *deaccession*. When a sponsoring organiza-
tion considers the possible relocation or removal of a public artwork, it
must recognize its multiple responsibilities: to the artist, as represented in
the original artist contract; to the community, through its legal mandate
and stewardship role; and to our cultural heritage. Decisions about reloca-
tion or removal must comprise carefully conceived policies, a deliberate and
explicit review process, assistance from professionals, and thoroughgoing
documentation of the process.

William Keyser, Jr.,
maple and steel benches,
Alewife Subway Station,
Cambridge, Massachu-
setts, Massachusetts Bay
Transportation Authority
and the Cambridge Arts
Council, 1984.

Funding collection management activities

A collection management plan is only effective if the means exist to imple-
ment it. Obviously, then, a sponsoring agency seeking to create or enhance
a collection management plan must find adequate administrative resources
(both staff and funds) to carry out these functions. How can the processes
of managing a public art collection—activities which are unglamorous but
critical—be funded?

In the first half of this workbook, we considered a number of ways in which
public art programs are funded. We noted then, and will reiterate here,
that it is all too rare that provisions are made for the ongoing costs of man-
aging and maintaining collections. To compound the problem, such
costs only tend to increase as the collection grows and ages. Following are
examples which show how some agencies are supporting the cost of
collection management.

Reserving a percentage of the allocation for artwork is, in some senses, the
easiest and most consistent course of action. The San Francisco percent for
art program, for example, sets aside 5 percent of each art budget specifi-
cally for maintenance and conservation needs. Under this policy, agencies
receiving artwork are "encouraged to assume these costs after a ten-
year period." But while this approach solves some immediate problems, it
doesn't address several others. What if the reserved amount proves
insufficient or runs out (a particular problem for lower-budget projects)?
Aren't there cases in which 5 percent is too much to reserve? And, what
guarantee is there that receiving agencies will actually assume these costs
at the end of ten years?

However, while reserving a percentage of the art budget ensures at least
some funds for collection care, it necessarily reduces the amount of
money available for the creation of new artwork. This may limit what the
artist can do in response to a given site, or it may force the commissioning
agency to continually seek additional funds in order to implement
more costly projects. Given these disadvantages, this method of funding
collection management activities is viewed by many professionals as the
least desirable option.

Other methods have been developed which reflect a similar premise but
don't draw down the art budget. In the 1984 revision to the Metro-Dade
Art in Public Places ordinance, an existing restriction on the use of
the 1.5 percent allocation strictly for art was lifted. The revised ordinance
states that if the program's total income is not used for the acquisition
of works of art, these monies which are deposited in the Art Trust Fund
may be applied against the program's administrative costs, insurance
costs, or repair and maintenance costs. Decisions about use of these pooled
funds are made by APP staff with its trustees' approval. (The pooled

funds may also be used to supplement other appropriations for the acquisition of artworks or to place artworks at previously constructed government facilities.) This provision, then, allows for more flexible applications of funds while maintaining a clear priority on art acquisition.

Another approach comes from the Multnomah County percent for art program, administered by the Metropolitan Arts Commission in Portland, Oregon. Multnomah County has added .33 percent to its existing 1 percent allocation for art. This additional fraction of a percent is explicitly intended to cover primarily education-related expenses, but also may be used for administrative and conservation-related ones. In yet another case, Dallas' ordinance established .25 percent for maintenance costs in addition to .25 percent for administration and 1 percent for artwork.

As noted earlier (see Funding: Percent for Art Model), the revisions proposed in 1983 to Washington State's percent for art legislation called for the ongoing maintenance costs of the state's collection to be covered by interest earned as a result of placing all percent for art resources in a revolving fund. Although cited by many observers as an ideal solution, this plan did not pass. The revised legislation instead stipulates that maintenance costs must be covered from funds other than those derived through the percent for art mechanism. However, the "interest for maintenance" approach is worthy of further study, particularly for active, ongoing programs with the capacity to pool those funds.

Establishing a line item in the agency budget which is supported from a source other than the art acquisition allocation has been strongly supported as the best approach to funding ongoing collection management costs. Some percent for art ordinances prohibit the use of percent funds for collection management or educational purposes. This is the case, for example, in Seattle, where legislators have attempted to avoid the gradual reduction of funds available for commissioning new artwork as the collection ages and conservation demands increase. The Seattle Arts Commission has taken on the responsibility of care for all city-owned artworks, historical and contemporary, and, in doing so, is performing a larger duty for the city. As a result, the Seattle Arts Commission annually requests collection management funds from the city's general revenues as a separate line item.

Two disadvantages to this approach are immediately apparent. First, there is always the possibility that such a budget request will be denied in light of competing priorities. And second, annual budget battles require substantial time commitments. Nevertheless, the management of a collection is correctly viewed as a necessary administrative expense, similar to the maintenance and repair costs associated with a public building. All cities budget for

the maintenance needs of their buildings and should be persuaded to adopt a similar approach to public art.

If the regular, internal sources of funding outlined above prove inadequate, it may be necessary to consider creating an *endowment* for a given public art collection. Of course, if securing an endowment were easy, no public art program would be without one. In all cases, finding endowment money—and particularly for the somewhat mundane tasks of collection management— requires a major commitment of time and energy. Programs without extensive fundraising experience may want to consider employing professional fundraisers for part or all of an endowment campaign.

One interesting approach to establishing an endowment, although not strictly focused on public art, was developed beginning in 1985 during the restoration of Winthrop Square Park in Cambridge, Massachusetts. The oldest public park in the city and once a showpiece for landscape architect Frederick Law Olmsted, Winthrop Square fell into disrepair in the early decades of this century. Various efforts to restore the park, including a 1985 attempt by the city to secure state funding, failed. At that point, the Program on Public Space Partnerships (PSP), based at Harvard's Kennedy School of Government, became interested in using Winthrop Square Park as the site for a demonstration project.

PSP secured contributions from 150 corporate and individual subscribers, many of whom used or abutted Winthrop Square. These contributions were used to establish a nonprofit trust responsible for managing the park, which the city helps administer. Both the trust and the city are contractually committed to make annual contributions to the upkeep of the park. "This is the first park," as Clarissa Rowe, head of the design team commented in an interview, "for which we've put out the maintenance contract with the construction contract". ● Obviously, Winthrop Square has important implications for public art administrators in search of funding for collection management, particularly for communities or programs whose focus is on occasional projects, rather than numerous annual projects.

● See "Winthrop Square Park: A Unique Heritage," Bibliography.

New York City's Municipal Art Society has recently implemented an endowment-oriented program to restore and maintain a number of the city's public monuments (see related articles, facing page). In March of 1987, the city announced that it was putting twenty public monuments up for adoption. The explanation was straightforward. Only $175,000 —sufficient for seven or eight employees and supplies—was being spent annually on the upkeep of some 800 statues and 700 other monuments within the city. The city's curator of parks estimated that he needed at least four times as many workers just to keep up with annual maintenance needs. Other officials estimated that just to restore the 20 monuments in question would cost over $1.3 million.

Stanislaw K. Ostrowski, *King Jagiello*, Central Park, New York City, Gift of the Central Polish-American Societies, Inc., 1939. Adopted by The American Conservation Society.
photo: Phyllis Samitz Cohen

VOL.CXXXVI.... No. 47,073 Copyright © 1987 The New York Times

City Seeks Adoptive Parents For 20 Orphaned Monuments

By DAVID W. DUNLAP

Almost abandoned by the public treasury that was supposed to care for them, 20 monuments in New York City have been put up for private adoption so they can survive an increasingly hostile environment.

Their designers are in the forefront of art and architecture: Augustus Saint-Gaudens, Stanford White, Daniel Chester French, John Quincy Adams Ward and Richard Upjohn. Their subjects are in the forefront of history: Columbus, Joan of Arc, Washington, Lafayette, Lincoln and Maj. Gen. William Jenkins Worth, who was buried beneath his monument.

Today, this public legacy bears deep scars. Acid rain, automobile fumes and factory emissions have eaten away at bronze and turned marble sponge-like. Vandals have torn off heads and arms, pausing only to cover granite pedestals with spray paint.

Repairs Exceed City Budget

And the city government spends about $175,000 a year on seven or eight workers who care for 800 statues and 700 other public monuments. In contrast, some $1.3 million is needed to repair and restore the 20 monuments in question. Repairs for the monuments up for adoption are expected to cost from $3,500 to $275,000.

"These works of art are barometers of our impotence over controlling the world in which we live," said Kent L. Barwick, president of the Municipal Art Society, which organized and will coordinate the "Adopt-a-Monument"

program with the Parks and Recreation Department and the City Art Commission.

Before the fiscal crisis of the last decade, the city's monuments crew had as many as 14 full-time workers, according to Joseph P. Bresnan, a former parks agency official who is now executive director of the Landmarks Preservation Commission. After the fiscal crisis, he said, the crew was reduced to one.

While the crew has grown since then, it is half the size it was in the 1960's — "totally unrealistic," the Curator of Parks, Donald M. Reynolds, said. Mr. Reynolds said he would need 21 more workers to maintain the monuments properly.

In recent years, civic groups and corporations have adopted single monuments on an ad hoc basis. But this is the first attempt to meet the need citywide. It also amounts to an acknowledgment that government cannot adequately care for this artistic patrimony.

As far as its organizers know, "Adopt-a-Monument" is the only program in the country that seeks to restore such a wide range of monuments with private money.

Not all of the works chosen are masterpieces. "We wanted a representation in all five boroughs and a wide range of prices," said Paul Gunther, director of development at the Municipal Art Society.

Nine are in Manhattan, four in Brooklyn and three in Queens, and there are two each in the Bronx and on Staten Island. At the high end, work on the Columbus Monument at Columbus Circle and the Heinrich Heine Fountain in the Bronx would cost $275,000 each. On the other end, work on "Alamo" on Astor Place would cost $3,500.

The Municipal Art Society, which was founded in the 19th century to beautify New York, is to deposit the donation in an account with the New York Community Trust and serve as intermediary, working with government agencies to secure needed approvals and as restoration manager, contracting the needed work.

An informal group called the Bronze Committee, composed of city officials and private curators and conservators, will be consulted about appropriate restoration techniques. "We are not going to force conservation methods on anyone," said Phyllis Samitz Cohen, an organizer of the program.

Recognition of Donors

When it comes to recognition of donors, they will be entitled to all the printed publicity they can get but nothing of the engraved variety — with the possible exception of monuments that are on large sites where a plaque would be less conspicuous.

Two monuments, both in Central Park, have already found patrons. "King Jagiello" has been adopted by the American Conservation Association for $30,000. "Still Hunt" has been adopted by William S. Beinecke for $3,500.

Some statues that were not so lucky will be on display beginning Thursday in the Villard Houses, 457 Madison Avenue at 51st Street, in a show that is being assembled by Ms. Cohen.

There is a "Discus Thrower" that was removed from Randalls Island after vandals wrenched off the discus, sawed off the left arm and were halfway through cutting off the right arm. There is a bust of John Howard Payne (composer of "Home, Sweet Home"), which vandals were rolling down a hill in Prospect Park when the police stopped them.

A Sword Returned

On Friday, Ms. Cohen got a welcome surprise. Allan Cox, supervisor of monuments for the Parks Department, arrived with the sword that Gen. Henry Warner Slocum once brandished over Grand Army Plaza in Brooklyn. The Slocum monument is up for adoption and the sword had been presumed lost.

Underlying both the adoption program and the show is the theme of civic indifference. Mr. Barwick said he did not think that the city's budget priorities were "inappropriate, given the problems of the homeless and education."

But Joan K. Davidson, president of the J. M. Kaplan Fund, which supports the arts in New York, said: "Monuments and other outdoor works of art are integral elements of public spaces and therefore as deserving of governmental assistance as are the trees in our parks. In the meantime, the private sector is trying to carry out a holding operation."

"I think it's wonderful that any monuments are being cared for," said Lewis I. Sharp, curator of American paintings and sculpture at the Metropolitan Museum of Art. "But it's a shame that the city has never developed a program for maintenance that is more responsible than it has been."

Speaking about the adoption program, Parks Commissioner Henry J. Stern said: "It's not like Little Orphan Annie looking for Daddy Warbucks.

"The city can provide a certain level of care. It can't polish every monument every morning. Obviously, if we get private funds, the monuments can get a higher level of care. It's an effort we appreciate."

Commissioner Stern said he was seeking to increase the budget for monuments by $1.3 million. However, when asked if there was a political ally who would champion such a cause in budget negotiations, Mr. Stern said, "If there is, his name so far escapes me."

The Adopt-a-Monument program, coordinated by New York City's Municipal Art Society, acknowledges the limited local government funds which exist to care for the hundreds of outdoor monuments in the city and seeks private monies to restore a select twenty public artworks.

These articles from *The New York Times* describe the scope of the conservation problem facing New York City and the Adopt-a-Monument program.
Reprinted by permission of The New York Times.

SUNDAY, MARCH 15, 1987

The City's Statues
Monumental Generosity From All Over

DONORS last week began flocking to accomplish what the City of New York cannot do: properly care for the public monuments that make up an extraordinary but devastated artistic patrimony.

The Municipal Arts Society, the Parks and Recreation Department and the city's Art Commission announced Monday that they had put 20 monuments up for private "adoption." By week's end, more than half seemed to be on their way to finding new caretakers.

Officials of the Municipal Art Society would not disclose the identity of newly adopted statues or prospective benefactors for fear of compromising delicate negotiations and stealing thunder from donors who wished to make their own announcements.

They would say only that interest had come from half a dozen states and every borough but Staten Island. There was even a nibble from overseas, but Kent L. Barwick, president of the nonprofit society, would pinpoint it no more than to say it had come "from the free world."

"The response has been beyond our expectations," said Paul Gunther, the society's director of development. The society is to collect tax-deductible donations, see that the restoration work gets needed approvals and then contract the work. Besides donors, the society has heard from artisans who have offered their expertise in restoration.

In announcing the program, Mr. Barwick lamented that the works "are barometers of our impotence over controlling the world in which we live." But, as the telephone calls and letters poured in last week, Mr. Barwick brightened. "People do seem to care about these works of art," he said.

DAVID W. DUNLAP

In keeping with the terms of the Adopt-a-Monument plan, the Municipal Art Society, a private group organized a century ago to beautify the city, accepted contributions to the program. Working with the city Parks and Recreation Department, the Art Society also assumed responsibility for supervising the restoration process. Costs for adopting the "orphaned" statues ranged from $3,500 to $275,000, and within a week, half of the monuments were spoken for. As of November 1987, thirteen monuments had been adopted, some by individual donors, but primarily by local organizations including private foundations, a chamber of commerce, churches, and corporations.

Unfortunately, such fundraising efforts in support of public-sector assets are often crisis-driven. In other words, public assets usually have to reach an extreme state of deterioration before private funds start to flow. (The Statue of Liberty is another dramatic case in point.) Establishing a regular source of funds for ongoing care can head off such crises—and often for a lower overall price than the cost of a crash program.

To reiterate: Individual public art projects, as well as ongoing programs, should develop collection management policies *at the outset*, rather than after the fact. Such policies should include a clear and effective plan for funding collection management activities.

Finally, a collection management plan should be seen as a tool for improving the care and management of a given collection. Since the job of collection management can change over time, the tools may also have to change. Collection management plans should be reviewed regularly, and amended or otherwise updated to ensure that both the needs of the collection and those of the public are being served.

This description of the Alamo is excerpted from the Adopt-a-Monument booklet distributed to prospective adoptors by the Municipal Art Society of New York City. It makes clear to the adoptor both immediate restoration and ongoing maintenance needs.
Reprinted by permission of the Municipal Art Society of the City of New York.

Alamo, 1966–1967
Bernard (Tony) Rosenthal

Cor-ten steel painted black. Astor Place, intersection of Lafayette Street and 8th Street. Gift of the Knoedler Gallery, Bernard Rosenthal and an anonymous donor.

A fifteen-foot high sectionalized cube of Cor-ten steel pivots on one point at the intersection of Astor Place, Cooper Square. Its powerful scale and impenetrable strength suggested the title *Alamo* (so named by the artist's wife). Designed by Tony Rosenthal (born 1914) the piece was originally exhibited in the 1967 avante-garde "Sculpture in the Environment" show organized by the Department of Parks, Recreation and Cultural Affairs. Sculptures were placed throughout the City in locations identified by the artists. *Alamo* became the first work from this provocative exhibition to be acquired by the City.

Ironically, the proportions of the eight-foot cube, were delimited by the size of the truck transporting the piece from the artist's studio in New York to the Lippincott fabricator in Connecticut. Its geometric simplicity and strong industrial presence reflect the Minimalist style of the sixties. The sculpture invites participation as curious viewers push and rotate the work on its mounting.

When *Alamo* was installed in 1967 the weathering Cor-ten steel was painted flat black. Shortly after its placement, the cube was marred by Vietnam War protest posters. Discouraged, the artist took responsibility for cleaning it before other volunteers assumed the task. The earnest but inconsistent efforts to conserve the work led to layers of different paint applications. Difficult to remove posters were covered with paint until the surface accumulated nearly one-fourth inch of unplanned texture. Recently the sculpture has been tended by engineering students from Cooper Union.

Immediate measures call for stripping the massive work. The cube can be removed from its base, allowing for restoration at an off-street location. Once cleaned to bare metal, the piece must be primed and painted flat black, using a paint type that can be matched for future touch-ups. An essential component of this project is a maintenance program for the removal of posters, graffiti, and for repainting. In addition, the bronze plaque merits refinishing.

The cost of restoring the sculpture is $3,500; funding of an annual maintenance program is $2,500.

Documentation serves the future preservation of public artworks through systematic recordkeeping about the works in a collection. The system should strive to gather information needed for future actions, whether aimed at individual artworks or an entire collection, and should be designed to make that information easily accessible.

When a given work is installed and receives final approval from the sponsoring agency, a sequence of steps to document and "register" that work within the collection should occur. If an agency has insufficient documentation of preexisting artwork, records should be created retroactively to the best of the agency's ability and in cooperation with the artist, if he or she is available.

For a detailed summary of the system, see *Documentation for Public Art Collections: An Informational Packet*, developed by artist, Lynda K. Rockwood, Bibliography.

Every public art program should set up a system which both recognizes any effective existing systems and also meets its own information needs. A model of such a system has been developed by the Washington State Arts Commission for its own collection management and has been adapted for use by other public art programs. Some basic components of the system are described here.

Accessing documents: accession number

The first step is to give each artwork an accession number to identify it in its chronology in the collection and enable easy location of all records. A standard numbering model commonly used includes: (1) a letter designation for the collection (such as "CD" for the City of Dallas); (2) four digits for the year in which the work was acquired, followed by a decimal point; and (3) the number representing that artwork's chronological sequence in a given year's acquisitions (example: CD1987.2). For works created by one artist as a series, another decimal point and then the number in that series would be added so that each work in the series would have a distinct accession number (CD1987.2.1, CD1987.2.2, etc.). For artworks consisting of multiple but separate parts, each part would instead add a letter after the sequence number (CD1987.2a, CD1987.2b, etc.). In order to always identify an artwork by its accession number, the number should be permanently attached to the work, although only in a way that will not harm the work or interrupt its formal qualities.

See Accession Ledger, Appendix.

Numbers are assigned sequentially as artworks are acquisitioned and entered in an accession ledger. The ledger is the central list of all public artworks in a collection. A different ledger should be created for each distinctive collection, such as portable works, historical/commemorative monuments, percent for art acquisitions, and so on.

Information needs

What kinds of information should be documented?

Curatorial information

See Catalogue forms from the Washington State Arts Commission and the Fairmount Park Art Association, Appendix.

Information regarding the artist and the actual artwork establishes the work of public art in the artist's career and in the cultural and historical context of the collection, the community, and perhaps the national or international art world.

A catalogue form is again adapted from the museum field to record information about artwork and artist.

Curatorial information should include the following basic elements (see forms for more specifics):

artist's biographical information, (including current address and changes in address);

__ title of the artwork;

__ date work was completed;

__ provenance of the work (if an existing work);

__ purchase or commission price, and insurance value upon acquisition;

__ descriptive information (formal, dimensions, location, specific siting);

__ content/intent of the work as described by the artist;

__ context of the work (as related to its creation, content, and form); and

__ published material about the artwork, its reception by public viewers, critics, historians, etc.

Andrea Blum, *Place for Rainier*, Rainier School, Buckley, Washington, Department of Social and Health Services, Washington State Arts Commission, 1985.
photo: Colleen Chartier

When a public artwork's meaning is derived from its context, it is valuable for documents to include an explanation by the artist to that effect which can be incorporated into educational efforts related to the artwork. Precise definitions of the work as "site-specific" may also inform future decisions about a work's proposed relocation, removal, or conservation.

The cataloguing process records the artist's intent and can support contractual arrangements which come to bear on an artwork's relationship to its site and/or social context and on how various actions regarding the work may affect that relationship.

Conservation information

This information ensures that appropriate care will be provided for the artwork. A conservation record should be completed by the artist, ideally with assistance from a conservator, upon completion of the artwork. This is commonly a required addendum to the artist's contract. While the agency should request, as part of the artist's initial proposal, information about the methods and costs of maintaining the artwork, this information should be seen as preliminary. Many projects evolve in the process of their fabrication and the specifications for conservation information have to change accordingly.

Information collected on the conservation record includes:
— specific materials and sources used in the execution of the piece;
— method(s) of fabrication, including diagrams and names of fabricators;
— installation specifications (method, description, and diagram of structural support, company and persons involved in installation);
— method and frequency of maintenance, including routine maintenance requirements, cyclical maintenance requirements, recommendations and cautions about possible negative influences on work (such as climate, pollutants, sunlight, etc.); and
— desired appearance (for example, matte or glossy patina).

These factors are discussed in greater detail in the Conservation section. Also discussed in that section are condition reports, which should be conducted periodically.

Administrative information

This information enables the agency responsible for managing the collection to clarify issues or questions of accountability, legality, finances, and the process by which the public artwork was acquired. Administrative documentation should include:
— a legal instrument of conveyance, transferring title of the artwork (unless transfer of title is clearly defined in the contract);

Evan Levy, *Distracted*,
temporary installation for
the Atlanta Arts
Festival's Regional Site
Works Program, 1986.

— the artist's contract and copies of the agency's or artist's contracts with
fabricators, installers, consultants (such as engineers), etc.;

— agencies involved (e.g., funding source, commissioning agency, owner,
caretaker, etc.) and their respective roles and responsibilities,
particularly regarding the care and funding of such activities. (The
Interagency Agreements may suffice for these purposes; see Guidelines
for Implementation Section.);

— significant dates (e.g., project initiation, signing of contract,
installation, dedication, etc.);

— permits;

— project cost and sources of funds; and

— insurance documents and other relevant policies of the artist and/or
the agency as applicable (see Contracts Section).

Photographic documentation

Quality photographs are an extraordinarily important part of the documen-
tation of a public art collection. If a work is stolen or destroyed, or meant
to be temporary, the photographic record may be all that exists to document
the original artwork. Photographs not only serve curatorial purposes,
they may also be reproduced in educational and promotional materials that
can bring recognition to the artist, the work, and the public art program.
And finally, photographs—particularly if taken from multiple angles and van-
tage points, including close-ups—can be valuable supplementary tools to
guide conservation processes.

Many public art programs contractually require artists to provide color
slides and black and white photographs of the completed work. These same
agencies often admit that the quality of photographs submitted is not
consistently professional. Many agencies are now stipulating, therefore, that
contractually required photos must be of professional quality; or,
alternatively, the sponsoring organization is augmenting artist-supplied
photographs with photographs taken by hired professionals.

Protecting documents

Finally, the experience of the Works Progress Administration (see
Collection Management Section), where critical records documenting the
locations of hundreds of artworks were lost, points to an important
lesson.

Meticulous record-keeping alone is not enough. Those records must be
protected against loss, damage, and other fates. This may be accomplished,
in part, by having duplicate records wherever possible and practical. It
an also be accomplished by using special archival materials and handling
and storage procedures which minimize the possibility of deterioration,
and protect against fire, water damage, and so on.

For more details on these
and related subjects, consult
a museum professional,
or see *Documentation for
Public Art Collections*,
Bibliography.

Most public artworks are created with some expectation of durability. But artists and owners have often learned, to their dismay, that this expectation was unrealistic. Some materials and methods of fabrication have not stood the test of time. Artworks in the outdoor environment are exposed to numerous corrosive influences, such as acid rain. They are also threatened by extremes of temperature and climate, and even by overuse by an enthusiastic public. Even works sheltered in building lobbies can suffer from exposure to direct sunlight or cigarette smoke, or from inept maintenance procedures. And finally, almost all public artworks are vulnerable to vandalism and accidents.

Every public art program must establish plans for the long-term care of artworks in its collection. Such plans guide both preventative and restorative actions. A separate conservation policy should be created which is designed to:

— establish the standards for the conservation of public artworks;
— ensure that appropriate preventive measures are taken to protect against harm to works;
— establish a regular procedure for evaluating conservation needs;
— ensure that conservation is governed by careful procedures; and
— ensure that the intention of the artist is respected.

A conservation policy must also identify sources of funding to support ongoing conservation efforts (see Collection Management Section). In other words, a conservation program may be adopted on the basis of high-minded or emotional appeals, but it has to be carried out in a spirit of practicality.

In this section, the conservation policy from the King County (Washington) percent for art program is presented with annotations from a variety of professional perspectives. The rest of this section clarifies and complements that policy and its annotations, particularly in regard to conservation specifications at the contract stage and roles and responsibilities for implementing conservation efforts.

Clarifying terminology

Outside of the conservation field, a number of terms, such as conservation, preservation, maintenance, and restoration, are used more or less interchangeably, with no consistent distinctions made among their meanings. Within the field, however, these terms have distinctly different meanings and are used to denote very different kinds of activities.

As the fields of public art and conservation intersect to an increasing extent, it is more and more useful to adopt the conservation field's specific definitions of these terms. The following definitions are from the National Institute for Conservation:

See *Conservation of Cultural Property in the United States*, Bibliography.

151

Funding situations may not allow each work to be inspected once a year. In these cases, it is recommended that the "high risk" works be reviewed annually. High risk works are defined by their location, materials, and/or method of presentation. All exterior works are reviewed with priority given to painted metal over cast iron. Works in lobbies (high traffic) have priority over conference room or private office sited works. Exposed materials such as tapestries or painted canvas have priority over framed and glazed prints, drawings, etc.
 Artech (maintenance and conservation service)

(encompasses maintenance and repair)

Within the context of the agency's commitment to maintain the work for its intended life, this is good. It doesn't require the artist to get insurance or bonding, which are expensive. It only asks the artist to assume the responsibility for a year.
 Public Art Administrator

152

This is reasonable if publicly funded. A public agency has a responsibility to expend public funds wisely.
 Lawyer

The agency could take responsibility and insure the artist for liability and performance.
 Landscape Architect and Urban Planner

What guarantees does the owner have that the artist will have sufficient funds to cover repairs? Should a portion of the commission contract be held for that year to guarantee funds? The money would be paid to the artist with interest if it were not used. Artists won't like this but neither do the commissioning agencies when fix up time arrives without money. I don't have the answer, I only have the problem.
 Artech (maintenance and conservation service)

This should include a set of "as built drawings," too. Experience has shown that such things as concrete footings change from the time of being drawn and then built.
 Artech (maintenance and conservation service)

The contract should state if, or to what extent, the artist may make alterations from the original design, color, finish, etc.
 Conservator

Too weak--this leaves too much possibility that neither agency will take responsibility. Spell it out!
 Public Art Administrator

**KING COUNTY ARTS COMMISSION
SEATTLE, WASHINGTON**

CONSERVATION

POLICY ON ~~MAINTENANCE~~ OF WORKS OF ART

*Adopted by the Commission February 20, 1979
revised March 16, 1982
Revised March 18, 1986*

I. OBJECTIVES

 A. To insure regular maintenance to King County artworks.
 B. To provide for the regular inspection of County artworks.
 C. To establish a regular procedure for effecting necessary repairs to County artworks.

II. POLICY

 A. Artworks within the King County Collection shall be maintained in the best possible condition.
 B. Artworks within the King County collection shall be examined for condition and location regularly.
 C. When King County artworks require maintenance or repairs, the King County Arts Commission shall provide for such, or in cooperation with the agency that houses the work of art.

III. RESPONSIBILITIES

 A. Artist
 1. Within the terms of the contract, the artist shall guarantee and maintain the work of art against all defects of material or workmanship for a period of one year following installation.
 2. Within the terms of the contract, the artist shall provide the King County Arts Commission with drawings of the installation and with detailed instructions regarding routine maintenance of the artwork.
 3. Within the terms of the contract, all repairs and restoration which are made during the lifetime of the artist shall have the mutual agreement of the County and the artist and, to the extent practical, the artist shall be given the opportunity to accomplish such repairs at a reasonable fee.

 B. Agency
 1. Routine maintenance of artwork shall be the responsibility of the agency that houses the artwork, upon the advice of the King County Arts Commission, and be consistent with Materials and Care information sheet supplied by the artist.
 2. Responsibility for extraordinary maintenance or repairs of artworks shall be negotiated between the Arts Commission and the agency which houses the artwork.
 3. The agency shall not effect any maintenance or repairs to artworks without the consent of the King County Arts Commission.
 4. The agency shall not move any artwork from the site for which it was selected, nor remove it from display, without the prior consent of the King County Arts Commission.

 C. King County Arts Commission
 1. Staff
 a. Regularly (At least once annually) the KCAC staff shall provide for the inspection of and shall report on each work of art in the County Collection, including:
 (1) present location of the artwork
 (2) present condition of the artwork
 (3) recommendations regarding needed maintenance or repairs.
 b. Within procedures authorized by the King County Arts Commission, this regular inspection may be accomplished by the staff itself or by another individual or group contracted to perform this service.
 2. Commission
 a. The Visual Arts Committee shall review the condition report and report it to the full Commission.
 b. On the basis of the condition report, the Visual Arts Committee shall, for those works needing attention, recommend:
 (1) that no action be taken
 (2) that staff negotiate maintenance and repairs with the agency
 (3) that the repairs be accomplished, in whole or in part, suggesting means of accomplishing the repairs
 (4) that the work be deaccessioned. (review process be triggered.)

Consult a professional conservator to evaluate the condition report if that report was not generated by a conservator (as in this case), and recommend

This does not address at what point professional services become necessary nor what the qualifications should be.
 Public Art Administrator

— *Conservation* refers to the broad concept of care, and encompasses three activities: examination, preservation, and restoration;

— *Examination* is a preliminary investigation to determine the original structure and materials comprising an artwork (if that information is otherwise unavailable) and the extent of deterioration, alteration, and loss, if any;

— *Preservation* refers to actions taken to retard or prevent deterioration or damage in artworks by control of their environment and/or treatment of their structure; and to maintain them in as unchanging a state as possible (the maintenance function is therefore most closely aligned with preservation); and

— *Restoration* is the treatment of a deteriorated or damaged artwork to approximate as nearly as possible its original form, design, color, and function with minimal further sacrifice of aesthetic and historic integrity.

Conservation record: a contract element

Without exception, it is better for both sides (artist and sponsoring agency) to articulate maintenance expectations up front. The best juncture at which to do this is during contract negotiations. Some basic expectations regarding the intended life of the artwork should be clarified. If the work is "temporary," for example, how long is temporary?

Similarly, the concept of "permanence" should be clarified. Artist and agency may agree that the artwork cannot be maintained beyond a specified life span or outside of a certain set of conditions. Such an understanding should be included in the contract.

For these and similar reasons, the artist contract should include an addendum which we will call the *conservation record.* ● In this record, the artist specifies ongoing maintenance requirements and provides information and diagrams indicating final fabrication and installation methods. The latter information should include such details as the kinds of bolts used, the brands and mixes of pigments, varnish brand and type, and so on.

For commissioned works, the information on the conservation record form is obviously best supplied after the artwork is completed, in order to reflect any late changes in materials, fabrication, or installation. Nevertheless, the sponsoring agency should request at the contract stage information about the nature, frequency, and anticipated costs of maintenance so that the agency can assess whether it can accommodate these requirements.

This raises an important issue concerning the selection of artworks. Some observers suggest that agencies may decline to commission or other-

● See this section.

The commentary on and revisions to this policy document arose out of discussion by participants at one of the Public Art Policy Project task force meetings. King County's policy was felt to provide a good basis for protecting the condition of the artwork and, as a result, the artist's intent. However, annotations point to some weaknesses prevalent in existing public art conservation program guidelines and the need for:

— specificity in the artist's contract regarding instructions for routine maintenance and the appearance desired by the artist over time;

— clarity and specificity in the various agencies' responsibilities for the care and funding of routine and extraordinary conservation efforts.

— clarity and specificity regarding the role and timing of a professional conservator's services in the evaluation of artwork condition and actual treatment.

Reprinted by permission of the King County Arts Commission.

153

"In asking one artist how he wished to have a fragile patina treated in the future, he said, 'it's fantastic; it will last a long time.' His foundry does not share that opinion. We have to know if he wants these patinas revived when they lose a certain intensity. We have to build up records of what artists want for the future of their work."

Virginia Naudé, conservator

"After about the first year [that the work has been in place], what I call the 'use/abuse patterns' start emerging. You see things happening to the work that you wouldn't normally plan on—whether people sit on it, whether water pools up. You have to make it all the way through a full season, especially with outdoor works, in order to find out how nature will affect them."

Alexis Smith, artist

wise acquire artworks which require above-average maintenance measures. They further suggest that a premature estimate of anticipated maintenance requirements may interfere with the creative process. It seems clear, though, that it is only through an effective conservation policy and program that an agency can deploy its resources—funds, staff, and access to skilled technicians—in such a way that high-maintenance works can be accommodated and that the artistic goals of the collection are not compromised.

What information should be provided on the conservation record? Most forms in contracts have been predisposed toward specifications for either traditional object sculpture or two-dimensional work and are therefore overly narrow. In order to serve the wide range of formal, material, and contextual characteristics of public artworks, the conservation record should not only generate certain kinds of basic data, but should also allow more open-ended responses.

Very often, neither the artist nor the administrator has sufficient knowledge of the material-related, engineering or environmental factors which may necessitate (or preclude) certain maintenance procedures. In many cases, a professional conservator should be asked to evaluate the artist's proposal and the completed artwork to recommend a conservation plan. The conservator can help think through issues with which the artist may not be thoroughly familiar, such as protective barriers against vandalism, the potential effects of the local climate, or even aspects of the formal character of the work which may accelerate deterioration.

The Martin Luther King, Jr. Memorial, a 30-foot welded corten steel cube by artist William Tarr, commissioned in 1973, was removed for safety reasons in 1986 from its site outside a public school in New York City. The sculpture had become so corroded that pieces were literally falling off its faces. While it is now known that corten steel is not the "permanent" material it was once thought to be, some attribute the deterioration of Tarr's piece to design elements which allowed water to collect on exterior horizontal surfaces and inside the hollow cube. This apparently accelerated the corrosion process.

The New York Board of Education, which has responsibility for this popular public artwork, has called upon a conservator to evaluate restoration possibilities. Whether or not those options prove feasible, in retrospect, if a conservator had been involved at the artist's design stage, some aspects of the corrosion problem might have been avoided.

Because there is always a degree of uncertainty about what will happen when an artwork is placed in its public environment, a conservation plan

The Conservation Record requires the artist to specify maintenance requirements and anticipate factors which may later affect the integrity of the work. The form should serve as a guide for discussion at the proposal stage, but should be completed as an attachment to the artist's contract after the artwork is completed. This form was compiled as a result of the Public Art Policy Project. It is meant to be examined and modified to meet the needs of particular public art programs or projects.

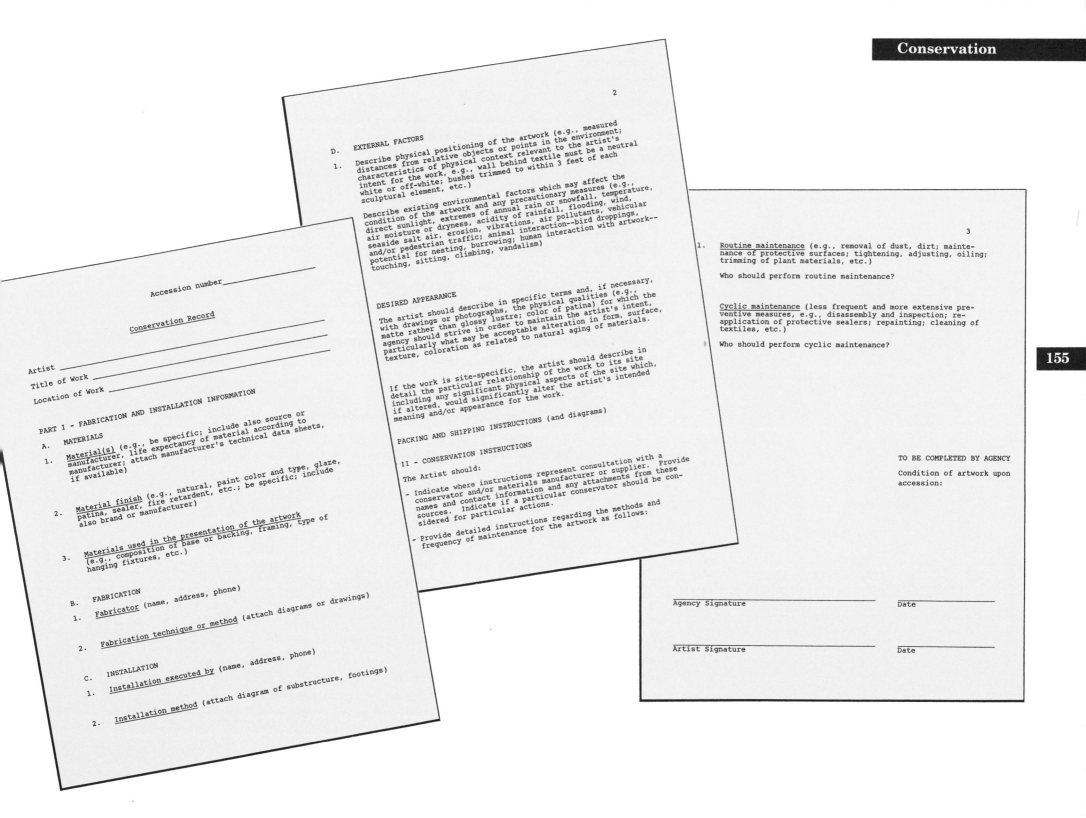

Accession number _____

Conservation Record _____

Artist _____
Title of Work _____
Location of Work _____

PART I - FABRICATION AND INSTALLATION INFORMATION

A. MATERIALS

1. Material(s) (e.g., be specific; include also source or manufacturer; life expectancy of material according to manufacturer; attach manufacturer's technical data sheets, if available)

2. Material finish (e.g., natural, paint color and type, glaze, patina, sealer, fire retardent, etc.; be specific; include also brand or manufacturer)

3. Materials used in the presentation of the artwork (e.g., composition of base or backing, framing, type of hanging fixtures, etc.)

B. FABRICATION

1. Fabricator (name, address, phone)

2. Fabrication technique or method (attach diagrams or drawings)

C. INSTALLATION

1. Installation executed by (name, address, phone)

2. Installation method (attach diagram of substructure, footings)

2

D. EXTERNAL FACTORS

1. Describe physical positioning of the artwork (e.g., measured distances from relative objects or points in the environment; characteristics of physical context relevant to the artist's intent for the work, e.g., wall behind textile must be a neutral white or off-white; bushes trimmed to within 3 feet of each sculptural element, etc.)

Describe existing environmental factors which may affect the condition of the artwork and any precautionary measures (e.g., direct sunlight, extremes of annual rain or snowfall, temperature, air moisture or dryness, acidity of rainfall, flooding, wind, seaside salt air, erosion, vibrations, air pollutants, vehicular and/or pedestrian traffic; animal interaction--bird droppings, potential for nesting, burrowing; human interaction with artwork-- touching, sitting, climbing, vandalism)

DESIRED APPEARANCE

The artist should describe in specific terms and, if necessary, with drawings or photographs, the physical qualities (e.g., matte rather than glossy lustre; color of patina) for which the agency should strive in order to maintain the artist's intent, particularly what may be acceptable alteration in form, surface, texture, coloration as related to natural aging of materials.

If the work is site-specific, the artist should describe in detail the particular relationship of the work to its site which, including any significant physical aspects of the site which, if altered, would significantly alter the artist's intended meaning and/or appearance for the work.

PACKING AND SHIPPING INSTRUCTIONS (and diagrams)

II - CONSERVATION INSTRUCTIONS

The Artist should:

- Indicate where instructions represent consultation with a conservator and/or materials manufacturer or supplier. Provide names and contact information and any attachments from these sources. Indicate if a particular conservator should be considered for particular actions.

- Provide detailed instructions regarding the methods and frequency of maintenance for the artwork as follows:

3

1. Routine maintenance (e.g., removal of dust, dirt; maintenance of protective surfaces; tightening, adjusting, oiling; trimming of plant materials, etc.)

Who should perform routine maintenance?

Cyclic maintenance (less frequent and more extensive preventive measures, e.g., disassembly and inspection; reapplication of protective sealers; repainting; cleaning of textiles, etc.)

Who should perform cyclic maintenance?

TO BE COMPLETED BY AGENCY

Condition of artwork upon accession:

Agency Signature _____ Date _____

Artist Signature _____ Date _____

155

should be flexible and responsive. If possible, the agency, artist, and/or conservator should evaluate the adequacy of the maintenance plan after an appropriate period of time has passed. If necessary, adjustments can then be made in the maintenance plan.

Conserving existing public artworks
Examination

The William Tarr sculpture is symbolic of the many public artworks created ten or more years ago that are now showing signs of neglect and aging. An even larger collection of artworks—the uncounted thousands of historical/ commemorative works created over the last century—have waited even longer for expert conservation and are now commanding formal *examination* of their condition and conservation needs.

The vast collection of historical works in the city of Philadelphia is an instructive example. In 1982, the Fairmount Park Art Association (which has stewardship over all the city's public monuments, as well as within the boundaries of Fairmount Park) organized a conservation program to identify those sculptures in need of conservation attention. Steps in the development of the program included:

— a survey to assess the condition of a targeted group of artworks;
— an evaluation of the various conservation methods then available and the controversies surrounding some of those methods;
— the selection of a conservator who could deal sensitively with the needs of the particular works at hand; and
— the establishment of treatment priorities.

These steps are discussed in greater detail in "Choreography and Caution: The Organization of a Conservation Program."

See Appendix.

The Fairmount Park experience, as well as several other similar programs, underscore the fact that evaluating the condition of public artworks should not be deferred until the artworks have experienced serious damage or deterioration. In fact, a schedule of regular examinations should be established to prevent such damage from occurring.

How often should a formal examination be conducted? The first such examination should be performed by the agency (in concert with the artist, if possible) upon the agency's acquisition of the work. Some agencies build such a formal examination into their acquisition process so that problems resulting from poor workmanship, shipping and handling, or inadequate installation can be identified before title is formally transferred.

Subsequent examinations should be performed at reasonable intervals, with the frequency established (where possible) either by the artist or by a professional conservator and, of course, whenever the work is abused or otherwise damaged.

Who should conduct examinations? Day-to-day changes in an artwork can and should be monitored by on-site maintenance personnel who have been instructed in what to look for. However, formal examinations should be carried out using a condition report form to ensure consistency of observations. Such condition report forms should be prepared by a conservation professional in order to solicit information specifically relevant to the fabrication, materials, surface, and site of the artwork in question. Condition reports should then be prepared periodically by a conservator who can often identify problems not apparent to the layman. Early identification of impending problems can avoid costly repairs later.

The Seattle Arts Commission, for example, employs Artech, a fine arts handling service with expertise in preservation techniques, to perform the majority of its conservation work.

The condition report is *not* generally used to specify conservation treatment. A *treatment proposal* is a separate step which may take a number of additional factors—the pros and cons of various conservation methods, the opinion of the artist, and cost factors—into consideration.

"Economic considerations always play a role in conservation decisions," explains conservator Virginia Naudé, "and you have to establish a list of priorities." The conservation treatment ultimately selected by the Fairmount Park Art Association, for example, was the one which was determined to be the most cost-effective. It enabled a larger number of sculptures to receive some treatment—and thereby be protected against further deterioration—rather than performing comprehensive restoration of a smaller number. In other words, some kinds of treatment, such as the removal of unsightly but stable repairs previously made, were not done in cases where such a condition was not detrimental to the work.

See "Choreography and Caution: The Organization of a Conservation Program," Appendix.

Preservation and maintenance

As noted earlier, *preservation* is an effort to stabilize (or otherwise control) an artwork and/or the environment surrounding it. The overriding principle, again, is to preserve as much as possible the artist's original vision for the work. That vision may well include transformational processes which should be taken into account in any program of preservation and maintenance.

The National Park Service's Cultural Resources conservation plan defines three kinds of maintenance. *Routine maintenance* includes the removal of accumulated dirt, the maintenance of protective surfaces (e.g., through waxing), and such mechanical activities as tightening, adjusting, and oiling. With proper demonstration and documented instructions by either an artist

157

Sculpture conservator Virginia Naudé, center, describes the restoration process being used for the terra cotta sculpture of Hahnemann University founder, Dr. Constantine Hering. The sculpture is being steam-blasted to restore its original reddish brown color.

"You can take two objects that are exactly the same. One of them can go into a museum and have a controlled temperature and have conservators cleaning it with Q-tips. The other can go into a public building and be bashed by a janitor's mop. One person sees their role as being that of preserving culture for posterity. The other sees this as an enormous burden that is conspicuously out of place in the landscape and demands a lot of extra trouble."

Alexis Smith, artist

or conservator, most such "housekeeping" activities can safely be performed by conscientious laypeople. Some types of graffiti may even be removed by maintenance personnel, but only if appropriate solvents and methods are determined by a conservator.

Generally performed less frequently, *cyclic maintenance* usually involves more extensive treatment, such as disassembly, inspection, barrier application, and repainting. The conservation record should indicate who may perform these activities. Commonly, the artist's contract gives the artist first opportunity to carry out these critical maintenance functions, including repairs or restoration, at a reasonable fee. If the artist is unavailable, such functions should be performed by a conservator or a conservator-supervised technician or layperson.

Budgetary constraints often influence who provides regular care. As Penny Balkin Bach of the Fairmount Park Art Association explains, "We are now considering educational seminars for select groups of maintenance workers in our city, because there is a level at which it is cheaper and possibly more effective for the people who are right there to take care of routine tasks—especially if they know more about what they should and shouldn't do." Conservator Virginia Naudé qualifies, "The approach of training maintenance workers is better than nothing. It is *not* an alternative to funding a longer-term solution—that is, having access to a conservator who periodically becomes involved and responsible for maintenance and documentation and who can specify or carry out restoration as required."

Because there are no training facilities for the specific conservation requirements of artworks in the subtropical climate of Miami, the Metro-Dade Art in Public Places program is exploring the development of the Subtropical Conservation Institute in collaboration with local university and college programs. The public art collection would be used by the institute as a sort of laboratory, under the direction of professional conservators and in conjunction with the artist when possible.

Restoration: general principles

Restoration, as previously noted, is the treatment of deteriorated or damaged artwork to approximate as nearly as possible its original (or artist-intended) form and function, with minimal further sacrifice of aesthetic and historic integrity.

As we discuss this most interventionistic mode of conservation, it is worthwhile to reflect on the nature and status of the art conservation field. Professional conservators adhere to a code of ethics, which outlines their guiding principles for the practice of conservation. Among these principles are respect for the integrity of the artwork, and

reversibility—avoiding the use of materials or techniques which cannot be undone.

In addition, the code states that "in compensating for damage or loss, a conservator may supply little or much restoration, according to a firm previous understanding with the owner or custodian, and the artist, if living. It is equally clear that he cannot carry compensation to the point of modifying the known character of the original."

Beyond these general principles, however, there is much debate about which of the currently available treatment techniques is most appropriate, even with a standard material like bronze. As Dan Riss, conservator with the National Park Service, stated at a 1985 conference of conservators, "The question of how an outdoor bronze is supposed to look is not an easy one. Artists have sometimes wanted their work to be maintained like new; others do not mind a certain amount of weathering and may even prefer their work to change with time."

He further notes that the preservation of a public artwork involves a "constellation of interrelated and interdependent attributes." An artwork, in addition to being a product of a particular artistic sensibility and talent, is also a symbol and an industrial product, and the preservation of one of these aspects may not be relevant to, or compatible with, the needs of other aspects. For example, what is good for the material may not result in the most desirable appearance, from an aesthetic viewpoint. According to Riss, it is the job of the conservator—trained in art, art history, and chemistry—to try to balance these various interests in determining the best restoration approach.

The treatment of a traditional material like bronze, which has been used for public sculptures for thousands of years, can nevertheless raise heated debate among conservators because reliable information about the long-term effects of many treatments and coatings in our aggressive outdoor environment is not yet available. It is no wonder, then, that the conservation field cannot responsibly recommend standard treatments for conserving the range of old and new materials and art forms in contemporary public art, including earthworks and landscape elements, neon and laser lights, sounds, and plastics.

Who should be involved in restoration decisions and implementation? Even given the limitations of the conservation field vis-à-vis public art, it is still important to call upon a conservator's knowledge and sensibility, whenever possible. The agency should refer to the Conservation Record completed by the artist to see if a particular conservator has been recommended. If not, the agency should seek one whose expertise is most closely aligned with the nature of the materials involved and with the intent of the artist. The conservator then assesses the condition of the artwork and makes a

"Our profession has not developed to the point where we can serve the public art community in all the ways they have a right to expect from us. There are relatively few conservators who specialize in this area and fewer who work with regular scientific support to evaluate treatments and coatings. We must be very cautious and can only say with certainty what should not be done. Outdoor conservation is still very much tied to the ways of museums. The code of ethics and standards of practice were developed by painting conservators. These are all issues we are addressing within the conservation fields."

Virginia Naudé, conservator

See American Institute for Conservation Code of Ethics and Standards of Practice, Bibliography.

See "Managing the Care of Outdoor Metal Monuments by the National Park Service," Bibliography.

159

proposal to the agency specifying a program of repairs, including schedule and fees.

Agencies should also seek to involve the artist. The artist's contract should reflect the extent to which the artist wishes to be involved. Joyce Kozloff recounts, "A work of mine at the Harvard Square Subway Station in Cambridge is over a river. During the winter, freezing and thawing of the river can cause cracks in the subway walls. Control joints are set at stress points to prevent cracking, but one stress point was missed. During a cold winter, a vertical crack developed which went through my tiles. Because there was a good contract and everyone was concerned, the tiles were removed, a cut was made through the wall, a control joint was inserted, and new tiles replaced the old ones. I was adequately reimbursed for my time and expense." The Arts On The Line standard maintenance contract addresses this point as follows:

"All repairs and restorations which are made during the lifetime of the Artist shall have the mutual agreement of the Authority and the Artist, and shall be based upon the recommendations and estimates of an appropriate impartial conservator. To the extent practical, the Artist shall be given the opportunity to accomplish said repairs and restorations at a reasonable fee. If the Authority and the Artist cannot agree regarding repairs, then the Authority may accomplish such repairs as it deems necessary. In that event, the Authority agrees to no longer represent the work as that of the Artist, upon receipt of a written request to that effect from the Artist."

Vandalism

Vandalism is a constant concern and a recurrent public issue. Unfortunately, it is often not until serious damage has been done that protective measures are taken. For example, eight monumental paintings on the commercial concourse of the Empire State Plaza in Albany, New York, were brutally slashed by a vandal several years ago. At that point, knee-high barriers and an electronic security system were installed—progress, to be sure, but still a modest degree of protection for a publicly-funded collection of contemporary paintings valued at over $12 million.

Artwork in a public setting is obviously more vulnerable to vandalism than artworks in private settings, and much of the restoration energy expended on public artworks is spent undoing acts of vandalism. While the issue is complex, there are a number of practical preventive measures, such as the following, which have proven effective against vandalism:

— placement of the work in a visible location;
— lighting the work at night;

See "The Empire State Plaza Collection," Bibliography.

— the use of conservator-approved and vandal-proof protective coatings on sculptures;

— the involvement of the community in the public art process;

— and in particularly vulnerable areas, the alerting of the police to the presence and value of the artwork, and the requesting of attention by patrols.

Such measures should be considered jointly by the agency and the artist, with care being taken that vandal-prevention steps don't threaten the integrity of the artwork. A fabric hanging in an interior setting may need to be seen at eye-level to appreciate its texture and detail. A clear plastic barrier would certainly protect such a piece, but it might also destroy an intimate viewing experience which the artist intended.

No measure or even combination of measures results in a vandal-proof art-work. If and when a work is vandalized, it is imperative to restore the work as quickly as possible. A work that is allowed to linger in such a state is significantly more vulnerable to further damage. And the public may perceive a lack of care—rightly or wrongly—as a statement that the art-work is not worth preserving.

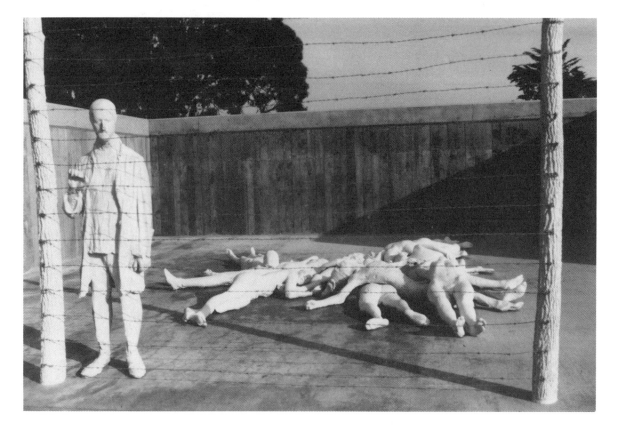

George Segal, *The Holocaust,* Legion of Honor Park, San Francisco, 1984.
photo: Debra Lehane

Summary

For a variety of cultural, historical, and economic reasons, the conservation of contemporary artworks should be a primary concern of sponsoring agencies, and well before a given collection starts to age and deteriorate.

First, public art embodies the history and values of a culture. As symbols of our culture, public artworks deserve protection. Second, as public assets, public artworks are an investment (often of public monies) which must be conserved. If well cared for, public artworks are more likely to appreciate in value. And finally, preventive maintenance is almost always more cost-effective than restoration after the fact.

While many of the current methods for examination, preservation, and restoration of public artworks need to be improved upon, the conservation field offers a systematic approach to evaluating conditions, a way of carefully considering the ramifications of treatment, and a set of established standards by which to assess proposed treatments.

Most conservation specialists are quite willing to take direction from the most appropriate authority, that is, from the artist. As Virginia Naudé notes: "We really only respond to what the artists require. We are very much guided by the contemporary artist, and what he or she anticipates. When the artist is alive, the contribution of the conservator is assuring the continuity and standards of maintenance. When the artist is dead, one of our chief responsibilities is to ensure that the artist's intent survives."

Continuity can only grow out of effective planning. Once again, therefore, the conclusion is that the sponsoring agency must create an environment in which foresight is encouraged. In such an environment, the artist can work with appropriate conservation specialists, as well as with the sponsoring agency, to define well in advance how maintenance and conservation techniques can be applied to a given artwork.

See "Deaccession Practices in Museums," Bibliography.

In the museum world, deaccessioning—the removal of works from a collection—has undergone intensive scrutiny and reevaluation in recent years. As Stephen Weil noted in a 1987 article, deaccessioning was considered at least questionable, and possibly unethical, as recently as a generation ago. After all, the argument went, museums are the preservers of our culture, and the relinquishment of *any* object could be construed as a violation of the mission of the institution.

But this attitude no longer prevails as the realities of growing collections intrude. Larger collections demand more storage space, increased maintenance funds, and additional staff time. Moreover, collection philosophies sometimes change, and previous acquisitions can become a bad fit within the new collection framework. Recognizing the limits on their resources and the obligation to actively acquire new works, most museums now view the removal of existing works as both practical and responsible when guided by very rigorous review processes.

The removal of a public artwork is far more complicated, and if anything, the stewardship implications must be considered even more carefully. Nevertheless, there are sometimes compelling reasons to consider the removal of a public artwork.

Vulnerability to the physical environment is an obvious one: Lacking the security of limited access, climate controls, and guards, public artworks are subjected to all the hazards of the elements, pollution, and vandals. Several such cases, including St. Gaudens's Farragut monument, Ed McGowin's *Inscape*, and Richard Fleischner's *Chain Link Maze*, have been cited earlier (see Threats and Rights). The St. Gaudens sculpture, for example, raises questions of how environmental changes may alter the work in such a way that it no longer reflects the artist's intent. All three examples raise the issue of maintaining the integrity of the artwork (through ongoing conservation efforts) and reveal the problems inherent in protecting the artist's reputation in the face of a deteriorating work.

Changes in ownership or use of sites can also jeopardize artworks. In the case of Ed McGowin's *Inscape*, the sculpture was commissioned by the first owner of a building, a developer who was interested in and committed to the arts. The work was later vandalized while under a new owner who refused to restore the sculpture, and ultimately removed it.

Of course, the *use* of a given building may also change, even without a corresponding change in ownership. An artwork conceived in the context of a particular constituency can lose its contextual meaning if that constituency is removed.

Few effective safeguards against such events exist in the private sector. Even in cases when private sector entities cooperate with public agencies to commission artworks, safeguards are often difficult to enforce. Moral rights laws,

See "Public Art and Public Policy," Appendix.

contractual provisions between the artist and the commissioning entity, or covenants passing on responsibility for the care of artwork to new owners may prove the best means of protecting artists and their works in cases where no other laws are applicable.

And finally, *adverse reaction* to a public artwork, whether by the public, site users, or even the sponsoring agency, is the most complicated and controversial catalyst for the removal of public artworks, with Richard Serra's *Tilted Arc* being a notable example.

Gaining a perspective on controversy

Although recent controversies about public artworks have garnered much media attention, such controversies are not a new phenomenon. Perhaps the classic case concerns Rodin's *Monument to Balzac*, commissioned by the National Literary Society in 1871. Rodin's unconventional depiction of Balzac shocked both the Society and the public at large. One critic likened the sculpture to a large side of beef; another suggested that the work represented Balzac in his morning robe fending off creditors. Most observers agreed that Rodin's "crude sketch" was an unworthy artistic summation of Balzac's genius.

Today, of course, *Monument to Balzac* is considered one of Rodin's finest works and commands a significant position in art history. A plausible conclusion is that the criticisms by an artist's contemporaries may not always prove to be enduring.

In contemporary public art, there are numerous examples of works which endured a hostile public reception, only to be embraced at a later juncture. The classic case here is Alexander Calder's *La Grande Vitesse*, in Grand Rapids, Michigan. (See introductory section, Stretching the Terrain: Sketching Twenty Years of Public Art.) Other cases abound where controversy subsided and the public is now reconciled to the artwork, for example, Carl Andre's *Stone Field Sculpture*, commissioned in Hartford, Connecticut in 1977, or Michael Heizer's *Adjacent, Against, Upon*, commissioned in Seattle in 1975.

History suggests, therefore, that proposals to remove or relocate public artworks must be very carefully considered, particularly when *aesthetic* objections are being cited. Unfortunately, in the present, such careful consideration has been the exception, rather than the rule.

For example, artist Alan Sonfist's *Time Landscape of St. Louis*, a dense planting of native Missouri trees atop a shaped mound of earth and surrounded by a formal French garden in downtown St. Louis, was completed in 1986. Sonfist conceived of the work as a "poetic metaphor," symbolizing the city's natural history and French heritage. In October of 1987, as

Robert Arneson, *Portrait of George*, collection of Foster and Monique Goldstrom, Oakland, California, 1981.

reported in the November 2 *New York Times*, the work was leveled by a city bulldozer after the St. Louis Parks Department had declared it a public eyesore. The city's public art policy specifically required a formal review of all proposed removals of artworks; nevertheless, the parks department made a unilateral decision to destroy the work, without consultation with the artist.

A similar unilateral action was taken by the mayor of San Francisco, Diane Feinstein, who ordered the removal of a work by Robert Arneson. Arneson had created a commemorative bust of Feinstein's assassinated predecessor, George Moscone. Included in its imagery were references to Moscone's assassin and the murder weapon. These references were deemed offensive and inappropriate, and the bust was removed.

The roots of controversy

These examples underscore two more key responsibilities of the sponsoring agency: first, to anticipate that controversy may well be part of the public art process; and second, to help resolve any controversies that do erupt in a constructive manner. The effective management of controversy may well preclude a protracted (and perhaps acrimonious) review process.

Obviously, then, the key is to understand the roots of the controversy. As public art administrator Sande Percival noted at the Public Art in America conference (sponsored by the Fairmount Park Art Association in Philadelphia, October 1987), not all public art controversies are anti-art or even anti-bureaucratic. At times, issues essentially unrelated to art may fuel debate. In one situation, for example, employees working in a state office building expressed outrage at the cost of a particular artwork recently sited in their building. It later emerged that the state workers had been negotiating unsuccessfully for pay increases and a link had been forged in their minds between their own financial situations and the money allocated to the artwork.

In fact, artworks often serve as lightning rods. "Artists are used to weathering changes of taste," notes artist Alexis Smith. "In the public arena, not only do you have changes of taste, but you have changes of priority, changes of funding, changes of administration, and political scapegoating. All of a sudden, public art becomes a focus for the alienation of the people around it. It doesn't really have anything to do with the artwork. It's just an opportunity."

Earl Blumenauer, commissioner of public works for the city of Portland, Oregon, agrees. At the 1987 convention of the National Assembly of Local Arts Agencies, Blumenauer (a former county commissioner and Oregon state representative) articulated the need for public art administrators to

"You cannot betray the confidence of the artists who are subjected to enough cruelty during the selection process. Once the selection is made, it should stick."

George Segal, artist

165

work closely with politicians. According to Blumenauer, this working relationship entails two principal responsibilities: first, to educate community leaders from the very beginning of a project or program; and second, to respond appropriately to controversies arising in response to specific works.

Removal policies and procedures

Any proposal to remove a public artwork touches on a number of complex issues. These include: definitions of (and responsibilities to) the "public trust," freedom of artistic expression, the integrity of the work in question (and, by extension, the artist's reputation), and contractual obligations. A second broad class of contextual considerations may also be involved, such as the sorts of changes in the physical environment outlined earlier. Given this inherent complexity, it is clear that any proposal to remove a public artwork must proceed according to clearly defined policies and procedures.

The Public Artwork Review Process presented in this section was drafted by participants in the 1987 Public Art Policy Project of the National Endowment for the Arts. It attempts to recognize both the rights of the artist and of the community that interacts with the artwork. Although prompted in part by a recent spate of community-inspired removals of public artworks, the review process which follows is intended to guide reviews inspired by a variety of causes, as outlined in the document.

Summary of the review process

The accompanying review process is guided by several key principles, outlined in its statement of policy. In brief, those principles suggest that:

— Any work of public art should come into being through a process both informed by professional judgment and sensitive to the interests of the public. The conception and implementation processes should be guided by carefully developed policies and procedures;

— Any proposal to remove or relocate an artwork should be reviewed according to equally deliberate policies and procedures in order to protect that work against short-term political pressures and fluctuations in public taste;

— Throughout this process, the sponsoring agency's primary concern should be to assure continuing access to the work by the public (emphasizing that the essential quality of public art is that it is accessible to the public).

The review process itself should be triggered by the sponsoring agency. The sponsoring agency should determine if there is an appropriate course of action other than relocation or removal which will resolve the problem at hand. This "in-house" process should include a review of the artist's

This Public Artwork Review Process was created by a national task force of recognized artists, public art administrators, design professionals, urban planners, lawyers, and conservators as a primary concern of the Public Art Policy Project initiated by the Visual Arts Program of the National Endowment for the Arts. It addresses issues of removal and relocation of public artwork through policy and procedures which protect the integrity of the artwork and the process that brought it into being, while keeping in perspective reasonable rights of the community, owner, and the artist. As with any model, these guidelines are meant to be examined and, perhaps, modified to meet the needs of a particular public art program.

Annotations, unless attributed, reflect the general direction of discussions of task force participants.

Looking at historic preservation, one finds that the economic value and sheer construction costs protect a building from demolition in its early years. Therefore, rules were designed to consider for preservation only those buildings with a history of 30 years or more. However, for most public artwork, the first few years are the most fragile because of the potential for public controversy, the smaller scale of art, and its lesser cost.

PUBLIC ARTWORK REVIEW PROCESS

I. OBJECTIVES

 A. To establish an orderly process for reviewing the status of public artwork.

 B. To establish a procedure for removal or relocation of public works of art.

II. POLICY

Public artworks generally enter the public environment through a careful process informed by the best available professional judgment and advice from affected public interests. They are created by artists specifically for the public context.

In all circumstances, sponsors of public art should seek to insure the ongoing presence and integrity of the work at the site for which it is created, in accordance with the artist's intention. The sponsoring agency's primary concern should be to assure continuing access to the work by the public.

Public art has a long, historical tradition of controversy. Review of the status of a public artwork should be undertaken cautiously, in order to avoid potential influence of fluctuations in taste and the immediate pressures of public controversy. A work should not be removed from public view simply because it is controversial or unpopular. A decision may implicate basic questions of public trust, freedom of artistic expression, censorship, contractual obligations, copyright, moral rights, and the integrity of the artwork.

Consideration of removal should involve the same degree of careful review as a decision to sponsor a work; informed by professional judgment and the interests of the public and proceeding according to carefully developed policies and procedures. Generally, removal should be considered only when a work has been in place for ten years. In the case of temporary work, generally removal or relocation should not be considered before a work has been in place for 60% of its anticipated life span. Criteria for reviewing public art should address the quality of the work itself as representative of its style or genre, and its relation to the public context.

①

"In the field of public art, we have a narrow perspective in terms of timing. The ten-year time span frightens me when I think of historic collections. I would rather err on the side of more time than less. Ten years may be too short. There are far too many examples of great works lost due to precipitous actions-- twenty, fifty, even 100 years later."
 Public art administrator

The ten-year figure is felt to be a long enough period to allow emotion to subside and for the work to stand the aesthetic test of time, but short enough a period that public concerns would be dealt with in a foreseeable future. The figure of ten years would not necessarily apply to concerns which might be better dealt with in a shorter time span, such as public safety or the work being irreparably damaged. Ten years should be seen as an absolute minimum guarantee.

The chief administrative officer has to weigh the legitimacy and merit of the original request to remove or relocate the artwork--the volume and nature of phone calls, articles in the newspaper, if excessive maintenance has been required--and determine the appropriateness of the request.

The agency has a responsibility for public display of public artworks. This is only a viable reason if the agency cannot suitably display the work, for example, if a work was purchased for a portable collection without thought to proper site or a work is too fragile to continue in its current site. An alternative like trading the work for another by that artist or selling the work may be a reasonable thing to do.

This could become a catchall. "Suitable site" could be used too loosely.

"There are often a number of feasible sites but the people at that site won't take the artwork."

Artist

The artist's contract should spell out what changes in the character or design of the site s/he feels affect the integrity of the artwork (see Conservation Record, previous Section), and/or give the artist a role in making sure the work's integrity is protected in the event of such changes.

Note that it is the sponsoring agency and not the owner agency that makes the determination. In other words, it is the body which recommended initial acquisition of the work. In the case of a state percent for art program, for example, in which the state arts council commissions artwork, it would be the state arts commission which would determine the merit of the request to further consider removal or relocation of a public artwork. It is not the agency receiving the artwork nor the funding source, if different.

(See discussion of warranties, Contracts Section.)

What is significant? What is an extended period of time? These terms need to be defined. For the purposes of this draft these are open questions. The aim here is to allow a legitimate vehicle for public concern. However, the intent is not to activate this review process at the first blush of public controversy.

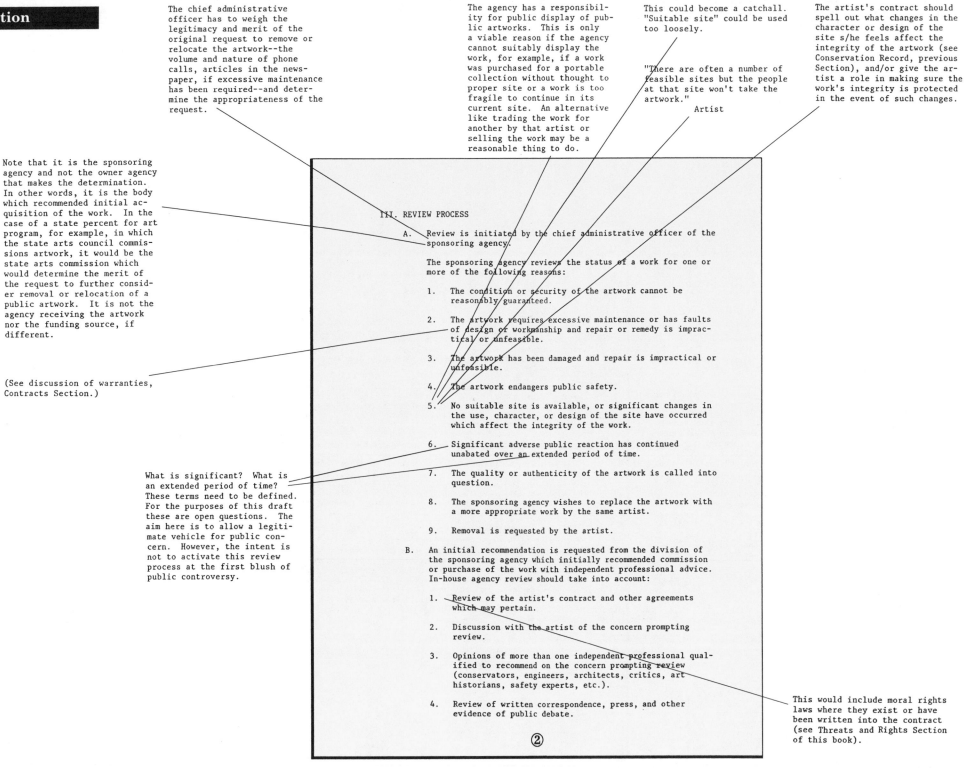

III. REVIEW PROCESS

A. Review is initiated by the chief administrative officer of the sponsoring agency.

The sponsoring agency reviews the status of a work for one or more of the following reasons:

1. The condition or security of the artwork cannot be reasonably guaranteed.

2. The artwork requires excessive maintenance or has faults of design or workmanship and repair or remedy is impractical or unfeasible.

3. The artwork has been damaged and repair is impractical or unfeasible.

4. The artwork endangers public safety.

5. No suitable site is available, or significant changes in the use, character, or design of the site have occurred which affect the integrity of the work.

6. Significant adverse public reaction has continued unabated over an extended period of time.

7. The quality or authenticity of the artwork is called into question.

8. The sponsoring agency wishes to replace the artwork with a more appropriate work by the same artist.

9. Removal is requested by the artist.

B. An initial recommendation is requested from the division of the sponsoring agency which initially recommended commission or purchase of the work with independent professional advice. In-house agency review should take into account:

1. Review of the artist's contract and other agreements which may pertain.

2. Discussion with the artist of the concern prompting review.

3. Opinions of more than one independent professional qualified to recommend on the concern prompting review (conservators, engineers, architects, critics, art historians, safety experts, etc.).

4. Review of written correspondence, press, and other evidence of public debate.

②

This would include moral rights laws where they exist or have been written into the contract (see Threats and Rights Section of this book).

These agencies should be competent, third party, nonprofit organizations which are of and/or in the community of interest--but not having vested interests such as: historic preservation leagues, urban planning departments, local universities, museums, arts service organizations, artists' coalitions, or volunteer support groups which are accustomed to balancing public, special and governmental interests (see "Public Art and Public Policy," Appendix).

The panel that makes the decision should not be composed of individuals with vested interests; that is, it should not include the artist, project architect, representatives of the commissioning agency, or the individual or group which made the original request to remove or relocate the artwork. The panel should, however, make decisions informed by the perspectives of those with vested interests.

C. A recommendation specifying reasonable measures to address the concern prompting review is forwarded to the sponsoring agency administrator.

Note: In the case of an arts commission or public body, such a recommendation should be reviewed at an open public meeting, and the review placed on the agenda in advance. The decision should be by two-thirds vote of the voting members.

Should the sponsoring agency determine that reasonable measures to resolve the concern prompting review have been taken in good faith and have failed to resolve the concern, and removal must be considered, then the agency shall ask a competent but disinterested third party nonprofit organization to assist it by designating a panel of disinterested persons qualified to make a final determination. The selection of the mediating organization should be by mutual consent of the parties to the dispute. The panel should include a balance of viewpoints from the fields of: visual art (artists, curators, art historians, arts administrators, urban planners), designers (architects, landscape architects, preservationists, arts or public interest lawyers, community (policy analysts, arts or public interest lawyers, social psychologists, policy analysts, community activists).
The panel should review these points:

1. Assess whether the sponsoring agency was correct in its determination that reasonable efforts to resolve the concern were taken in good faith and have failed to resolve it. The panel should explore first whether measures to resolve the concerns short of removal can be taken, and if so, make recommendations to the sponsoring agency.

2. If the panel recommends specific measures to resolve the concern short of relocation or removal, the sponsoring agency shall be given a reasonable time to carry out the recommended measures.

If these measures are then unsuccessful, the sponsoring agency must again certify to the panel that those measures have not resolved the concern. Then the panel shall consider, in order of priority, the following:

a. Relocation. If the work was created for a specific site, relocation must be to a new site consistent with the artist's intention. The artist's assistance and consent will be required.

③

b. Removal of the work from the collection by sale, extended loan, trade, or gift. Three independent professional appraisals of the fair market value of the work are obtained to inform further decisions at this point.

 i. If feasible, the artist should be given first option on purchase.

 ii. Sale may be through auction, gallery resale, or direct bidding by individuals.

 iii. Trade may be through artist, gallery, museum, or other institutions.

 iv. Proceeds from the sale of the work of art should be deposited into an account to be used for future public art projects. Any pre-existing contractual agreements between the artist and the (Responsible Agency) regarding resale shall be honored.

c. Destruction of the work.

D. The panel's decision should be returned to the sponsoring agency and taken as final and binding as a resolution of the concern prompting review.

E. The process and decision should be documented by the sponsoring agency.

④

"A curator puts his or her career on the line every time a decision is made to de-accession a work of art. The same is going to be true for the public art agency."
 Conservator

The formal process for choosing an arbitrator used by the field of labor arbitration may provide a useful model in composing an impartial review panel for public art review. In this model, a list of prospective arbitrators (panelists) qualified to review the nature of the dispute is prepared by a specially designated staff person of the American Arbitration Association (third party nonprofit organization). The list is then reviewed by the adversarial parties and either party may cross off any names to which it objects. Where parties are unable to find a mutual choice of an arbiter (panel members), the Association (third party organization) appoints the panel. In no case, however, will an arbitrator (panel member) whose name was crossed off by either party be appointed. (See "Labor Arbitration Procedures and Techniques," American Arbitration Association, Bibliography.)

contract, discussions with the artist, and consultation with appropriate
arts professionals.

Should the sponsoring agency determine that reasonable measures to
resolve the conflict have proven unsuccessful, then that agency's
administrators should seek the assistance of a disinterested third-party
entity to assist in making a final decision.

Final thoughts

The review process outlined in this section offers safeguards to afford due
process to both the artist and the artwork. In this context, it is important to
consider once again the artist's contract.

Several of the case studies presented in this book have illustrated the need
for contractual provisions which protect the integrity of the artwork. As
a prospective task, that is, having the artist and representatives of the spon-
soring agency sit down at the table to hammer out a contract which
anticipates possible turns of events, this may seem unrealistic and unneces-
sary. Recent history suggests, though, that any such investment of time is
well worth the effort.

Obviously, no contract negotiation can make provisions for *all* possible out-
comes for an artwork in a changing public context. But both parties should
certainly articulate their expectations regarding the permanence of the
work. They should also speak explicitly about whether the artistic intent of
the artwork depends on its exact position on the proposed site, or whether
relocation is a possibility, and if so, under what circumstances. These
expectations should be reconciled and represented in the final draft of the
contract.

Once again, the review process underscores the critical importance of
the process which brings the artwork into being; specifically, how the artist
is selected and how the community is actively engaged in the project
or program. The point is that the artwork is ultimately better protected by
attending to these concerns.

But as noted earlier, *change* is the only constant in the realm of public
art. A dialogue about a given artwork may clarify that process of change and
does so in terms of the relationship between the artwork and its host
community. Art consultant Patricia Fuller offers one last thought:
"If we emphasize the role of the community in the process of public art—that
is, that public art is a dialogue between the artist and the community—
then at a certain point, the arts agency has got to let go. At a certain point,
the public has to participate meaningfully in an orderly process which
entertains all the different interests, and finally in the disposition of the
work. We have got to let public art succeed or fail on its own terms,
in other words, that it is not in a museum, but in the public environment."

"One thing that is essential to the art experience is some kind of shared values between the artist, the culture, and the person who looks at the work. MacArthur Park was a wonderful opportunity to use art to address some of the social and functional problems which plagued the area. It brought together the merchants and the gangs. Different pieces have different meanings to different people. That's one of the project's successes."

Alexis Smith, artist

Public involvement, including public education, is a crucial element of the preservation process. Evidence from numerous public art programs around the country suggests that an artwork's welfare is greatly enhanced if the public feels a sense of ownership about that work.

Artist Kent Twitchell, whose unfortunate experience with removal of one of his murals was summarized in the Threats and Rights Section, told the *Los Angeles Times* another more heartening story. With the help of members of a neighborhood street gang, Twitchell painted a mural of a Mexican Jesus on the wall of a liquor store. "The piece is being protected," Twitchell noted, "by the Solos gang, whose leaders wanted a Jesus in the area where there had been so many murders. . . . If anyone goes near it, someone is likely to appear from behind an alley and say, 'What's going on?'"

How can this sense of community ownership be instilled and cultivated? The answer lies, in part, in a regular program of educational and promotional activities. Such activities generate a broader community appreciation of public art and a recognition of its place in a community's continuing culture. As already noted (see Community Involvement and Education), there are a number of ways to achieve this goal, including:

— community-based advisory committees;
— artist interaction with the community;
— effective use of the media; and
— special events, such as exhibitions, public art tours, artist-in-residence programs, school programs, publications, and public meetings.

We have already reviewed the rationale for creating ways to ensure the ongoing conservation and review of public artworks. The same arguments can be made for guaranteeing that educational activities have a permanent place in the overall public art program. Elements of an ongoing educational policy should include:

— funding (other than the art budget);
— community representation and participation (both timely and meaningful) in the process of bringing public artworks into being;
— the education of public art planners and participants from participating agencies;
— means for managing public controversy;
— means for working effectively with the media;
— means for promoting the project or program (locally, regionally, and/or nationally; to various audiences, such as the arts community, related professions, and/or the general public; through existing promotional vehicles, such as tourism and local public affairs agencies; and through special promotional opportunities);

— the definition of specific audiences to be reached by educational
activities, such as school children, neighborhoods affected by projects,
public officials, public works employees, etc.;
— the involvement of artists, art educators, and other appropriate profes-
sionals in the design of educational methods and content.

As the preceding pages have suggested, the preservation of public art is not
simply a matter of caring for the physical welfare of the artwork or
of documenting relevant information for posterity. Fundamentally, it is a
process of monitoring and preserving a connection between the artwork
and the community for which it was created, in part through promotion and
education. Kathy Halbreich, in her introduction to this book, aptly
summarized a primary responsibility of the public art planner—that is, to
"place the means and criteria for making substantial judgments in its
[the audience's] hands."

The intent of this book has been to identify and to address current challenges in administration and preservation which confront artists, administrators, and communities as they develop public art programs and individual projects. Two challenges, in particular, which are posed by public art may be reiterated in closing.

That contemporary art itself continues to present a challenge for the viewer is, perhaps, the most obvious obstacle for the artist and the public art administrator. This does not mean that art should be subtley pressured to satisfy expectations. Leaders in science, literature, sociology, health care, politics, or any other field of human endeavor cannot stand still in time. They must remain cognizant of what is relevant and vital to human thought and action in order to serve society's needs, and the artists of this time should be free to genuinely reflect what is here and now. As in other fields where new advances may be difficult to understand but are, nonetheless, respected, we must develop methods of meaningful involvement and education which enable the public to respect that which public art contributes to our lives and culture. Artists through their art can significantly enrich our public spaces and provide beauty, identity, meaning, and formal qualities which engage the viewer in many ways.

A second challenge public art poses is to the traditional design professions. As artists have increased their activity in public spaces, there has been a necessary overlap with architects and landscape architects. But the role of artists is not to conform to another set of imperatives, or to supplant these professionals, but rather to complement—sometimes contradict—their designs. Art provides the surprise that can stimulate fresh perceptions. "We're the random element," observes artist Buster Simpson. "Let's hope we remain the random element, because that's what they're hiring us for."

Appendix

175 Documents

177 Washington State Percent for Art Legislation

184 Downtown Art in Public Places Policy,
Los Angeles Community Redevelopment Agency

201 San Francisco Planning Code for Art
in Public Places

202 Metro-Dade Art in Public Places Master Plan

205 Metro-Dade Art in Public Places
Implementation Guidelines

208 NOAA Fine Arts Program and Chronology

210 New York City Bar Model Artist Agreement

232 Downtown Seattle Transit Project Scope
of Work samples

236 MBTA Arts On The Line Action List

236 "How Public Art Becomes A Political Hot Potato"

240 "How Art Becomes Public"

252 "Art of the Matter"

254 "Ways of Looking: the setting, the audience
and the artwork"

256 "Art & the Law: Moral Rights Comes to New York"

259 Memorandum regarding Artist Fee Structures

260 Accession Ledger and Catalogue Sheets

262 "Choreography and Caution:
The Organization of a Conservation Program"

268 "Public Art and Public Policy"

281 Bibliography

284 Resource List

287 Public Art Programs

288 Government Agencies
295 Nonprofit Organizations
297 Collections, Sculpture Parks, Colleges
298 Private Sponsors

299 Participants

Reprinted by permission of the Washington State
Arts Commission.

Annotations to Washington State's Art in Public
Places legislation, offered by Sandra Percival,
program manager, elaborate on the merits and flaws
in the legislation as well as on the intent of various
sections. For other insights, see the section on Percent
for Art programs.

States intent of the legislation; original language which restricted the program to "public buildings" was made more generic to "public buildings and lands" to provide for the broad pooling intent of the revised legislation.

Establishes that all works of art acquired through the program are part of a "state art collection" under the authority of the Arts Commission. Works of art previously acquired under the program are also to be considered part of the state art collection.

WASHINGTON STATE ARTS COMMISSION REVISED LEGISLATION, 1983

PERCENT- FOR - ART - STATUTES

43.46.090 Commission as reflecting state's responsibilities — Acquisition of works of art for public buildings and lands — Visual arts program established. The legislature recognizes this state's responsibility to foster culture and the arts and its interest in the viable development of her artists and craftsmen by the establishment of the Washington state arts commission. The legislature declares it to be a policy of this state that a portion of appropriations for capital expenditures be set aside for the acquisition of works of art to be placed in public buildings or lands. There is hereby established a visual arts program to be administered by the Washington state arts commission. [1983 c 204 § 1; 1974 ex.s. c 176 § 1.]

Sunset Act Application: See note following chapter digest.

Severability — 1983 c 204: "If any provision of this act or its application to any person or circumstance is held invalid, the remainder of the act or the application of the provision to other persons or circumstances is not affected." [1983 c 204 § 11.]

Allocation of moneys for acquisition of works of art — Expenditure by arts commission — Conditions: RCW 43.17.200.

Colleges and universities, purchases of works of art — Procedure: RCW 28B.10.025.

Purchase of works of art — Procedure: RCW 43.19.455.

School districts, purchases of works of art — Procedure: RCW 28.A.58.055.

43.46.095 State art collection. All works of art purchased and commissioned under the visual arts program shall become a part of a state art collection developed, administered, and operated by the Washington state arts commission. All works of art previously purchased or commissioned under RCW 43.46.090, 43.17.200, 43.19.455, 28B.10.025, or 28A.58.055 shall be considered a part of the state art collection to be administered by the Washington state arts commission. [1983 c 204 § 2.]

Severability — 1983 c 204: See note following RCW 43.46.090.

Establishes a fiscal system by which the Arts Commission becomes the central accounting, contracting, and administering agency for percent-for-art funds. Different states may have different sources of funding for capital projects such as general funds, bonded funds, federal funds, self-sustaining funds, etc. The last sentence provides a 30-day timeline for percent-for-art funds derived from bonds to be made available to the Arts Commission. "Interagency reimbursement" is a state term which means that the Arts Commission bills another state agency for the percent-for-art funds appropriated to their projects in the Capital Budget and the agency transfers the funds to the Arts Commission for expenditure.

Stipulates that all state agencies will allocate one-half of 1 percent from capital projects for works of art. Language revised in 1983 expanded the definition of "state agencies" to include all potential agencies utilizing state funds for capital projects. At the time of revising the legislation, the Convention Center was being built as a "quasi-public corporation" (part state, part private funding). Gives the expenditure authority to the Arts Commission rather than to the generating agency. The term "original" construction has caused some conflict in being interpreted to mean that the ½ percent formula is to be applied only to the construction bid costs rather than to the entire appropriation. (This language could be clearer. A concise statement of what the percent formula applies to is desirable in the legislation to avoid differing opinions and interpretations of the language governing the program.)

Provides that percent-for-art funds shall be used for the administrative costs of the program. (The word "shall" can be problematic as it can be interpreted to mean all costs including overhead, staff, panels, etc. It would be preferable to use the word "may" which would allow for both general funds and percent funds to provide for administrative costs.)

States the broad "pooling" concept by which the works of art may be placed on "public buildings or lands" (public refers to any state agency). This section replaced previous language which permitted pooling of funds within a single state agency but not on an interagency basis.

State Agencies

43.17.205 Purchase of works of art — Interagency reimbursement for expenditure by visual arts program. The funds allocated under RCW 43.17.200, 28A.58.055, and 28B.10.025 shall be subject to interagency reimbursement for expenditure by the visual arts program of the Washington state arts commission when the particular law providing for the appropriation becomes effective. For appropriations which are dependent upon the sale of bonds, the amount or proportionate amount of the moneys under RCW 43.17.200, 28A.58.055, and 28B.10.025 shall be subject to interagency reimbursement for expenditure by the visual arts program of the Washington state arts commission thirty days after the sale of the bond or bonds. [1983 c 204 § 3.]

Severability — 1983 c 204: See note following RCW 43.46.090.

43.17.200 Allocation of moneys for acquisition of works of art — Expenditure by arts commission — Conditions. All state agencies including all state departments, boards, councils, commissions, and quasi public corporations shall allocate, as a nondeductible item, out of any moneys appropriated for the original construction of any public building, an amount of one-half of one percent of the appropriation to be expended by the Washington state arts commission for the acquisition of works of art. The works of art may be placed on public display, integral or attached to a public building or structure, detached within or outside a public building or structure, part of a portable exhibition or collection, part of a temporary exhibition, or loaned and exhibited in other public facilities. In addition to the cost of the works of art the one-half percent of the appropriation as provided herein shall be used to provide for the administration of the visual arts program by the Washington state arts commission and all costs for the installation of the works of art. For the purpose of this section building shall not include highway construction sheds, warehouses or other building of a temporary nature. [1983 c 204 § 4; 1974 ex.s. c 176 § 2.]

States the Arts Commission's authority to determine the funds to be made available and provides for this responsibility to be carried out "in consultation" with the applicable state agency directors.

States that maintenance costs shall be provided from funds other than percent-for-art funds. In Washington's case, maintenance funds cannot come from funds for new projects; similarly, new building construction funds cannot be used for agency maintenance needs such as roof repairs.

Stipulates the same terms as above for state agencies which fall under the Department of General Administration for management of their capital projects.

Severability — 1983 c 204: See note following RCW 43.46.090.

Acquisition of works of art for public buildings and lands — Visual arts program established: RCW 43.46.090.

Purchase of works of art
interagency reimbursement for expenditure by visual arts program: RCW 43.15.205.

procedure: RCW 43.19.455.

State art collection: RCW 43.46.095.

43.17.210 **Purchase of works of art — Procedure.** The Washington state arts commission shall determine the amount to be made available for the purchase of art in consultation with the agency, except where another person or agency is specified under RCW 43.19.455, 28A.58.055, or 28B.10.025, and payments therefor shall be made in accordance with the law. The designation of projects and sites, selection, contracting, purchase, commissioning, reviewing of design, execution and placement, acceptance, maintenance, and sale, exchange, or disposition of works of art shall be the responsibility of the Washington state arts commission in consultation with the directors of the state agencies. However, the costs to carry out the Washington state arts commission's responsibility for maintenance shall not be funded from the moneys referred to in RCW 43.17.200, 43.19.455, 28A.58.055, or 28B.10.025, but shall be contingent upon adequate appropriations being made for that purpose. [1983 c 204 § 5.]

Severability — 1983 c 204: See note following RCW 43.46.090.

43.19.455 **Purchase of works of art — Procedure.** Except as provided under RCW 43.17.210, the Washington state arts commission shall determine the amount to be made available for the purchase of art under RCW 43.17.200 in consultation with the director of general administration, and payments therefor shall be made in accordance with the law. The designation of projects and sites, selection, contracting, purchase, commissioning, reviewing of design, execution and placement, acceptance, maintenance, and sale, exchange, or disposition of works of

Delineates the Arts Commission's responsibilities for program operations and specifies these for all aspects of acquiring works of art for projects under the legislation. These responsibilities are: (a) determination of projects and sites (i.e., if all funds are potentially pooled, the Arts Commission determines what agencies and sites will become projects-- these may or may not correspond to capital projects generating the funds); (b) selection (allows the commission to determine the selection process --direct, invitational, or open competition--and panel according to the program's rules/guidelines); (c) contracting (artist contracts directly with the Arts Commission, and Arts Commission enters into interagency agreement to insure compliance of other agencies with the terms of the contract between the artist and Commission; (d) review of design, execution, placement, and acceptance (determination of compliance with contract and design by Commission); and (e) maintenance, sale, exchange, or disposition (deaccessioning). Provides that all of these responsibilities will be carried out "in consultation" (i.e., Arts Commission is authority but does not work in isolation in its decision-making process) with the state agencies.

art shall be the responsibility of the Washington state arts commission in consultation with the director of general administration. However, the costs to carry out the Washington state arts commission's responsibility for maintenance shall not be funded from the moneys referred to under this section, RCW 43.17.200, 28A.58.055, or 28B.10.025, but shall be contingent upon adequate appropriations being made for that purpose. [1983 c 204 § 6; 1974 ex.s. c 176 § 3.]

Severability — 1983 c 204: See note following RCW 43.46.090.

Colleges and Universities

Provides the same terms as sections 4 & 5 for all university, college, and community college capital projects.

28.B.10.025 Purchases of works of art — Procedure. The Washington state arts commission shall, in consultation with the boards of regents of the University of Washington and Washington State University and with the boards of trustees of the regional universities, The Evergreen State College, and the community college districts, determine the amount to be made available for the purchases of art under RCW 28B.10.027, and payment therefor shall be made in accordance with the law. The designation of projects and sites, selection, contracting, purchase, commissioning, reviewing of design, execution and placement, acceptance, maintenance, and sale, exchange, or disposition of works of art shall be the responsibility of the Washington state arts commission in consultation with the board of regents or trustees. However, the costs to carry out the Washington state arts commission's responsibility for maintenance shall not be funded from the moneys referred to under this section, RCW 43.17.200, 43.19.455, or 28A.58.055, but shall be contingent upon adequate appropriations being made for that purpose. [1983 c 204 § 8; 1977 ex.s. c 169 § 8; 1974 ex.s. c 176 § 4.]

Severability — 1983 c 204: See note following RCW 43.46.090.

Severability — Nomenclature — Savings — 1977 ex.s c 169: See note following RCW 28B.10.016.

Acquisition of works of art for public buildings and lands — Visual arts program established: RCW 43.46.090.

Allocation of moneys for acquisition of works of art — Expenditure by arts commission — Conditions: RCW 43.17.200.

Purchase of works of art — Interagency reimbursement for expenditure by visual arts program: RCW 43.17.205.

State art collection: RCW 43.46.095.

28B.10.027 Allocation of moneys for acquisition of works of art — Expenditure by arts commission — Conditions. All universities and colleges shall allocate as a nondeductible item, out of any moneys appropriated for the original construction or any major renovation or remodel work exceeding two hundred thousand dollars of any building, an amount one-half of one percent of the appropriation to be expended by the Washington state arts commission with the approval of the board of regents or trustees for the acquisition of works of art. The works of art may be placed on public lands of institutions of higher education, integral to or attached to a public building or structure of institutions of higher education, part of a portable exhibition or collection, part of a temporary exhibition, or loaned or exhibited in other public facilities.

In addition to the cost of the works of art the one-half percent of the appropriation shall be used to provide for the administration of the visual arts program by the Washington state arts commission and all costs for installation of the work of art. For the purpose of this section building shall not include sheds, warehouses, and other buildings of a temporary nature. [1983 c 204 § 9.]

Severability — 1983 c 204: See note following RCW 43.46.090.

Common Schools

28A.58.055 Purchase of Works of Art — Procedure. The state board of education and superintendent of public instruction shall allocate, as a nondeductible item, out of any moneys appropriated for state assistance to school districts for the original construction of any school plant facility the amount of one-half of one percent of the

Adds remodeling projects as eligible to the percent-for-art legislation ("original construction" means new construction only).

Provides that the "pooling" of funds may occur between projects and sites within university, college, or community college buildings or lands ("institutions of higher education") rather than between different types of state agencies and universities, i.e., Department of Fisheries funds may be pooled to a university project since universities are "state agencies," but University of Washington funds could not be pooled to the Department of Fisheries since it is not a public building or land within institutions of higher education.

Provides for the roles and responsibilities for projects which are under the State Board of Education and Superintendent of Public Instruction. All of the same terms as sections 4 & 5 apply to the schools.

In Washington, school construction is funded by both state funds and local district matching funds. The percent legislation applies only to the state funds and not to the local district funds. The state has decentralized the operations of the schools to the local district. Thus the application of the percent legislation to the state funds only supports the statewide intent of the current program.

181

States that "pooling" may be applied according to the state constitution. In Washington, the state constitution restricts school construction funds to use at school sites only. In the other sections of the legislation, i.e., applying to state agencies, restriction of the funds is statutory rather than constitutional and are amended by the percent legislation. It is important for those drafting legislation to understand the funding process, funding sources, and legalities governing the use of funds and authorities under which the legislation can be implemented.

Special provisions added in 1981 for local districts were carried into the 1983 revised legislation for school district boards of directors "of districts where the sites are selected" (i.e., the Arts Commission establishes where projects will be and then the local district may exercise these provisions).

182

appropriation to be expended by the Washington state arts commission for the acquisition of works of art. The works of art may be placed in accordance with Article IX, sections 2 and 3 of the state Constitution on public lands, integral to or attached to a public building or structure, detached within or outside a public building or structure, part of a portable exhibition or collection, part of a temporary exhibition, or loaned or exhibited in other public facilities. The Washington state arts commission shall, in consultation with the superintendent of public instruction, determine the amount to be made available for the purchase of works of art under this section, and payments therefor shall be made in accordance with law. The designation of projects and sites, selection, contracting, purchase, commissioning, reviewing of design, execution and placement, acceptance, maintenance, and sale, exchange, or disposition of works of art shall be the responsibility of the Washington state arts commission in consultation with the superintendent of public instruction and representatives of school district boards of directors. However, the costs to carry out the Washington state arts commission's responsibility for maintenance shall not be funded from the moneys referred to under this section, RCW 43.17.200, 43.19.455, or 28B.10.025, but shall be contingent upon adequate appropriations made for that purpose: Provided, that the superintendent of public instruction and the school district board of directors of the districts where the sites are selected shall have the right to:

(1) Waive its use of the one-half of one percent of the appropriation for the acquisition of works of art before the selection process by the Washington state arts commission;

(2) Appoint a representative to the body established by the Washington state arts commission to be part of the selection process with full voting rights;

(3) Reject the results of the selection process;

(4) Reject the placement of a completed work or works of art on school district premises if such works are portable.

Rejection at any point before or after the selection process shall not cause the loss of or otherwise endanger state construction funds available to the local school district.

These special conditions provide that the local school district board of directors may: (a) waive use of percent-for-art funds (i.e., choose not to participate in the program); (b) have a representative on the selection panel with the Arts Commission appointed members; (c) reject the selection process; and/or (d) reject the work of art (if portable). The legislation then goes on to protect the contracts, artists, and artworks by insuring that the funds and/or artworks are retained by the Arts Commission for the program.

For organizations adopting new legislation, these special terms may not be necessary. They are a development to Washington's legislation as a result of the program's history.

Any works of art rejected under this section shall be applied to the provision of works of art under this chapter, at the discretion of the Washington state arts commission, notwithstanding any contract or agreement between the affected school district and the artist involved. In addition to the cost of the works of art the one-half of one percent of the appropriation as provided herein shall be used to provide for the administration by the Washington state arts commission and all costs for installation of a work of art. For the purpose of this section building shall not include sheds, warehouses, or other buildings of a temporary nature.

The executive director of the arts commission, the superintendent of public instruction and the Washington state school directors association shall appoint a study group to review the operation of the one-half of one percent for works of art under this section. [1983 c 204 § 7; 1982 c 191 § 2; 1974 ex.s. c 176 § 5.]

Implementation — 1983 c 204: "Implementation of section 7 of this 1983 Act shall become effective upon approval by the arts commission, the superintendent of public instruction and the Washington state school directors association." [1983 c 204 § 10.] "Section 7 of this 1983 act" is the 1983 c 204 amendment to RCW 28A.58.055.

Severability — 1983 c 204: See note following RCW 43.46.090.

Effective date — Severability — 1982 c 191: See notes following RCW 28A.57.170.

**Downtown Art in Public Places Policy,
Los Angeles Community Redevelopment Agency**

Reprinted by permission of the Los Angeles
Community Redevelopment Agency.

Reprinted here almost in its entirety, the Los Angeles
Community Redevelopment Agency's policy is
exhaustive and innovative on many counts: the estab-
lishment of the Downtown Cultural Trust Fund; a
broad definition of public art, including programming
and facilities as well as on-site art; and options for
artist selection processes with review measures that
help maintain standards of excellence. For further
information, see the section on Redevelopment.

184

A public art program as ambi-
tious and complex as this one
presumes and underscores the
requirement for an agency-based
arts professional to administer
the program. The responsibil-
ity cannot be delegated to pro-
ject architects or rotating
consultants.
 CRA Staff

DOWNTOWN ART IN PUBLIC PLACES PROGRAM: GUIDELINES FOR PRIVATE DEVELOPERS

I. **POLICY**

Pursuant to the provisions of Sections 327.6 and 401.5 of the
Central Business District Redevelopment Plan and
Section 821 of the Bunker Hill Redevelopment Plan and of
Section 400 and 518 of the Little Tokyo Redevelopment
Plan, the Community Redevelopment Agency of the City of
Los Angeles approved a Downtown Art in Public Places
Policy on August 26, 1985, pledging itself to promote the
enhancement of downtown as a cultural center through the
support, development and creation of innovative programs,
facilities and public artworks encompassing a variety of
artistic expression. Specifically the Agency pledged itself
to require that at least one percent (1.0 percent for art) of
the private development costs for new commercial and
multi-family development, excluding low and moderate
income housing that is assisted by the Agency, subject to an
Owner Participation Agreement (OPA) or a disposition and
development agreement (DDA), shall be allocated by the
developer to finance the provision of cultural and artistic
facilities and features within the Project area and that 40%
of that obligation shall be deposited into a Downtown
Cultural Trust Fund account to be used for the general
enhancement of downtown's public cultural resources. The
requirements and conditions of this policy shall be effective
after August 26, 1985 for all Agency assisted projects in the
above three Redevelopment Project Areas, excepting those
projects which have substantially confirmed terms of
agreement for either an OPA or DDA by the effective date.

II. **PROGRAM GOALS**

The Community Redevelopment Agency of the City of Los
Angeles has shown its commitment to the involvement of
the arts in the daily lives of its residents by implementing a
wide variety of projects ranging from on-site installation of
public art to facilitation of temporary exhibits and festivals
to the development of cultural facilities such as the Museum
of Contemporary Art and the Los Angeles Theatre Center.
It is the CRA's intention to continue development of an Art
in Public Places Program that is diverse and of the highest
quality; that will, over the decades, reflect the City itself
and the minds of its citizens; that will improve the quality
of life in the downtown area and be a source of pride to all
City residents. It is the policy of the Agency that all
programs be implemented without discrimination based on
race, religion, sex, marital status, color, national origin,

1

Downt
Art in
Public
Place

Polic

Adopted August 26, 1985

ancestry or creed. The Agency seeks to develop this Program in such a way that it is intimately integrated into the fabric of the City and reflects a broad range of community input and involvement by artists and arts professionals. Specifically, CRA's objectives are to:

o Develop a public art program that is unique to Los Angeles.

o Increase the understanding and enjoyment of public art by Los Angeles' residents.

o Invite public participation in and interaction with public spaces.

o Provide unusual and challenging employment opportunities for artists.

o Encourage collaborations between artists and architects, and artists and engineers.

o Encourage and support participation by women and minority groups that have been traditionally under-represented.

o Support artist participation on design teams for planning public projects.

o Encourage and support Los Angeles' pluralistic culture.

o Encourage variety of art forms: temporary and permanent, object and event, single or dispersed locations.

III. **ART BUDGET/ELIGIBLE COSTS**

A. Budget

As noted above, projects developed within the three downtown Redevelopment Project Areas, which are subject to an OPA or DDA, have a Percent for Art obligation.

The developer is required to allocate and expend a minimum of one percent (1.0%) of the total project costs, excluding land and off-site improvements, on an Art in Public Places Program. The Program must be planned before construction begins on the overall project. Therefore, the preliminary art budget must be based upon the estimated costs of the project.

Of the total Percent for Art obligation, at least 40% shall be deposited into a Downtown Cultural Trust Fund, administered by the Agency, at the time that a Certificate of Occupancy is issued to the project but no later than the issuance of a Certificate of Completion (see Form #5 in Appendix). The developer may elect to allocate a greater proportion of his total (1.0%) public art obligation to the Trust Fund. However, the total amount expended on public art required by the Program shall not be less than one percent (1.0%) of the total project costs, as determined no later than 30 days after funding of developer's construction financing. If the final project cost is higher than the cost figure used to calculate the preliminary art budget, the art budget must be increased as necessary to equal 1.0% of the actual total project cost.

In lieu of developing an on-site art program, an 80% cash contribution to the Trust Fund of the total Percent for Art obligation, or 0.8% of the project cost shall be accepted as the full Percent for Art obligation.

B. Eligible Costs

All artworks created by artists (as described in Section IV, page 17) are considered eligible expenses for the Art in Public Places Program as well as the following:

o Structures which enable the display of artwork(s).

o Artists' budgets for projects which will be expected to cover:

- Professional fees for the artist(s).

- Labor of assistants, materials, and contracted services required for the production and installation of the work of art.

- Any required permit or certificate fees.

- Business and legal costs directly related to the project.

- Studio and operating costs.

- Dealer's fees, if necessary and where appropriate (the National Endowment for the Arts, and several other arts agencies around the country, recommends that no more than 10% of the artist's fees be paid as a dealer/gallery commission).

While developers generally have had little reaction to this diversity of art opportunities, some have tried to make a case for 100 percent of the one percent public art allocation to be spent for on-site work as opposed to diverting 40 percent of it to the Trust Fund. One developer/collector cautioned that a critical mass of visible art objects should be developed before diversifying into other forms such as programming or facilities. Others have felt that on-site use of the entire allocation would allow greater possibilities for integrated art. The CRA has, however, remained committed to the goal of developing different types of public art opportunities.
CRA Staff

Consider the options of cultural programming and facilities carefully. LA is huge with lots of development and can afford to add this component.
Public Art Administrator

IV.

- Communication and other indirect costs (insurance, utilities).

- Travel expenses of the artist for site visitation and research.

- Transportation of the work of art to the site.

- Preparation of site to receive artwork.

- Installation of the completed work of art.

o Up to 10% of the total budget for administrative costs incurred by the developer in the process of selection, fabrication and installation of artworks (art consultant fees, a plaque to identify the artwork are eligible costs).

o Documentation (color slides and black and white photographs) of the artwork's fabrication and installation will be covered by the Agency's Art in Public Places Program budget.

C. Ineligible Costs

1. Directional elements such as supergraphics, signage, or color coding except where these elements are integral parts of the original work of art.

2. "Art objects" which are mass produced of standard design such as playground equipment, fountains or statuary objects.

3. Reproductions, by mechanical or other means, of original works of art, except in cases of film, video, photography, printmaking or other media arts.

4. Decorative, ornamental, or functional elements which are designed by the building architect as opposed to an artist commissioned for this purpose.

5. Landscape architecture and landscape gardening except where these elements are designed by the artist and/or are an integral part of the work of art by the artist.

6. Services or utilities necessary to operate or maintain the artwork over time.

4

ELIGIBLE PUBLIC ART COMPONENTS

Public art may manifest itself in three basic components: On-Site Art in Public Places, On-Site Cultural Programming, and On-Site Art Spaces or Cultural Facilities. On-site public art project development is administered cooperatively by the Agency and the developer, while the CRA alone administers the Cultural Trust Fund.

A. On-Site Projects

1. On-Site Art in Public Places

The CRA's Art in Public Places Program is receptive to the broadest definitions of art and encourages imaginative interpretations of media. The possible media and materials which might be used for permanent or temporary installation, decorative or functional purpose, include:

o Sculpture: Free standing, wall supported or suspended; kinetic, electronic, etc., in any material or combination of materials.

o Murals or portable paintings: in any material or variety of materials, with or without collage or the addition of non-traditional materials and means.

o Earthworks, fiberworks, neon, glass, mosaics, photographs, prints, calligraphy, any combination of forms of media including sound, film, holographic and video systems, hybrids of any media and new genres.

o Standardized fixtures such as gates, streetlights, signage, etc., may be contracted to artists for unique or limited editions.

2. On-Site Cultural Programming

Eligible components for on-site cultural programs include:

o Performance Arts: theatre, dance, music.

o Literary Arts: Poetry readings and story telling.

o Media Arts: Film and video, screenings and installations.

o Education: Lectures and presentations about art.

5

o Special Events: Parades, festivals and celebrations.

Artist-in-Residence programs in the fine arts or media and literary arts may be eligible if the "product" of the residency program involves or is available to the public.

Events which are basically commercial in nature, such as theatrical productions or movies, etc., are not eligible, nor are amateur productions.

3. On-Site Cultural Facilities

The availability of exhibit or performance space is equal in value to support given for the creative effort. Therefore, in certain locations it may be more desirable to develop or make available space for art rather than commission the art itself. Eligible components include gallery/exhibition space, performance spaces, artist studio spaces, arts education facilities, artist hotel, etc. Space developed under this program will be exclusively available to non-profit institutions.

B. **Downtown Cultural Trust Fund (Refer to pages 13-18 for a more detailed Program description.)**

The Downtown Cultural Trust Fund is a funding mechanism which aggregates individual portions of the private, site specific Percent for Art requirement and redistributes these funds to public sites throughout downtown. Thus the program aims to finance projects and place artworks in the downtown community that might otherwise not be possible. Additionally, components of the Trust Fund will support artists and institutions that are committed to downtown's revitalization. Specific components include:

o Art in Public Places - Temporary and permanent objects and events, artist participation in the design of public spaces.

o Cultural Facilities: Assistance to downtown cultural facilities, particularly for physical plant needs, not operating costs.

o Special Cultural Programming by Organizations: Program support for one-time or special annual events.

o Individual Artist Support: Support for artist participation on a design team and artist initiated public art projects.

6

o Los Angeles Festival: Major bi-annual international festival located primarily in the downtown area, a sequel to the Olympic Arts Festival.

V. **ELIGIBLE PUBLIC ART LOCATIONS**

Spaces that are accessible to the public a minimum of 12 and preferably up to 18 hours a day, either on private or public property, may be considered suitable locations for public art. Such facilities include commercial or residential buildings and adjoining plazas, parks, sidewalks, traffic islands, public buildings, power stations, etc. Spaces may be interior or exterior. Locations can include surface treatments of buildings, retaining walls and bridges. The definition of "location" can also be expanded by an artists' ability to extend the possibilities for public art, and would then be determined on a case-by-case basis. However, the primary objective of visual or interactive public accessibility must be realized for the specific number of hours per day. The Owner Participant would agree to take all steps and execute and record all reasonable documents necessary to assure the right of public access to the public art site.

VI. **PUBLIC ART SELECTION PROCESS (Refer to pages 19-27 for a more detailed process description.)**

The developer will be briefed as soon as possible regarding the Percent for Art requirement and the need for the artist(s) to work with the architect from the initial planning phase forward. Working with CRA staff and the Arts Advisory Committee (AAC), (see page 19), the developer will choose either an Art Selection Panel of arts professionals or an Arts Consultant to actually select the artist and develop the artwork or program. Alternatively, some developers may suggest a specific artist to the AAC that they would like to implement their arts program. A decision will also be made jointly by the developer and the AAC as to the most appropriate selection process for the situation. The developer may choose among the following options:

o Open Competition
o Invitational Competition
o Direct Selection

7

Every ongoing public art pro-
gram should prepare a document
similar to the Cultural Devel-
opment Framework. This process
forces the identification of
program goals and gets at the
issue of public purpose.
Urban Planner

VII.

CRITERIA FOR SELECTION OF ART SELECTION PANEL

All voting panel members shall be local (California State) arts professionals, unless otherwise mandated by the AAC in response to specific project needs (as in the case of a Seven Person Panel). For these purposes, arts professionals in the visual, performance or literary fields may include, as appropriate to the project, artists, curators, artistic directors, critics, historians, fine art collectors, architects and other design professionals with a relevant arts background who are:

o Respected in their fields.

o Knowledgeable about contemporary visual, performance, or literary arts, particularly in a public, outdoor context.

o Capable of engaging effectively in a jury process.

o Open minded and responsible.

o Willing to carry out the CRA's Art in Public Places Program policies and Redevelopment Project Area objectives.

Out of state arts professionals, architects, residents, users, Project Area Committee (PAC) members, technical CRA or City staff, and the developer may be involved as non-voting advisors to the Selection Panel where appropriate.

Gallery owners, dealers, producers, agents and other profit-oriented intermediaries are ineligible.

CRA staff will periodically issue a Request for Qualifications (RFQ) and will maintain a file of potential jurors and their qualifications, which will be available to the Arts Advisory Committee. The Committee will not be limited to select panelists from the Agency file.

VIII.

CRITERIA FOR DEVELOPMENT AND SELECTION OF PUBLIC ART PROJECTS

All Art in Public Places Program projects, whether they are permanent or temporary artworks, cultural programs or facilities, will be developed to respond to a specific site or building location, with the exception of artworks or programs that are conceptually intended to circulate among various sites or facilities within the Project Area.

Art project, program or facility proposals will be evaluated by the Arts Advisory Committee, CRA staff and participating selection panel members within the context of

the CRA's Art in Public Places Program goals and objectives established by the Downtown Cultural Development Framework. The Cultural Development Framework will identify priority sites and/or generalized locations for public artworks, cultural programming and arts spaces/facilities within downtown, and will present alternative project themes, approaches or forms of expression and will identify cultural facility needs for consideration by the developer and his designer(s)/artist(s) team during the project's concept development phase.

For commission of permanent artworks and facilities or annual events, artists must be selected before schematic design work begins on the building program and preferably before concept development so that the artists and designer can work collaboratively toward a totally integrated solution.

The Agency will seek to ensure that, over time, the Art in Public Places Program commissions will be spread among a wide number of nationally recognized, as well as young artists, and that they reflect an overall diversity of scale, aesthetic vocabulary, community values and forms of expression.

Each proposed Art in Public Places Program project will be also evaluated as to: its artistic excellence; appropriateness in terms of scale, material and content relative to the immediate and general architectural, social and historic context; and long term durability against vandalism, weather, theft, and excessive maintenance.

IX.

CRITERIA FOR ELIGIBLE ARTISTS

It is the CRA's goal that the best and most appropriate artwork will be commissioned and consequently there is no overall policy about residency requirements for artists. It is hoped that after several years there will be a good mixture of work done by local Los Angeles City and County, state, and national and international artists. Residency requirements, if appropriate, will be determined on a project-by-project basis by the Arts Advisory Committee.

Subject to a few limitations specified below, any artist may request to be considered for an Art in Public Places Program commission. Each artist's eligibility will be determined by the members of each project's Art Selection Panel or by the developer's approved Arts Consultant, based on past achievement or current artistic potential.

The developer's responsibility
is left too open-ended and the
City's too open to neglect.
Routine maintenance and the
possibility of extraordinary
conservation efforts must be
thoroughly addressed. A more
specific framework here would
foster greater detail in
individual contracts.
 CRA Staff

The CRA has published a guide,
Public Art in Downtown Los
Angeles, and is developing a
portable photographic display
showing works in the collection.
Developers are beginning to
regard public artworks as assets
to be promoted in sales pack-
ages to prospective occupants
and corporate customers.
 CRA Staff

Not eligible to be selected for commissions are the projects'
architects or/members of consulting architectural or design,
landscape or engineering firms, members of the selection
panel, members of the Arts Advisory Committee or,
members of their immediate families, or employees of the
Community Redevelopment Agency or the City of Los
Angeles.

X.

ARTIST COMPENSATION

All financial arrangements are negotiated between the
developer and the artist and should be verified in a written
agreement. Copies of the executed contracts between the
developer and the artist(s) shall be submitted to the Agency
within thirty (30) days of their execution.

XI.

ARTWORK OWNERSHIP/MAINTENANCE

Artwork provided under the conditions of the OPA or DDA
may be permanent on-site improvements, temporary
improvements, regularly scheduled events or a permanent
cultural facility. Under certain circumstances, when the art
is situated at or on property or facilities owned or occupied
by the city, the developer may transfer ownership to the
City. Such a gift will entitle the developer to all
appropriate tax deductions for charitable contributions.

The continued maintenance of artwork will be the
responsibility of the developer, unless the artwork is deeded
to the City and the City chooses to assume some portion, or
all, of the maintenance responsibilities. Maintenance
stipulations will be recorded in the OPA or DDA under
covenants affecting real property.

The CRA will encourage artists and developers to include
maintenance provisions in the artwork contract that
stipulate the length of time (typically one year) the artist
will be responsible for repairs, that urge artists to provide a
maintenance manual, and that allow the artist first-refusal
on repair contracts within a fair market rate of
renumeration. Finally, should the property be destroyed on
which the artwork is situated, the artist will be given first
refusal to buy the piece.

When a developer elects to provide on-site programming
other than a permanent improvement, such commitments
will be fully articulated in the covenants as well. These will
usually take the form of an annual programming budget
commitment, to reflect the 1% public art obligation, but
may be renegotiated after a period of one year and
converted to a permanent public art installation or facility.

XII.

PROMOTION OF ART IN PUBLIC PLACES PROGRAM

To promote the CRA's stated Art in Public Places Program
goals of achieving a broad diversity of projects, encouraging
artistic innovation and striving for widespread community
participation and awareness, the Agency may periodically
promote implemented projects and programs and may
organize educational events such as exhibits, artists' public
appearances, prepare pamphlets describing their work
and/or slide shows and video clips documenting the
development and installation of selected artworks,
performance events or artist/community interaction.

The CRA recognizes the potential for controversy in any
effective public art program. These suggested activities are
intended to bring the general public into closer contact with
the work of art and/or the artist and thereby assist in
promoting understanding of the work produced under the Art
in Public Places Program and, thereby, a greater awareness
and enjoyment of downtown's public environment. The CRA
encourages developer and community participation in all
aspects of these activities.

The developers may elect to purchase an announcement or
advertisement in a national art-publications to promote the
completed artwork and artist. At a minimum, for all
permanent installations of artwork, the developer will be
required to affix a plaque of durable material adjacent to
the artwork listing the title of the artwork, the artist's
name and the date completed.

XIII.

EXEMPTIONS TO THE PROGRAM

The following categories of projects are exempt from the
percent for art requirement:

o Low and moderate income housing projects.

o Non-profit social service institutions.

o Adaptive re-use or rehabilitation of existing buildings at
 less than $250,000 total construction costs.

o Non-profit cultural institutions are exempt from
 contributing to the Downtown Cultural Trust Fund only.
 They must provide an on-site art program in cost of
 0.6 percent of total development costs.

189

It has been suggested that the flexibility the Trust Fund provides should be extended further to support other needs of individual artists--studio space, insurance, technical assistance--because this is usually not readily available otherwise. A public art program cannot be everything to everyone. It should, however, work in tandem with municipal arts departments, state arts agencies, and other local arts organizations to help address these areas.
CRA Staff

190

XIV.

MISCELLANEOUS

The staff of the CRA is experienced in public art projects and is available for consultation and advice.

Collaboration between artists and architects, engineers and/or designers is encouraged. In exceptional circumstances, approval may be given for an art budget to allocate funds for the architect's fee or a portion of the costs of the architecture if it is determined that the work for which the funds are proposed to be so allocated is an integral part of the artwork proposed pursuant to the Agency's Program and would not have been done otherwise. (For example, an artist and a landscape architect might collaborate to design a plaza that includes paving, fountains and trees. The design and construction of the area may not be charged entirely to the art budget, because some landscaping would have been incorporated anyway. However, approval might be given to allocate from the art budget the costs over and above the "standard" landscaping if such landscape or improvements were initiated or designed by the artist).

However, no such collaboration should be undertaken, and no such allocation will be approved, unless the plans thereto are presented to and approved by the responsible agency(ies) before the costs are incurred.

In developing these guidelines the CRA has tried to allow for a flexible series of public art possibilities while still attempting to maintain a high artistic standard. If the developer wishes to pursue a direction not indicated in these guidelines, as part of the submitted Preliminary Art Plan (see Appendix, Form #2), he should so indicate to Agency staff.

The determination of what percentage of an integrated art and architecture budget can be seen as part of the percent for art obligation is difficult to make. For one recent project, we developed a formula of splitting the costs between the architecture and fine art budgets 50/50. However, this could not be an iron-clad formula.
CRA Staff

DOWNTOWN ART IN PUBLIC PLACES PROGRAM: DOWNTOWN CULTURAL TRUST FUND

PROGRAM SUMMARY

A Downtown Cultural Trust Fund (DCTF) will enhance downtown as a cultural center through the support, development and creation of innovative programs, facilities and public art works encompassing a variety of artistic media and disciplines, thereby encouraging the use of cultural expression as a redevelopment tool. The Trust Fund is intended to broaden the opportunities for public involvement in art created for public spaces and in the development of cultural programs. Implementation of the Trust Fund programs will widen the range of publicly accessible cultural experiences and expand their geographic locations beyond those of new, private projects. The Downtown Cultural Trust Fund is a funding mechanism which aggregates portions of the individual private, site-specific Percent for Art requirement and redistributes these funds to finance cultural programs and art projects throughout downtown. Fifty percent (50%) of the Trust Fund monies will be earmarked for the Los Angeles Festival.

Program Sections Administered by CRA (50% of Trust Fund Budget)*

1. Art in Public Places (public and/or private incorporation of art project into publicly accessible areas)

2. Cultural facilities development (refurbishment and preservation of existing spaces or development of new facilities)

3. Special cultural programming (outdoor and indoor performance events produced in designated public spaces)

4. Individual artist projects (funding and/or site access for artist initiated projects)

Program Sections Administered by Others (50% of Trust Fund Budget)*

1. Proposed Los Angeles Festival.

*Footnote: In the event that the Los Angeles Festival is discontinued, funds earmarked for the Festival shall be reallocated to the DCTF Program components as indicated on Chart A.

Funding Mechanism

The Downtown Cultural Trust Fund establishes procedures by which each new development will deposit a portion (40 to 80 percent) of the 1.0% for Public Art requirement in a public Trust Fund account in lieu of an on-site art installation. Each development will have the option of choosing to implement its Percent for Art obligation via a 1.0% combined on-site program and DCTF contribution or an exclusive 0.8% Trust Fund donation. The Fund itself will be subdivided into two administrative components as indicated above under Program Objectives.

PROGRAM OBJECTIVES AND COMPONENTS

SECTION I

ART IN PUBLIC PLACES

Component A - Public, Publicly Accessible Property

This component includes all government properties, i.e., libraries, parks, office buildings, sidewalks, traffic islands, power stations, etc. Areas of these facilities which are accessible to the general public may be considered as potential art sites. The lobby, plaza, adjacent open spaces or exterior treatment of an office building may be potential sites, but the offices themselves may not be so considered.

Component B - Private, Publicly Accessible Property

Outdoor areas of private property that are accessible and used by the public a minimum of 18 hours a day may be considered potential sites. Exterior places such as parks, walkways, plazas and surface treatments of outdoor spaces, including building surfaces are easily identified as publicly accessible. Interior spaces, including lobbies, courtyards, malls, etc., may be eligible if they are accessible to the public a minimum of 12 hours per day.

Component C - Building Integrated Art for CRA-Facilitated Projects

Projects facilitated by the CRA will have art programs integrated into their design by engaging artists to work cooperatively with architects from the initial planning stages forward. Art that is specifically generated for a particular space can better serve the specific needs of

that space than an object which is moved from a studio to a public site. Projects can also include artist designed features that might otherwise be provided by commercial sources, such as gates, water fountains, tile and surface materials, doors, furniture, clocks, lighting fixtures, railings, signage, etc.

Component D - Artist Design Services for New Construction

Artists can be paid to serve as members of design teams for construction projects as diverse as street furniture, sidewalks, parking structures, residential and commercial structures, bus shelters, power stations, etc. Focus will be on artist input into the general design concept and not directed specifically toward the creation or incorporation of specific art pieces.

Component E - Event or Time Limited Project

A number of artists are currently creating projects in public places that are intentionally temporary. Performance-oriented events or multi-disciplinary presentations can be regularly scheduled as well as scheduled on a one-time basis. Sites within downtown can be adapted to such events and become identified with them.

Installations can also be utilized to seek out new sites, exploring their specific conditions and developing new audiences. Sculpture and other object-oriented art can be created on a temporary basis, utilizing vacant structures or future development sites. Work can be participant activated, using video feedback, sound, and real "artifacts" of downtown or work can be distant and purely visual. Events should occur on weekends, and evenings as well as during weekday lunch hours. The intention is to convey downtown as a place of discovery.

SECTION II

CULTURAL FACILITIES

Component A - Planning Grants for New or Existing Facilities to Establish Project Feasibility

Planning grants may be made to non-profit (non-matching) and for-profit (one to one match required) organizations, intended to assist them in determining the feasibility of establishing and/or expanding a cultural facility in the downtown area.

The successful implementation
of artist initiated projects
is dependent upon the artist's
ability to understand how the
Art in Public Places Program
works and to propose projects
relevant to the agency's goals.
We are developing a guide for
use by artists to help them
approach the agency for funding.
— CRA Staff

Component B – Capital Costs for New and Refurbished Facilities

Construction loans may be made to non-profit (non-matching) and for-profit (one-to-one match required) cultural organizations for physical improvement to facility. The program is to be preferably coordinated with Component C.

Component C – Artist/Artisan Fees for Restoration/Rehabilitation

Direct fee payments may be made to artist/artisans for such work as architectural detailing (plaster, wood, stone work) mural restoration, etc., on cultural facilities and City or nationally registered historical landmarks. For-profit organizations and developers must match CRA participation with labor or material costs.

SECTION III

CULTURAL PROGRAMMING

Component A – On-going Programs (Seed Money)

Organizations may be assisted at an initial stage to help implement special programs that reach new audiences and/or activate spaces that have been under-utilized. Particular emphasis will be placed on the use of public spaces as a forum for innovative programs.

Component B – One-time Presentation (Matching Grants)

Programs which are conceived as a one-time event for a public space will be eligible for matching grants. These might be musical, dramatic, media, intermedia, or participant-oriented events.

Component C – Staff Consultant for Program Development

Institutions that wish to expand their programming, change focus, develop a new/larger audience, or utilize new spaces, will be eligible for assistance from relevant CRA staff or consultants.

16

SECTION IV

INDIVIDUAL ARTIST PROJECTS

Component A – Artist Initiated Fine Arts or Performance Projects

Planning grants for concept development and/or fabrication may be awarded to artists proposing projects for downtown. Projects must be developed as public art pieces with significant community input or participation in concept development or fabrication.

Component B – Space/Site Bank

A catalogue of spaces available for temporary and/or permanent use by artists for development as public art sites will be developed and maintained by CRA staff. Spaces can be either public or private but must be publicly accessible. Staff may assist artists in determining a suitable site.

Component C – Technical and/or Professional Staff Support Services

Artists developing pubic art projects may be assisted by CRA staff in a number of areas including technical advice (code requirements, engineering problems, environmental impact report, etc.) permits, licenses, design consultation, briefing on urban design objectives, and referral to other appropriate agencies.

Component D – Insurance and/or Installation Costs

Assistance may be available for liability insurance for public art projects, either by obtaining "riders" for existing policies or by contracting a comprehensive policy for a series of temporary events and installations. Assistance may also be available for expenses artists may incur in the installation of work.

Component E – Artist Fees for Participation on Design Teams

Artists may be paid to participate as consultants on design teams within the CRA, or on projects that are facilitated by the CRA in which input from an artist is desirable. The artist's participation would help develop a comprehensive perspective from a new point of view rather than merely to identify areas for artistic ornamentation.

17

SECTION V

LOS ANGELES FESTIVAL

The resounding success of the Los Angeles Olympic Arts Festival and the growing reputation of downtown as a regional cultural center has prompted Festival organizers and civic leaders to organize the Los Angeles Festival, focused primarily on sites and facilities within the downtown area. Significant support and funding commitments from major private and public institutions have been secured. Program components for this objective will be developed by the Los Angeles Festival Organizing Committee in consultation with the Arts Advisory Committee. Partial funding, up to 10% of the total festival budget, will be generated by the Cultural Trust Fund. Eligible program components funded by the Cultural Trust Fund shall be responsive to program objectives and funding criteria established by the Arts Advisory Committee.

DOWNTOWN ART IN PUBLIC PLACES PROGRAM: PUBLIC ART SELECTION PROCESS

Public art can become a major source of identity for a city. From the Statue of Liberty in New York to the Watts Towers in Los Angeles, civic pride can take concrete form in works of art. Public art can uniquely contribute to the life of a city by sensitively and creatively manipulating the man-made environment in places where city inhabitants, employees, and visitors congregate, pass through, or otherwise use. The successful creation of art in public places depends upon the quality of the art itself, sensitivity to its social context as well as an appropriate relationship to the physical site. The public art selection process must consider the complex set of needs that converge in the urban environment. Community members, developers and artists must have faith in the integrity of the selection process before common ground can be mutually determined. The CRA's public art selection process has been designed to respond to a variety of community interests and to consider them within the framework of the redevelopment process. To insure a high level of professionalism and continuity in the implementation of CRA's public art goals and objectives throughout all project areas, the Agency has established an administrative structure and art selection process as outlined in the attached chart.

ARTS ADVISORY COMMITTEE

The Arts Advisory Committee (AAC) is a community-based group that provides both long-range and short-term input into the Art in Public Places Program. Members of the Committee will be appointed by the Agency Board and will be compensated for their time as an administrative expense of the Cultural Trust Fund. The AAC is an integral component of the artist selection process; its primary role is to advise Agency Commissioners and inform the community on the selection of public art. To fulfill this responsibility it will determine Art Selection Panel composition for actual art selection, or assist developer/architects in selecting appropriate art consultants, review the selected artist's preliminary designs and convey the final public art design to the Agency Commissioners for approval. The AAC's ability to perform these tasks is dependent upon its knowledge of the arts, artists, the art community, art in public places and the allied disciplines of architecture, landscape architecture and urban planning.

194

It's important that the bureaucracy remain open. As a result of the allowance of artist initiated projects, Dance Gallery is getting a very attractive land lease for a facility. Dance Gallery is still required, though, to raise the money for the building.
CRA Staff

The value of the AAC is increased in proportion to its understanding of redevelopment objectives in general and art issues in particular. Due to the specialized and complex nature of these fields, members of the AAC must be conversant with art issues and hopefully have an understanding of redevelopment issues as well. In addition to ongoing review functions for specific projects, the AAC will annually review Art in Public Places policies and procedures and recommend any necessary changes. Members will serve two year terms so that they may become more knowledgeable and hence more useful to the process. Terms expire on a rotational basis to insure even proportions of continuity and fresh perspectives. AAC members will be compensated for their time proportional to time spent.

Membership of the AAC will include one artist, two arts professionals (such as curators, academics, arts administrators and critics), one member from the Cultural Affairs Commission and one representative of the business/development community. Commercial dealers and private for-profit arts consultants are not eligible for AAC membership. In some circumstances the inclusion of a collector may be considered appropriate. The AAC may ask non-voting advisors to participate on a project-by-project basis.

PHASE I

PROJECT INITIATION (See Chart D, Public Art Selection Process)

Within Redevelopment Project Areas there are three basic initiating sources for art in public places: a property owner or developer; CRA staff; and artists or community representatives. While each may be characterized by different interests, and each may be involved with the Agency in different roles, the selection process remains essentially constant for each initiator.

A. Property Owner/Developer Initiation

In the downtown Redevelopment Project Areas, property owners or developers entering into an Owner Participation Agreement (OPA) or Disposition and Development Agreement (DDA) with the CRA are obligated to expend a designated percentage of their project's total cost on public art and/or to contribute to a Cultural Trust Fund. At the start of discussion or negotiations with the CRA they are notified of this requirement and informed that the art program and artist selection process is to be incorporated as early as possible into project planning and design phases. The Preliminary Art Budget Estimate (see Appendix

Form #1) will be conveyed to the CRA at this time. The developer will work with the AAC and CRA staff in choosing the artist selection process most appropriate to the nature of the project, the development time frame and CRA Project Area objectives.

B. CRA Staff Initiation

During the course of preparing or implementing Redevelopment Project objectives, staff may identify certain projects that will facilitate CRA goals. These projects and their respective budgets will be reviewed and, if approved, adopted by the Agency Board as part of the Annual Work Program. Projects may be of a permanent or temporary nature. Some of the stages of the selection process may not be necessary for projects initiated by staff, such as Initiator Briefing; otherwise the implementation process remains intact, with participation of the AAC.

C. Community/Artist Initiation

The CRA will remain responsive to suggestions from community members, particularly artists or arts institutions, for ideas about art in public places. Proposals that are within the guidelines of the CRA will be considered both for program merit and budget. Those projects that are accepted will proceed with the selection process as outlined and may be implemented through a combination of private and public funds.

PHASE II

PROJECT INITIATOR BRIEFING

This briefing phase is intended to help the initiator understand the interrelationships inherent in the redevelopment process and specifically how the art program needs to respond to these relationships. Staff will organize at least two discussion sessions with the initiator to include appropriate CRA project staff, consultants, the AAC and possibly community members. The topic areas that will be discussed include:

o CRA's urban design objectives.

o Relationship of public art project to urban design objectives.

o Relationship of public art project to its immediate location.

o Local community and other social factors.

o Relationship of public art project to developer/architect objectives,

o Project's functional requirements or special site limitations.

o Outline of art program development process and determination of selecting body.

o Cooperative nature of art program, with artist participation encouraged from initial planning phase forward.

o Long-term maintenance and liability issues.

Some time during the course of this phase of project development, the developer will be asked to submit a Preliminary Art Budget (see Appendix, Form #1).

PHASE III

PROCESS ADOPTION

The Arts Advisory Committee will meet with the initiator to provide additional contextual information and to further refine the project as articulated in Phase II, Initiator Briefing. During this step the AAC, in consultations with the initiator and CRA staff, will determine the process (open competition, invitational competition or direct selection) and the kind of selecting body (arts consultant or panel) to select the art. In the event the developer wishes to work with a specific artist, the AAC will review the artist's suitability for the proposed project. The selection process would then be shortened by omitting Phases IV, V and VI and proceeding directly to Phase VII, Artist Briefing. Appropriate modifications in the Process will be made by the AAC for the development of Cultural Facilities or Programming.

PHASE IV

CONSULTANT/PANEL APPOINTMENT

Discussions during the Initiator and Process Adoption Briefing sessions will outline the options for choosing the consultant(s) who will select an artist. The options are to choose either a panel of arts professionals or an arts consultant. Should a panel be selected, the Arts Advisory Committee will determine its size and composition, including non-voting advisory members. Staff may assist by providing a file of potential panelists confirming availability of selected panelists, by informing them of their fee and how much of their time will be required. If a developer

chooses to work with an arts consultant, the AAC will either confirm his selection or help him find a more appropriate choice for the project.

A. Panel as Selector

Panels may have 3, 5 or 7 members. The three member panel must include one artist and 2 arts professionals. The five member panel would include 2 artists, 3 arts professionals. The seven member panel would include 2 artists, 3 arts professionals, 1 developer or architect and 1 Redevelopment Project Area Committee (PAC) member. Advisors may be added as necessary and may include the developer, project architect, PAC member, engineers, community members, future users.

CRA staff will assist the AAC in determining panel composition by maintaining a file of potential panelists. Staff will contact invited panelists, confirm plans and arrange for panel briefings and selection sessions.

Open competitions and direct selection may require only one panel session, which will include a briefing session and site visit prior to the selection phase. Invitational Competitions will require at least two sessions. The first session will be for briefing, site visit and determination of invitees. The second session will be selection of an artist from proposals.

Panelists will be paid for their time by the Agency. Out-of-town panelists will receive traveling expenses for their time as well.

B. Arts Consultant as Selector

A list of arts consultants and their experience will be made available to developers. The AAC will discuss with staff the suitability of the developer's chosen arts consultant to the project task. The AAC may recommend the developer seek an alternative art consultant.

Briefing sessions for the consultant will be organized by staff to introduce him/her to CRA objectives. Appropriate staff and additional relevant parties will provide further context. The consultant may select one artist or invite several artists to develop preliminary proposals. All artists will be asked to submit proposals or preliminary concept drawings. Artists asked to submit proposals will be paid for their work.

The consultant will keep staff informed of developments in the selection process. Once the artists have been selected the consultant may or may not be included in the artist's briefing session. Should the developer wish the consultant to continue to serve as his/her representative then the consultant should be present. In this case the consultant may continue to work with the artist in conveying the ideas of the developer. The presentation of the preliminary schematics for review by the AAC and the Cultural Affairs Commission might include the consultant. Throughout these steps staff will serve an educational and facilitating role, both for the arts consultant as well as the various parties with which he/she will be dealing.

Art consultants will be paid by developers.

PHASE V **CONSULTANT/PANEL BRIEFING**

Staff will organize sessions for the selector(s) to become familiar with the project objectives and their relationship to the redevelopment process. Staff will bring together relevant parties, both from within the CRA as well as those based in the community. The importance of including the artist in the design process from its initial planning phase will be stressed. Staff will arrange a site visit for the selector which will include an overview of the project itself, as well as the surrounding area. The logistics of the selection process will be outlined and refined if necessary, particularly in the case of arts consultants who may work from approaches other than a structured panel.

PHASE VI **ARTIST SELECTION PROCESS**

During the Consultant/Panel Briefing phase, the nature of the specified selection process will be outlined by the AAC. Roles of all parties will have been clarified and the selection task facilitated by staff work. The three basic forms for artist selection are Open Competition, Invitational Competition, and Direct Selection.

A. Open Competition

The open competition is a call-for-entries in a specific project. Artists are usually asked to submit evidence of their past work rather than proposals for the project at hand. The kinds of work requested for the competition will depend upon the requirements of the project. Project planners and the selection panel or consultant will need to consider what kind of art is relevant for the project. The parameters of this need will vary from the most broad to the specific. Most conventionally, this might mean defining the art by discipline; painting (and its sub-categories such as murals and varieties of signage) and sculpture (sub-categories such as environmental and functional forms). The call-for-entries will need to make clear the parameters of the art component so that artists who are not eligible do not waste their time applying and so that the selection process is not unduly burdened with unnecessary applications.

B. Invitational Competition

The Invitational Competition is a process in which a limited number (3-9) of artists are asked to submit proposals for a specific site. Proposals need not be elaborately detailed, but must indicate the general direction of the artist's thinking. Artists will be paid for this preliminary proposal.

The success of this process is highly dependent upon the knowledge of the panel or arts consultant.

This process requires a minimum of two panel discussions. The first meeting will concern itself with project information (objectives and context). Panelists will meet with the developer, architect, community people and other key figures in assessing the needs and situational possibilities for the arts component. As in all familiarization processes, a visit to the site is essential. Upon completion of this education and project refinement phase, the panel will begin to consider possible approaches to the site. Selection of candidates will proceed from this discussion. Anywhere from 3 to 9 candidates might be asked to participate. Some ranking may be appropriate to provide alternatives should any candidate decline to participate. Once the panel has designated the candidates, they will be contacted by staff confirming their intention to participate. Those willing to submit proposals will be sent project specifications. Also, they will be asked to visit the site, if possible, and subsequently meet with key project and community people. As an integral tool of the redevelopment process, the artist must understand and be sympathetic to the project and the community the project is intended to serve. A thorough briefing, including meetings and supplementary materials will help insure that candidates understand the complex relationships at work in the project.

C. Direct Selection

The Direct Selection process may proceed either through a panel or arts consultant mechanism. Once the initiator has consulted with staff and the AAC has selected either a panel or consultant, staff will begin the organizational process. The selector(s) will be confirmed by staff and advised as to the briefing process. The briefing session and site visit will clarify project parameters and objectives. Input from a variety of sources will be sought. The refining process will be aimed toward the goal of easing the direct selection method through clarity of purpose. After considering the site, project objectives, and interviews with various sources, panelists will be able to develop a list of appropriate candidates. Staff will be available to assemble materials on these candidates for the panel. Staff may also prepare materials on additional artists that may not have been included in the panelists list.

The artist may be selected at the initial briefing session or a second session may need to be scheduled, depending upon the complexity and nature of the task. Several artists will be chosen, ranked by preference, should the first (or second) be unable to accept. A briefing session will be organized as soon as possible for the artist to meet with the developer/architect, staff, community members, engineers and other concerned parties. The artist will maintain communication with the architect to help insure the art works as an integral component within its site.

PHASE VII

ARTIST BRIEFING

Each artist involved in a commissioned work will need to understand the specific objectives of the project in which the art is a part as well as the larger context in which the project is located. Staff will organize briefing sessions with a variety of participants so that the artist will develop a perspective indicative of the complex and variegated forces that come to bear on any one project. The AAC or some of its members, could also provide useful information during this phase. Some of these participants, such as future users, PAC members, and CRA staff, will provide contextual information. Other participants, particularly the developer/architect and the landscape architect, will be involved in on-going discussions and cooperative development with the artist.

Staff will consult with the artist to develop a project timeline and explain some of the inter-relationships between the various parties. Staff will be available to facilitate ongoing cooperation between artist and architect.

PHASE VIII

CONCEPT DEVELOPMENT

During this phase, the artist will have clarified project objectives and will begin to conceptualize the art work. Meetings with the architect will allow for cooperation and insure that the artwork can function as an integral component within the project. Staff will be available to assist as needed, and may be called upon by the artist to arrange additional briefing sessions. This phase will conclude with the initiator submitting the Preliminary Art Plan and 50% Schematics (see Appendix, Form #2).

PHASE IX

SCHEMATIC REVIEW

The timeline confirmed with the artist during Phase VII will provide a deadline for the presentation of a 50% completed schematic design. The schematic, in drawing and/or maquette form, will be reviewed by the AAC and the Cultural Affairs Commission (CAC) if appropriate. Modifications may be suggested at this time to the artist, and if relevant to the architect and/or landscape architect.

PHASE X

FINAL REVIEW

The artist will proceed to complete plans by the deadline established in Phase VII. Modifications and suggestions from the AAC or CAC must be considered and appropriately integrated. Continued cooperation between the artist and architect remains critical during this phase.

The Final Schematic (see Appendix, Form #3) will be reviewed and approved by the AAC and forwarded to the CRA Board for official approval.

The Final Art Plan (see Appendix, Form #4), including any budget revisions, will be submitted by the initiator following Board approval of the final design but no later than sixty (60) days prior to anticipated approval of Final Construction Drawings.

PHASE XI

IMPLEMENTATION AND COMPLETION

Staff will continue to monitor the implementation stage, verifying performance as contracted. Upon final installation of work, Agency will acknowledge completion of all contractual obligations. Provisions for maintenance and liability will be confirmed between all parties as outlined during the Project Initiator Briefing phase on pages 21-22.

The CRA has proposed that the Certificate of Occupancy Issue date be changed to the Building Permit Issue date which would mean that the Trust Fund contribution could be made up to two years earlier.
CRA Staff

APPENDIX A

PROCEDURES (See Chart C, Chart D, and Form Nos. 1-5)

1. During discussions with CRA staff regarding any development proposal (for a project subject to the CRA's Art in Public Places Program) the developer may be asked to complete the Preliminary Art Budget Estimate (attached hereto as Form # 1).

2. Within thirty (30) days after the CRA staff resolves to work with a property owner or tentatively selects a developer on the basis of a development proposal, the developer shall submit Form #1 and contact the CRA and invite staff to make a presentation regarding the CRA's Art in Public Places Program to the developer and project architects.

3. Within sixty (60) days after the CRA executes a DDA or OPA, the developer shall submit a Preliminary Art Plan and 50% Schematics in the form attached hereto as Form #2, to the Agency as documentation of Phases I through VIII of the Public Art Selection Process (see pages 18-23).

4. CRA staff and the Arts Advisory Committee will review the developer's Preliminary Art Plan. The AAC shall recommend approval, revision or other action on said Plan based upon the CRA's Program; these recommendations may include a request that the developer make a second presentation to the AAC. If any recommendations other than approval are to be made, these must be transmitted to the developer within thirty (30) days after the developer's latest presentation to the AAC; if no such recommendations are transmitted within said thirty day period, the AAC shall approve the Preliminary Art Plan as presented.

 The Arts Advisory Committee's approval of the Preliminary Art Plan must be received before the CRA will approve the Developer's Design Development Drawings for the development project.

5. The developer shall submit Final Schematics (Form #3) to the Agency after the approval by Design Development Drawings and at least sixty (60) days before the submission of Final Construction Drawings.

6. The developer shall submit a Final Art Plan, in the form attached hereto as Form #4, to the Agency not later than sixty (60) days before submission to the Agency of the developer's Final Construction Drawings and Landscape Plans for the development project. Within sixty (60) days after submission of the Final Art Plan the developer and the Arts Advisory Committee shall meet, at which time the developer shall present the Final Art Plan to the Committee.

7. The CRA staff and Arts Advisory Committee shall review the Final Schematics and Final Art Plan. The AAC shall recommend approval, revision or other action on said Plan based upon the Agency's Program and the previously approved Preliminary Arts Plan.

The Arts Advisory Committee approval of the Final Art Plan must be received before the CRA will approve the developer's Final Construction Drawings for the development project. The CRA Board will ratify the decision of the Arts Advisory Committee.

8. At the time that the City issues a Certificate of Occupancy for the development project and no later than when the CRA issues a Certificate of Completion, the developer shall deposit a minimum 40% of the estimated Public Art Budget into the Downtown Cultural Trust Fund, Form #5.

9. The artwork must be installed and completed in conformity with the approved Final Art Plan unless modifications have been previously agreed to by the CRA. Upon such installation and completion the developer shall notify the CRA in writing.

 Within thirty (30) days after receipt of such notification the CRA staff shall inspect and review the artwork; and if the artwork conforms to the approved Final Art Plan (including any agreed upon modifications), issue a written confirmation of such conformity or if the artwork does not so conform staff shall notify the developer in writing of the deficiencies.

 Confirmation that the artwork conforms to the approved Final Art Plan (including agreed upon modifications) must be made before the Agency will issue a Certificate of Completion to the developer.

10. No later than 30 days after funding of developer's construction financing the total project costs shall be recalculated. In the event of a cost discrepancy between the estimated and final project costs, the Public Art Budget shall be adjusted accordingly.

ART IN PUBLIC PLACES PROGRAM

THE COMMUNITY REDEVELOPMENT AGENCY OF THE CITY OF LOS ANGELES

FORM #2 Page 1

Preliminary Art Plan and 50% Schematics

Please complete and return this form and 50% Schematics to the Community Redevelopment Agency (CRA) within sixty (60) days after execution of an OPA or DDA.

Developer _____

Contact Person _____

Address _____

Telephone _____ Date _____

Property Location _____

Artist _____

Address _____

Telephone _____

Architect _____

Address _____

Telephone _____

Other consultants (e.g., Landscape Architect, Arts Consultant, etc.)

Architect _____

Address _____

Telephone _____

Property Location _____

Description and Proposed Use of Structure _____

Total Square Feet: Building _____ Site _____

Number of Anticipated Occupants _____

Estimated Total Development Cost _____

Estimated Schedule: Preliminary Design Drawings _____
 Design Development Drawings _____
 Final Art SchematicsDrawings _____
 Final Construction Drawings _____
 and Final Landscape Plan
 Construction Start _____
 Construction Complete

ART IN PUBLIC PLACES PROGRAM

THE COMMUNITY REDEVELOPMENT AGENCY OF THE CITY OF LOS ANGELES

FORM #2 Page 2

Preliminary Art Plan

1. Estimated Arts Budget _____

 One percent (1%) of the estimated total project development costs excluding land and off-site improvements. Please note that when the Certificate of Completion is issued by the Agency for the Project, the final arts budget will be 1% of the estimated total cost at that time.

2. Which Public Art component was selected to satisfy the % for Public Art Obligation?

 Permanent Artwork installation () Temporary Artwork Installation ()
 Cultural Facility _____ () Cultural Programming _____ ()

 Will the art component be concentrated in one area or distributed throughout the public spaces? (Please respond to this and following questions on the attached blank page).

3. Is the proposed project/program a collaborative effort? If so, specify the participants, responsibilities and proposed arts budget allocation to non-arts components, if applicable.

4. How will the art component function within the whole development? Activate a space? Provide a landmark? Serve a function (gateway, seating, etc.)?

5. Who are the primary and secondary audiences for the artwork or cultural program (pedestrians, building users, tourists, automobile traffic, etc.)?

6. How has the anticipated audience influenced your choice of artwork, program or cultural facility?

7. If applicable, describe plans for artwork to conform to necessary safety and functional requirements. Who will assist on these requirements?

8. Describe plans for fabrication and installation of the artwork.

9. Describe needs and plans for ongoing maintenance or program development responsibilities.

10. Please submit 50% Schematic Desing, with model if appropriate.

The Schedule of Performance,
including the art program's
schedule, becomes part of the
contract between the CRA and
developer. Timelines are ad-
justed as needed to reflect
project specifics. Annotations
are by CRA staff.

CHART C - SCHEDULE OF PERFORMANCE

BUILDING AND LANDSCAPE PROGRAM

PRELIMINARY PROJECT DEVELOPMENT
DISCUSSION (DEVELOPER/ARCHITECT/
CRA STAFF).

EXCLUSIVE RIGHT TO
NEGOTIATE SIGNED
(OPTIONAL).

PREPARATION OF INITIAL
CONCEPT DRAWINGS AND OPA.

EXECUTION OF OPA, APPROVAL
OF INITIAL CONCEPT DRAWINGS.

PREPARATION AND SUBMISSION OF
PRELIMINARY DESIGN DRAWING
AND PRELIMINARY LANDSCAPE PLAN.

APPROVAL OF PRELIMINARY
DESIGN DRAWING AND
PRELIMINARY LANDSCAPE PLAN.

PREPARATION AND SUBMISSION OF DESIGN
DEVELOPMENT DRAWINGS.
WORKING DRAWINGS INITIATED.

APPROVAL OF DESIGN
DEVELOPMENT DRAWINGS.

PREPARATION AND SUBMISSION OF FINAL
CONSTRUCTION DRAWINGS AND FINAL LANDSCAPE
PLAN. POTENTIAL START OF CONSTRUCTION.

APPROVAL OF FINAL
CONSTRUCTION DRWGS
AND LANDSCAPE PLANS

Generally, an integrated arts
program must be initiated no
later than the preliminary de-
sign drawings.

ART PROGRAM

(NOT APPLICABLE TO CULTURAL
PROGRAMMING OR CULTURAL FACILITIES).

PRELIMINARY BUDGET ESTIMATE (FORM #1)
CONVEYED TO DEVELOPER AT STAFF
DESCRETION. (CHART C, PHASE I).

DEVELOPER/AAC BRIEFING AND REVIEW
OF PROJECT OBJECTIVES (PHASE II).

ART SELECTION PROCESS AND SELECTING BODY
APPROVED. (PHASE II, III, IV, AND V).

ARTIST SELECTED
(PHASE VI).

ARTIST CONSULTS WITH ARCHITECT.
PREPARATION AND SUBMISSION OF 50%
SCHEMATICS (PHASE VII AND VIII).

PRELIMINARY ART PLAN
AND 50% SCHEMATICS
SUBMITTED (FORM #2).

ARTS ADVISORY COMMITTEE APPROVAL
OF 50% SCHEMATICS. (PHASE IX).

PREPARATION AND SUBMISSION OF FINAL
SCHEMATICS, (FORM #3) ON-GOING
CONSULTATION WITH ARCHITECT AND STAFF.

BOARD APPROVAL OF FINAL
DESIGN (PHASE X).

FINAL ART PLAN SUBMITTED
AND APPROVED (FROM #4).

For a variety of reasons, some
art projects are hard to get
(or keep) rolling. Rather
that find developers in
default of an agreement,
the Agency will try to
renegotiate a revised
schedule of performance.

A delay in getting an
artist on board usually
means the opportunity
for integrated art
will be more difficult
to achieve and may, in
some cases, be precluded
altogether.

It's important during this
period for CRA staff to lend
support and technical assis-
tance to both artist and devel-
oper as ideas develop and under-
go review and revision.

TIME FRAME IN MONTHS

0 1 2 3 4 5 6 7 8 9 10 11 12 13 14 15 16 17 18 19 20 21 22 23 24 25 26 27 28 29 30 31 32

Reprinted by permission of the San Francisco
Department of City Planning.

As the line between the artist's
and architect's work becomes
harder to define, this defini-
tion might become a problem.
Artist

Bravo!
Artist

Artistic merit is the question
here. Without evaluation of
quality, we'll likely get star-
ving-artist-clearing house-
sofa-sized-original-oil paint-
ings.
Artist

The 1":32' model is to observe
the building within its immedi-
ate context. The purpose of
the 1":100' model is to keep
updated the model of San
Francisco's downtown.
San Francisco Planner

SEC. 149. ART WORKS, RECOGNITION OF ARCHITECT AND ARTISTS AND MODEL
REQUIREMENTS IN C-3 DISTRICTS.

(a) Art Works. In the case of construction of a new building or
addition of floor area in excess of 25,000 square feet to an
existing building in a C-3 district, works of art costing an
amount equal to 1% of the construction cost of the building
or addition as determined by the Superintendent of the Bureau
of Building Inspection shall be installed and maintained (i)
in areas on the site of the building or addition and clearly
visible from the public sidewalk or the open space feature
required by Section 138 or (ii) on the site of the open space
feature provided pursuant to Section 138, or (iii) upon the
approval of any relevant public agency, on adjacent public
property, or (iv) in a publicly accessible lobby area of a
hotel. Said works of art shall be installed prior to
issuance of the first certificate of occupancy, provided,
however, that if the Zoning Administrator concludes that it
is not feasible to install the works within that time and
that adequate assurance is provided that the works will be
installed in a timely manner, the Zoning Administrator may
extend the time for installation for a period of not less
than 12 months. Said works of art may include sculpture,
bas-relief, murals, mosaics, decorative water features,
tapestries or other art works permanently affixed to the
building or its grounds, or a combination thereof, but may
not include architectural features of the building. Art
works shall be displayed in a manner that will enhance their
enjoyment by the general public. The type and location of
art work, but not the artistic merits of the specific art
work proposed, shall be approved in accordance with the
provisions of Section 309. The term "construction cost"
shall be determined in the manner used to determine the
valuation of work as set forth in Section 304 of the Building
Code.

(b) Recognition of Architects and Artists. In the case of
construction of a new building or an addition of floor area
in excess of 25,000 square feet to an existing building in a
C-3 district, a plaque or cornerstone identifying the project
architect and the creator of the artwork provided pursuant to
subsection (a) and the erection date shall be placed at a
publicly conspicuous location on the building prior to the
issuance of the first certificate of occupancy.

(c) Models. In a C-3 district, in the case of construction of a
new building, or any addition in height in excess of 40' to
an existing building, two models shall be submitted to the
Department of City Planning prior to approval of the project
as follows:

- 87 -

149(c)1

1. One model of the building at a scale of 1"=100'; and

2. One model of the block in which the building is located
at a scale of 1"=32', which model shall include all the
buildings on the block on which the building is located
and the streets surrounding the block to the centerline
of the streets and shall use as its base the land form
starting at sea level; provided, however, that if the
Department of City Planning determines that it has an
up-to-date model of the block in which the building is
located, only a model of the building shall be submitted.

(d) Procedure Regarding Certificate of Occupancy. The
Superintendent of the Bureau of Building Inspection shall
provide notice in writing to the Zoning Administrator at
least five business days prior to issuing the first
certificate of occupancy for any building subject to the
provisions of this section. If the Zoning Administrator
notifies the Superintendent within such time that the
provisions of this section have not been complied with, the
Superintendent shall deny the permit. If the Zoning
Administrator notifies the Superintendent that the provisions
of this section have been complied with or fails to respond
within five business days, the permit of occupancy shall not
be disapproved pursuant to this section. As used herein, the
first certificate of occupancy shall mean either a temporary
certificate of occupancy or a Certificate of Final Completion
and Occupancy as defined in San Francisco Building Code
Section 307, whichever is issued first. The procedure set
forth in this subsection is not intended to preclude
enforcement of the requirements of this section through any
means otherwise authorized.
(Added Ord. 414-85, Approved 9/17/85)

7502B/651A

We need to start thinking past
the building, past the block,
and start to see the larger
context. The City of Seattle
Department of Community Develop-
ment has a model of its down-
town which, though painted a
consistent beige, serves to
describe the mass and volume
of the city.
Artist

- 88 -

Reprinted by permission of Metro-Dade Art in Public Places.

The Master Plan for the Metro-Dade Art in Public Places Program serves the long-term vision for public art in Dade County by outlining goals, operating principles, and the unique urban features of the city of Miami (beaches, air and seaports, thoroughfares) and relating these to public art potential and community education.

METROPOLITAN DADE COUNTY, FLORIDA

METRO-DADE

METRO-DADE CENTER

ART IN PUBLIC PLACES
SUITE 610
111 N.W. 1st STREET
MIAMI, FLORIDA 33128-1982
(305) 375-5362

Dan Paul,
Chairman

Bettie B. Barkdull,
Vice Chairman

Patricia Wallace,
Secretary-Treasurer

Betty Bigby-Young
Mark A. Cohen
Sonia Cohen
Keeker Cornell
Sharon G. Grau
Mira T. Lehr
Penelope McPhee
E.N. Papper, M.D.
Audrey Renault
Raul L. Rodriguez
Dennis Scholl
Francena Thomas

DADE COUNTY ART IN PUBLIC PLACES

THE MASTER PLAN

The purpose of the Master Plan is to insure a coherent acquisition program for Art in Public Places in Dade County, and to provide a framework which guides art work acquisitions. The Master Plan establishes criteria and policies for the Art in Public Places program and priorities for art work at certain tourist-oriented locations in Dade County, as called for in the Ordinance.

For the purposes of the Master Plan, "art in public places" means "works of art of exceptional quality executed on an appropriate scale and for general public access in public places other than museums, which enrich and give dimension to the public environment".

Section I: Goals

The principal goals of the Art in Public Places Program are:

A. To enhance and preserve the artistic heritage of Dade County;

B. To enrich the public environment for both residents and visitors to the area through incorporation of the visual arts;

C. To enable Dade County to attain recognition as a national leader in art in public places and in cultural life;

D To increase public access to works of art, and to promote understanding and awareness of the visual arts in the public environment;

E. To enhance the climate for artistic creativity in Dade County; and

F. To contribute to the civic pride of our community.

Section II: Criteria

A. Standard of Excellence
Acquisitions for Art in Public Places shall be, in the judgment of recognized art experts, of exceptional quality and enduring value.

B. Appropriateness to Site
Relationship of art work and site shall be considered in terms of the physical dimensions, social dynamics, local character and surrounding urban context of the site, existing or planned.

Section III: Policy

A. Art Funds - Prohibition of Use
The Trust funds shall not be spent for:

1. Reproductions or unlimited editions of original work;

2. "Art objects" that are mass produced;

3. Works that are decorative, ornamental or functional elements of the architecture or landscape design, except when commissioned from an artist as an integral aspect of a structure or site; or

4. Architectural rehabilitation or historical preservation, although works may be acquired in connection with such projects.

B. Focus of Art in Public Places
In concert with Dade County's development, which emphasizes contemporary architecture, the focus of Art in Public Places shall be contemporary art. This shall not, however, preclude the acquisition of important historical works which provide a context for contemporary art, where most appropriate for the site.

C. Relationship to Site
The Trust views art in public places as a dynamic process, which challenges artists to respond innovatively to Dade County's unique subtropical environment.

1. In order to encourage works which respond to the County's rich physical setting and diversity of public sites, commission of new works shall have priority over purchase and siting of existing works.

2. Collaboration between artists and architects in the design process shall be encouraged to promote the integration of art work and site.

D. Diversity
Recognizing the multi-lingual and multi-cultural nature of Dade County's population, the Trust shall promote diversity and pluralism in art in public places, which shall reflect as wide a range of expression as possible.

E. Responsibility to the Community
The Trust recognizes that works of art often significantly alter public places, becoming a major new presence in the environment. In recent decades, visual art has rapidly evolved and diversified, creating at times a gap between contemporary art and its appreciation by the general public. The program shall endeavor to bridge this gap, by broadening community awareness of the issues involved in contemporary art and its historical context, and encouraging informed debate among all segments of the community.

F. Professional Conduct
The Trust shall oversee the acquisition of public art on the basis of informed and carefully considered professional judgment. The Trust shall also foster a professional approach in dealings with artists, supporting the artist's aesthetic judgment in the interest of always securing the best possible work.

G. The Private Sector
The County Commission shall refer to the Trust proposed donations of works of art or funds for the acquisition of works of art in public places from the private sector.

Acceptance or rejection of proposed gifts is based on the criteria and policies established in the Master Plan.

Section IV: Art Work at Tourist-Oriented Locations

A. Major Facilities: the Airport and the Seaport
Art work projects will be developed in concert with long-range facility planning. A balance will be sought between

works on a large scale and works which relate to areas where people congregate, wait, rest or engage in social activity. Location of art works, advertising, functional installations and signage will be planned to avoid conflicts.

1. The Airport. As the principal point of entry and exit for the greater Miami area, the airport is an important projection of the area's cultural image. Priorities for art work include:

 a) Major entry and exit points.

 b) Passenger and visitor areas.

 c) Perimeter areas which interface with surrounding communities, where works of art can provide amenities and encourage use by the public to ease the transition between the airport and its surroundings.

2. The Seaport. As an important arrival and departure point for tourism and commerce, the seaport should reflect Dade County's cultural vitality and its unique environment. The facility is an opportunity for artists to respond to elements such as light and water and to marine vistas in innovative ways. Priorities for art work include:

 a) Major entry and exit points.

 b) Passenger and visitor areas.

 c) Downtown approaches, where works of art can encourage seaport users to further explore the greater Miami area and its cultural offerings.

 d) Areas visible from surrounding thoroughfares and public places.

B. Systems: Parks, Beaches and Thoroughfares
 Art work projects will be planned in concert with system-wide development. Art works may enhance the continuous features which link elements in the system, or the individual and variable local character of sites within it.

 1. Parks. Art work projects for parks will recognize the leisure activities accommodated at individual sites, the extent to which users are drawn from primarily local or regional and visitor populations, and the urban or suburban character of the park's surroundings. Park and beach sites are seen as excellent opportunities for art works that offer tactile experiences,

invite interaction or participation, establish resting places or focal points, or respond to natural elements or landscape features at the site. Priority will be given to:

 a) Sites not used exclusively for programmed activity or active recreation.

 b) Sites under development or improvement, where art works can be integrated through the planning and design process.

2. Beaches. As major resources which are extensively used by residents and visitors, and strongly identified with Dade County's image, the beaches represent an opportunity for artists to respond to their special environmental characteristics. Emphasis will be placed on:

 a) Environmental features such as water, light, wind, sand and air.

 b) Sites under development or improvement where art works can be integrated through the planning and design process.

3. Thoroughfares. Art work projects will recognize the urban design functions of thoroughfares as major vehicle movement routes, as pedestrian passages, as visual links within the cityscape. Priorities will include:

 a) Pedestrian passages, promenades, malls and routes which open onto important public spaces and centers of activity.

 b) Thoroughfares which function as strong visual links and directional orientations.

Section V. While certain priorities for art work are identified, this shall not preclude consideration of exceptional opportunities for art work, where they are in keeping with the criteria and policies established in the Master Plan.

Metro-Dade Art in Public Places Implementation Guidelines

Reprinted by permission of Metro-Dade Art in Public Places.

Metro-Dade's Implementation Guidelines follow. By way of clarification, the roles of the Art in Public Places Trust and the Professional Advisory Committee are excerpted here from the ordinance. The ordinance also stipulates that administrative staff be provided by the County Manager in order to effectively carry out the charge of the Trust.

2. **Art in Public Places Trust**
There shall be an Art in Public Places Trust to administer the Program.

(a) **Purpose.** The Trustees of the Art in Public Places Trust shall act in the public interest upon all matters relating to the Program and shall support the Program's goals and objectives. The Trustees' responsibilities include the selection, maintenance, planning, public education and curatorship of works of art acquired by the Program.

(1) **Membership qualifications.** The Trust shall be composed of fifteen (15) Trustees appointed to staggered three-year terms by the Board of County Commissioners, serving without compensation. Additionally, the Mayor shall appoint two members of the Board of County Commissioners to sit as ex-officio Trustees. Each Trustee must be knowledgeable in public art, must be a resident of Dade County and may not operate, own or be employed by any art dealer, art gallery, artists' representative, museum or other entity which derives income from the sale or display of art work. Membership is governed by Sections 2-11.38 and 2-11.39 of the Dade County Code

(2) **Term of office.** Each Trustee shall serve a three year term and may be reappointed for a second consecutive term; provided that of the initial fifteen Trustees, five shall be appointed for one year terms and five shall be appointed for two year terms, and at least four and not more than seven initial Trustees shall have been members of the Art in Public Places Committee previously appointed by the County Manager for terms expiring not earlier than June 1982.

(3) **Duties.** The Trustees shall prepare a Master Art Plan to insure a coherent acquisition program and Implementation Guidelines, both of which shall be approved by the Board of County Commissioners. The Trustees shall approve all program acquisitions in accordance with the Master Art Plan and Implementation Guidelines and shall oversee the public education and curatorial aspects of the Program. The Trustees shall recommend to the County Manager an executive director, a budget for staff and other expenditures necessary to operate the Program and shall deliver an annual report to the Board of County Commissioners.

(b) **Professional Advisory Committee.** The Professional Advisory Committee shall be composed of eleven members appointed by the Trust, and shall be compensated for professional services in accordance with a schedule established by the Trust, although this shall not preclude donation of such services.

(1) **Membership, qualifications.** Each member of the Professional Advisory Committee shall be a professional in the fields of art, architecture, art history, or architectural history. Members' reasonable expenses shall be reimbursed at a uniform rate to be established from time to time by the Trust.

(2) **Term of office.** Each Professional Advisory Committee member shall serve a two-year term and may be reappointed for a total of three consecutive terms.

(3) **Duties.** The Professional Advisory Committee will screen submissions and will recommend to the Trust for each acquisition not more than three possible selections, which may be existing works of art or new commissions.

(4) **Proceedings.** For each acquisition the Trust shall direct the Professional Advisory Committee to act as a committee of the whole or in smaller subcommittees.

Metro-Dade County's Art in Public Places Program provides for a minimum of 1.5% of construction costs of new government buildings for works of art.

This is an important qualification on the ordinance. The Trust, with APP staff, may envision art possibilities where the County Commission may not.
 Public Art Administrator

METRO DADE ART IN PUBLIC PLACES IMPLEMENTATION GUIDELINES

The Guidelines govern the manner and method of the submission of proposed works of art to the Professional Advisory Committee, the process by which the Professional Advisory Committee shall make recommendations to the Trust members and the process by which the Trust members shall approve acquisitions, as called for in the Ordinance.

Section I: Art Work Projects

A. Development of Projects
The Art in Public Places Trust oversees the implementation of individual art work projects in accordance with the Master Plan. Art in Public Places staff works with County staff to identify construction projects eligible under the Ordinance for the allocation of art funds. Before considering any request for waiver of the art allocation, the County Commission will seek a recommendation from the Art in Public Places Trust. Art funds are then deposited in a central Art Trust Fund. Staff researches and identifies planned construction projects and existing facilities in the county which are potential art work sites. An inventory of artwork sites is then established and continually updated, to include for each site: current information on the extent of public access, special user groups involved, environmental conditions, the surrounding community or urban area, and the design and construction schedule for each site. The Trust on an annual basis approves an art work budget which designates art work projects, the allocation of funds and the method of art work selection for each project, consistent with the Master Plan. A selection committee and a ad-hoc liaison committee is appointed for each group of related sites or major project.

B. Guidelines for Art Work Projects
1. Siting. Art work may be sited as an integral part of a construction project, or may be sited at other public places under County jurisdiction or by agreement with other governmental entities. At a given art work project site, several locations for art work may be identified, or the PAC selection committee or the selected artist may be asked to propose one or more locations for art work. In any case, siting shall be subject to the approval of the Trust, and in consultation with the County department.

Section II: The Professional Advisory Committee

A Professional Advisory Committee of eleven members is appointed
to two-year terms by the Trust, to make recommendations for ac-
quisitions. Selection committees are drawn from the PAC member-
ship to recommend acquisitions for individual artwork projects.
PAC members are professionals in the fields of art, art history,
architecture or architectural history. They are generally rec-
ognized by their peers as authorities with art historical know-
ledge and expertise in contemporary and/or modern art and with
substantial experience with art in public places. Consultants
may be called on to provide additional expertise to PAC selec-
tion committees.

Section III: Liaison Committees

An ad-hoc liaison committee is appointed for each acquisition or
related group of acquisitions.

 A. Composition
 The Chairman of the Trust and the Executive Committee
 appoint two Trust members of each ad-hoc liaison com-
 mittee. Additional members may be architects, engi-
 neers or other design professionals; community
 residents and those who will be in constant contact
 with the work, and others. The composition of each
 ad-hoc liaison committee depends on the nature of
 the art work project and the location of the site,
 and members serve without compensation.

 B. Duties
 1. The ad-hoc liaison committees provide assistance
 to the PAC selection committees, advising them
 on the Art in Public Places program, the Master
 Plan, the project site and the surrounding
 community or urban area.

 2. Once a selection is made, the ad-hoc liaison
 committee provides communication among the artist,
 the community and the Trust.

Section IV: Art Work Selection

Art work may be acquired by commissioning new work specifically
for the site, or by purchasing existing work. Selections are
made in accordance with the criteria set forth in the Master Plan.

 A. PAC Selection Committee
 Staff assigns and schedules the PAC selection committees.
 The PAC selection committee recommends no more than three

choices for each acquisition and submits a written
report of its recommendations to the Trust.

 B. Announcement
 Commissions are widely publicized in advance of the
 selection committee meeting. Announcements inform
 artists of the method of selection and of submission
 requirements.

 C. Review of Artists
 Consideration of artists is by review of work or by
 review of proposals.

 1. Review of work. Slides and visual representations
 of recent work are reviewed by the PAC selection
 committee. Proposals for the site are not requested
 or considered at this time. PAC selection committee
 members may propose artists for consideration from
 those submitting, or from others at large.

 2. Review of Proposals. Artists submit proposals for
 the site to the PAC selection committee for review.

 D. Methods of Selection
 Art work is selected through direct selection, invita-
 tion, or open competition.

 1. Direct selection. The PAC selection committee rec-
 ommends acquisitions on the basis of review of work.

 2. Invitation. The PAC selection committee recommends
 a limited number of artists on the basis of review
 of work. The selected artists are invited to pre-
 pare proposals for the project, and are paid accord-
 ing to the scope of the work. The PAC selection
 committee then reviews the proposals and recommends
 acquisitions.

 3. Open competition. The PAC selection committee
 reviews proposals submitted by artists in response
 to the project advertisements, and a) recommends
 artists for acquisition or b) recommends a limited
 number of artists who are paid to develop more
 detailed proposals. The PAC selection committee
 then reviews these developed proposals and recom-
 mends acquisitions.

 E. Trust Approval
 Each acquisition must be approved by the Trust. Approval
 shall require a majority vote of a quorum present at a
 duly called meeting of the Trust. Prior to Trust review
 of a proposed acquisition, technical feasibility and

The Metro Dade Guidelines demonstrate a crucial commitment to community education, maintenance, and documentation which many programs skim over at best.
 Public Art Administrator

Good start. More detailed thought would be even better here and/or a reference to a collection management policy. (For more on this topic, see Collection Management and Conservation sections.)
 Public Art Administrator

maintenance acceptability are investigated by staff, in consultation with the agency responsible for the site and with the assistance of technical consultants if required, and a report is made to the Trust.

Section V: Implementation

Following Trust approval of an acquisition, Art in Public Places staff prepares and negotiates the contract for purchase or commission of the work and the contract is approved by the Trust and executed by the County Manager or his designee. Liaison between the artist or provider of the work and County agencies in the administration of the contract is provided by Art in Public Places staff. Dedication of the work is coordinated with the ad-hoc liaison committee for the project.

Section VI: Public Information and Community Education

Public information and education activities will be supported to bring the public, the visual arts and artists closer together through informed discussion of art in public places and its history. Extensive efforts will be made to promote art in public places as a significant cultural resource to residents and visitors.

A. Art work projects
 Information on art work projects, the artists involved and progress of their work will be disseminated regularly, and the Trust will seek to provide opportunities for dialogue between artists and the public.

B. The Art in Public Places Program
 Working with local arts and community organizations and with both print and broadcast media, the Trust seeks to develop greater awareness of the Dade County Art in Public Places Program, its diversity and the cultural resource it offers residents and visitors. The program will initiate and cooperate with activities designed to stimulate public understanding of the visual arts and awareness of art in public places in Dade County. Activities may include conferences, symposia, tours, information easily accessible in public places, special media programming, cooperative programs with educational and arts institutions and organizations, special activities coinciding with art work dedications and other events in the community.

Section VII: Care and Maintenance of Art Work

The Art in Public Places Trust is responsible for the care and maintenance of art work acquired under the County's Art in Public Places Program. A system providing for the care and maintenance of art in public places acquisitions will be developed and administered by the Art in Public Places staff. The system will provide for location, documentation, condition monitoring, and repair or relocation of works. Consultants may be retained, as necessary, to design and implement the system.

Section VIII: Documentation

The art work selection, acquisition and installation process will be accurately recorded, and the construction or provenance of each work acquired fully documented.

Section IX: Gifts of Works of Art

Proposed gifts to the County of works of art in public places, or of funds for the acquisition of works of art in public places, are referred to the Trust.

A. Proposed gifts of works of art are referred to the PAC for their review and recommendation to the Trust. Review is based on the criteria established in the Master Plan, on the work's condition, its appropriateness for a given available site, and its maintenance acceptability.

B. Proposed gifts of funds for the acquisition of works of art, if restricted or dedicated in any way, are reviewed to insure that such restrictions or dedications are consistent with the Master Plan.

C. Proposed gifts of sites for works of art are reviewed by the Trust to insure consistency with the Master Plan.

- end -

Approved by the Art in Public Places Trust on December 13, 1983.

Approved by the Dade Board of County Commissioners on January 17, 1984.

207

Reprinted by permission of The Real Comet Press, publisher.

This outline is excerpted from *Five Artists at NOAA: A Casebook on Art in Public Places* (see Bibliography). The book chronicles the three year process of bringing to fruition a major public art project at the National Oceanic and Atmospheric Administration's (NOAA) Sandpoint regional center in Seattle, Washington. The installation of five public artworks by nationally important artists represented cooperation between NOAA, the Seattle Arts Commission (SAC), the National Endowment for the Arts (NEA), Naramore Bain Brady and Johanson (NBBJ, architects), the public, and the artists themselves. NOAA officials were concerned that the process for selecting artists and artwork be responsive to local concerns. Selection of artwork solely by agency officials or by the architects would conflict with NOAA's commitment to work with the community and with its concern for artistic excellence. Working closely with the community, the SAC, and the NEA, a careful step by step process was laid out and is presented here. *Five Artists at NOAA* provides a thorough look at the process and issues of this one project. See also the "Chronology" from the same publication, opposite page.

NOAA FINE ARTS PROGRAM

Note: As agreed to by SAC and NOAA at the outset of the project, this document was the blueprint for carrying out the artwork program at the Western Regional Center. While adjustments were made or called for during the course of the project (as can be seen in the Chronology), the basic format was adhered to throughout.

The budget for the Western Regional Center project includes $250,000 (approximately one-half of one percent of the construction portion) for procurement and installation of artwork. An agreement has been reached with the Seattle Arts Commission (SAC) who, in conjunction with the National Endowment for the Arts (NEA) will administer an artist and artwork selection process on behalf of NOAA.

The following procedure has been developed by the SAC and NOAA and approved by the NOAA Administrator. The artist-selection process will begin in February 1981 when SAC advertises for submission of artists' material in their monthly journal.

PART I ARTIST-SELECTION PROCEDURE
1. Panel composition defined by NOAA/SAC/NEA.
2. SAC/NOAA make public announcement of program, its goals and procedures.
3. Panel selected and advisors appointed. The panel is moderated by SAC/NEA staff.

 ARTIST-SELECTION PANEL COMPOSITION
 - Six voting members selected from architects, museum representatives, artists, or other design professionals with experience in the visual arts, and five nonvoting advisors.
 - SAC appoints three voting members from within the Pacific Northwest.
 - NEA appoints three voting members, at least one from within the Pacific Northwest.
 - SAC/NOAA appoint advisors to the panel including one NOAA representative, one NBBJ representative, and three community representatives.
4. SAC/NOAA develop prospectus, including site and criteria by which artists will be selected.
5. SAC advertises project, invites proposals.
6. SAC/NOAA/NBBJ provide information to interested artists.
7. SAC receives slides and resumes from artists responding to SAC advertising of project.
8. NOAA Administrator invited to attend selection panel meeting.
9. SAC/NOAA and three community representatives meet with Mayor's Citizen Liaison Committee and brief them on artist selection process, and gather input.
10. Selection panel also asked to recommend a variety of artists whose work they feel might be appropriate. SAC/NEA would collect slides and resumes of these specific artists for consideration along with artists responding to the advertisement.
11. Panel and advisors convene and tour site.
12. Panel and advisors briefed by NOAA, NBBJ, SAC.
13. Panel reviews artists' materials and selects one artist and one alternate for each proposed commission. Alternate artist's name is not advertised to public and is to be used only in the event that first-choice artist does not accept commission or is unable to complete commission.

14. Panel selects artwork location, budget for each artist, and documents reasons for selecting individual artists. This information is to be given to the selected artists along with detailed information on NOAA's mission and the site to aid them in their proposed design.
15. SAC contacts selected artists and briefs them on project.
16. NOAA negotiates a fixed-price contract with selected artists for design (artwork proposal), execution and installation of the work of art, and all other contract requirements. Artists will be given notice to proceed with execution and installation after proposals have been reviewed and approved according to procedures described in Part II. Negotiations take place at project site.
17. SAC/NOAA make public announcement of artists selection.
18. SAC returns artists' materials to artists.

PART II ARTWORK REVIEW AND APPROVAL PROCEDURE
1. NOAA Administrator invited to attend Artwork Review Panel meeting.
2. Selected artists present specific proposals to Artwork Review Panel.

 ARTWORK REVIEW PANEL COMPOSITION
 - Four regional voting members of the artist-selection panel (three SAC and one NEA appointees).
 - Artist-selection panel nonvoting advisors (one NOAA, one NBBJ, and three community representatives).
3. Four voting members of artist-selection panel review proposals based on artistic quality.
4. NOAA reviews proposals and advises review panel on matters of safety, maintenance, and site preparation.
5. NBBJ advises review panel on relationship of proposed artwork to architecture.
6. Community advisory group reviews proposals and provides additional input to the review panel.
7. Artwork review panel assimilates input and advice and approves proposal or asks artist to prepare alternate proposal.
8. Approved proposals submitted to NOAA Administrator for final approval.
9. After approval artists given notice to proceed with execution and installation.
10. Six weeks prior to installation, SAC/NOAA hold a press conference to introduce the work and unveil the artist's model.
11. Within six weeks from the date of installation, a dedication of the work is held by SAC/NOAA. A permanent identification plaque is installed adjacent to the artwork.

46

CHRONOLOGY

1976
Development of the NOAA Western Regional Center (WRC) begins. NOAA management decides to follow federal General Services Administration policy and allocates $250,000 (one-half of one percent of the congressional appropriation for construction costs) to develop an art program for the WRC.

1980
January
NOAA representatives, chiefly Dale Gough, Director of the Northwest Administrative Service Office and Chair of the WRC Building Committee, and Jim Watkins, Project Engineer for the WRC, hold discussions with Seattle Arts Commission (SAC) Executive Secretary Karen Gates, and Art in Public Places Coordinator Richard Andrews, and with National Endowment for the Arts (NEA) Coordinator for Art in Public Places Patricia Fuller about structuring an artwork program. Important considerations include: NOAA's desire for an artist-selection process sensitive to community, the agency and the unique character of the site; SAC interest in works of art which complement those already in the city and which take full advantage of the site's potential; and NEA concern for professional selection procedures and consideration of artists on a national level for federal projects.

May
NOAA national headquarters approves decision for WRC to manage its own art program at the regional level, in collaboration with SAC and NEA.

June–October
NOAA and SAC develop the artwork program and artist-selection procedures in consultation with NEA. NOAA contracts with SAC to administer the artist-selection process and coordinate the artists' participation. Gough and Andrews meet with NOAA Building Committee and Sand Point Community Liaison Committee to discuss the developing artwork project.

November–December
SAC and NEA agree on composition of selection panel. NEA appoints Parks Anderson, artist, Issaquah, Washington; Richard Koshalek, then Director of the Hudson River Museum, Yonkers, N.Y.; Dianne Vanderlip, Curator of 20th Century Art, Denver Art Museum, Colorado. SAC appoints Anne Gerber, Seattle art patron, collector and Arts Commissioner; Arnold Jolles, Director, Seattle Art Museum; and Seattle artist Norie Sato.

SAC and NOAA appoint as nonvoting members to the panel: Dr. John Apel of NOAA; architect David Hoedemaker of The NBBJ Group; and community representatives Ina Bray, community resident and former King County Arts Commissioner, and Charles Kindt and Dorothy McCormick, both members of the Laurelhurst Community Club and of the Sand Point Community Liaison Committee.

1981
January–February
NOAA and SAC develop a prospectus describing the WRC art program and the criteria and procedures for selection of artists, and make a joint public announcement of the project. SAC advertises the project nationally; selection panelists are requested to begin gathering material on artists for consideration.

March–April
SAC receives slides and resumes from artists responding to prospectus.

May
Andrews and Gough meet with NOAA Building Committee and Sand Point Community Liaison Committee to brief them on the artwork selection process and to gather input for the panel.

May 29–30
Selection panel convenes with advisors. After briefing by advisors, panelists tour site and review slides and other material representing work of over 250 artists. Panel unanimously recommends five artists: Siah Armajani, Scott Burton, Douglas Hollis, Martin Puryear and George Trakas. The panel also recommends individual project budgets ranging between $30,000 and $50,000, and recommends the artists be given flexibility in siting their projects.

June
Following acceptance of the panel's recommendations by NOAA Administrator John V. Byrne, SAC contacts the artists and arranges for all five to visit the NOAA site together.

Andrews and Watkins meet with the NOAA Building Committee and Sand Point Community Liaison Committee to show slides of selected artists' work and discuss how the project will unfold.

August 3–7
The artists come to Seattle to see the site and meet with NOAA project staff. They tour every division of NOAA and meet with employees to get a feeling of the scope of NOAA's mission, and activities at the workplace. They also meet with the Sand Point Community Liaison Committee to discuss concerns for the site. After meetings with architects and landscape architects, artists make preliminary decisions about siting, and ask for an interim meeting in six months.

September–October
NOAA, in connection with SAC, negotiates a fixed-price contract with each artist for design, execution and installation of a work of art at the WRC.

SAC and NOAA make a joint public announcement of artists commissioned for the WRC.

1982
February 18–19
The five artists return for the interim meeting and make individual presentations of their preliminary ideas to the NOAA Building Committee, Sand Point Community Liaison Committee, architects, and local members of the original selection panel. The artists' ideas are presented as

preliminary, and all agree that the occasion is for comments and questions, not final judgments. The artists also meet together on their own to coordinate their plans and to develop the idea of the Shoreline Walk.

February–June
Watkins and Andrews meet frequently to coordinate and provide information to the artists.

June 24
The final proposals are presented to representatives from all departments of NOAA, NBBJ, Jones and Jones, the Seattle art community and the Sand Point community. The artists present their proposals after a summary of the process by Watkins and Andrews. The response is enthusiastic; many people stay on to talk with the artists afterwards.

June 25
The artwork selection panel reconvenes to review the artists' proposals and formally recommends acceptance to Administrator Byrne. The artists, community and city representatives and Stacy Paleologos of NEA assemble for the presentation. At the end of the artists' presentation, Byrne announces enthusiastically that he will accept the artists' proposals, as recommended by the panel.

June 26–29
Artists meet with contractors and project staff to coordinate schedules for construction and installation of their works.

June 28–29
The artists' proposal drawings and models are placed on display at NOAA. Watkins and Andrews are there to explain and take comments to forward to NOAA's Washington, D.C. office.

July 26
Administrator Byrne gives formal approval to proceed with construction.

July 1982–January 1983
Andrews meets with artists, NOAA project staff and landscape architects on-site as proposals are developed in detail.

1983
January
Trakas begins work on-site. Others locate fabricators and artist-collaborators locally.

January 27–February 27
Seattle Art Museum exhibition of the artists' proposals for NOAA: *Five Sculptors/NOAA Collaboration.*

February 12
Contemporary Art Council of the Seattle Art Museum and the King County Arts Commission present *The NOAA Project: A Symposium on Issues in Public Art.*

March–April
On-site work begins on other pieces and continues through the summer.

October 24–28
Week of activities to dedicate the Western Regional Center.

October 26
Artworks dedicated and Shoreline Walk formally opened to the public.

October 28
Western Regional Center dedicated.

New York City Bar Model Agreement

Reprinted by permission of the Association of the Bar
of the City of New York Committee on Art Law.

The New York Bar Association's *Annotated Model Agreement for Commissioning a Work of Public Art,* prepared in 1985, has become an important reference for both artists and commissioning agencies. It incorporates clauses of public art contracts that have already acquired a history in negotiation and utilization and, in its development, relied on the experience of numerous artists, public art administrators, and lawyers. The reader is urged to read the agreement in its entirety, including the introduction which sets forth the situation on which the model is posited, as well as common situations which it does not address. Additional thinking on liability insurance and other contract clauses is offered in the section on Contracts. The Agreement is reprinted by permission of the Association of the Bar of the City of New York Committee on Art Law. It is available through the American Council on the Arts (see Bibliography).

COLUMBIA

LAW

Commi
An
The Comm
of the

JOINTLY PUBLISHED BY COLUMBIA UNIVERSITY SCHOOL OF LAW
AND VOLUNTEER LAWYERS FOR THE ARTS

Commissioning a Work of Public Art: An Annotated Model Agreement

by THE COMMITTEE ON ART LAW OF
THE ASSOCIATION OF THE BAR OF THE CITY OF NEW YORK

PREFACE

Federal, state and municipal governments, as well as private corporations and real estate developers, have become more active in commissioning works of fine art for temporary or permanent exhibition in public places. Such commissions have become larger in terms of scale, cost and complexity of fabrication and installation. Artists have been asked to participate, often in collaboration with other design professionals, in developing innovative solutions to public design problems in such areas as building design and park development. It is thus not surprising that the experience and skills of lawyers have been increasingly called upon in the preparation of the contractual documents governing these projects.

Each project is necessarily unique in its particular public/private sector involvement, matching funds participation, timing and scheduling, formalities for review and acceptance of the proposed work and the finished, installed work, not to mention the apportionment of the burdens of obtaining and paying for materials, labor (including labor union involvement at installation), site preparation work and insurance coverage, to name a few common considerations. Thus it would be folly to propose that a single form of agreement be used for all projects.

Nevertheless, all public art projects do have certain aspects in common. They all involve creative work by an artist under circumstances in which the integrity and authenticity of the artist's creation must be assured throughout the often lengthy and costly process of fabrication and installation, and beyond installation to exhibition, maintenance and repair of the work of fine art.

In addition, the high visibility of public art has led, in some instances, to community reaction and strong controversy, particularly

1

as the contemporary public artist uses new forms and symbols unfamiliar to the taste and culture of the community served. As George Segal, a noted sculptor, stated in discussing the difference between private and public commissions: "Now I have to take public feelings into account. . . . The question is whether you can maintain the density of your subject matter at a decently high level of thinking and still be accessible to a lot of people." Partners for Livable Places, Art in Public Places, 1981 at 75.

Because the considerations of reconciling artistic integrity and public accommodation are not commonly found in other public works construction agreements, they often give rise to concern on the part of attorneys and their clients who are unfamiliar with them.

The Model Agreement is proposed in the hope that it will elucidate some of these issues, both for legal practitioners and their clients. Thus, the accompanying annotations are intended to be as valuable as the specific agreement language which serves as their framework.

The Model Agreement incorporates those aspects of public art contracts that have already acquired a history in negotiation and utilization in actual case situations. The objective has been to strike a balance of fairness between the legitimate concerns of an artist who desires to obtain a commission and realize a work that enhances the artist's reputation and the concerns of a commissioning body conscious of its responsibility to ensure that a project of quality is realized.

In the interest of clarity, the typical situation posited in the Model Agreement is one of the simplest: an agreement between a municipality that wishes to commission a work of art and an individual artist who will be responsible for all aspects of the conception, creation, fabrication and installation of the finished work. Nevertheless, the issues raised and annotated in the Model Agreement are also applicable when a private or public foundation, a private corporation, or a real estate developer commissions a work of art for a public space.

The Model Agreement assumes that a municipality, subject to a "percent for art" requirement that a certain percentage of capital construction costs for public buildings be dedicated to fine arts, wishes to retain an individual artist to conceive, propose, fabricate and install a particular work of art. The commission method, as distinct from the direct purchase of an existing art work or the selection of the artist on the basis of the submission of a competitive proposal, entails selecting the artist to create a new work after evaluation of the artist's portfolio. The commission method affords the advantage

of creative participation and involvement for the construction project architect, the contracting agency, the arts commission and the public, since no product exists at the time of the commission; on the other hand, the commission method involves the hazards inherent in communication and the creative process.

The Model Agreement also assumes, for purposes of simplicity, that the artist will fabricate the major part of the work in a studio or foundry. It does not provide for an elaborate construction phase, which would involve the artist in on-site supervision in order to insure that the work is executed in a professional and workmanlike manner and in accordance with the original design.

In order to maintain its focus upon aspects unique to the commissioning process, the Model Agreement does not address many common situations. Three such areas not covered are:

1. An artist's use of a corporation to undertake some or all of the responsibilities of carrying out a public art project. For instance, a commissioning body concerned that an individual artist may die or become physically incapacitated during the fabrication and installation phases of a project might require that the artist establish or retain a corporation or provide for some other successor to assume the fabrication and installation obligations after the artist's death or incapacitation. Similarly, an artist concerned about individual contractual or tort liability in case of loss or damage to the work in process or injury caused to others by materials or fabrication/installation activities may wish to avail himself of the limited liability of the corporate form, at least with regard to the non-conceptual aspects of the artist's services.

Some artists have joined together in corporate or partnership form to produce collaborative works of public art and, in an increasing number of cases, artists' tax situations will suggest the appropriateness of using a corporation to carry out the bulk of a complicated public art project. Since the decision of whether, or how, to use a corporation to participate in a public art project will depend on the circumstances, the Model Agreement does not suggest any apportionment of services between an artist and a corporation to fulfill the artist's role in the project described in the Model Agreement.

2. An artist's role as a subcontractor. A major public or private construction project will delegate to the architect, engineer, general contractor or landscape architect of the entire project the task of selecting and integrating into the project design a significant work of fine art by an outside artist. In such cases, the artist is customarily retained as a consultant under a contract entered into between the

artist and the architect, engineer or landscape architect, which contract is made subject to the various prior agreements in force between the overall project developer and the professional retaining the artist. Although the structure of such a contract will vary from the Model Agreement, many of the issues reflected in the Model Agreement annotations will be relevant.

3. The commissioning body's active involvement in implementing the artist's design. Some public art projects have involved commitments of resources (materials, labor, organization and scheduling) beyond those available to the artist retained to conceive the work of art. In such instances, the role of the artist (or the artist's corporation) is often limited to one of conception, design, site supervision and consultation to insure that the construction of the art work conforms to the artist's design; preparation of the site, acquisition and transportation of materials, and supervision of installation labor are essentially performed by the commissioning body. Such a situation may be vastly simpler, or substantially more complicated, than the prototypical public art project described in the Model Agreement.

Even the simple "model" public art situation posited here must contain alternative texts for certain items, such as the system of providing compensation to the artist. The Model Agreement, recognizing the always unique character of the issue of insurance coverage, does not address either the form or the substance of insurance coverage requirements to be imposed on either the commissioning body or the artist.

As indicated above, the Model Agreement incorporates clauses of public art contracts that have already acquired a history in negotiation and utilization. In drafting the Model Agreement, the members of the Committee on Art Law have reviewed numerous commission agreements, discussed the Model Agreement with other lawyers, art administrators and artists, and relied on their own experience and expertise in order to arrive at a balanced agreement which takes into consideration the needs of the artist, the public and the commissioning body. Given the diversity of contemporary public art projects and the varying character and goals of commissioning bodies, it is clear that not every clause in the Model Agreement is essential or appropriate to every situation. Further, some clauses will become elements in the bargaining process, and whether they are included or modified will become largely a function of the price paid for the art work. The clauses placed in brackets are most likely to change as a function of the nature of the work, the nature of the project and the bargaining process.

It should be kept in mind that there is no substitute for sound legal advice, and that the Model Agreement has been drafted only for use by or in conjunction with an attorney. The Committee would be most interested in receiving comments and experiences from readers, especially those who have used the Model Agreement in negotiating a commission for a work of public art. Comments and experiences should be directed to Barbara Hoffman, c/o Committee on Art Law, The Association of the Bar of the City of New York, 42 West 44th Street, New York, New York 10036.

The Committee would like to express its gratitude to those who took time to comment on the Agreement, as well as to the law firm of Paul, Weiss, Rifkind, Wharton & Garrison, which provided crucial word processor support for this project.

<div align="center">

Committee on Art Law

The Association of the Bar
of the City of New York

Neale M. Albert, Chair

Barbara Hoffman, Chair,
Subcommittee on Public Art

</div>

Stanley M. Ackert III*	Gregory K. Marks
Robert Anthoine	Edward C. Marschner*
Elizabeth D. Bauman	Steven B. Miller
Catherine A. Bostron*	Rex W. Mixon, Jr.
Ronald Wellington Brown	Hanno D. Mott
Tatyana Doughty	Robert L. Poster
Robert A. Feldman	Susan Berggren Rothschild
Gary N. Horowitz	Arlene Shuler
Ricky Dale Horton	William S. Sterns III
Theodore N. Kaplan	Beverly M. Wolff
Barry Mitchell Koch	Carl L. Zanger

* Member, Subcommittee on Public Art.

Table Of Contents

			Page
Article 1	Scope of Services		8
	Section 1.1	General	8
	Section 1.2	Proposal	9
	Section 1.3	Structural Design Review	13
	Section 1.4	Execution of the Work	14
	Section 1.5	Delivery and Installation	16
	Section 1.6	Post-Installation	16
	Section 1.7	Final Acceptance	17
	Section 1.8	Risk of Loss	18
	Section 1.9	Indemnity	19
	Section 1.10	Title	19
	Section 1.11	Ownership of Documents, Models	19
Article 2	Compensation and Payment Schedule		21
	Section 2.1	Fixed Fee	21
	Section 2.2	Sales Taxes	22
	Section 2.3	Artist's Expenses	22
[Alternative Article 2			22
[Article 2	Compensation and Payment Schedule		22
	[Section 2.1	Preliminary Design Proposal	22
	[Section 2.2	Further Agreement	22
	[Section 2.3	Addendum]	22
Article 3	Time of Performance		23
	Section 3.1	Duration	23
	Section 3.2	Construction Delays	23
	Section 3.3	Early Completion of Artist Services	23
	Section 3.4	Time Extensions	24
Article 4	Warranties		24
	Section 4.1	Warranties of Title	24
	Section 4.2	Warranties of Quality and Condition	24
Article 5	Insurance		26
	Section 5.1	General	26
	Section 5.2	Performance Bonds	27
Article 6	Reproduction Rights		28
	Section 6.1	General	28
	Section 6.2	Notice	28
	Section 6.3	Credit to City	28

	Section 6.4	Registration	29
Article 7	Artist's Rights		31
	Section 7.1	Identification	31
	Section 7.2	Maintenance	32
	Section 7.3	Repairs and Restoration	32
	Section 7.4	Alteration of the Work or of the Site	33
	Section 7.5	Permanent Record	34
	Section 7.6	Artist's Address	34
	Section 7.7	Surviving Covenants	34
	Section 7.8	Additional Rights and Remedies	35
	[Section 7.9	Resale Royalty]	36
Article 8	Artist as Independent Contractor		37
Article 9	Assignment, Transfer, Subcontracting		37
	Section 9.1	Assignment or Transfer of Interest	37
	Section 9.2	Subcontracting by Artist	37
Article 10	Termination		38
Article 11	Contract Administrator		40
Article 12	Non-Discrimination		40
Article 13	Compliance		40
Article 14	Entire Agreement		41
Article 15	Modification		41
Article 16	Waiver		41
Article 17	Governing Law		41
Article 18	Heirs and Assigns		41
Article 19	Arbitration		41
Article 20	Notices		42

8 COLUMBIA-VLA JOURNAL OF LAW & THE ARTS [Vol. 10:1

AGREEMENT FOR COMMISSION OF PUBLIC ART WORK

AGREEMENT BY AND BETWEEN THE CITY OF _____ AND _____

THIS AGREEMENT, entered into this ____ day of _____, 19__, by and between the City of _____ (the "City"), acting by and through the _____ Art Commission (the "Commission") and _____ (the "Artist") residing at _____

WHEREAS, the City is implementing a public art program pursuant to [local ordinance or funding source] by allocating certain funds for the establishment of artworks in public places and authorizing the making of payments for the design, execution, fabrication, transportation and installation of works of art and the support of an artist-selection process; and

WHEREAS, [City Department] percent-for-art funds have been allocated for the selection, purchase and placement of art work; and

WHEREAS, the Artist was selected by the City through the procedures duly adopted by the Arts Commission to design, execute, fabricate and install a [three-dimensional] work of art (the "Work") in a public space located at [locality] described as set forth in Exhibit ____ hereto (the "Site"); and

WHEREAS, both parties wish to promote and maintain the integrity and clarity of the Artist's ideas and statements as represented by the Work;

NOW, THEREFORE, the City and the Artist, for the consideration and under the conditions hereinafter set forth, agree as follows:

ARTICLE 1. SCOPE OF SERVICES.

1.1 *General.*

a. The Artist shall perform all services and furnish all supplies, material and equipment as necessary for the design, execution, fabrication, transportation and installation of the Work at the Site.

b. The Artist shall determine the artistic expression, scope, design, color, size, material, texture, [and location on the Site] of the Work, subject to review and acceptance by the City as set forth in this Agreement.

1985] COMMISSIONING A WORK OF PUBLIC ART 9

Annotation

Paragraph (a) of this Section describes the more tangible aspects of the Artist's services. If the Artist is to perform only some, and not all, of these services, the interaction between the Artist and others should be specified. For example, this provision could define the roles of the architects, engineers or landscape architects retained by the commissioning body and the manner in which the commissioning body will assure that those professionals coordinate effectively with the Artist to avoid delay or confusion.

Similarly, if any of the supplies, material, equipment, fabrication, transportation or installation work is to be provided by the commissioning body or agents or contractors designated by it (or by another participant in the project), the respective roles of all participants should be clearly defined and linked.

A provision like paragraph (b) reserves to the Artist the artistic, aesthetic aspects of the services, subject in each instance to the review and acceptance prerogatives of the commissioning body. The Model Agreement includes location on the Site as one of the artistic elements. While the Site will be predetermined by the commissioning body, artists are increasingly being asked to collaborate in the design of the space for their artwork. For example, the design for New York's 3-½-acre waterfront plaza project at Battery Park City was a collaborative effort among the architect Cesar Pelli, landscape architect M. Paul Friedberg, and artists Siah Armajani and Scott Burton. " 'We wanted to redefine the traditional role of artist and architect in the design of public spaces,' said Richard A. Kahan, Chairman of the Battery Park City Authority. 'We wanted artists to actually design space and not be assigned spaces in which to do pieces of art.' " N.Y. Times, Dec. 1, 1983, at C28.

1.2 *Proposal.*

a. As promptly as possible after the execution of this Agreement, the Artist shall carry out such reasonable site inspections, interviews and research as may be necessary, including meetings with the [City Department] and the project architect, in order to prepare a design proposal for the Work (the "Proposal"). The City shall make available to the Artist the necessary background materials and information on matters affecting the Site and installation of the Work including, where applicable, a written program of requirements and specifications for the Work and the plans for the underlying capital project (the "Project"). It is the intent of the parties that the City and the Artist shall establish a close and cooperative consultation throughout the duration of this Agreement.

b. The City will arrange for the Artist to meet with representatives of the community in order for the Artist to learn of their concerns.

c. [If the inspections, interviews, research and meetings provided for in paragraphs (a) and (b) require more than [three (3)] trips by the Artist to the [locality] before approval of the Proposal, the City shall promptly reimburse the Artist's reasonable expenses for travel and lodging on additional trips.]

d. Within ninety (90) days after the execution of this Agreement, the Artist shall prepare and submit the Proposal to the City. The Proposal shall specify such materials, dimensions, weight, finish and preliminary maintenance recommendations and proposed installation method and include such [drawings and other documents and models] as are required to present a meaningful representation of the concept and design of the proposed Work. [The Proposal shall include a budget, not to exceed $_____, that includes estimated costs for design, execution, fabrication, transportation and installation and the Artist's fee.]

e. The City shall, within thirty (30) days following the next regularly scheduled Commission meeting after the Artist's submission of the Proposal, notify the Artist whether it approves or disapproves the Proposal. During this period the Artist shall be available as reasonably required to meet with the City to discuss the Proposal.

f. If the City shall determine that the Proposal is disapproved, it shall provide the Artist with a statement in writing of its reasons for such disapproval. In such event, the Artist shall be afforded an opportunity either to submit a second Proposal for the Work within a reasonable period of time specified by the City, or to terminate this Agreement. Within thirty (30) days following such submission by the Artist, the City shall notify the Artist in writing whether it approves or disapproves the Proposal. If the City shall determine that the second Proposal is disapproved, it shall provide the Artist with a statement in writing of its reasons for disapproval, whereupon this Agreement shall terminate.

g. In the event of termination of this Agreement pursuant to paragraph (f), the Artist shall retain the Proposals and all compensation theretofore paid and neither party shall be under any further obligation to the other in respect of the subject matter thereof.

Annotation

The most important practical contribution of a written contract for public art is found here: the clear, step-by-step description of the process for the conception and approval of the design of the proposed Work.

Experience suggests that the following elements should receive special attention:

(a) The need for close cooperation and a full exchange of information regarding the Site, the Project, all scheduling and the respective roles of all participants in the Project. To the extent possible, the Model Agreement attempts to provide close interaction between the architect and the Artist and, where appropriate, a true collaboration in the design process at the earliest time.

(b) The manner in which the Artist is expected to familiarize himself with community and user concerns. Any specific representations regarding the way in which those concerns are to be reflected in the proposed Work should be stated here. Much of the public controversy surrounding public art has occurred because of inadequate communication between the Artist and his clients, i.e., the Commission, the relevant City Department and the community. One of the unresolved issues in public art is the definition of that community. Since much contemporary art is based on an iconography that is not widely shared, it is suggested that only with public involvement and participation from inception to dedication can the art become accessible to the public it serves. The success of public art must be related, in part, to the power of art work to generate public response and a dialogue over its meaning. The public should be invited to experience and discuss a given project.

(c) The number of visits to the Site the Artist is obligated to make when engaged in studying and preparing a creative proposal. At this stage, he should not be required to spend inordinate time and resources in repeated meetings and trips to a distant city. A provision for the commissioning body to bear the expenses incurred by the Artist (or even to pay a per diem for his time), beyond an agreed reasonable number of meetings and trips, would be normal.

(d) The content of the Proposal to be submitted. The commissioning body may wish to develop a standard proposal format. A Proposal can be a simple paragraph describing the Work, or it can be an elaborate combination of budget, three-dimensional scale model, engineering drawings, artist's renderings, environmental impact statements, and other expensive features designed to assist the commissioning body in presenting the Proposal to its own constituents (e.g., a city council, a corporate board of directors, or a community hearing). For the usual public art project, the initial Proposal includes merely schematic drawings (not drawn to scale), perhaps a simple maquette for three-dimensional works and, as regards a budget, rough estimates of materials costs, labor expense, and transportation, installation and insurance costs, with the remainder of the total estimated compensation allocated as the so-called "Artist's fee."

It should be kept in mind that the Proposal submitted is the complete focus of the approval process. This means that the finished Work must faithfully reflect the Proposal unless the areas of

216

subsequent creative leeway reserved for the Artist are clearly reflected in the Proposal itself.

It is extremely useful for the commissioning body and for the Artist that the Proposal include a written description of the aspects of the Proposal that may change as fabrication and installation go forward. For example, the Proposal should, if appropriate, contain a caveat that the colors, texture, dimensions, materials and scale of the finished Work may depart significantly from those indicated in the Proposal. Providing such a caveat permits both parties to avoid disagreements in the future regarding elements of the Work that the commissioning body deems to be essential to its approval of the Proposal. The Artist should also specify in his Proposal any elements of the Work he considers as integral elements which may not be readily apparent to the commissioning body, such as lighting for the Work or Site.

(e) The need for a reasonable period of time for the commissioning body to consider the Proposal. The commissioning body is required to state in writing its acceptance or disapproval of the Proposal and, in the case of disapproval, to specify its reasons. The time allotted for consideration of the Proposal by the commissioning body will depend on how unwieldy the commissioning body's internal procedures are. The Model Agreement contemplates an active art commission with a regular schedule of meetings to review proposals for public art projects. In other circumstances, a fixed time period of 30, 60 or 90 days is usually adopted, so that the Artist will not be left waiting for a response to a Proposal in which he has invested a great deal of time and expense.

(f) The course of events if the Proposal is disapproved. In the event of disapproval of the Proposal, the Artist is offered a second (and sometimes third) opportunity to resubmit either the same Proposal or an entirely new Proposal to take account of the reasons for the earlier refusal. Usually the time periods for the Artist's submission of the revised Proposal, and for the commissioning body's review of it, are shorter than the time periods provided for the initial submission.

Unless the Artist has received an installment on his fee at the time of submission of the initial Proposal, the Artist during this period is working from the initial installment of compensation. This means that he will have to anticipate, while preparing the first Proposal, that he may have to go through the time and expense of preparing a second Proposal if the first is refused. The Artist should have the right to decline to prepare a second Proposal, thereby causing termination of the agreement, if he feels that it would be too costly or that, based on the reasons stated by the commissioning body in its refusal, a new Proposal would not be accepted either. The commissioning body should not have the right to prevent a second Proposal, but it should not be required to spend a very long period of time waiting for it and then reviewing it, since the commissioning body may wish to offer the public

art project to another artist if it finds the first Proposal entirely unacceptable.

(g) The consequences of acceptance and refusal of the Proposal at each step should be clearly set forth.

1.3 *Structural Design Review.*

a. Within _____ days after the City approves the Proposal, the Artist shall[, after consultation and collaboration with the project architect,] prepare and submit to the City detailed working drawings of the Work and the Site, together with such other graphic material as may reasonably be requested by the City in order to permit the City to carry out structural design review and to certify the compliance of the Work with applicable statutes and ordinances. Upon request by the Artist, the City [and the project architect] shall promptly furnish all information, materials and assistance required by the Artist in connection with said submission.

b. The City may require the Artist to make such revisions to the Proposal as are necessary for the Work to comply with applicable statutes, ordinances or regulations of any governmental regulatory agency having jurisdiction over the project.

c. The City may also request revisions for other practical (nonaesthetic) reasons.

d. The Artist's fee shall be equitably adjusted for any increase or decrease in the Artist's cost of, or time required for, performance of any services under this Agreement as a result of revisions made under this Section 1.3. Any claim of the Artist for adjustment under this paragraph must be asserted in writing within thirty (30) days after the date of the revision by the Artist.

e. Within _____ days after its receipt of the Artist's submission pursuant to this Section 1.3, the City shall notify the Artist of its approval (or disapproval) of such submission and of all revisions made in the Proposal as a result thereof. Revisions made pursuant to this Section 1.3 become a part of the Proposal.

Annotation

It is time consuming and expensive for an Artist to prepare the initial Proposal. It is usually too burdensome to ask the Artist at that stage, when the Proposal has not yet been accepted even in principle, to engage the additional expense involved in preparing engineering drawings drawn to scale, so as to permit the commissioning body to evaluate in detail the problems of integration of the Work into the Site and to coor-

dinate the installation work with schedules for site preparation and other adjacent construction.

The Model Agreement reflects the common requirement that such detail work be reserved for *after* approval of the Proposal, when the Artist has presumably received a second installment of his fee to help him meet the expenses of detailed planning.

The compensation provisions of the Agreement should be generous enough in the early installments to permit the Artist to pay his professional architect and engineer advisors for their services in preparing detailed drawings.

The schedule for submissions of detailed drawings and specifications should clearly delineate the deadlines to be respected by both the Artist and the commissioning body.

The consultation with the project architect initiated in the preliminary design phase should continue. In projects where the commissioning body will be primarily responsible for implementing construction of the Work, the Artist will not be responsible for the preparation of detailed structural drawings, but will only be required to approve the documents prepared by the engineer and architect to assure that the final construction conforms to his design.

1.4 *Execution of the Work.*

a. After written approval of the submissions and revisions made pursuant to Section 1.3, the Artist shall furnish to the City a tentative schedule for completion of fabrication and installation of the Work, including a schedule for the submission of progress reports, if any. After written approval of the schedule by the City, the Artist shall fabricate, transport and install the Work in accordance with such schedule. Such schedule may be amended by written agreement between the City and the Artist.

b. The City shall have the right to review the Work at reasonable times during the fabrication thereof. The Artist shall submit to the City progress reports in accordance with the schedule provided for in Section 1.4(a).

c. The Artist shall complete the fabrication and installation of the Work in substantial conformity with the Proposal.

d. The Artist shall present to the City in writing for further review and approval any significant changes in the scope, design, color, size, material or texture of the Work not permitted by or not in substantial conformity with the Proposal. A significant change is any change in the scope, design, color, size, material, texture or location on the Site of the Work which affects installation, scheduling, site preparation or maintenance for the Work or the concept of the Work as represented in the Proposal.

Annotation

The importance of the completion schedule referred to in paragraph (a) above cannot be overemphasized. Any time parameters within which the schedule must fit should be clearly specified in the commission agreement. All other parties involved (such as the architect) should be consulted in the formulation of the schedule. The Artist should send copies of the schedule to all parties involved.

Many commissioning bodies will not require written progress reports or the right to visit the Work during fabrication, as provided in paragraph (b). If requested, however, these are reasonable requirements if they do not so unduly burden the Artist as to delay his completion of the Work.

Paragraphs (c) and (d) reflect the need for leeway to the Artist as the creative process goes forward, while assuring the commissioning body that the Proposal is executed as approved. The Artist must execute the Work in substantial conformity with the Proposal. Minor changes as the Work progresses are permitted; however, significant changes which affect installation scheduling, site preparation and maintenance for the Work and the concept of the Work require further written approval of the commissioning body.

An example of the type of controversy with which paragraphs (c) and (d) are concerned is that surrounding the creation of a public art commission in San Francisco in 1981. Robert Arneson was chosen in a competitive process to execute a bust of the assassinated Mayor George Moscone for the Moscone Convention Center. All of the nationally known artists who competed were asked to submit a sketch "sufficiently detailed so that judgment can be made." Arneson's preliminary design showed a broadly smiling head on an unadorned pedestal. In the final work, the artist embellished the pedestal with biographical notes. Most controversial were the imprinting of a Smith and Wesson revolver, bloodlike splatters of red glaze, and the inscription "Twinkie," referring to a novel defense raised by the assassin. There was uniform approval of the design and execution of the portrait likeness, but strong criticism regarding the references to the murder and the murderer's defense. The Art Commission rejected the work as inappropriate to the site after receiving a letter from Mayor Feinstein stating that Arneson's pedestal did not reflect the "spirit of non-violence to which the City committed itself when it claimed for itself the name of St. Francis." Mayor Feinstein also argued that "an artist must be held accountable to his or her maquette" and that there must be "assurance that guidelines will not be spurned and standards disregarded." Arneson, upon advice of counsel, returned the compensation he had received for the commission. The bust was returned to him and subsequently sold to a private collector. Controversial Public Art from Rodin to di Suvero, Milwaukee Art Museum, 1983.

The Model Agreement seeks to provide a mechanism for resolving the type of controversy raised by the Arneson situation by delimiting the creative discretion to be allowed the Artist after approval of the

Proposal. In this connection, Arneson might have noted in his Proposal the nature of his previous work, and that the spirit of that work often evoked social and political commentary which would be an integral part of the Work not subject to subsequent review by the commissioning body. Finally, to the extent possible, all parties should refrain from actions which inhibit the Artist in reaching creative solutions to the design problems the Artist has been commissioned to solve. The Artist, on his part, must be sensitive to the unique qualities of public art and to the guidelines and parameters upon which the parties have agreed.

1.5 *Delivery and Installation.*

a. The Artist shall notify the City in writing when fabrication of the Work is completed and he is ready for its delivery and installation at the Site.

b. The Artist shall deliver and install the completed Work at the Site in compliance with the schedule approved pursuant to Section 1.4.

c. The City shall be responsible for all expenses, labor and equipment to prepare the Site for the timely installation of the Work, including landscaping, footings, plumbing, public access, public security, and area and spot lighting of the Work.

Annotation

Where the size or scope of the Work or the fee compensation schedule make it appropriate, final approval of the fabricated Work, as being in conformity with the Proposal, should be made before delivery and installation, in order to facilitate modifications in design and avoid unnecessary costs of transportation and installation. When the commissioning body is responsible for site preparation, the Artist should coordinate closely with it to ascertain that the Site is prepared to receive the Work.

In those projects in which the Artist is a member of the design team and the Work is constructed on the Site as an integral part of the environment, a more detailed description of the Artist's role in site supervision, construction and installation may be provided.

1.6 *Post-Installation.*

a. Within _____ days after the installation of the Work, the Artist shall furnish the City with the following photographs of the Work as installed:

(i) two sets of three 35 mm. color slides of the completed Work, one taken from each of three different viewpoints;

(ii) two sets of three different 8" x 10" glossy black and white prints of the Work and negatives; and

(iii) a set of three color transparencies of the completed Work.

b. At the City's expense, the Artist shall be available at such time or times as may be agreed between the City and the Artist to attend any inauguration or presentation ceremonies relating to the transfer of the Work to the City. The City shall use its best efforts to arrange for publicity for the completed Work in such art publications and otherwise as may be determined between the City and the Artist as soon as practicable following installation.

c. Upon installation of the Work, the Artist shall provide to the City written instructions for appropriate maintenance and preservation of the Work.

Annotation

Public art projects usually require photographic documentation for archival purposes. The photographic documentation requested will, of course, depend on the requirements of the commissioning body. In rare instances it may be more appropriate to require the commissioning body to pay for and provide for photographic documentation.

Paragraph (b) of this section continues the dialogue previously encouraged between the community and the Artist. Even with a work conceived, approved and installed, the dialogue is not complete. The dedication often sets the tone for initial public reaction and, to the extent that the Work may evoke controversy, the Artist should be a participant in the debate.

The Artist should specify any special requirements for maintaining and preserving the Work. This section should be read in conjunction with the warranty section of Article 4 and the section on maintenance in Article 7.

1.7 *Final Acceptance.*

a. The Artist shall advise the City in writing when all services required prior to those described in Section 1.6(b) have been completed in substantial conformity with the Proposal.

b. The City shall notify the Artist of its final acceptance of the Work.

c. Final acceptance shall be effective as of the earlier to occur of (1) the date of the City's notification of final acceptance or (2) the 30th day after the Artist has sent the written notice to the City required under Section 1.7(a) unless the City, upon receipt of such notice and prior to the expiration of the 30-day period, gives the Artist written notice specifying and describing the services which have not been completed.

Annotation

The purpose of this provision is to provide a method of determining with some degree of certainty when the Work has been finally accepted by the commissioning body, since this a signal event for the creating or shifting of obligations between the parties. Final acceptance is usually referred to in the Section 2.1 schedule of payments due the Artist; it is expressly referred to in the succeeding Sections 1.8 through 1.11 as a factor in determining title, ownership of documents, risk of loss and indemnity.

While the mechanism for final acceptance starts with the assumption that the commissioning body will, in due course, notify the Artist of its acceptance of the Work, it also recognizes that the Artist necessarily exercises an artistic judgment as to when the Work is complete, and that the Artist should therefore initiate the acceptance process.

Final acceptance is based upon completion of the artistic services referred to generally under Section 1.1. Failure to complete or comply with obligations or requirements under the contract which are independent of and clearly ancillary to the performance of the artistic services should not provide grounds for denial of final acceptance. Thus, failure to have obtained a performance bond, if required, should not prevent final acceptance once performance is completed.

However, final acceptance could be reasonably conditioned upon the Artist's certification that all obligations incurred by the Artist, pursuant to Section 1.1, for "supplies, material and equipment as necessary for the design, execution and installation of the Work" have been fully satisfied. Since final acceptance triggers a general indemnity, the commissioning body may wish to add to the agreement a provision requiring the Artist either to disclose any outstanding or disputed claims against the Artist arising out of the Work, or to certify that no such claims exist. Such a provision would go further than the general warranty against liens contained in Section 4.1(d). Since not all claims become liens, the commissioning body might be subject to nuisance suits brought by individuals who have provided materials or services to the Artist, the warranty of Section 4.1(d) notwithstanding.

1.8 *Risk of Loss.* The risk of loss or damage to the Work shall be borne by the Artist until final acceptance, and the Artist shall take such measures as are necessary to protect the Work from loss or damage until final acceptance; except that the risk of loss or damage shall be borne by the City prior to final acceptance during such periods of time as the partially or wholly completed Work is in the custody, control or supervision of the City or its agents for the purposes of transporting, storing, installing or performing any other ancillary services to the Work.

Annotation

This provision sets forth the standard practice of leaving the risk of loss or damage to the work-in-progress with the Artist until final acceptance. The question of insurance for loss or damage is one which is left entirely to the Artist's judgment under the circumstances.

It is recognized, however, that the Artist increasingly functions as an element of a larger project, and that portions of the Artist's work may have to be performed outside the confines of the studio. Site preparation, transportation, storage and installation may be responsibilities undertaken by the Artist, but they are often performed by the commissioning body or its agencies and contractors. Under these circumstances, while the Work is substantially removed from the Artist's continuing dominion and control the risk of loss will shift accordingly.

The *force majeure* provision under Section 3.4 contemplates only an extension of time for performance in the event that the Work is damaged or destroyed; however, substantial damage or destruction of the Work may permit either party to invoke the termination provisions of Article 10.

1.9 *Indemnity.* Upon final acceptance of the Work, the City shall, to the extent permitted by law, indemnify and hold harmless the Artist against any and all claims or liabilities then existing or arising thereafter in connection with the Work, the Site, the Project or this Agreement, except claims by the City against the Artist and claims which may occur as a result of the Artist's breach of the warranties provided in Article 4.

Annotation

This provision may vary depending upon the statutory limitations affecting the ability of state or municipal agencies and bodies to enter into indemnity agreements.

This section is keyed to the final acceptance process. The possibility that the commissioning body may find itself indemnifying the Artist against the claims for the Artist's suppliers and subcontractors is reduced considerably if final acceptance is conditioned upon certification by the Artist that all such underlying claims, liens and encumbrances have been or will be satisfied. Similarly, bonding and insurance provisions may be included in the agreement to protect against such claims.

1.10 *Title.* Title to the Work shall pass to the City upon final acceptance.

1.11 *Ownership of Documents, Models.* Upon final acceptance, all studies, drawings, designs, maquettes and models prepared and sub-

mitted under this Agreement shall be returned to the Artist and shall belong to the Artist. The City may select and the Artist shall convey to the City [one] of the original drawings submitted pursuant to Section 1.2 as part of the Proposal, the City representing that such drawing(s) will be used by it solely for exhibition and held by it in permanent safekeeping.

Annotation

Most public art commissions give ownership of all maquettes, drawings and other designs prepared in connection with the commission to the Artist. One notable exception is the present General Services Administration Art in Architecture Contract, where such items are retained by the government for the National Museum of American Art of the Smithsonian Institution.

It generally should not be presumed that the commissioning body has purchased the maquettes and models. At best, the artist usually only breaks even financially on public art commissions, and the ability to sell the maquettes, sketches, drawings, etc., produced in connection with the project often provides an essential source of income.

In many respects the artist as a provider of design services can be analogized to the architect. The American Institute of Architects standard form owner-architect contract provides that all drawings, models and maquettes remain the property of the architect, but gives the owner the right to copies of the drawings and plans.

The commissioning body and the public do have legitimate interests in documenting the history and evolution of the Work. In those instances in which the commissioning body intends to exhibit the sketches and keep them for documentation and archival purposes, the second sentence in Section 1.11 may be added.

The exact language should be keyed to the specific requirements adopted for the Proposal. In some circumstances the commissioning body may wish to negotiate for ownership of all drawings, maquettes and models prepared and submitted in connection with the Proposal. This may be appropriate when museum and other exhibition spaces are available.

In certain exceptional situations, the commissioning body may require acquisition of all drawings and maquettes prepared and submitted in connection with the Proposal as part of the fixed Artist's fee. This position may not be justified if the only intention of the commissioning body is resale. In no event should the commissioning body, without further adjustment in price, obtain ownership of documents prepared by the Artist subsequent to the Proposal.

The question of ownership of the documents under this Section does not affect copyright in the sketches, models and maquettes, which remains with the Artist, except as modified in Article 6. The commissioning body may wish to retain the right to the photographic reproduction of the Proposal for public information and exhibition purposes.

ARTICLE 2. COMPENSATION AND PAYMENT SCHEDULE.

2.1 *Fixed Fee.* The City shall pay the Artist a fixed fee of $_____, which shall constitute full compensation for all services and materials to be performed and furnished by the Artist under this Agreement. The fee shall be paid in the following installments, expressed as percentages of such fixed fee, each installment to represent full and final, nonrefundable payment for all services and materials provided prior to the due date thereof:

a. _____ percent (%) upon the execution of this Agreement, recognizing that the Artist has already invested time and expense in preliminary design coordination with the City and other interested parties;

b. _____ percent (%) within ten (10) days after the City notifies the Artist of its approval of the Proposal;

c. _____ percent (%) within ten (10) days after the City notifies the Artist of its approval of the submission of detailed working drawings required under Section 1.3.

d. _____ percent (%) within ten (10) days after the Artist notifies the City that the Work is fabricated and ready for installation at the Site.

e. _____ percent (%) within ten (10) days after final acceptance.

Annotation

This traditional installment system for payment of compensation usually contemplates payments of a percent of a fixed fee upon readily defined dates such as the following: the execution of the agreement, submission of the Proposal, notice of approval of the Proposal, submission of detail drawings, arrival of materials at the Artist's fabrication facilities or at the Site, notice by the Artist that installation is ready to begin, similar notice that installation is completed, and final acceptance.

If reasonable persons may differ as to the occurrence of a specified event, the installment should be payable upon notice given to one or the other that the event has occurred, or the definition of the occurrence should be modified to make it readily determinable in an objective manner. For example, installments should be paid on completion of defined phases, not when the work is "half complete."

In public art projects where the commissioning body and the Artist are sharing the expense of materials or labor, the installments are sometimes calculated and paid ratably as the expenses of materials and labor are incurred. This is done either on a percentage basis or dollar-for-dollar against vouchers for expenses incurred or soon to be incurred for materials and labor.

In some commissions, particularly in those in which the Artist is re-

tained as a design consultant, the Artist will receive a fee for design and supervision, with out-of-pocket expenses paid against vouchers and all other costs of construction, installation, insurance and the like paid for by the commissioning body.

2.2 *Sales Taxes.* Any sales, use or excise taxes, or similar charges relating to services and materials shall be paid by the City.

2.3 *Artist's Expenses.* The Artist shall be responsible for the payment of all mailing or shipping charges on submissions to the City, the costs of transporting the Work to the Site and the costs of all travel by the Artist and the Artist's agents and employees necessary for the proper performance of the services required under this Agreement.

Annotation

Sections 2.2 and 2.3 merely allocate those related expenses which are reimbursable to the Artist and those which are costs to be paid from the fixed fee.

ALTERNATIVE ARTICLE 2

ARTICLE 2. COMPENSATION AND PAYMENT SCHEDULE.

2.1 *Preliminary Design Proposal.* Upon the execution of this Agreement by the City, the City shall pay to the Artist an initial fee of $_____ for the preparation of the Proposal as set forth in Section 1.2. The initial fee may be retained by the Artist, and no part of it shall be refunded, provided the Artist submits the Proposal to the City as provided in Section 1.2(c). If the Proposal is not so submitted, the City may by notice to the Artist require the initial fee to be refunded to the City, whereupon this Agreement shall terminate and there shall be no further obligations between the parties.

2.2 *Further Agreement.* Acceptance of the Proposal shall be contingent upon agreement between the City and the Artist upon a second fee, not expected to exceed $_____ for execution, fabrication, transportation and installation of the Work.

2.3 *Addendum.* The payments for the Artist's services for the execution, fabrication, transportation and installation of the Work shall be made at intervals specified by addendum to this Agreement,

signed by the Artist and the City, upon approval of the Proposal by the City.

[Sections 2.2 and 2.3 of usual Article 2 become Sections 2.4 and 2.5 if this Alternative Article 2 is used.]

Annotation

The alternative compensation language is offered for situations in which the scale and cost of the final project will not be known until after the Proposal is approved.

In this circumstance, it is usual to pay the Artist for preparing the Proposal and to postpone until after acceptance of the Proposal the fixing of the further fee due to the Artist (or a fabrication and installation corporation designated by him) for completion of the post-approval aspects of the project.

The disadvantage of this approach is the uncertainty of a commitment of either the Artist or the commissioning body to proceed with the project even after a Proposal is approved, since later negotiations over compensation and scheduling may sometimes defeat an otherwise worthwhile project.

ARTICLE 3. TIME OF PERFORMANCE.

3.1 *Duration.* The services to be required of the Artist as set forth in Article 1 shall be completed in accordance with the schedule for completion of the Work as proposed by the Artist and approved by the City pursuant Section 1.4, provided that such time limits may be extended or otherwise modified by written agreement between the Artist and the City.

3.2 *Construction Delays.* If, when the Artist completes fabrication or procurement of the Work in accordance with the approved schedule and notifies the City that the Work is ready for installation, the Artist is delayed from installing the Work within the time specified in the schedule as a result of the construction of the Site not being sufficiently complete reasonably to permit installation of the Work therein, the City shall promptly reimburse the Artist for reasonable transportation and storage costs incurred for the period between the time provided in the schedule for commencement of installation and the date upon which the Site is sufficiently complete reasonably to permit installation of the Work.

3.3 *Early Completion of Artist Services.* The Artist shall bear any transportation and storage costs resulting from the completion of his

services hereunder prior to the time provided in the schedule for installation.

3.4 *Time Extensions.* The City shall always grant a reasonable extension of time to the Artist in the event that there is a delay on the part of the City in performing its obligations under this Agreement or in completing the underlying capital project, or if conditions beyond the Artist's control or Acts of God render timely performance of the Artist's services impossible or unexpectedly burdensome. Failure to fulfill contractual obligations due to conditions beyond either party's reasonable control will not be considered a breach of contract; provided that such obligations shall be suspended only for the duration of such conditions.

Annotation

The provisions of the Model Agreement providing for careful coordination of schedules between the commissioning body and the Artist, and responsibility for the coordination with other participants in related work, cannot be over-emphasized. More unsuccessful public art projects have come to grief through poor coordination than for any other reason.

The Model Agreement attempts to provide rigor in the establishment of a schedule and equitable flexibility in the procedures for maintaining communication necessary to modify the schedule as required. The objective is the maintenance of cooperation to ensure that the Work will be realized.

Article 4. Warranties.

4.1 *Warranties of Title.* The Artist represents and warrants that: (a) the Work is solely the result of the artistic effort of the Artist; (b) except as otherwise disclosed in writing to the City, the Work is unique and original and does not infringe upon any copyright; (c) that the Work, or a duplicate thereof, has not been accepted for sale elsewhere; and (d) the Work is free and clear of any liens from any source whatever.

4.2 *Warranties of Quality and Condition.* The Artist represents and warrants, except as otherwise disclosed to the City in writing in connection with submission of the Proposal pursuant to Section 1.2, that: (a) the execution and fabrication of the Work will be performed in a workmanlike manner; (b) the Work, as fabricated and installed, will be free of defects in material and workmanship, including any defects

consisting of "inherent vice" or qualities which cause or accelerate deterioration of the Work; and (c) reasonable maintenance of the Work will not require procedures substantially in excess of those described in the maintenance recommendations to be submitted by the Artist to the City hereunder.

The warranties described in this Section 4.2 shall survive for a period of one year after the final acceptance of the Work. The City shall give notice to the Artist of any observed breach with reasonable promptness. The Artist shall, at the request of the City, and at no cost to the City, cure reasonably and promptly the breach of any such warranty which is curable by the Artist and which cure is consistent with professional conservation standards (including, for example, cure by means of repair or refabrication of the Work).

Annotation

Section 4.1 recognizes that the Artist is responsible for assuring that the Work is original and free of liens, does not infringe any copyright and has not previously been sold.

Section 4.2 reflects the Artist's responsibility for fabricating the Work in quality materials, in accordance with professional, "workmanlike" standards and with a sensitivity to the nature and long-term behavior of materials and methods used, the conservation goals of the commissioning body and the conditions of the installation site (including weather, temperature, type and density of audience, and other environmental and architectural features of the site).

By permitting written disclosure of factors at odds with these concerns, and excluding such disclosed factors from the Artist's warranties, the Agreement also recognizes that the Artist's aesthetic choices and goals may sometimes be antithetical to — and of paramount importance to — concerns of maintenance and conservation. For example, the Artist may choose to work with materials that are intended to change in appearance over time or exposure to the elements, or the Artist may wish to try experimental techniques and materials that do not age in a traditional way or the conservation impact of which is not yet fully known. Such inventiveness should not be discouraged so long as these artistic choices are disclosed at a time when the commissioning body can make an informed evaluation of the impact of such choices on the standard warranties, i.e., upon submission of the Proposal pursuant to Section 1.2.

The Artist's warranties relating to defects and "inherent vice" (a term used by conservators to describe a quality of a work of art which causes or accelerates physical deterioration of the work) are particularly important to a potential owner of an art work in view of the fact that most standard fine arts insurance policies will not cover damage or loss of value sustained as a result of a defect or inherent vice in a work. Defects in design and materials can result in a decrease or total loss in value of

the art work, expenses for conservation work to rectify defects, and even liability for personal injury.

Costs of conservation and maintenance undertaken as a result of normal "wear and tear" on an art work are also not reimbursable under an insurance policy but are rather continuing expenses of upkeep of a work. A purchaser of a commissioned art work should be aware of any extraordinary conservation procedures or any high-cost maintenance factors.

The Artist's warranties relating to the condition and quality of the Work are limited to a period of one year, since most instances in which serious defects have become evident in public art have occurred within that time. The length of the warranty should, however, be set in light of the nature of the Work, the type of materials and methods used with respect to the Work, the conservation record relating to similar works, the period of time during which defects are likely to manifest themselves, the cost of the Work and the potential liability involved.

The Artist is required to cure, at the request of the commissioning body, defects resulting from substandard workmanship, if such cure is consistent with professional conservation standards.

If a breach of a warranty is not curable by the Artist, the Artist may then be responsible for reimbursing the commissioning body for damages, expenses and loss incurred by the commissioning body as a result of a breach of or inaccuracy in a warranty or representation.

Other responsibilities, warranties and remedies may arise under applicable law, in addition to those expressly provided for by contract.

In view of the probable importance of conservation considerations to the commissioning body, the limitation on certain of the Artist's warranties and the likely failure of insurance coverage to respond to these issues, it may be desirable for the commissioning body to obtain an independent expert evaluation of the materials and techniques used in the Work prior to acceptance.

ARTICLE 5. INSURANCE.

5.1 *General.* []

Annotation

No model clauses are provided with respect to liability insurance, since appropriate provisions would vary greatly in different circumstances, depending on state or local requirements, the size of the project, whether extensive or prolonged fabrication and installation will be performed at the Site, and other factors.

The person who is responsible for obtaining and paying for insurance coverage — whether the Artist, the commissioning body, or another person such as a general contractor, if the project also involves building construction — will also vary, depending on the nature of the activities of the persons involved in the project and the availability and cost of coverage to each such person.

For example, if the Artist is primarily responsible for designing a

Work that will be installed by others at the Site, it is unlikely that the Artist would be responsible for obtaining liability insurance coverage.

Normally, insurance would cover claims and losses for both personal injury and property damage arising from performance under the agreement, and would cover subcontractors and employees of the insured. Workmen's compensation insurance and automobile liability insurance, as well as public liability insurance, may also be required.

Regardless of who is responsible for obtaining coverage, each of the other parties among the Artist, the commissioning body, and the landowner, if different, should be named in the policy as an additional insured with respect to the coverage. The party contracting the insurance is usually required to provide a certificate of insurance or other evidence of adequate coverage to the others. Such certificate would also likely provide for at least ten days' prior notice of change or cancellation of the policy.

5.2 *Performance Bonds.* The Artist shall not be required by the City to post any performance bonds or similar undertakings, and any requirement of any other authority for performance bonds shall be the responsibility of the City.

Annotation

Contractors on usual public works construction projects are routinely required to obtain bonds guaranteeing performance of the contract and proper payment to all subcontractors, materialmen and suppliers. Public art commissions customarily do not require artists to obtain performance bonds; however, when artists are given design responsibility for an entire site, and as projects shift from the isolated art object to artwork integrated with its environment, administrators may feel compelled to request performance bonds.

A recent opinion by a county attorney construed a state statute which required a performance bond for a "work" or "improvement" on public property as including an artwork commissioned for the county jail. The artwork involved extensive on-site construction. The Sacramento Metropolitan Arts Commission had never required a performance bond for an art project with the city but was asked by the county to handle a public art project for it: an aquarium serving as a wall, and a seating area, to be designed by Doug Hadlis as part of a jail construction project. The bond was required because the artist was not known to the county and because the administrator thought the work resembled "construction" rather than "a work of art." The premium cost of the bond was ultimately added to the project budget, relieving the artist of the additional expense.

The Miller Act, 40 U.S.C.A. § 270a, requires a performance bond on all federal construction contracts over $25,000. To avoid this problem in connection with a federal art commission in Seattle, Washington, the project director of the Art Program at the National Oceanic and Atmo-

spheric Agency chose to negotiate professional services contracts rather than construction contracts with the artists involved, even though the projects resembled construction more than studio pieces. An identical contract was used for architects, construction managers, and researchers on the project.

Architects and engineers are typically exempt from bonding requirements. The Oregon Court of Appeals explained, "[s]ince performance of a contract involving esthetic judgment cannot be measured objectively, it would not be reasonable to require an architect to post a performance bond." Mongiovi v. Doerner, 24 Or. App. 639, 546 P.2d 1110, 1113 (1976).

The analogy to the architect is appropriate for the public artist. Since the artist is a provider of professional services which are unique, the performance bond seems unsuitable as a mechanism for assuring performance. The artist's performance is best assured by a contract (such as the Model Agreement) with payments in installments on completion of phases of the project and, if appropriate, an invoice for final payment which is accompanied by a statement from each subcontractor that the financial obligation has either been met in full or has been settled to the subcontractor's satisfaction. If a performance bond is required, it should cover only that percentage of the artist's fee which represents on-site fabrication.

ARTICLE 6. REPRODUCTION RIGHTS.

6.1 *General*. The Artist retains all rights under the Copyright Act of 1976, 17 U.S.C. §§ 101 et seq., and all other rights in and to the Work except ownership and possession, except as such rights are limited by this Section 6.1. In view of the intention that the Work in its final dimension shall be unique, the Artist shall not make any additional exact duplicate, [three]-dimensional reproductions of the final Work, nor shall the Artist grant permission to others to do so except with the written permission of the City. The Artist grants to the City and its assigns an irrevocable license to make two-dimensional reproductions of the Work for non-commercial purposes, including but not limited to reproductions used in advertising, brochures, media publicity, and catalogues or other similar publications, provided that these rights are exercised in a tasteful and professional manner.

6.2 *Notice*. All reproductions by the City shall contain a credit to the Artist and a copyright notice substantially in the following form: © [Artist's name], date of publication.

6.3 *Credit to City*. The Artist shall use his best efforts to give a credit reading substantially, "an original work owned and commis-

sioned by [City]," in any public showing under the Artist's control of reproductions of the Work.

6.4 *Registration*. The City shall at its expense cause to be registered, with the United States Register of Copyrights, a copyright in the Work in the Artist's name.

Annotation

Copyright is a property right which allows the Artist (or one to whom he transfers the right) to prevent unauthorized copying, publishing or other use of his copyrighted work. In effect, the copyright law gives the initial owner of the copyright the exclusive right to reproduce the work and to prepare derivative works.

A new federal copyright law, the Copyright Act of 1976, 17 U.S.C. §§ 101 et seq., became effective in 1978.

Under the new law the owner of the rights protected by copyright is the creator of the work unless the work is a "work made for hire." A work made for hire is defined as (1) "a work prepared by an employee within the scope of his or her employment" or (2) "a work specially ordered or commissioned" for certain uses specified in the statute. 17 U.S.C. § 201(b). A work of art commissioned for a public space would not normally constitute such a use. It is generally accepted, therefore, that the Artist initially owns the copyright in the work. Unless there is a written agreement that transfers the copyright to the purchaser of a work of art, the creator automatically retains the copyright. Not only is copyright completely separate from ownership of a physical work of art, but each of the exclusive rights of copyright can be subdivided.

The Model Agreement does not provide for a blanket assignment of copyright ownership to the commissioning body. A blanket transfer to the commissioning body of copyright control in the Work would give the commissioning body more than it reasonably needs and, more importantly, probably more than it has paid for, given the fact that the Artist's fee is not usually sufficient to reflect compensation for reproduction rights; as noted previously, public commissions are rarely financially rewarding for the Artist. Article 6 of the Model Agreement strikes a balance to permit the commissioning body to utilize reproductions in connection with publicity about the Work, and protects its legitimate interest in not having the Artist reproduce identical works for others. At the same time, the Artist controls the important right to derivative utilization of the Work in ways which do not deprive the commissioning body of the unique quality of its purchase and its potential symbolic effect. The Artist is thus free to use the Work or the themes embodied therein, in future works — an important right for artists developing a continuing body of work.

The image of a work of public art may often become a symbol for a locality. For example, the Alexander Calder piece "La Grande Vitesse" has given a sense of place to the square in Grand Rapids, Michigan, in

which it is located, and the image of the sculpture is reproduced on city vehicles and on the mayor's stationery. Article 6 does not prohibit such use, unless such use would interfere with an Artist's trademark or constitute unfair competition with prior works of the Artist.

However, the language of Article 6 prohibits the commissioning body from reproducing the work on tee shirts, post cards and posters, or making other commercial use of the image. Of course, additional language can be negotiated by which the Artist transfers an exclusive or non-exclusive license to the commissioning body, presumably for a royalty or some other additional compensation.

The Oregon Arts Commission in a recently adopted contract provided the following alternative language:

> The WORK created under this agreement shall be the property of the CITY. Any rights of copyright shall be in the CITY after completion and transfer of the WORK to the CITY. ARTIST shall deliver a bill of sale or other appropriate evidence of transfer to the CITY of all rights, including copyright, upon payment of ARTIST's fee.
>
> ARTIST shall not make any type of reproductions of the finished work except by written permission of the CITY. However, ARTIST shall have the right to include photographs or other representation of the WORK in ARTIST's portfolio, catalogues or other similar publications, provided there is prominent reference to the fact that the WORK is installed in the building under the CITY's One Percent for Art Program, administered by the Metropolitan Arts Commission. ARTIST shall also have the right to reproduce the maquette for ARTIST's personal collection.
>
> Similarly, the CITY shall not make any type of reproductions of the finished work except by written permission of ARTIST. However, the CITY shall have the right to include photographs or other representation of the WORK in the CITY's portfolio, catalogues or other similar publications, provided there is prominent reference of the fact that the WORK was created by ARTIST.

The rationale raised by the Oregon Arts Commission for this complex transfer and retransfer (which may deprive the Artist of the valuable right to make derivative works) was that the Commission would have the right to proceed against infringing third parties only if it were the copyright holder. While this is correct as a matter of copyright law, the artist would normally have an even more compelling interest in preventing unauthorized reproductions.

Section 6.2 serves to protect the copyright of the Artist by requiring that the appropriate notice appear on all copies of the Work. Further, even if the commissioning body were to breach its agreement and omit the notice, under the Copyright Act of 1976 the omission of notice does not cause the work to fall into the public domain if the notice was left off copies against written instructions (here set forth in the Model Agreement) that the notice appear on the Work. 17 U.S.C. § 405(a)(3).

Registration is not necessary to gain copyright protection but does

have important advantages. Registration must occur before an infringement in order to obtain an award of statutory damages and attorneys' fees. If the only rights provided to the commissioning body are those in the Model Agreement, the commissioning body may be unwilling to register the copyright in the Artist's name. Registration by the commissioning body may encourage the Artist to protect his own rights from infringement if statutory damages and attorneys' fees are available.

Section 6.2 should probably be omitted if the Artist retains *all* rights to copyright; in such case, the Artist should register the Work.

ARTICLE 7. ARTIST'S RIGHTS.

7.1 *Identification.* The City shall, at its expense, prepare and install at the Site, pursuant to the written instructions and subsequent approval of the Artist, a plaque identifying the Artist, the title of the Work and the year of completion, and shall reasonably maintain such notice in good repair against the ravages of time, vandalism and the elements.

Annotation

Article 7 of the Model Agreement provides for certain limited artist's rights originally found in the civil law doctrines of *droit moral*, or moral rights.

Droit moral is distinct from copyright. Copyright protects the artist's right to exploit a work — a property right. The right of *droit moral* is a personal right protecting an artist's reputation, personality and expression.

Under the doctrine of *droit moral*, the creator of a work of art retains a legally protected interest in the treatment of his work notwithstanding the transfer of ownership. The moral rights doctrine primarily protects two rights: the right of paternity and the right of integrity. The right of paternity is the artist's right to be recognized by the public as the creator of a particular work of art (Section 7.1), and, under certain circumstances, to be able to disclaim authorship. The right of integrity is the right of the artist, even after he relinquishes title to a work, to prevent the alteration, mutilation or distortion of the work [Section 7.4].

The traditional American value of the free alienability of property conflicts with this civil law concept. In the past, the concept of *droit moral*, if recognized at all, was recognized under theories of contract, libel, privacy and unfair competition law. Gilliam v. ABC, 538 F.2d 14 (2d Cir. 1976); Granz v. Harris, 198 F.2d 585 (2d Cir. 1952).

Recently, however, several states have enacted statutes that grant artists significant moral rights protection (Section 7.8 and Annotation). In addition, the rights contained herein have already acquired a history in public art commission agreements.

Section 7.1 incorporates certain aspects of the right of paternity: the

New York City Bar Model Agreement
continued

Artist has the right to be recognized by the public as the creator of the Work.

7.2 *Maintenance.* The City recognizes that maintenance of the Work on a regular basis is essential to the integrity of the Work. The City shall reasonably assure that the Work is properly maintained and protected, taking into account the instructions of the Artist provided in accordance with Section 1.6(c), and shall reasonably protect and maintain the Work against the ravages of time, vandalism and the elements.

Annotation

When an art work is first installed no one can be sure how it will hold up. Someone must assume the responsibility for maintenance and security. It is usually the responsibility of the commissioning body to maintain the art work.

The standard of care imposed on the commissioning body is one of reasonable care.

7.3 *Repairs and Restoration.*

a. The City shall have the right to determine, after consultation with a professional conservator, when and if repairs and restorations to the Work will be made. During the Artist's lifetime, the Artist shall have the right to approve all repairs and restorations, provided, however, that the Artist shall not unreasonably withhold approval for any repair or restoration of the Work. If the Artist unreasonably fails to approve any repair or restoration, the City shall have the right to make such repair or restoration. To the extent practical, the Artist, during the Artist's lifetime, shall be given the opportunity to make or personally supervise significant repairs and restorations and shall be paid a reasonable fee for any such services, provided that the City and the Artist shall agree in writing, prior to the commencement of any significant repairs or restorations, upon the Artist's fee for such services.

b. All repairs and restorations shall be made in accordance with recognized principles of conservation.

Annotation

Many artists are adamant about having the right of first refusal if repairs are necessary. The Model Agreement supports this view but requires that all repairs be carried out in accordance with professional conservation standards. The important point is that a professional con-

servator should be consulted for any repair or restoration. Section 7.3 and Section 7.4 not only protect the legitimate interest of the Artist in his artistic and intellectual creation but also reflect the public interest in preserving cultural and artistic creations.

7.4 *Alteration of the Work or of the Site.*

a. The City agrees that it will not intentionally damage, alter, modify or change the Work without the prior written approval of the Artist.

b. The City shall notify the Artist of any proposed alteration of the Site that would affect the intended character and appearance of the Work and shall consult with the Artist in the planning and execution of any such alteration and shall make a reasonable effort to maintain the integrity of the Work.

c. Nothing in this Section 7.4 shall preclude any right of the City (1) to remove the Work from public display or (2) to destroy the Work [*limiting conditions*]. If the City shall at any time decide to destroy the Work, it shall by notice to the Artist offer the Artist a reasonable opportunity to recover the Work at no cost to the Artist except for an obligation of the Artist to indemnify and reimburse the City for the amount by which the cost to the City of such recovery exceeds the costs to the City of the proposed destruction.

Annotation

(a) Section 7.4(a) is the classic expression of the right of integrity. The commissioning body's obligation under this section need not extend to alteration of the Site unless the Artist has specifically provided that the Site is an integral part of the Work. As to remedies for a breach of this section, equitable relief may be appropriate when damages are inadequate or difficult to ascertain and when the wrong can be cured. This may compel the commissioning body to cure the wrong by restoration since in many cases alteration may occur before preventive remedies such as injunctive relief are available. Damages for breach of this contractual obligation may be more difficult to establish but presumably would encompass the resulting injury to the Artist's reputation.

(b) Even in situations in which the Site is not an integral part of the Work so as to make alterations of the Site fall within the parameters of paragraph (a) of this Section, to the extent that alterations of the Site affect the Work, the commissioning body under the terms of Section 7.4(b) must consult with the Artist.

(c) Most foreign jurisdictions do not, under the doctrine of *droit moral*, prohibit the destruction of art work, on the ground that once a work of art no longer exists, an artist's reputation cannot be injured. It is a matter of heated debate whether a public art commission agreement

should restrict the right to destroy the work of public art. Notwithstanding any strong public interest in the preservation of works of public art, it appears that, in the end, any limitations placed on this right of the commissioning body must be left to the negotiating process. For example, limitations of the right to destroy a work of public art might permit the commissioning body to destroy the Work only if the Site was needed for other purposes and the Work could not be removed without significant alteration. Similarly, a limitation negotiated by the Artist on the right to remove the Work from public display might require that the Work shall remain on public display for a period of at least a specified time after completion unless liquidated damages of an agreed amount of money are paid to the Artist for every month that the period of such public display is shortened.

It is generally thought advisable that commissioning bodies engaged in programs of public art develop a procedure which details the conditions under which a work of art can be removed from public display or destroyed.

7.5 *Permanent Record.* The City shall maintain on permanent file a record of this Agreement and of the location and disposition of the Work.

Annotation

It is important for archival and notice purposes to maintain a record of works of art commissioned by public bodies. This requirement may sometimes be omitted in private commissions.

7.6 *Artist's Address.* The Artist shall notify the City of changes in his address. The failure to do so, if such failure prevents the City from locating the Artist, shall be deemed a waiver by the Artist of the right subsequently to enforce those provisions of this Article 7 that require the express approval of the Artist. Notwithstanding this provision, the City shall make every reasonable effort to locate the Artist when matters arise relating to the Artist's rights.

Annotation

The Artist will not be able to enforce his rights under Article 7 if he does not keep the commissioning body informed as to his whereabouts.

7.7 *Surviving Covenants.* The covenants and obligations set forth in this Article 7 shall be binding upon the parties, their heirs, legatees, executors, administrators, assigns, transferees and all their successors in interest, and the City's covenants do attach and run with the Work

and shall be binding to and until twenty (20) years after the death of the Artist. However, the obligations imposed upon the City by Sections 7.3(a) and 7.6 shall terminate on the death of the Artist. The City shall give any subsequent owner of the Work notice in writing of the covenants herein, and shall cause each such owner to be bound thereby.

Annotation

The Model Agreement provides that the covenants other than the right to make repairs (which is clearly a personal right) survive until twenty years following the Artist's death. (In Europe, the *droit moral* is perpetual, surviving the death of the Artist.)

7.8 *Additional Rights and Remedies.* Nothing contained in this Article 7 shall be construed as a limitation on such other rights and remedies available to the Artist under the law which may now or in the future be applicable.

Annotation

California, Massachusetts and New York have enacted statutes to protect the Artist's rights of authorship and integrity. The California and Massachusetts statutes differ substantially from the New York law in their approach.

The California Art Preservation Act, Cal. Civ. Code § 987 (West 1985) (the "California Act"), and Chapter 231 of the Massachusetts General Laws, Section 85S, are aimed directly at preventing the destruction and alteration of works of art of recognized quality, while the New York Artist's Authorship Rights Act, N.Y. Arts and Cultural Affairs Law §§ 14.51-14.59 (McKinney's 1984) (the "New York Act"), is aimed at preventing damage to an artist's reputation.

The New York Act borrows from the law of libel and misrepresentation and reflects an interest in the personal rights of the artist rather than the public's interest in the physical preservation of artwork. Thus the New York Act does not prevent the destruction of an artwork, but instead prevents the knowing public display or publication of a work of fine art of an artist "or a reproduction thereof in an altered, defaced, mutilated or modified form if the work is displayed, published or reproduced as being the work of the artist or under circumstances under which it would reasonably be regarded as being the work of the artist, and damage to the artist's reputation is reasonably likely to result therefrom."

The New York Act is primarily concerned with the right of paternity, but a limited right of integrity may be implied since the New York Act empowers the artist to prevent the display of his work in an altered

form with his name or in circumstances in which it would reasonably be assumed to be the artist's work.

It is too early to determine how the New York Act will be interpreted and enforced since its effective date was January 1, 1984. In some respects its application may be broader than the California Act, which protects against only the physical alteration of the work and does not apply to the context in which the work is displayed.

For example, in one of the early cases filed under the New York Act, the artist Larry Rivers alleged a violation of the Act when an illustration prepared by him was used to illustrate what he termed "offensive doggerel." Rivers v. Condé Nast Publications, Inc., Index No. 84 Civ. 5571 (MP) (S.D.N.Y. 1984).

Injunctive relief is available under both laws—in New York to prevent or terminate prohibited displays and publications, and in California to prevent intentional alteration or destruction of the work. Restoration of an altered work may also be compelled under the California Act. Both statutes provide for actual damages but provide little guidance in computing such damages.

In a recent New York case, Newmann v. Delmar Realty Co., Index No. 2955/84 (Sup. Ct., N.Y. County), a Supreme Court judge granted the artist Robert Newmann preliminary injunctive relief while the Court considered the issue of whether the new owner of a building was obligated by either property or contract law to display a Newmann mural which the previous owner had contracted to display. The Court held that under the New York Act, the artist had the right to finish the work so long as it was publicly displayed during the period of the injunction despite the fact that if the new owner prevailed, he would be entitled to destroy the work.

Section 7.8 makes clear that the contractual rights provided herein are in addition to, and do not constitute a waiver of, any rights or remedies created by statutes like those of California, Massachusetts and New York.

OPTIONAL

[7.9 *Resale Royalty*. If, during the life of the Artist, the City sells or otherwise disposes of ownership of the Work, the City shall pay the Artist a sum equal to fifteen percent (15%) of the appreciated value of the Work. For the purpose of this Agreement, appreciated value shall mean the sales price of the Work less the original fixed fee stipulated in this Agreement, as amended. Nothing in this Agreement shall be construed to impose any obligation on the City as to the method of sale or disposal. The choice of such method of sale or disposal shall be the sole right of the City.]

Annotation

Recognizing that *droit de suite* clauses have not received widespread utilization, we offer for consideration the Section 7.9 provision as one for which the Artist may wish to negotiate.

The basic goal of the *droit de suite*, or art resale royalty right, is to provide greater economic security for artists. Only California has enacted the resale royalty right into law. Cal. Civ. Code § 986 (West 1985). It is beyond the scope of this Annotation to discuss the arguments for and against the right. However, one of the arguments occasionally made by some opponents of proceeds rights statutes is that they are unnecessary because the artist can contract for such a right as one element in a bargaining process. Proponents argue that the artist has often sacrificed monetary gain for the public exhibition of his work, an advantage which is lost if the work is sold to a private collector for private exhibition. The proceeds right is offered as an optional provision because of its controversial nature.

ARTICLE 8. ARTIST AS INDEPENDENT CONTRACTOR.

The Artist shall perform all work under this Agreement as an independent contractor and not as an agent or an employee of the City. The Artist shall not be supervised by any employee or official of the City nor shall the Artist exercise supervision over any employee or official of the City.

Annotation

This provision of the Model Agreement reaffirms that the Artist is not an employee of the commissioning body. The Artist's status as an independent contractor is not only significant for copyright law purposes, but also has tax consequences; for example, the commissioning body will not withhold income taxes. In addition, the Artist will not be entitled to vacation, sick leave, retirement or other benefits afforded the commissioning body's employees.

ARTICLE 9. ASSIGNMENT, TRANSFER, SUBCONTRACTING.

9.1 *Assignment or Transfer of Interest*. Neither the City nor the Artist shall assign or transfer an interest in this Agreement without the prior written consent of the other, provided, however, that claims for money due or to become due from the City under this Agreement may be assigned to a financial institution without approval.

9.2 *Subcontracting by Artist*. The Artist may subcontract portions of the services to be provided hereunder at the Artist's expense pro-

vided that said subcontracting shall not affect the design, appearance or visual quality of the Work and shall be carried out under the personal supervision of the Artist.

Annotation

A material element of the Model Agreement is the personal skill, judgment and creativity of the Artist. The Artist is not permitted to assign or transfer the creative and artistic portions of the Work to a stranger without the prior written approval of the commissioning body. Similarly, the Artist should have the right to approve any transfer of the commissioning body's rights and responsibilities under the Agreement.

ARTICLE 10. TERMINATION.

If either party to this Agreement shall willfully or negligently fail to fulfill in a timely and proper manner, or otherwise violate, any of the covenants, agreements or stipulations material to this Agreement, the other party shall thereupon have the right to terminate this Agreement by giving written notice to the defaulting party of its intent to terminate specifying the grounds for termination. The defaulting party shall have thirty (30) days after receipt of the notice to cure the default. If it is not cured, then this Agreement shall terminate. In the event of default by the City, the City shall promptly compensate the Artist for all services performed by the Artist prior to termination. In the event of default by the Artist, all finished and unfinished drawings, sketches, photographs, and other work products prepared and submitted or prepared for submission by the Artist under this Agreement shall at the City's option become its property, provided that no right to fabricate or execute the Work shall pass to the City, and the City shall compensate the Artist pursuant to Article 2 for all services performed by the Artist prior to termination. Notwithstanding the previous sentence, the Artist shall not be relieved of liability to the City for damages sustained by the City by virtue of any breach of this Agreement by the Artist, and the City may reasonably withhold payments to the Artist until such time as the exact amount of such damages due the City from the Artist is determined.

Annotation

The normal remedies for breach of contract are damages and, in certain circumstances, specific performance. Article 10 provides that the Agreement may be terminated for cause provided the breaching party is afforded 30 days to cure the breach and fails to do so. It also provides

the commissioning body with the option of acquiring the maquettes and models as an offset to its damage claim, since under the Agreement the commissioning body would not be entitled to such drawings, maquettes and models if the Artist were not in breach.

In some situations, particularly where the underlying capital improvement project so provides, the commissioning body may require that the Agreement give the commissioning body the right to terminate for convenience as well as for cause. Construction contracts often include provisions permitting termination for convenience where the owner finds after entering into a contract that funding is unavailable or needs have changed. Ordinarily, where a contract is terminated for convenience, the contractor is entitled under the contract to receive full payment for all work performed. Without such a provision, most circumstances which would cause an owner to want to terminate a contract would not be sufficient to constitute impossibility, frustration of purpose or other grounds which would relieve the owner of contractual obligations.

Large-scale collaborative projects may require a termination for convenience clause. If the right to terminate for convenience is provided to the commissioning body, the Artist should also have the right.

A clause that combines both convenience and cause is as follows:

(a) The services to be performed under this Agreement may be terminated by either party, subject to written notice submitted thirty (30) days before termination, provided that attempts to reconcile the reason for termination have been undertaken but failed. The notice shall specify whether the termination is for convenience or cause.

(b) If the termination is for the convenience of the City, the Artist shall have the right to an equitable adjustment in the fee (without allowance for anticipated profit on unperformed services), in which event the City shall have the right at its discretion to possession and transfer of title to the sketches, designs and models already prepared and submitted or prepared for submission to the City by the Artist under this Agreement prior to the date of termination, provided that no right to fabricate or execute the Work shall pass to the City.

(c) If termination is for the convenience of the Artist, the Artist shall remit to the City a sum equal to all payments (if any) made to the Artist pursuant to this Agreement prior to termination.

(d) If either party to this Agreement shall willfully or negligently fail to fulfill in a timely and proper manner, or otherwise violate, any of the covenants, agreements or stipulations material to this Agreement, the other party shall thereupon have the right to terminate this Agreement by giving written notice to the defaulting party of its intent to terminate specifying the grounds for termination. The defaulting party shall have thirty (30) days after receipt of the notice to cure the default. If it is not cured, then this Agreement shall terminate. In the event of default by the City, the City shall promptly compensate the Artist for all services performed by the Artist prior to termination. In the event of de-

fault by the Artist, all finished and unfinished drawings, sketches, photographs, and other work products prepared and submitted or prepared for submission by the Artist under this Agreement shall at the City's option become its property, provided that no right to fabricate or execute the Work shall pass to the City, and the City shall compensate the Artist pursuant to Article 2 for all services performed by the Artist prior to termination. Notwithstanding the previous sentence, the Artist shall not be relieved of liability to the City for damages sustained by the City by virtue of any breach of this Agreement by the Artist, and the City may reasonably withhold payments to the Artist until such time as the exact amount of such damages due the City from the Artist is determined.

ARTICLE 11. CONTRACT ADMINISTRATOR.

The Contract Administrator for this Agreement shall be the [Executive Director of Arts Commission]. Wherever this Agreement requires any notice to be given to or by the City, or any determination or action to be made by the City, the [Executive Director] shall represent and act for the City.

Annotation

It is always important to identify the person authorized to give approvals, authorize changes and take all other actions on behalf of the commissioning body.

ARTICLE 12. NON-DISCRIMINATION.

In carrying out the performance of the services designated, the Artist shall not discriminate as to race, creed, religion, sex, age, national origin or the presence of any physical, mental or sensory handicap, and the Artist shall comply with the equality of employment opportunity provisions of Ordinance _____ as presently existing or hereafter amended.

Annotation

Non-discrimination (and often anti-bribe, as well) clauses are usually required by local laws for public authority contracts.

ARTICLE 13. COMPLIANCE.

The Artist shall be required to comply with Federal, State and City statutes, ordinances and regulations applicable to the performance of the Artist's services under this Agreement.

ARTICLE 14. ENTIRE AGREEMENT.

This writing embodies the entire agreement and understanding between the parties hereto, and there are no other agreements and understandings, oral or written, with reference to the subject matter hereof that are not merged herein and superseded hereby.

ARTICLE 15. MODIFICATION.

No alteration, change or modification of the terms of the Agreement shall be valid unless made in writing and signed by both parties hereto and approved by appropriate action of the City.

ARTICLE 16. WAIVER.

No waiver of performance by either party shall be construed as or operate as a waiver of any subsequent default of any terms, covenants and conditions of this Agreement. The payment or acceptance of fees for any period after a default shall not be deemed a waiver of any right or acceptance of defective performance.

ARTICLE 17. GOVERNING LAW.

This Agreement, regardless of where executed or performed, shall be governed by and construed in accordance with the laws of the State of _____.

ARTICLE 18. HEIRS AND ASSIGNS.

This Agreement shall be binding upon and shall inure to the benefit of the City and the Artist and their respective heirs, personal representatives, successors and permitted assigns.

ARTICLE 19. ARBITRATION.

All disputes or controversies that may arise between the parties with respect to the performance, obligations or rights of the parties under this Agreement, including disputes as to the physical acceptability of the work or any alleged breach thereof, shall be settled by arbitration to be held in _____, in accordance with the then current Rules of Commercial Arbitration of the American Arbitration Association; however, consideration of artistic merit being a matter for the exclusive determination of the Artist, no dispute or controversy may arise with respect thereto.

The dispute shall be referred to a panel of three arbitrators, one to be selected by the Artist, one to be selected by the City and the third to be selected by the first two. If an agreement on the third arbitrator cannot be reached within thirty (30) days after the appointment

of the second arbitrator, such arbitrator shall be appointed by _____.

The decision and award of the arbitrators, or that of any two of them, shall be final and binding on the parties, and judgment may be entered upon it in any court having jurisdiction thereof.

Annotation

In addition to the usual arguments favoring arbitration over court litigation of disputes (i.e., that it is quicker, less expensive and permits more flexible and informal rules of evidence and construction), there is also the consideration that disputes over public art works may be too controversial to risk submitting to a jury or any sort of public trial. The arbitration clause also provides the Artist with the assurance of being able to select a strong advocate for his position on the arbitral panel.

As a general proposition, states, municipal corporations and governmental agencies are competent to enter into agreements to arbitrate as a consequence of their power to enter into contracts. Exceptions to this rule arise either by reason of a specific restriction in a charter, statute or enabling document, or under circumstances where the dispute submitted to arbitration involves review of what amounts to executive acts which, as a matter of public policy, may only be reviewed through mandamus proceedings. In contrast to the general proposition, agencies of the Federal Government have no implied authority to enter into arbitration agreements and may do so only under express statutory authority.

This arbitration clause removes from the scope of arbitration disputes as to "artistic merit." Since, as a rule, the arbitrators decide the question of whether or not the dispute is covered by the arbitration clause, it may be expected that in many disputes the threshold issue to be addressed by the arbitrators will be whether or not the dispute is really over "artistic merit."

The Artist or commissioning body must take care to assert any claim in a timely fashion, since most statutory limitations for asserting claims against states and municipalities apply to arbitration as well as court litigation. In this regard, determination of when the claim arises may implicate the various notice and time provisions in the contract.

Further consideration must be given to whether the Artist is a prime contractor of the state or municipal agency or a subcontractor. The problem may arise that, even though a statutory prohibition against state or municipal arbitration may not extend to the arbitration provision in a subcontract, an arbitration award under the subcontract may not be recognized in settling claims between the prime contractor and the state or municipal agency.

ARTICLE 20. NOTICES.

All notices, requests, demands and other communications which are required or permitted to be given under this Agreement shall be

in writing and shall be deemed to have been duly given upon the delivery or receipt thereof, as the case may be, if delivered personally or sent by registered or certified mail, return receipt requested, postage prepaid, as follows:

a. if the City, to:

b. if to the Artist, at the address first above written with a copy to:

[address of Artist's attorney]

IN WITNESS WHEREOF the parties hereto have executed this Agreement on the day and year first written above.

[CORPORATE SEAL]

Attest: CITY,
 , Clerk By its Arts Commission

By: _____ By: _____
 Deputy Clerk Executive Director

 ARTIST:

_____ _____
 Witness (Name)

Approved as to form and
legal sufficiency: _____
 (Signature)

**Downtown Seattle Transit Project
Scope of Work Samples**

The Scopes of Work presented here are excerpts from artist contracts for two different public artworks for the Downtown Seattle Transit System. They define in detail the artist's responsibilities through the duration of the artist's contract . This duration differs for each project. The accompanying Architect / Engineer (A/E) Technical Support sheets likewise outline the architectural scope of work as it relates to the artist's efforts. Together, these sheets document the project to the degree needed to provide necessary information for the bidding and construction process.

```
                    EXHIBIT A
                     PART I
               ARTIST SCOPE OF WORK

C.P.S.-2    WATER FEATURE
            CONVENTION PLACE STATION

1.   GENERAL DESCRIPTION:

     Water feature configuration at south wall including
     water elements at the face of wall, pool, tile locations.

2.   WORK UNDER THIS CONTRACT:

     2.1    60% TASKS         due with 60% submittal of CUO4A

     2.1-1  Collaboratively define and locate water feature
            with the A/E and fountain consultant and wall
            artist.

     2.1-2  Assist A/E with preliminary specification and
            collaborate with A/E on construction procedure/
            approach.

     2.1-3  Submit water feature design sketches (plans,
            sections and elevations) in reproducible form
            to Metro for approval.

     TOTAL TASK 2.1

     2.2    90% TASKS         due with 90% submittal of CUO4A

     2.2-1  Collaboratively finalize the water feature design
            with the A/E and fountain consultant (90% complete).

     2.2-2  Collaborate water feature with tile design.

     2.2-3  Provide final specification input to A/E.

     2.2-4  Review final tile mapping of tile.

     TOTAL TASK 2.2

     2.3    100% TASKS        due with 100% submittal of CUO4A

     2.3-1  Furnish completed specification of work, Exhibit
            A, Part II.

     2.3-2  Complete design of water feature.

     TOTAL TASK 2.3
```

```
     2.4    CONSTRUCTION ASSISTANCE

     2.4-1  As requested by Metro, provide clarification on
            the art project during the bidding phase, attend
            pre-bid, pre-award conferences and/or public
            relations events (not to exceed 20 hours).

     2.4-2  In accordance with standard Metro construction
            management procedures of the CUO4 contract, review
            DSTP contractor's submittals; attend coordination
            meetings and/or inspect installation of the art
            work (not to exceed 52 hours).

     TOTAL TASK 2.4

TOTAL TASK
```

In the Water Feature Project for the Convention Place Station, the artist was designer of the water feature, but fabrication and installation of it were executed by contractors. The artist's work is completely documented through contract drawings and specifications.

The artist is paid a design fee through the 100% design (Task 2.3) and then is paid on an hourly basis through Construction Assistance (Task 2.4) at $40.00 per hour.

EXHIBIT A
PWC NO. 76AS/C.O. NO. 52
A/E TECHNICAL SUPPORT

C.P.S.-2 WATER FEATURE
 CONVENTION PLACE STATION

1. GENERAL DESCRIPTION:

 Water feature configuration at south wall including water elements at the face of wall, pool, tile locations

2. WORK UNDER PWC 76AS:

 2.1 60% TASKS due with 60% submittal of CUO4

 2.1-1 Collaboratively define and locate the water feature with the water feature artist, fountain consultant, and wall artist. Incorporate design into 60% submittal documents. Develop tile details.

 2.1-2 Develop preliminary specification in collaboration with water feature artist. Develop construction procedure/approach.

 2.1-3 N/A

 2.1-4 Develop preliminary construction cost estimate.

 2.1-5 Engage the services of a fountain consultant.

 TOTAL TASK 2.1 $

 2.2 90% TASKS due with 90% submittal of CUO4

 2.2-1 Collaboratively finalize water feature with water feature artist and fountain consultant (90% complete and incorporate components into final documents.

 2.2-2 Collaborate water feature design with the design artist.

 2.2-3 N/A

 2.2-4 Develop final technical specification including fabrication process/approach for water feature, tile and fountain.

 2.2-5 Review mylar tile mapping by artist for incorporation into DSTP construction documents (90%).

 TOTAL TASK 2.2 $

 2.3 100% TASKS due with 100% submittal of CUO4

 2.3-1 N/A

 2.3-2 Incorporate final water feature components into final DSTP construction documents (100%).

 2.3-3 Provide final construction cost estimate.

 2.3-4 Review final mylars of tile mapping by artist for incorporation into DSTP construction documents.

 TOTAL TASK 2.3 $

 2.4 CONSTRUCTION ASSISTANCE

 2.4-1 N/A

 2.4-2 Collaborate with water feature artist on review of submittals and make necessary approvals or take other appropriate action on contractors submittals. Make on-site observations during construction as required by Metro. (Assume 20 hours)

 TOTAL TASK 2.4 $

Downtown Seattle Transit Project
Scope of Work samples
continued

The Scope of Work for the Terra Cotta Park at the Westlake Station completely documents the artist's work into contract drawings but also places the artist in the contractor's factory during fabrication. In this case, the artist has documented the terra cotta molds into contract drawings that describe the levels of complexity of mold shapes and color. These molds are used by the contractor for castings with the artist

```
                    EXHIBIT A
                     PART I
               ARTIST SCOPE OF WORK

W.L.S.-1    TERRA COTTA PARK
            WESTLAKE STATION

1.   GENERAL DESCRIPTION:

     Colored terra cotta leaf assemblage on a portion of
     the Westlake Station south wall.

2.   WORK UNDER THIS CONTRACT:

     2.1    60% TASKS        due with 60% CUO4

     2.1-1  Collaborate with A/E on documentation and construc-
            tion approach and map location of art piece on
            wall elevation.

     2.1-2  Submit design development drawings of art piece
            elevation terra cotta leaf pattern and preliminary
            topo map of sample areas for approval by Metro.

     2.1-3  Collaborate with A/E for special material and
            fabrication process requirements for specifications.

     2.1-4  Collaborate with A/E for color, leaf pattern and
            glaze.

     2.1-5  Collaborate with A/E for preliminary cost estimate
            input.

     TOTAL TASK 2.1

     2.2    90% TASK        due with 90% submittal of CUO4

     2.2-1  Provide all necessary design information to A/E
            including final section profiles and/or topographic
            legend to enable final development of DSTP construc-
            tion documentations by the A/E.

     2.2-2  Not applicable.

     2.2-3  Provide all necessary specification information
            to A/E for incorporation into DSTP construction
            documents technical specifications.  Include any
            information regarding artist's role in fabrica-
            tion and/or installation procedures.

     TOTAL TASK 2.2
```

```
     2.3    100% TASKS        due with 100% submittal CUO4

     2.3-1  Provide all final information to A/E necessary
            to complete construction documents (100%).

     2.3-2  Complete final mapping for incorporation into
            DSTP construction documents.

     2.3-3  Provide construction cost input to A/E for
            incorporation into final construction cost
            estimate.

     2.3-4  Complete final specifications of work, Exhibit
            A, Part II.  Provide sample tiles to Metro for
            shape and color for review and approval.

     2.3-5  Provide mapping of all pieces on final mylars
            at a minimum scale of ¼" = 1'-0" for incorpora-
            tion into DSTP construction documents.  Include
            number of pieces and shapes (90% complete).

     TOTAL TASK 2.3

PHASE II

     2.4    CONSTRUCTION ASSISTANCE

     2.4-1  As requested by Metro, provide clarification on
            the art project during the bidding phase.  Attend
            pre-bid, pre-award conferences and/or public rela-
            tions events (not to exceed 80 hours).

     2.4-2  In accordance with standard Metro construction
            management procedures for CUO4, review DSTP
            contractor's submittals; attend coordination
            meetings and/or inspect installation of the art
            work (not to exceed 20 hours).

     2.4-3  Provide fabrication assistance to the DSTP con-
            tractor in accordance with the construction
            documents (assume travel anywhere in continental
            U.S. and two (2) months room and board).

     TOTAL TASK 2.4

TOTAL TASK
```

directing and applying glazes. The contractor then installs the cast pieces by using mapping provided in the documents (2.3-5) by the artist. The artist is paid for design and some fabrication time but materials and installation costs are part of the station's architecture budget.

Another project for the transit system, a tile veneer wall for the Prefontaine Entranceway (not reproduced here), exemplifies a more traditional method of artist work. The artist and architect cooperate on defining an area where the artist works and essentially leave those areas blank on the construction documents. Following completion of work by the contractor (who put up the structural wall in this case), the artist applies surface treatment. The artist is given a commissioned amount of money and, in this case, the architect adds money which would have been spent had he provided the finish for the wall.

```
                        EXHIBIT A
                PWC NO. 76AS/C.O. NO. 52
                  A/E TECHNICAL SUPPORT

W.L.S.-1    TERRA COTTA PARK
            WESTLAKE STATION

1.   GENERAL DESCRIPTION:

     Colored terra cotta leaf assemblage on a portion of the
     Westlake Station south wall.

2.   WORK UNDER PWC 76AS:

     2.1    60% TASKS        due with 75% submittal CUO4

     2.1-1  Develop the documentation and construction approach
            in collaboration with the artist for the work.

     2.1-2  N/A

     2.1-3  Develop special material and fabrication process
            requirements for specification in collaboration
            with artist for the work.

     2.1-4  Collaborate with artist for color and glaze
            characteristics of work.

     2.1-5  Develop preliminary construction cost estimate
            in conjunction with input from artist.

     TOTAL TASK 2.1                            $

     2.2    90% TASKS        due with 90% submittal CUO4

     2.2-1  Develop typical sections, profiles and details
            and other documentation related to the Terra
            Cotta Park, except mapping and topography, for
            incorporation into the DSTP construction docu-
            ments.  Provide design and structural support
            system including anchorage as necessary.  (R)

     2.2-2  N/A

     2.3-3  Develop final technical specifications.

     2.2-4  Review mylars prepared by artist.

     TOTAL TASK 2.2                            $
```

```
     2.3    100% TASKS        due with 100% submittal of CUO4

     2.3-1  Complete Task 2.2-1 about (100%)

     2.3-2  N/A

     2.3-3  Provide final construction cost estimate.

     2.3-4  N/A

     2.3-5  Review mylars prepared by artist.

     TOTAL TASK 2.3                            $

     2.4    CONSTRUCTION ASSISTANCE

     2.4-1  Provide bidding assistance to Metro if requested.

     2.4-2  Review submittals and shop drawings and make
            necessary approvals or take other appropriate
            action on the contractors submittals.  Assist
            artist with approval of color, leaf pattern and
            glaze and provide on-site observation during
            construction as required by Metro.  (Assume 20
            hours on-site assistance).

     TOTAL TASK 2.4                            $
```

MBTA Arts On The Line Action List

Reprinted by permission of the Massachusetts Bay
Transportation Authority.

Ideally the artist's proposed
artwork should be included in
the architect's final design
drawings and the document pre-
sented to the builder who bids
(and is hired) to do the con-
struction. That way site prep-
aration and installation costs
shall be borne by the contrac-
tor. The artist's specifica-
tions must be comprehensive so
that it is clear to a bidder
what is needed to do the work
(i.e., concrete foundation for
a sculpture--dimensions, weight,
load it will carry, site, etc.).

Artists should not rely on ad-
ministrators' and clients' (or
contractors') standard contracts.
The artist should hire a lawyer
knowledgeable about contract
law to review his/her contract.
Many local arts organizations
can recommend lawyers who work
specifically with artists.

ACTION LIST FOR

DESIGN, FABRICATION, INSTALLATION AND MAINTENANCE OF ART

After the artist is selected, he/she begins intensive work on his/her design with the art administrator and MBTA project director on the next four major phases of work: final design, fabrication, installation and maintenance.

Steps	Arts Administrator	Artist	MBTA	Contractor
	AREA OF RESPONSIBILITY			
1. Final design of and budget for proposed artwork.	X	X		
Specify: appropriate, durable materials; site; exact dimensions and weight; attachment plan; easy, reasonable and cost-effective maintenance; schedule of time and method(s) required to fabricate and install; special features; and all costs for fabrication and installation of the artwork.			X	
2. Review of final design and budget with artist.	X		X	
Schedule meeting(s) with MBTA Design Department, Operations and Safety, Legal, and/or Communications if the proposed artwork raises any technical questions that could be dealt with prior to negotiation of the fabrication/installation contract between the artist and the general contractor.	X		X	
Include site preparation and installation specifications in contract bid documents for work to be done by general contractor.			X	
3. Approval of design and budget.	X		X	
4. Draft of fabrication/installation contract between the artist and the general contractor (or MBTA) based on the artist's completed specifications of work and budget.		X		

This Action List is extracted from the *Arts On The Line Eight Year Report*, prepared by Pallas Lombardi and issued in 1986 by the Massachusetts Bay Transportation Authority. The chart details specific tasks of design, fabrication, and installation of a public artwork and where the responsibility lies for implementation within the AOTL management structure. Annotations are made by Pallas Lombardi, former director of the Arts On The Line Program.

	Arts Administrator	Artist	MBTA	Contractor
5. Review and draft of the fabrication/installation contract.		X		
6. Fabrication/installation contract submitted to artist's lawyer. (optional but recommended)		X		
7. Review fabrication/installation contract between the artist and the general contractor (or MBTA).	X		X	
8. Execute fabrication/installation contract.	X			X
9. Invoice for each payment stage prepared in advance by arts administrator and executed by artist (kept on file at arts office).	X	X		
10. Purchase materials and begin stage 1 fabrication.		X		
11. Inspect completed stage 1 fabrication work.	X			
If any problem arises, schedule a meeting with: to review the situation and decide how to proceed. Reaffirm the decision, in writing, to all parties.	X			
12. Submit approved artist's invoice to the MBTA for approval and submittal to the general contractor (or appropriate MBTA department) for payment.	X		X	X
13. Stage 2 fabrication begins upon receipt of payment of stage 1 work.		X		

No administrator is knowledgeable in all the artistic media and technical aspects of art fabrication. The administrator needs to rely on the professionalism of the artist, that he/she is constructing work to specification. It is helpful to have an engineer, if one is available on the project, to review specifications in advance and advise the administrator and artist of any potential technical problems (aesthetic decisions are left to the artist, i.e., change in shape, etc.).

	Arts Administrator	Artist	MBTA	Contractor
14. Inspect completed stage 2 fabrication work. If any problems arise, schedule a meeting with: and resolve the problem. Reaffirm decision, in writing, to all parties.	X			
15. Submit approved artist's invoice to the MBTA for approval and submittal to the general contractor (or appropriate MBTA department) for payment.	X			
16. Complete fabrication (Stage 3) of artwork and prepare for storage.		X		
17. Inspect completed artwork and review artist's storage plan.	X			
If any questions arise, schedule a meeting with: answer questions: reaffirm decision, in writing, to all parties.	X			
18. Store artwork until apprised of installation date.		X		
19. Submit approved artist's invoice to the MBTA for its approval and submittal to the general contractor (or appropriate MBTA department) for payment.	X		X	X
20. After general contractor completes site preparation for artwork, schedule installation date.				X
Inspect site preparation. If any changes are required, arts administrator schedules meeting with: Resolve problem. Reaffirm decision, in writing, to all parties.	X	X	X	

	Arts Administrator	Artist	MBTA	Contractor
21. Deliver artwork to site.		X		
22. Unload artwork from delivery vehicle, store or begin installation.				X
23. Store the artwork in a safe, clean, dry space when not being installed.				X
24. Supervise installation by union personnel.		X		
25. Install artwork.				X
26. Inspect finished, installed artwork.	X	X	X	
27. Submit approved final invoice for 5% retainage to the MBTA for approval and submittal to the general contractor (or appropriate MBTA department) for payment.	X			
28. Execute Maintainance/Copyright Art Agreement.		X	X	
29. Complete "catalogue" form specifying: the dates artwork was fabricated and installed, title, materials, finished dimensions and weight, etc.		X		
30. Install plaque specifying the artist's name, title of the artwork, installation date and that the MBTA commissioned the artwork through the Cambridge Arts Council's Arts On The Line Program.			X	

In this article, artist Robert Irwin recounts some painful and frustrating public art experiences where treatment by commissioning agencies is less than respectful of the artist as professional and is often characterized by inadequate understanding of how a public art project comes to fruition. Irwin then offers his thoughts about the social value of art and the viewer's need to achieve new ways of seeing.

HOW PUBLIC ART BECOMES A POLITICAL HOT POTATO

BY MILTON ESTEROW

Portal Park Slice in Dallas, 1978-80, raises a number of questions, says Irwin. Are "mounds of grass" sculpture?

IN ART SCHOOL ROBERT Irwin was a figurative artist "with never, never any conviction." He became an Abstract Expressionist in the 1950s. Some people thought he shifted to Minimalism in the '60s, but he was still an Abstract Expressionist, he says, "reducing the images but trying to increase the physicality." Early in the '70s he abandoned making objects for about four years because he "had no legitimate grounds for making them as that was defined." At the same time he emerged as what one writer called "something of a Socratic visionary," lectured on college campuses, took part in the first National Symposium on Habitability, sponsored by the National Aeronautics and Space Administration, and turned to creating public art in cities across the country. He was recently selected by the MacArthur Foundation for one of its so-called genius awards, which come with a grant of about $50,000 a year for five years. "The exact amount of the grant is based on how old you are," Irwin says.

"I don't have a nest, I'm totally transient," says Irwin, who was born in Long Beach, California. He is 57, lean and friendly, and smiles easily. "No art hangs in my house. Once I had some things, but I gave them all back to the artists. I see things every day that are more interesting than anything I've made or will make." He pauses and says, "We have a visual wonderland all around us. When

*Robert Irwin has clashed with city officials who agree that the <u>Pietà</u> is art
but turn down 'all that abstract nonsense'*

you walk down Park Avenue you see a series of black and white shadows. The whole city is divided by this amazing grid that runs down the entire length of the city. You know, you are given the world when you open your eyes.''

Irwin was sitting in an office at Pace Gallery in New York, where an exhibition had just opened of maps, models and photographs of some of his recent public-art projects. His book, *Being and Circumstance: Notes Toward a Conditional Art*, was published last year by Lapis Press in conjunction with Pace Gallery. Lapis was founded by the artist Sam Francis.

In the book, Irwin discusses his philosophical and esthetic theories and writes about 17 projects he has created in the last decade. Although the writing can in some places be a bit obscure, *Being and Circumstance* is a very important book on public art.

Among the projects discussed are *Two Ceremonial Gates, Asian Pacific Basin* at the San Francisco International Airport Terminal; *Filigreed Line* at Wellesley College, a line of stainless steel running along a ridge of grass and in front of a lake, with a pattern of leaflike shapes cut through the steel, which ranges from a few inches to two feet high; *48 Shadow Planes* in the Old Post Office in Washington, D.C., a grid of translucent scrim squares that appear to float in the building's atrium; and *Portal Park Slice* in Dallas, a line of Cor-ten steel, 12 feet high, one inch thick and 700 feet long, ''cutting like a knife through the mounds of grass, intersecting every passing street.''

Irwin raises a number of questions about the Dallas project. ''Can we actually claim 'mounds of grass' as sculpture?

''What then do we mean by the term 'sculpture'? What good is a word that includes everything? For instance, how do we now distinguish between sculpture and landscape? And sculptor and landscape architect?

''Isn't the 'art object' actually understood as a distinct and special category of thing?

''What actually happens to what was once distinct and special when we fold it into the fabric of its circumstances? Into our daily lives? Gain and loss?

''Are you intrigued by the possibilities—or put off by the complexities?''

The uncompleted projects include a proposal for the transit arrival area of Chicago's O'Hare International Airport. Irwin writes, ''The way I see this happening is that as you get off the train and begin your walk, a line of light would chase overhead along the platform, up the end escalator, and then disappear. The sound would then chase along behind, lingering as the 'G' [there would be a combination of the G and A strings plucked on the cello] resonates out. All of this might be in your peripheral field the first time around, you being not quite sure what it was. About the time you gave up on its being 'anything,' it would come charging around the corner of the upper corridor, chasing and disappearing in another direction.''

Irwin says of the O'Hare project: ''This was a humorous invitation, if you have a broad sense of humor. I was asked to visit Chicago to look at a site, but no one concerned with the project really believed anything much was possible or necessary.''

He is not reluctant to explain why other projects were not completed. In one case, a grant application was turned down and ''in effect discouraged an insecure group of people '' in Cincinnati. The mayor of New Orleans, Irwin says, ''lost his nerve.'' A project proposed for that city ''became a political hot potato and a media joke.'' He adds: ''Projects such as these are riddled with contradictions, risks, failures, successes and even a kind of black humor.''

Could he give any examples?

''The San Francisco project is a case study of what can go wrong with site—or public—art. I proposed two sculptural forms, one formal and black, the other floral and white. At the base of each sculpture is set, like an icon, a large two-ton red-pink onyx rock. The gates, each with huge steel plates, pass through the opening in the ceiling to the upper floor.

''You're dealing with people who are basically very sincere, and they try their damnedest and they do some of the most bizarre things, so you can't kick them for it. I got asked by a group and they're all volunteers and so in a sense they're doing their civic duty. So they bring you into a room and they offer you this project. You look at the project and you know right up front that this is a very dangerous project. I mean, very dangerous. Because what's happened is, it took them, say, three years to get to this point, three years of meetings and hammerings and bangings, in effect. Three years. They say, 'Well, we need this in three months.' How do you tell them that that's just awful wrong? This whole idea of theirs, that I'm going to make a masterpiece, I get three months to create it and have it completed and they have three years just to hammer out the so-called logistics.

What can you tell them? You can tell them, but what good does it do?

''I essentially said, 'Please tell me the rest of it. Just give me the facts, ma'am.' One of the first things that has to change in this country is the logistics of how these public-art projects are done.

*One of **Two Ceremonial Gates, Asian Pacific Basin**, at the San Francisco International Airport, completed in 1983.*

"So I asked them a number of questions about what it is they wanted and how they wanted it and so on. They were very kind of condescending, really, without intending to be, but they were definitely giving me a major opportunity in life. And I said that perhaps I could think of something. Well, I went home and I came up with something."

How long did it take?

"About a month and a half. I actually got lucky on this one. Sometimes I don't get an idea at all. Sometimes I get mediocre ones, and once in a while I get an interesting one. So I bring it back and present it to them. They have a lot of questions and comments that are fairly humorous. Like, 'You'll probably have to get somebody up there to dust it off on occasion.' You see, one of the things that stops more projects than anything is maintenance. The maintenance guy says, 'Hey, my broom is that wide and that thing is *that* wide. I can't get my broom around it.' Literally, that's how projects get stopped. The mayor agrees, the city council okays it, the parks people are in order, and along comes either somebody who interprets all the codes or some kind of safety laws, or the janitor, and says, 'No, you can't do that, we can't do this.'

"Another time in another city, there was a meeting with some officials. I said about four words and one of them said, 'Wait a second. I don't want to know about all that abstract nonsense. As far as I'm concerned, the *Pietà*, now that's art. If you can give me the *Pietà*, then we've got a deal.' And I said to him, 'Look, I'll tell you what. I will look at your situation, and if I can find anything interesting to do I'll show it to you. If you're interested, we'll do it. If you're not interested, we won't do it. All bets are off. It won't cost you a thing.' He said, 'Okay, I can understand that.'

"So I make a proposal which everybody decides they like. Now I'm supposed to do it. A year goes by, another year goes by, a third year goes by. My contract actually runs out. Mind you, all this time prices are escalating. I've got a budget. That's it. No more, no less. Prices are going up and I can't prepare for it because there's no date on the thing.

"So I wait and wait and wait. All of a sudden I get a call and the call says, 'It will be done in two weeks.' I say, 'You've got to be kidding.' I mean, I've been waiting three years and they are going to give me a two-week lead time? So the point is, that's it. Plain and simple. You could either get it done or forget about it.

"You're at the mercy of these incredible whims. Things like unions coming in and saying, 'Hey, we weld, we paint, we rivet. You can't do that stuff; we will. You have to pay us to do it.' I didn't want to pay them to do it because they wouldn't do it right. But I had to pay, and on top of my budget. I had to pay them to stand there and watch me do it. I had to pay the union $23,000.

"Because the arts commission and the committee had not done their homework in preparing the project, the prime contractor for the construction site was in no way obligated to cooperate with me or even let the artists onto the site. And was able to make me the scapegoat for the late penalty in *his* contract. I was literally forced to move my entire project— including 15 tons of steel and four tons of rock —back onto the street."

Irwin writes in his book, "The fact is, 'public art' projects most often fail for the lack of any clear understanding of the actual social value of art—an understanding capable of generating an appreciation of the worth of *qualities* in our lives in a world otherwise governed by the simpler pragmatics of quantities as the measure of worth."

Too many people walking down Park Avenue or attending, for example, the Renoir exhibition at the Museum of Fine Arts in Boston are missing the "visual wonderland" Irwin says. "The trick is really acknowledging the fact that the world is bigger than we previously assumed and not assuming we know everything but just the opposite, and that is to say, 'There is a great deal I don't know.' At certain times under certain circumstances, say when you go to a museum or gallery, is a good time to do it. From the moment you walk in, what you do is turn yourself inside out. Yes, inside out. In other words, the point is, don't go in assuming what it is you have come to look for or assuming what is supposed to be there. Go in there and attend what is there. Go in with the idea of being open. If you open yourself up, some of these things will begin to play on you.

"Don't go with assumptions. People have all kinds. For example, people ask me what kind of art I like and they expect me to talk about people who do things similar to what I do, so that we essentially are like a manifesto of how things should be. The people I like include somebody like Lucas Samaras, because he takes me to worlds that I don't know about, that I am not comfortable in or that I am not completely conversant with. But if I go to Samaras measuring him or looking for what I know or what I want, then I am never going to see Lucas Samaras at all. So open yourself up a bit. There are no rules, ultimately.

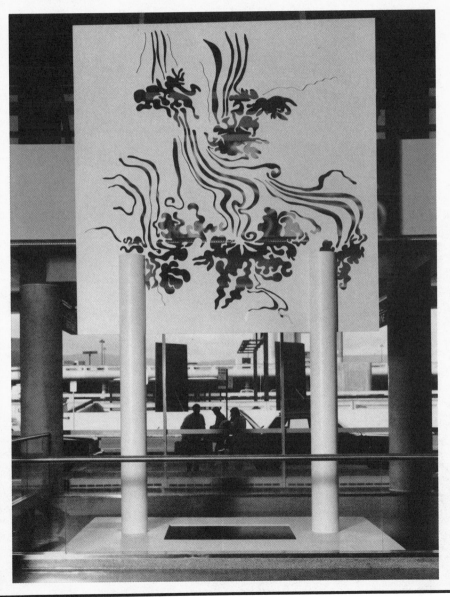

"Each artist at every creative time has redefined seeing for us. Let's say you are a mathematician or an economist and you want, in a sense, absolute rules and you want things to be clear. You live in a hard-edge world. You go into the Renoir exhibition and you are not going to find it because it is not a hard-edge world—it is soft, very subtle, with beautiful transitions, interplay between forms.

"I watch people walk into my show here. Some just look and walk right back out. That is not even a comment on me. That is a comment on their ability to look. They are telling me that they are not looking at all, because, like or don't like it, there is certainly something there to attend. You may, having gone through the thing three or four times, on the fifth time decide this is not all it is supposed to be. Or that he is full of baloney or that this doesn't do this or he falls down here. Yes, he can be picked apart. It is a series of possibilities. But they never get past base one, so they are never going to know.

"All I'm saying is that we don't pay attention. We don't look and we don't open up to the idea that art really does inform us and in informing us changes our lives. My highest ambition for the thing I do is to make you see a little bit more tomorrow than you saw today. When I teach, all I try to do is convince people that they are a potential and that the game is to fulfill that potential. I am not going to teach them what art is because I don't know what art is. I can talk about it in the realms it plays in, the roles that it is involved in, the kinds of histories it has. I can talk about its ambitions, I can talk about all its practices, all its tools, but I don't know what art is."

In any case, Irwin is an optimist. He thinks we are in an age that "seeks to discover and values the potential for experiencing beauty in everything. I like being an artist," he says. "We really have tremendously beautiful questions." ∎

How Art Becomes Public

In this article, Jerry Allen gives thoughtful exploration to some difficult issues surrounding public art, such as the definition of the term itself and what underlies the public's acceptance or rejection of contemporary public artworks. Allen poses five conclusions that might guide a commissioning agency's approach to management and education with the goal of bridging the gulf between public expectations and understanding about art and the need to pursue meaningful contemporary art for public spaces.

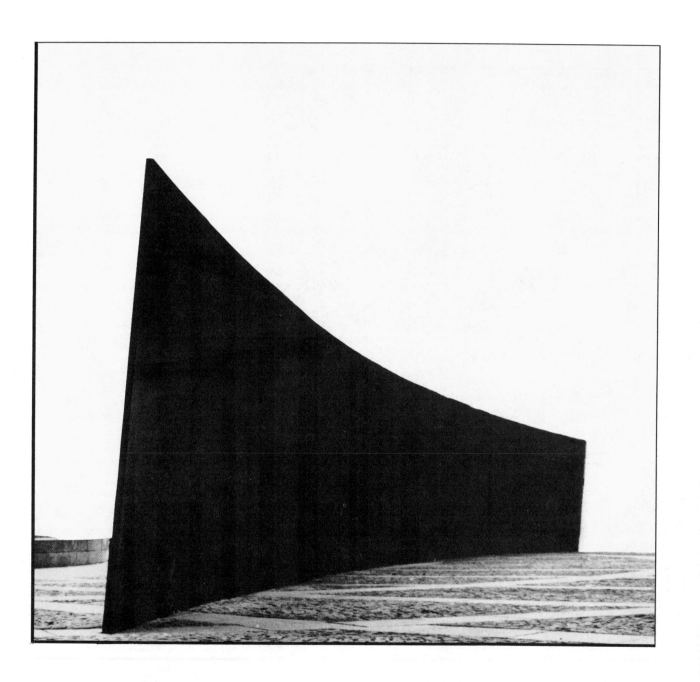

King County Arts Commission

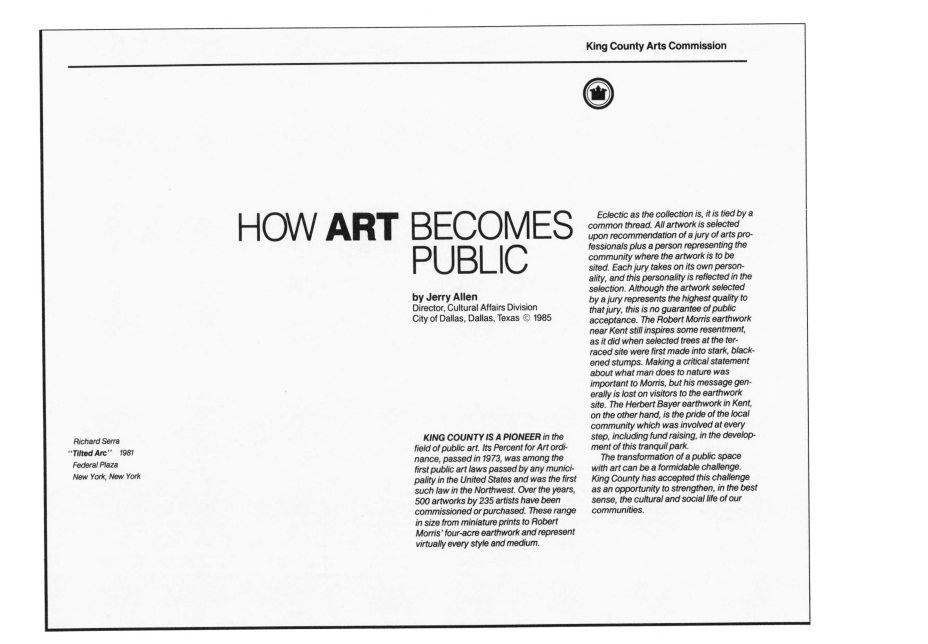

HOW **ART** BECOMES PUBLIC

by Jerry Allen
Director, Cultural Affairs Division
City of Dallas, Dallas, Texas © 1985

KING COUNTY IS A PIONEER in the field of public art. Its Percent for Art ordinance, passed in 1973, was among the first public art laws passed by any municipality in the United States and was the first such law in the Northwest. Over the years, 500 artworks by 235 artists have been commissioned or purchased. These range in size from miniature prints to Robert Morris' four-acre earthwork and represent virtually every style and medium.

Eclectic as the collection is, it is tied by a common thread. All artwork is selected upon recommendation of a jury of arts professionals plus a person representing the community where the artwork is to be sited. Each jury takes on its own personality, and this personality is reflected in the selection. Although the artwork selected by a jury represents the highest quality to that jury, this is no guarantee of public acceptance. The Robert Morris earthwork near Kent still inspires some resentment, as it did when selected trees at the terraced site were first made into stark, blackened stumps. Making a critical statement about what man does to nature was important to Morris, but his message generally is lost on visitors to the earthwork site. The Herbert Bayer earthwork in Kent, on the other hand, is the pride of the local community which was involved at every step, including fund raising, in the development of this tranquil park.

The transformation of a public space with art can be a formidable challenge. King County has accepted this challenge as an opportunity to strengthen, in the best sense, the cultural and social life of our communities.

Richard Serra
"Tilted Arc" 1981
Federal Plaza
New York, New York

245

King County Arts Commission

Louis T. Rebisso
Grant Monument
Lincoln Park
Chicago, Illinois

Public art is a very new phenomenon in modern terms. It is something still in the process of becoming. It does, however, seem surprising, nearly 26 years after the passage of the first Percent for Art ordinance in Philadelphia, that we still are unable to define exactly what public art is, or ought to be. What, at first glance, seems simple, becomes very complex, linguistically and conceptually. Indeed, the very notion of a "public art" is something of a contradiction in terms. In it, we join two words whose meanings are, in some ways, antithetical. We recognize "art" in the 20th Century as the individual inquiry of the sculptor or painter, the epitome of self-assertion. To that we join "public", a reference to the collective, the social order, self-negation. Hence, we link the private and the public, in a single-concept or object, from which we expect both coherence and integrity. This is no idle or curious problem but is central to an issue that has plagued public art in modern times: the estrangement of the public for whose benefit the artwork has been placed.

Herein lies the problem. Much of what we call public art simply isn't. We must acknowledge that from the beginning. The overwhelming majority of public artworks are simply private artworks—gallery or studio pieces—"slumming it" on a plaza or in the lobby of some public structure. Their traditional placement and their grand (and often exaggerated) scale give rise to the expectation that they should be public

in content, or monumental in terms other than scale. Alas, they are wolves in sheepskins. They are only big, private artworks.

Where, indeed, is the "public" in public art? Occasionally, the issue has been skirted by resorting to other language: Art in Public Places, rather than Public Art. It's a neat trick—define the art in terms of its placement. Ignore its content, its audience, or the processes by which it came into being. Unfortunately, it solves only the linguistic problem. As the critic Lawrence Alloway observed, "it takes more than an outdoor site to make a sculpture public."[1] If we define public art in terms of location alone, then the whole realm of visual pablum known as "corporate art" enters the discussion. The corporate logo, magnified a thousand-fold and exploded into three dimensions by all-too-willing artists, occupied the public plaza without ever passing into the public sensibilities as art, let alone what we might expect of a public art. Likewise, a whole generation of minimalist artworks haunts public spaces as so much visual clutter without assimilation into the common visual vocabulary.

Another way of defining public art might be in terms of audience. Art becomes, one might suggest, public when it addresses a wide audience. But we live in a very large, very pluralistic society. We have no unifying religion, no great patriotic urges, no other consensus about social, political or moral values. What type of art can express the great multiplicity of this

culture? Public art addresses a context that is both broad and heterogeneous. It enters an environment which removes art from the privileged and specialized status of the museum into a much wider realm which involves entertainment, politics, urban sociology and economics. This public sphere forces art to compete with the public culture of television and mass marketing for the attention of its audience. It further competes in a milieu of "visual

cacophony" with a myriad of distractions, natural and man-made, and engages an audience with virtually no understanding of, or stake in, the artist's aesthetic.

Alloway went on to suggest that the target of public art must be "the achievement of a focusing point for an undifferentiated audience."[2] Attractive as that notion may be, it is probably unrealistic to expect art to serve that role in a society lacking widespread aesthetic literacy. Without the training and knowledge to evaluate and appreciate art on its own terms, it is unlikely the general public will be able to use art as a focusing and value-setting mechanism in modern society. Only the vehicles of mass culture—television, films, the educational system—seem capable of such a feat. The wide audience we expect for public art simply cannot mean "lots of people." Neither can it mean "ordinary" people, in the sense of those who are outside the art *cognoscenti*. Our society is too large and our citizenry too diverse for the audience for public art to be literally everybody. The question is: Can substantially fewer than everybody be the audience for public art without destroying the public character of the art? It is a question to which I shall return later.

No doubt art before the modern period could be said to be a public art, although the public did not mean everybody—usually it meant the art of the ruling class. But art did have a role in focusing, interpreting and reinforcing societal values that were commonly held by the people. Whether it

333 Wacker Drive
Chicago, Illinois
Kohn, Pederson & Fox,
Perkins & Will, Architects

Kenneth Callahan
"Scraping and Painting" *1933*
Museum of History and Industry
Seattle, Washington

Howard Giske

took the form of religious icons, patriotic or national issues, or the great classical themes of justice, truth, beauty and liberty, art used symbolism, imagery and formal structures that were part of the visual vocabulary of the whole society. Every city has relics of this time—equestrian statues or great allegorical murals of commerce and industry. Unfortunately these aged artifacts, by virtue of their specificity, are now merely blips on the landscape, a part of the visual clutter. They may interest us, even engage us, but they are, as British architect Richard Shaw put it, "like cut flowers, beautiful but dead."[3]

Artists before the modern period stayed within the narrow confines of the iconography of their time and created their artworks within the limitations of that imagery. Art commemorated great events. Art illustrated great literature. Art glorified God. Art upheld great national and civic values. Art was created to express beliefs and value systems assumed to be correct for everyone, and revealed those beliefs and values through forms and symbols everyone could comprehend. These traditional monuments spoke a language in which the public was fluent: heroism, war, civic values clothed in classical robes, on gallant horses, and with heroic gestures. Every citizen spoke this language.

Moreover, it was widely accepted that the "meaning" of art derived not from the artist but from the society in which the artist worked. Only recently has the artist had exclusive rights to impart meaning to works of art. With no investment in the meaning of public artwork, the people began to part ways with the art. Art critic Kate Linker put it this way: "Public art's current situation is that of urges impeded by the unavailability of forms. If the 19th century closed the tradition of public art, plummeting the 20th into the private world of abstraction, it left behind no inklings, intimations or harbingers with which to commence a successive version. The lack of a coordinated style, equivalent to the court, or 'period' manner, left no context to inform artistic expectation or insure their acceptance. Similarly, with the demise of the commemorative and communicative aims that had characterized 19th century production, no valid function inhabited the field of civic art."[4]

Today, public art simply cannot be analyzed by the traditional tools—iconography, styles, formal structures—to reveal meaningful distinctions from private art. Some critics go so far as to assert that "public art is impossible. All we can ever do is put private art in public spaces."[5] Communal values and widely shared images (excepting mass culture) are not sufficiently prevalent to sustain a truly public art, they allege. Public arts agencies, perhaps agreeing to some measure, have devised numerous approaches that interject largely non-aesthetic content into their art projects. Sculpture as land reclamation, functional art and ethnic collections, as well as artist residencies, all seem a response, in some measure, to the separation of the art from the people it should be serving.

While the assertion that public art is impossible goes too far, Linker's idea that civic art came into the 20th century without a valid function needs to be explored. Even accepting the notion that contemporary works in public settings must not be seen as expressions of publicly shared values, it may be possible to find important measures of public significance. Janet Kardon, Director of Philadelphia's Institute of Contemporary Art, says, "Public art is not a style or a movement but a compound social service based on the premise that public well-being is enhanced by the presence of artworks in public spaces."[6] Most often it has been suggested that this public benefit arises out of the palliative effect of art on contemporary architecture. Volumes have been written on the spiritual and aesthetic poverty of our cities due to

248

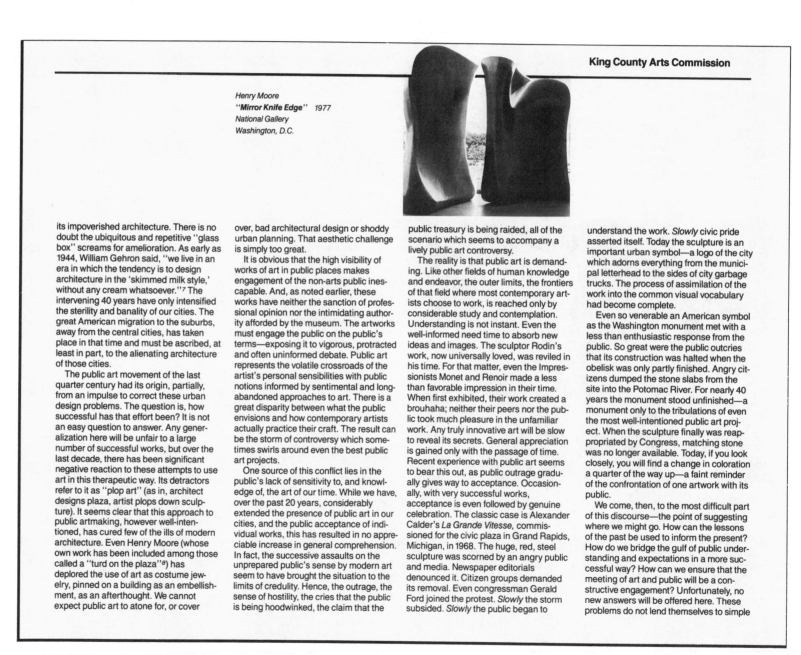

King County Arts Commission

Henry Moore
"Mirror Knife Edge" 1977
National Gallery
Washington, D.C.

its impoverished architecture. There is no doubt the ubiquitous and repetitive "glass box" screams for amelioration. As early as 1944, William Gehron said, "we live in an era in which the tendency is to design architecture in the 'skimmed milk style,' without any cream whatsoever."[7] The intervening 40 years have only intensified the sterility and banality of our cities. The great American migration to the suburbs, away from the central cities, has taken place in that time and must be ascribed, at least in part, to the alienating architecture of those cities.

The public art movement of the last quarter century had its origin, partially, from an impulse to correct these urban design problems. The question is, how successful has that effort been? It is not an easy question to answer. Any generalization here will be unfair to a large number of successful works, but over the last decade, there has been significant negative reaction to these attempts to use art in this therapeutic way. Its detractors refer to it as "plop art" (as in, architect designs plaza, artist plops down sculpture). It seems clear that this approach to public artmaking, however well-intentioned, has cured few of the ills of modern architecture. Even Henry Moore (whose own work has been included among those called a "turd on the plaza"[8]) has deplored the use of art as costume jewelry, pinned on a building as an embellishment, as an afterthought. We cannot expect public art to atone for, or cover

over, bad architectural design or shoddy urban planning. That aesthetic challenge is simply too great.

It is obvious that the high visibility of works of art in public places makes engagement of the non-arts public inescapable. And, as noted earlier, these works have neither the sanction of professional opinion nor the intimidating authority afforded by the museum. The artworks must engage the public on the public's terms—exposing it to vigorous, protracted and often uninformed debate. Public art represents the volatile crossroads of the artist's personal sensibilities with public notions informed by sentimental and long-abandoned approaches to art. There is a great disparity between what the public envisions and how contemporary artists actually practice their craft. The result can be the storm of controversy which sometimes swirls around even the best public art projects.

One source of this conflict lies in the public's lack of sensitivity to, and knowledge of, the art of our time. While we have, over the past 20 years, considerably extended the presence of public art in our cities, and the public acceptance of individual works, this has resulted in no appreciable increase in general comprehension. In fact, the successive assaults on the unprepared public's sense by modern art seem to have brought the situation to the limits of credulity. Hence, the outrage, the sense of hostility, the cries that the public is being hoodwinked, the claim that the

public treasury is being raided, all of the scenario which seems to accompany a lively public art controversy.

The reality is that public art is demanding. Like other fields of human knowledge and endeavor, the outer limits, the frontiers of that field where most contemporary artists choose to work, is reached only by considerable study and contemplation. Understanding is not instant. Even the well-informed need time to absorb new ideas and images. The sculptor Rodin's work, now universally loved, was reviled in his time. For that matter, even the Impressionists Monet and Renoir made a less than favorable impression in their time. When first exhibited, their work created a brouhaha; neither their peers nor the public took much pleasure in the unfamiliar work. Any truly innovative art will be slow to reveal its secrets. General appreciation is gained only with the passage of time. Recent experience with public art seems to bear this out, as public outrage gradually gives way to acceptance. Occasionally, with very successful works, acceptance is even followed by genuine celebration. The classic case is Alexander Calder's *La Grande Vitesse,* commissioned for the civic plaza in Grand Rapids, Michigan, in 1968. The huge, red, steel sculpture was scorned by an angry public and media. Newspaper editorials denounced it. Citizen groups demanded its removal. Even congressman Gerald Ford joined the protest. *Slowly* the storm subsided. *Slowly* the public began to

understand the work. *Slowly* civic pride asserted itself. Today the sculpture is an important urban symbol—a logo of the city which adorns everything from the municipal letterhead to the sides of city garbage trucks. The process of assimilation of the work into the common visual vocabulary had become complete.

Even so venerable an American symbol as the Washington monument met with a less than enthusiastic response from the public. So great were the public outcries that its construction was halted when the obelisk was only partly finished. Angry citizens dumped the stone slabs from the site into the Potomac River. For nearly 40 years the monument stood unfinished—a monument only to the tribulations of even the most well-intentioned public art project. When the sculpture finally was reappropriated by Congress, matching stone was no longer available. Today, if you look closely, you will find a change in coloration a quarter of the way up—a faint reminder of the confrontation of one artwork with its public.

We come, then, to the most difficult part of this discourse—the point of suggesting where we might go. How can the lessons of the past be used to inform the present? How do we bridge the gulf of public understanding and expectations in a more successful way? How can we ensure that the meeting of art and public will be a constructive engagement? Unfortunately, no new answers will be offered here. These problems do not lend themselves to simple

King County Arts Commission

Washington Monument (under construction)
Washington, D.C. (circa 1854)

Alexander Calder
"Le Grande Vitesse" 1968
Grand Rapids, Michigan

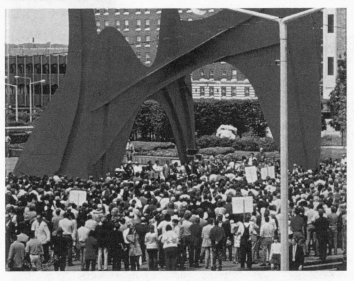

or facile solutions. There are, however, conclusions that we can draw from our experience that might guide us toward more reliable results:

1. *In general, the intellectual transactions posed by recent public art have been too private, or too esoteric, for the general public to understand.* This has implications for both the content of the art and the process by which the art reaches the public. The idea of speaking to an audience in a language foreign to them would strike us as silly. Yet every day public art goes up that attempts to do just that. If real communication is to take place, the solutions are obvious; either the work must be translated into the audience's language, or the audience must learn the artist's tongue.

Failure of these transactions can be deadly to public art. Richard Serra's "Tilted Arc", on the plaza of a federal building in downtown Manhattan, recently has been slated for relocation after several years of protests culminated in a public hearing by the General Services Administration. The irony is that Serra's work invariably means to expose and reflect its surroundings. Christopher Knight, art critic for the *Los Angeles Herald Examiner*, observed, "when this atrocious building and atrocious plaza opened, people weren't picketing and screaming about how awful this inhuman architecture was. No, people went in like sheep and got to work." [9] Serra's work reflected that cold and divisive design. The public, misinterpreting the message of the artwork,

assuming that the medium *was* the message, vented their rage on the artwork itself.

Without means of putting an artwork into context, the public often focuses on the art in a negative way. Artist/critic Brian O'Doherty warned against ignoring the public and spoke of the vernacular wit which is "the unconsulted public's only remaining weapon when confronted with 'elitist' monuments." [10] (He was speaking

specifically of a huge smooth mound of black marble outside a San Francisco bank which quickly was dubbed "the banker's heart.") Closer to home, another Serra work, "Wright's Triangle" at Western Washington University in Bellingham, has felt the sting of public comment in the form of graffiti which once declared: "Art is best when it has been defaced—i.e. demystified." [11]

2. *We must accept the notion that controversy is both inevitable and an acceptable part of the public art process.* Our society, and our government in particular, is predicated on the belief that controversy, and the public debate that ensues, are natural ingredients of a democracy. Most people involved in public art already accept this idea as gospel, but often they fail to take the next logical step, that public debate can be stimulated and channeled to reveal and clarify the insights of both artist and public. This process, however, takes time. We cannot expect that the public artwork is complete when the cord is pulled, the sculpture is unveiled and the politician delivers his public benediction. At the same time, when controversy does occur, we must insist that our public officials resist the temptation to exploit the situation by grandstanding for personal political gain.

3. *As a corollary, the process of assimilation of new ideas and images into the public's visual vocabulary is real and, if given time, will occur.* We must remember that there is nothing urgent about the public art business. We need not rush to judgment about a particular work. No work need be removed from display before a reasonable length of time has passed—at least five to ten years. Then it might be reasonable, even appropriate, to review a work and render a judgment as to whether it has stood the test of time. This act of reaffirming the original judgment, or deaccessioning the work after a suitable period

249

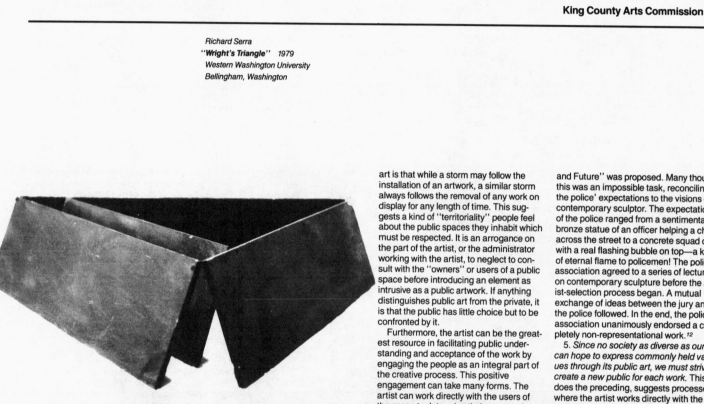

Richard Serra
"Wright's Triangle" *1979*
Western Washington University
Bellingham, Washington

art is that while a storm may follow the installation of an artwork, a similar storm always follows the removal of any work on display for any length of time. This suggests a kind of "territoriality" people feel about the public spaces they inhabit which must be respected. It is an arrogance on the part of the artist, or the administrator working with the artist, to neglect to consult with the "owners" or users of a public space before introducing an element as intrusive as a public artwork. If anything distinguishes public art from the private, it is that the public has little choice but to be confronted by it.

Furthermore, the artist can be the greatest resource in facilitating public understanding and acceptance of the work by engaging the people as an integral part of the creative process. This positive engagement can take many forms. The artist can work directly with the users of the space to determine their expectations and, hopefully, reconcile those expectations with his vision. The public art agency can provide for lectures, or public seminars, or can arrange for an exhibition of the artist's work. The artist can even do part of the creative work "on site" to allow for a broader public conception of the artist's ways of working.

This development process should be seen as an integral part of the public art process. An interesting example of how it can work happened recently in Dallas when a sculpture commission to commemorate "Dallas Police, Past, Present

and Future" was proposed. Many thought this was an impossible task, reconciling the police' expectations to the visions of a contemporary sculptor. The expectations of the police ranged from a sentimental bronze statue of an officer helping a child across the street to a concrete squad car with a real flashing bubble on top—a kind of eternal flame to policemen! The police association agreed to a series of lectures on contemporary sculpture before the artist-selection process began. A mutual exchange of ideas between the jury and the police followed. In the end, the police association unanimously endorsed a completely non-representational work.[12]

5. *Since no society as diverse as ours can hope to express commonly held values through its public art, we must strive to create a new public for each work.* This, as does the preceding, suggests processes where the artist works directly with the users of the public space. Recognizing that every artwork must grow out of a time and a place, and that it is not necessary that *everybody* be the audience for a particular work, it is sufficient to engage the people who are immediately affected by the project. Some will argue that this will threaten the creative process. Inevitably, they will say, this must compromise the art. For some—those who continue to subscribe to the view that only artists can lend meaning to artworks—this process would indeed compromise the art. But there is a new breed of artists, like Scott Burton, Robert Irwin and Siah Armajani, for whom

of time, could do much to reassure a skeptical public that they will not be stuck forever with a work they find unacceptable now. However, this should not be used merely as a means of silencing public debate in the hope that no one will protest the work ten years hence. Rather, periodic review of public collections should seek to finely balance two fundamental rights: the right of the artist to free, creative expression and the equally important right of the public to accept or reject that expression in a thoughtful way.

4. *The process of bridging the gap of understanding between the artist and the public through public education should be a part of every public art project.* No public artwork should ever suddenly appear overnight, as if by some miraculous (or calamitous, depending on your point of view) event. Thoughtful community development must precede, accompany and follow every installation. There are several reasons for this. Partly it's to prevent unexpected changes in the public environment. One of the interesting anomalies of public

working with the public as part of the creative process simply means getting rid of the artist's ego. Burton says, "as a public artist, you have to work within the decorum of public taste. This requires temperamental changes...you have to be able to not identify totally with one idea."[13] Irwin goes even farther, describing self-expression as one of the least useful artistic impulses or motivations, especially when working in public. These artists have come to regard engagement of the public as a necessary part of the process of researching and creating a public artwork.

Taken together, these observations say less about public art and its content than about the process by which art becomes public. It is imperative that we refine that process as best we can. We live in a time of extraordinary and disconcerting change. If contemporary art has any function, it is to allow us to monitor and comprehend those changes. It is the unique power of art that the shock of the new often precedes a profound understanding of the events of our lives.

1. Quoted by Benjamin Forgey, "It Takes More Than an Outdoor Site to Make Sculpture Public," *Art News,* September 1980, p. 86.

2. From an article by Suzaan Boettger, "Scenes from a Marriage: Public Art and the Public," *Newsletter of the International Sculpture Center,* July/August 1982.

3. Quoted by Barbralee Diamonstein, *Artists & Architects Collaboration,* Architectural League, 1981, p. 90.

4. Kate Linker, "Public Sculpture: The Pursuit of the Pleasurable and Profitable Paradise," *Art Forum,* March 1981, p. 68.

5. Amy Goldin, "The Esthetic Ghetto: Some Thoughts About Public Art," *Art in America,* May/June 1974, p. 32.

6. From the introduction to *Urban Encounters: A Map of Public Art in Philadelphia, 1959-1979,* by Janet Kardon, Falcon Press, Philadelphia, 1980.

7. Quoted by Kate Linker, *op. cit.,* p. 66.

8. The term "turd on the plaza" is attributed to James Wines of SITE Inc.

9. Quoted by Tim Jahns, "Public Art Stirs Debate," *State of the Arts,* California Arts Council, September/October 1982.

10. Brian O'Doherty, "Public Art and the Government," *Art in America,* October 1974.

11. John Beardsley, "Personal Sensibilities in Public Places," *Art Forum,* Summer 1981, p. 45.

12. William Tucker of New York was chosen to do this monument. The project did not proceed because needed private fund-raising efforts were not successful.

13. Quoted by Calvin Tompkins, "Like Water in a Glass," *The New Yorker,* March 21, 1983.

The public art project in MacArthur Park in Los Angeles has become a symbol for how the public art process of community involvement can transform not only the public space but the attitude and behavior of the citizens who use and reside near that space.

252

Monday, February 16, 1987

Art of the Matter

Gallery Chief Gets Job of Using Creative Process to Help MacArthur Park Area — and It Becomes His Obsession

By PENELOPE MCMILLAN, *Times Staff Writer*

On a nearby bare stretch of earth next to trash dumpsters in MacArthur Park, George Herms staked out the foundations of his "clock tower" sculpture—five old ocean buoys and a rusted chute.

Al Nodal stood nearby, watching. "This piece, for me, is a symbol of time changing," he said dramatically, and the "drastic changes" coming to the Westlake community surrounding the park.

The 16-foot tower will rise in one of the most unattractive areas of the 100 year-old park, amid a patch of scraggly bushes sticking out of the dirt, which Nodal calls the park's rose garden.

Nodal is that way about MacArthur Park. The director of exhibitions at the nearby Otis Art Institute of the Parsons School of Design, Nodal is the eternal optimist on the subject. In the 3 1/2 years since he joined the school, he has become the park's most relentless advocate.

Hired in part to head an Otis/Parsons program to install public art in MacArthur Park as a means of revitalizing it, he has turned the job into a personal mission.

He lives across the street from the 32-acre facility two miles from City Hall, in an apartment overlooking its lake, playground and trees. He keeps watch over the park with binoculars from his balcony.

Today, MacArthur Park is no longer the dilapidated, high-crime area that it was when Nodal came here in 1983. It is an interesting study in how one small project snowballed into positive change, and Nodal, many say, was the catalyst for that change.

"He made people believe in MacArthur Park, and the community responded," said Tom LaBonge, a deputy for John Ferraro, the city councilman who represented the area for 20 years. (It is now part of the newly formed First District, represented by Gloria Molina.)

Once the art program started, help began pouring in. A local electrical union installed a new lighting system, the Los Angeles Police Department assigned a daily foot patrol, and within the next few months the city Parks and Recreation Department will put in new playground equipment.

Please see PARK, Page 6

PARK: Art as a Medium to Help Area

Continued from Page 1

Crime has dropped dramatically. According to statistics from the Los Angeles Police Department's Rampart Division, robberies in the reporting district encompassing the park fell from 134 in 1983 to 28 in 1986, aggravated assaults fell from 70 to 32, and burglaries and thefts from vehicles from 220 to 64.

The park not only seems to have a new lease on life, but the neighborhood — through a MacArthur Park Community Council that Nodal persuaded local groups to start — now has the grass-roots leadership that has been missing for many years.

The design schools had not anticipated so much change when it initiated the arts project, said Roger Workman, dean of Otis/Parsons.

Their effort began as the institution sought ways to cope with the downhill slide of its surrounding community, he noted. Other art schools in the area had long since gone. In the last decade, the population had swelled with an influx of Central American immigrants, combined with a hard-core transient group that traditionally hung around the park.

"When you try to save an area there are a couple of ways," Workman said. "Either you lobby the city to get more police and put up fences, or you do it another way, which is what we're trying to do. We didn't know what the outcome would be. We were taking a very big chance."

Otis/Parsons hired Nodal, 37, a former artist who previously ran the Washington Project for the Arts in Washington. The school then raised $250,000 to finance a public art program for the park and committed another $150,000 in staff and support services.

Nodal's job was to make it all work: Use art as the tool to focus interest on the park, and the park to focus attention on the community.

He first organized the artists— mostly Californians, picked by a national panel of experts—so that their resulting works would reflect the area.

The new Herms piece, for example, "is in some ways a tribute to the senior citizens of the area," the sculptor said. Herms reuses materials that have been discarded in the "throwaway culture." In this case, he said, "one of the treasures our culture throws away is the experience of our senior citizens."

The clock tower is the eighth artwork, out of 10 planned, to be installed in the park, bringing the program nearly to a close.

Early on, Nodal said, he realized that the program couldn't function in a vacuum. So he organized local businessmen, most of whom didn't know each other, and contacted representatives of the parks department, Police Department and a councilman.

The group decided to form a "community council" to address their major concerns, which at first had more to do with crime and trash than public art.

"Several different times in the past we'd tried to get people organized, for neighborhood watch meetings, anything, but we all fizzled," said Peter Daniels, president of the community council and owner of H.G. Daniels, an art materials supplier bordering on the park.

"I often asked myself, 'Is this any way to run an art program—crime watch, trash cleanup, graffiti eradication, all these things?' " the short, dark-haired Nodal said as he walked the park one morning, obsessively picking up pieces of litter. "I know now that it goes hand in hand."

Nodal views the community like a family, with MacArthur Park at its center. He keeps constant tabs on the park, making friends with street people who live there and watching out for the latest graffiti scrawls.

He paused on his walk, stared at a bench and noted, "There's some graffiti. It wasn't there yesterday." Occasionally he paints out new graffiti himself, before park maintenance crews can get to it, and he has spent several late-night hours in the park looking to catch the person who keeps writing a single-word Spanish-language obscenity around the park.

"I almost have a relationship with this guy," Nodal said. "I always paint it out, he paints it back. I've been up on my balcony with binoculars looking for this guy."

Nodal has organized an Otis/Parsons sponsored "design team" that has begun considering ways to re-landscape the park areas such as the "rose garden," where flowers have all but disappeared. The setting of the statue of Gen. Douglas MacArthur, after whom the park is named, will also be redesigned.

Nodal wants to see the park lavatories modernized, summer youth programs expanded, the boathouse redone, and a better maintenance program to protect the artworks as well as park property.

Addressing the question of where he will be five years from now, he replied, "Probably MacArthur Park." He smiled. "I'm hoping to get my own bench out of this."

Ways of Looking: the setting, the audience and the artwork

This article appeared in *Seattle Arts* in May 1984 and is reprinted by permission of the Seattle Arts Commission.

In a series of three articles which appeared in *Seattle Arts*, the newsletter of the Seattle Arts Commission, arts educator Barbara Loeb explored ways for the uninitiated to look at and experience contemporary public art. She describes a personal system

Ways of Looking:
the setting, the audience and the art work

This is the last in a three-part series of articles aimed at providing "tools" to aid the viewer who is less-than-familiar with contemporary artworks. While many of Seattle Arts' readers are practicing visual artists or educated viewers of artworks, these articles are primarily for those artwork viewers who may find themselves feeling befuddled.

by Barbara Loeb

Last summer on a peaceful canoe trip my fellow paddlers pounced on me about an irritating lump of concrete???? near their offices. What they were talking about is Martin Puryear's "Knoll for NOAA," a shallow dome newly installed with four other pieces on the grounds of the National Oceanic & Atmospheric Administration's Western Regional Center at Sand Point. "What is this art work?" I had not yet laid eyes on the irritating sculpture but had a gut reaction that led me to say something about the form growing from the ground. It must have been one of my more brilliant gut reactions because their mood instantly reversed as though a secret had been revealed, and these fellow paddlers began to talk about the feel of that form on the ground and what it was like to stand on

top of it. I came away thinking of two more tools for looking at contemporary art. One is the way the work involves us physically. The other is the relationship between the art work and its location.

My intrigue with the way these tools worked for my friends has been coupled with the fact that this integration of art and place is becoming increasingly important to modern art. It is becoming especially important to sculpture. More and more artists, like the craftsmen of old, are designing their work to fit a specific space, the difference being that they are working with the urban landscape instead of a church or a royal palace. In doing so, they are considering elements like the size, shape, and function of the site, the weather, the more distant landscape, surrounding man-made objects, and the culture of the city. More and more artists are also wanting you to become a physical part of their creations and are designing work for you to climb over, walk through, sit on, or manipulate. This means that you, armed with these two additional tools for looking, will have no trouble finding modern sculptures to move into, climb onto, or examine in terms of integration with the surrounding land.

One way to examine a contemporary sculpture in terms of how it relates physically to you, the viewer standing in front of it, is to ask a simple question. What size is it? Size can drastically affect the way you feel about a sculpture. A tall, massive piece can be awesome and overbearing. One that is human in scale has the potential to feel more approachable and more gentle. Thinking back to the Noguchi rock sculptures discussed in the first of these articles (December 1983), I feel sure that their human scale contributes to their quiet, unimposing nature.

To get at the issue of actual physical interaction, try playing with questions like these: Can you see through it? Can you walk through it or stand on it? Does this art work keep you outside its boundaries or invite you into the very center? A suggestion here . . . If you can move around, through, or over a piece, don't just contemplate that fact. Do it. What you experience may not be the same as your intellectual expectations. Precisely this happened to me when I climbed around Lloyd Hamrol's "Gyro Jack" (at Third Ave. & Bell St.), whose pleasing sense of spinning disks led me to expect a playful, whimsical experience. The job of walking around those four disks turned out to be dizzying and a little unnerving.

The other question, that of art and its environment, is a rich one that can take many forms, focussing on the way the work fits into its space and the way it relates to the surrounding culture and geography. A piece can take up a whole site or fill a small corner. Sometimes, as with Robert Irwin's "Nine Spaces, Nine Trees," the art work IS the area. The work can become a functioning bench, a functioning jungle gym, or just sit there. It can refer in some manner to Northwest Coast geography, Seattle life, or the history of the specific site. It can move with the weather, melt with the weather, or ignore the weather. For outdoor works, circumstantial weather is important whether the artist intends it to be or not. In Seattle, the factor is probably rain. Thus "Gyro Jack" that I had been climbing around can make a pleasant bench on a sunny day, but it felt uninviting, ugly, and downright irritating when I visited it in the pouring rain.

When you go to look at the modern sculpture of Seattle in terms of how it goes with its location, you may find the above list of ques-

for viewing artwork which involves looking at the materials of the artwork with an imaginative eye to how they feel, how the artist may have worked with them, and what mood and associations they evoke. Loeb's second article explores line and color.

The third in the series, presented here, explores how public art relates physically to its site and to the viewer.

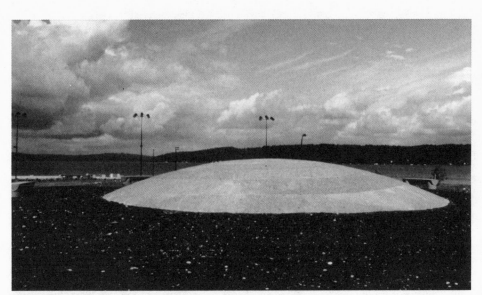

Martin Puryear's "Knoll for NOAA".

tions a bit cumbersome. To simplify the list I suggest three basic questions. How does the shape and size of the piece fit its location? Does it tie in somehow with the surrounding geography or culture, in the form of materials, shape, subject, color, or other elements you can best discover yourself? Thirdly, how does weather affect the work?

Armed with precisely these three questions, plus the question of viewer involvement, I convinced my steadfast experimentee, Carol Beers, to abandon her Wall Street Journals to test our third and last set of tools for looking at abstract art. This time we had two targets, the whimsical Viewland/Hoffman City Light Substation on 105th and Fremont North and "Knoll for NOAA," the same piece that had puzzled my paddling friends last summer. Our goals were to try the above questions and to key in on ways the artists' choices affected our feelings about the works.

The Viewland/Hoffman Substation, with its fantantistical windmills of old spoons, toy wheels, dust pans, funnels, and other mundane objects, led us into a real web of interplays between the art and the world around it. The question of weather was the easiest. The windmills worked because there was wind, and that affected us with a sense of fun and energy. Physically, we found ourselves experiencing opposing sensations simultaneously. Because a chain-link fence surrounded the windmill area and the substation, we were clearly locked out, yet the tunnel-like walkway between the two areas drew us "inside." The truly complex question, however, became the relationship between the windmills and their setting. We realized immediately

that this goofy, whirligig world had been made for precisely this place. My financial analyst companion, with a little prodding, started with subject, noting the connection between windmill as a power source and substation as a power source. From there she went into materials, especially the similarity of the substation and the tall, grey, metal posts that supported the windmills. Indeed, this little, whirling forest did look a bit like a fantasy substation. Reciprocally, the substation was painted in pastel greens and pinks, borrowing the colors of the windmills.

These observations were straightforward ones most of us would make quickly enough if we were thinking about the environment of this substation windmill. What was intriguing was the way she was able to use these simple ideas to jump into a personal response. Once she recognized that the windmills and the substation shared colors, materials, and shapes, she began to see them as a single structure. She also began to see the substation as decidedly friendly. The close relationship with the windmills and the pastel paints transformed it from something "hard, harsh, and hard" into something "light, warm, and friendly."

The "Knoll for NOAA" turned into a much more pleasing experience than either of us expected. Driving along Sand Point, I myself was feeling less than enthusiastic, having found the photographs cold and uninspiring. Ms. Beers, as she spied the small dome in the distance, came up with an incredulous, "You want me to look at THAT?" Yet with hardly a forethought, we walked across the lawn, directly up the sloping sides, to the top of this unusual dome and felt good about standing there. Obviously, the artist wanted us to stand on this sculpture, and he made it very approachable.

To answer the question of the sculpture's relationship to the area around it, I tossed the whole ball to my companion who quickly defined it as part of the natural landscape rather than the manmade building around it. She saw it as a vantage point for looking at the lake, as a round-topped echo of the mountains visible in two directions, and as a large rock like those most of us scrambled on in our childhoods. Describing the subtle nature of the color and the shape, she said, "It fits into the landscape." Indeed, from its top, this dome seemed like a natural extension of its landscape.

Before ending this series on tools you can use to look at art your own way, I would like to tackle one stumbling block. All of us may try our darnedest to retain a mental list of all the traits discussed in the last three articles, including materials, color, line, shape, size, location, etc., yet the brain may feel dull as a butter knife. If so, try the old art history trick of comparing and contrasting. Compare the work you are looking at to one down the street or another you remember. If no art works come to mind, try something else for comparison, to a car or the sandwich you surely made so you could brown bag it while you wandered around, over, and through a sculpture or two. In fact, a sandwich offers an ideal starting point, especially for environmental context. A round and leafy head of lettuce and a four-legged cow have been reformed to fit two square pieces of bread. How does that compare to art works? The question is yours.

Barbara Loeb is a Seattle arts educator who has spoken widely and has taught arts education classes for the University of Washington. Her Ph.D is from the University of Washington and she was Acting Curator in the Department of Art at the University of Texas.

Reprinted by permission of Walter Robinson, author.
This article originally appeared in *Art in America*,
October 1983.

Art & the Law: "Moral Rights" Comes to New York

Should the law protect an art work's integrity? European legal doctrine has long said yes; with its brand new "Artists' Authorship Rights Act," New York State now concurs.

BY WALTER ROBINSON

On May Day in 1933, Diego Rivera painted a portrait of Lenin near the center of a 63-by-17-foot fresco he had been commissioned to do in Rockefeller Center. The painting also included depictions of venereal disease germs and a crowd of people marching with red flags past Lenin's tomb, all elements absent from his original proposals. Rivera uncompromisingly refused young Nelson Rockefeller's request to replace the head of Lenin with that of another person, or even to balance it with a portrait of Lincoln. The fresco was covered by tarpaper and a wooden screen, Rivera was paid his fee and sent packing, and eventually the work was destroyed and replaced by another mural.

This story has come to epitomize the unavoidable culture gap between artists and their patrons, as personified by the Communist artist-provocateur and the scion of capitalism's first family; the anecdote recounts the martyrdom of a single work, while at the same time celebrating the idea of the autonomy of the artist and his inspiration. Rivera reportedly considered bringing suit to force exhibition of the work, but was advised that as Rockefeller had paid for it, he effectively owned it outright; if he wished to destroy it, that was his legal right. Though the fresco is lost, the episode, in a sense, turned out well for all: Rivera made both a scandal and an esthetic sacrifice (and got paid for it); Rockefeller made a magnanimous gesture and got paid a second, noncontroversial picture; and, of course, we have a story with a rich cultural flavor. If New York State had had a moral rights law, perhaps the fresco could have been saved; but what would have happened to the story?

After three years of hearings and other efforts in the state legislature, New York State this summer passed an "Artists' Authorship Rights Act," thus becoming the second state in the country (after California) to adopt a "moral rights" law for artists. The term "moral rights" is shorthand for a type of legal control that artists have sought to retain over their work after it is sold, notably the right to protect its physical integrity; prior to the passage of the law, artists had no such right unless it was specified in a contract.

The New York State law, which takes effect on Jan. 1, 1984, is brief and to the point. It prohibits the display or reproduction of art work in "altered, defaced, mutilated or modified form" without the consent of the artist who made it, and allows an artist to sue for damages (and to disclaim authorship) if the alteration is likely to detract from the artist's reputation. The law also provides artists with the right to require notice of authorship whenever their work is displayed or reproduced.

Three types of "alteration" are specifically exempted from the provisions of the New York State act: ordinary efforts of conservation (except when shown to be negligent); ordinary changes that occur when an art work is reproduced in another medium (such as in a magazine); and normal changes due to the passage of time or the inherent nature of the materials. Fine art covered by the law includes painting, sculpture, graphics, and photographs and multiples in editions up to 300 copies. Not included are commercial art created under contract for advertising or other trade use and "sequential imagery such as that in motion pictures," which presumably includes video art as well. As a state law, the new act applies only to artworks actually in New York State, and allows only artists themselves to bring suit, not their heirs or estates.

Moral rights has been a leading issue for artist-activists in the U.S. for some time—and an area in which they lag well behind their European and other foreign counterparts. More than 60 nations recognize varying versions of the moral rights principle; in France, *droit moral* was formally encoded in statute in 1957, though court cases dealing with moral rights issues go back at least to the 19th century; Italy encoded its moral rights laws in 1941 and Germany in 1965. The principle is also recognized in international agreements and conventions, notably the 1928 revision of the Berne Copyright Convention—to which the U.S. is not a signatory. No U.S. moral rights law exists on the federal level, though bills have been regularly introduced; at the state level, California's Art Preservation Act was passed in 1979 [see *A.i.A.*, Nov. '79] and has some slight but notable differences from the new New York State law (e.g., the California law does not include prints or photographs in its purview and forbids the actual destruction, as well as the alteration and defacement, of works of art).

The California moral rights law has been in effect for three years and has inspired no legal actions—which could imply either that it is extraordinarily effective or that it is only rarely needed. But transgressions against artists' moral rights, though infrequent, have occurred. A brief look at the New York State law in relation to some of the better known controversies of the past may help to delineate its advantages and limitations.

A case tailor-made for the act was the 1960 alteration of a David Smith sculpture, *17 h's*, which was stripped of its original red paint by its owner. Smith was unable to force the owner to restore the work and publicly disavowed authorship of it. Assuming that the sculpture was in New York State, Smith could have invoked the new law, which was designed precisely to protect the artist in such a situation.

A similar case involved a black and white mobile by Alexander Calder installed from 1958 to 1978 in the rotunda of the Greater

Pittsburgh International Airport. This unfortunate work was repainted the county's colors (green and yellow), had weights added to raise its lower elements higher from the floor and was motorized to turn with mechanical regularity; furthermore, it was not lit, it was allowed to become grimy, and a large kiosk with advertisements was placed in the open space beneath it. Calder could not compel changes in the work then, nor could he do so now, even if he were alive, since the mobile is outside of New York State, and thus not subject to the provisions of the new law.

David Smith's work was again subjected to alteration more than a decade after the first incident, when six sculptures in his estate were repainted or stripped to bare metal and then varnished [see *A.i.A.*, Sept.-Oct. '74]. In this case, the New York moral rights law would have provided no remedy, since it can only be exercised by artists themselves, and not their heirs.

An earlier incident involved the painter Alfred Crimi, who painted a 26-by-33-foot mural for Rutgers Presbyterian Church in Manhattan in 1938. The congregation, apparently because the "portrayal of Christ with so much of His chest bare placed more emphasis on His physical attributes than on His spiritual qualities," painted the mural over in 1946. Crimi sued, seeking to have the church either restore the mural, allow him to remove it at the church's expense, or pay him damages of $150,000. The judge found no precedent in U.S. law or court decisions that supported the concept of artists' moral rights. For Crimi to retain such an interest in his work, he would have to have spelled out his intention in the original commission contract. Again, the New York State moral rights act would not have helped Crimi protect his work, since it does not forbid the destruction of an art work, but only its display in mutilated form.

In a 1980 incident, a sculpture by Isamu Noguchi designed in 1975 for the lobby of the New York headquarters of the Bank of Tokyo Trust Company was taken down and cut into pieces for storage (and eventually destroyed) without the artist's knowledge or consent [see *A.i.A.*, Summer, '80]. The work, *Shinto*, weighed 1,600 pounds and was suspended from the ceiling; it was removed, according to the bank, because of its threatening appearance and because it frightened customers and employees. Since the bank owned the sculpture, Noguchi had no legal redress; under the new moral rights law, he would still have no legal case, since the work was destroyed, and not displayed in mutilated form.

Carl Andre's contretemps with the Whitney Museum in 1976 over the museum's unresponsiveness to his directions concerning the proper exhibition of one of his works [see *A.i.A.*, Sept.-Oct. '76] raises more complicated questions. While it may seem as if artists should be able to control the context in which their work is displayed, particularly if a work's installation and its relationship to surrounding space are of esthetic significance, how should this right be balanced against the museum's right to curate exhibitions as it sees fit? This is a question the New York moral rights law does not address—one which would be open to the interpretation of the judge in any court case—and it seems unlikely that a court would find in favor of the artist. In this instance, Andre was able to withdraw the work he had originally lent to the exhibition, but the museum replaced it with one from its own collection. The artist could not prohibit the museum's action, even though he offered to buy the work back at cost plus ten percent. The "right to withdraw" (even after an unconditional sale) is sometimes considered as an artist's moral right, but it is not one that is legally recognized in New York State—or anywhere else.

Yet another, related moral right which is not included in the New York law is known as the "right to create," a right illustrated by an 1898 French case involving a portrait commission given by Lord Eden to James McNeill Whistler. After Whistler's portrait of Eden's wife, *Brown and Gold, Portrait of Lady E...*, was exhibited and accepted, but not delivered, the two had a disagreement over the price. Whistler painted out Lady Eden's face and painted in another; Lord Eden sued to compel restoration and delivery of the portrait under the original agreement. On appeal, the French court ordered Whistler to pay damages, but refused to compel the artist to create, noting that until delivery was made, "the painter remains master of his work."

The New York State legislation has not been universally welcomed. It was opposed by the Art Dealers Association as well as by a number of New York City museums, who feared that the law would encourage litigation over issues of conservation or display. This viewpoint may seem odd, since museums are presumably dedicated to the preservation and presentation of artists' works; but it does suggest an institutional memory of those occasions—not necessarily restricted to situations involving artists' moral rights—when museums have found themselves in confrontation with and in opposition to artists' positions.

Ashton Hawkins, counsel to the Metropolitan, noted that the museum community supported the concept of moral rights but considered the N.Y. State law to be too broadly drawn. "The problem is," he said, "that none of the terms the statute uses—*alter*, *deface*, *mutilate* or *modify*—are defined by it. We're concerned about how an artist might interpret these terms, particularly *modify*," which could conceivably cover how a work was framed or mounted, in what context it was reproduced, or how a work was installed. From this point of view, Hawkins said, the law reads like an invitation to litigate. A letter sent to the governor by counsel to the Whitney Museum made similar arguments. On the other hand, a spokesman for the Museum of Modern Art said, "Our official position is that we don't wish to comment; we're waiting to see what impact the law actually has."

How do artists themselves feel about the law? It is not that easy to find any who are aware of its passage. Nancy Spero said, "It's probably all to the good, but it's a matter of enforcement. Mostly artists just send their works out into the world and hope they end up in sympathetic hands." Jackie Winsor, who in the past has included moral rights provisions—prohibitions against using her work as furniture, for example—in her sales contracts, said, "Museums will probably end up suffering from it; like most laws dealing with art, they inhibit the well-intentioned but don't correct the ignorant."

Jon Hendricks, a veteran of the Art Workers Coalition in the '60s who works with Jean Toche, said, "It's long overdue that artists have a way to protect the original intentions of their work. . . . A lot of us who do verbal, conceptual pieces have had problems with people who will take part of a piece and represent it as the whole piece—which can substantially distort it."

Bert Diener, president of New York Artists Equity, a 36-year-old association with some 1,600 members, was also very pleased with the law. "Many of our members have had problems of this sort, and we've felt for a long time that artists should have the right to litigate to protect their work and have some legislation to back them up." He also said he understood the museums' fear of frivolous lawsuits, and agreed that the moral rights act could have been more carefully drawn. "I don't think galleries and museums

should be concerned that they'll be sued because of something that happens in a brochure," he said. "We're only interested in protecting against mutilations or changes in the artist's work."

Rubin Gorewitz, an artists' accountant who has long been involved with artists' rights issues, said he thought the law was "important and very vital, but it needs a lot of clarification, definition and penalty impositions." He thinks protection against the destruction of art works should have been included in the law, and says, "A work should be offered back to the artist for $1 before it's destroyed." He also saw a possibility that the law might provoke conflict between artists, noting the tendency of some artists to use the work of others in collage—a practice which, under the new legislation, could invite a lawsuit. "Now that we have the law," Gorewitz said, "let's clean it up."

Some of the uncertainties surrounding the moral rights issue are due to the difficulty of encoding artistic behavior in legal terms, a translation problem that characteristically haunts "art law." And such legal matters are hardly central concerns to most artists; the issues belong, rather, to art-lobbyists and politicians. The final passage of the New York moral rights law, which was sponsored by Assemblyman Richard Gottfried (D-N.Y.), was one result of the formation in March, 1979 of the state assembly's Committee on Tourism, the Arts and Sports Development—a leisure-activity grouping that handles legislation ranging from appropriations for the New York State Council on the Arts to bills promoting bicycle safety. Though the linkage between the arts and tourism is familiar from its frequent invocation in support of arts funding during times of budget cuts, the odds-and-ends sound of the committee's name underlines the fact that certain stretches of the imagination are required when art and politicians meet.

The new law implies that fine art is not ordinary property and that it requires special protection. The law also promises, if the museums' worst fears are realized, to spur all manner of controversy. Perhaps New York State's law could have gone further—for example, by protecting art works from destruction and by allowing artists' heirs to take action to protect their works, or alternately, by exempting museums from its provisions. As it stands, the Artists' Authorship Rights Act is a first attempt to bridge a gap in current law—that is, to balance owners' property rights against artists' continuing interest in their works after they have been sold. Whether the new law will promote unending litigation, or be cited only once every decade, remains to be seen. □

Author: *Walter Robinson is an artist who also writes on art.*

Reprinted by permission of Mitchell / Giurgola
Architects.

8 July 1987

Mitchell/Giurgola Architects
170 West 97th Street New York New York 10025-6492

Memorandum regarding Artist Fee Structures
NEA Public Art Policy Project
From: Paul Broches

The question has been raised whether useful models exist for developing fee
structures for artists working on collaborative projects. Following are several
models that our firm has encountered and some "Pros and Cons" based on our
experience.

I. One Phase Fee Structure

A simple fee amount is established for the entire project to include both
design fee and cost for fabrication and installation. With this arrangement
it is up to the artist to allocate sums between design and construction.

A payment schedule is agreed upon at the outset. It is usual for the
payment schedule to reflect progress towards completion. Often, a retainer
at the inception of the project to finance start-up and a 5-10% retention
upon completion is agreed upon to be released upon acceptance of the work by
the client.

Pro: Client knows full extent of their financial exposure.

Con: Linking design and construction funds leaves artist in a bind
relative to allocating costs. There is an inherent conflict
between design fee and construction cost.

Con: Unless it is clearly stated in the fee payment schedule, there
may be a problem in establishing a fair settlement with the
artist should the project be terminated during the design
process.

II. Two Phase Fee Structure

A) Artist develops a concept sketch for a modest fee ($5,000-$10,000) to
be submitted to client for approval to develop scheme further.

If the scope of the project is known beforehand, it is desirable to fix
the fee for the entire project before commencing any work. If the
scope is uncertain, the fee should be fixed once the scope is
determined, but definitely before proceeding to the second phase.

B) Fee for second phase will encompass design development, working
drawings, and execution/installation phases. It is usual to schedule
periodic progress payments correlated with work progress as in Model
I.

Pro: Client can initiate the design process with a modest
investment and obtain a good idea of artist's response to
the project mandate before making total commitment.

Con: Major part of artist's contribution is in the initial
concept for which compensation is disproportionately low
relative to total value.

Mitchell/Giurgola Architects
170 West 97th Street New York New York 10025-6492

III. Multiple Phase Fee Structure

In some cases the artist's compensation may run parallel to that of the
architect. Historically, the design phases and associated "value" of the
work has been, as follows:

Schematics	15%
Design Development	20%
Working Drawings	40%
Construction Administration	25%

Pro: While there are many variations on the number of phases
and relative values, the principle remains that
compensation is related to value of work received.

Pro: If the projected is terminated at any stage of the process
one can determine the value of work completed and
therefore, the compensation due to the designers.

Con: While architects have accepted the notion that
compensation should parallel labor productivity, artists
may well want to challenge that and stress the greater
value of the "big idea" developed during the schematic
phase.

Forms are reprinted by permission of the Washington State Arts Commission and the Fairmount Park Art Association.

A standard system for documentation of each public artwork acquired should be developed and consistently maintained. The Washington State Arts Commission (WSAC) published *Documentation For Public Art Collections: An Informational Packet,* by Lynda Rockwood (see Bibliography), which outlines WSAC's system as adapted from museum registration and photographic archival documentation standards. It contains detailed procedures and many sample forms for cataloguing, loaning the artwork, amongst others.

Included here are two forms from this publication. The Accession Ledger is a running chronological log of acquired artworks recorded by accession number.

The Catalogue sheet is used to record vital information about the artist and artwork. In addition to these samples, a form used by the Fairmount Park Art Association for the inventory of its collection of historical monuments is shown on the facing page.

ACCESSION LEDGER

ACCESSION NO.	DATE OF ACCESSION	ARTIST (L, F, I)	TITLE/DESCRIPTION	MEDIUM	FUNDING PROJECT

CATALOG SHEET

ATTACH CONTACT PROOF

ACCESSION NO. _____

CLASSIFICATION _____

ARTIST _____

NATIONALITY _____ BIRTHDATE _____

TITLE OF WORK _____

MEDIUM OR MATERIAL _____

EDITION INFORMATION _____

DATE AND PLACE EXECUTED _____

COLLABORATING ARTIST _____ MAKER OTHER THAN ARTIST _____

LOCATION AND DESCRIPTION OF SIGNATURE, WATERMARK, (COPYRIGHT MARK IF IT OCCURS) _____

DIMENSIONS:

Painting, drawing, etc. (without frame or mat): Height _____ in Width _____ in
_____ cm _____ cm

Sculpture (without pedestal) Height _____ in Width _____ in Depth _____ Apprx. Wt. _____
_____ cm _____ cm _____ cm

Frame and/or pedestal Height _____ in Width _____ in Depth _____ in Apprx. Wt. _____
_____ cm _____ cm _____ cm

CONDITION ON AQUISITION _____

_____ DATE EXAMINED _____

SOURCE OF AQUISITION _____

PURCHASE PRICE _____ INSURANCE VALUE/DATE _____

EXHIBITIONS/COLLECTIONS _____

REPRODUCTIONS/PERIODICALS _____

REMARKS _____

PHOTOGRAPHIC DOCUMENTATION: _____ PHOTO C [] _____ PHOTO B [] _____ SLIDE [] _____ PHOTO N

CATALOGED BY _____ DATE _____

DEACCESSIONED: Authorized by _____ DATE _____

261

**DATE OF
DEACCESSION**

FAIRMOUNT PARK ART ASSOCIATION
CATALOGUING WORKSHEET
=======================================

OBJECT TITLE _____

ARTIST (s) _____

Dates born _____ location _____
 died _____ location _____
 Citizenship _____
 Minority Artist (specify per code)
Current
Address _____
Education/ Background
(brief) _____

Awards
(brief listing) _____

MATERIAL/MEDIUM

Medium _____
Mode of
Fabrication _____

Dimensions h_____ w_____ d_____
Weight _____ (lbs)
Base/Pedestal:
Medium _____
Dimensions h_____ w_____ d_____ d.
Weight _____ (lbs)
Brief
Description
(brief) _____

DATE SUMMARY

Project Initiated _____

Object Executed _____ Installed _____

 Dedicated _____

 Moved _____ To _____

Description

 (brief) _____

OBJECT TITLE _____

LOCATION/SITE

Current location _____
Address _____
Original siting _____
 site specific _____ interior _____ exterior _____
Reason for move _____

LOCATION SUMMARY TABLE

___ 1 Unknown
___ 2 College Campus
___ 3 Park
___ 4 Government Property
___ 5 Garden
___ 6 Walkway
___ 7 Church
___ 8 Battlefield
___ 9 Private Property
___ 10 Courtyard
___ 11 Street/Roadside
___ 12 Cemetery
___ 13 Corporate Property
___ 14 Plaza
___ 15 Public Facility
___ 16 Traffic Circle
___ 17 Residential Complex
___ 18 Bridge
___ 19 Health Care Facility
___ 20 School
___ 21 Library
___ 22 Museum/Gallery
___ 23 Office Building
___ 24 Shopping Center
___ 25 Parking Lot
___ 26 Recreation Center
___ 27 Warehouse
___ 28 Zoo

AFFILIATION/OWNERSHIP

Initiated by _____
 Commissioned
___ Purchased by _____
 for _____
 Cost _____

Gift/donation by _____
 to _____
 Provenance _____

Agency Affiliation _____
Current owner/
Custodian _____
 agent _____ title _____
Address _____
Description
of Patronage _____

 (i.e., public/federal funds

OBJECT TITLE _____

FORM/ICONOGRAPHY TABLE

___ 1 Fountain
___ 2 Commemorative
___ 3 Architectural
___ 4 Religious
___ 5 Earthwork
___ 6 Unknown
___ 7 War Monument
___ 8 Equestrian
___ 9 Non-Commemorative
___ 10 Abstract
___ 11 Athletic
___ 12 Relief
___ 13 Allegorical
___ 14 Memorial
___ 15 Figurative
___ 16 Animal
___ 17 Mural
___ 18 Ornamental
___ 19 Portrait
___ 20 Mosaic
___ 21 Kinetic
___ 22 Map
___ 23 Plant
___ 24 Play Sculpture
___ 25 Wall Hanging/Tapestry

Description (brief)

PRODUCTION DATA (cite source)

Edition/casting _____
Contractor _____
Architect _____
Carver _____ reproduction
Foundry/fabricator _____
Designer _____
Competition information _____

Description (brief)

OBJECT TITLE _____

CONSERVATION

Date	Treatment	Conservator

HISTORIC/BIBLIOGRAPHIC INFORMATION (cite sources)

REFERENCES/FOOTNOTES

This excerpt is reprinted from *Sculptural Monuments in an Outdoor Environment* by permission of the publisher, Pennsylvania Academy of the Fine Arts, Virginia Norton Naudé, editor, 1985.

CHOREOGRAPHY AND CAUTION:
The Organization of a Conservation Program

Penny Balkin Bach

The formal establishment of Philadelphia's outdoor sculpture tradition began in 1871. Two neighbors, Henry Fox and Charles Howell, young men in their early twenties, were determined that something was to be done to redeem Philadelphia from what they called the "reproach of excessive industrialism." Only a few years before, the city had established the Fairmount Park Commission and was proceeding to buy land to extend the city's holdings to the northern Wissahickon and the city's watershed. At the same time, Philadelphia had just been confirmed as the site for the 1876 Centennial Fair. One can imagine the great enthusiasm and youthful idealism of these men when in 1872 they established the Fairmount Park Art Association. By charter, the Art Association was designed to "promote and foster the beautiful in Philadelphia, in its architecture, improvement and general plan."

Herein lies the key, in my opinion, to Philadelphia's great tradition of public art; for over a century, the Association has been concerned not only with the commission of public sculpture but also with the placement and relationship of the sculpture to the plan of the city and to the spirit of the city. According to the Association's archives, this tradition has been characterized by innovation and agitation, followed by cooperative efforts with other civic bodies. It is this same process, I believe, that we have established while developing the conservation program, and it is this process that brings us together here today.

Over the years, the Association has initiated some of the most important concepts related to the physical and artistic growth of Philadelphia. For example, in 1907, the Association commissioned the plan for the Benjamin Franklin Parkway by Jacques Gréber, the noted French landscape designer. That same year, it established the "Committee on a Municipal Art Gallery," which urged the placement of a public art gallery (Philadelphia Museum of Art) at the end of the Parkway. In 1911 the Association successfully lobbied for the creation of a Municipal Art Jury to approve and to recommend works of art that would become the property of the city. This established an early prototype for the city's Art Commission. In 1944 the Association commissioned plans for the area now known as Independence National Historic Park. Board members have also supported the creation of the city's Planning Commission and the city's "one percent for art" ordinance.

The Association has traditionally stirred public interest by initiating projects that have been "worthy of the public good." Then it has cooperated with existing institutions, often establishing new ones, to follow through with the original concept. Clearly there has been a time-honored practice of "filling in the gaps," and the care of works of art in Philadelphia certainly falls into this category. I would also like to fill in the gaps by addressing the questions that owners and custodians of works of art may have.

In this context, a conservation program was initiated three years ago, when the Association simultaneously began an ambitious program to commission contemporary sculpture. The Association recognized the need to preserve Philadelphia's existing sculptural history, even as we explored new directions and approaches to public art. As we looked toward the future, we were equally concerned with the treasures of the past. Because I had already been invited by the Association to direct its public art programs, the administration of the Conservation

Program also became my responsibility. From my point of view, the issues of care, maintenance, artistic intent, and environmental concerns are the business of all public art, no matter when the work is created. And since, in one way or another, public art ultimately reflects civic values, I would like to examine these issues.

Last month I received some photographs and a note which said, "Behold vandalism and neglect!" A sculpture of Stephen Girard stood hidden by trees and defaced by graffiti. A recent inspection revealed that the trees had been pruned and the graffiti removed. However, given the vast holdings of the city and the park, it is not uncommon to see works that are in serious need of attention. By the establishment of a Sculpture Conservation Program, the Association has attempted to raise public consciousness. The fact that this seminar brings us together points to the growing local and regional concern for the care of public art. Through the news media, we have also been able to stimulate general public awareness of sculpture in today's environment.

I have been asked to focus on the "nuts-and-bolts" issues of conservation. When the Association began to explore the idea of a conservation program, members of the board first consulted with knowledgeable professionals in the field. The board itself is composed of museum directors, museum curators, lawyers, architects, business people, and concerned citizens; in effect, the board is a microcosm of people who have a vested interest in conservation. Various treatments were explored, and treatment proposals were elicited from several conservators. This was a complex endeavor, particularly because at that time there did not seem to be conclusive data available from the conservation profession. The Association examined the available data concerning environmental problems, the methods of conservation, and the controversies surrounding these issues.

Simultaneously, sixteen works of particular artistic and historic importance to the city of Philadelphia were identified for treatment. Very soon it was concluded that a program had to be initiated immediately because serious deterioration had already occurred.

After careful deliberation, Steven Tatti was selected as the principal conservator for our project. It is important to recognize that the client engages (and purchases) not only the hand of the conservator but his/her critical eye and years of experience in the examination of works of art and the understanding of their scientific treatment. Tatti had broad experience in the treatment of outdoor sculpture; the board was very impressed with his work for the city of Baltimore, which similarly had embarked on a methodical conservation program.

The selected treatment is based on the application of a hard paste wax to a clean and heated bronze surface. First, the sculpture is cleaned of all surface dirt, grime, and other foreign matter. After cleaning, the sculpture is heated with propane torches; this heating process drives out any entrapped moisture and opens the metal to receive the first of a series of wax applications. This treatment does not remove any surface materials or current patinas. Rather, the sculpture is cleaned, protected, and stabilized, as the wax fills in the pitting and arrests the uneven deterioration of the work. As a result, the treatment also improves the appearance of the sculpture. It produces a cohesive physical and visual surface on which, in most cases, the modeling as intended by the artist becomes visible. The surface of J. Otto Schweizer's *All Wars Memorial to Colored Soldiers and Sailors* prior to treatment presented an image that was less than heroic; there was so much pitting, uneven corrosion, and visual activity that the actual rendering of the sculpture was obscured (figure 40). To be able to look at the forms as the artist intended, with gestures, expressions and details, is very exciting indeed (figure 41).

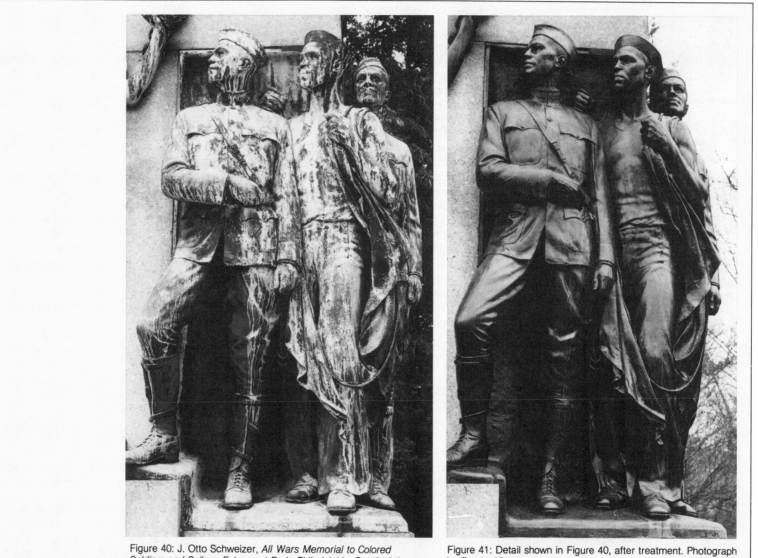

Figure 40: J. Otto Schweizer, *All Wars Memorial to Colored Soldiers and Sailors,* Fairmount Park, Philadelphia. Detail of three figures before treatment. Photograph by Franko Khoury.

Figure 41: Detail shown in Figure 40, after treatment. Photograph by Franko Khoury.

It is important to understand why the Association, its board, and its committees selected this particular conservation treatment. At that time, we were not considering a single work with a single owner. Rather, we found ourselves in a rather unusual situation. Although the Art Association originally had commissioned many of the works, they had been donated over a period of time to the city of Philadelphia, under the jurisdiction of the Fairmount Park Commission. Considering the many and growing responsibilities of the city and the park, it is not difficult to understand why conservation was not a priority.

This particular treatment was cost effective in that it enabled us to attend a larger number of neglected sculptures than any comparable method, protecting the sculptures against further deterioration. With this method, no original metal is removed. Further, the materials used for stabilization are reversible; the sculpture is retreatable. If and when other treatments become proven or desirable or if a benefactor is willing to give a large amount of money for a more thorough investigation of individual works, other treatments may still be pursued. However, choosing this system enabled the Association to "buy time" and to protect the sculpture from further deterioration.

Once the treatment, the conservator, and the estimated costs were established, the Association looked for funding for this project. We found ourselves with an unanticipated dilemma. Because the Association had donated the works to the city, we discovered that we were ineligible for funding from most sources because we were not the "owners" of the works of art. For example, the National Endowment for the Arts, through the Museum Program, does fund conservation projects for organizations other than museums; however, it will only fund projects when the owner is also the grantee. (In the future, we can anticipate working with the city to apply for funds from the Endowment.) After considerable discussion and application to a number of funding sources, we found that we really "fell between the cracks." However, in April 1982 the Mabel Pew Myrin Trust generously granted $200,000 for a two-year conservation program. The trust acknowledged the critical need for initiating a program and for establishing a dialogue among those agencies that are ultimately responsible for the care of Philadelphia's sculpture.

This raises the issues of the responsibilities of maintenance and ownership. To this end, I have examined the early documents of the Association to determine if there was any thought or consideration given to the notion of maintenance. I could find none. What did our predecessors think about this? What I did discover was that the spirit of the time (1871-1921, the first fifty years of the Association's growth) was based upon a reaction to "the effect of a mechanical civilization upon human character and the human soul."[3] It was a very romantic, idealized view of the city. Most of the sculpture commissioned at that time glorified the idea of the beautiful or commemorated a particular person for having done a particular deed. Absorbed by beautification and commemoration, our city fathers never gave much thought at all to what was to become of these works with the passage of time. James M. Beck, a trustee since 1902, made some amusing statements in 1921 on the occasion of the fiftieth anniversary of the Art Association. He mused that if he could suspend animation and return in a hundred years, he would walk up to the Parkway, up the steps of the Art Museum, which he helped initiate, to look over Philadelphia, which would then have become the Athens of America. He never imagined that the ravages of time, nature, and vandalism would affect our lives so dramatically that, in fact, we would share with Athens not only our vast holdings of public monuments but also the pollutants that threaten our environment and our sculpture.

After the funding was confirmed, we began a yearlong process of work, which included approvals by the city's Art Commission and by the Fairmount Park Commission, both granted in June 1982. During the following fall and winter, we proceeded to establish procedures for permits with the Fairmount Park Commission. We established a working process to solve logistical problems, such as access to water, storage of supplies, and examination of insurance, and to draft an agreement which would address the issues of cost, responsibilities, and record keeping.

Such an agreement is probably the most important conservation document. It describes and specifies the nature of the work and the documentation that is expected. Properly written, it allows for inspection and intervention, if necessary, at various stages of the working process. In this case, we requested at least three points in time when staff and board would have the opportunity to inspect the work prior to continuation of the working process. It is crucial to establish a working process that allows for the possibility to intercede and to intervene, if necessary, during the course of the treatment. We did not always feel the need to exercise this privilege, but the opportunity was available to us.

The agreement sets forth a payment process as well. In this case, the cost of individual treatments varied from two thousand dollars to eleven thousand dollars, with a total sum that was not to be exceeded. This allowed for fluctuations in the cost for any particular work; we realized that once the conservator was on the site, he might discover something that would make a treatment more or less expensive. Payments were made in accordance with the submission of conservation proposals (which evaluated conditions and proposed treatments) and conservation reports (which were submitted upon completion). At every stage, these written submissions were signed and authorized for payment by various board members. As a result, there were a number of different people who saw the reports along the way.

The agreement also outlines the responsibilities of the conservator and the client. Who pays for transportation? Who pays for equipment? Who pays for scaffolding? Who is responsible for photographic services? Who is responsible for water? What about repair of adjacent property, if for any reason it is disturbed in the course of the work? And who secures permits? These are all questions that must be answered and responsibilities that must be defined. Liability, insurance, and indemnity also must be addressed in the agreement. The client, for example, ought to request listing as an additional named insured on the conservator's policy. Certificates of insurance ought to be submitted to the client for review and carefully examined by the client's agent. Dispensing free insurance advice would be foolhardy; however, the agent will probably recommend bodily injury and property damage with excess umbrella coverage, independent contractors' coverage with completed operations, broad form comprehensive, general liability, and worker's compensation coverage. This may seem overwhelming, but working in an outdoor environment carries unanticipated risks and is quite different from working within the protection of the artist's studio or the conservator's laboratory. Dealing with all of these problems creates a working relationship between the client and the conservator. The end result is therefore improved, because one anticipates problems and guards against them. By the time the work is initiated, it ought to flow fairly smoothly—which it did in our case.

The agreement also can establish a time schedule, and it provides a working document which clarifies responsibilities. The format for proposals and treatments can be designed at this time, taking into consideration the immediate and long-range documentation needs of the

organization. In this case, we designed treatment forms jointly with the conservator—forms that would work for him on site and that would add to our archives as documentation for the sculpture.

What are the implications? We must pay attention to all the issues raised today. We must set up a system that will establish a survey and maintenance program for this city's holdings. We must engage artists in an ongoing dialogue. Artists who are creating contemporary outdoor works must be made aware of the problems of the environment and the problems of maintenance. We must think about problems we can only imagine. As I reflect upon our predecessors, I realize they could not have imagined what the effects of pollution would be in today's world. We must provide careful documentation of the conservation process. Information concerning the fabrication of new sculptures as well as documentation of the artist's intent will prove useful to future generations.

We also must watch the results of our efforts over a period of time. We need to examine these different treatments at regular intervals. When one takes a dog to a veterinarian, the doctor keeps a series of records, and one can tell from year to year what is happening to the dog's coat and vital functions; our doctors do the same for our bodies. A similar method of record keeping must be initiated for sculpture so that we can look at it over a period of time. Many of our assumptions are based on things we have just recently discovered.

Finally, we must work cooperatively to see that these goals are addressed. Why "Choreography and Caution," the topic of this paper? The choreographer plans the movements of others so that they can perform in harmony. I suggest that the role of the administrator is to keep all aspects of a program—in this case, a conservation program—in harmony. I will guarantee that one performer or another is going to get out of step, and it is the role of the administrator somehow to get everybody moving together and working together again. Caution? I can only reflect that we have proceeded very, very carefully in order to serve the best interest of the sculpture. Time, on the one hand, is not on our side because of the rapid deterioration that we have observed. On the other hand, we ought not to make quick decisions that we cannot reverse.

NOTES

1. Lippard, Lucy R. *Overlay: Contemporary Art and the Art of Prehistory*. New York: Pantheon Books, 1983, p. 221.

2. Holt, Nancy, ed. *The Writings of Robert Smithson*. New York: New York University Press, 1979, p. 183.

3. Beck, James Montgomery, LL.D. "The Utility of Civil Beauty." *Fiftieth Anniversary Publication No. 59*. Philadelphia: Fairmount Park Art Association, 1922, p. 20.

Public Art and Public Policy

Reprinted in abridged form by permission of the authors, Judith H. Balfe and Margaret J. Wyszomirski from *The Journal of Arts Management and Law*, vol. 15, no. 4, Winter 1986.

Public Art and Public Policy

JUDITH H. BALFE and MARGARET J. WYSZOMIRSKI

Recent controversies about the commissioning, installation, and maintenance of public art—especially sculpture—have raised a number of issues, but resolved few of these. In some cases, public outcry has prevented a work from being installed or has contributed to its redesign. In other cases, opposition has rapidly quieted as the once-offended public has come to accept, even to enthusiastically champion, the previously detested work. Each instance has been seen as essentially idiosyncratic, hence few commonalities have been discerned to provide guidelines for future commissions and installations, although commissioning agencies have adjusted their procedures in response to "mistakes" and controversies.

This article attempts to identify and examine the major legal (state and federal), political, sociological, and aesthetic issues involved in the commissioning of public art, and to suggest ways of accommodating the various interests so as to manage those controversies that may occur.

Our analysis centers upon the interactions of three "parties," each with its own interests to be served:

Judith H. Balfe is assistant professor of sociology at the College of Staten Island—CUNY. Margaret J. Wyszomirski is director of the Graduate Public Policy Program at Georgetown University. Together they edited Arts, Ideology, and Politics. *This paper was originally presented at the Conference on Social Theory, Politics, and the Arts, held at the New School and Adelphi University, October 25–27, 1985.*

1) **the artists**, who desire artistic freedom, recognition, and security for their work;
2) **the commissioning public agency**, which is responsible for the promotion of the long-term aesthetic welfare of society, while confronting immediate political and procedural constraints upon its actions; and
3) **the public**, which must assent to the funding and give community acceptance to the particular works installed in its midst.

Respectively, the major focus for each varies. For the artist, the primary issue is aesthetic. For the public agency, it is legal and political. For the public, a mixture of sociological and aesthetic issues is foremost. In the best of circumstances, the interests of these three parties converge to their mutual benefit. On other occasions, the interests may diverge. In such cases, how can the various rights and obligations of each party be balanced and accommodated, through predictable and rational procedures to which all assent? Does any party, interest, or issue take precedence over the others? What processes are most suitable for the adjudication of disputes, both substantive and procedural?

All of these questions have been raised in the current controversy over the Richard Serra sculpture—"Tilted Arc"—which the GSA Art-in-Architecture program commissioned and installed on the plaza in front of the Jacob Javits Building in lower Manhattan.

The Case of "Tilted Arc"

The federal building whose construction provided for the eventual commission of "Tilted Arc" was erected in 1968 in Foley Square, in the vicinity of other federal and state courthouses and office buildings. Subsequently named after the long-term New York senator, it is the second largest federal office building after the Pentagon, and houses the regional offices of GSA, among those of other federal agencies. During this initial construction phase, the Art-in-Architecture program was not functioning, having been suspended in 1966 following a controversy over one of its commissions.[1] When an addition to the building was planned in the mid-

seventies, the GSA Art-in-Architecture program (which had been re-established in 1972) decided to commission a work to be installed in the 160-foot-square plaza in front of the building's entrance. In 1979, an NEA-appointed advisory panel composed of three artworld professionals recommended that Richard Serra be awarded the commission to create a work specifically for this site; this recommendation was subsequently approved by the GSA administrator.

Serra is an internationally acclaimed sculptor whose work is stylistically consistent: he follows a formalist, minimalist aesthetic, often using monumental slabs of corten steel (which acquire a rusty surface upon weathering) to transect specific sites and establish new lines of spatial tension, visual excitement and an elegant—if brutally powerful—presence in and through the work itself. After considerable study of the Javits plaza and office building and consultation with a representative of the original architectural firm, Serra presented the design for "Tilted Arc." GSA officials raised a number of objections, and required further studies of the impact of the work upon the site and the effect it would have upon the use of the plaza by the 10,000 office workers who cross it daily. Satisfied by the results of these "environmental impact" studies, GSA agreed to complete the commissioning of the proposed work.

Installed in 1981, "Tilted Arc" is sited on a small, barren plaza which seems even smaller than it is, as it is cornered on two sides by the enormous towers of the Javits building. The work itself bisects the plaza at an angle, curving slightly along its 120-foot length, and also vertically up its 12-foot height. However elegant in form it may be when seen from either end or from windows overlooking the plaza from above, "Tilted Arc" is a rusty wall of enormous size when encountered broadside at ground level. While it does not interfere with the most frequent pedestrian paths across the plaza, its visible presence is impossible to ignore.

Immediately upon its installation, the work was greeted with hostility by many of the plaza office workers.[2] Indeed, their evident lack of understanding of "Tilted Arc" might have been predicted, as in this case the

Art-in-Architecture program did not follow its own guidelines for the installation of public sculpture. These procedures mandate "introductory" programs for community groups to enhance their understanding of commissioned works, and generally require that considerable local public relations work be done in advance of any installation. On this occasion, GSA let the public come to terms with "Tilted Arc" largely uninstructed and on its own. Not surprisingly, there was an immediate outcry, with antagonistic letters to GSA and 1300 signatures on petitions for the work's removal. But as in previous instances of controversy over Art-in-Architecture commissions, GSA stood behind the artist and the work, and attempted to "tough out" the opposition it engendered. In time, overt hostility toward "Tilted Arc" seemed to subside—whether out of fatalism or out of increased acceptance and understanding is hard to say. In any case, there was no further overt objection for two years.

But in the fall of 1984, the relatively new regional GSA administrator, William J. Diamond, queried office workers and others about their views of "Tilted Arc," asking if they wanted its removal. He obtained nearly 4000 signatures on petitions to remove. It is worth noting here that he did not also ask for suggestions about what might otherwise be desirable to enhance the plaza and facilitate its public use (e.g., chairs and tables, planters, or sponsored performances such as are common in other NYC parks under public sponsorship). Diamond's own hostility to "Tilted Arc" was evident from the beginning. His initiative in promoting what was clearly a recall drive could be seen as consistent with the general Reagan Administration policy of enhancing state and local control, while diminishing federal power which, in this instance, had been responsible for commissioning and installing a locally-disliked work.[3]

In March 1985, Diamond convened a three-day hearing before a five-man panel (which included himself and two of his own GSA appointees) to consider the disposition of "Tilted Arc." Over 180 people testified at the hearing, more than 120 of whom vehemently supported "Tilted Arc"'s retention.[4] They backed up their position with petitions containing 4,000 signatures. Hundreds of letters in support of "Tilted Arc" poured in to

GSA and the White House from every country in Western Europe, Japan, and from across the United States—from artists with widely varying styles, from other artworld personnel, and from the wider public as well. In contrast, those seeking "Tilted Arc" 's removal included only a handful of Javits Building employees, even though these federal employees were among those most affected by the presence of the work. Very few "anti-Arc" letters were received.

The controversy and hearing attracted considerable media attention, contributing to the hyperbolic polarization of the antagonistic claims to "moral" correctness by each side. Those supporting retention of "Tilted Arc" on the Javits Plaza site did not all claim to like the work, but all took stands on behalf of artistic freedom, and of expression from censorship and First Amendment rights. They also emphasized the site-specificity of the work which supported Serra's claim that its removal would be tantamount to its "destruction"; the responsibility of GSA, rather than the artist, to assist the uninformed public in interpreting and understanding an admittedly "difficult" work; and the obligation to maintain the contractual agreement between GSA and Serra which, like all Art-in-Architecture contracts, promised "permanence" for work on the chosen site. In sum, these were classic statements of the artist's interests.

Those (including Diamond) who insisted upon the removal of "Tilted Arc" just as classically argued that official responsibility for the public's aesthetic and non-aesthetic welfare was being violated by the permanent presence of a disliked work. They claimed that GSA contractual ownership of all its commissioned sculptures gave the agency the right to remove them; that any guarantee of permanence was contingent upon circumstance, as was the building itself, and thus the site could not be expected to endure forever; that public art must not offend the public that pays for it; that to retain a work against public wishes would interfere with the public's "freedom of expression" which the agency was obligated to protect as much as that of any artist.

Not surprisingly, given Diamond's declared goal of removing "Tilted Arc," the hearing panel determined that it should indeed be relocated. Thereupon, Serra announced his intention to sue GSA for breach of contract and to petition for an injunction to prevent removal of the "Arc" pending settlement of his suit. Once again letters flooded GSA in his support, questioning the aesthetic and political judgment, legality, ethics, and procedure of the panel's decision. Despite the furor, the acting GSA administrator, Dwight Ink (a career bureaucrat noted as a trouble-shooter), endorsed the panel's decision, thus supporting his own staff. But he also declared that "Tilted Arc" 's relocation would be determined by a new NEA-appointed panel that was to include artworld figures (as before), but also representatives from the community, not just from that area around the present site at Javits Plaza but including some from the site to which it would be relocated.[5] As yet, no such site has been determined, and finding such a site is likely to prove problematic. Since most artworld institutions adopt the artist's perspective, these institutions have supported Serra and therefore might refuse to accept the work even if asked by GSA. The controversy is obviously far from settled, although a supposedly final decision is to be announced momentarily.

Clearly the present situation seems to have no winners and many losers. The government in general and GSA in particular have been cast by many as inept, arrogant, and willing to violate both law and principle, either through installing artworks without adequately consulting the public, or in subsequently attempting to remove them against the wishes of their creators. Consequently, the GSA program fears that the controversy might once again lead to its suspension or else compromise the hard-won trust it has among artists. Conversely, this political controversy raises questions about the legitimacy of arts institutions and artists, whose aesthetic has received GSA support but does not command public approval. Alternately, the public is derided as philistine and easily misled by the regional administrator, who is accused of grandstanding for the sake of his own

political ambitions. Any decision—however long it may be delayed—will offend many.

But while polarization of the controversy demonstrates the extreme positions and specific interests of artists on one hand, and of public agencies on the other, there has been little expression of the interests of the third party to the dispute, the public or, more properly, the publics who must support and find positively meaningful the authoritative expression of *both* of the other two parties if those parties' competing interests are to be resolved.

Procedural Problems in the Commissioning of "Tilted Arc"

During the remainder of the decade, the GSA and NEA repeatedly discussed the problem of community involvement with, and acceptance of, public art, while tinkering with the commissioning and installation procedures. Despite this recurring attention, however, a 1980 report of a joint GSA-NEA task force still observed that:

> Obstacles to the continuing success of the program (Art-in-Architecture) have arisen as a result of initial adverse responses to works of art in the community. The roots of this response seem to lie in public perceptions that there is not a relationship between the community and the Art-in-Architecture program's goals and procedures. . . .

It went on to point out that this was particularly problematic since art in public places "has much greater visual and psychological impact and touches a great many more people than does art in the traditional museum context."[19] Given this impact and a community's unfamiliarity with contemporary art, the task force said that the tenor of community response and the constructiveness of public debate regarding a public artwork could be significantly affected by public education and information programs preceeding and accompanying a piece's installation.

Despite these procedural refinements, the case of "Tilted Arc" illustrates some of their remaining shortcomings.[20] To begin with, a commission for the plaza of the GSA building in New York City had not been integrated with the original design at the time of its construction. Since the Art-in-Architecture program was in suspension in the late 1960s when this building was erected, the commissioning of artworks for this site had to await reestablishment of the program. Then, once this was accomplished, the small program found itself confronted with a significant backlog of potential commissions as well as ongoing projects. Thus, none received the full attention it might have had from an ongoing, current program.

In addition, the process of commissioning and installing "Tilted Arc" spanned a period of significant political change. Serra was awarded the commission in 1979, but the work was not installed until 1981. During the

interim, yet another new administration had taken office in Washington, and the New York regional director of GSA was in the process of being replaced. Hence the political conditions, public personnel, and presumed popular mandate that had existed when the commission had been awarded were different from those at the time of installation. Similarly, commissioning and installation procedures had been modified during the interim to institute more extensive community involvement, but could not be employed retroactively in this case.

Finally, changed assumptions concerning the probable community reception of "Tilted Arc" may have influenced GSA action (or inaction) during and immediately after installation. Specifically, the case of "Tilted Arc" illustrates the ambiguity—and the changing political meanings—of the "community." If "the community" meant the New York art cognoscenti, then community response was likely to be well-informed and positive.

If "the community" referred to the residents of the area adjacent to the Javits Plaza, then reaction was likely to be accepting. These diverse ethnic and socio-economic groups were already familiar with artworks in public places, since many had been installed in this vicinity as a result of corporate, private, and governmental efforts. Furthermore, neighborhood residents used the Javits Plaza site for their own purposes only when it was otherwise empty—on weekends.

Finally, if the "community" was composed of the federal workers employed in the buildings on the plaza, then its reaction was not readily predictable and might presumably be negative. Yet, these would be the people who would most come in contact with "Tilted Arc," both daily and involuntarily, as they came to and from work.

While the first "community" (arts cognoscenti) needed little, if any, introduction to "Tilted Arc," the other two "communities" (neighborhood residents and federal workers) presumably could have benefitted from informational and educational efforts. Indeed, the latter, who were easily reachable, might have been particularly responsive to such efforts. Such outreach programs were not, however, conducted for either group. Responsibilities for outreach efforts were in the process of being shifted from the federal to regional authorities at the time of this installation and apparently were not addressed at all in this case. As a result, only quite inadequate efforts were made to inform people, especially building workers, of what to expect. A model displayed in a case in the GSA building lobby gave little real notion of the impact and scale of the full-size piece. Nor did a pole and string stake-out of the piece on the plaza itself give an accurate impression of the mass and solidity of the artwork. Finally, upon installation, when opposition to the piece was voiced, no educational efforts were made. And when opposition resurfaced in 1984, again GSA made no effort from Washington to convene a hearing to air opinions and engage in a productive discussion of the work (as it had nearly a decade earlier in the Baltimore case concerning Sugarman's work). Clearly, the specific processes used to commission and install "Tilted Arc" were distinctly flawed. It is, perhaps, ironic that during this time, procedures were being revised and improved but were not being adopted retroactively.

In any case, it should have been obvious that Serra's work was likely to be controversial and difficult. In 1980, another of his pieces that had been commissioned by community sponsors and the NEA program had been rejected by the local Peoria sponsor upon presentation of his model.[21] In another instance, Serra and architect Venturi had been unable to agree upon an integrated concept for a piece that would have been part of the Pennsylvania Avenue Redevelopment Project in Washington, D.C.[22] Generally, there has been a record of particular difficulties concerning local acceptance of corten steel works by any artist, especially if these were installed in congested urban settings and/or away from communities that were accustomed to dealing with abstraction (e.g., university campuses). Clearly, then, the agency might have been alerted to the possibility that this particular work was likely to require public relations efforts to enhance community receptivity to it.

Unresolved Issues

As demonstrated by the nearly twenty-year records of both major federal programs for commissioning public art (the NEA's Art-in-Public

Places program and the GSA's Art-in-Architecture program), everyone has benefitted. Contemporary artists have not only been given opportunities and the freedom from censorship to practice their art but have also received public funds to sustain them while they do so. Whether this may have enhanced, even if only subliminally, their sense of trust in dealing with government and the general public cannot be measured, but neither should its possibility be ignored, especially since one evident role of the arts is to serve as a sort of "social glue."[23] Furthermore, public commissions have afforded many artists with "a chance to work on a grand scale"[24] and to reach infinitely more people than they might have through more established gallery or museum forums. In turn, the general public has had its aesthetic horizons broadened: it has gained a better understanding of and familiarity with various genres of modern art as well as a more sophisticated sense of space and place. Finally, the sponsoring government agencies have gained the enthusiastic support of much of the arts community. Demonstrably, these agencies have reaped a highly productive public investment, both in financial and aesthetic terms. As Art-in-Architecture Director Don Thalacker likes to point out, the total value of the public artworks he has commissioned has appreciated by at least 400 percent—a figure equalled by few other recent federal programs. Aesthetically, Art-in-Architecture commissions have generally been well received by local communities, thus showing that the agency has fulfilled its mandate to stimulate and elevate the national spirit in each of its local settings.

Of course, both the NEA and GSA programs are similarly engaged: both have operated concurrently and even collaboratively, and both have confronted similar controversies over some of their projects. Despite these commonalities of the two programs, the GSA Art-in-Architecture program seems to have encountered stronger and more pronounced episodes of criticism, to the point that these have constrained its operational scale and procedures, and indeed threatened its very continuance.

How do we account for the differences in the public acceptance and political support of the NEA's program and the works it has sponsored, compared with the incidents of protracted public opposition to some of

GSA's commissions and the political vulnerability of the Art-in-Architecture program? Representing government's interests, both agencies seem to address similar concerns and to have sponsored a collection of artworks of similar artistic quality and stylistic diversity using many of the same artists. Both agencies are required to work in the public trust, according to the perceived political mandate of the current administration. Thus, both agencies have common interests and appear to have used comparable (though not identical) means. The presence or absence of controversy would also seem independent of the variance among artists, whose interests are identical regardless of commissioning agency. Not surprisingly, given NEA appointment of panelists, even those Art-in-Architecture artists who have not also been supported by the NEA program appear similar to those that have, in terms of the range of styles and media. Many of these artists work in the highly formalist aesthetic of Richard Serra, and some work in corten steel—the medium that seems so objectionable to "Tilted Arc" 's antagonists. In any event, the artworks that Art-in-Architecture commissions are no more difficult, avant garde, or potentially unpopular than those sponsored by the NEA. Thus, the artists' creative range and opportunities seem equally addressed by both government commissioning programs. As for the "third party," the "public" interest would seem to remain constant regardless of government agency and exhibit little (if any) awareness of which federal agency might be the sponsor. Indeed, public reaction of approval or disapproval of a commissioned sculpture has clearly been independent of knowledge of the specific federal sponsor and of its established procedures.

Therefore, the major distinction between the GSA and the NEA programs lies in procedural variance: in the extent and timing of involvement by community-based parties in the commissioning process. The NEA program has scrupulously placed a non-federal "buffer" between itself and the individual artist, as well as between itself and the general public. While in some cases this "buffering" institution is local government, in a majority of instances the "buffer" is a non-profit cultural, educational, or civic organization which has taken the initiative in designing and proposing a

273

274

public art work project. Additionally, these same buffer organizations have the ultimate responsibility for selecting the artist, for installing and assuming ownership of the artwork, and for dealing with public reaction—either positive or negative.

Obviously, such local non-profit organizations perform this critical "buffering" function for all involved parties—the state, the public, and the artist. They interpose a layer of local (generally private) patronage that can act to protect an artist from federally imposed standards of taste, censorship, or partisan interest. Likewise, these organizations also channel, respond to, and guide community interests in a manner that must be perceived as being legitimate if it is to function at all. Thus, they are instrumental in synchronizing artistic conception with community ethos and in informing and educating the public to enhance its understanding and appreciation of new ideas and objects.

Clearly, such organizations have insulated the NEA from much of the political "fallout" that may accompany either aesthetic or political controversy. After all, the NEA does not require that particular communities or sites accept a work of art; rather, it responds to and assists communities in realizing public art projects that originate at the grassroots level. Nor does the NEA dictate artist, style, or medium concerning the form such an artwork will take; that, too, is decided locally. If a community responds negatively to a public artwork, it communicates its opposition to those responsible, i.e., the local sponsoring organization, its members and supporters.

Similarly, the NEA's commissioning procedures limit the financial investment and ownership responsibilities of the agency. The NEA is only a partner—and often only a junior partner—in the financing of each project. Furthermore, the NEA retains no ownership interest in any artwork project; it simply awards a grant-in-aid based on an expert assessment of project merit made on a competitive basis. The completed art project is the property and thus the responsibility of its originating sponsor. Clearly, the extent of the NEA's aesthetic direction and financial contribution is distinctly limited. Concomitantly, the extent of its political responsibility and public accountability is limited.*

The situation is in marked contrast to the procedures of the GSA, which is directly, fully, and permanently responsible for all artworks commissioned through the Art-in-Architecture program. In these instances, the federal agency determines where an artwork will be placed, what kind of work it will be, who the artist will be, and the amount of each commission to be awarded. There is no community initiative to which the federal government responds; rather, there is only a federal decision which will have a local impact. Similarly, the GSA has sole financial responsibility for, and title to, its commissions. It spends national tax revenues to wholly underwrite the purchase of individual, tangible artworks that are then permanently installed at federal sites located throughout the country. Contractually, the GSA accepts ownership of duly executed commissions as the property of the United States government and assumes responsibility for the maintenance of each piece at its permanent installation site.

Therefore, if difficulties or differences arise concerning the execution of a commission, the agency must deal directly with the artist. From the artist's perspective, there is then no buffer to mitigate the apparent heavy hand of government censorship at work. Nor is there any buffer organization to facilitate the agency's need for a sense of bureaucratic control and predictability. As for the public interest, the GSA is responsible for informing and preparing the local and other publics to receive each Art-in-Architecture-commissioned artwork. If community response (whether individually or institutionally expressed) is negative, and perhaps even escalates to opposition, then the agency absorbs the brunt of the controversy as well as any political repercussions that may ensue.

But GSA's options in responding to instances of local opposition are apparently limited to persuasion, perseverance, and assertion. It can try to persuade the public to accept (and hopefully understand) a difficult or controversial piece. It can persevere in retaining artworks at their sites, hoping that public clamor will eventually "die down." Or it can assert that it has a moral obligation to protect the artist's creative freedom and a legal obligation to honor its contractual commitment to maintain an artwork's permanent installation at the agreed upon site and to protect it from public harm

This practice is not unique to the Art-in-Public-Places program; rather, it is a general administrative strategy employed by the NEA in most of its program activities.

(e.g., vandalism, removal) as the property of the United States.

Clearly these procedures and their consequences place the GSA's Art-in-Architecture program "on the front line" of any controversy, often caught between the differing demands made by artists, the general and/or various specific publics, and public officials. Because of its administratively-determined existence and funding, this program is not as resilient to political criticisms as it would be if it were congressionally enacted and funded through annual appropriations. Lacking such institutional support, the Art-in-Architecture program has cultivated a rapport with the artistic community as an interest group. While this tactic has been effective in generating "expert" support and media visibility for the program, it has also, on occasion, seemed to place the program in the anomalous position of putting the special interests of the artistic community above those of the general public interest which, as a government agency, it is required to serve. Thus, the GSA Art-in-Architecture program may be seen as behaving like a "captive agency" or as an illustration of one of the key failings of pluralist politics—in this case, the unequal mobilization and hence effectiveness of potentially competing interests (i.e., those of the artistic community and those of the general public).

The Management of Public Controversy: The Lessons of "Tilted Arc"

The conflicts of interests indicated here are comparable to those imbedded in other public policy issues. Specifically, governmental policies concerned with aesthetic welfare, such as those related to the commissioning of public sculpture, must consider and balance social ends as well as artistic ones. Furthermore, as we have seen, the governmental agency has its own interests in perpetuating public trust in the government of which it is a part. But the focus of all interests is the artworks themselves, whose aesthetic qualities contribute to audience perceptions, (mis)understandings, and (non)acceptance of the works. Obviously, works of "acceptable" style and/or content engender fewer controversies than those which are

"unacceptable," but the threshhold of acceptability varies according to how the commissioning process is carried out.

This is particularly the case with sculpture designed for permanent installation. Works of temporary display or performance allow for pluralistic use of public sites, and works ranging stylistically from the traditional to the avant garde all seem to be generally accepted. Controversies related to public support of such performed works focus essentially on funding rather than on aesthetics. Since the amount of money available for public art is small (e.g., the entire NEA budget is smaller than the Defense Department's allocation for military bands!), considerable private support is usually determinative of whether even government-sponsored work gets performed or displayed at all.

But sculpture commissioned by government agencies for permanent installation in public places denies competing uses of the same site and therefore imposes a particular aesthetic upon present and future publics who may not ever decide to accept it. Avant garde art is always difficult for many to understand, simply because it is new; its acceptance by a majority takes time, and acceptance by everyone is seldom achieved. But not all art equally survives the "test of time." Even the greatest artists and the most sensitive art experts make mistakes. Such "errors of judgment" are all the more likely precisely regarding works in avant garde styles which are the newest, the most risky, and ironically the most to be encouraged and patronized due to their creativity and innovativeness. Without encouragement, the whole range of artistic innovation may suffer, yet those closest to the process of encouragement, patronage, and especially creative activity itself may be least able to distingush "flowers" from "weeds."

To be sure, public patronage of innovative work is actually one step removed from the riskiest judgments of significant aesthetic quality, in that review panels of artworld experts and the artists whose work they consider have already survived and achieved eminence through the intense competition of the private-sector artworld. In other words, artworld/artist achievements and their obviously related interests have already become clear before any commission is made. Similarly, the interests of the com-

missioning agency are clear, however subject to revision to some degree upon change in elected administration.

What remains hardest to discern are the interests of the public,[25] as these may have internal differences and contradictions that surface only *after* artists and government agencies have contracted to act on the public's behalf. Indeed, media coverage of any public art controversy generally fails to clarify public interests. Rather, it focuses on the interests of artists or of the government, perhaps since each of these can be easily identified and mobilized. In contrast, the public's interests are likely to be diverse, disorganized, and less articulate.

To be sure, the revisions of GSA Art-in-Architecture commissioning guidelines, put into place between the commissioning of Serra's "Tilted Arc" and its installation, afford more "input" from groups in the community in which the work will find permanent location. We have indicated the theoretical and empirical grounding for such input from a range of community "third sector" institutions, and illustrated how they have worked effectively in application for the NEA's Art-in-Public-Places program as distinct from GSA's original Art-in-Architecture program.

A signal point in this regard is that in the GSA program, community representatives are still sought only from those who are both "knowledgeable about the community in which the work of art will be commissioned, and knowledgeable in current American art."[26] This weights any commissioning panel towards those already immersed in the contemporary artworld and accepting of its prevailing styles. This may be expertly informed opinion, but it is not synonymous with public opinion. Such expert opinion is, nonetheless, appropriate for the commissioning panel; otherwise, one might end up with a plebiscite to determine what styles or artworks might be publicly installed in advance of their creation, let alone their installation. Such caution would probably be regarded by artists as a form of prior censorship and would inevitably inhibit creativity, if not preclude the participation of the most avant garde artists in any program of public sculpture. Clearly, the artists' interests must be protected from such abridgement.

But if controversies arise after the fact of government commissions of artworks, then provision of a public appellate review would seem to be in order. Such an appellate panel could review and reevaluate commissions already installed if, after some considerable period, the public has not come to accept them or if site problems/changes require reconsideration. Such a review panel would have the ability to find that mistakes in judgment may have been made by either the artist or the funding agency with regard to the artwork itself, or its suitability for a particular site. It therefore seems inappropriate that this panel be composed of the very artworld professionals who, in one way or another, are already involved parties, hence likely to weight their support toward the artists' interests regardless of the merits of a particular case. However, neither should the panel include representatives of the government agency which sponsored the commission. The agency's interests are already evident, and it would be a conflict of interest for agency (or related agency) staff to sit in further judgment on its own decisions. An appellate panel must function as a neutral third party, rather than as a representative of one of the adversarial interests engaged in the conflict.

Violations of these principles of neutrality were evident in the case of "Tilted Arc," and contributed to the exacerbation of the dispute. For example, the universality of the aesthetic judgment of the artistic community was compromised by the admission of many who supported Serra at the hearing that they might not validate the quality of the piece or agree as to the appropriateness of its siting, even as they insisted upon the principle of artistic freedom of expression. Virtually every major American sculptor, fine art critic, and museum curator/director who was on record, either in letters to the GSA, in testimony at the hearing, or through published interview, asserted this position and therefore supported Serra, at least in principle. Given the invariability and publicness of this stance, where was one to find reputable arts experts who would be able and willing to serve on any subsequently convened review panel with an open mind?

Similarly, GSA's self-interests were obvious and divided. On the one hand, many objected to the proposed removal of "Tilted Arc" because they

found the review conducted by the regional GSA administrator Diamond to be a political grandstand waged for the gaining of public visibility and enhanced political advantage. The fact that Diamond chaired the panel after he had announced that his intention was to have ''Tilted Arc'' removed, in itself violated the principle of neutrality. This was further compromised by his appointment of two other panel members who were his employees—individuals whose self-interest was clearly dependent upon the person who thus, in effect, ''stacked'' the review committee. Thus, on-site agency actions seemed to indicate that the artist would not receive a fair hearing.

On the other hand, in Washington, GSA program and higher agency officials worried that any action might lose them the support of a critical constituency. If it supported the artists' interests, the agency might appear unresponsive to local and community feelings and hence lose political legitimacy—a quite tangible threat to the Art-in-Architecture program given its history of suspension and cutback in the wake of earlier controversies. If GSA acceded to local interests who opposed ''Tilted Arc,'' then it would seem in danger of losing its hard-won trust among artists, some of whom thought such action would undercut the relationship between artists and government, and that might lead the best artists to ''get out of making public sculpture altogether.''[27]

In sum, having failed to include representatives of various publics' interests all the way along, GSA compounded its difficulties at every turn, from the first 1979 decision to award the Javits Plaza commission to Serra, to the 1985 hearing to determine the disposition of the piece. It is clear that both the interests of the artist and of the sponsoring agency have dominated the controversy. The interests of the third party—the publics—especially as represented by ''third sector'' non-profit institutions, have yet to have an equal say. As a result, neither of the other two parties has received the desired legitimation of its own agenda.

Yet the success of third-party involvement in all aspects of NEA commissions indicates its indispensability. We specifically do not advocate a plebiscite, much less one conducted through the mechanism of competing petitions. As seen in the case of ''Tilted Arc,'' such petitions are all too readily used by grandstanding representatives of one or another interest. Nor do we quarrel with the fact that GSA must control and own its commissioned works (as NEA does not) because federal property and funding are exclusively involved. Rather we see the ideal role of mediating or ''buffering'' local non-profit, community-based groups as twofold.

One is to be involved in the process of assisting GSA in its educational outreach programs to explain its commissioned works, both prior to and accompanying installation. Following installation, other non-profit groups could facilitate and further the use and enjoyment of federal sites where permanently-installed Art-in-Architecture pieces could become a focus for many other kinds of temporary artistic and community activities. Such uses of the site and artwork by a range of publics for a variety of purposes would integrate the artwork into the community and legitimize it with diverse publics.

A second role for third-sector buffering institutions would be to provide reputable panelists for any appellate review should it become necessary to convene such a hearing. Such institutions could provide legitimate representatives of the various publics via such groups as community action organizations, neighborhood associations, artists' associations, or federal workers unions. Additionally, other non-profit organizations such as historic preservation leagues, urban planning departments, local universities, artists' unions or coalitions (e.g., Artists Equity), or volunteer professional support groups (e.g., Volunteer Lawyers for the Arts) might provide knowledgeable panelists accustomed to balancing public, special, and governmental interests. A panel drawn from such third sector organizations might thus include preservationists, urban planners, social psychologists, artists' representatives, cultural sociologists, policy analysts, arts or public interest lawyers, and/or community improvement activists. Collectively, a panel of such individuals would seem acceptable to all involved parties as neutral, expert, and representative—the necessary attributes for an effective arbitrator in such conflictual circumstances. Further provision might be made that any such review panel could only be convened after some set interval of time (perhaps 5 or 10 years) had demonstrated the in-

tractability of a controversial governmentally-commissioned artwork. Such an appellate procedure could also have application in instances where physical changes in public artwork sites might necessitate a reconsideration and/or relocation of an uncontroversial and locally-accepted piece.

As the comparison to both historic federal arts programs and the NEA's contemporary Art-in-Public places program indicates, direct federal involvement in artistic creativity and ongoing responsibility for artistic products is an invitation to controversy. Such controversy generally works to the detriment of all interests—artist, public, and government—whether singly or in combination. In contrast, reliance upon third-sector institutions to act as intermediaries or buffers between government and the populace (whether artistic or general) seems to optimize everyone's interests. Such arrangements are, therefore, conducive to a public art and to public policy that is legitimate and "successful," both in political and in aesthetic terms.

NOTES

1. The controversy involved a mural by Robert Motherwell for the John F. Kennedy Memorial Building in Boston. The work—an abstract expressionist piece entitled "New England Elegy"—was interpreted to be presentative of the moment of President Kennedy's assassination. The work, which some considered to be hideous and disrespectful, brought considered criticism to bear on the relatively young GSA Art-in-Architecture program at a time when the Johnson Administration was looking for ways to reduce government expenditures. This combination of factors contributed to the suspension of the Art-in-Architecture program.

2. *The New York Times*, 25 September 1981, p. 24.

3. Some of Diamond's critics charged that Diamond may have seen the opposition to "Tilted Arc" as an issue he could exploit to make his name better known in advance of a possible bid for elective office.

4. For newspaper coverage of the hearing, see *The New York Times*, 7 March 1985, pp. B1, B6; and *The Washington Post*, 7 March 1985, pp. D1, D16. Transcripts of the testimony were also made available to the authors by Donald Thalacker, Director of the Art-in-Architecture program.

5. On the decision, see *The New York Times*, 1 June 1985, pp. 25, 28.

6. For example, the "infamous" Horatio Greenough statue of George Washington that Congress commissioned in 1834. The work was strongly criticized because it portrayed Washington in the garb and style of an imperial Roman rather than as a man of a democratic people. More recently, the initial reaction to the sparse, abstract style of the Vietnam War memorial is another example of controversy over the form in which a public commission was executed.

7. On the variety of New Deal art programs and their differences, see Lawrence Mankin, "Government Patronage: An Historical Overview" in Kevin V. Mulcahy and C. Richard Swaim, eds., *Public Policy and the Arts* (Boulder: Westview Press, 1982), pp. 111–140; and Helen Townsend, "The Social Origins of the Federal Arts Project" in *Art, Ideology and Politics,* ed. Judith H. Balfe and Margaret Jane Wyszomirski (New York: Praeger, 1985), pp. 264–292.

8. As quoted in "Art and Politics in Cold War America," Jane DeHart Mathews, *American Historical Review*, Vol. 81 (October 1976).

9. *Ibid*, pp. 776–777. On the controversial exhibit, see also Montgomery Museum of Fine Arts, "Advancing American Art, Politics and Aesthetics in the State Department Exhibition, 1946–1948," with essays by Margaret Lynne Ausfeld and Virginia M. Mecklenburg (Montgomery, Alabama: 1984).

10. On the political unpopularity of modern art, especially Abstract Expressionism, see Mathews, *ibid* and Gary O. Larson, *The Reluctant Patron* (Philadelphia: University of Pennsylvania Press, 1983). Clearly this was an instance where aesthetic questions about "modern" style were compounded and confused by political questions about the ideological persuasions of artists, many of whom were denounced as left wing radicals and Communists.

11. Andy Leon Harvey, ed., *Art in Public Places*, Introduction by John Beardsley (Washington, D.C.: Partners for Livable Places, 1981), p. 10.

12. *Ibid*, p. 13.

13. Patricia Fuller, "Foreword," in Harvey, ed., *Art in Public Places*, p. 6.

14. Donald W. Thalacker, *The Place of Art in the World of Architecture* (New York: Chelsea House Publishers, 1980), p. xii.

15. On the early GSA Art-in-Architecture program activities and problems, see Jo Ann Lewis, "A Modern Medici for Public Art," *Art News* (April 1977), p. 39.

16. Interview with Nicholas Panuzio, Washington, D.C., 10 May, 1985 as quoted in unpublished paper by Julie Madison, "GSA's Art-in-Architecture Program," prepared for class on Public Policy and the Arts, Georgetown University, Spring 1985.

17. Lewis, "A Modern Medici . . .," *Art News* (April 1977), p. 40.

18. Thalacker, p. xiii.

19. "Report of the Joint GSA-NEA Task Force on the Art-in-Architecture Program" (Washington, D.C.: document copy, dated 22 January, 1980), p. 1.

20. Information about the commissioning of "Tilted Arc" is based, in part, upon an interview with Donald W. Thalacker, Director of the A-in-A program, Washington, D.C., 22 May, 1985.

21. See *The New York Times*, 16 March, 1981.

22. The "Tilted Arc" controversy may now be having a spillover effect. Within months of the announcement that "Tilted Arc" would be removed, the City of St. Louis announced that it was considering holding a referendum on whether to remove another Serra sculpture.

This piece—"Twain"—was commissioned under the NEA Art-in-Public-Places program and was installed in 1982 following several years of community involvement and fundraising. See *The New York Times*, 21 August, 1985, p. C13.

23. For an example of another government policy that has sought to employ the arts as a form of "social glue," see Judith H. Balfe and Margaret Jane Wyszomirski, "Socio-Political Factors in the Development of New Jersey Culture," *Journal of Regional Culture* (forthcoming, 1985).

24. Lewis, "A Modern Medici . . .," *Art News* (April 1977), p. 40.

25. This near absence of the public's interests is noted by Richard Storr in his article, " 'Tilted Arc': Enemy of the People," *Art in America*, September 1985, pp. 90–97. Relatedly, Stephen Luecking in "What's Public About Public Sculpture?" makes the point that many public artworks "achieve visual elegance but speak to no ideology except that of the formal aesthetic issues they espouse." Such works are seldom "the expression of shared values of a people or institutions . . .," hence, they are "art that is publicly present rather than publicly significant." See *The New Art Examiner* (November 1984), pp. 39–43, particularly p. 40.

26. From summary recommendations of "The Report of the Joint GSA-NEA Task Force . . .," 22 January, 1980, p. 8.

27. These views were expressed by artists Nancy Holt and Michael Heizer, both of whom have created public sculpture. See *The New York Times*, 6 June, 1985.

Selected Bibliography

General

Auping, Michael. *Common Ground: Five Artists in the Florida Landscape.* Sarasota: John and Mable Ringling Museum of Art, 1982.

Beardsley, John. *Art in Public Places: A Survey of Community Sponsored Projects Supported by the National Endowment for the Arts.* Washington, D.C.: Partners for Livable Places. 1981.

Beardsley, John. "Personal Sensibilities in Public Places." *ARTFORUM* vol. XIX, no. 10 (Summer 1981): 43-45.

Berger, David. *Private Visions / Public Spaces* (special publication). Bellevue, WA: Bellevue Art Museum, (April 1987).

Clay, Grady. "Vietnam's Aftermath: Sniping at the Memorial." *Landscape Architecture.* vol. 72 (March 1982): 54-56.

Dixon, Jenny. "Resolving the Polarities in Public Art." *Place* (January 1983): 1-5.

Forgey, Benjamin. "It Takes More than an Outdoor Site to Make Sculpture Public." *ARTnews* vol. 79, no. 7 (September 1980): 84-89.

Friedman, Mildred, ed. "Site: The Meaning of Place in Art and Architecture." *Design Quarterly* 122 (1983).

Larson, Kay. "The Expulsion from the Garden: Environmental Sculpture at the Winter Olympics." *ARTFORUM* (April 1980): 36-45.

Linker, Kate. "Public Sculpture: The Pursuit of the Pleasurable and Profitable Paradise." *ARTFORUM* vol. XIX, no. 7, (March 1981): 64-73.

Linker, Kate. "Public Sculpture II: Provisions for the Paradise." *ARTFORUM* (Summer 1981): 37-42.

Redstone, Louis G., and Ruth R. Redstone. *Public Art: New Directions.* New York: McGraw-Hill Book Co., 1981.

Scherer, M.A. "What Happened to Our Art?" *The Capital Times.* Madison, WI: 6 May 1985.

Scruggs, Jan C. and Joel L. Swerdlow. *To Heal A Nation: The Vietnam Veterans Memorial.* New York: Harper & Row Publishers, Inc., 1985.

Senie, Harriet. "The Right Stuff." *ARTnews* (March 1984): 50-59.

Stroll (The Magazine of Outdoor Art and Street Culture). New York: Creative Time (published twice a year).

Thalacker, Donald W. *The Place of Art in the World of Architecture.* New York: Chelsea House Publishers, 1980.

Tomkins, Calvin. "The Art World: Like Water in a Glass." *The New Yorker,* 21 March 1983: 84.

Directions in Public Art

Art in America (issue devoted to public art in Europe). (September 1987).

Art in Public Places. Reading, PA: Freedman Gallery, Albright College, 1985.

Beardsley, John. *Earthworks and Beyond.* New York: Abbeville Press, Inc., 1984.

Beardsley, John. *Probing the Earth: Contemporary Land Projects.* Washington, D.C.: Smithsonian Institution Press, 1977.

Davies, Hugh M. and Ronald J. Onorato. *Sitings.* La Jolla, CA: La Jolla Museum of Contemporary Art, 1986.

Forgey, Benjamin. "When Plain is a Plus: Baltimore's Smashing Pearlstone Park." *The Washington Post,* 20 July 1985.

Goldin, Amy. "The Esthetic Ghetto: Some Thoughts about Public Art." *Art in America* (May-June 1974): 30-35.

Harris, Stacy Paleologus, ed. *Insights / On Sites: Perspectives on Art in Public Places.* Washington D.C.: Partners for Livable Places, 1984.

Howett, Catherine M. "Landscape Architecture: Making a Place for Art." *Places* vol. 2 no. 4 (1985): 52-60.

Lippard, Lucy R. "Complexes: Architectural Sculpture in Nature." *Art in America* (January-February 1979): 86-97.

Lippard, Lucy. "Gardens: Some Metaphors for a Public Art." *Art in America* 69 (November 1981): 136-50.

Nilson, Lisbet. "Christo's Blossoms in the Bay." *ARTnews* (January 1984): 54-62.

Rose, Barbara (essay). *Sculpture Off the Pedestal.* Grand Rapids: Grand Rapids Art Museum, 1973.

Rosen, Nancy. *Ten Years of Public Art, 1972-1982.* New York: Public Art Fund, Inc., 1982.

Seattle Art Museum. *Earthworks: Land Reclamation As Sculpture.* Seattle: Seattle Art Museum, 1979.

Spies, Werner. *The Running Fence Project: Christo.* New York: Harry N. Abrams, 1980.

Winerip, Michael. "Computerized Billboard Brightens Up Times Square with Art-of-the-Month." *The New York Times,* 26 August 1983: B-14.

Art in the Urban Context

Design, Art, and Architecture in Transportation. Washington, D.C.: U.S. Government Printing Office, 1977-1980.

Downtown Art in Public Places Policy. Los Angeles: Los Angeles Community Redevelopment Agency, 1985.

Fleming, Ronald Lee, and Renata von Tscharner. *Place Makers: Public Art That Tells You Where You Are*. New York: Hastings House Publishers, 1981.

Hager, Connie and S. Jerome Pratter. *Financial Incentives for Better Design*. Washington, D.C.: National League of Cities, 1981.

Haigh, Ann. "Art and Animation Enliven Europe's Subways." *Place* (December 1982): 4-6.

Land Use and Transportation Plan for Downtown Seattle. Seattle: City of Seattle, Land Use & Transportation Project, 1985.

Lipse, Mike. *Places as Art*. New York: Publishing Center for Cultural Resources, 1985.

Lynch, Kevin. *The Image of the City*. Cambridge, MA: Harvard University Press, 1960.

Lynch, Kevin. *What Time is This Place?* Cambridge, MA: MIT Press, 1972.

McNulty, Robert H., Leo Penne, and Dorothy R. Jacobson. *The Economics of Amenity: Community Futures and Quality of Life*. Washington, D.C.: Partners for Livable Places, 1985.

Page, Clint, and Penelope Cuff. *Public Sector Designs*. Washington, D.C.: Partners for Livable Places, 1984.

Page, Clint and Penelope Cuff, ed. *Negotiating for Amenities*. Washington, D.C.: Partners for Livable Places, 1982.

A Study of Airports: Design, Art, and Architecture. Washington, D.C.: Federal Aviation Administration, 1981.

Thompson, Lynn, ed. *Artwork/Network: A Planning Study for Seattle: Art in the Civic Context*. Seattle: Storefront Press, 1984.

Urban Encounters-Art, Architecture, Audience. Philadelphia: University of Pennsylvania Institute of Contemporary Art, 1980.

Whyte, William H. *The Social Life of Small Urban Spaces*. Washington, D.C.: The Conservation Foundation, 1980.

Project Management

Allocation for Art for Public Facilities: A Model Act. Washington, D.C.: National Assembly of State Arts Agencies, 1984.

American Arbitration Association. *Labor Arbitration Procedures and Techniques* (pamphlet). New York.

Arts On The Line: Eight Year Report. Boston: Massachusetts Bay Transportation Authority, 1986.

Association of the Bar of the City of New York, Committee on Art Law. *Commissioning a Work of Public Art: An Annotated Model Agreement*. New York: Volunteer Lawyers for the Arts (distributed by American Council for Arts), 1985.

Brady, Jim. "Bethesda's Beauty Pageant: Zoning Shift Sparks Battle Among Developers." *The Washington Post*, 19 February 1983.

College Art Association. "Public Art Works." *CAA Newsletter* vol. 12 no. 4 (winter 1987/88).

Cruikshank, Jeffrey L. and Pam Korza. *Going Public: A field guide to developments in art in public places*. Amherst, MA: Arts Extension Service and the National Endowment for the Arts, 1988.

Design Competition Manual. Washington, D.C.: National Endowment for the Arts, Design Arts Program, 1980.

Design Competition Manual II: On-site charette. Washington, D.C.: National Endowment for the Arts, Design Arts Program, 1982.

Downtown Art in Public Places Policy. Los Angeles: Los Angeles Community Redevelopment Agency, 1985.

Esterow, Milton. "How Public Art Becomes a Political Hot Potato." *ARTnews* (January 1986).

Freeman, Allen. "Extraordinary Competition: The Winning Design for the Vietnam Memorial and other Entries." *AIA Journal* (August 1983): 47-53.

Fuller, Patricia. *Five Artists at NOAA: A Casebook on Art in Public Places*. Seattle: Real Comet Press, 1985.

Howett, Catherine M. "The Vietnam Veterans Memorial: Public Art and Politics." *Landscape* (April 1985): 1-9.

O'Connor, Francis C. *Federal Support for the Visual Arts: The New Deal and Now*. Greenwich, CT: New York Graphic Society, Ltd., 1969.

Raine, Nancy. *Arts On The Line: A Public Art Handbook*. Cambridge, MA: Cambridge Arts Council, 1987.

U.S. Department of Transportation. *Aesthetics in Transportation: Guidelines for Incorporating Design, Art, and Architecture into Transportation Facilities*. Cambridge, MA: Moore-Heder Architects, 1980.

Van Bruggen, Coosje, ed. *Claes Oldenburg Large-Scale Projects, 1977-1980*. New York: Rizzoli Books, 1980.

Westbrook, John. "Places of the Art." *Place* (September-October 1986).

"Winthrop Square Park: A Unique Heritage." *Program on Public Space Partnerships Report* (winter/spring 1987): 3-5.

Witzling, Lawrence and Jeffrey Ollswang. *The Planning and Administration of Design Competitions*. Milwaukee: Midwest Institute for Design Research, 1986.

Collaboration

Committee on the Visual Arts. *Artists and Architects Collaborate: Designing the Wiesner Building.* Cambridge, MA: Massachusetts Institute of Technology, 1985.

Cumbow, Robert C. "Public Art/Private Vision." *Arts Line* vol. III no. 1 (May 1985).

Dean, Andrea O. "Bunshaft and Noguchi: An Uneasy but Highly Productive Architect Artist Collaboration." *AIA Journal* (October 1976): 52-55.

Diamonstein, Barbaralee, ed. *Collaboration: Artists and Architects.* New York: Watson-Guptill Publications, Whitney Library of Design, 1981.

Joseph, Nancy. "Artists On Design Teams." *Seattle Arts* (November 1983).

Schwartz, Joyce Pomeroy. *Artists and Architects: Challenges in Collaboration.* Cleveland: Cleveland Center for Contemporary Art, 1985.

Community Involvement

Allen, Jerry. "How Art Becomes Public." *Public Art Collection Portfolio* (special publication). King County, WA: King County Arts Commission, 1985.

"Architecture and Public Spaces." *The Public Interest*, vol. 74 (Winter 1984).

Art in Public Places and Contemporary Sculpture in a Rural Community. Big Rapids, MI: State College Office of the Arts, 1979.

Fuller, Patricia. *Five Artists at NOAA: A Casebook on Art in Public Places.* Seattle: Real Comet Press, 1985.

Harney, Andy. "Expanding the dialogue on public art." *Place* (September 1981).

Larson, Kay. "The Expulsion from the Garden: Environmental Sculpture at the Winter Olympics." *ARTFORUM* vol. XVIII no. 8 (April 1980): 36-45.

Loeb, Barbara. "Ways of Looking: the setting, the audience, the artwork." *Seattle Arts* (May 1984).

McMillan, Penelope. "Art of the Matter." *The Los Angeles Times*, 16 February 1987.

Nordland, Gerald (essay). *Controversial Public Art: From Rodin to di Suvero.* Milwaukee Art Museum, 1983.

Robinette, Margaret. *Outdoor Sculpture: Object and Environment.* New York: Watson-Guptill Publications, Whitney Library of Design, 1976.

Sommer, Robert. *Street Art.* New York: Links Books, 1985.

Stalker, Douglas and Glymour, Clark. "The Malignant Object: Thoughts on Public Sculpture." *The Public Interest* (winter 1982).

Storr, Robert. "Tilted Arc: Enemy of the People?" *Art in America* (September 1985): 91-97.

Artists' Rights

Association of the Bar of the City of New York, Committee on Art Law. *Commissioning a Work of Public Art: An Annotated Model Agreement.* New York: Volunteer Lawyers for the Arts (distributed by American Council for Arts), 1985.

Dubin, Zan. "Freeway Mural: A Lady is Waiting." *The Los Angeles Times*, 22 January 1987.

Esterow, Milton. "How Public Art Becomes a Political Hot Potato." *ARTnews* (January 1986).

Feldman, Franklin and Stephen E. Weil, with Susan Duke Biederman. *Art Law: Rights and Liabilities of Creators and Collectors.* vol.s I and II. Boston: Little, Brown and Company, 1986.

Forgey, Benjamin. "The Perils of Street Sculpture: Ed McGowin and the Marring of Inscape." *The Washington Post,* 13 February 1985.

Robinson, Walter. "Art & the Law: Moral Rights Comes to New York." *Art in America* (October 1983).

Scheir, Wendy, ed. *National VLA Directory.* New York: Volunteer Lawyers for the Arts, 1986.

Simmons, Robert Hilton. "Calder: Out of Site." *The Washington Post*, 30 March 1984.

Collection Management

American Institute for Conservation of Historic and Artistic Works. *AIC Code of Ethics and Standards of Practice.* Washington, D.C.: AIC National Office, 1979.

Bach, Penny Balkin. "Choreography and Caution: The Organization of a Conservation Program." *Sculptural Monuments in the Outdoor Environment.* Philadelphia: Pennsylvania Academy of the Fine Arts, 1985.

Balfe, Judith H. and Margaret J. Wyszomirski. "Public Art and Public Policy." *The Journal of Arts Management and Law* vol. 15 no. 4 (winter 1986).

Cruikshank, Jeffrey L. and Pam Korza. *Going Public: A Field guide to developments in art in public places.* Amherst, MA: Arts Extension Service and the National Endowment for the Arts, 1988.

Dornberg, John. "Art Vandals: Why do they do it?" *ARTnews* (March 1987): 102-109.

Dubin, Zan. "Freeway Mural: A Lady is Waiting." *The Los Angeles Times*, 22 January 1987.

Malaro, Marie C. "Collections Management Policies." *Museum News* (November/December 1979): 57-61.

Naudé, Virginia Norton, ed. *Sculptural Monuments in an Outdoor Environment.* Philadelphia: Pennsylvania Academy of the Fine Arts, 1985.

O'Connor, Francis V., ed. *Art for the Millions: Essays from the 1930s by Artists and Administrators of the WPA Federal Art Project.* Greenwich, CT: New York Graphic Society, 1973.

Reynolds, Patrick T. "The Threat to Outdoor Art." *Historic Preservation.* vol. 36 no. 3 (June 1984): 34-39.

Riss, Dan. "Managing the Care of Outdoor Metal Monuments by the National Park Service." *Sculptural Monuments in the Outdoor Environment.* Philadelphia: Pennsylvania Academy of the Fine Arts, 1985.

Rockwood, Lynda K. *Documentation for Public Art Collections.* Olympia, WA: Washington State Arts Commisssion, 1982.

Sherin, Kerry. "The Empire State Plaza Collection." *Capital Region* (March 1987): 29.

Suro, Roberto. "Saving the Treasures of Italy." *The New York Times Magazine*, 21 December 1986.

Weil, Stephen E. "Deaccession Practices in Museums." *Museum News* (February 1987): 44-50.

Art in Form. *Contemporary Art Publications* (Art books, catalogues, recordings, periodicals). Seattle: Art in Form.

Douglas, Nancy E. *Public Plazas, Public Art, Public Reaction.* Monticello, IL: Vance Bibliographies, 1983.

International Art Alliance. *Directory of Corporate Art Collections.* 3rd Ed. International Art Alliance, Inc., 1984.

Schwartz, Myra E. *Annotated Bibliography on Art in Public Places.* Monticello, IL: Vance Bibilographies, 1984.

Ticho, Suzy. *Directory of Artists Slide Registries.* New York: American Council for the Arts, 1980.

Resource List

American Craft Council
45 West 45th Street
New York, NY 10036
212-869-9423

American Craft Council maintains the largest artisan slide registry for contemporary American crafts in the United States. It is available for use by art consultants, designers, and gallery and shop owners. ACC publishes the bimonthly periodical *American Craft* which highlights completed public artworks by American craftspeople and lists public art competitions and opportunities.

American Institute for Conservation of Historic and Artistic Works
3545 Williamsburg Lane, N.W.
Washington, DC 20008
202-364-1036

AIC was formed to coordinate and advance knowledge and practice in the maintenance and preservation of cultural property. AIC facilitates and coordinates professional conservation activities and acts as a center for information exchange. Useful publications include *Guidelines for Selecting a Conservator* and the *AIC Directory*, which lists AIC members and other conservation and related organizations.

ART on FILE
1837 East Shelby
Seattle, WA 98112
206-322-2638

ART on FILE is a photographic resource service with extensive collections of slides of public artworks. Slide collections include: New Directions in Public Art, New Directions in Public Architecture; and Form and Function: The Artist and the City. Detailed annotations accompany each set of slides.

Arts Extension Service
Division of Continuing Education
University of Massachusetts
Amherst, MA 01003
413-545-2360

Arts Extension Service provides technical assistance in public art management to communities; has compiled an extensive range of public art resource materials available by topic; and published and distributes *Going Public: A field guide to developments in art in public places*. AES serves the management needs of local arts agencies and artists in business through consulting, workshops, and information services.

Association of Professional Art Advisors, Inc.
P.O. Box 2485
New York, NY 10163
212-645-7320

APAA is a membership organization of advisors who provide planning and coordination assistance to the public and private sectors in areas of public art, art collecting, and program planning.

Center for Arts Information
1285 Avenue of the Americas, 3rd floor
New York, NY 10019
212-977-2544

Center for Arts Information acts as a clearinghouse for information on the arts and provides reference and referral services for artists, arts administrators and related professionals. CAI publishes *Memo,* a list of percent for art programs in the United States.

Environmental Images, Inc.
300 Eye Street, N.E., Suite 101
Washington, DC 20002
202-675-9108

Environmental Images, Inc. provides a full range of communication services, such as the creation of video and slide presentations which promote public understanding of environmental issues. Environmental Images has produced for NEA's Design Arts Program: Places as Art, a multi-image program which promotes the concept of public places as art; and Design Competitions, and Design to Build, about planning and managing effective design competitions.

Headlands Center for the Arts
944 Fort Barry
Sausalito, CA 94965
415-331-2787

Headlands Center for the Arts is a laboratory for artists in all media who are interested in "non-studio" issues. Residencies are available for artists and administrators to research and develop ideas. Symposia, lectures, publications, and events on place, land use, collaborations, and other public art topics are regularly scheduled.

International Sculpture Center
1050 Potomac Street, N.W.
Washington, DC 20007
202-965-6066

International Sculpture Center houses an international artist registry and referral files with information on public art workshops, employment opportunities, and other services relevant to the sculpture discipline. ISC publishes, *International Sculpture*, which highlights current public art projects and lists international events and opportunities in public art.

National Artists Equity Association
P.O. Box 28068, Central Station,
Washington, DC 20038
202-628-9633

National Artists Equity Association provides a listing of public art opportunities for artists and referral, advocacy, conferences, workshops, and research services with emphasis on visual art law, business practice, accounting, marketing, contracts, and federal and state legislation. AEA publishes the *National Artists Equity Newsletter.*

National Assembly of Local Arts Agencies
1420 K Street, N.W., Suite 204,
Washington, DC 20005
202-371-2830

NALAA is dedicated to strengthening and enhancing local arts agencies throughout the United States. Information services include referrals and computerized data reports on local arts agency activities; *Connections*, a quarterly journal; and seminars and conferences on issues of local arts development.

National Assembly of State Arts Agencies
1010 Vermont Avenue, N.W., Suite 920,
Washington, DC 20005
202-347-6352

NASAA represents the needs of state arts agencies at the federal level and provides information and advocacy services to its members. NASAA published in 1984 *Allocation for Art for Public Facilities: A Model Act*, which reviews elements of state percent for art legislation and provides brief profiles of state percent programs.

National Association of Artists' Organizations, Inc.
1007 D Street, N.E.
Washington, DC 20002
202-544-0660

NAAO's publications and activities are designed to serve and promote the activities of artists' organizations. They include: the *NAAO Directory* of artist organizations; the *NAAO Bulletin*, a bi-monthly newsletter; the *FLASH* newsletter for news deserving immediate attention; regional and national conferences; and information services.

National Conference of Mayors
1620 I Street, N.W.
Washington, DC 20006
202-293-7330

National Conference of Mayors provides telephone information referral services on city public art programs. The annual City Livability Award is sponsored by the Conference.

National Conference of State Legislatures
1125 Seventeenth Street, Suite 1500,
Denver, CO 80202
303-623-7800

National Conference of State Legislatures provides an information exchange service to legislators which addresses public art, cultural resource, and tourism concerns. Quarterly conferences bring together artists, arts administrators, and legislators to address issues such as public art. The publication, *Arts in the States*, provides an overview of all legislation pertinent to the arts and follows policy development in the arts.

National Endowment for the Arts Visual Arts Program
Nancy Hanks Center
1100 Pennsylvania Avenue, N.W.
Washington, DC 20506
202-682-5448

The Visual Arts Program provides support to organizations that serve visual artists and fellowships to individual artists. Funding for public art projects is possible through the Art in Public Places category and a pilot funding category, Collaborations in Art/Design, developed jointly with the Design Arts program. The Visual Arts program also acts as a national forum to assist in the exchange of ideas and as a catalyst to promote the best developments in the arts and education about the arts.

National Institute for the Conservation of Cultural Property, Inc.
Arts & Industries Building, Room 2225
900 Jefferson Drive, S.W.
Washington, DC 20560
202-357-2295

NIC works nationally to assist institutions, programs, and individuals in preserving the nation's cultural heritage through programs such as the Public Monument Conservation Project, a national inventory and condition survey of historic sculptural monuments conducted by volunteers using model instruments developed by NIC.

Partners for Livable Places
1429 21st Street, N.W.
Washington, DC 20036
202-887-5990

Partners for Livable Places offers technical assistance and information services focusing on the built environment. Partners has developed an art in public places data base of grant recipients from the National Endowment for the Arts' Art in Public Places grant category. Partners publishes *Place*, a magazine with information on public art projects, arts facilities, artist housing, cultural planning, public/private partnerships in the arts, and economic development and the arts.

285

Project for Public Spaces, Inc.
153 Waverly Place
New York, NY 10014
212-620-5660

Project for Public Spaces, Inc. specializes in public space planning, design, and management. PPS assists city agencies, community groups, private developers, and planners in selecting and placing art in public spaces. PPS maintains an art slide file containing the work of artists and artisans. PPS offers educational workshops and conferences on issues in public space planning.

The Public Art Fund, Inc.
25 Central Park West, 25R
New York, NY 10023
212-541-8423

The Public Art Fund, Inc. was created to promote the integration of art in the urban landscape. PAF sponsors art installations in public places throughout New York City and provides educational and informational services. PAF publishes a triannual newsletter devoted to national and international coverage of public art programs and projects.

Social and Public Arts Resource Center (SPARC)
685 Venice Boulevard
Venice, CA 90291
213-822-9560

SPARC is committed to heightening the visibility of artworks, especially public art, that reflects the lives and concerns of America's diverse ethnic populations, women, working people, youth, and the elderly. Services and programs are directed toward the distribution and preservation of public art and include: exhibitions, workshops, and informational services.

Visual Arts Information Service
119 North 4th Street, #303
Minneapolis, MN 55401
612-332-0093

Visual Arts Information Service provides a listing of regional, national, and international grants and competitions that include public art projects and collaborative efforts in architecture. Visual Arts publishes the monthly *Art Paper* which provides information on public art concerns.

Volunteer Lawyers for the Arts
1285 Avenue of the Americas, 3rd floor
New York, NY 10019
212-977-9270

Volunteer Lawyers for the Arts provides free legal assistance to individual artists of every discipline who are unable to afford legal services and have an arts-related problem. VLA publishes books and pamphlets on arts and the law.

Professional Service Organizations

American Institute of Landscape Architects
1733 Connecticut Avenue, N.W.
Washington, DC 20009
202-466-7730

American Planning Association
1776 Massachusetts Avenue, N.W.
Washington, DC 20036
202-628-9633

The American Institute of Architects
1735 New York Avenue, N.W.
Washington, DC 20006
202-626-7300

Publications

Art in America: The annual guide to galleries, museums, and artists
Art in America
980 Madison Avenue
New York, NY 10021
212-734-9797

Art in America publishes *The annual guide to galleries, museums, and artists* which contains 3000 annotated listings; artists and gallery affiliations, and catalogue indexes. Pictorial reviews of the past year in art include public art projects.

Fine Art Film and Video Source Book (1987)* and *Supplement (1988)
artsAmerica, Inc.
12 Havemeyer Place
Greenwich, CT 06830
203-637-1454

artsAmerica, Inc. is the publisher of the artsAmerica *Fine Art Film and Video Source Book (1987)* and *Supplement (1988)* which contains over 700 documentary films and videotapes on visual artists, architecture, crafts, and technique. Each listing

The following list includes public art programs that responded to a survey conducted in 1987 by the Arts Extension Service and the National Assembly of Local Arts Agencies. The survey was designed to supplement information being collected for the Public Art Policy Project, initiated by the Visual Arts Program of the National Endowment for the Arts. The respondents include 195 organizations —government, nonprofit, educational, and corporate—throughout the United States which have ongoing public art programs or which develop public art projects on a regular basis. The fact that, of the 195 programs listed, 107 have been established in the last ten years, with 39 having been instituted since 1985, points to the increasing frequency with which art is recognized as an integral aspect of public spaces. Yet, there are undoubtedly a far greater number of projects undertaken annually than this list indicates. Unrepresented here are a multitude of single projects implemented by a variety of organizations as well as many programs which have begun only recently and were not reached by our survey.

The purpose of the list is to provide the user with basic information in order to identify and connect with public art programs of interest. The criteria for a program to be included were as follows:

— artworks must be accessible to the public; and

— the organization must reflect an ongoing or continuing commitment to developing public art projects.

Format of the listing

The range of organizations which present public art are diverse. They are organized into four categories:

— Government agencies;

— Nonprofit organizations;

— Outdoor public art collections, sculpture parks, and colleges;

— Private sponsors of art in public places; primarily corporations.

Within each category, programs are listed alphabetically by state. In addition to basic contact information, each listing notes:

— the program's primary funding source;

— the year the public art program was established; and

— artists' eligibility to participate in public art projects sponsored by that organization.

Government agencies

A major reason for the dramatic increase in public art activity in the last two decades has been the increase in publicly funded or initiated programs. A total of 135 such programs are listed. While the majority of government-initiated public art programs (73 percent) are funded through percent for art ordinances or legislation, 13 percent allocate public funds for art in public places on a line item basis, and 9 percent (12 public agencies including redevelopment agencies and planning boards) mandate or encourage private developers to include public art in development projects. The remaining 5 percent of the government-initiated programs rely on other funds as their primary source, such as public and private grants, revenues from special taxes such as a hotel/motel tax, or receive public funds on a project by project basis.

Of the 99 *percent for art* programs included in this list, 53 were established since 1980, compared with 35 programs in the 1970s, and only a handful in the late '50s and '60s. The majority (79 programs) *mandate* a certain percentage of funds for public projects, while 20 programs make this a *voluntary* action on the part of the particular agency which has a public building project at hand. Of these 99 programs:

— 74 are municipal or county based;

— 24 are state programs; and

— one, the Art-in-Architecture program of the General Services Administration, is a federal program.

Nonprofit organizations

Within this category are included: arts and artist organizations which demonstrate ongoing activity in public art and/or commission temporary public artworks. Specifically, they range from private, nonprofit arts councils, to arts festivals, to artists' spaces. Without the guarantee of ongoing funds for public art such as percent for art programs afford, many of these organizations seek funds on a project-by-project basis. Most rely heavily on a combination of public and private support.

Collections, sculpture parks, colleges

There are many outdoor facilities throughout the country which exhibit large collections of sculptural artworks. Facilities like Storm King and Laumeier Sculpture Park, with their multi-acre grounds and large collections provide one important way for the public to view large-scale outdoor artworks. Colleges and universities have also provided artists with opportunities for researching and experimenting with new approaches to art. Some of the most prominent of these collections, initiated by both the public and private sectors, are presented here. For more comprehensive information, see: "Sculpture Parks and Gardens Throughout the World," *Sculptors International*, vol. 3, no. 1. (February 1984) International Sculpture Center, Washington, D.C.: 10-15.

Private sponsors

An increasing number of corporations are developing programs which actively commission artists to create new artworks for publicly accessible spaces in corporate settings. The General Mills Corporation, for example, has involved artists and a landscape architect in the creation of a coherent outdoor environment for the grounds of its suburban Minneapolis complex. The masterplan for this area, which is accessible to employees and the community, integrates topography, plantings, and sculpture. General Mills's art program provides opportunities for artists to experiment in large scale and with permanent materials, and enables them to select and design specific sites for their works.

The private sponsors listed here are primarily those whose activity extends beyond the purchase of existing works and includes the commissioning of new works. For more comprehensive information on corporate art collections, the following resources are useful:

— *ARTnews Directory of Corporate Art Collections*, published by ARTnews, New York, NY.

— *Directory of Corporate Art Collections*, published by the International Art Alliance, Largo, FL.

— "Corporate Collecting: A 1986 Survey of America's Most Active Corporate Collections," *Art & Auction*, October 1986, New York, NY.

**Government
Agencies**

Alaska

**Alaska State Council on
the Arts**
619 Warehouse Avenue, #220
Anchorage, AK 99501-1682
907-279-1558
Established 1975
Mandatory 1% constrct. costs
Open to all artists/preference
to local or in-state artists

**Municipality of Anchorage
P.O. Box 196550**
Anchorage, AK 99519-6650
907-264-6473
Established 1978
Mandatory 1% constrct. costs
Open to all artists

Arkansas

Arkansas Arts Council
Heritage Center East
Suite 250
Little Rock, AR 72201
501-371-2539
Established 1985
Voluntary .5% constrct. costs
Open to all artists/preference
to local or in-state artists

Arizona

**Arizona Commission on
the Arts**
417 West Roosevelt
Phoenix, AZ 85003
602-255-5882
Established 1967
Grants program category
Artist eligibility varies

**Casa Grande Arts &
Humanities Commission**
300 East Fourth Street
Casa Grande, AZ 85222
602-836-7471
Established 1986
Mandatory 1% constrct. costs
Restricted to in-state artists

City of Chandler
125 East Commonwealth
Chandler, AZ 85225
602-821-8520
Established 1983
Mandatory 1% constrct. costs
Open to all artists

Glendale Arts Commission
5127 West Northern Avenue
Glendale, AZ 85301
602-937-7554
Established 1983
Mandatory .5% constrct. costs
Open to all artists/preference
to local or in-state artists

Phoenix Arts Commission
2 North Central Ave.
Suite 125
Phoenix, AZ 85004
602-262-4637
Established 1987
Mandatory 1% constrct. costs
Open to all artists

Tucson/Pima Arts Council
P.O. Box 27210
Tucson, AZ 85726
602-624-0595
Established 1985
Voluntary 1% constrct. costs,
not to exceed $25,000
Open to all artists/preference
to local or in-state artists

California

**Berkeley Civic Arts
Commission**
2180 Milvia Street
Berkeley, CA 94704
Established 1985
Mandatory 1% constrct. costs

California Arts Council
1901 Broadway, Suite A
Sacramento, CA 95818-2492
916-445-1530
Established 1976
Line item appropriation
within administering agency's
budget
Open to all artists/preference
to local or in-state artists

Carlsbad Cultural Arts
City of Carlsbad
1200 Elm Avenue
Carlsbad, CA 92008
619-931-2901
Established 1985
Voluntary 1% constrct. costs
Artist eligibility varies

**City and County of
San Francisco
Department of City
Planning**
450 McAllister Street
San Francisco, CA 94102
415-558-2266
Mandatory 1% constrct. costs
Open to all artists

City of Brea
No. 1 Civic Center Circle
Brea, CA 92621
714-990-7713
Established 1976
Mandatory 1% constrct. costs
of private development
projects over $500,000;
donation to public art fund
instead is possible
Open to all artists

**City of Concord
Planning Department**
Concord, CA
415-671-3159
Established 1986
Mandatory .5% of private
development costs in excess
of $40,000 deposited into
Public Art Fund

City of Davis
Parks & Community Service
Department
23 Russell Boulevard
Davis, CA 95616
916-756-3747
Established 1974
Mandatory 1% constrct. costs
Open to all artists

City of Garden Grove
11391 Acacia Parkway
Garden Grove, CA 92640
714-38-6856
Established 1987
Mandatory .25% constrc. costs
Artist eligibility varies

City of Irvine
2815 McGaw / P.O. Box 19575
Irvine, CA 92713
714-660-3801
Established 1984
Private contributions
Artist eligibility varies

City of Laguna Beach
505 Forest Avenue
Laguna Beach, CA 92651
714-497-3311 x 211
Established 1986
Mandatory 1% constrct. costs
Open to all artists/preference
to local or in-state artists

**City of Mountain View
Planning Department**
P.O. Box 7540
Mountain View, CA 94039
Private development funds
encouraged but not required

City of Palm Desert
73510 Fred Waring Drive
Palm Desert, CA 92260
619-346-0611 x 288
Established 1986
Mandatory .5% constrct. costs
Open to all artists

City of Palo Alto
1313 Newell Road
Palo Alto, CA 94303
415-329-2218
Established 1977
Line item appropriation
within administering agency's
budget
Open to all artists

City of San Jose
Fine Arts Office
145 West San Carlos Street
San Jose, CA 95113
408-277-5144
Established 1984
Mandatory 1% constrct. costs
Open to all artists/preference
to local or in-state artists

City of Santa Barbara
P.O. Drawer P-P
Santa Barbara, CA 93102
805-963-1663
Established 1986
Request per project to City
Council
Open to all artists/preference
to local or in-state artists

City of Thousand Oaks
401 West Hillcrest Drive
Thousand Oaks, CA 91360
805-497-8611 x 200
Established 1986
Mandatory 1% constrct. costs
Artist eligibility varies

City of Walnut Creek
P.O. Box 8039
Walnut Creek, CA 94596
415-943-5866
Established 1983
Mandatory % of construction
costs for private and public
projects; % varies with private
development projects
Open to all artists

County of Santa Cruz
701 Ocean Street, Room 220
Santa Cruz, CA 95060
408-425-2395
Established 1981
Line item appropriation
within administering agency's
budget
Restricted to local artists

**Los Angeles Community
Redevelopment Agency**
354 South Spring Street
Los Angeles, CA 90013
213-977-1763
Established 1985
Mandatory 1% of private
development funds
Open to all artists

**Sacramento Housing &
Redevelopment Agency**
c/o Sacramento Metropolitan
Arts Commission
800 Tenth Street, Suite 2
Sacramento, CA 95814
916-449-5558
Established 1982
Re-development funds
Artist eligibility varies

**Sacramento Metropolitan
Arts Commission
City Percent for Art**
800 Tenth Street, Suite 2
Sacramento, CA 95814
916-449-5558
Established 1979
Mandatory 2% constrct. costs
Artist eligibility varies

**Sacramento Metropolitan
Arts Commission
County Percent for Art**
800 Tenth Street, Suite 2
Sacramento, CA 95814
916-449-5558
Established 1983
Mandatory 1% constrct. costs
Artist eligibility varies

**San Francisco Arts
Commission**
45 Hyde Street, Room 319
San Francisco, CA 94102
415-558-3463
Established 1969
Mandatory 2% constrct. costs
Open to all artists/preference
to local or in-state artists

**Santa Barbara County
Arts Commission**
1100 Anacapa Street
County Courthouse
Santa Barbara, CA 93101
805-963-7131
Established 1979
Mandatory 1% constrct. costs
Artist eligibility varies

**Santa Cruz City Arts
Commission**
346 Church Street
Santa Cruz, CA 95060
408-429-3778
Federal revenue sharing
Restricted to local artists

**Santa Monica Arts
Commission**
215 Santa Monica Pier
Santa Monica, CA 90401
213-393-9975
Established 1984
Mandatory 1% constrct. costs
Open to all artists/preference
to local or in-state artists

Comm. of the Marianas

**Commonwealth Council
for the Arts & Culture**
P.O. Box 553, CHRB
CNMI Convention Center
Saipan, CM 96950
670-322-9983
Line item appropriation
within administering agency's
budget
Open to all artists/preference
to local or in-state artists

Colorado

Colorado Council on the Arts & Humanities
770 Pennsylvania Street
Denver, CO 80203
303-866-2618
Established 1977
Mandatory 1% constrct. costs
Open to all artists/preference
to local or in-state artists

Commission on Cultural Affairs
303 West Colfax
Suite 1600
Denver, CO 80204
303-575-2678
Established 1987
Mandatory 1% of construction
costs
Open to all artists/preference
to local or in-state artists

Loveland High Plains Arts Council
Box 7058
Loveland, CO 80537
303-667-2659
Established 1984
Mandatory 1% constrct. costs
Open to all artists

Connecticut

Connecticut Commission on the Arts
190 Trumball Street
Hartford, CT 06106
203-566-4770
Established 1978
Mandatory 1% constrct. costs
Open to all artists

City of Hartford
Office of Cultural Affairs
550 Main Street, Room 300
Hartford, CT 06103
203-722-6493
Pending
Mandatory % constrct. costs
Open to all artists/preference
to local or in-state artists

City of Middletown Commission on Art
Spencer Municipal Annex
207 Westfield Street
Middletown, CT 06457
203-344-3520
Established 1977
Line item appropriation
within administering agency's
budget
Restricted to local artists

City of New Haven
Department of Cultural
Affairs
770 Chapel Street
New Haven, CT 06510
203-787-8956
Established 1983
Mandatory .25% to 1% of
construction costs
Open to all artists/preference
to local or in-state artists

District of Columbia

District of Columbia Commission on the Arts
1111 E Street, N.W.
Suite B500
Washington, DC 20004
202-724-5613
Established 1986
Mandatory 1% constrct. costs
Open to all artists

General Services Administration
Art-in-Architecture Program
18th & F Sts, N.W., Room
3331
Washington, DC 20405
202-566-0950
Established 1972
Voluntary .5% constrct. costs
Open to all artists

Delaware

Wilmington Arts Commission
City/County Building
800 North French Street
Wilmington, DE 19801
302-571-4100
Established 1981
Mandatory 1% constrct. costs
Open to all artists/preference
to local or in-state artists

Florida

Broward County Art in Public Places Program
100 South Andrews Avenue
Fort Lauderdale, FL 33301
305-357-7457
Established 1976
Mandatory $1.00 per square
foot of area accessible to the
public
Open to all artists

City of Miami Planning Department
275 Northwest Second Street
Miami, FL 33218
305-579-6086
Private development funds
encouraged for public art as
amenity in
bonused plaza spaces

**Florida Department of State
Div. of Cultural Affairs**
The Capitol
Tallahassee, FL 32399-0250
904-488-2180
Established 1979
Mandatory .5% constrct. costs
Open to all artists/preference
to local or in-state artists

Lee County Art in Public Places Board
P.O. Box 398
Dept. of Community Services
Fort Myers, FL 33902
813-335-2284
Established 1983
Voluntary 1.5% constrct. costs
Open to all artists/preference
to local or in-state artists

Metro-Dade Art in Public Places
111 N.W. First St., Suite 610
Miami, FL 33218
305-375-5362
Established 1973
Mandatory 1.5% constrct.
costs
Open to all artists

Orlando Public Art Board
Planning & Development
Department
400 South Orange Avenue
Orlando, FL 32801
305-849-2300
Established 1983
Mandatory 1% constrct. costs
Open to all artists

Georgia

Clarke County Community Relations Division
P.O. Box 352
Athens, GA 30603
404-354-2670
Established 1986
Voluntary variable % of
construction costs
Open to all artists/preference
to local or in-state artists

Fulton County Arts Council
42 Spring Street, S.W.
Plaza Level 16
Atlanta, GA 30303
404-586-4941
Established 1985
Line item appropriation
within admin. agency's budget
Open to all artists/preference
to local or in-state artists

Hawaii

Mayor's Office on Culture & the Arts
530 South King Street
4th Floor, City Hall
Honolulu, HI 96813
808-523-4674
Established 1968
Mandatory 1% constrct. costs
Open to all artists/preference
to local or in-state artists

State Foundation on Culture & the Arts
335 Merchant Street, Room 202
Honolulu, HI 96813
808-548-7657
Established 1967
Mandatory 1% constrct. costs
Open to all artists

Iowa

Iowa Arts Council
State Capitol Complex
Des Moines, IA 50319
515-281-4451
Established 1974
Mandatory .5% constrct. costs
Open to all artists/preference
to local or in-state artists

Illinois

Art-in-Architecture Program
IL Capital Development Board
401 South Spring, 3rd Floor
Springfield, IL 62706
217-782-9561
Established 1977
Mandatory .5% constrct. costs
Restricted to in-state artists

Beacon Street Gallery
4520 North Beacon
Chicago, IL 60640
312-561-3500
Re-development funds
Open to all artists

Chicago Office of Fine Arts
78 East Washington Street
Chicago, IL 60602
312-744-8941
Established 1978
Mandatory 1% constrct. costs
Open to all artists

Evanston Arts Council
Noyes Center
927 Noyes
Evanston, IL 60201
312-491-0266
Established 1986
Private contributions
Restricted to in-state artists

Louisiana

Arts Council of New Orleans
World Trade Center
2 Canal Street
Suite 936
New Orleans, LA 70130
504-523-1465
Established 1985
Mandatory 1% constrct. costs
Open to all artists/preference
to local or in-state artists

Maine

Maine Commission on the Arts and Humanities
55 Capitol Street, Station 25
Augusta, ME 04333
207-289-2724
Established 1979
Mandatory 1% constrct. costs
Open to all artists/preference
to local or in-state artists

Maryland

City of Baltimore Civic Design Commission
700 Municipal Building
Baltimore, MD 21202
301-396-3671
Established 1964
Mandatory 1% constrct. costs
Open to all artists

Mayor's Advisory Committee on Art & Culture
21 South Eutaw Street
Baltimore, MD 21201
Established 1974
Public and private funds
Artist eligibility varies

Montgomery County Art in Public Architecture
Department of Facilities & Services
110 North Washington Street
Rockville, MD 20850
301-738-8411
Established 1983
Mandatory 1% constrct. costs
Artist eligibility varies

Montgomery County Planning Department
8787 Georgia Avenue
Silver Springs, MD 20907
301-495-4570
Established 1983
Private development funds
required for public art within
bonused areas

Massachusetts

Arts On The Line
Cambridge Arts Council
57 Inman Street
Cambridge, MA 02139
617-864-5150
Established 1978
U.S. Department of
Transportation funds

Cambridge Arts Council
57 Inman Street
Cambridge, MA 02139
617-498-9033
Established 1979
Mandatory 1% constrct. costs
Open to all artists/preference
to local or in-state artists

Massachusetts Council on the Arts & Humanities
80 Boylston Street
Boston, MA 02116
617-727-3668
Established 1983
Mandatory 1% constrct. costs
Open to all artists

Office of the Arts & Humanities
City Hall, Room 720
Boston, MA 02201
617-725-3850
Established 1974
Private contributions
Open to all artists/preference
to local or in-state artists

Michigan

Cultural Arts Division
Parks & Recreation Department
26000 Evergreen
Southfield, MI 48037
313-354-4717
Established 1980
Line item appropriation
within admin. agency's budget
Open to all artists/preference
to local or in-state artists

Michigan Commission on Art in Public Places
1200 Sixth Avenue, P-120
Detroit, MI 48226
313-256-2800
Established 1980
Voluntary 1% constrct. costs
Open to all artists/preference
to local or in-state artists

Minnesota

Duluth Public Arts Commission
400 City Hall
Duluth, MN 55802-1196
218-723-3385
Established 1986
Mandatory 1% constrct. costs

Minnesota State Arts Board
Department of Administration
432 Summit Avenue
St. Paul, MN 55102
612-297-3371
Established 1983
Voluntary 1% constrct. costs
Open to all artists/preference to
local or in-state artists

Missouri

Kansas City Municipal Arts Commission
City Hall, 26th Floor
Kansas City, MO 64106
816-274-1515
Established 1986
Mandatory 1% constrct. costs

Regional Arts Commission
329 North Euclid Avenue
St. Louis, MO 63108
314-361-7441
Established 1986
Line item appropriation within
administering agency's budget
Open to all artists/preference to
local or in-state artists

Montana

Montana Arts Council
35 South Last Chance Gulch
Helena, MT 59620
406-444-6430
Established 1983
Voluntary 1% constrct. costs
Open to all artists

North Carolina

North Carolina Arts Council
Department of Cultural
Resources
Raleigh, NC 27611
919-733-2111
Established 1982
Line item appropriation
within administering agency's
budget
Open to all artists/preference
to local or in-state artists

The Arts Council, Inc.
305 West Fourth Street
Winston-Salem, NC 27101
919-722-2585
Private contributions
Open to all artists/preference
to local or in-state artists

Nebraska

Nebraska Arts Council
1313 Farnam-on-the-Mall
Omaha, NE 68102-1873
402-554-2122
Established 1979
Mandatory 1% constrct. costs
Open to all artists

New Hampshire

New Hampshire State Council on the Arts
40 North Main Street
Concord, NH 03301
603-271-2789
Established 1979
Mandatory .5% constrct. costs
Restricted to regional artists

New Jersey

Cape May County Cultural & Heritage Commission
DN 101 Library Office Bldg.
Cape May Court House
Cape May, NJ 08210
609-465-7111 x419
Established 1983
Voluntary 1.25% construction
costs
Open to all artists/preference
to local or in-state artists

New Jersey State Council on the Arts
109 West State Street,
CN-306
Trenton, NJ 08625
609-292-6130
Established 1978
Voluntary 1.5% constrct. costs
Open to all artists

New Mexico

City of Albuquerque
Cultural Affairs
423 Central Avenue, N.W.
Albuquerque, NM 87102
505-848-1370
Established 1979
Mandatory 1% constrct. costs
Open to all artists

City of Las Cruces
200 North Church
Las Cruces, NM 88001
505-526-0280
Established 1985
Line item appropriation
within administering agency's
budget
Restricted to local artists

New Mexico Arts Division
224 East Palace Avenue
Santa Fe, NM 87501
505-827-6490
Established 1986
Mandatory 1% constrct. costs
Open to all artists/preference
to local or in-state artists

New York

Arts Council of Rockland
Rockland County Health
Center
Building A, Room 201
Pomona, NY 10970
914-354-8400
Established 1987
Mandatory 1% constrct. costs

Battery Park City Redevelopment Authority
1 World Financial Center
18th Floor
New York, NY 10281-1097
212-416-5376
Private development funds
through redevelopment
authority

Buffalo Arts Commission
920 City Hall
Buffalo, NY 14202
716-855-5035
Established 1982
Voluntary 1-2% constrct.
costs
Open to all artists

Metro Transportation Authority
Arts for Transit
347 Madison Avenue, 5th
Floor
New York, NY 10017
212-878-7452
Established 1985
Voluntary 1% constrct. costs
Open to all artists

New York State Council on the Arts
915 Broadway
New York, NY 10010
212-614-2900
Established 1965
Line item appropriation
within administering agency's
budget
Open to all artists

New York City Department of Cultural Affairs
Percent for Art Program
2 Columbus Circle
New York, NY 10019
212-974-1150
Established 1983
Mandatory 1% constrct. costs
Open to all artists

Port Authority of New York & New Jersey
1 World Trade Center,
Room 82W
New York, NY 10048
212-466-4211
Established 1969
Voluntary 1% constrct. costs
Open to all artists/preference
to local or in-state artists

Ohio

**Arts Commission of
Greater Toledo**
618 North Michigan Street
Toledo, OH 43624
419-255-8968
Established 1977
Mandatory 1% of construction
costs
Open to all artists

Ohio Arts Council
727 East Main Street
Columbus, OH 43205-1796
614-466-2613
Established 1980
Line item appropriation within
administering agency's budget
Open to all artists

Oklahoma

Tulsa Arts Commission
2210 South Main
Tulsa, OK 74114
918-584-3333
Established 1969
Mandatory 1% constrct. costs
Open to all artists/preference
to local or in-state artists

Oregon

Beaverton Arts Commission
P.O. Box 4755
Beaverton, OR 97076
503-526-2222
Established 1985
Mandatory 1% constrct. costs
Open to all artists

**Facilities Development
Department
City of Eugene**
One Eugene Center
Eugene, OR 97401
503-687-5074
Established 1971
Mandatory 1% constrct. costs
Open to all artists

**Metropolitan Arts
Commission
City Percent for Art**
1120 S.W. Fifth Avenue
Portland, OR 97204
503-796-5111
Established 1980
Mandatory 1% constrct. costs
Open to all artists

**Metropolitan Arts
Commission
County Percent for Art**
1120 S.W. Fifth Avenue
Portland, OR 97204
503-796-5111
Established 1980
Voluntary 1.33% construction
costs
Open to all artists

Oregon Arts Commission
835 N.E. Summer Street
Salem, OR 97301
503-378-3625
Established 1975
Mandatory 1% constrct. costs
Open to all artists/preference
to local or in-state artists

Pennsylvania

**City of Pittsburgh Art
Commission**
Public Safety Building
Pittsburgh, PA 15219
412-255-2211
Established 1978
Mandatory 1% constrct. costs
Restricted to local artists

**Fairmount Park Art
Association**
1530 Locust Street
Suite 3A
Philadelphia, PA 19102
215-546-7550
Established 1872
Public and private funds
Open to all artists

Office of Arts & Culture
Percent for Art Program
1680 Municipal Services
Building
Philadelphia, PA 19102-1684
215-686-8685
Established 1959
Mandatory 1% constrct. costs
Artist eligibility varies

**Philadelphia
Redevelopment Authority**
1234 Market Street, 8th Floor
Philadelphia, PA 19107
215-854-6692
Established 1959
Mandatory 1% of private
development funds
Open to all artists

Rhode Island

**Warwick Consortium of
the Arts & Humanities**
3275 Post Road
Warwick, RI 02886
401-738-2000 x 372
Established 1988
Mandatory 1% constrct. costs
Open to all artists

South Carolina

**South Carolina Arts
Commission**
1800 Gervais Street
Columbia, SC 29201
803-734-8696
Established 1981
Voluntary .5% constrct. costs

Tennesee

**Tennesee Arts
Commission**
320 Sixth Avenue, North
Suite 100
Nashville, TN 37219
615-741-1701
Established 1967
Line item appropriation
within administering agency's
budget
Restricted to in-state artists

Texas

**Arts Council of Brazos
Valley**
111 University, Suite 217
College Station, TX 77840
409-268-2787
Established 1970
Hotel/motel tax
Open to all artists/preference
to local or in-state artists

**City of Austin/Art in
Public Places**
Parks & Recreation
Department
P.O. Box 1088
Austin, TX 78767
512-477-1508
Established 1985
Mandatory 1% constrct. costs
Open to all artists

City of Corpus Christi
c/o Multicultural Center
1581 North Chaparral
Corpus Christi, TX 78401
512-883-0639
Established 1987
Mandatory 1.25% constrct.
costs
Open to all artists/preference
to local or in-state artists

**Division of Cultural
Affairs**
Majestic Theatre, Suite 600
1925 Elm Street
Dallas, TX 75021
214-670-3687
Established 1988
Mandatory 1.5% constrct.
costs
Open to all artists

**Texas Commission on the
Arts**
Box 13406
Capitol Station
Austin, TX 78711
512-463-5535
Established 1979
Voluntary 1% constrct. costs
for select public buildings
Open to all artists/preference
to local or in-state artists

Utah

Salt Lake Art Design Board
54 Finch Lane
Salt Lake City, UT 34102
801-538-2171
Established 1979
Mandatory 1% constrct. costs
Open to all artists/preference
to local or in-state artists

Utah Arts Council
617 East South Temple
Salt Lake City, UT 84102
801-533-5895
Established 1985
Voluntary 1% constrct. costs
Open to all artists/preference
to local or in-state artists

Virginia

Virginia Beach Arts & Humanities Commission
Municipal Center
Virginia Beach, VA 23456
804-427-4701
Established 1986
Mandatory 1% constrct. costs
Open to all artists/preference
to local or in-state artists

Washington

Bellevue Arts Commission
P.O. Box 90012
Bellevue, WA 98009
206-455-6885
Established 1987
Mandatory 1.7% cnstrct. costs

City of Kent Arts Commission
220 Fourth Avenue, South
Kent, WA 98032
206-872-3350
Established 1986
Line item appropriation
within administering agency's
budget
Open to all artists

City of Seattle Department of Construction & Land Use
400 Municipal Building
Seattle, WA 98104
206-625-4591
Established 1985
Private development funds
required for public art
to accompany certain public
amenities

Edmonds Arts Commission
700 Main Street
Edmonds, WA 98020
206-775-2525 x 269
Established 1979
Mandatory 1% constrct. costs
Open to all artists/preference
to local or in-state artists

Everett Cultural Commission
3002 Wetmore
Everett, WA 98201
206-259-8708
Mandatory 1% constrct. costs
Open to all artists/preference
to local or in-state artists

King County Arts Commission
828 Alaska Building
618 Second Avenue
Seattle, WA 98104
206-344-7580
Established 1973
Mandatory 1% constrct. costs
Open to all artists/preference
to local or in-state artists

Mountlake Terrace Fine Arts Council
5303 228th Street, S.W.
Mountlake Terrace, WA
98043
206-776-8956
Established 1976
Mandatory 1% constrct. costs
Restricted to regional artists

Municipality of Metropolitan Seattle Downtown Seattle Art in Transit Project
821 Second Avenue
Seattle, WA 98199
206-684-1406
Voluntary .5% constrct. costs
Open to all artists

Renton Municipal Arts Commission
200 Mill Avenue, South
Renton, WA 98055
206-235-2580
Established 1975
Mandatory 1% constrct. costs
Restricted to regional artists

Seattle Arts Commission
305 Harrison Street
104 Center House
Seattle, WA 98109
206-625-4223
Established 1973
Mandatory 1% of all capital
construction and bond issues
Open to all artists

Spokane Arts Commission
West 808 Spokane Falls
Boulevard
Spokane, WA 99201-3333
509-456-3857
Established 1982
Mandatory 1% constrct. costs
Open to all artists/preference
to local or in-state artists

Washington State Arts Commission
Mail Stop GH-11
Olympia, WA 98504-4111
206-753-3860
Established 1974
Mandatory .5% constrct. costs
Open to all artists

Wenatchee Arts Commission
P.O. Box 2111
Wenatchee, WA 98801
509-662-6991
Established 1977
Mandatory 1% constrct. costs

Wisconsin

Madison Committee for the Arts
215 Monona Avenue
Room 120
Madison, WI 53710
608-266-6089
Established 1978
Line item appropriation
within administering agency's
budget
Open to all artists

Milwaukee Art Commission
P.O. Box 324
Milwaukee, WI 53201
414-223-5818
Established 1979
Voluntary 1% constrct. costs
Restricted to in-state artists

Wisconsin Arts Board
107 South Butler Street
Madison, WI 53703
608-266-1968
Established 1980
Mandatory .2% constrct. costs
Open to all artists/preference
to local or in-state artists

West Virginia

West Virginia Arts & Humanities Commission
Department of Culture &
History Culture Center
Capitol Complex
Charleston, WV 25305
304-348-0240
Established 1977
Line item appropriation
within administering agency's
budget
Open to all artists

Wyoming Council on the Arts
2320 Capitol Avenue
Cheyenne, WY 82002
307-777-7742
Established 1985
Mandatory 1% constrct. costs
Open to all artists/preference
to local or in-state artists

Nonprofit Organizations

Foundation for Art Resources
P.O. Box 38145
Los Angeles, CA 90038
213-661-2290
Established 1977
Open to all artists

Installations
930 E Street
San Diego, CA 92101
619-232-9915
Established 1983
Open to all artists

Inter-Arts of Marin
1000 Sir Francis Drake Blvd.
San Anselmo, CA 94960
415-457-9744
Established 1980
Private contributions
Artist eligibility varies

Los Angeles Festival
P.O. Box 5210
Los Angeles, CA 90055-0210
213-689-8800
Public and private funds

Otis Arts Institute
Parsons School of Design
2401 Wilshire Boulevard
Los Angeles, CA 90051
213-251-0556
Established 1983
Public and private funds
Open to all artists

San Luis Obispo County Arts Council
P.O. Box 1710
San Luis Obispo, CA 93406
805-544-9251
Established 1985
Restricted to in-state artists

International Sculpture Center
1050 Potomac Street
Washington, DC 20007
202-965-6066
Established 1980
Private contributions
Open to all artists

Washington Project for the Arts
434 Seventh Street, N.W.
Washington, DC 20004
202-347-4813
Open to all artists

Palm Beach County Council of the Arts
1555 Palm Beach Lakes
Boulevard, #206
West Palm Beach, FL 33401-2371
305-471-2901
Established 1982
Line item appropriation
within administering agency's budget
Restricted to local artists

Pasco Fine Arts Council
2011 Moog Road
Holiday, FL 33590
813-845-7322
Established 1986
Local arts development grant
Open to all artists/preference
to local or in-state artists

Arts Festival of Atlanta
1404 Spring Street, Suite 1
Atlanta, GA 30309
404-885-1125
Public and private funds
Open to all artists

Cedar Arts Forum, Inc.
415 Commerical, Suite 310
Waterloo, IA 50701
319-291-6333
Established 1977
Restricted to local artists

Cedar Rapids/Marion Arts Council
P.O. Drawer 4860
Cedar Rapids, IA 52407
319-398-5322
Established 1984
Public and private grants
Open to all artists

Visiting Artists, Inc.
106 East Third Street
Suite 220
Davenport, IA 52801
319-326-5190
Established 1980
Public and private funds
Open to all artists

Mile 4 Sculpture Exhibition
Lakeside Group
600 North McClurg Court
Chicago, IL 60611
312-787-6858
Established 1982
Private contributions

Contemporary Sculpture at Chesterwood
P.O. Box 827
Stockbridge, MA 01262
413-298-3579
Public and private funds

Maryland Art Place
218 West Saratoga Street
Baltimore, MD 21201
301-962-8565
Established 1985
Re-development funds
Open to all artists

Metro Arts
P.O. Box 1077 DTS
Omaha, NE 68101
402-341-7910
Established 1978
Private contributions
Open to all artists

Collaborative Projects, Inc.
P.O. Box 404
Prince Street Station
New York, NY 10012
Established 1978
Open to all artists

Creative Time
66 West Broadway Avenue
New York, NY 10007
212-619-1955
Established 1973
Public and private funds
Open to all artists

Organization of Independent Artists
201 Varick Street
New York, NY 10014
212-929-6688
Established 1977
Open to all artists

Public Art Fund
25 Central Park West
New York, NY 10023
212-541-8423
Established 1977
Public and private grants
Open to all artists/preference to local or in-state artists

Miami Valley Arts Council
P.O. Box 95
Dayton, OH 45402
513-228-0737
Established 1977
Public grants
Open to all artists

SPACES
Committee for Public Art
1216 West Sixth Street
Cleveland, OH 44113
216-621-2314
Established 1984
Private contributions
Open to all artists

Fairmount Park Art Association
1530 Locust St., Suite 3A
Philadelphia, PA 19102
215-546-7550
Established 1872
Public and private funds
Open to all artists

Mattress Factory
500 Sampsonia Way
Pittsburgh, PA 15212
412-231-3169
Open to all artists

Three Rivers Arts Festival
207 Sweetbriar Street
Pittsburgh, PA 15211
412-481-7040
Public and private funds

Diverseworks
214 Travis Street
Houston, TX 77002
713-223-9140
Established 1982
Restricted to in-state artists

Navarro Council of the Arts
P.O. Box 2224
119 West Sixth Avenue
Corsicana, TX 75110
214-872-5411
Established 1978
Line item appropriation within administering agency's budget
Open to all artists/preference to local or in-state artists

Collections, Sculpture Parks, Colleges

La Jolla Museum of Contemporary Art
700 Prospect Street
La Jolla, CA 92037
619-454-3541

Stanford University Art Department
Panel on Outdoor Art
Crown Quadrangle
Stanford, CA 94305

Stuart Collection
University of California at San Diego
B-027
La Jolla, CA 92093
619-534-2117
Public and private funds

The Art Museum and Galleries
1250 Bellflower Boulevard
California State University
Long Beach, CA 90840

Hayden Gallery
Massachusetts Institute of Technology
77 Massachusetts Avenue
Cambridge, MA 02139
617-253-4680

University Gallery
Fine Arts Center
University of Massachusetts
Amherst, MA 01003
413-545-3670

University of Massachusetts Arts Council
125 Herter Hall
University of Massachusetts
Amherst, MA 01003
413-545-0202
Established 1987
Line item appropriation within administering agency's budget
Open to all artists

Laumeier Sculpture Park
12580 Rott Road
St. Louis, MO 63127
314-821-1209
Established 1976
Private contributions
Open to all artists

New Mexico State University
University Gallery
Department of Art
Las Cruces, NM 88001
505-646-2545

Artpark
Box 371
Lewiston, NY 14092
716-754-9001
Established 1974
Public and private funds
Open to all artists

PEPSICO, Inc.
700 Anderson Hill Rd.
Purchase, NY 10577
914-253-2000

Socrates Sculpture Park
Broadway at Vernon Blvd.
P.O. Box 6259
Long Island City, NY 11106
718-956-1819

State University of New York
Neuberger Museum
Purchase, NY 10577
914-253-5087

Storm King Art Center
Old Pleasant Hill Road
Mountainville, NY 10953
914-534-3190
Public and private funds

Fairmount Park Art Association
1530 Locust Street
Suite 3A
Philadelphia, PA 19102
215-546-7550
Established 1872
Public and private funds
Open to all artists

Institute of Contemporary Art
University of Pennsylvania
34th & Walnut Streets
Philadelphia, PA 19104
215-898-7108

Richland College
12800 Abrams
Dallas, TX 75243
214-238-6133
Established 1982
Student funds
Open to all artists

University of Houston
4800 Calhoun
Houston, TX 77004
713-749-1329
Established 1966
Voluntary % of construction costs
Open to all artists/preference to local or in-state artists

Western Washington University
Bellingham, WA 98225
206-676-3255
Open to all artists

**Private
Sponsors**

Bank America Corporation
CRE - Art Program #3021
P.O. Box 37000
San Francisco, CA 94137
415-622-1265

C.J. Segerstrom & Sons
3315 Fairview Road
Costa Mesa, CA 92626
714-546-0110

Maguire Thomas Partners
1299 Ocean Avenue
Suite 1000
Los Angeles, CA 90405
213-680-1787

The Koll Company
1731 Technology Drive, #300
San Jose, CA 954110
408-280-6400

John Madden Company
6312 S. Fiddler's Green Circle
Suite #150E
Englewood, CO 80111
303-773-0400

Bakery Centre
Martin Z. Margulies
Collection
5201 Sunset Drive
South Miami, FL 33143
305-662-4155

First Banks Minneapolis
P.O. Box 522, M3 FE 020
1300 First Bank Place East
Minneapolis, MN 55480
612-343-1575

General Mills, Inc.
P.O. Box 1113
Minneapolis, MN 55440
612-540-7269

Commerce Bancshares
1000 Walnut
Box 13686
Kansas City, MO 64106
816-234-2968

Johnson & Johnson
1 Johnson & Johnson Plaza
New Brunswick, NJ 08933

Art in Public Space, Inc.
150 Purchase Street
Rye, NY 10580
914-967-7500

Chase Manhattan Bank
410 Park Avenue
New York, NY 10022
212-223-6132

Equitable Investment
787 Seventh Avenue
New York, NY 10019
212-554-1704

Olympia & York Properties
World Financial Center
200 Liberty Street, 18th Floor
New York, NY 10281
212-945-2600

Gerald P. Hines Interests
2800 Post Oak Boulevard
Houston, TX 77056
713-621-8000

**Raymond D. Nasher
Corporation**
8950 North Central
Suite 400
Dallas, TX 75231
214-369-6551

Jerry Allen is the director of the Division of Cultural Affairs in Dallas, Texas. Allen implemented a comprehensive study of the potential for a public art program for Dallas which has resulted in the recent passage of a percent for art ordinance. He is the former director of the King County Arts Commission in Seattle, Washington, where he oversaw the county's percent for art program. With the Arts Commission, he designed and managed special projects in the visual arts including the 1979 international sculpture symposium, EARTHWORKS: Land Reclamation as Sculpture. Allen consults in public art and is also a sculptor.

Penny Balkin Bach is executive director of the Fairmount Park Art Association, a private nonprofit organization chartered in 1872 and dedicated to the support of public sculpture in Philadelphia. A commitment to the integration of art and urban planning characterizes the work of the Association. Formerly director of the Department of Community Programs at the Philadelphia Museum of Art, Bach currently serves on the mayor's Cultural Advisory Council and the Advisory Committee for Public Sculpture for the City of Philadelphia. She was a member of the Advisory Panel for the Public Monument Conservation Project of the National Institute for the Conservation of Cultural Property and has worked with communities and public agencies to plan, select, and execute public art programs.

Paul Broches has been associated with Mitchell/Giurgola Architects since 1971 and has been managing partner since 1982. The firm engages primarily in commissions for public and institutional buildings such as the House of Parliament in Canberra, Australia; state office buildings in Harrisburg, Pennsylvania, and St. Louis, Missouri; and many university buildings. In all these projects Mitchell/Giurgola has either initiated or strongly encouraged the inclusion of significant works of art. Broches has been directly involved in collaborative efforts with artists for site-specific works that have been successfully executed in connection with Mitchell/Giurgola building projects. These include the Paris Opera Competition with Richard Fleischner and the Volvo Corporate Headquarters, Gothenburg, Sweden. He has been a visiting critic at the Schools of Architecture at Columbia, Tulane, and Virginia Polytechnic Institute.

David Collens is the director/curator for the Storm King Art Center in Mountainville, New York, one of the largest outdoor sculpture museums in the United States with works by international artists exhibited in a 350-acre park. Collens completed a graduate fellowship in Museum and Communication Methods at the Rochester Museum and Science Center. He is a member of the Arts Advisory Committee for the Metropolitan Transportation Authority in New York City.

John Dryfhout is the North Atlantic Regional Curator for the National Park Service. Prior to that, Dryfhout was the superintendent and chief curator for the Saint-Gaudens National Historic Site in Cornish, New Hampshire. He is assisting the New York City Commission on the Arts in recommendations for the disposition of the Saint-Gaudens monuments of Admiral Farragut and Sherman. Dryfhout is the author of several publications on Saint-Gaudens and other topics of historic preservation.

Jackie Ferrara is an artist living in New York City. Public commissions in progress include a 400-foot limestone courtyard set into the side of a hill for the General Mills Sculpture Garden in Minneapolis; a terrace for the Science Building at the University of California at San Diego under the auspices of the Stuart Collection; and a courtyard for a county building in Atlanta, Georgia, in collaboration with M. Paul Friedberg. In one of many past collaborations, Cardinal Industries, Inc., makers of modular housing, invited Ferrara to design an outdoor work to be built by factory workers. The work then toured to three museums.

M. Paul Friedberg, landscape architect, product designer, educator, and writer has been on the faculty of Columbia University, The New School for Social Research, and Pratt Institute. At present he is director (as well as founder) of the Urban Landscape Architecture Program at City College of New York. Mr. Friedberg is a fellow of the American Society of Landscape Architects and serves as advisor to the Institute of Urban Design and the International Design Conference in Aspen. He is a trustee of the American Academy in Rome, a member of the American Institute of Planners, and is on the advisory board of the School of Architecture at Cornell. He was a founding partner in 1958 for M. Paul Friedberg and Partners, Landscape Architecture and Urban Design, and is partner in charge of design and planning.

Patricia Fuller consults and lectures nationally on public art. She has been associated with both public and private organizations and has consulted on the legislation, planning, and implementation of municipal and state public art programs. As visual arts coordinator for the Seattle Arts Commission between 1976 and 1978, she implemented that city's new percent for art ordinance. She served as coordinator for Art in Public Places at the NEA from 1978 to 1981 and as executive director of the Metro-Dade County Art in Public Places program from 1983 to 1985.

Richard Haas is best known for his monumental trompe l'oeil urban murals. Since 1974, he has received numerous public and private commissions, recently among them: the Smithsonian's new Quadrangle Museum Complex in Washington, D.C., Harry Cain Tower in Miami (through Metro-Dade Art in Public Places), and the Thunderbird Fire and Safety Equipment Corporation, in Phoenix. Mr. Haas is on the board of directors of New York City's Public Art Fund.

Kathy Halbreich is an independent curator and arts consultant currently organizing exhibitions for the Hirschorn Museum and Sculpture Garden in Washington, D.C. and the Carnegie Museum in Pittsburgh. She was the director of the List Visual Arts Center at the Massachusetts Institute of Technology where she oversaw an innovative exhibition program and was responsible for MIT's publicly-sited permanent collection. She administered the institution's one percent for art funds which made possible the collaboration between I.M. Pei, Scott Burton, Kenneth Noland, and Richard Fleischner on the Jacob Wiesner Building at MIT. Halbreich is also a member of the Massachusetts Council on the Arts and Humanities.

Thomas Hine has been architecture and design critic for *The Philadelphia Inquirer* since 1973. His column, "Surroundings," and other articles are distributed to more than 100 newspapers throughout the United States. He has also written for *Architecture, Progressive Architecture, Portfolio,* and other magazines. He has written nearly 2,000 articles on architecture, urban design, planning issues, public art, furniture, product design, and related subjects. He has taught in both the architecture and urban studies programs at Temple University and in the Graduate School of Fine Arts at the University of Pennsylvania.

Barbara Hoffman practices law with Steckler, Hoffman, and Steckler in New York City. As former chair of the Subcommittee on Public Art for the Association of the Bar of the City of New York, she guided the drafting of the Annotated Model Agreement for the Commissioning of a Work of Public Art. In addition, Hoffman has been an arts and entertainment lawyer for 15 years, was president and founder of Washington Lawyers for the Arts, an associate professor of law at the University of Puget Sound School of Law from 1975 to 1982, and a visiting professor of land use law at the Graduate School of Architecture and Urban Planning at the University of Washington, Seattle. She also teaches a course in art and the law at the School of Visual Arts in New York.

Sam Hunter is an art historian and professor in the Department of Art and Archaeology at Princeton University. He is serving onthe task force appointed by the National Endowment for the Artsto review issues of relocating Richard Serra's *Tilted Arc.* Besides numerous other teaching posts, Hunter has organized international exhibitions including the American section at the1976 Venice Biennale. Hunter is the author of many books on modern art and artists such as George Segal, Isamu Noguchi, and Joseph Albers. He has been an editor for Harry N. Abrams, Inc., publishers, associate curator in the Department of Painting and Sculpture at the Museum of Modern Art, and founding director of the Rose Art Museum and Poses Institute of Fine Arts at Brandei University.

Richard A. Kahan is managing director of Continental Development Group, Inc., a real estate development firm specializing in large complex projects. From 1976 through 1984, Mr. Kahan served as president and chief executive officer of New York State Urban Development Corporation, chairman of the Battery Park City Authority, and president of Convention Center Development Corporation. Under his direction, the Battery Park City Authority initiated a review of financial and developmental options for lower Manhattan's Battery Park City. Mr. Kahan instituted the model architectural and design program joining artists and designers in a collaborative process to develop the plan for the residential and commercial complex.

Cindy Kelly was the director of Visual Arts programs at the Maryland State Arts Council where she was responsible for maintaining the Visual Arts Resource Center, a program she designed and which resulted in many commission and exhibition opportunities for Maryland artists. In addition, she administered the Council's Art in Public Places program, which over seven years commissioned some of the country's leading artists. She is also a frequent panelist and consultant for visual arts programs in the Mid-Atlantic region and served as a consultant to the Montgomery County Planning Commission from 1983-85 to coordinate public art projects in Bethesda. Kelly holds a masters degree in art history from the Johns Hopkins University and taught art history at Goucher College from 1978-80.

Joyce Kozloff has a long and established career as a painter with pieces in the collections of the Metropolitan Museum and the Museum of Modern Art in New York, and in the National Gallery in Washington, D.C. Currently she is working on a series of tile architectural installations for urban transportation systems in Detroit and southern California. She previously completed four similar projects in Cambridge, Wilmington, San Francisco, and Buffalo. Kozloff is a past advisory board member of New York City's Public Art Fund.

Pallas Lombardi is the artistic director at CityPlace, a multi-arts facility operated by the Artists Foundation within the new Massachusetts Transportation Building in Boston. She is the former director of Arts On The Line, a nationally recognized public art in the subways project of the U.S. Department of Transportation and the Massachusetts Bay Transportation Authority, coordinated by the Cambridge Arts Council. She also serves as a public art consultant, is graduate lecturer in Cultural Policy and the Arts at Lesley College in Cambridge, and received one of twelve Governor's Design Awards as director of Arts On The Line and one of five AIA National Awards for the same program.

Jack Mackie is an artist living in Seattle. He is presently the lead artist on the design team for the Downtown Seattle Transit Project's public art program. He has served as a consultant for the city of Dallas on a public art plan and for a Seattle architectural firm on site planning and building exteriors for a project of the Seattle Parks and Recreation Department. He has had several permanent public art commissions including a collaborative project with artist Buster Simpson to develop the First Avenue Landscape plan, an ongoing artists' laboratory for urban design and public art.

Edward C. Marschner, a partner in the New York law firm of Fox Glynn & Melamed, generally advises clients on structures for international business activities. Among his early arts-related work was representing the architects Piano & Rogers in the construction of the Centre Pompidou in Paris. After representing a number of artists in negotiating contracts for commission of painting and sculpture in public places, Marschner participated, as a member of the Committee on Art Law (Association of the Bar of the City of New York), in the preparation of the Annotated Model Agreement for the Commission of Public Art.

Virginia Norton Naudé is a conservator of sculpture and decorative arts with a specialty in the conservation of stone, terra cotta, wood, plaster, and metals. She is a consultant and contractor to institutions and private collectors for surveys, seminars, laboratory and site treatments and currently directs a laboratory at the Pennsylvania Academy of the Fine Arts in Philadelphia. In 1985, Naudé organized for the Academy a conference on outdoor sculpture preservation and edited *Sculptural Monuments in an Outdoor Environment* which summarizes the conference.

John Neff is the director of the Art Program and art advisor for The First National Bank of Chicago whose collection contains over 5,000 works of art and is displayed in bank branches worldwide. Neff oversees acquisitions, exhibition, conservation, and educational programs related to the collection. He is the former director of the Museum of Contemporary Art in Chicago where he initiated commissions of sound, facade, and wall installations as an integral and permanent part of the structure of a museum building addition. Neff has lectured extensively on a variety of topics in contemporary art including issues of public art. He has served on numerous art juries and is a Professional Advisory Committee member for the Metro-Dade Art in Public Places program.

Al Nodal is the director of the Contemporary Arts Center in New Orleans. He is the former director of the Exhibition Center at the Otis Art Institute of Parsons School of Design in Los Angeles. While there, he was the director of the MacArthur Park Public Art Program which has become a model program for community outreach in the form of neighborhood organizing. Nodal was the executive director of the Washington Project for the Arts in Washington, D.C., during which time he was cited as Washingtonian of the Year and was given the Mayor's Art Award for Community Service. Nodal has also coordinated citywide sound installations for the New Music America '85 Festival.

Sandra Percival has, since 1980, managed the Washington State Arts Commission's Art in Public Places Program. She has organized symposia and conferences on public art, including the 1981 "Art in Institutions" symposium in Washington State and the 1982 and 1985 national meetings of visual and public art professionals. Percival has exhibited her own work, coordinated exhibitions for the American Craft Museum, and published on topics in the visual arts.

Nancy Rosen is a principal in the Fine Arts Planning Group in New York City and has been a fine arts consultant to developers, corporations, and nonprofit organizations since 1974. She was the fine arts consultant and program coordinator of the public art program for the Battery Park City commercial and residential development in lower Manhattan. She has recently been an advisor for the public art component of a complex proposed for lower Manhattan that includes the Staten Island Ferry Terminal, the Battery Maritime Building, and an office tower. Rosen has organized a number of sculpture exhibitions including the American artists for Documenta 6, an international exhibition in 1976, and Monumenta, in Newport, Rhode Island, in 1974.

George Segal is an artist living in New Jersey. His work is in the collections of the Museum of Modern Art, the Metropolitan Museum of Art, the Hirschorn Museum and Sculpture Garden and the Art Institute of Chicago, among others. He has been commissioned to do numerous public art-works, many of which have been the subject of public controversy. Public artworks include: *The Holocaust* in San Francisco, *Gay Liberation* commissioned for Sheridan Square in Manhattan, the *Kent State Memorial* at Princeton University, and *The Restaurant* in Buffalo, New York.

Ari Sikora is a principal in Urban Strategies, a Los Angeles-based development consulting firm. Previously, Sikora worked as an urban designer and redevelopment planner in the private and public sectors. She has planned and/or managed a variety of large-scale land development projects, municipal general plans, and public and private redevelopment projects throughout the United States and one in Iran. Sikora is a past director of the Policy Planning Team for the 1,500-acre Central Business District Redevelopment Project administered by the Los Angeles Community Redevelopment Agency. Sikora was also responsible for the Agency's initiation of numerous cultural programs and arts-affiliated projects such as the development of the $16 million UDAC-assisted Los Angeles Theatre Center, the $23 million Museum of Contemporary Art, the Agency's Downtown Art Collection, and the recently adopted Downtown Art in Public Places Policy.

Alexis Smith is an artist living in Los Angeles. Smith's public artworks include *Monuments*, which was part of the MacArthur Park (Los Angeles) Public Art Program, *The Grand,* a permanent painted installation with collage works on three levels, in Grand Center, Grand Rapids, Michigan, and *Starlight*, for Unity Savings and Loan in West Hollywood, California. Smith has had one-person exhibitions at the Whitney Museum of American Art, the Walker Art Center, Minneapolis, the Brooklyn Museum and the Aspen Art Museum. She has also received two National Endowment for the Arts Fellowships and has taught at UCLA since 1979.

Lynne Sowder is curator and director of Visual Arts for The First Banks in Minneapolis, where she has been instrumental in developing an adventurous collection and in directing attention to the education of adults about contemporary art. Sowder is an art historian and former independent consultant.

Susanna Torre is partner in charge of design at the New York firm of Wank Adams Slavin Associates, Architects and Engineers. She is also an associate professor of architecture at Columbia University's Graduate School of Architecture and Urban Planning. She curated and designed the exhibition, "Women in American Architecture: An Historic and Contemporary Perspective," which opened at the Brooklyn Museum of Art in 1977 and toured the United States for six years. A native of Argentina, Torre created the first department of architecture and design in a Latin American Museum at the University of Buenos Aires.

Cesar Trasobares is the executive director of Metro-Dade County Art in Public Places. As director, and prior to that, as project coordinator at Metro-Dade, he has been responsible for projects by Richard Haas, Rockne Krebs, Claes Oldenburg, Elyn Zimmerman, Max Neuhaus, Nam June Paik, David Antin, and Robert Irwin, among others. He has developed a strong community education focus including education programs linking public schools with the county's public art collection. Trasobares was chairman of the Department of Continuing Education at Miami-Dade Community College where he managed the Institute for Urban Community Education. He has also been an instructor of the arts in the Miami area elementary schools. A visual artist, Trasobares has received artists' fellowships from the Cintas Foundation (1979) and the National Endowment for the Arts (1980).

John Westbrook is the president and co-founder of Placemakers, a design and development corporation in Kensington, Maryland. Westbrook organized the first Urban Design Division for the city of Baltimore, where he led efforts on urban design for the Inner Harbor as well as for various neighborhood and commercial centers. As chief of the Urban Design Division for the Maryland National Capital Park and Planning Commission, he coordinated the Bethesda Metro Center, a mixed-use development project. Westbrook's negotiations with developers resulted in public amenity improvements including several public art projects. Westbrook has also worked as a design coordinator for the Rouse Company.

Deborah Whitehurst is the executive director of the Phoenix Arts Commission. Under her direction, the Commission proposed and successfully passed a percent for art ordinance after a comprehensive study to define the role of the Arts Commission, established by the city in 1985. Whitehurst was formerly the deputy director of the Arizona Commission on the Arts where she initiated a program to make direct grants to cities and towns for art in public places projects. Whitehurst has been active in issues of urban planning regarding downtown streetscapes, freeways, and historic neighborhood preservation.

Elyn Zimmerman is an artist living in New York City. Zimmerman's permanent public art commissions include *Terrain*, at the O'Hare International Center in Chicago, a multilevel plaza/garden inspired by the glaciated terrain of the Great Lakes, *Keystone Island*, a 'rock island' set into a tidal lagoon adjacent to the Dade County Courthouse in Miami, and *Marabar*, for the National Geographic Society Headquarters in Washington, D.C. She has completed numerous temporary commissions and recently won a competition in collaboration with Mitchell/Giurgola Architects for a civic plaza for Davenport, Iowa. Zimmerman has received NEA Artist Fellowships and is in the collections of the Los Angeles County Museum of Art, the Whitney Museum of American Art, the Chase Manhattan Bank, and other public and corporate institutions.